Jacob Lawrence

Jacob Lawrence
PAINTINGS, DRAWINGS, AND MURALS (1935–1999)
A CATALOGUE RAISONNÉ

Peter T. Nesbett

Michelle DuBois

WITH ASSISTANCE FROM

Stephanie Ellis-Smith

University of Washington Press,

Seattle and London

in association with

Jacob Lawrence Catalogue Raisonné Project,

Seattle

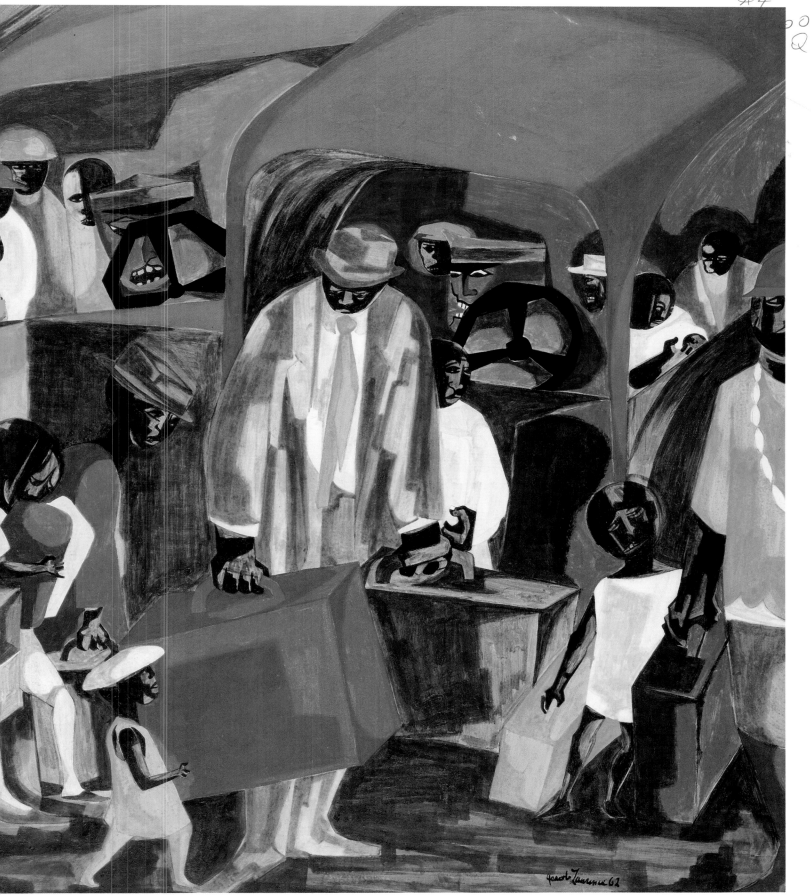

Dedicated to
Shelly Bancroft and David Gambill

Partial support for this book has been provided
by the National Endowment for the Humanities,
Washington, D.C., a federal agency, and the
J. Paul Getty Trust, Los Angeles.

Published by University of Washington Press,
Seattle and London in association with the Jacob
Lawrence Catalogue Raisonné Project, Seattle.

Copyright © 2000 Jacob Lawrence Catalogue
Raisonné Project
 www.jacoblawrence.org, jlcrp@aol.com

Edited by Elizabeth Franzen and
Domenick L. Ammirati
Proofread by Sharon Vonasch
Designed by John Hubbard
Image scanning by Jason Wiley
Color management by Gary Hawkey
Typeset by Christina Gimlin
Produced by Marquand Books, Inc., Seattle
 www.marquand.com
Printed and bound by CS Graphics Pte., Ltd.,
Singapore

Library of Congress Cataloging-in-Publication
Data
Nesbett, Peter T.
 Jacob Lawrence : paintings, drawings, and
murals (1935–1999) : a catalogue raisonné /
Peter T. Nesbett, Michelle DuBois ; with assis-
tance from Stephanie Ellis-Smith.
 p. cm.
 Includes bibliographical references.
 ISBN 0-295-97966-6 (cloth: alk. paper)
 1. Lawrence, Jacob, 1917–2000—Catalogues
raisonnés. I. DuBois, Michelle. II. Title.
N6537.L384 A4 2000
759.13—dc21 00-56408

Jacket front: *Magic Man,* 1958, egg tempera on
hardboard, 20 × 24 in. (50.8 × 61 cm). Hirshhorn
Museum and Sculpture Garden, Smithsonian
Institution. Gift of Mr. and Mrs. Henry Folkerson,
1981.

Jacket back: *Builders in the City,* 1993, gouache on
paper, 19 × 28½ in. (48.3 × 72.4 cm). Courtesy of
SBC Communications, Inc.

Frontispiece: *Northbound,* 1962, tempera on hard-
board, 24 × 40 in. (61 × 101.6 cm). Collection of
Mr. Merrill C. Berman, New York.

Page 6: *The Libraries Are Appreciated,* 1943,
gouache on paper, 14¹¹⁄₁₆ × 21⅝ in. Philadelphia
Museum of Art. The Louis E. Stern Collection.

Contents

Foreword

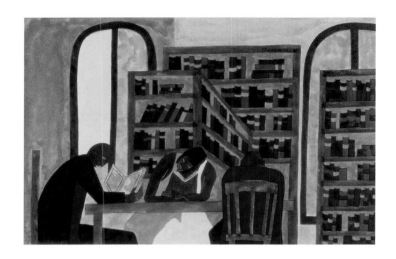

THIS BOOK IS THE RESULT of a five-year effort to locate and document the entire oeuvre of American visual artist Jacob Lawrence (1917–2000). It presents the state of knowledge on the artist's paintings, drawings, and murals as of December 31, 1999.

Like most catalogues raisonnés, this project has been a labor of love. Reconstructing the full scope of this artist's career has been a complex process of discovery and reconciliation: every new artwork located, every collector, exhibition, and publication has enhanced our understanding of the subject. Trying to temporarily arrest this dynamic situation for the sake of publication has been an enormous challenge. We are presenting this information to the public now with the knowledge that our understanding of this artist's contributions will continue to evolve indefinitely.

I was introduced to Lawrence's work in 1990 during a visit to the Philadelphia Museum of Art. I only saw one painting by the artist on that particular day—a small gouache on paper entitled *The Libraries Are Appreciated* (1943). Oddly enough, it was neither the palette nor the subject matter that captured and held my attention. Rather, it was the dramatic foreshortening of the central bookcase—an extreme, isolated gesture that establishes a vortex in the midst of the otherwise still composition. That single bookcase initiated my long-term interest in this artist's work. At that time, I had no idea that I, with Michelle DuBois, would spend more than half a decade devoted to its study.

This catalogue differs from standard catalogues raisonnés in several important ways. It was prepared on the work of a living artist, and though the artist passed away as the book was going to press, it will continue to be an ongoing project. Paintings and drawings that are located in the future will be pub-

lished on a website at www.jacoblawrence.org. Additionally, this catalogue is the first catalogue raisonné on the work of an American artist of African descent. Aside from presenting the full range and development of Lawrence's oeuvre, it aims to provide a unique perspective on the evolution of modern aesthetic tastes, artistic patronage, art criticism, and the categorization of artistic tendencies.

Most catalogues raisonnés are funded by the artist's estate, a single private foundation, or a commercial gallery. By contrast, this catalogue received financial support from hundreds of individuals—of varying means—as well as a handful of corporations, museums, universities, foundations, and the federal government. The range and variety of support reflects a broadly shared belief that Lawrence's work is a part of our collective national heritage and should be documented for future generations. I am enormously grateful to everyone who has made this effort possible, especially the University of Washington Press, the National Endowment for the Humanities, and the J. Paul Getty Trust.

Peter T. Nesbett, Founder and Director
Jacob Lawrence Catalogue Raisonné Project
New York

Acknowledgments

ANY CATALOGUE RAISONNÉ PROJECT is a significant undertaking, requiring long-term commitment, a great deal of patience and persistence, and the cooperation of hundreds, if not thousands, of individuals. This project was no exception. Given the fact there was no published monograph on Jacob Lawrence's work before 1986—fully fifty years into his career—and our desire to share our research with other scholars in a timely manner, we were faced with considerable challenges. We are grateful to everyone who contributed valuable time, energy, and resources to documenting Lawrence's artistic legacy for present and future generations.

From the start, Jacob and Gwendolyn Knight Lawrence were a source of inspiration. They responded graciously to the many demands asked of them over the past five years and gave us encouragement and valuable information. They provided access to their own collection and archives, assisted us in identifying past owners, answered an unending array of questions about their own histories, and entrusted our authentication committee to make decisions regarding authorship.

A handful of individuals have been actively involved with the project from the beginning, and we are grateful for their sustained support. Special acknowledgment must be made to our board of directors: Dr. Thaddeus H. Spratlen, Seattle; Dr. Walter O. Evans, Detroit; and Dr. Leslie King-Hammond, Baltimore. All endured cross-country travel at inconvenient times to provide critical assistance. Dr. Evans played a particularly active role, and we are the beneficiaries of his passionate commitment. Additionally, Francine Seders, director of the Francine Seders Gallery, Seattle, provided seed money and the support of her staff during the early stages of research. Without her early interest

and sustained commitment, this project never may have been undertaken.

Stephanie Ellis-Smith has been instrumental through much of the process, coordinating photography and digitalization of the more than nine hundred images that appear in this volume. She coordinated this undertaking with skill and agility, working closely with collectors, photographers, digital imaging technicians, as well as rights and reproductions managers. She also oversaw the creation of a high-resolution digital archive of the artist's work for future use. Gary Hawkey, formerly the chief technology officer for Getty Images/Photodisc, Seattle, provided invaluable consultation in this process, helping us develop the standards and protocols we used in digital imaging and preparing the digital files for book publication. We are grateful for his generous support. Jason Wiley scanned and color-corrected all the images over a two-year period. His commitment to seeing this process through to completion is greatly appreciated and resulted in a consistency in image quality that otherwise would not have been possible.

The desire to preserve a lasting record of Lawrence's work for future generations necessitated the involvement of conservators from the early stages of the project. Elizabeth Steele, a paintings conservator in Washington, D.C., played a seminal role in helping us better understand the artist's use of materials and techniques. In addition to sitting on the authentication committee, she traveled extensively to view works, to analyze works with curators and other conservators, and to assist the Getty Conservation Institute (GCI) in collecting and studying paint samples from dozens of Lawrence paintings completed between 1938 and 1977 that were analyzed in the GCI's labs. We

are grateful to Dr. Barry Munitz, CEO, J. Paul Getty Trust, for generously providing the scientific resources for this study. Additionally, we appreciate the commitment and expertise of Getty staff: Michael Schilling, Narayan Khandekar, James Druzik, Erin O'Toole, Rona Sebasstian, and Alberto Tagle.

We are grateful for the support of our advisory board who provided counsel throughout the process. They are Edmund Barry Gaither, Museum of the Center of Afro-American Artists, Boston; Bruce Guenther; Barbara Haskell, Whitney Museum of American Art; Harry Henderson; Patricia Hills, Boston University; Barbara Johns, Tacoma Art Museum; Dr. Paul J. Karlstrom, Archives of American Art; Drs. Herbert J. Kayden and Gabriel H. Reem; Bridget Moore, DC Moore Gallery; John Whitney Payson, Midtown Payson Galleries; Francine Seders, Francine Seders Gallery; Lowery Stokes Sims, The Metropolitan Museum of Art; Patterson Sims, The Museum of Modern Art; Governor Carlton Skinner; Charles F. Stuckey, Kimbell Art Museum; Elizabeth Hutton Turner, The Phillips Collection; and Jeanne Zeidler, Hampton University Museum. Individuals with experience working on catalogues raisonnés also provided valuable insight in the early stages, including Barbara Buhler Lynes, Georgia O'Keeffe Catalogue Raisonné Project; Michael and Mary Quick, George Inness Project, Santa Monica; Melissa Webster, Frederic Remington Catalogue Raisonné Project; William Agee; and the late Paul Cummings.

Many individuals and organizations supported this effort financially, and their selfless generosity echoes the compassionate spirit of Lawrence's work. Those that contributed directly to this publication include the Allen Foundation for the Arts, Janet and John W. Creighton, Mary McLellan Williams, Francine Seders Gallery, and the University of Washington Press Development Advisory Board. Others that contributed generously to offset our research expenses include Ted Alexander III, Clarence and Jacqueline Avant, Dr. James A. Banks and Dr. Cherry McGee Banks, Dr. John J. and Pearle Bernick, Edward R. Bradley, Jr., and Patricia Blanchet, David and Jackie Burks, June and Walter Christmas, Dr. and Mrs. Volna Clermont, Dr. Sheryl L. Colyer, Dr. C. Arnold Curry, James L. and Vivian A. Curtis, Edward DeLuca, Walter and Linda Evans, Timothy A. Greensfelder and Sari B. Granat, George C. Hill, Timothy E. Hillard, Drs. Herbert J. Kayden and Gabrielle H. Reem, Greg Kucera and Larry Yocum, Larry and Vernita McNiel, Bill and Holly Marklyn, Paul and Dolly

Marshall, Alfred Mays, Dr. Curtiz D. Meriwether, Marva J. Morris and Barton W. Morris, Jackie Mullins, Craig Parker, Alan and Susan Patricof, Leslie Payne, John Whitney Payson, John Reed and Karen Overstreet, Mrs. Miriam Reed, Judson P. Reis, Pablo Schugurensky, Mr. and Mrs. T. Edward Sellers, Jr., Thaddeus H. and Lois Price Spratlen, Dr. Donald Toatley, Mr. and Mrs. Brian Weck, George and Joyce Wein, Julia B. Williams, Jr., Edward Wilson, Jr., Dr. Michael H. Wood, Deborah C. Wright, and Jason H. Wright. Others who provided financial support include Ellsworth and Nancy Alvord, Margery Aronson, The Bullitt Foundation, Rudolph P. Byrd, Peggy Cash, Evelyn T. and David V. Cohn, Patricia Collins, Paralee Day, Dr. Shirley Dixon, Gloria Donaldson, Cheryl and Millison Fambles, Drs. Dexter Fields and Margaret Betts, P. Raaze Garrison, Kenneth D. Gibbs, Judith Golden, Mr. William B. Harvey, Betty and Dick Hedreen, Gail Hewitt-Rainey, Patricia Hills and Kevin Whitfield, Zakiya Hollifield, Mr. and Mrs. Elbert Jenkins, Dr. S. Jenkins-Phelps, June and Ira Kapp, Shirley G. Kennedy, Jane McManus Kowals, Myron Kowals, and Rebecca R. Kowals, Mercedes A. Laing, Hubert G. Locke, Dexter Lockamy, Iris and James Marden, Marsteller Family Foundation, Michigan National Bank, Danna and Joel Mirviss, Roy Neuberger, Dr. Arthur and Mary Park, Christina Reed, The Rudin Foundation, Mr. and Mrs. Kermit Scott, Jr., Kevin B. Scott, Esq., Mable Martin-Scott, Esq., and Kourtney N. Scott, Mark Shiner, Silvia W. Sims, Sinai Radiation Oncology, Governor Carlton Skinner, Dr. Gail Smith, Susan Smith Stephens, Diane Stewart-Mathis, Percy Ellis Sutton, Ovid Thompson, Eric B. Vaughn, Dr. Charles and Martha Vincent, Marc Weuker, Lou Stovall, Workshop, Inc., Washington, D.C., and Virginia Bloedel Wright.

Many individuals also organized, hosted, or participated in special events that gave visibility to this documentary effort. We would particularly like to thank Linda Evans, Detroit; David R. Jones, CEO, Community Service Society, New York; Randreta Ward-Evans, New York; Dr. Lorna L. Thomas, Detroit; Kathy McAuliffe; Mrs. Faye Allen, Seattle; Joseph McDonnell, Seattle and New York; Sam Thomas and the Friends of African and African American Art at The Detroit Institute of Art; Michael Findlay, Andrew Schoelkopf, and Karen Short, Christie Manson & Woods, International, New York; and Sandra Bloodworth and Jodi Moise, MTA/Arts for Transit, New York as well as DC Moore Gallery, New York, and Francine Seders Gallery, Seattle. Special thanks are also due to Doug Smith; Nettie Seabrooks; Millie

Russell; Martin Puryear; Michael Spafford; Mary Gardner Gates, director, Seattle Art Museum; Norman B. Rice, former mayor of Seattle; Richard McCormick, president, University of Washington, Seattle; Diane Douglas, director, Bellevue Art Museum, Washington; Chase Rynd, former director, Bellevue Art Museum, Washington; John E. Buchanan, director, Portland Art Museum, Oregon; John B. Simpson, former dean, College of Arts and Sciences, University of Washington, Seattle; Richard Andrews, director, Henry Art Gallery, University of Washington, Seattle; and Peter Donnelly, Corporate Council for the Arts, Seattle.

Corporations, foundations, and educational institutions also provided financial support throughout the process. We would like to thank David Wallace and Joseph Herring at the National Endowment for the Humanities, Washington, D.C.; Dr. Barry Munitz, J. Paul Getty Trust, Los Angeles; Richard Manoogian and Lillian Bauder, Masco Charitable Trust, Detroit; Helen Love, Ford Motor Company, Detroit; Idelisse Malave and Phong Dinh, Tides Foundation, San Francisco; Samual Sachs, former director, The Detroit Institute of Arts; Dr. Jeanne Zeidler, Hampton University Museum, Virginia; William Neukom and Deborah Paine, Microsoft Corporation, Redmond, Washington; and Suzanne F. W. Lemakis, Citigroup, New York. Others who provided financial assistance include Berk & Associates, Seattle; Joshua Green Corporation, Seattle; Johnson & Johnson, New Brunswick, New Jersey; Motown Records, New York; Jon and Mary Shirley Foundation, Bellevue, Washington; The Phillips Collection, Washington, D.C.; United American Healthcare, Detroit; and University of Michigan, Dearborn.

Many people assisted us with research over the past five years. Lawrence's primary dealers have played a critical role in the process of identifying owners by providing us access to their records and helping to arrange for the photography of artworks. DC Moore Gallery, New York, has provided valuable assistance and responded to countless queries, and we are grateful for their involvement. Particularly responsive to our many requests were Bridget Moore, Ed DeLuca, and Heide Lange. Francine Seders Gallery has also graciously fielded many questions over the years, as have members of her staff. We would particularly like to thank Alison Stamey, Pat Scott, Esther Luttikhuizen, and Deidre Czoberek. Many other dealers provided valuable information on the whereabouts of artwork or assisted with the location and documentation of work, including Philippe Alexandre, Tibor de

Nagy Gallery, New York; Michael Rosenfeld and halley harrisburg, Michael Rosenfeld Gallery, New York; Chanda Souskil-Chapin and Terry Dintenfass, Terry Dintenfass Inc., New York; John Braseth, Gordon Woodside/John Braseth Galleries, Seattle; and Alitashe Kebede, Los Angeles. Other gallerists and art dealers who provided information regarding the whereabouts of Lawrence works in private collections include Peg Alston, Peg Alston Fine Arts, New York; Jeffrey Bergen and Doreen Bergen, ACA Galleries, New York; Eugene Foney, Artcetera, Houston; Jeffrey Fuller, Jeffrey Fuller Fine Arts, Philadelphia; Julia Hotton, New York; Lynda Hyman, Hyman Fine Art, New York; Corinne Jennings, Kenkeleba Gallery, New York; Ruth Jett, Cinque Gallery, New York; June Kelly, June Kelly Gallery, New York; Andrea Moody, formerly of DC Moore Gallery and Sid Deutsch Gallery, New York; George N'Namdi, G.R. N'Namdi Gallery, Birmingham, Michigan; Aaron Payne, Owings-Dewey Fine Art, Santa Fe; Alan Pensler, Pensler Gallery, Washington, D.C.; Joel Rosenkranz, Conner-Rosenkranz, New York; Luise Ross, Luise Ross Gallery, New York; Seth Taffee, New York; and Susan Woodson, Chicago.

Individual collectors and museums that are the stewards of Lawrence's work have been instrumental in the research process. Collectors who did not wish to remain anonymous are credited in the entry cataloguing their artwork. Numerous individuals at museums and research institutions assisted us with cataloguing, photography, and general research inquiries, and we regret that this listing may not be complete. We would like to thank Allison Kemmerer, Addison Gallery of American Art, Andover, Massachusetts; Laura Catalano, Albright-Knox Art Gallery, Buffalo; Virginia Dajani, American Academy of Arts and Letters, New York; Mire Beauchamp-Byrd, Wayne Coleman, and Paula Allen, Amistad Research Center, New Orleans; Jane Myers, Amon Carter Museum, Fort Worth; Brian Young and Ann Gochenour, Arkansas Arts Center, Little Rock; Mark Pascale, Daniel Schulman, and Amy Trendler, The Art Institute of Chicago; Jacquie Meyer and Frances Klapthor, Baltimore Museum of Art; Dr. Alma Adams, Bennett College, Greensboro, North Carolina; Lisa Calden, Berkeley Art Museum, California; Melissa Faulkner, Birmingham Museum of Art, Alabama; Sue Ellen Jeffers, Blanton Museum of Art, University of Texas, Austin; Barbara Gallati and Deborah Wythe, Brooklyn Museum of Art; Samantha K. Kimpel, The Butler Institute of American Art, Youngstown, Ohio; Renee Gross and April Paul, Chaim Gross

Museum, New York; Jennifer Aronson, University Library, Carnegie Mellon University, Pittsburgh; Elizabeth L. Kelley, Chicago Public Art Program; Tina Dunkley, Clark-Atlanta University, Atlanta; Jane Glaubinger and Louis Adrean, The Cleveland Museum of Art; Lynn Marsden-Atlas, Colby College Museum of Art, Waterville, Maine; Dr. Susan J. Barnes, Dallas Museum of Art; Dr. Mary F. Holahan, Delaware Art Museum, Wilmington; Jane Fudge, Denver Art Museum; Nancy Sojka, Ellen Sharp, and Julia Henshaw, The Detroit Institute of Arts; Nancy Deihl, The AXA Gallery, New York; Mary S. Schnepper, Evansville Museum of Arts and Sciences, Illinois; Maxine Rosston, Fine Arts Museums of San Francisco; Christopher R. Young, Flint Institute of Arts, Michigan; Scott Zetrouer, Gibbes Museum of Art, Charleston, South Carolina; Donald Keyes and Lynne Perdue, Georgia Museum of Art, Athens; Martha R. Severens, Greenville County Museum of Art, South Carolina; Xiougin Zhou, Haggarty Museum of Art, Marquette University, Milwaukee; Jeffrey Bruce and Mary Lou Hultgren, Hampton University Museum, Virginia; Harry Cooper, Harvard University Art Museums, Cambridge, Massachusetts; Judy Sourakli, Henry Art Gallery, University of Washington, Seattle; Carrie Przybilla, High Museum of Art, Atlanta; Judith Zilczer, Hirshhorn Museum and Sculpture Garden, Washington, D.C.; Kelly Pask, Hood Museum of Art, Dartmouth College, Hanover, New Hampshire; Eileen Johnston, Scott Baker, and Tritobia H. Benjamin, Howard University Gallery of Art, Washington, D.C.; Elizabeth Le, Hunter Museum of Art, Chattanooga, Tennessee; Harriet Warkel, Indianapolis Museum of Art; Margaret Holben Ellis, Institute for Fine Arts, New York; Nancy Green and Shannon Smith, Herbert F. Johnson Museum of Art, Cornell University, Ithaca, New York; Janet L. Farber, Joslyn Art Museum, Omaha; Cath Brunner, King County Arts Commission, Seattle; Gabriel Tenabe and E. L. Briscoe, James E. Lewis Museum of Art, Morgan State College, Baltimore; Marilyn Sohi, Madison Art Center, Wisconsin; Marjorie B. Searl, Memorial Art Gallery, Rochester, New York; Lori Mott, University of Michigan Museum of Art, Ann Arbor; Margaret Lynne Ausfeld, Montgomery Museum of Arts, Alabama; L. Elizabeth Schmoeger and Dean Sobel, Milwaukee Art Museum; Bruce Lilly, Minnesota Museum of Art, Saint Paul; Ann C. Madonia, Muscarelle Museum of Art, College of William and Mary, Williamsburg, Virginia; Lora Urbanelli and Claude Elliott, Museum of Art, Rhode Island School of Design, Providence; Theodore E. Stebbins, Jr., Karen E. Haas, and Shelly Langdale, Museum of Fine Arts, Boston; Laura Rosenstock, The Museum of Modern Art, New York; Dita Armory, National Academy of Design, New York; Mark Rosenthal and Carlotta J. Owens, National Gallery of Art, Washington, D.C.; Elizabeth Broun, Virginia Mecklenberg, and Lenore B. Fein, National Museum of American Art, Washington, D.C.; Claire Kelly, Fred Voss, Lucynda Walker, and Ann P. Wagner, National Portrait Gallery, Washington, D.C.; Briane Lawler, Nelson-Atkins Museum of Art, Kansas City; Patricia Magnani, Neuberger Museum of Art, State University of New York, Purchase; Joseph Jacobs, The Newark Museum, New Jersey; Michelle Erton, New Britain Museum of Art, Connecticut; Zoltan Buki, New Jersey State Museum, Trenton; Paul Tarver, New Orleans Museum of Art; Nancy Kelley, New York State Museum, Albany; Norman E. Pendergraft, North Carolina Central University Art Museum, Durham; Michael Klauke and Huston Paschal, North Carolina Museum of Art, Raleigh; Pamela S. Parry, Norton Museum of Art, West Palm Beach, Florida; Cheryl Leibold and Silvia Yount, Pennsylvania Academy of the Fine Arts, Philadelphia; Darrell L. Sewell and Lilah J. Mittelstaedt, Philadelphia Museum of Art; Karen Schneider, Elsa Mezvinsky-Smithgall, and Meaghan Kent, The Phillips Collection, Washington, D.C.; Prudence Roberts, Portland Museum of Art, Oregon; Sharon Palladino and Ellen Agnew, Maier Museum of Art, Randolph-Macon Woman's College, Lynchburg, Virginia; Ellen Kutcher, Reynolda House Museum of American Art, Winston-Salem, North Carolina; Connie Hamburg and Jeremy Strick, Saint Louis Museum of Art; Rachel Mauldin, San Antonio Museum of Art; Howard Dodson, Theresa Martin, Victor N. Smythe, and Tammi Lawson, Schomburg Center for Research in Black Culture, New York; Gail Joyce, Seattle Art Museum; Barbara Goldstein, Seattle Arts Commission; Cinamon Perry, Sheldon Memorial Art Gallery, University of Nebraska, Lincoln; Dr. Sandra Kraskin, Sidney Mishkin Gallery, Baruch College, New York; Kevin Grogan, University Gallery, Fisk University, Nashville; Lorilee C. Huffman, University Museum, Southern Illinois University, Carbondale; Dr. Akua McDaniel, Spelman College, Atlanta; Valerie Mercer and Kinshasha Conwill, formerly with the Studio Museum in Harlem, New York; Patricia Whitesides, The Toledo Museum of Art, Ohio; Ronald Schnell, Tougaloo College, Edwards, Mississippi; Kevin Mullins, Edwin A. Ulrich Museum of Art, Wichita State University, Kansas; Cindee Herrick, United States Coast Guard Museum, New

London, Connecticut; Dr. Peter S. Briggs, University of Arizona Museum of Art, Tucson; Kurt Keifer, University of Washington Campus Art Collection, Seattle; Caryl Butner, Virginia Museum of Art, Richmond; Deirdre Bibby, Wadsworth Atheneum, Hartford, Connecticut; Karen Duncan, Rosemary Furtak, Joseph King, Laura Muessig, and Jill Vetter, Walker Art Center, Minneapolis; Lorin Doyle, Washington State Arts Commission, Olympia; Drew Crooks, Washington State Capitol Museum, Olympia; Jim Becker, Weisman Art Museum, Minneapolis; Nancy McGary and Elizabeth Dunbar, Whitney Museum of American Art, New York; Lois F. Crane, Wichita Art Museum, Kansas; Rachel U. Tassone, Williams College Museum of Art, Williamstown, Massachusetts; Phillip A. Robertson, T. W. Wood Gallery and Arts Center, Montpelier, Vermont; and Susan E. Strickler and David Brigham, Worcester Art Museum, Massachusetts.

We would also like to thank the staffs at libraries, research centers, universities, museums, and traveling exhibition services throughout the country who searched diligently for information on early exhibitions and publications. We would like to thank the staff of the Fine Arts Division of the Boston Public Library, who graciously assisted with countless research requests, particularly Evelyn Lannon and Kim Tenney. Also helpful were Nicholas Fox Weber, Josef and Anni Albers Foundation, Bethany, Connecticut; Mark Tullos, Alexandria Museum of Art, Louisiana; Kathy Kienholz, American Academy of Arts and Letters, New York; Judy Throm and Wendy Hurlock, Archives of American Art, Smithsonian Institution, Washington, D.C.; Stephanie Cassidy, Art Students League, New York; Mimi Gaudieri, Association of Museum Directors, New York; Mariam Sternberg and Brian Wallace, Bellevue Art Museum, Washington; Carolyn Davis and Domenic J. Iacono, Bird Library, Syracuse University, New York; Heather Wahl, Carnegie Museum of Art, Pittsburgh; Gerald Marsella, Exhibits USA, Kansas City, Missouri; Jesse Carney Smith, Fisk University, Nashville; Thomas Tanselle, John Simon Guggenheim Memorial Foundation, New York; Camille Billops, Hatch-Billops Archive, New York; Kathleen A. Foster, Indiana University Art Museum, Bloomington; Rebecca D. Steel, Kalamazoo Institute of Arts Library, Michigan; Barbara W. File and Nathan Augustine, Meadows Museum, Southern Methodist University, Dallas; The Metropolitan Museum of Art, New York; Rene Paul Barilleaux, Mississippi Museum of Art, Jackson; Mary E. Murray, Munson-Williams-Proctor Institute, Utica, New York; Deborah Willis, Museum of African Art, Washington, D.C.; Gerard Wertkin, Museum of American Folk Art, New York; Mary Johnson, Museum of Contemporary Art, San Diego; Jennifer J. Culvert, The Museum of Modern Art, New York; Regina Stewart, New York Artists Equity, New York; T. Bourke, New York Public Library; Jayne Campbell, Oklahoma City Art Museum; Karen Schneider, The Phillips Collection, Washington, D.C.; Margot Karp, Pratt Institute, New York; Linda McKee, John and Mable Ringling Museum of Art, Sarasota, Florida; Harold Oakhill, Rockefeller Archives, Tarrytown, New York; David L. Kencik and Clara A. Norred, S. C. Johnson & Company, Racine, Wisconsin; San Diego Museum of Art; Julie Franklin, San Jose Museum of Art, California; Dodie Amenta, Santa Barbara Museum of Art, California; Mary Jo Fenton and staff, Seattle Public Library; Caroline Carpenter, Smithsonian Institution Traveling Exhibition Service, Washington, D.C.; Brenda Brinkley and Michelle Homden, The Tate Gallery, London; Timothy J. Johnson, University of Minnesota Libraries, Minneapolis; University of Washington Libraries, Seattle; Whitney Museum of American Art library, New York; and Andrea Hindig, YMCA National Archives. Other individuals provided valuable information on the location of Lawrence's work, including Blanche Brown, Tarin Fuller, Lynn Igoe, Oren and Tamar Jacoby, and David Soyer. Amy Ross provided valuable research assistance with the bibliography.

In the artist materials and conservation communities, many individuals and institutions beyond those already acknowledged assisted us in determining what media Lawrence used at various points in his career. Several people were helpful in identifying available commercial paints and their recipes, including Robert Auger, Ron Delese, Ed Flax, Holly Krueger of the Library of Congress, Zora Pinney, Louis Rosenthal, Steve Steinberg, Wyndell Upchurch, and Clare Wilson. Many institutions generously assisted with visual examinations using binocular microscopes and infrared cameras or allowed us to take paint samples of works in their collections. We are particularly grateful to Amy Gerbracht, Brooklyn Museum of Art; Lawrence Hoffman, Susan Lake, Margaret Dong, Judith Zilczer, and Phyllis Rosenzweig, Hirshhorn Museum and Sculpture Garden, Washington, D.C.; Tritobia H. Benjamin and Scott Baker, Howard University Art Gallery, Washington, D.C.; Marjorie Shelley and Rachel Mustalisch, The Metropolitan Museum of Art, New York; Irene Konefal, Rhona Macbeth, and James Wright, Museum of Fine

Arts, Boston; Kirk Varnedoe, James Coddington, Anny Aviram, and Susanne Siano, The Museum of Modern Art, New York; Jay Krueger, Rene de la Rie, Suzanne Lomax, Judith Walsh, and Shelly Fletcher, National Gallery of Art, Washington, D.C.; Jacquelyn D. Serwer and Catherine Maynor, National Museum of American Art, Washington, D.C.; Windy Wick Reaves and Ann Prentice Wagner, National Portrait Gallery, Washington, D.C.; Friedericke Steckling and Jennifer Sherman, New York University Conservation Institute, New York; Sensors Unlimited, Princeton, New Jersey; and Rita Albertson, Phillip Klusmeyer, and Joan Wright, Worcester Art Museum, Massachusetts.

Additionally, we would like to thank our lawyers and accountants who provided their services on a pro-bono basis over a period of five years. These include Howard Donkin, Morrison, Donkin CPA, Bellevue, Washington, and William Weigand, Partner, Davis Wright Tremaine, Seattle. Additional appreciation to Leonard Weber, Merrill Lynch, Seattle, and Chris Pesce, formerly with Davis Wright Tremaine.

Our manuscript editors, copyeditors, and proofreaders have made invaluable contributions to the manuscript and have given elegant form to an unwieldy amount of research data. We would like to thank Elizabeth Franzen and Domenick Ammirati of the Solomon S. Guggenheim Museum, New York, who edited the text and cross-referenced the entries in this catalogue. Special acknowledgments to Sharon Vonasch, Seattle, who proofread the manuscript and offered additional suggestions that improved it considerably, and Petra Siemion, Flight of Hand, Seattle, who entered the manuscript edits on the disk. At Marquand Books, John Hubbard is responsible for the excellent design of this catalogue and the accompanying monograph; Ed Marquand, Christina Gimlin, and Marie Weiler also contributed to the books' production. Pat Soden, director, Donald R. Ellegood, director emeritus, Nina McGuinness, Mary Anderson, Alice Herbig, and the rest of the staff at the University of Washington Press, Seattle, have shown their unstinting commitment to this effort from the early stages, and their encouragement and generosity are tremendously appreciated.

Finally, a special note of appreciation to our spouses, Shelly Bancroft and David Gambill. They are as familiar with the contents of this publication as we are, and they have—over a period of five years—shared in our moments of discovery and desperation. If there is any reason that this book is complete, it is due to their support, love, and patience.

Peter T. Nesbett
Michelle DuBois

Notes to the Catalogue

Scope

This catalogue documents all the known paintings, drawings, and murals created by Jacob Lawrence from 1935 through December 1999. It does not include limited-edition prints, which have been published separately (see Peter Nesbett, *Jacob Lawrence: Thirty Years of Prints (1963–1993)* [Seattle: Francine Seders Gallery in association with University of Washington Press, 1994]). Also not included in this catalogue are unfinished paintings and drawings, teaching studies, or works falsely attributed to the artist. Those works have been documented, however, in the eventuality that they are placed on the market either with or without the artist's consent. If photographs of missing works have been found and the authenticity is well established, the works are included here. If no photograph or reproduction of a work is known, and the work has not been located, we have not included any information about that work. Any artworks located after publication will be made accessible to scholars via the Internet at www.jacoblawrence.org.

Organization

The catalogue has been divided into four categories: paintings, drawings, Figure Studies after Vesalius (graphite drawings based on the prints of the sixteenth-century anatomist Andreas Vesalius), and murals. Paintings, drawings, and murals are arranged chronologically; Figure Studies after Vesalius are arranged by type—the pose of the figures. For paintings and drawings, it is impossible to determine the order within a given year in which the works were created. If gallery records or correspondence provides insight into the specific date or time of year that a work was completed, we have taken this information into account in developing the chronology. Figure Studies after Vesalius were completed over a thirty-year period and most remained undated until 1996, when some were postdated, reworked, and placed on the market. Because the works are expressive studies of anatomical form and based on a limited number of source images, we hope that the arrangement by pose will prove more fruitful than chronology would to understanding the issues the artist was exploring in their creation.

The distinction between paintings and drawings requires some clarification. Because most of Lawrence's work consists of aqueous media (i.e., tempera, gouache, watercolor, and ink) on paper, classification by media has often produced different results. For example, drawing departments at museums are often the stewards of the artist's paintings because they are on paper. We used a number of criteria to distinguish between paintings and drawings: the medium employed, the degree to which the medium covers the support, the manner in which the medium was employed, and whether or not one or more colors were used. Works completed in tempera, gouache, or watercolor are generally considered to be paintings. The artist did, however, on occasion create works in black gouache that have been classified as drawings because of their linear execution, the use of a single color, and the fact that the artist left substantial portions of the paper exposed.

Series vs. Individual Works

Groups of paintings that the artist has defined as series are treated in this publication as individual artworks, regardless of ownership. Like other individual works, the series have one entry and one catalogue number.

Over the past sixty years, there has been confusion regarding which works constitute a series and which do not. In part,

the confusion stems from the marketing and promotion of the artist's work, but it also stems from the broad definition of the term as it is used in the art world, in which "series" refers to a group of works on a single theme. Lawrence changed the way he executed his series over the years, and such determinants as artistic process, dating, scale, and format or the use of narrative texts do not provide a ready-made litmus test to resolve such questions.

In June 1999 the artist was asked to articulate his definition of the term *series* as it applies to his work. He stated that for him a series is a "connective narrative," one that is sequential in nature and conceptualized as multiple images functioning together to convey an intended meaning. Using this criterion, we have determined the following to be series:

> *The Life of Toussaint L'Ouverture* (1938)
> *The Life of Frederick Douglass* (1939)
> *The Life of Harriet Tubman* (1940)
> *The Migration of the Negro* (1941)
> *The Life of John Brown* (1941)
> *War* (1946–7)
> *Struggle . . . From the History of the American*
> *People* (1954–6)
> *Harriet and the Promised Land* (1968)
> *George Washington Bush* (1973)
> *Eight Studies for the Book of Genesis* (1989)

The temporal element is important to the artist's definition of a series. All of these works have a progressive or chronological development with a distinct beginning and an end, even if they contain repetition or circular narrative elements.

Works on the same subject or theme that were exhibited together do not necessarily constitute a series. The artist refers to these works as "thematic groups." An important distinction for the artist is that the paintings function individually: removing one painting from a group does not diminish or significantly compromise understanding of the others. Works that in the past have been considered series but that have been catalogued here as individual works include paintings on the themes of Harlem (1943), Coast Guard life (1943–5), Hillside Hospital (1949–50), theater/performance (1951–2), libraries (1960–6), Nigeria (1962–6), dreams (1965–7), builders (1967–December 1999), and Hiroshima (1983).

Authentication

The artworks contained in this volume were authenticated by a three-person committee: Peter Nesbett, Michelle DuBois, and Elizabeth Steele. Each work was reviewed either in person or from photographs following a protocol that included stylistic and material analysis, as well as a review of existing documentation. Jacob and Gwendolyn Knight Lawrence were consulted when the committee had questions regarding authorship or dating, but otherwise their involvement with the authentication process was minimal. They did not review every artwork, instead investing the committee with the authority to make decisions regarding authorship and the contents of this publication. Unanimous agreement among committee members was a prerequisite for the inclusion of any artworks in this volume.

There exist several cases in which the authentication committee's opinion differs from that of the artist. All of those cases involve a work that is deemed authentic by the committee but for which the artist has expressed either a degree of doubt or a belief that the artwork is not by his hand. The artist has made these claims in several instances both in writing or in conversation to individual members of the committee. For those works included in this volume, we have opted for full disclosure, noting the artist's opinion in the remarks contained in the relevant entry. There are no cases where the committee determined that an artwork is not authentic but the artist believes it is.

Research and Problems

We have made every effort to locate and document all of Lawrence's output. Nonetheless, works are thought to exist that could not be located in time for publication. Still others have been lost, stolen, destroyed by fire, floods, or subject to other harsh conditions. We lacked basic scholarly resources that most catalogue raisonné projects take for granted, including detailed inventory lists, extensive photo archives, and the existence of a substantial body of work in the artist's personal collection.

Lawrence has maintained no records of the paintings and drawings that left his studios between 1935 and 1999. He has kept no inventory books, no card files, and few photographs of his works. There exist no known inventory lists of the contents of any of his studios at any time. To add further to the challenge this situation poses, few paintings and finished drawings remained in the artist's possession in 1995 when the index of known works was originally drafted for this catalogue. Though Lawrence owned early paintings (1930s–40s) for decades after they were completed, he put most of these works on the market in the 1970s, 1980s, and early 1990s.

The artist provided members of the committee complete access to studio and office, enabling us to look through file cabinets, flat files, storage closets, drawing portfolios, and his sup-

plies. The goal in reviewing these items was to find artworks that may not have been previously documented by the artist's agents. But it was also to find sketches, study drawings, and photographic source material for paintings that are known from gallery records or correspondence only by title, but not by image. Although drawings were located, very little study material was found, confirming what was suspected, that the artist does not and has never worked from notebooks, sketchbooks, or photographs in planning his paintings.

Published documentation of Lawrence's work is slight, despite the fact that his work has been exhibited in galleries and high-profile museum exhibitions for sixty years. In fact, few exhibition catalogues and no monographs were published between 1935 and 1986 that reproduce individual artworks or document ownership. Those that do often republish the same artworks—paintings and drawings that are well known and easily traceable. Ellen Harkins Wheat's *Jacob Lawrence: American Painter* (Seattle and London: University of Washington Press in association with the Seattle Art Museum, 1986) was the first substantial publication on the artist's work, reproducing approximately two hundred paintings, drawings, and murals, many for the first time. Subsequent publications have presented, also for the first time, the artist's early series, but none has provided a broad sweep of the artist's individual paintings, drawings, and murals.

Consequently, gallery documentation was our primary resource in identifying and locating work. Though the data was often old and outdated, contacting past owners or their descendants helped us to locate current owners. The artist had consistent gallery representation between 1941 and December 1999, when research for this publication stopped, except for a five-year break between 1957 and 1962, a situation that resulted in a consistent paper trail that was instrumental in reconstructing the artist's oeuvre. The galleries and dates in question were the Downtown Gallery, New York, 1941–53; The Alan Gallery, New York, 1953–7; Terry Dintenfass Inc., New York, 1962–86; Francine Seders Gallery, Seattle, 1975–present; Midtown Payson Galleries, New York, 1993–6; DC Moore Gallery, New York, 1997–present.

The records for the Lawrence's agents prior to 1957 are accessible to scholars through the Archives of American Art, Smithsonian Institution, Washington, D.C. (AAA) ["Downtown Gallery Papers" and "Alan Gallery Papers"]. These are the most extensive and reliable records on the artist's early work after 1941. They include gallery inventory books, sales records, exhibition checklists, exhibition mailers, brochures, notes on loans to museums and universities, selected correspondence, press clip-

pings, and photographs. Additionally, the AAA houses selected early records from Terry Dintenfass Inc. ["Terry Dintenfass Papers"], which we reviewed. Inventory books, the majority of the gallery's sales records, and the visual archive remain in Terry Dintenfass's possession. Terry Dintenfass provided us access to her inventory books and visual archive, but we did not review sales records that were located in her apartment, and the inventory books often did not contain the names of sellers for works on consignment to the gallery. The records for the artist's recent or current agents are not publicly available, but all the galleries provided us sales and consignment information. Francine Seders Gallery gave us access to its Lawrence-related files and direct access to its inventory database.

Overall, the gallery records are a reliable source of information regarding titles, dates, and collection information, but not medium. Consignment receipts and inventory books for the same painting often contain conflicting information, and later sources (e.g., gallery inventories and exhibition catalogues) have compounded the confusion. This is due, in part, to the difficulty of identifying certain water-based paints by sight. But it is also due to the fact that Lawrence frequently used several media in a single composition, a fact that was generally not acknowledged in gallery records (see Medium, below).

Works from several distinct periods in the artist's career have not been well documented prior to this project, and extensive research has yielded important, but sadly few, discoveries. Paintings and drawings executed before 1941—the year Lawrence began to be represented by the Downtown Gallery in New York—have remained particularly elusive. Those that remained in the artist's collection until the 1980s and 1990s are well documented, but many works that were sold or given away by the artist prior to 1941 exist only as titles on checklists for exhibitions. These checklists are available in the Jacob Lawrence Papers at the George Arents Research Library, Syracuse University, and the Archives of American Art.

The paintings Lawrence produced from 1938 to 1940 while employed by the Easel Division of the Works Progress Administration/Federal Art Project (WPA/FAP) are also underrepresented here. This is not uncommon for WPA-era works. It is estimated that during Lawrence's eighteen-month tenure with the WPA/FAP, he produced approximately thirty-six paintings, many of which are unidentified, even by title. Generally, WPA/FAP Easel Division works were lent to not-for-profit institutions (e.g., schools, hospitals) on a long-term basis. Many paintings that remained the property of the government when the WPA was disbanded in 1942–3 were destroyed, as the nation prepared

for World War II. Though research was conducted at the National Archives in Washington, D.C., where the records of the New York City Easel Division records are stored, no inventory lists or receipts have been located that would indicate the whereabouts of these paintings, or confirm whether they were destroyed.

The majority of paintings and drawings Lawrence executed while serving in the United States Coast Guard (October 1943–December 1945) are still missing. For most of his active duty, Lawrence had a public relations rating that allowed him to paint full-time. When completed, these paintings became the property of the U.S. Coast Guard, and though eight works were lent for exhibition to the Museum of Modern Art, New York, in 1944, and others were eventually sold through the Downtown Gallery, most have disappeared. The rapid demilitarization after World War II created confusing conditions that were ideal for works to disappear—offices were closed, furniture and supplies were sold and/or casually obtained for personal use by government workers. Research into the location of these works was initiated in the early 1970s by the Whitney Museum of American Art during preparations for the artist's retrospective in 1974 and again in the early 1980s by Ellen Harkins Wheat, though few works were located. Our extensive research into the whereabouts of these works has resulted in the discovery of additional works but has yielded little information regarding the fate of dozens of remaining works. Interviews with descendants of U.S. Coast Guard personnel, as well as with U.S. Coast Guard curators and historians, indicate that these works may have been destroyed in the 1950s, following a decade of storage at the Coast Guard Academy in New London, Connecticut.

Entries

The catalogue entries for each artwork contain standard cataloguing data as outlined below.

CATALOGUE NUMBERS

All entries are preceded by a catalogue number consisting of a letter for the object type, the last two digits of the year in which the work was completed, and an identifying number. Paintings are identified by *P*; drawings by *D*; the Vesalius studies by *V*; and murals by *M*. For example, a painting completed in 1943 and first in the sequence of paintings for that year is listed as "P43-01." The catalogue numbers for the Vesalius studies, however, do not include the two digits corresponding to the year because most of these drawings are undated. Instead, they are numbered in an abbreviated format: "V-01."

TITLES

Titles used in this catalogue are the earliest known titles for the works. Because the artist did not keep inventory records, titles were culled from inscriptions on the works themselves, exhibition checklists, gallery inventory books, receipts, or old labels. Descriptive titles have been used sparingly and appear in brackets (e.g., *Untitled [Man with Hammer]*). Alternative titles are noted in either the exhibition or publication histories (as *Title*) or in Remarks. If a title for a work was given by the artist only many years after completing the work and no earlier title is known to exist, the new title is used. *Untitled* means that a work was never titled by the artist or the title remains unknown—*Untitled* is not a title given by the artist to the work.

DATES

In general, Lawrence dated his work on completion and prior to its leaving the studio, usually on the face of the work (either within the image or in the margin if there is one), and occasionally also on the verso.

For most entries, a single date is given. This is the year that the work was completed (with the assumption that it may have been started in one year and completed in the next). If it is known that the artist worked on a single painting over a prolonged period of time (more than two years), a hyphenated date (e.g., 1945–50) is given. If the artist began a work one year, put it aside, and completed it many years later, then two dates separated by a comma are used to indicate the two distinct periods of activity (e.g., 1967, 1976).

Undated paintings and drawings remained in the artist's possession for many years that were later postdated and sold by galleries. If stylistic analysis or historical documentation indicates that the date assigned by the artist is incorrect, we have revised the date. (When the artist postdated his works, he did not have the benefit of reviewing images from his entire career.) In these instances, the date in the entry will differ from the one that appears in the inscription. If a work has not been dated by the artist, we have attempted to date it. Uncertainty is indicated by "ca." If a work is too difficult to date, as is the case with many of the Vesalius studies, "n.d." (no date) is used.

MEDIUM

In an effort to avoid repetition in catalogue entries, two assumptions have been made with regard to medium. Based on the fact that every painting that was inspected in person was determined to have a visible graphite underdrawing, "over graphite" is not included in the medium line unless it is at

the request of a museum or the presence of graphite is substantial. In addition, for all paintings on hardboard, it is assumed that the hardboard was prepared with a white ground and this information, too, is not provided in the medium line. Early paintings on hardboard have a ground mixed and applied by the artist; later works exhibit a commercially prepared surface. For works on paper, Lawrence never applied a ground layer before painting.

In many cases, our media attributions will differ from previously published attributions. For paintings, the following terminology is used: gouache, watercolor, egg tempera, casein tempera, and tempera. Though it is difficult to distinguish between gouache and watercolor, every reasonable effort has been made to do so. If the binding medium of a tempera paint can be identified as either egg or casein, that information is given. If the binding medium has not been identified or two different types of tempera paints (e.g., egg tempera and casein tempera) appear to have been used but this has not been confirmed, the more generic term *tempera* is used. The binding media were typically glue and/or gum mixtures, in addition to egg or casein. Many of the paints used in the early paintings of the mid- to late 1930s are inexpensive, commercially produced paints marketed to the design professional and to students as poster paints and showcard colors. Regardless of the names used on the labels of these products, all are tempera paints and are catalogued as such here.

It was impossible to conduct visual or material analyses of every painting, though every effort was made to look at as many works in person as possible. Because in many cases visual analysis was not sufficient to determine media, a representative sampling of twenty-one paintings were analyzed using gas chromotography and other methods of chemical analysis at the Getty Conservation Institute in Los Angeles. The results of this research, coupled with historical documentation and additional information provided by other conservators throughout the country, assisted us with our media line determinations.

As noted above, it was discovered in the course of visual and chemical analysis that the artist often used more than one water-based paint within a painting. Therefore, a painting that has for decades been catalogued as gouache may actually have been made with gouache *and* watercolor, or gouache and several types of tempera (e.g., casein *and* glue). Lawrence has stated to the authors that his use of several media within a single composition had as much to do with practical matters (i.e., whether or not he had the color he needed in the medium he was using) as it did with the various media's aesthetic properties.

DIMENSIONS

Dimensions are provided in inches followed by centimeters in parentheses; height precedes width. Dimensions are for the support only (i.e., hardboard, paper) and not the image, unless otherwise noted, though paintings completed between 1935 and 1946, and paintings commissioned after that date for translation to posters or for use on magazine covers (e.g., *Fortune*) have an unpainted border. This border, or margin, ranges in width from approximately three-quarters to one-and-a-half inch.

Every effort was made to remeasure as many works as possible. Often, however, in the case of very fragile works or works that were on extended tour that could not be unframed, dimensions were taken from either gallery records or labels. In several cases, only image dimensions—excluding the border—are available from existing sources, and in these cases, the dimensions are preceded by "image." When information from other sources was not available, measurements were taken of the image visible through the glass in the frame. When the dimension line notes a "sight" dimension, it can be assumed that the datum was obtained in this manner.

INSCRIPTIONS

Information included in the inscription line is considered to be in the artist's hand. All inscriptions are within the image unless noted as being in the margin of the work. The use of an oblique line (/) denotes a line break. Upper- and lowercase letters are distinguished. If the inscription is within the image, "lower" and "upper" describe its location. "Bottom" and "top" indicate that the inscriptions are located in the margin and not within the image. "Unsigned" designates that a work is not signed or dated. "Inscription unknown" means that the inscription is not visible in the reproduction and the work has not been examined in person by a member of the authentication committee.

Inscriptions on the verso are included if they are in the artist's hand and have been seen in person or in a photograph. Because some paintings were viewed in person and were not unframed (see Dimensions, above), verso inscriptions may exist that are not included in this catalogue.

Lawrence signed most of his work when it was completed, and in 1998 he stated that he does not sign works that he considers unfinished or unsuccessful. However, on several occasions, he did sign works many years after they were completed and then put them on the market. Several of these works are known to be studies for other works. If a work is known to have been postdated, that information is included under Remarks.

COLLECTION LINES

Collection lines are consistent with the wishes of the owner and are not consistent with regard to wording. Collectors wishing to remain anonymous are listed as "Private collection." Collection of the artist is listed as "Jacob and Gwendolyn Knight Lawrence," acknowledging the fact that the artist was alive when research was completed on December 31, 1999.

PROVENANCE

Provenance is listed from earliest to most recent owner, excluding the current owner, who is credited in the collection line. Every effort has been made to confirm the provenance of each work, either by reviewing historical documentation or by contacting previous owners or their descendants. When a known gap exists and the transfer of ownership between one party and the next cannot be confirmed, a question mark (?) appears between the two entries. Dealers, galleries, auction houses, or other entities acting as the intermediary or agent during a transfer of ownership are enclosed in square brackets ([]), and only the selling agent is listed. If a work was consigned to one gallery, became available through another, and was finally sold through a third, only the final gallery is listed in the provenance. If an artwork was consigned by the artist to a gallery and later returned to him unsold, the gallery does not appear in the provenance. It is assumed in all cases that the artist was the first owner of all the artworks. Lawrence's name appears in the provenance section only if the artwork remained in his collection for more than five years after its completion or if ownership was transferred from the artist directly to another party without the intermediary of a gallery or other agent. For artworks obtained by the Alan Gallery from the artist between 1957 and 1962, the gallery is treated as an owner, not as an agent.

EXHIBITIONS

Exhibition entries are listed in chronological order, beginning with the earliest exhibition and ending with the most recent. Each entry contains the name of the organizing institution, the exhibition title, the dates at the first venue, and the checklist number for the artwork. For serial works (e.g., *The Migration of the Negro*), the individual panel numbers follow the entry in square brackets (e.g., [4, 6, 8, 10]) if only a portion of the series was exhibited. If the exhibition traveled and the organizing institution was not a venue, then the dates for the full tour are noted (e.g., 1944–6). Exhibition itineraries are not included in each artwork entry. Instead, they can be found in the exhibition chronology at the back of this book. Exhibition catalogues are not included here, nor are auction house viewings. If an exhibition catalogue contains significant commentary or an illustration of the artwork, it is listed under References. Complete information for exhibition entries given in abbreviated form is available in the abbreviations list. For museums and galleries, historic names are used.

REFERENCES

Publication entries are listed in chronological order, beginning with the earliest and ending with the most recent. This includes exhibition catalogues and brochures, periodicals, and newspapers. Auction catalogues are not included. A priority has been placed on publications that include either a reproduction of the work or significant commentary. If a reference includes an illustration, that fact is noted (ill.). If no note is made of an illustration, the reference is to be understood as including only commentary. The city of publication of a newspaper, journal, or magazine can be found in the Bibliography.

REMARKS

For reasons of economy, remarks are kept to a minimum and only given to provide information on alternative titles, inscriptions, date discrepancies, commissions, or important comments on subject matter. If the artist has made comments regarding authorship that contradict those of the authentication committee, that information is included here.

Paintings

P35-01
The Eviction
1935
tempera on brown paper
28⁷⁄₁₆ × 38⁷⁄₈ in. (72.2 × 98.7 cm)
signed and dated lower right "LAWRENCE 35" [vertical]; verso:
inscribed "By Jacob Lawrence / 142 W. 143rd N.Y.C. 1/22/36"

Collection: Jack S. Blanton Museum of Art, The University of Texas at Austin.
Purchased through the generosity of Mari and James A. Michener, 1969.

Provenance: ?; [Robert Schoelkopf Gallery, New York].

Exhibitions: Archer M. Huntington Art Gallery, University of Texas at Austin, *Recent Acquisitions of the Michener Collection*, August 3–30, 1970; Archer M. Huntington Art Gallery, University of Texas at Austin, *American Social Realism between the Wars: From the Michener Collection*, November 14–21, 1971; Archer M. Huntington Art Gallery, University of Texas at Austin, *Form and the Creative Process: Selections from the Michener Collection*, May 15–June 30, 1972; Archer M. Huntington Art Gallery, University of Texas at Austin, *The Michener Collection: American Paintings of the Twentieth Century*, November 22, 1972–March 1, 1973; Archer M. Huntington Art Gallery, University of Texas at Austin, *Twentieth-Century American Painting: The First Five Decades, from the Michener Collection*, July 22, 1974–January 5, 1975; Archer M. Huntington Art Gallery, University of Texas at Austin, *American Paintings of the Twentieth Century: Selections from the Michener Collection*, February 2–December 28, 1975; Archer M. Huntington Art Gallery, University of Texas at Austin, *Twentieth-Century American Figurative Painting in the Michener Collection*, July 4–August 1, 1976, no. 23; Nave Museum, Victoria, Tex., *Between the Wars: American Painting and Graphics*, November 3–December 18, 1977; Wichita Falls Museum and Arts Center, Tex., *Selections from the Michener Collection*, October 15–November 16, 1980.

References: "The Michener Collection: The University of Texas at Austin," *Texas Quarterly* 13, 1 (spring 1970), n.p., ill. (as *#2, The Eviction 1/22/36*).

P35-02
The Party
1935
tempera on paper
17½ × 22½ in. (44.5 × 57.2 cm)
signed and dated lower right "LAWRENCE 35" [vertical]

Collection: Clarence and Jacqueline Avant, Beverly Hills.

Provenance: ?; [Bernice Steinbaum Gallery, New York].

Exhibitions: Bellevue Art Museum, Wash., *Hidden Heritage: Afro-American Art, 1800–1950*, September 14–November 10, 1985, no. 76; Downtown Arts Gallery at Church Street Centre, Nashville, *American Resources: Selected Works by African-American Artists*, June 18–August 18, 1989.

References: "Jacob Lawrence American Painter," *Dallas Weekly*, June 25–July 1, 1987, p. C2, ill.; *American Resources: Selected Works by African-American Artists/Contemporary American Artists* (Nashville: Fisk University, 1989), n.p., ill.

P36-01
Studio Corner
1936
watercolor on paper
24¼ × 18¼ in. (61.6 × 46.4 cm)
signed lower right "Jacob Lawrence"; verso: inscribed center "#4 Studio Corner / by Mr. Jacob Lawrence / 142 West 143rd Street, N.Y.C. 1/22/36—Apt. 30"

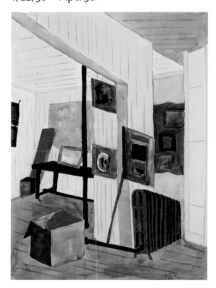

Collection: Private collection.

Provenance: Jacob and Gwendolyn Knight Lawrence, New York and Seattle.

Remarks: This painting depicts the artist's studio space and worktable at 306 West 141st Street, New York. The address inscribed on the verso is the apartment Lawrence lived in with his mother, brother, and sister.

P36-02
The Homecoming
1936
tempera on brown paper
35 × 22 in. (88.9 × 55.9 cm)
signed and dated lower right "JACOB LAWRENCE / 36" [vertical]

Collection: Mrs. Daniel Cowin.

Provenance: [The Downtown Gallery, New York]; Walter Pach, New York; George Washington Carver School, New York; ?; [Terry Dintenfass Inc., New York]; Daniel Cowin, New York.

P36-03
Street Scene—Restaurant
ca. 1936
tempera on paper
26¼ × 35 in. (66.7 × 88.9 cm)
signed and dated lower right "Jacob Lawrence / c. 36–38"

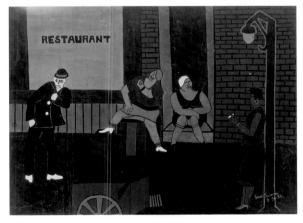

Collection: The Collection of Philip J. and Suzanne Schiller, American Social Commentary Art, 1930–1970.

Provenance: Jacob and Gwendolyn Knight Lawrence, New York; Dr. and Mrs. Emanuel Klein, New York; [Terry Dintenfass Inc., New York].

Exhibitions: Seattle 1986–7, no. 2; American Federation of Arts, New York, *In the Eye of the Storm: An Art of Conscience, 1930–1970, Selections from the Collection of Philip J. and Suzanne Schiller*, 1995–8.

References: Patricia Hills, with an essay by Raphael Soyer, *Social Concern and Urban Realism: American Painting of the 1930s*, exh. cat. (Boston: Boston University Art Gallery, 1983), p. 64, ill; Seymour Chwast and Steven Heller, eds., *The Art of New York* (New York: Harry N. Abrams, 1983), p. 76, ill.; Stephanie Stokes Oliver, "Jacob Lawrence," *Essence* (November 1986), pp. 89–91, 134, ill.; Wheat 1986, p. 49, pl. 1; American Federation of the Arts, *In the Eye of the Storm: An Art of Conscience, 1930–1970, Selections from the Collection of Philip J. and Suzanne Schiller*, exh. cat. (New York: Pomegranate Art Books, 1995), p. 46, ill.; "Other People Art Looking at Us: Visual Commentaries on Social Change," *American Visions* 11 (April–May 1996), pp. 14–9, ill.

P36-04
Ice Peddlers
1936
tempera on paper
26 × 19½ in. (66 × 49.5 cm)
signed lower left "Lawrence"

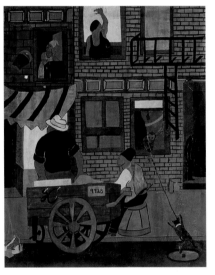

Collection: The Walter O. Evans Collection of African American Art.

Provenance: Jacob and Gwendolyn Knight Lawrence, New York and Seattle; [Francine Seders Gallery, Seattle].

Exhibitions: American Artists School 1939, no. 3; USIA Caribbean 1989, no. 4; Katonah 1992; Northwest Art 1997; Henry Art Gallery 1998.

References: Lewis and Sullivan 1982, p. 11, ill.; Ellen Harkins Wheat, "Jacob Lawrence and the Legacy of Harlem," *Archives of American Art Journal* 26, 1 (1986), p. 21, ill.; Lewis and Hewitt 1989, p. 23, ill.

Remarks: Exhibited and published after 1988 as *Ice Man*.

P36-05
Street Orator's Audience
1936
tempera on paper
24⅛ × 19⅛ in. (61.3 × 48.6 cm)
signed and dated lower right "LAWRENCE / 36" [vertical]

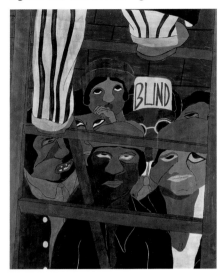

Collection: Collection of Tacoma Art Museum. Gift of Mr. and Mrs. Roger W. Peck by exchange.

Provenance: Jacob and Gwendolyn Knight Lawrence, New York and Seattle; [Francine Seders Gallery, Seattle].

Exhibitions: American Artists School 1939, no. 20; AFA 1960–2, no. 1; ACA Galleries, New York, *Protest Paintings—USA: 1930–1945*, April 4–23, 1966, no. 16; The Museum of the National Center of Afro-American Artists, Roxbury, Mass., *Five Famous Black Artists: Romare Bearden, Jacob Lawrence, Horace Pippin, Charles White, Hale Woodruff*, February 9–March 10, 1970; Whitney 1974–5, no. 1; Gallery 1199, New York, *Social Concern and Urban Realism: American Painting of the 1930s*, April 8–May 14, 1983, no. 28; Seattle 1986–7, no. 1; USIA Caribbean 1989, no. 19; Katonah 1992; Nassau County Museum of Art, Roslyn Harbor, N.Y., *American Realism between the Wars: 1919–1941*, April 10–June 5, 1994; Midtown Payson 1995a; Henry Art Gallery 1998.

References: Sol Wilson, *Jacob Lawrence and Samuel Wechsler*, exh. cat. (New York: American Artists School, 1939); Saarinen 1960, p. 20, ill.; Lee Nordness, ed., *Art: USA Now*, exh. cat. (Lucerne, Switzerland: C. J. Bucher, 1962), p. 322, ill.; Lindsay Patterson, *International Library of Negro Life and History: The Negro in Music and Art* (New York: Publishers Company, 1967), p. 238, ill.; Virginia Lee, "Jacob Lawrence—Story Teller," *Northwest Art News and Views* 1 (March–April 1970), p. 21, ill.; Brown 1974, p. 18, ill.; Lewis and Sullivan 1982, p. 6, ill.; Patricia Hills, with an essay by Raphael Soyer, *Social Concern and Urban Realism: American Painting of the 1930s*, exh. cat. (Boston: Boston University Art Gallery, 1983); Wheat 1986, p. 49, pl. 2; p. 206, ill.; Amy Fine Collins, "Jacob Lawrence: Art Builder," *Art in America* 76, 2 (February 1988), p. 133, ill.; Lewis and Hewitt 1989, p. 22, ill.; Patricia Hills, "Jacob Lawrence as Pictorial Griot: The *Harriet Tubman* Series," *American Art* 7, 1 (winter 1993), p. 42, ill.; Constance Schwartz and Franklin Hill Perrell, *American Realism between the Wars: 1919–1941*, exh. cat. (Roslyn Harbor, N.Y.: Nassau County Museum of Art, 1994), p. 35, ill.; Midtown Payson 1995b, inside front cvr., ill.

Remarks: Exhibited and published after 1959 as *Street Orator*.

P37-01
The Bo-Lo Game
1937
tempera on composition board
10⅛ × 15 in. (25.7 × 38.1 cm)
signed and dated lower left "J. Lawrence 37"

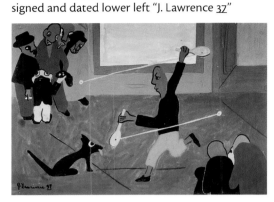

Collection: The Newark Museum. Purchase with funds from The Members' Fund, 84.32.

Provenance: Jacob and Gwendolyn Knight Lawrence, New York; Edwin and Helen Coates, New York; [Christie, Manson & Woods, New York, March 23, 1984, Sale 5520, lot 142].

Exhibitions: The Newark Museum, *Twentieth-Century Afro-American Artists: Selections from the Collection of The Newark Museum*, October 1985; Chubb Group of Insurance Co., Warren, N.J., *American Drawings 1900–1960 from the Permanent Collection of The Newark Museum*, September 3–November 1, 1994.

Remarks: A.k.a. *The Yo-Yo Game.*

P37-02
Junk
1937
tempera on paper
17⅞ × 12 in. (45.4 × 28.6 cm)
signed and dated lower right "J. Lawrence 37"

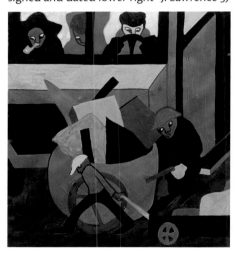

Collection: John P. Axelrod, Boston.

Provenance: ?; John Willis, Hightstown, N.J.; Lawrence Hilton, Trenton, N.J.

Exhibitions: 135th Street YMCA, New York, *Presenting Jacob Lawrence in an Exhibition of Paintings*, February 1938, no. 16; New Jersey State Museum, Trenton, and Prefecture of Fukui, Japan, *Dream Singers, Storytellers: An African-American Presence*, 1992–4, no. 137.

References: Alison Weld and Sadao Serikawa, *Dream Singers, Storytellers: An African-American Presence*, exh. cat. (Trenton, N.J.: New Jersey State Museum; Fukui, Japan: Fukui Fine Arts Museum, 1992), pl. 137.

Remarks: A.k.a. *Junkman.*

P37-03
Halloween Sand Bags
1937
tempera on paper
8¾ × 12¾ in. (22.2 × 32.4 cm)
signed and dated upper left "J. Lawrence 37"

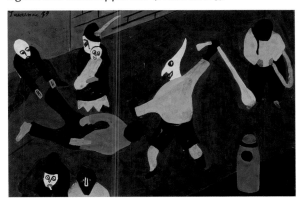

Collection: The Harmon and Harriet Kelley Foundation for the Arts.

Provenance: ?; [Terry Dintenfass Inc., New York].

Exhibitions: 135th Street YMCA, New York, *Presenting Jacob Lawrence in an Exhibition of Paintings*, February 1938, no. 2; American Artists School 1939, no. 11 (as *Hallowe'en Sand Boys*); Bellevue Art Museum, Wash., *Hidden Heritage: Afro-American Art, 1800–1950*, September 14–November 10, 1985, no. 77 (as *Street Scene*); Katonah 1992 (as *Street Scene—Halloween*); San Antonio Museum of Art, *The Harmon and Harriet Kelley Collection of African American Art*, February 4–April 3, 1994; Henry Art Gallery 1998.

References: David C. Driskell, *Hidden Heritage: Afro-American Art, 1800–1950*, exh. cat. (San Francisco: Art Museums Association of America, 1985), p. 88, fig. 59.

P37-04
Moving Day
1937
tempera on paper
sight: 30 × 24¾ in. (76.2 × 62.9 cm)
signed and dated lower left "J. Lawrence 37"

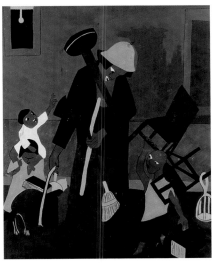

Collection: Private collection.

Provenance: Jacob and Gwendolyn Knight Lawrence, New York; ?; Leah Salisbury, New York.

Exhibitions: American Artists School 1939, no. 18; Katonah 1992.

Remarks: This painting was in the inventory of the Downtown Gallery, New York, until 1946 when it was returned to the artist. When Leah Salisbury bought it ca. 1950 at a benefit auction or from a dealer other than Edith Halpert, the work had acquired the title *Dispossessed*.

P37-05
Dining Out
1937
tempera on paper
11½ × 9 in. (29.2 × 22.9 cm)
signed and dated lower left "J. Lawrence 37"

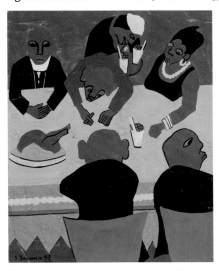

Collection: Collection of the Madison Art Center, Madison, Wisconsin. Gift of the Estate of Janet Ela.

Provenance: ?; [Terry Dintenfass Inc., New York]; Janet Ela, Madison, Wis.

Exhibitions: Madison Art Center, Wis., *Dane County Collects: An Exhibition of Works from Area Corporate and Private Collections*, February 16–April 16, 1997.

P37-06
Woman with Veil
1937
tempera on brown paper
17 × 13½ in. (43.2 × 33.9 cm)
signed and dated lower right "J. Lawrence 37"

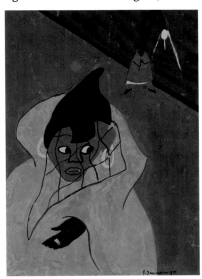

Collection: The Walter O. Evans Collection of African American Art.

Provenance: Jacob and Gwendolyn Knight Lawrence, New York and Seattle; [Francine Seders Gallery, Seattle].

Exhibitions: 135th Street YMCA, New York, *Presenting Jacob Lawrence in an Exhibition of Paintings*, February 1938, no. 14; American Artists School 1939 (as *Lady with Veil No. 1*); USIA Caribbean 1989, no. 15 (as *The Woman in Green*); Henry Art Gallery 1998.

References: Lewis and Hewitt 1989, p. 29, ill. (as *The Woman in Green*).

P37-07
Rain No. 1
1937
tempera on paper
image: 28½ × 20¾ in. (72.4 × 52.7 cm)
signed and dated lower right "J. Lawrence 37"

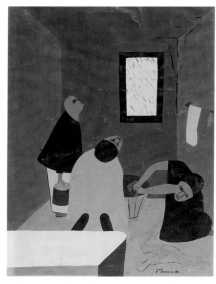

Collection: Wadsworth Atheneum, Hartford, Connecticut. The Ella Gallup Sumner and Mary Catlin Sumner Collection Fund.

Provenance: Jacob and Gwendolyn Knight Lawrence, New York and Seattle; [Francine Seders Gallery, Seattle].

Exhibitions: 135th Street YMCA, New York, *Presenting Jacob Lawrence in an Exhibition of Paintings*, February 1938, no. 15; American Artists School 1939, no. 8; Black Mountain College, Asheville, N.C., July 2–August 28, 1946; AFA 1960–2, no. 3; Whitney 1974–5, no. 3; USIA Caribbean 1989, no. 3.

References: Saarinen 1960; Brown 1974, p. 19, ill.; Lewis and Hewitt 1989, p. 28, ill.

Remarks: Exhibited and published after 1945 as *Rain*.

P37-08
Library
1937
tempera on paper
sight: 11½ × 8½ in. (29.2 × 21.6 cm)
signed and dated lower left "J. Lawrence 37"

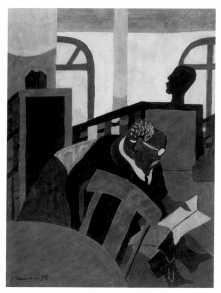

Collection: Schomburg Center for Research in Black Culture, New York Public Library, Astor, Lenox & Tilden Foundations.

Provenance: ?; Edwin and Helen Coates, New York; [Terry Dintenfass Inc., New York].

Exhibitions: American Artists School 1939, no. 22; The Studio Museum in Harlem, New York, *Chicago/New York: WPA and the Black Artist*, November 13, 1977–January 8, 1978; Gallery 62, National Urban League Headquarters, New York, *Golden Opportunity*, September 18–November 30, 1978; The Schomburg Center for Research in Black Culture, New York, *Augusta Savage and the Art Schools of Harlem*, October 9, 1988–January 28, 1989, no. 52; The Schomburg Center for Research in Black Culture, New York, *Black Artists of the Twentieth Century: Selections from The Schomburg Center Collections*, November 17, 1998–April 4, 1999.

References: Ruth Ann Stewart, *New York/Chicago: WPA and the Black Artist*, exh. cat. (New York: The Studio Museum in Harlem, 1977), ill.; Regenia A. Perry, *Golden Opportunity*, exh. cat. (New York: Gallery 62, National Urban League, 1978), pl. 10; Wheat 1986, p. 152; Deirdre L. Bibby, *Augusta Savage and the Art Schools of Harlem*, exh. cat. (New York: The Schomburg Center for Research in Black Culture, 1988); Elizabeth Hutton Turner, ed., *Jacob Lawrence: The Migration Series*, exh. cat. (Washington, D.C.: Rappahannock Press in association with The Phillips Collection, 1993), p. 38, ill.; Sharon Fitzgerald, "The Homecoming of Jacob Lawrence," *American Visions* 10 (April–May 1995), p. 23, ill.

Remarks: A.k.a. *Portrait of Arthur Schomburg* and *The Curator*. The subject of this work is Arthur A. Schomburg, the curator of the Division of Negro History, Literature, and Prints at the 135th Street branch of the New York Public Library where Lawrence regularly conducted research. Lawrence did not know Schomburg well, and the painting was not intended to be an exact likeness of him, though he served as the subject's inspiration. Schomburg died the following year.

P37-09
Christmas
1937
tempera on paper
sight: 25 × 27½ in. (63.5 × 69.9 cm)
signed and dated lower right "LAWRENCE / 37" [vertical]

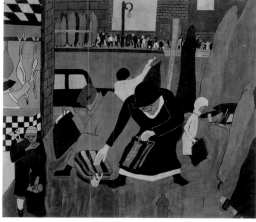

Collection: Joshua and Rachel Skolnick.

Provenance: Jacob and Gwendolyn Knight Lawrence, New York and Seattle; [Midtown Payson Galleries, New York].

Exhibitions: American Artists School 1939, no. 17; USIA Caribbean 1989, no. 2; Katonah 1992; Midtown Payson 1993a.

References: Lewis and Hewitt 1989, p. 25, ill.

P37-10
Interior (Family)
1937
tempera on paper
30⅜ × 25½ in. (77.2 × 64.8 cm)
signed and dated lower right "J. Lawrence 37"

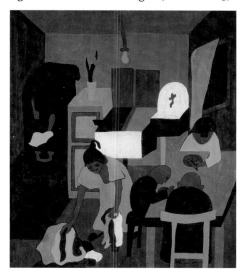

Collection: Collection of AXA Financial.

Provenance: Jacob and Gwendolyn Knight Lawrence, New York and Seattle; [Mary Ryan Gallery, New York].

Exhibitions: USIA Caribbean 1989, no. 1; Katonah 1992; Midtown Payson 1993a; Henry Art Gallery 1998.

References: Wheat 1986, p. 50, pl. 3; Lewis and Hewitt 1989, p. 27, ill. (as *Family*); Tom Stabile, "Reconstructing Jacob Lawrence: A Scholarly Team Prepares the Master Catalog," *Humanities* 19, 6 (November–December 1998), p. 27, ill.; Peter T. Nesbett, "An IFAR Evening: The Jacob Lawrence Catalogue Raisonné Project," *International Foundation for Art Research Journal* 2, 2 (spring 1999), p. 13, ill.

P37-11
Free Clinic
1937
tempera on paper
28 × 29½ in. (71.1 × 74.9 cm)
signed and dated lower right "Lawrence 37"

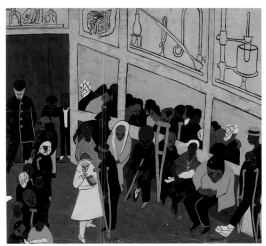

Collection: The Art Institute of Chicago.

Provenance: Jacob and Gwendolyn Knight Lawrence, New York and Seattle; [Francine Seders Gallery, Seattle].

Exhibitions: AFA 1960–2, no. 2 (as *Clinic*); ACA Galleries, New York, *Protest Paintings–USA: 1930–1945*, April 4–23, 1966, no. 15; YM-YWHA Essex County, West Orange, N.J., *WPA Artists: Then and Now*, October 29–November 28, 1967, no. 45; Whitney 1974–5, no. 2; Francine Seders Gallery, Seattle, *Graphics by Jacob Lawrence*, October 15–November 3, 1976; USIA Caribbean 1989, no. 11; The Art Institute of Chicago, *Since the Harlem Renaissance: Sixty Years of African-American Art*, May 18–August 25, 1996, n.p., ill.; Henry Art Gallery 1998.

References: Saarinen 1960, p. 20, ill.; Hilton Kramer, "Differences in Quality," *New York Times*, November 4, 1968, sec. 2, p. 27, ill.; Matthew Baigell, *The American Scene: American Painting of the 1930s* (New York: Praeger Publishers, 1974), p. 200, fig. 120 (as *Free Clinic* [*Harlem Hospital*]); R. M. Campbell, "The New Art of Jacob Lawrence," *Seattle Post-Intelligencer*, October 22, 1976, ill.; Lewis and Hewitt 1989, p. 24, ill.; Ellen Harkins Wheat, *Portraits: The Lives and Works of Eminent Artists* 2, 3 (1992), ill.; Romare Bearden and Harry Henderson, *A History of African-American Artists from 1972 to Present* (New York: Pantheon Books, 1993), p. 296, ill.

P37-12
Bar and Grill
1937
tempera on brown paper
sight: 22½ × 23¾ in. (57.2 × 60.3 cm)
signed and dated lower right "Lawrence 37"

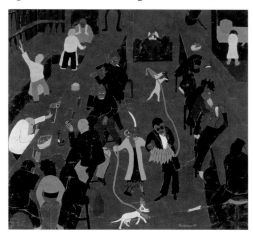

Collection: San Antonio Museum of Art, San Antonio, Texas. Purchased with funds provided by Mr. and Mrs. Hugh Halff by exchange, Dr. and Mrs. Harmon Kelley and Dr. Leo Edwards.

Provenance: Jacob and Gwendolyn Knight Lawrence, New York and Seattle; [Francine Seders Gallery, Seattle].

Exhibitions: 135th Street YMCA, New York, *Presenting Jacob Lawrence in an Exhibition of Paintings*, February 1938, no. 1; American Artists School 1939, no. 2; Mead Art Museum, Amherst College, Mass., *American Art of the Depression Era*, February 25–March 19, 1969; Whitney 1974–5, no. 4 (as *Bar 'n Grill*); Seattle 1986–7, no. 3 (as *Bar 'n Grill*); Midtown Payson 1995a (as *Bar 'n Grill*).

References: Charles Alston, *Jacob Lawrence*, exh. cat. (New York: James Weldon Johnson Literary Guild, 1938); Lewis and Sullivan 1982, p. 10, ill.; Wheat 1986, p. 206, ill.; Romare Bearden and Harry Henderson, *A History of African-American Artists from 1972 to Present* (New York: Pantheon Books, 1993), p. 296, ill.; *The Twentieth-Century Art Book* (London: Phaidon, 1999), p. 263, ill.

Remarks: The bar depicted is Joe's Bar, which was, in 1937, located at 141st Street and Eighth Avenue, New York. The bar was around the corner from 306 West 141st Street, New York, where the artist had his studio.

P37-13
Interior Scene
1937
tempera on composition board
28½ × 33¾ in. (72.4 × 85.7 cm)
signed and dated lower right "Lawrence / 37"

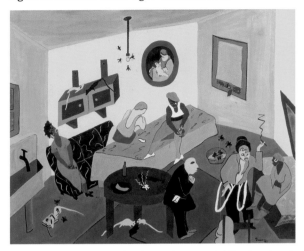

Collection: The Collection of Philip J. and Suzanne Schiller, American Social Commentary Art, 1930–1970.

Provenance: ?; Dr. and Mrs. Emanuel Klein, New York; [Terry Dintenfass Inc., New York].

Exhibitions: New Jersey State Museum, Trenton, *Six Black Americans: Benny Andrews, Romare Bearden, Sam Gilliam, Richard Hunt, Jacob Lawrence, Betye Saar,* January 26–March 30, 1980, no. 1; Gallery 1199, New York, *Social Concern and Urban Realism: American Painting of the 1930s,* April 8–May 14, 1983, no. 27; Seattle 1986–7, no. 4; American Federation of the Arts, New York, *In the Eye of the Storm: An Art of Conscience, 1930–1970, Selections from the Collection of Philip J. and Suzanne Schiller,* 1995–8.

References: David Piper, *The Illustrated Dictionary of Art and Artists* (New York: Random House, 1984); Ellen Harkins Wheat, "Jacob Lawrence and the Legacy of Harlem," *Archives of American Art Journal* 26, 1 (1986), p. 22, ill.; Wheat 1986, p. 50, pl. 4; Elizabeth Hutton Turner, ed., *Jacob Lawrence: The Migration Series,* exh. cat. (Washington, D.C.: Rappahannock Press in association with The Phillips Collection, 1993), p. 47, ill.; American Federation of the Arts, *In the Eye of the Storm: An Art of Conscience, 1930–1970, Selections from the Collection of Philip J. and Suzanne Schiller,* exh. cat. (New York: Pomegranate Art Books, 1995); "Other People Art Looking at Us: Visual Commentaries on Social Change," *American Visions* 11 (April–May 1996), ill.

P38-01
Woman
1938
tempera on paper
11¾ × 9 in. (29.8 × 22.9 cm)
signed and dated lower left "J. LAWRENCE 38"

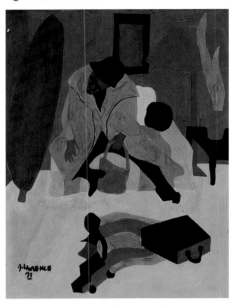

Collection: Mrs. Suzanne Schwartz Cook.

Provenance: Sadie Klein, New York; [Terry Dintenfass Inc., New York].

Exhibitions: 135th Street YMCA, New York, *Presenting Jacob Lawrence in an Exhibition of Paintings,* February 1938, no. 10.

References: Charles Alston, *Jacob Lawrence,* exh. cat. (New York: James Weldon Johnson Literary Guild, 1938).

P38-02
Untitled [*Street Scene with Policemen*]
1938
tempera on paper
11½ × 13 in. (29.2 × 33 cm)
signed and dated lower left "J. Lawrence 38"

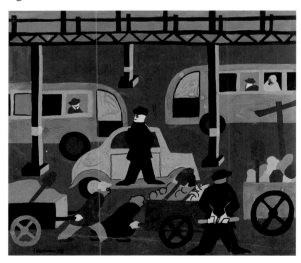

Collection: Private collection, San Francisco.

Provenance: Jacob and Gwendolyn Knight Lawrence, New York; Cyril and Jean Olliviere, New York.

P38-03
The Life of Toussaint L'Ouverture
1938
tempera on paper (41 paintings)
11½ × 19 in. (29.2 × 48.3 cm) // 19 × 11½ in. (48.3 × 29.2 cm)
each painting signed and dated lower right "J. Lawrence 38"

Collection: Amistad Research Center, Tulane University, New Orleans. Aaron Douglas Collection.

Provenance: Collection of the artist, New York; The Harmon Foundation, New York; Fisk University, Nashville; United Church Board for Homeland Ministries, Cleveland.

Exhibitions: The Baltimore Museum of Art, *Contemporary Negro Art*, February 3–19, 1939; DePorres Interracial Center, New York, *Jacob Lawrence*, New York, May 22–June 5, 1939; Tanner Gallery, American Negro Exhibition, Chicago, *Exhibition of the Art of the American Negro, 1851–1940*, July 2–September 2, 1940; Columbia University Art Gallery, New York [*The Life of Toussaint L'Ouverture*], November 15, 1940–February 1, 1941; Fisk University, Nashville, *Afro-American Art*, December 1940 [3 panels]; The Institute for Modern Art, Boston, *Four Modern American Painters: Peter Blume, Stuart Davis, Marsden Hartley, Jacob Lawrence*, March 2–April 1, 1945; Phillips Memorial Gallery, Washington, D.C., *Three Negro Artists: Horace Pippin, Jacob Lawrence, Richmond Barthé*, December 14, 1946–January 6, 1947; Sheraton Hotel, Philadelphia, *Afro-American Art Exhibition: Paintings, Drawings and Prints*, July 28, 1968 [6, 17]; The Art Gallery, Fisk University, Nashville, *Jacob Lawrence: The Toussaint L'Ouverture Series*, December 8–30, 1968; Talladega College, Ala., *Arts Festival*, April 16–20, 1969 [6]; The Studio Museum in Harlem, New York, *Jacob Lawrence: Toussaint L'Ouverture Series*, November 2, 1969–January 4, 1970; Whitney 1974–5, nos. 5–12 [2, 9, 17, 20, 23, 36, 38, 41]; Los Angeles County Museum of Art, *Two Centuries of Black American Art*, September 30–November 21, 1976 [11, 17, 20, 23, 26]; Conference for the Council of Churches, New York, *Jacob Lawrence: Toussaint L'Ouverture Series*, September 1982; Lowe Art Museum, University of Miami, Coral Gables, Fla., *Jacob Lawrence: Toussaint L'Ouverture Series*, December 8, 1982–January 16, 1983; Howard University Gallery of Art, Washington, D.C., *Jacob Lawrence: Toussaint L'Ouverture Series*, October–November 1983; Hampton University Museum, Va., *Jacob Lawrence: Toussaint L'Ouverture Series*, November–December 1983; Oklahoma City Art Museum, *The Aaron Douglass Collection: Nineteenth and Twentieth Century Black Experience and the Arts*, January 14–February 17, 1984; Portland Art Museum, Ore., *Jacob Lawrence: Toussaint L'Ouverture Series*, September 11–November 4, 1984; Jamaica Arts Center 1984; Seattle 1986–7, nos. 5–11 [7, 19, 25, 35, 36, 38]; Aetna Gallery, Hartford, Conn., *Jacob Lawrence: Toussaint L'Ouverture Series*, January 4–March 4, 1990; New Orleans Contemporary Arts Center, *Jacob Lawrence: Toussaint L'Ouverture Series*, January–March 1991; University of Kentucky Art Museum, Lexington, *Jacob Lawrence: Toussaint L'Ouverture Series*, January 1–March 31, 1997; Hayward Gallery, London, *Rhapsodies in Black: Art of the Harlem Renaissance*, June 19–August 17, 1997, nos. 40–80; University of Iowa, Iowa City, *Jacob Lawrence: Toussaint L'Ouverture Series*, November 1–December 21, 1997; The Wood Street Galleries, Pittsburgh, *Jacob Lawrence: The Toussaint L'Ouverture Series and Aesop's Fables*, January 23–March 7, 1998; The Newark Museum, *Jacob Lawrence: Toussaint L'Ouverture Series*, January 1–March 31, 1999; Indianapolis Museum of Art, *Jacob Lawrence: Toussaint L'Ouverture Series*, November 1–December 31, 1999.

References: Jean McGleughem, "An Exhibition of Negro Art," *Baltimore Museum of Art Quarterly* 3, 4 (1938–9), p. 10, ill. [41]; A. D. Emmart, [Review of *The Life of Toussaint L'Ouverture*], *Baltimore Sun*, February 5, 1939; "Baltimore Museum Becomes the First to Stage Large Show of Negro Art," *Newsweek* 13 (February 6, 1939), p. 26; "Baltimore: Art by Negros," *ARTnews* 37, 20 (February 11, 1939), p. 17; "First Generation of Negro Artists: Paintings by Archibald J. Motley, Malvin Gray Johnson, Elton Fax, Jacob Lawrence," *Survey Graphic* 28, 3 (March 1939), p. 225, ill. [5]; Alain Locke, "Advance on the Art Front," *Opportunity* 17, 5 (May 1939), p. 133; "Art Exhibit Depicts Life of Ouverture," *Crisis* 46 (June 1939), p. 180; Alain Locke, *The Negro in Art: A Pictorial Record of the Negro Artist and of the Negro Theme in Art* (Washington, D.C.: Associates in Negro Folk Education, 1940), pp. 127–9, ill. [7, 10, 16, 18, 20, 28, 39, 40]; "Life of Toussaint," *Art Digest* 15, 6 (December 15, 1940), p. 12; Aline B. Louchheim, "Lawrence: Quiet Spokesman," *ARTnews* 43, 13 (October 15–31, 1944), p. 15, ill. [7]; *The Toussaint L'Ouverture Series*, exh. cat. (Nashville: Fisk University Art Gallery, 1968), exh. cat., n.p., ill. [1, 2, 20], cvr., ill. [20]; John Canaday, "Art: Scanning America of the Nineteenth Century," *New York Times*, November 1, 1969, p. 29; Alain Locke, *The Negro in Art: A Pictorial Record of the Negro Artist and of the Negro Theme in Art* (New York: Hacker Art Books, 1971), pp. 127–9, ill. [7, 10, 16, 18, 20, 28, 39, 40]; Romare Bearden and Harry Henderson, *Six Black Masters of American Art* (Garden City, N.Y.: Doubleday, 1972), p. 109, ill. [2]; Brown 1974, p. 20, ill.; Ruth Berenson, "Art: A Different American Scene," *National Review* 26, 33 (August 16, 1974), p. 930 [41]; David C. Driskell, *Amistad II: Afro-American Art*, exh. cat. (Nashville: Fisk University, 1975), pp. 51, 78, ill. [4, 25]; David C. Driskell, *Two Centuries of Black American Art*, exh. cat. (Los Angeles: Los Angeles County Museum of Art, 1976), p. 185, ill.; Floyd Coleman, "Towards an Aesthetic Toughness in Afro-American Art," *Black Art* 2, 3 (spring 1978), p. 33, ill. [20]; Ponchitta Pierce, "Black Art in America," *Reader's Digest* 112 (June 1978), pp. 182–3, ill. [23]; David C. Driskell, *The Toussaint L'Ouverture Series*, exh. cat. (New York: United Church Board for Homeland Ministries, 1982); Lewis and Sullivan 1982, pp. 49, 55 [20, 34, 36]; Paul Von Blum, *The Critical Vision: A History of Social and Political Art in the U.S.* (Boston: South End Press, 1982), p. 144, fig. 6-2 [20]; Vivien Raynor, "Forty-One Paintings Tell a Tale of Haitian Revolt," *New York Times*, April 18, 1982, sec. 2, p. 20, ill. [20]; Wheat 1986, pp. 52–3, pls. 6–8 [10, 17, 36] and pp. 206–7, ill. [7, 17, 19, 25, 35, 36, 38]; Ellen Harkins Wheat, "Jacob Lawrence: Chronicler of the Black Experience," *American Visions* 2, 1 (February 1987), p. 32, ill. [25]; Gary A. Reynolds and Beryl J. Wright, *Against the Odds: African-American Artists and the Harmon Foundation*, exh. cat. (Newark: The Newark Museum, 1989); Lewis and Hewitt 1989, n.p., ill. [17]; Elizabeth Hutton Turner, ed., *Jacob Lawrence: The Migration Series*, exh. cat. (Washington, D.C.: Rappahannock Press in association with The Phillips Collection, 1993), p. 49, ill. [20]; "Jacob Lawrence: Greatest Living Black Painter," *Ebony* (September 1992), p. 64, ill. [20]; Powell 1992, n.p., ill. [17]; Romare Bearden and Harry Henderson, *A History of African-American Artists from 1972 to Present* (New York: Pantheon Books, 1993), p. 298, ill. [1, 2, 20, 25]; Peter Nesbett, with an essay by Patricia Hills, *Jacob Lawrence: Thirty Years of Prints (1963–1993), A Catalogue Raisonné* (Seattle: Francine Seders Gallery in association with University of Washington Press, 1994), pp. 12–3, figs. 5, 7 [27, 38]; Karen Wilkin, "The Naïve and The Modern: Horace Pippin and Jacob Lawrence," *The New Criterion* 13, 7 (March 1995), p. 36; Richard G. Tansey and Fred S. Kleiner, *Gardiner's Art through the Ages* (New York: Harcourt Brace College Publishers, 1996), p. 1087, pl. 27-78 [36]; Stephen Wallis, "Jacob Lawrence: Portrait of a Serial Painter," *Art and Antiques* 19, 11 (December 1996), p. 60, ill. [17]; Richard J. Powell, *Rhapsodies in Black: Art of the Harlem Renaissance*, exh. cat. (Los Angeles: University of California Press, 1997), pp. 144–51 [2, 7, 12, 20, 23, 25, 30, 37]; Shaniece A. Bell, "Art of the African World, Jacob Lawrence: One of the World's Most Preeminent Artists," *The Black Collegian* (October 1998), p. 12, ill. [36].

Remarks: The captions accompanying each image are those used when the paintings were exhibited at the DePorres Interracial Center, New York, in 1939.

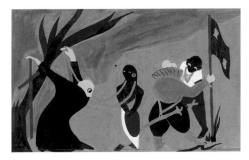

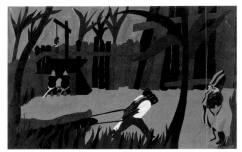

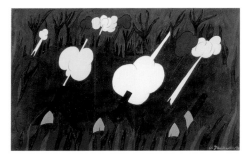

1. Columbus discovered Haiti on December 6, 1492. The discovery was on Columbus' first trip to the New World. He is shown planting the official Spanish flag, under which he sailed. The priest shows the influence of the Church upon the people.

2. Mistreatment by the Spanish soldiers caused much trouble on the island and caused the death of Anacanca, a native queen, 1503. Columbus left soldiers in charge, who began making slaves of the people. The queen was one of the leaders of the insurrection which followed.

3. Spain and France fought for Haiti constantly, 1665–1691.

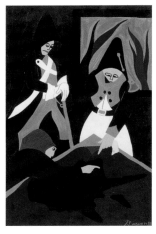

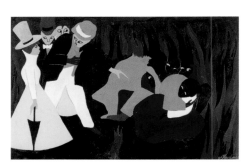

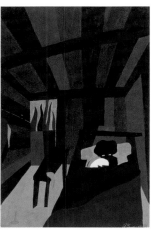

4. Spain and France agree to divide Haiti, 1691.

5. Slave trade reaches its height in Haiti, 1730.

6. The birth of Toussaint L'Ouverture, May 20, 1743. Both of Toussaint's parents were slaves.

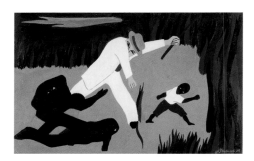

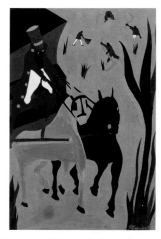

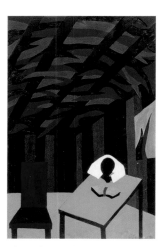

7. As a child, Toussaint heard the twang of the planter's whip and saw the blood stream from the bodies of slaves.

8. In early manhood his seemingly good nature won for him the coachmanship for Bayou de Libertas, 1763. His job as coachman gave him time to think about how to fight slavery. During this period, he taught himself to read and to write.

9. He read Rynol's Anti-Slavery Book that predicted a Black Emancipator, which language spirited him, 1763–1776.

10. The cruelty of the planters towards the slaves drove the slaves to revolt, 1776. Those revolts, which kept cropping up from time to time, finally came to a head in the rebellion.

11. The society of the Friends of the Blacks was formed in England, 1778, the leading members being Price, Priestly, Sharp, Clarkson and Wilberforce.

12. Jean Francois, first Black to rebel in Haiti.

14. The blacks were led by three chiefs, Jean Francois, Biassou, and Jeannot; Toussaint serving as aide-de-camp to Biassou.

15. The Mulattoes, enemies of both the Blacks and the Whites, but tolerated more by the Whites, joined their forces in battle against the Blacks, 1793.

13. During the rebellion of Jean Francois, Toussaint led his master and mistress to safety.

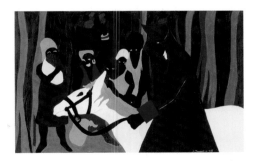

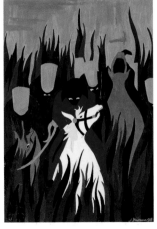

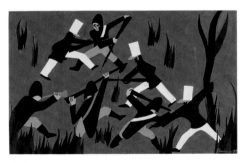

16. Toussaint captured Dondon, a city in the center of Haiti, 1795.

17. Toussaint captured Marmelade, held by Vernet, a mulatto, 1795.

18. Toussaint captured Ennery.

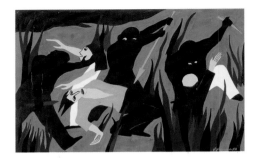

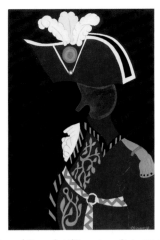

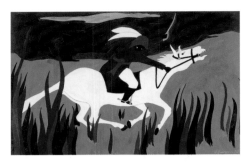

19. The Mulattoes had no organization; the English held only a point or two on the Island, while the Blacks formed into large bands and slaughtered every Mulatto and White they encountered. The Blacks learned the secret of their power. The Haitians now controlled half the Island.

20. General Toussaint L'Ouverture, Statesman and military genius, esteemed by the Spaniards, feared by the English, dreaded by the French, hated by the planters, and reverenced by the Blacks.

21. General Toussaint L'Ouverture attacked the English at Artibonite and there captured two towns.

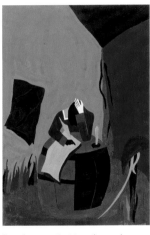

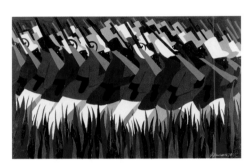

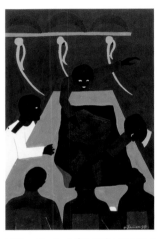

22. Settling down at St. Marc, he took possession of two important posts.

23. General L'Ouverture collected forces at Marmelade, and on October the 9th, 1794, left with 500 men to capture San Miguel.

24. General L'Ouverture confers with Leveaux at Dondon with his principal aides, Dessalines, Commander of San Miguel, Duminil, Commander of Plaisaince, Desrouleaux, Ceveaux and Maurepas, Commanders of Battalions, and prepares an attack at St. Marc.

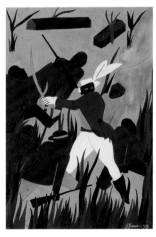

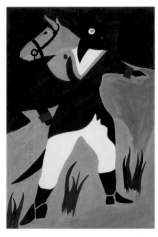

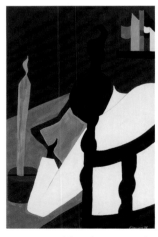

25. General Toussaint L'Ouverture defeats the English at Saline.

26. On March 24, he captured Mirebalois.

27. Returning to private life as the commander and chief of the army, he saw to it that the country was well taken care of, and Haiti returned to prosperity. During this important period, slavery was abolished, and attention focused upon agricultural pursuits.

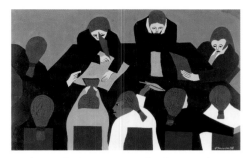

28. The constitution was prepared and presented to Toussaint on the 19th day of May, 1800, by nine men he had chosen, eight of whom were white proprietors and one mulatto. Toussaint's liberalism led him to choose such a group to draw up the constitution. He was much criticized for his choice, but the constitution proved workable.

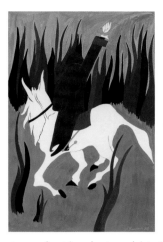

29. L'Ouverture made a triumphant march into San Domingo on the 2nd of January, 1801, at the head of 10,000 men, and hoisted the flag of the French Republic. Toussaint did not wish to break with the French, the largest group of Haitian inhabitants. The Blacks themselves spoke patois French.

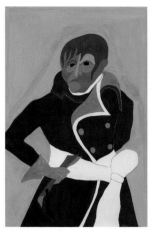

30. Napoleon Bonaparte begins to look on Haiti as a new land to conquer. Conquest inevitably meant further slavery.

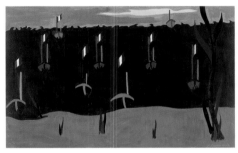

31. Napoleon's troops under LeClerc arrive at the shores of Haiti.

32. Henri Christoph, rather than surrender to LeClerc, sets fire to La Cape. Christoph, one of Toussaint's aides, sent word that the French were in Haitian waters—that he had held them off as long as possible.

33. General L'Ouverture, set for war with Napoleon, prepares Crete-a-Pierrot as a point of resistance. Toussaint took his troops into the mountains, deciding upon guerrilla warfare.

34. Toussaint defeats Napoleon's troops at Ennery.

35. Yellow fever broke out with great violence, thus having a great physical and moral effect on the French soldiers. The French sought a truce with L'Ouverture.

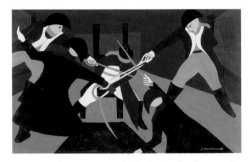

36. During the truce Toussaint is deceived and arrested by LeClerc. LeClerc felt that with Toussaint out of the way, the Blacks would surrender.

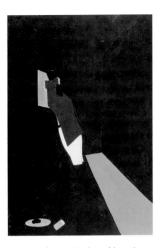

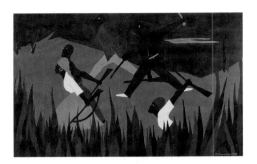

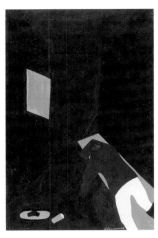

37. Toussaint is taken to Paris and imprisoned in the dungeon of the Castle Joux—August 17, 1802.

38. Napoleon's attempt to restore slavery in Haiti was unsuccessful. Desalines, Chief of the Blacks, defeated LeClerc. Black men, women, and children took up arms to preserve their freedom.

39. The death of Toussaint L'Ouverture in the Prison of Le Joux, April, 1803. Imprisoned a year, Toussaint died of a broken heart.

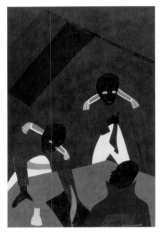

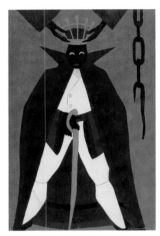

40. The Declaration of Independence was signed January 1, 1804—Desalines, Clevaux, and Henri Christoph. These three men made up a new constitution, writing it themselves. The Haitian flag shows in the sketch.

41. Desalines was crowned Emperor October 4, 1804, thus: Jean Jacques the First of Haiti. Desalines, standing beside a broken chain, has the powers of dictator, as opposed to Toussaint's more liberal leadership.

P38-04
Untitled
1938
tempera on paper
14 × 12⅝ in. (35.6 × 32.1 cm)
signed and dated upper left "J. Lawrence 38"; inscribed bottom right in margin "8"

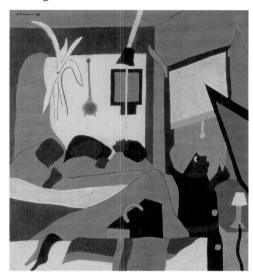

Collection: Indianapolis Museum of Art. Gift of the National Coalition of 100 Black Women, the Alliance of the Indianapolis Museum of Art, and the Mr. and Mrs. Richard Crane Fund, Indianapolis Museum of Art.

Provenance: ?; Private collection, New York; [Terry Dintenfass Inc., New York].

Remarks: A.k.a. *Untitled (The Birth)*.

P38-05
Untitled [*Pickpockets*]
1938
tempera on paper
12¾ × 12½ in. (32.4 × 31.8 cm)
signed and dated upper right "J. Lawrence 38"; inscribed bottom right in margin "77"

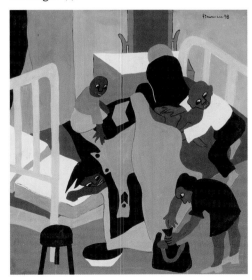

Collection: Private collection.

Provenance: Collection of the artist, New York; Norman and Oida Lewis, New York.

Exhibitions: Whitney 1974–5, no. 14.

Remarks: A.k.a. *Mental Hospital*.

P38-06
Fire Escape
1938
tempera on paper
12¼ × 10⅞ in. (31.1 × 27.6 cm)
signed and dated lower right "J. Lawrence 38"

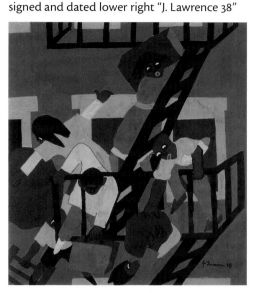

Collection: Jules and Connie Kay.

Provenance: Collection of the artist, New York; Norman and Oida Lewis, New York; [Midtown Payson Galleries, New York].

Exhibitions: Whitney 1974–5, no. 13; Midtown Payson 1995a.

P38-07
Dust to Dust
1938
tempera on paper
12½ × 18¼ in. (31.8 × 46.4 cm)
signed and dated upper left "J. Lawrence 38"

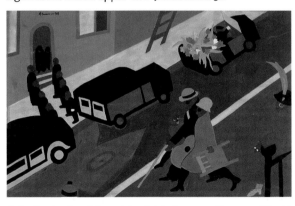

Collection: Jacob and Gwendolyn Knight Lawrence. Courtesy of Francine Seders Gallery, Seattle.

Exhibitions: American Artists School 1939, no. 15; USIA Caribbean 1989, no. 16; Katonah 1992; Midtown Payson 1995a; Henry Art Gallery 1998.

References: Lewis and Sullivan 1982, p. 7, ill. (as *Funeral*); Wheat 1986, p. 51, pl. 5; Deborah Soloman, "The Book of Jacob," *New York Daily News Magazine*, September 27, 1987, p. 19, ill. (as *The Funeral*); Lewis and Hewitt 1989, p. 26, ill.; Robin Updike, "Jacob Lawrence," *Seattle Times*, July 2, 1998, p. E1, ill.

P38-08
Harlem Diner
1938
tempera on paper
12⅝ × 19⅛ in. (32.1 × 48.6 cm)
signed and dated upper left "J. Lawrence / 1938"

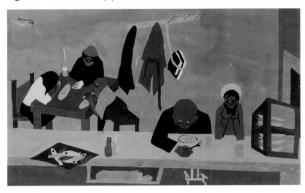

Collection: Mr. and Mrs. Elie Hirschfeld, New York.

Provenance: ?; Private collection, Los Angeles; [Christie, Manson & Woods, New York, December 4, 1987, lot 362].

Remarks: A.k.a. *Café Scene.*

P38-09
Shoe Shine Girl
1938
tempera on paper
dimensions unknown
signed and dated lower right "J. LAWRENCE 38"

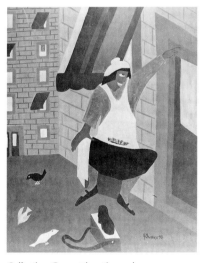

Collection: Current location unknown.

Provenance: WPA Federal Art Project, New York.

Exhibitions: American Artists School 1939, no. 6.

Remarks: The artist and his wife have expressed doubt concerning the authenticity of this work. A photograph of this work exists in the WPA Federal Art Project Archives.

P38-10
Men
1938
tempera on paper
dimensions unknown
signed and dated lower right "J. Lawrence 38"

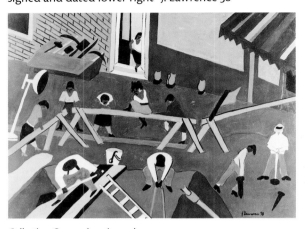

Collection: Current location unknown.

Provenance: WPA Federal Art Project, New York.

P38-11
Night
1938
tempera on paper
dimensions unknown
signed and dated lower left "J. Lawrence 38"

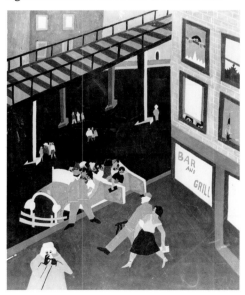

Collection: Current location unknown.

Provenance: WPA Federal Art Project, New York.

P38-12
Firewood
1938
tempera on unknown support
dimensions unknown
signed and dated lower left "J. Lawrence 38"

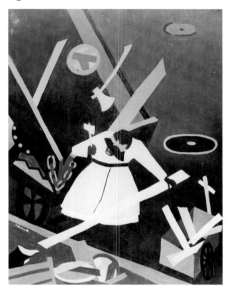

Collection: Current location unknown.

Provenance: WPA Federal Art Project, New York.

References: James A. Porter, *Modern Negro Art* (Washington, D.C.: Howard University Press, 1992), p. 266, ill.

P38-13
Employment
1938
tempera on paper
dimensions unknown
signed and dated lower right "J. Lawrence 38"

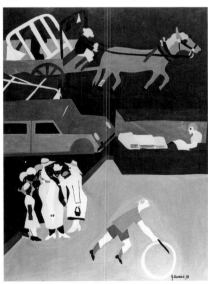

Collection: Current location unknown.

Provenance: WPA Federal Art Project, New York.

P38-14
Beggar No. 1
1938
tempera on composition board
20 × 15 in. (50.8 × 38.1 cm)
signed and dated lower right "J. LAWRENCE 38"; verso: inscribed top left (in artist's hand) "Blind Beggars" and "6941"; inscribed center "Jacob Lawrence"

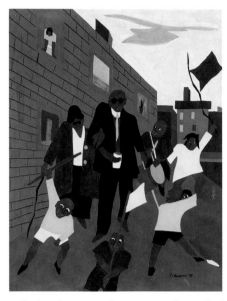

Collection: The Metropolitan Museum of Art. Gift of New York City WPA, 1943, 43.47.28.

Provenance: WPA Federal Art Project, New York.

Exhibitions: American Artists School 1939, no. 7 (as *Beggar No. 1*); The Metropolitan Museum of Art, New York, *Twentieth-Century Painters: A Special Exhibition of Oils, Watercolors, and Drawings Selected from the Collections of American Art at The Metropolitan Museum*, June–August 1950; The Gallery Association of New York State, *New Deal for Art: The Government Art Projects of the 1930s with Examples from New York City and State*, 1977, no. 12; Emily Lowe Gallery, Hofstra University, Hempstead, N.Y., *A Blossoming of New Promise: Art in the Spirit of the Harlem Renaissance*, February 5–March 18, 1984, no. 26; Seattle 1986–7, no. 12; Katonah 1992; Nassau County Museum of Art, Roslyn Harbor, N.Y., *American Realism between the Wars: 1919–1941*, April 10–June 5, 1994; The Metropolitan Museum of Art, New York, *I Tell My Heart: The Art of Horace Pippin*, February 1–April 30, 1995.

References: Robert Beverly Hale, *One Hundred American Painters of the Twentieth Century*, exh. cat. (New York: The Metropolitan Museum of Art, 1950), p. 84, ill.; John Arthur Garraty, *The American Nation: A History of the United States, A History of Men and Ideas* (London: Penguin Press, 1968); Matthew Baigell, *The American Scene: American Painting of the 1930s* (New York: Praeger Publishers, 1974), p. 200, fig. 119; Marlene Park and Gerald E. Markowitz, *New Deal for Art*, exh. cat. (New York: The Gallery Association of New York, 1977), p. 79, ill.; Gail Gelburd, *A Blossoming of New Promise: Art in the Spirit of the Harlem Renaissance*, exh. cat. (Hempstead, N.Y.: Hofstra University, 1984), n.p., ill.; Wheat 1986, p. 207, ill.; Powell 1992, n.p., pl. 2; Kathy Grantham, "Jacob Lawrence in Retrospect," *North County News* (March 25–31, 1992), p. V2, ill.; Romare Bearden and Harry Henderson, *A History of African-American Artists from 1972 to Present* (New York: Pantheon Books, 1993), p. 295, ill.; Franklin Hill Perrell and Constance Schwartz, *American Realism between the Wars: 1919–1941*, exh. cat. (Roslyn Harbor, N.Y.: Nassau County Museum of Art, 1994), p. 35, ill.; Peter T. Nesbett, "An IFAR Evening: The Jacob Lawrence Catalogue Raisonné Project," *International Foundation for Art Research Journal* 2, 2 (spring 1999), p. 12, ill.

Remarks: Exhibited and published after 1949 as *Blind Beggars*.

P38-15
Pool Players
1938
tempera on brown paper
image: 17¾ × 11¾ in. (45.1 × 29.8 cm)
signed and dated upper center "J. Lawrence / 1938"

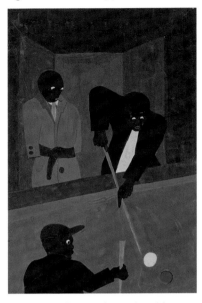

Collection: Collection of AXA Financial.

Provenance: Jacob and Gwendolyn Knight Lawrence, New York and Seattle; [Mary Ryan Gallery, New York].

Exhibitions: Bedford-Stuyvesant Restoration Corporation, Brooklyn, *Selected Works by Black Artists from the Collection of The Metropolitan Museum of Art*, April 14–June 14, 1976, n.p., ill.; USIA Caribbean 1989, no. 13; Katonah 1992; Midtown Payson 1993a; Henry Art Gallery 1998.

References: Wheat 1986, p. 157, pl. 74a; Lewis and Hewitt 1989, p. 30, ill.

Remarks: A.k.a. *Pool Hall.*

P38-16
Subway
1938
tempera on composition board
20 × 15½ in. (50.8 × 39.4 cm)
signed and dated lower left "Jacob Lawrence 38"; verso: signed and inscribed "Jacob Lawrence / Subway / 7737"

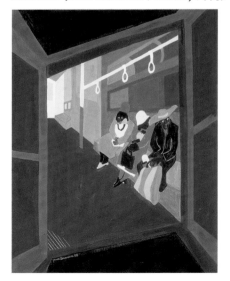

Collection: Schomburg Center for Research in Black Culture, New York Public Library, Astor, Lenox & Tilden Foundations.

Provenance: WPA Federal Art Project, New York; ?.

Exhibitions: American Artists School 1939, no. 19.

P38-17
The Butcher Shop
1938
tempera on paper
17½ × 24 in. (44.5 × 61 cm)
signed and dated lower right "J. Lawrence 38"

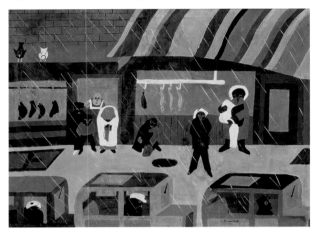

Collection: Joan H. King, New York.

Provenance: Jacob and Gwendolyn Knight Lawrence, New York and Seattle; [Terry Dintenfass Inc., New York].

Exhibitions: 135th Street YMCA, New York, *Presenting Jacob Lawrence in an Exhibition of Paintings*, February 1938; New Society of Art, Berlin, *American Art: 1920–1940*, November 1980–February 1981; Katonah 1992.

References: Charles Alston, *Jacob Lawrence*, exh. cat. (New York: James Weldon Johnson Literary Guild, 1938); Wheat 1986, p. 207, ill.; Patricia Hills, "Jacob Lawrence as Pictorial Griot: The *Harriet Tubman* Series," *American Art* 7, 1 (winter 1993), p. 43, ill.

Remarks: This painting is nearly identical to a painting completed several years later (see P43-28). The early provenance on this work is unknown. It is possible that it was completed for the WPA Federal Art Project and lent to T. W. Wood Art Gallery in Vermont in 1940 (WPA records indicate a loan of a painting of this title and date to the Wood Art Gallery). While on loan, the painting was damaged or suffered from an inherent condition problem and was returned to the artist for repair ca. 1942–3. Instead of repairing this painting, the artist executed a new painting that was sent to the T. W. Wood Art Gallery. This version of *The Butcher Shop* remained in the artist's personal collection until 1981 when it was consigned to Terry Dintenfass for sale and subsequently restored.

P39-01
The Life of Frederick Douglass
1939
casein tempera on hardboard (32 panels)
12 × 17⅞ in. (30.5 × 45.4 cm) // 17⅞ × 12 in. (45.4 × 30.5 cm)
unsigned

Collection: Hampton University Museum, Hampton, Virginia.

Provenance: Collection of the artist, New York; The Harmon Foundation, New York.

Exhibitions: Whitney 1974–5, nos. 15–46; The Detroit Institute of Arts, *The John Brown Series by Jacob Lawrence*, October 14–November 26, 1978 [exhibited concurrently with *The Life of John Brown*]; New Jersey State Museum, Trenton, *American Art of the 1930s: A Survey*, February 10–April 22, 1979 [1]; Chrysler 1979a [4, 5, 12, 13, 14, 25, 29, 32]; Portsmouth Community Art Center, Va., January 31–March 1, 1981; U.S. Army Transportation Museum, Fort Eustis, Va., *Jacob Lawrence: The Frederick Douglass Series*, September 3–18, 1982; Heritage Plantation of Sandwich, Mass., *Young America: Children and Art*, May 4–October 27, 1985 [1]; Museum of Science and Industry, Chicago, *Choosing: An Exhibition of Changing Perspectives in Modern Art and Art Criticism by Black Americans, 1925–1985*, February 1–March 15, 1986 [3, 29]; Seattle 1986–7, nos. 14–24 [4, 5, 9, 10, 12, 13, 16, 18, 19, 22, 31]; Hampton University Museum, Va., *Jacob Lawrence: The Frederick Douglass and Harriet Tubman Series of 1938–40*, 1991–8; Addison Gallery of American Art, Phillips Academy, Andover, Mass., and The Studio Museum in Harlem, New York, *To Conserve a Legacy: American Art from Historically Black Colleges and Universities*, 1999–2001 [7, 30]; National Museum of American Art, Washington, D.C., *Picturing Old New England: Image and Memory*, April 2–August 29, 1999 [18].

References: Lloyd Lewis, "Frederick Douglass, The Abolitionist Who Began as a Slave," *New York Times Book Review*, April 6, 1947, p. 3, ill.; Ben Richardson, *Great American Negros* (New York: Crowell, 1956, 2nd ed.), p. 105; Brown 1974, p. 4, ill. [15]; Hilton Kramer, "Art: Lawrence Epic of Blacks," *New York Times*, May 18, 1974, p. 25, ill. [18]; Hilton Kramer, "Art: Chronicles of Black History," *New York Times*, May 26, 1974, sec. 2, p. 17, ill. [7]; Chrysler 1979b; Wheat 1986, pp. 54–5, pls. 9–11 [22, 30, 33]; pp. 207–8 [4, 5, 9, 10, 12, 13, 16, 18, 19, 22, 31]; Stephanie Stokes Oliver, "Jacob Lawrence," *Essence* (November 1986), p. 91, ill. [5]; Robert Wernick, "Jacob Lawrence: Art As Seen through a People's History," *Smithsonian* 18, 3 (June 1987), pp. 58–9, ill. [12, 18, 22]; Jacqueline Fonevielle-Bontemps, *Choosing: An Exhibition of Changing Perspectives in Modern Art and Art Criticism to Black Americans, 1925–1985* (Washington, D.C.: Museum Press, Inc., 1989); Guy C. McElroy, *Facing History: The Black Image in American Art, 1710–1940*, exh. cat. (San Francisco: Bedford Arts Publishers in association with The Corcoran Gallery of Art, 1990), p. 46, ill. [10, 30]; Jock Reynolds, *American Abstraction at the Addison* (Andover, Mass.: Addison Gallery of American Art, Phillips Academy, 1991), p. 209, ill. [30]; Ellen Harkins Wheat, *Jacob Lawrence: The Frederick Douglass and Harriet Tubman Series of 1938–40* (Hampton, Va.: Hampton University Museum, 1991); Donna Tennant, "Jacob Lawrence: The Frederick Douglass and Harriet Tubman Series, 1938–40," *Museum and Arts Houston* (September 1992), pp. 29–31, ill. [4, 13, 18, 30]; "Jacob Lawrence:

Greatest Living Black Painter," *Ebony* (September 1992), p. 62, ill. [8]; Patricia C. Johnson, "A Painter of Stories," *Houston Chronicle*, September 11, 1992, p. A5, ill. [21]; Susan Chadwick, "Stirring Paintings Capture Spirit of Former Slaves," *Houston Post*, September 15, 1992, pp. D1, D8; "Museums: Houston, Texas: Jacob Lawrence," *Southwest Art* 22, 5 (October 1992), ill.; Janet Tyson, "Exhibit Pays Homage to Douglass, Tubman," *Austin American-Statesman*, October 7, 1992, p. B5; Ellen Sharp, "The Legend of John Brown and the Series by Jacob Lawrence," *Bulletin of the DIA* 67, 4 (1993), p. 23, ill. [24]; Kyle McMillan, "Paintings about Abolitionists Still Hold Meaning," *Omaha World-Herald*, February 13, 1993; Christopher Knight, "Panels Take a Small Look at Large Lives," *Los Angeles Times*, June 14, 1993, p. F1; Karen Wilkin, "The Naïve and The Modern: Horace Pippin and Jacob Lawrence," *The New Criterion* 13, 7 (March 1995), p. 36; Stephen Wallis, "Jacob Lawrence: Portrait of a Serial Painter," *Art and Antiques* 19, 11 (December 1996), p. 60, ill. [18]; Staci Sturrock, "The Beauty of Struggle," *Greenville News*, February 2, 1997, p. E6, ill. [21]; Tom Stabile, "Reconstructing Jacob Lawrence: A Scholarly Team Prepares the Master Catalog," *Humanities* 19, 6 (November–December 1998), p. 26, ill. [21]; Bruce Robertson, "Yankee Modernism," in *Picturing Old New England: Image and Memory* (Washington, D.C.: National Museum of American Art, Smithsonian Institution, 1999), p. 195, ill. [18]; Richard J. Powell and Jock Reynolds, *To Conserve a Legacy: American Art from Historically Black Colleges and Universities*, exh. cat. (Andover, Mass.: Addison Gallery of American Art; New York: The Studio Museum in Harlem, 1999), p. 209, ill. [7, 30]; Yuval Taylor, ed., *I Was Born a Slave: An Anthology of Classic Slave Narratives, Volume One, 1770–1849* (Chicago: Lawrence Hill Books, 1999), cvr., ills. [1, 4].

Remarks: The artist began research at The Schomburg Collection, New York, in 1938 and completed the series in 1939 while employed by the WPA. He gave the series to the Harmon Foundation in 1939, as collateral against a $100 loan. They remained there until 1967 when the Foundation was disbanded and the panels were transferred to Hampton University. The loan was never repaid and Lawrence never retook possession of the paintings. He signed a deed of gift to Hampton University in 1998.

As Ellen Harkins Wheat has noted (see Wheat, *Jacob Lawrence: The Frederick Douglass and Harriet Tubman Series of 1938–40*, 1991, pp. 114–5), there are some lingering questions regarding the numbering of the series. All of the panels are inscribed with numbers that indicate their position in the series. Panels nos. 14–32, however, are inscribed with two sets of numbers. Panel no. 14 is inscribed "14–15," and the inscriptions for every subsequent panel have been revised one digit higher. Panel no. 32 is inscribed "33." It is not clear who revised the numbering—the artist or the Harmon Foundation—or whether a panel is missing, though the artist believes that the series as it exists today is complete.

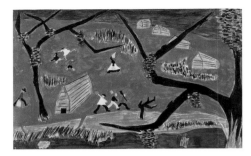

1. In Talbot County, eastern shore, state of Maryland, in a thinly populated worn-out district inhabited by a white population of the lowest order, among slaves who in point of ignorance were fully in accord with their surroundings—it was here that Frederick Douglass was born and spent the first years of his childhood—February 1818.

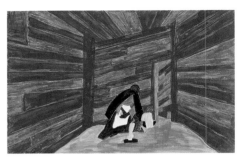

2. One of the barbarous laws of the slave system was that of hiring out members of families who were slaves, this occurring in the Douglass family. The only recollections he had of his mother were those few hasty visits she made to him during the night.

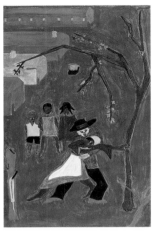

3. When old enough to work, he was taken to Colonel Lloyd's slave master. His first introduction to the realities of the slave system was the flogging of Millie, a slave on the Lloyd plantation.

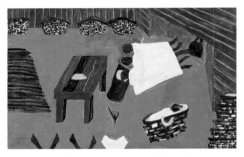

4. In the slaves' living quarters, the children slept in holes and corners of the huge fireplaces. Old and young, married and single, slept on clay floors.

5. The master's quarters or "the great house" was filled with luxuries. It possessed the finest of foods from Europe, Asia, Africa, and the Caribbean. It contained fifteen servants. It was one of the finest mansions in the South.

6. Hired out from Colonel Lloyd's plantation, Frederick Douglass arrived in Baltimore at the age of eight. His new mistress, never before having been a slaveholder, consented to his request to teach him to read, to which the master of the house told her the laws of the slave system—one being that a slave must learn one thing—to obey—1826.

7. Douglass, forced by his master to discontinue his learning, continued his studies with his white friends who were in school.

8. Frederick Douglass, having earned a few cents as a bootblack, purchased *The Columbian Orator*. In this book he studied Sheridan's speeches on the Catholic Emancipation, Lord Chatham's speech on the American war, and speeches by the great William Pitt and Fox.

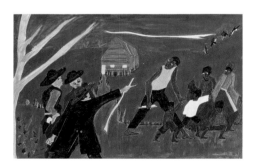

9. Transferred back to the eastern shore of Maryland, being one of the few Negroes who could read or write, Douglass was approached by James Mitchell, a free Negro, and asked to help teach a Sabbath school. However, their work was stopped by a mob who threatened them with death if they continued their class—1833.

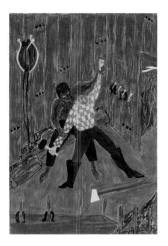

10. The master of Douglass, seeing he was of a rebellious nature, sent him to a Mr. Covey, a man who had built up a reputation as a "slave breaker." A second attempt by Covey to flog Douglass was unsuccessful. This was one of the most important incidents in the life of Frederick Douglass: he was never again attacked by Covey. His philosophy: a slave easily flogged is flogged oftener; a slave who resists flogging is flogged less.

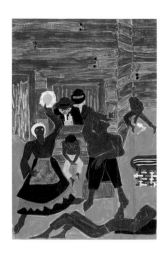

11. The slaves were invariably given a Christmas and New Year's holiday, which they spent in various ways, such as hunting, ball playing, boxing, foot racing, dancing, and drinking—the latter being encouraged the most by the slaveholders, this being the most effective way of keeping down the spirit of insurrection among slaves.

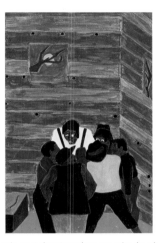

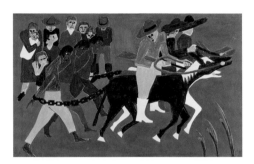

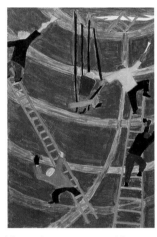

12. It was in 1836 that Douglass conceived a plan of escape, also influencing several slaves around him. He told his co-conspirators what had been done, dared, and suffered by men to obtain the inestimable boon of liberty.

13. As the time of their intended escape drew nearer, their anxiety grew more and more intense. Their food was prepared and their clothing packed. Douglass had forged their passes. Early in the morning they went into the fields to work. At mid-day they were all called off the field, only to discover that they had been betrayed.

14. Frederick Douglass was sent to Baltimore to work in the shipyards of Gardiner. Here the workers were Negro slaves and a poor class of whites. The slaveholders caused much friction between the two groups. It was in one of the many brawls here that Douglass almost lost an eye. Douglass had become a master of his trade, that of ship caulker. Seeing no reason why at the end of each week he should give his complete earnings to a man he owed nothing, again he planned to escape.

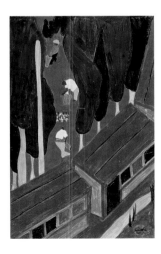

15. Frederick Douglass's escape from slavery was a hazardous and exciting twenty-four hours. Douglass disguised himself as a sailor—best, he thought, because he knew the language of a sailor and he knew a ship from stem to stern. On he traveled through Maryland, Wilmington, Philadelphia, and to his destination, New York. Frederick Douglass was free.

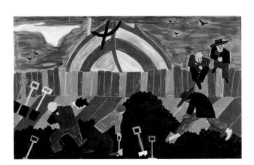

16. Douglass's first three years in the North were spent as a laborer, on the wharfs, sawing wood, shoveling coal, digging cellars and removing rubbish.

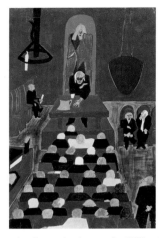

17. Douglass listened to lectures by William Lloyd Garrison. He heard him denounce the slave system in words that were mighty in truth and mighty in earnestness.

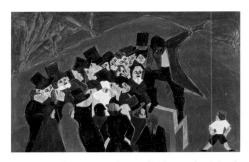

18. It was in the year 1841 that Frederick Douglass joined the forces of William Lloyd Garrison and the abolitionists. He helped secure subscribers to *The Anti-Slavery Standard* and *The Liberator*. He lectured through the eastern counties of Massachusetts, narrating his life as a slave, telling of the cruelty, the inhuman and clannish nature of the slave system.

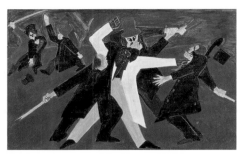

19. The Garrisonians in the year 1843 planned a series of conventions in order to spread and create greater antislavery sentiment in New Hampshire, Vermont, New York, Ohio, Indiana, and Pennsylvania. In one of these conventions, Douglass and two of his fellow workers were mobbed at Pendleton, Indiana.

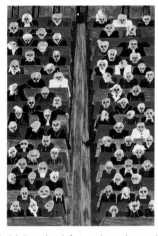

20. Frederick Douglass left America to lecture in Great Britain. Here he met some of the most progressive and liberal-minded men in the English-speaking world. He made a great speech in Covent Garden Theatre on August 7, 1846, in which he told of the people he represented—how at that moment there were three million colored slaves in the United States.

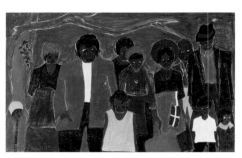

21. Another important branch of Frederick Douglass's antislavery work was the Underground Railroad, of which he was the stationmaster for Rochester, controlling Lake Ontario and the Queen's Dominions.

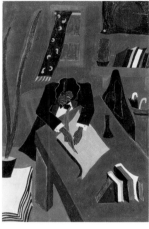

22. Leaving England in the spring of 1847 with a large sum of money given him by sympathizers of the antislavery movement, he arrived in Rochester, New York, and founded the Negro paper *The North Star*. As editor of *The North Star*, he wrote of the many current topics affecting the Negro, such as the Free Soil Convention at Buffalo, the nomination of Martin Van Buren, the Fugitive Slave Law, and the Dred Scott Decision.

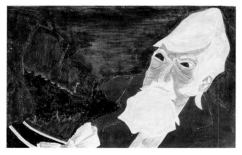

23. It was in 1847 at Springfield, Massachusetts, that Frederick Douglass first met Captain John Brown, one of the strongest fighters for the abolishment of slavery. Here, John Brown talked with Douglass about his plan to fight slavery. He had long been looking for a man such as Douglass, as an admirer and champion of Negro rights—he had found the man.

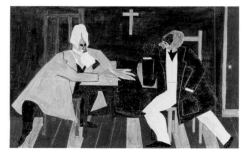

24. John Brown discussed with Frederick Douglass his plan to attack Harper's Ferry, an arsenal of the United States Government. Brown's idea was to attack the arsenal and seize the guns. Douglass argued against this plan, his reason being that the abolishment of slavery should not occur through revolution.

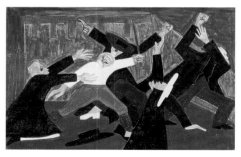

25. With Abraham Lincoln of the Republican party elected president of the United States, with states threatening their withdrawal from the Union—thus the country in war fever—the abolitionists made their speeches frequently—and were more often attacked by those who relished slavery.

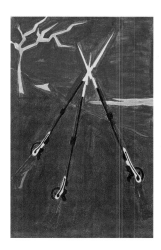

26. The North and South were at war. Governor Andrew of Massachusetts asked the help of Frederick Douglass in securing two colored regiments. Douglass spoke before the colored men of Massachusetts. He told them that a war fought for the perpetual enslavement of the colored people called logically and loudly for colored men to help suppress it. He brought to their memories Denmark Vesey and Nat Turner, and Shields Green and John Copeland who fought side by side with John Brown. The 54th and 55th colored regiments were mustered.

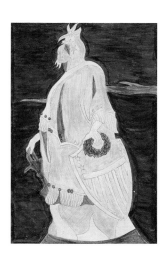

27. The government, having assured colored men that if they went into the battlefield their treatment would be the same as for whites, and not keeping its promise, Douglass protested, and his protest led him to Washington and to President Lincoln. Lincoln, proving to be a man of great human qualities, gave Frederick Douglass confidence and encouragement. Douglass left with the feeling that the black man's salvation was on the battlefield.

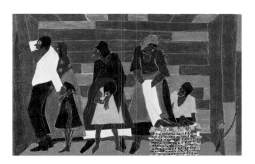

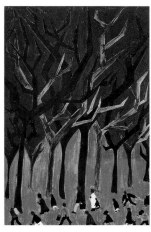

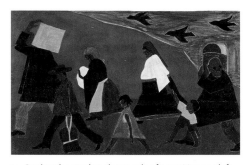

28. A cowardly and bloody riot took place in New York in July 1863—a mob fighting the draft, a mob willing to fight to free the Union, a mob unwilling to fight to free slaves, a mob that attacked every colored person within reach disregarding sex or age. They hanged Negroes, burned their homes, dashed out the brains of young children against the lamp posts. The colored populace took refuge in cellars and garrets. This mob was a part of the rebel force, without the rebel uniform but with all its deadly hate. It was the fire of the enemy opened in the rear of the loyal army.

29. The war was over. The slaves were literally turned out by their masters into a world unknown to them. They had ceased to be slaves of man and had become slaves of nature.

30. During the exodus, thousands of poor Negroes left the South in search of better country. Douglass spoke of this movement at the Social Science Congress at Saratoga, New York. "The habit of roaming from place to place is never a good one until a man has endeavored to make his immediate surroundings in accord with his wishes. The business of this government is to protect its citizens where they are, and not send them where they do not need protection."

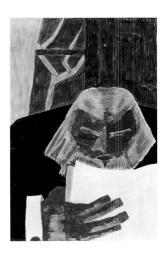

31. An appointment to any important and lucrative office under the United States Government usually brings its recipient a large measure of praise and congratulations on the one hand and much abuse and disparagement on the other. With these two conditions prevailing, Frederick Douglass was appointed by President Rutherford B. Hayes to be United States marshal of the District of Columbia, 1877.

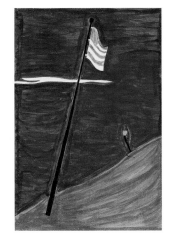

32. Frederick Douglass revisited the eastern shore of Maryland—here he was born a slave, now he returned a free man. He left unknown to the outside world and returned well known. He left on a freight boat and returned on a United States revenue cutter. He was a citizen of the United States.

P40-01
The Life of Harriet Tubman
1940
casein tempera on hardboard (31 panels)
12 × 17⅞ in. (30.5 × 45.4 cm) // 17⅞ × 12 in. (45.4 × 30.5 cm)
unsigned

Collection: Hampton University Museum, Hampton, Virginia.

Provenance: Collection of the artist; The Harmon Foundation, New York.

Exhibitions: Southside Community Art Center, Chicago, *Jacob Lawrence: Life of Harriet Tubman*, 1940; Whitney 1974–5, nos. 48–55 [2, 4, 7, 9, 18, 20, 26, 29]; The Detroit Institute of Arts, *The John Brown Series by Jacob Lawrence*, October 14–November 26, 1978; Chrysler 1979a [2, 7, 9, 16, 24, 29]; Portsmouth Community Art Center, Va., January 31–March 1, 1981; Stewart Center Gallery, Purdue University, West Lafayette, Ind., September 19–October 9, 1983; Alford House–Anderson Fine Arts Center, Ind., October 4–31, 1984; The Chrysler Museum of Art, Norfolk, Va., February 19–March 16, 1985; Montgomery Museum of Fine Arts, Ala., *Turning Point: The Harlem Renaissance*, March 26–May 30, 1985; Albright-Knox Art Gallery, Buffalo, *Jacob Lawrence: The Harriet Tubman Series*, January 18–March 2, 1986; Seattle 1986–7, nos. 25–38 [1, 2, 4, 5, 7, 9, 10, 16, 19, 22, 23, 27, 28, 29]; Hampton University Museum, Va., 1989; Hampton University Museum, Va., *Jacob Lawrence: The Frederick Douglass and Harriet Tubman Series of 1938–40*, 1991–8; Addison Gallery of American Art, Phillips Academy, Andover, Mass., and The Studio Museum in Harlem, New York, *To Conserve a Legacy: American Art from Historically Black Colleges and Universities*, 1999–2001 [7].

References: Alain Locke, *The Negro Artist Comes of Age*, exh. cat. (New York: Albany Institute of History and Art, 1945), p. vi; Grace Glueck, "New York Gallery Notes: Who's Minding the Easel?" *Art in America* 56, 1 (January–February 1968), p. 113; Brown 1974, p. 22, ill. [18]; Robert Pincus-Witten, "Jacob Lawrence: Carpenter Cubism," *Artforum* 13, 66 (September 1974), p. 66, ill. [29]; Chrysler 1979b; Susan Krane, *Jacob Lawrence: The Harriet Tubman Series*, exh. cat. (Buffalo: Albright-Knox Art Gallery, 1986); Wheat 1986, pp. 56–8, pls. 12–5, [1, 2, 7, 29]; pp. 209–10, ill. [1, 2, 4, 5, 7, 9, 10, 16, 19, 22, 23, 27, 28, 29]; Avis Berman, "Commitment on Canvas," *Modern Maturity* (August–September 1986), p. 69, ill. [7]; Lyn Smallwood, "The Nation, Seattle, Jacob Lawrence, Seattle Art Museum," *ARTnews* 85, 7 (September 1986), p. 53, ill. (as *She Nursed Soldiers*); Ellen Harkins Wheat, "Jacob Lawrence: Chronicler of the Black Experience," *American Visions* 2, 1 (February 1987), p. 32, ill. [4]; Robert Wernick, "Jacob Lawrence: Art As Seen through a People's History," *Smithsonian* 18, 3 (June 1987), pp. 58, 62, ill. [4, 7]; Michael Kimmelman, "Art, Art, Everywhere Art," *New York Times*, September 20, 1991, p. C1, ill. [7]; Michael Kimmelman, "Review/Art: Stark or Sweet Images Tell Black History's Tale," *New York Times*, September 20, 1991, p. C24, ill. [28]; Ellen Harkins Wheat, *Portraits: The Lives and Works of Eminent Artists* 2, 3 (1992), ill. [9]; Powell 1992, n.p., pl. 3 [18]; Donna Tennant, "Jacob Lawrence: The Frederick Douglass and Harriet Tubman Series, 1938–40," *Museum and Arts Houston* (September 1992), pp. 28–30, 33, ill. [4, 7, 9, 22]; "Jacob Lawrence: Greatest Living Black Painter," *Ebony* (September 1992), p. 62, ill. [6, 7]; Patricia C. Johnson, "A Painter of Stories," *Houston Chronicle*, September 11, 1992, p. E5, ill. [29]; M. S. Mason, "Emancipation Heroes Get Their Due, in Art," *Christian Science Monitor*, September 15, 1992, p. 10, ill. [4, 10]; Susan Chadwick, "Stirring Paintings Capture Spirit of Former Slaves," *Houston Post*, September 15, 1992, pp. D1, D8; Janet Tyson, "Exhibit Pays Homage to Douglass, Tubman," *Austin American-Statesman*, October 7, 1992, p. B5; Kyle McMillan, "Paintings About Abolitionists Still Hold Meaning," *Omaha World-Herald*, February 13, 1993; Christopher Knight, "Panels Take a Small Look at Large Lives," *Los Angeles Times*, June 14, 1993, pp. F1, F9; Patricia Hills, "Jacob Lawrence as Pictorial Griot: The *Harriet Tubman* Series," *American Art* 7, 1 (winter 1993), pp. 41, 48–58 [1–32]; Laurie Schneider Adams, *A History of Western Art* (New York: Harry N. Abrams, 1994), p. 446, pl. 28.14 [7]; Wayne Craven, *American Art: History and Culture* (New York: Harry N. Abrams, 1994), p. 549, fig. 365, ill. [7]; Marlena Donohue, "Telling History in Brushstrokes: Artist Jacob Lawrence Talks About His Sixty-Year Career and His Narrative Paintings," *Christian Science Monitor*, February 4, 1994, p. 12, ill. [4, 7, 40]; Regina Hackett, "True to Life, Jacob Lawrence's Art Honors the Real Lives of Real People," *Seattle Post-Intelligencer*, March 10, 1994, pp. C1, C4, ill. [4, 7]; Robin Updike, "Lives of Tubman, Douglass à la Jacob Lawrence," *Seattle Times*, March 17, 1994, p. E2, ill. [7]; Karen Wilkin, "The Naïve and The Modern: Horace Pippin and Jacob Lawrence," *The New Criterion* 13, 7 (March 1995), p. 36; Stephen Wallis, "Jacob Lawrence: Portrait of a Serial Painter," *Art and Antiques* 19, 11 (December 1996), p. 61, ill. [29]; Staci Sturrock, "The Beauty of Struggle," *Greenville News*, February 2, 1997, p. E1, ill. [2]; Orlando Patterson, *Rituals of Blood: Consequences of Slavery in Two American Centuries* (Washington, D.C.: Civitas, 1998), cvr., ill. [2]; Richard Powell and Jock Reynolds, *To Conserve a Legacy: American Art from Historically Black Colleges and Universities*, exh. cat. (Andover, Mass.: Addison Gallery of American Art; New York: The Studio Museum in Harlem, 1999), p. 209, ill. [7].

Remarks: The artist began research for this series at The Schomburg Collection in 1939 and completed the panels in 1940. Upon completion, he gave the series to the Harmon Foundation as collateral against a loan of approximately $100. The paintings remained with the Harmon Foundation until it was disbanded in 1967, and they were then transferred to Hampton University. The artist signed a deed of gift to Hampton University in 1998.

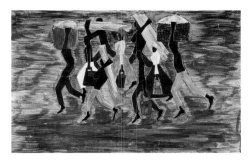

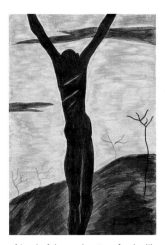

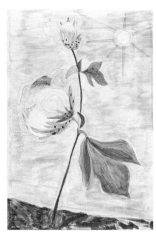

1. "With sweat and toil and ignorance he consumes his life, to pour the earnings into channels from which he does not drink."—Harriet Ward Beecher

2. "I am no friend of slavery, but I prefer the liberty of my own country to that of another people, and the liberty of my own race to that of another race. The liberty of the descendants of Africa in the United States is incompatible with the safety and liberty of the European descendants. Their slavery forms an exception (resulting from a stern and inexorable necessity) to the general liberty in the United States."—Henry Clay

3. "A house divided against itself cannot stand. I believe that this government cannot last permanently half slave and half free. I do not expect this union to be dissolved; I do not expect the house to fall, but I do expect it will cease to be divided. It will become all one thing or the other."—Abraham Lincoln

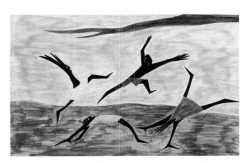

4. On a hot summer day about 1820, a group of slave children were tumbling in the sandy soil in the state of Maryland—and among them was one, Harriet Tubman. / Dorchester County, Maryland.

5. She felt the sting of slavery when as a young girl she was struck on the head with an iron bar by an enraged overseer.

6. Harriet heard the shrieks and cries of women who were being flogged in the Negro quarter. She listened to their groaned-out prayer, "Oh Lord, have mercy."

7. Harriet Tubman worked as water girl to field hands. She also worked at plowing, carting, and hauling logs.

8. Whipped and half starved to death, Harriet Tubman's skull injury often caused her to fall faint while at work. Her master, not having any more use for her, auctioned her off to the highest bidder.

9. Harriet Tubman dreamt of freedom ("Arise! Flee for your life!"), and in the visions of the night she saw the horsemen coming. Beckoning hands were ever motioning her to come, and she seemed to see a line dividing the land of slavery from the land of freedom.

10. Harriet Tubman was between twenty and twenty-five years of age at the time of her escape. She was now alone. She turned her face toward the North, and fixing her eyes on the guiding star, she started on her long, lonely journey.

11. "$500 Reward! Runaway from subscriber on Thursday night, the 4th inst., from the neighborhood of Cambridge, my negro girl, Harriet, sometimes called Minty. Is dark chestnut color, rather stout build, but bright and handsome. Speaks rather deep and has a scar over the left temple. She wore a brown plaid shawl. I will give the above reward captured outside the county, and $300 if captured inside the county, in either case to be lodged in the Cambridge, Maryland, jail. / (Signed) George Carter / Broadacres, near Cambridge, Maryland, / September 24th, 1849"

12. Night after night, Harriet Tubman traveled, occasionally stopping to buy bread. She crouched behind trees or lay concealed in swamps by day until she reached the North.

13. "I had crossed the line of which I had been dreaming. I was free, but there was no one to welcome me to the land of freedom. Come to my help, Lord, for I am in trouble."

14. Seeking help, Harriet Tubman met a lady who ushered her to a haycock, and Harriet found herself in a strange room, round and tapering to a peak. Here she rested and was fed well, and she continued on her way. It was Harriet Tubman's first experience with the Underground Railroad.

15. In the North, Harriet Tubman worked hard. All her wages she laid away for the one purpose of liberating her people, and as soon as a sufficient amount was secured she disappeared from her Northern home, and as mysteriously appeared one dark night at the door of one of the cabins on the plantation, where a group of trembling fugitives was waiting. Then she piloted them North, traveling by night, hiding by day, scaling the mountains, wading the rivers, threading the forests—she, carrying the babies, drugged with paragoric. So she went, nineteen times, liberating over 300 pieces of living, breathing "property."

16. Harriet Tubman spent many hours at the office of William Still, the loft headquarters of the antislavery Vigilance Committee in Philadelphia. Here, she pored over maps and discussed plans with the keen, educated young secretary of that mysterious organization, the Underground Railroad, whose main branches stretched like a great network from the Mississippi River to the coast.

17. Like a half-crazed sibylline creature, she began to haunt the slave masters, stealing down in the night to lead a stricken people to freedom.

18. At one time during Harriet Tubman's expeditions into the South, the pursuit after her was very close and vigorous. The woods were scoured in all directions, and every person was stopped and asked: "Have you seen Harriet Tubman?"

19. Such a terror did she become to the slaveholders that a reward of $40,000 was offered for her head, she was so bold, daring, and elusive.

20. In 1850, the Fugitive Slave Law was passed, which bound the people north of the Mason and Dixon Line to return to bondage any fugitives found in their territories—forcing Harriet Tubman to lead her escaped slaves into Canada.

21. Every antislavery convention held within 500 miles of Harriet Tubman found her at the meeting. She spoke in words that brought tears to the eyes and sorrow to the hearts of all who heard her speak of the suffering of her people.

22. Harriet Tubman, after a very trying trip North in which she had hidden her cargo by day and had traveled by boat, wagon, and foot at night, reached Wilmington, where she met Thomas Garrett, a Quaker who operated an Underground Railroad station. Here, she and the fugitives were fed and clothed and sent on their way.

23. "The hounds are baying on my track, / Old master comes behind, / Resolved that he will bring me back, / Before I cross the line."

24. It was the year 1859, five years after Harriet Tubman's first trip to Boston. By this time, there was hardly an antislavery worker who did not know the name Harriet Tubman. She had spoken in a dozen cities. People from here and abroad filled her hand with money. And over and over again, she made her mysterious raids across the border into the South.

25. Harriet Tubman was one of John Brown's friends. John Brown and Frederick Douglass crossed into Canada and arrived at the town of St. Catharines, a settlement of fugitive slaves, former "freight" of the Underground Railroad. Here, Douglass had arranged for a meeting with "Moses." She was Harriet Tubman: huge, deepest ebony, muscled as a giant, with a small close-curled head and anguished eyes—this was the woman John Brown came to for help. "I will help," she said.

26. In 1861, the first gun was fired on Fort Sumter, and the war of the Rebellion was on.

27. Governor John Andrew of Massachusetts, knowing well the brave, sagacious character of Harriet Tubman, sent for her and asked her if she could go at a moment's notice to act as a spy and scout for the Union Army and, if need be, to act as a hospital nurse. In short, to be ready for any required service for the Union cause.

28. Harriet Tubman went into the South and gained the confidence of the slaves by her cheerful words and sacred hymns. She obtained from them valuable information.

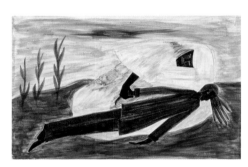

29. She nursed the Union soldiers and knew how, when they were dying by large numbers of some malignant disease, with cunning skill to extract a healing draught from roots and herbs that grew near the source of the disease, thus allaying the fever and restoring soldiers to health.

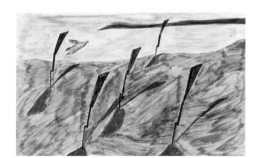

30. The war was over, men were being mustered out, and regiments melted away overnight. For Lincoln's words were now not paper words: they had been written in the travail and blood of the men whom Harriet Tubman had known.

31. Harriet Tubman spent the rest of her life in Auburn, New York. When she died, a large mass meeting was held in her honor. And on the outside of the county courthouse, a memorial tablet of bronze was erected.

P41-01
The Migration of the Negro
1941
casein tempera on hardboard (60 panels)
12 × 18 in. (30.5 × 45.7 cm) // 18 × 12 in. (45.7 × 30.5 cm)
unsigned

Collection: The Phillips Collection, Washington, D.C. (odd numbered panels) and The Museum of Modern Art, New York, gift of Mrs. David M. Levy (even numbered panels).

Provenance: [The Downtown Gallery, New York].

Exhibitions: The Downtown Gallery, New York, *Jacob Lawrence: The Migration of the Negro*, November 1941 [in conjunction with publication of series in *Fortune* magazine]; The Downtown Gallery, New York, *American Negro Art: Nineteenth and Twentieth Centuries*, December 9, 1941–January 3, 1942; Phillips Memorial Gallery, Washington, D.C., *Jacob Lawrence: The Migration of the Negro*, February 14–March 3, 1942; The Museum of Modern Art, New York, *Jacob Lawrence: The Migration Series*, 1942–4; MoMA 1944; YMCA, Brooklyn, February 11–15, 1945; The Institute for Modern Art, Boston, *Four Modern American Painters: Peter Blume, Stuart Davis, Marsden Hartley, Jacob Lawrence*, March 2–April 1, 1945, nos. 40–2 [18, 28, 58]; The Ohio State University Museum, Columbus, September 1945 [1, 3, 5, 7, 9, 11, 13, 15, 17, 19, 21, 23, 25, 27, 29, 37, 39]; The Tate Gallery, London, *American Painting, from the Eighteenth Century to the Present Day*, June 14–August 5, 1946 [44, 52, 58]; Phillips Memorial Gallery, Washington, D.C., *Three Negro Artists: Horace Pippin, Jacob Lawrence, Richmond Barthé*, December 14, 1946–January 6, 1947 [21, 22, 28, 29, 31, 39, 57, 59]; The Downtown Gallery, New York, *In 1950: An Exhibition of Paintings and Sculpture by Leading Americans*, March 14–April 1, 1950, no. 11 [2 panels]; Washington International Center, Washington, D.C., June–October 1953 [39, 55, 57]; AFA 1960–2, nos. 4–8 [2, 10, 40, 50, 58]; West African Cultural Center, American Society of African Culture, Lagos, Nigeria, October 1962 [25 panels]; The Phillips Collection, Washington, D.C., *Jacob Lawrence: The Migration Series*, December 1962 [24 panels]; Albany Institute of History and Art, *Centennial Celebration of the Emancipation Proclamation*, April 10–30, 1963; Bowdoin College Museum of Art, Brunswick, Maine, *The Portrayal of the Negro in American Painting*, May 12–September 16, 1964; UCLA Art Galleries, Dickson Art Center, Los Angeles, *The Negro in American Art*, September 11–October 16, 1966 [26, 32, 36, 48]; Forum Gallery, New York, *The Portrayal of Negroes in American Painting: United Negro College Fund Exhibition*, September 25–October 6, 1967; Art Center at Hargate, St. Paul's School, Concord, N.H., *Jacob Lawrence: The Migration Series*, November 14–December 7, 1969; La Jolla Museum of Art, Calif., *Dimensions of Black*, February 14–March 29, 1970, nos. 89–90 [all]; The Museum of Modern Art, New York, *The Artist as Adversary*, July 1–September 27, 1971; The Phillips Collection, Washington, D.C., *Jacob Lawrence: The Migration Series*, September 10–October 23, 1972; Whitney 1974–5, nos. 56–70 [1, 3, 7, 11, 13, 16, 18, 21, 39, 42, 48, 50, 55, 57, 58]; The Art Museum, Princeton University, N.J., *Fragments of American Life, An Exhibition of Paintings: Romare Bearden, Joseph Delaney, Rex Gorleigh, Lois Mailou Jones, Jacob Lawrence, Hughie Lee-Smith, Hale Woodruff*, January 25–March 28, 1976 [16]; National Archives and Records Service, Washington, D.C., *Afro-American Album*, February–April 1980 [3, 45]; International Communication Agency, Washington, D.C., *Painting in the United States from Public Collections in Washington, D.C.*, 1980–1 [11]; Lowe Art Museum, University of Miami, Coral Gables, Fla., *Jacob Lawrence: Toussaint L'Ouverture Series*, December 8, 1982–January 16, 1983 [odd]; Stockton State 1983, nos. 2–9 [8, 16, 24, 32, 44, 48, 52, 58]; Washington Project for the Arts, Washington, D.C., *Art in Washington and Its Afro-American Presence, 1940–1970*, March 30–May 11, 1985 [40]; Seattle 1986–7, nos. 39–48 [1, 3, 11, 22, 42, 48, 50, 53, 57, 58]; Brooklyn College, *Tides of Immigration*, October 7–December 9, 1986 [23]; The Corcoran Gallery of Art, Washington, D.C., *Facing History: The Black Image in American Art, 1710–1940*, January 13–March 25, 1990, nos. 113, 114 [1, 3]; The Museum of Modern Art, New York, *Art of the Forties*, February 24–April 30, 1991, p. 47, ill. [4, 22, 28, 46, 52, 56, 58]; Katonah 1992 [1, 3, 22, 48, 53, 58]; The Phillips Collection, Washington, D.C., *Jacob Lawrence: The Migration Series*, September 23, 1993–January 9, 1994; The Phillips Collection, Washington, D.C., *Jacob Lawrence: The Migration Series from The Phillips Collection*, 1996–7; Henry Art Gallery 1998 [even]; Whitney Museum of American Art, New York, *The American Century: Art and Culture, 1900–1950*, April 23–August 22, 1999 [1, 50, 59].

References: Alain Locke, "'. . . And The Migrants Kept Coming': A Negro Artist Paints the Story of the Great American Minority," *Fortune* 24 (November 1941), pp. 102–9, ill. [1, 4, 8, 9, 11, 14, 15, 16, 17, 18, 22, 24, 40, 42, 45, 48, 51, 52, 53, 54, 55, 56, 59, 60]; Howard Devree, "A Reviewer's Notebook: Brief Comment on Some of the Recently Opened Shows," *New York Times*, November 9, 1941, p. X9; "Art News of America: Picture Story of the Negro's Migration," *ARTnews* 40, 15 (November 15–30, 1941), pp. 8–9; "American Negro Art Given Full-Length Review in New York Show," *Art Digest* 16, 6 (December 15, 1941), p. 16; "Here and There: Washington, D.C.," *New York Times*, February 22, 1942, sec. 8, p. 9; "And the Migrants Kept Coming," *South Today* 7, 1 (spring 1942), pp. 5–6

[1, 48, 55]; James A. Porter, *Modern Negro Art* (New York: The Dryden Press, 1943), p. 267, ill. [52, 58]; "Migration of the Negro: Exhibition of Sixty Panels by Lawrence," *Portland Museum Bulletin* 4, 2 (June 1943), p. 2; Aline B. Louchheim, "Lawrence: Quiet Spokesman," *ARTnews* 43, 13 (October 15–31, 1944), p. 15, ill. [1]; Josephine Gibbs, "Jacob Lawrence's Migrations," *Art Digest* 19, 3 (November 1, 1944), p. 7; Alain Locke, *The Negro Artist Comes of Age*, exh. cat. (New York: Albany Institute, 1945), p. vi; Marjorie E. Greene, "Jacob Lawrence," *Opportunity* 23, 1 (January–March 1945), pp. 26–7; Elizabeth McCausland, "Jacob Lawrence," *Magazine of Art* 38, 7 (November 1945), p. 252, ill. [52]; "Proceedings of the Annual Meeting of the Association Held in Columbus, Ohio, October 26–28, 1945," *Journal of Negro History* 31 (January 1946), p. 8; Paul Zucker, "Social Scene," *Saint Louis Pageant*, April 1947, p. 38, ill. [52]; Alfred H. Barr, Jr., *Painting and Sculpture in The Museum of Modern Art* (New York: The Museum of Modern Art, 1948), p. 151, ill. [22, 52, 58]; C. J. Bulliet, "More Integrated Modernism Marks Chicago Watercolor Biennial," *Art Digest* 23, 4 (November 15, 1948), p. 24; A. L. Chanin, "The World of Art: Art's in Bloom on Both Sides of the Tracks," *Sunday Compass*, March 19, 1950; Aline B. Louchheim, "An Artist Reports on the Troubled Mind," *New York Times Magazine*, October 15, 1950, p. 15, ill. [52]; Ralph M. Pearson, *The Modern Renaissance in American Art: Presenting the Work and Philosophy of Fifty-Four Distinguished Artists* (New York: Harper & Brothers, 1954); Ben Richardson, *Great American Negros* (New York: Crowell, 1956); Cedric Dover, *American Negro Art* (Greenwich, Conn.: New York Graphic Society, 1960), p. 172, pl. 92 [45]; Saarinen 1960, pp. 22–3 [2, 10, 40, 50, 58]; Clifford Wright, "Jacob Lawrence," *The Studio* (January 1961), p. 26, ill. [50]; Bennett Schiff, "Closeup: The Artist as Man in the Street," *New York Post Magazine*, March 26, 1961, p. 2, ill. [55]; Moses Asch and Alan Lomax, *The Leadbelly Songbook* (New York: Oak Publications, 1962), pp. 55, 60, ill. [4, 17]; Frank Getlein, "Work of Foremost American Negro Artist at Phillips," *The Sunday Star*, December 9, 1962, p. B10, ill. [55, 57]; Melvin Maddocks, "The Negro Writer's Scene," *Christian Science Monitor*, February 15, 1966, p. 9, ill. [58]; Forum Gallery, *The Portrayal of Negroes in American Painting*, exh. cat. (New York: Forum Gallery, 1967), pl. 24 [60]; Lois Pierre-Noel, "American Negro Art in Progress," *Negro History Bulletin* 30, 6 (October 1967), p. 8, ill. [55]; Herbert Temple, "Evolution of Afro-American Art, 1800–1950," *Ebony* 23, 4 (February 1968), p. 117, ill. [10 as *They were Poor*]; Carroll Greene, Jr., "The Negro Artist in America, Part I," *The Journal* [United Church of Christ, Council for Higher Education] 7 (January 1969), ill.; Alfred Werner, "Black Is Not a Color," *Art and Artists* 4, 2 (May 1969), p. 14, ill. [60]; Miriam Brumer, "In the Museums: An Introduction to the Negro in American History," *Arts* 44, 1 (September–October 1969), p. 58; Henry J. Seldis, "'Dimensions in Black': A Conclusion for America," *Los Angeles Times*, February 22, 1970, p. 46, ill. [42]; "Los Angeles: Dimensions of Black, La Jolla Museum," *Artforum* 8, 9 (May 1970), p. 84; Bernard A. Weisberger, "The Immigrant Within," *American Heritage* 22, 1 (December 1970), pp. 32–9, ill. [1, 15, 17, 28, 40, 45, 49, 52, 54]; Romare Bearden and Harry Henderson, *Six Black Masters of American Art* (Garden City, N.Y.: Doubleday, 1972), p. 112, ill. [10, 24, 30, 60]; Joanna Eagle, "Washington," *Art Gallery* 15, 10 (summer 1972), p. 84; David Bourdon, "Washington Letter," *Art International* 16, 10 (December 1972), p. 37, ill. [25]; Helen M. Franc, *An Invitation to See: One Hundred Twenty-Five Paintings from The Museum of Modern Art* (New York: The Museum of Modern Art, 1973), p. 113, ill. [48, 58]; Brown 1974, pp. 23–4, ill. [3, 50, 58]; Milton Williams, "America's Top Black Artist," *Sepia* 23, 8 (August 1974), p. 75, ill. [21]; Ruth Berenson, "Art: A Different American Scene," *National Review* 26, 33 (August 16, 1974), p. 930 [16]; John Wilmerding, *American Art* (New York: Penguin Books, 1976), pl. 247 [1]; Paul Von Blum, *The Art of Social Conscience* (New York: Universe Books, 1976), p. 213, ill. [55]; Floyd Coleman, "African Influences on Black American Art," *Black Art* 1, 1 (fall 1976), p. 10, ill. [57]; Alfred H. Barr, Jr., *Painting and Sculpture in The Museum of Modern Art, 1929–1967* (New York: The Museum of Modern Art, 1977), p. 558, no. 278, ill. [10, 12]; Paul Von Blum, "A Convergence of Conscience," *Black Art* 2, 1 (fall 1977), p. 55, ill. [55]; Milton W. Brown, Sam Hunter, John Jacobs, Naomi Rosenblum, and David M. Sokol, *American Art* (New York: Harry N. Abrams, 1979), p. 452, pl. 485 [52]; Edmund Burke Feldman, *The Artist* (Englewood Cliffs, N.J.: Prentice-Hall, 1982), p. 116, ill. [52]; Lewis and Sullivan 1982, pp. 13–4, ill. [50, 55]; Paul Von Blum, *The Critical Vision: A History of Social and Political Art in the U.S.* (Boston: South End Press, 1982), p. 145, fig. 6-3 [10]; Milton W. Brown, with the assistance of Judith H. Lanius, *One Hundred Masterpieces of American Painting* (Washington, D.C.: Smithsonian Institution Press, 1983), p. 171, ill. [11]; Avis Berman, "Jacob Lawrence and the Making of Americans," *ARTnews* 83, 2 (February 1984), p. 80, ill. [52]; Michael David Zellman, *American Art Analog, Volume III, 1874–1930* (New York: Chelsea House Publishers in association with American Art Analog, 1986), p. 1005, ill. [1]; Wheat 1986,

pp. 77–9, pls. 16–9 [1, 15, 52, 54]; pp. 210–1, ill. [1, 3, 11, 22, 42, 48, 50, 53, 57, 58]; Liz M. Weiman, "Museum Notebook: The World of Jacob Lawrence," *Southwest Art* 16, 2 (July 1986), p. 80, ill. [58]; Ellen Harkins Wheat, "Jacob Lawrence: Chronicler of the Black Experience," *American Visions* 2, 1 (February 1987), p. 31, ill. [3]; Paul Richard, "The Light in the Mirror: Jacob Lawrence, Fifty Years of Images at the Phillips," *Washington Post*, April 4, 1987, p. C1, ill. [52]; Amy Fine Collins, "Jacob Lawrence: Art Builder," *Art in America* 76, 2 (February 1988), p. 134, ill. [15]; David G. Wilkins and Bernard Schultz, *Art Past, Art Present* (New York: Harry N. Abrams, 1990), pl. 523 [52]; Guy C. McElroy, *Facing History: The Black Image in American Art, 1710–1940*, exh. cat. (San Francisco: Bedford Arts Publishers in association with The Corcoran Gallery of Art, 1990), p. 129, ill. [1, 3]; Samella Lewis, *African American Art and Artists* (Berkeley, Calif.: University of California Press, 1990), pp. 130–1, ill. [1, 50]; Michelle Wallace, "Defacing History," *Art in America* 78, 12 (December 1990), p. 127, ill. [1 as "3"]; Riva Castleman, *Art of the Forties*, exh. cat. (New York: The Museum of Modern Art, 1991), p. 47, ill. [4, 22, 28, 46, 52, 56, 58]; Elizabeth Hutton Turner, ed., *Jacob Lawrence: The Migration Series*, exh. cat. (Washington, D.C.: Rappahannock Press in association with the Phillips Collection, 1993), ill. [1–60]; Powell 1992, n.p., pl. 4 [16]; William Zimmer, "A Painterly Storyteller Takes Black America As His Subject," *New York Times*, April 5, 1992, p. WC20, ill. [1]; Romare Bearden and Harry Henderson, *A History of African-American Artists from 1972 to Present* (New York: Pantheon Books, 1993), p. 302, ill. [3, 10, 30, 45, 48, 59]; Elizabeth Hutton Turner, "Jacob Lawrence, Black Migration Series," *American Art Review* 5, 5 (fall 1993); "Calendar: Jacob Lawrence, The Migration Series," *Museum News* 72, 5 (September–October 1993), p. 16, ill. [58]; Hank Burchard, "On Exhibit: Lawrence's Moving Portrait," *Washington Post*, September 24, 1993, *Weekend* magazine, p. 60, ill. [45]; Michael Kimmelman, "A Sense of Epic, a Lore of the Ordinary," *New York Times*, November 14, 1993, p. 39, ill. [23]; Robert Hughes, "Stanzas from a Black Epic," *Time* (November 22, 1993), pp. 70–1, ill. [10, 23, 57]; Eric Gibson, "Exhibition Notes: 'Jacob Lawrence—The Migration Series' at the Phillips Collection," *The New Criterion* 12, 4 (December 1993), p. 51; Mary Elizabeth Cronin, "Finding Common Thread in an Uncommon Canvas," *Seattle Times*, December 22, 1993, p. E1, ill. [1]; Curtia James, "Reviews: Jacob Lawrence, Phillips Collection," *ARTnews* 93, 1 (January 1994), p. 169, ill. [53]; "Jacob Lawrence's Paintings Depict Negro Exodus," *The Economist* 330 (January 8, 1994), p. 82, ill. [24]; Jim Higgins, "African-American Epic," *Milwaukee Sentinel*, January 28, 1994, p. 14, ill. [1, 11]; Marlena Donohue, "Telling History in Brushstrokes: Artist Jacob Lawrence Talks About His Sixty-Year Career and His Narrative Paintings," *Christian Science Monitor*, February 4, 1994, p. 13, ill. [59]; Connie Porter, "Children's Books," *New York Times Book Review*, February 13, 1994, p. 27, ill. [35]; "Jacob Lawrence's 'Migration Series' Comes to Portland," *Portland Skanner*, March 30, 1994; Elizabeth Hutton Turner, "Jacob Lawrence: Chronicles of Color," *Southwest Art* 23, 11 (April 1994), pp. 72–5, ill. [1, 5, 11, 18, 34, 38, 45, 57, 58]; Lynn Matthews, "In Pursuit of Hope," *Columbian* (April 15, 1994), p. 3, ill. [11]; Randy Gragg, "Masterpiece on the Move," *The Oregonian*, April 17, 1994, p. B1, ill. [18, 52, 58]; Lynn Matthews, "Migration of Hope and Tears," *Columbian* (April 21, 1994); Randy Gragg, "Jacob Lawrence, Chronicler," *The Oregonian*, April 21, 1994, pp. D1, D6; Douglas McLennan, "Jacob Lawrence's Migration," *News Tribune*, April 24, 1994, pp. 11–4; Frederick Kaimann, "Half-Century after Painting It, Lawrence and 'Migration Series' Still on the Move," *Birmingham News*, July 3, 1994, pp. F1, F4; Kathy Kemp, "The Migration," *Birmingham Post-Herald*, July 8, 1994, pp. B1, B8; Kathy Kemp, "Artist Migrates with His Paintings," *Birmingham Post-Herald*, July 14, 1994, p. 1; Laurie S. Hurwitz, "Exhibits: On Migration," *American Artist* 58 (August 1994), p. 8, ill. [57]; Nicole Crawford, "In Search of the Promised Land," *Service Employees Union* 8, 1 (winter 1994), p. 7, ill. [8]; Charles M. Christian, *Black Saga: The African American Experience, A Chronology* (Washington, D.C.: Civitas, 1995), cvr., ill.; Amei Wallach, "Northern Exposure," *New York Newsday*, January 8, 1995, ill. [1, 17, 45, 53]; Roberta Smith, "Art Review: The Migration from the South in Sixty Images," *New York Times*, January 13, 1995, p. C1, ill. [18]; "Series of Paintings Depicts Mass Exodus to North," *Folk Art Finder* (spring 1995), ill. [1]; Sharon Fitzgerald, "The Homecoming of Jacob Lawrence," *American Visions* 10 (April–May 1995), p. 21, ill. [3]; "Jacob Lawrence: The 'Migration' Series," *Maine Antique Digest* (April 1, 1995); Wilma Eisenlau, "Jacob Lawrence: The Migration Series," *Atlanta Bulletin*, April 22, 1995; Lee May, "It's Our Story," *Atlanta Daily*, May 1, 1995, p. B10, ill. [1, 18, 45]; "Jacob Lawrence: The Migration Series," *Antiques and the Arts Weekly*, May 5, 1995; Marty Shuter, "The Migration Series," *Savannah News-Press*, May 14, 1995; Judy M. Willis, "Jacob Lawrence: A Painter of History," *Atlanta Tribune*, May 15, 1995, p. 57, ill. [1, 11]; Catherine Fox, "Lawrence Captures Blacks' Flight North," *Atlanta Constitution*, May 19, 1995, ill. [18]; Doug Mason, "'Migration Series' on First-Ever Tour," *Knoxville News-Sentinel*, May 21, 1995, ill. [18, 38]; "Jacob Lawrence: The Migration Series," *Urban Spectrum*, July 1995; Niki Hayden, "Due North," *Sunday Camera* (July 9, 1995), pp. B1–2, ill. [1, 15, 53, 58]; Steven Rosen, "Painting the Great Migration," *Denver Post Magazine*, July 9, 1995, pp. 8–10; Michael Paglia, "Gone with the Wind," *Westwood* (August 2–8, 1995), p. 55, ill. [11, 58]; William Mullen, "The Great Migration," *Chicago Tribune Magazine* (September 24, 1995), pp. 22–3, ill. [1, 5, 11, 15, 52, 53, 55]; Cristal Britton, *African American Art: The Long Struggle* (New York: Todtri, 1996), p. 62, ill. [50]; Barry Schwabsky, "Black Exodus," *Art in America* 84, 3 (March 1996), pp. 88–93, ill. [4, 7, 15, 29, 31, 35, 37, 47, 50, 56, 57]; Michael Kimmelman, "An Invigorating Homecoming: At the Met and Modern with Jacob Lawrence," *New York Times*, April 12, 1996, p. C4, ill. [18]; Stephen Wallis, "Jacob Lawrence: Portrait of a Serial Painter," *Art and Antiques* 19, 11 (December 1996), pp. 58, 59, ill. [1, 15]; Harvey J. Kaye, *Why Do the Ruling Classes Fear History?* (New York: St. Martin's Griffin, 1997), cvr., ill. [58]; H. W. Janson and Anthony F. Janson, *History of Art* (New York: Harry N. Abrams, 1997), p. 819, ill. [3]; Robert Hughes, *American Visions: The Epic History of America in Art* (New York: Alfred A. Knopf, 1997), pp. 454–7, ill. [10]; Christopher Lane, *The Psychoanalysis of Race* (New York: Columbia University Press, 1998), cvr., ill. [19]; H. H. Arnason et al., *History of Modern Art* (New York: Harry N. Abrams, 1998), p. 415, pl. 226 [1]; Sharon F. Patton, *African-American Art* (New York: Oxford University Press, 1998), pp. 154–5, ill. [1, 50]; Robin Updike, "A Modern Master," *Seattle Times*, June 28, 1998, *Pacific Northwest* magazine, p. 19, ill. [46]; Tom Stabile, "Reconstructing Jacob Lawrence: A Scholarly Team Prepares the Master Catalog," *Humanities* 19, 6 (November–December 1998), p. 26, ill. [57]; Barbara Haskell, *The American Century: Art and Culture, 1900–1950*, exh. cat. (New York: Whitney Museum of American Art, 1999), p. 234, ill. [1, 50, 59].

Remarks: Jacob Lawrence applied for and received a $1,500 fellowship from the Rosenwald Foundation to complete a series of "forty to fifty" panels on the "Great Negro Migration." He conducted research at The Schomburg Collection in 1940 and completed the series in 1941. Though the series was originally meant to remain together as one work, the artist consented to a joint purchase by the two museums in the winter of 1941–2. The even numbered paintings from the series are in the collection of the Museum of Modern Art in New York, and the odd numbered paintings are in the Phillips Collection, Washington, D.C. The captions provided here are the original captions from 1941, not the revised captions provided by the artist to the Museum of Modern Art and the Phillips Collection in 1992.

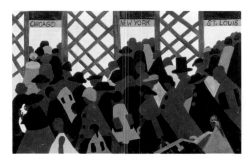

1. During the World War there was a great migration North by Southern Negroes.

2. The World War had caused a great shortage in Northern industry and also citizens of foreign countries were returning home.

3. In every town Negroes were leaving by the hundreds to go North and enter into Northern industry.

4. The Negro was the largest source of labor to be found after all others had been exhausted.

5. The Negroes were given free passage on the railroads which was paid back by Northern industry. It was an agreement that the people brought North on these railroads were to pay back their passage after they had received jobs.

6. The trains were packed continually with migrants.

7. The Negro, who had been part of the soil for many years, was now going into and living a new life in the urban centers.

8. They did not always leave because they were promised work in the North. Many of them left because of Southern conditions, one of them being great floods that ruined the crops, and therefore they were unable to make a living where they were.

9. Another great ravager of the crops was the boll weevil.

10. They were very poor.

11. In many places, because of the war, food had doubled in price.

12. The railroad stations were at times so over-packed with people leaving that special guards had to be called in to keep order.

13. Due to the South's losing so much of its labor, the crops were left to dry and spoil.

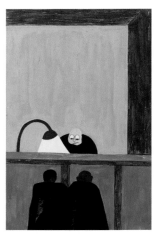

14. Among the social conditions that existed which was partly the cause of the migration was the injustice done to the Negroes in the courts.

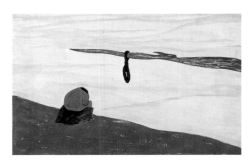

15. Another cause was lynching. It was found that where there had been a lynching, the people who were reluctant to leave at first left immediately after this.

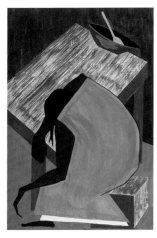

16. Although the Negro was used to lynching, he found this an opportune time for him to leave where one had occurred.

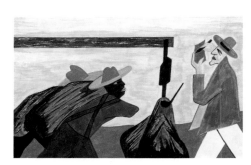

17. The migration was spurred on by the treatment of the tenant farmers by the planter.

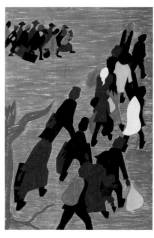

18. The migration gained in momentum.

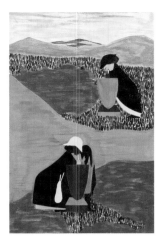

19. There had always been discrimination.

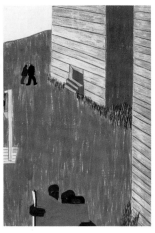

20. In many of the communities the Negro press was read continually because of its attitude and its encouragement of the movement.

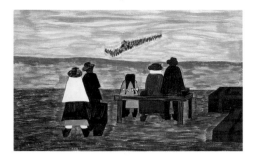

21. Families arrived at the station very early in order not to miss their train North.

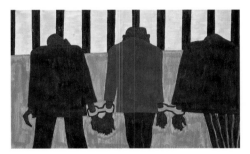

22. Another of the social causes of the migrants' leaving was that at times they did not feel safe, or it was not the best thing to be found on the streets late at night. They were arrested on the slightest provocation.

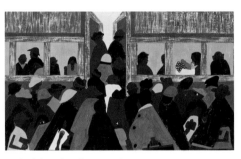

23. And the migration spread.

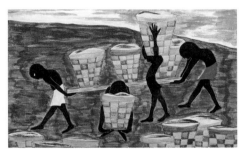

24. Child labor and a lack of education was one of the other reasons for people wishing to leave their homes.

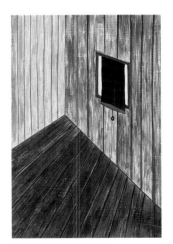

25. After a while some communities were left almost bare.

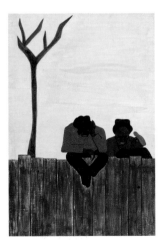

26. And people all over the South began to discuss this great movement.

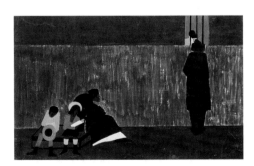

27. Many men stayed behind until they could bring their families North.

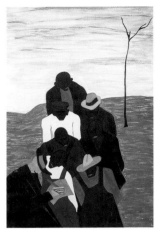

28. The labor agent who had been sent South by Northern industry was a very familiar person in the Negro counties.

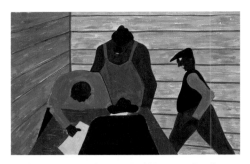

29. The labor agent also recruited laborers to break strikes which were occurring in the North.

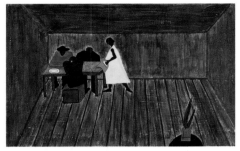

30. In every home people who had not gone North met and tried to decide if they should go North or not.

31. After arriving North the Negroes had better housing conditions.

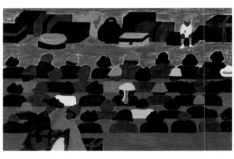

32. The railroad stations in the South were crowded with people leaving for the North.

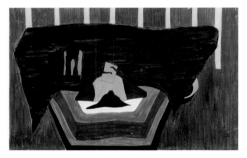

33. People who had not yet come North received letters from their relatives telling them of the better conditions that existed in the North.

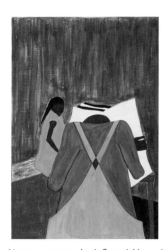

34. The Negro press was also influential in urging the people to leave the South.

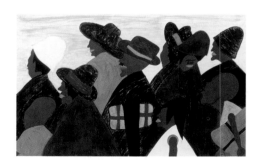

35. They left the South in large numbers and they arrived in the North in large numbers.

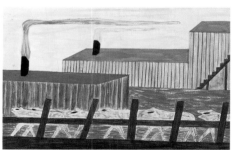

36. They arrived in great numbers into Chicago, the gateway of the West.

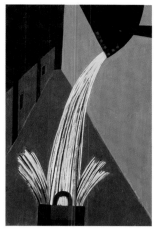

37. The Negroes that had been brought North worked in large numbers in one of the principal industries, which was steel.

38. They also worked in large numbers on the railroad.

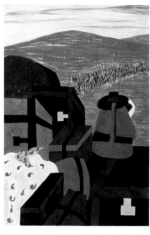

39. Luggage crowded the railroad platforms.

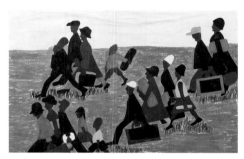

40. The migrants arrived in great numbers.

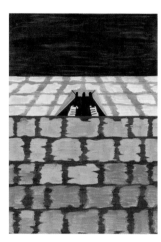

41. The South that was interested in keeping cheap labor was making it very difficult for labor agents recruiting Southern labor for Northern firms. In many instances, they were put in jail and were forced to operate incognito.

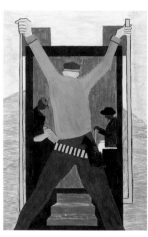

42. They also made it very difficult for migrants leaving the South. They often went to railroad stations and arrested the Negroes wholesale, which in turn made them miss their train.

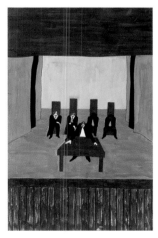

43. In a few sections of the South the leaders of both groups met and attempted to make conditions better for the Negro so that he would remain in the South.

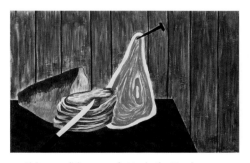

44. Living conditions were better in the North.

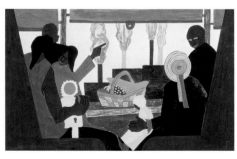

45. They arrived in Pittsburgh, one of the great industrial centers of the North, in large numbers.

46. Industries attempted to board their labor in quarters that were oftentimes very unhealthy. Labor camps were numerous.

47. As well as finding better housing conditions in the North, the migrants found very poor housing conditions in the North. They were forced into overcrowded and dilapidated tenement houses.

48. Housing for the Negroes was a very difficult problem.

49. They also found discrimination in the North although it was much different from that which they had known in the South.

50. Race riots were very numerous all over the North because of the antagonism that was caused between the Negro and white workers. Many of these riots occurred because the Negro was used as a strike breaker in many of the Northern industries.

51. In many cities in the North where the Negroes had been overcrowded in their own living quarters they attempted to spread out. This resulted in many of the race riots and the bombing of Negro homes.

52. One of the largest race riots occurred in East St. Louis.

53. The Negroes who had been North for quite some time met their fellowmen with disgust and aloofness.

54. One of the main forms of social and recreational activities in which the migrants indulged occurred in the church.

55. The Negro being suddenly moved out of doors and cramped into urban life, contracted a great deal of tuberculosis. Because of this the death rate was high.

56. Among one of the last groups to leave the South was the Negro professional who was forced to follow his clientele to make a living.

57. The female worker was also one of the last groups to leave the South.

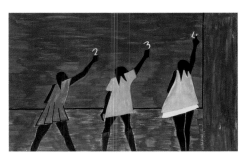

58. In the North the Negro had better educational facilities.

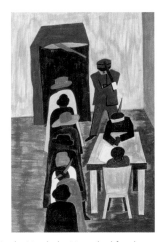

59. In the North the Negro had freedom to vote.

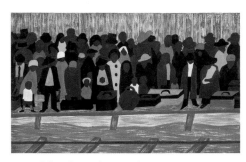

60. And the migrants kept coming.

P41-02
The Wall
1941
gouache on paper
22½ × 18 in. (57.2 × 45.7 cm)
signed and dated lower left "J. Lawrence 41"

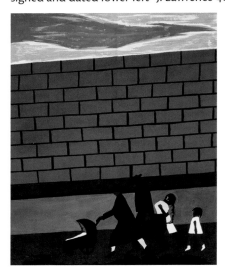

Collection: Private collection. Courtesy of Guggenheim, Asher Associates Inc., New York.

Provenance: Jacob and Gwendolyn Knight Lawrence, New York; Helen Grayson, New York; Cecile Starr, New York; [Guggenheim, Asher Associates Inc., New York].

Exhibitions: Midtown Payson 1995a.

References: Midtown Payson 1995b, p. 1, ill.

P41-03
Untitled [Two People in a Bar]
1941
tempera and gouache on brown paper
14¾ × 25 in. (37.5 × 63.5 cm)
signed and dated lower right "J. Lawrence 41"

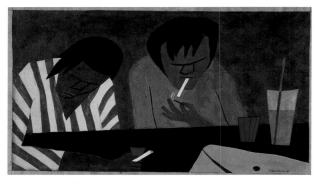

Collection: Brooklyn Museum of Art. Gift of Jay Leyda, 87.192.

Provenance: Collection of the artist, New York; Jay Leyda, New York.

Remarks: A.k.a. *Two Men in a Bar;* inscribed on original mat: "To Jay Leyda From Jacob Lawrence."

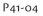

P41-04
Rampart Street
1941
tempera on paper
23⅞ × 18 1/16 in. (60.6 × 45.9 cm)
signed and dated lower right "J. LAWRENCE - 41"; inscribed bottom left in margin "RAMPART STREET"

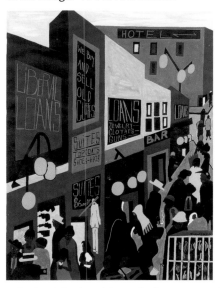

Collection: Collection of the Portland Art Museum. Gift of Mr. and Mrs. Jan de Graaff.

Provenance: [The Downtown Gallery, New York]; Jan de Graaff, New York.

Exhibitions: The Downtown Gallery, New York, *Watercolors—Drawings, By Leading American Artists,* January 7–24, 1942; Henry Art Gallery, University of Washington, Seattle, *Art of the Thirties: The Pacific Northwest,* April 1–30, 1972; Henry Art Gallery 1998.

Remarks: A.k.a. *Harlem Street.*

P41-05
The Green Table
1941
gouache on composition board
22½ × 16½ in. (57.2 × 41.9 cm)
signed and dated upper left "J. Lawrence - 41"

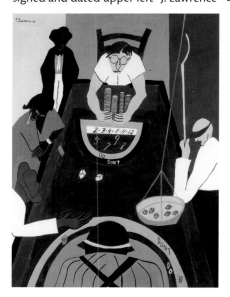

Collection: Private collection.

Provenance: [The Downtown Gallery, New York]; John R. Crawley; [The Alan Gallery, New York]; Mr. and Mrs. John Marin, Jr., New York.

Exhibitions: The Downtown Gallery, New York, *American Negro Art: Nineteenth and Twentieth Centuries*, December 9, 1941–January 3, 1942, no. 35; AFA 1960–2, no. 9; Whitney 1974–5, no. 72; Seattle 1986–7, no. 49.

References: Saarinen 1960, p. 24, ill.; Emily Genauer, "Ideas Still Move Today's Painters," *New York Herald Tribune*, November 27, 1960, ill.; Carroll Greene, Jr., "Jacob Lawrence: Story Teller," *The American Way* (July–August 1969), ill.; Virginia Lee, "Jacob Lawrence— Story Teller," *Northwest Art News and Views* 1 (March–April 1970), p. 18, ill.; Wheat 1986, p. 211, ill.

Remarks: Painted in New Orleans during the fall of 1941.

P41-06
Catholic New Orleans
1941
tempera on paper
17⅞ × 23¾ in. (45.4 × 60.3 cm)
signed and dated upper left "J. Lawrence - 41"; inscribed lower left "CATOLIC [sic] NEW ORLEANS FRAME"

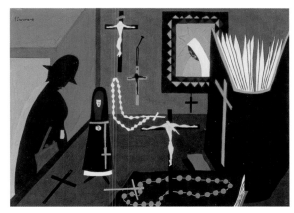

Collection: University Art Museum, Berkeley. Purchased with the aid of funds from the National Endowment for the Arts (Selected by the Committee for the Acquisition of Afro-American Art).

Provenance: [The Downtown Gallery, New York]; Charles Sheeler; Estate of Charles Sheeler; [Terry Dintenfass Inc., New York].

Exhibitions: The Downtown Gallery, New York, *American Negro Art: Nineteenth and Twentieth Centuries*, December 9, 1941–January 3, 1942, no. 36; Whitney 1974–5, no. 71; Indianapolis Museum of Art, *Perceptions of the Spirit in Twentieth-Century American Art*, September 20–November 27, 1977, no. 53; Henry Art Gallery 1998.

References: Jane and John Dillenberger, *Perceptions of the Spirit in Twentieth-Century American Art*, exh. cat. (Indianapolis: Indianapolis Museum of Art, 1977), pp. 23, 98–9, ill.

Remarks: Painted in New Orleans during the fall of 1941.

P41-07
Bus
1941
gouache on paper
17 × 22 in. (43.2 × 55.9 cm)
signed and dated upper left "J. Lawrence 41"

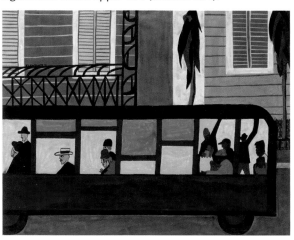

Collection: George and Joyce Wein, New York.

Provenance: ?; [Terry Dintenfass Inc., New York].

Exhibitions: Bellevue Art Museum, Wash., *Hidden Heritage: Afro-American Art, 1800–1950*, September 14–November 10, 1985, no. 78; Katonah 1992.

References: Alain Locke, ed., "How We Live in South and North: Paintings by Jacob Lawrence," *Survey Graphic* 31, 11 (November 1942), pp. 478–9, ill.; Wheat 1986, p. 80, pl. 20.

Remarks: Painted in New Orleans during the fall of 1941.

P41-08
Bar and Grill
1941
gouache on paper
16¾ × 22¾ in. (42.5 × 57.8 cm)
signed and dated upper right "J. Lawrence - 41"

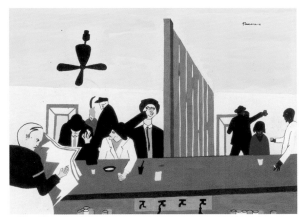

Collection: Delaware Art Museum. Gift of the National Academy of Design, Henry Ward Ranger Fund.

Provenance: ?; Allan Daniel, New York; [Terry Dintenfass Inc., New York]; Dr. and Mrs. Ned Rifkin, New York; [Terry Dintenfass Inc., New York]; National Academy of Design, New York.

Exhibitions: The Lowe Art Museum, University of Miami, Coral Gables, Fla., *The American Prophets*, February 21–March 25, 1973; New York Cultural Center, *Blacks: USA: 1973*, September 26–November 15, 1973.

Remarks: Painted in New Orleans during the fall of 1941.

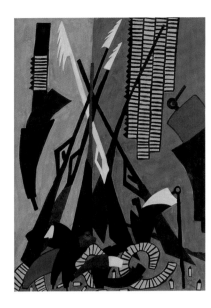

P41-09
John Brown's Arsenal
1941
gouache and tempera on paper
20 × 11 in. (50.8 × 27.9 cm)
signed lower right "Jacob / Lawrence"

Collection: Maier Museum of Art, Randolph-Macon Woman's College, Lynchburg, Virginia. Purchase with Centennial Campaign funds donated by Suzanne Goodman Elson '59, 1997.

Provenance: Jacob and Gwendolyn Knight Lawrence, New York and Seattle; [DC Moore Gallery, New York].

Remarks: This painting is presumed to be an outtake from the *Life of John Brown* series, as it relates compositionally to no. 18 in that series. The work remained in the artist's collection until ca. 1996, when it was signed.

P41-10
The Life of John Brown
1941
gouache and tempera on paper (22 paintings)
13⅝ × 19⅞ in. (34.6 × 50.5 cm) // 19⅞ × 13⅝ in. (50.5 × 34.6 cm)
unsigned

Collection: The Detroit Institute of Arts. Gift of Mr. and Mrs. Milton Lowenthal.

Provenance: [The Downtown Gallery, New York]; Mr. and Mrs. Milton Lowenthal.

Exhibitions: The Downtown Gallery, New York, *Nineteenth Annual Fall Exhibition: New Paintings and Sculpture by Leading American Artists*, October 3–28, 1944, no. 9 [1]; The Institute for Modern Art, Boston, *Four Modern American Painters: Peter Blume, Stuart Davis, Marsden Hartley, Jacob Lawrence*, March 2–April 1, 1945, nos. 46–8 [1, 11, 18]; The Downtown Gallery, New York, *Jacob Lawrence: John Brown, A Series of Twenty-Two Paintings in Gouache*, December 4–29, 1945; American Federation of Arts, New York, *The Life of John Brown by Jacob Lawrence*, 1946–7; Whitney Museum of American Art, New York, *Edith and Milton Lowenthal Collection*, October 1–November 2, 1952, nos. 56–77; AFA 1960–2, nos. 15–20 [4, 6, 11, 14, 16, 22]; Hope College, Holland, Mich., *Fine Arts Festival Exhibition*, April 24–May 17, 1965 [2, 4]; First World Festival of Negro Arts, Dakar, Senegal, *Ten Negro Artists from the United States*, April 1–24, 1966, nos. 12–4 [11, 13, 20]; La Jolla Museum of Art, Calif., *Dimensions of Black*, February 14–March 29, 1970 [20]; The Detroit Institute of Arts, *Jacob Lawrence: John Brown Series*, May 4–June 6, 1971; Whitney 1974, nos. 73–7 [6, 7, 8, 21, 22]; The Detroit Institute of Arts, *The John Brown Series by Jacob Lawrence*, October 14–November 26, 1978; Seattle 1986–7, nos. 50–2 [4, 20, 22].

References: A[line] B. L[ouchheim], "Brisk and Brighter: An October Opening," *ARTnews* 43, 12 (October 1, 1944), p. 24 [1]; Alain Locke, *The Negro Artist Comes of Age*, exh. cat. (Albany: Albany Institute of History and Art, 1945), p. vi; Florence S. Berryman, "News of Art and Artists: John Brown's Struggles," *Sunday Star*, October 6, 1945, p. B5 [1, 4]; [Review of the *Life of John Brown* series at The Downtown Gallery], *New York Sun*, December 8, 1945; Ben Wolf, "The Saga of John Brown," *Art Digest* 20, 6 (December 15, 1945), p. 17, ill. [6]; "The Passing Shows," *ARTnews* 44, 17 (December 15–31, 1945), p. 23; Matt Wayne, "Sights and Sounds: 'Strange Fruit,'" *New Masses* 57, 12 (December 18, 1945), pp. 29–30, ill. [11]; "Art: John Brown's Body," *Newsweek* 26, 26 (December 24, 1945), p. 87, ill. [22]; *The Life of John Brown by Jacob Lawrence*, exh. brch. (Washington, D.C.: The Barnett Aden Gallery, 1946), n.p., ill. [21]; Howard Devree, "By Groups and One by One," *New York Times*, May 12, 1946, sec. 2, p. 11; Lester D. Longman, "Everybody Gets in the Act at Chicago's Watercolor Show," *ARTnews* 45, 5 (July 1946), pp. 20–1, 51, ill. [6]; "Jacob Lawrence," *Magazine of Art, Flint Institute Edition* (May 1947), p. 3, ill. [19]; "John Brown Series by Jacob Lawrence," *Portland Museum Bulletin* 8 (July 1947), p. 2; Gwendolyn Bennett, "Meet Jacob Lawrence, Harlem-Born, Nationally Known," *Masses and Mainstream* (winter 1947), p. 97, ill. [5, 11, 18, 19, 20, 22]; C. J. Bulliet, "More Integrated Modernism Marks Chicago Watercolor Biennial," *Art Digest* 23, 4 (November 15, 1948), pp. 24, 51; "Accessions, 1955–56," *Bulletin of the DIA* 35, 2 (1955–6), p. 53; Ben Richardson, *Great American Negros* (New York: Crowell, 1956), p. 107; Cedric Dover, *American Negro Art* (Greenwich, Conn.: New York Graphic Society, 1960), ill. [12]; Saarinen 1960, pp. 27–30 [4, 6, 11, 14, 16, 22]; Clifford Smith, "Bright Sorrow," *Time* 77 (February 24, 1961), pp. 60–3, ill. [6]; Hale Woodruff, *Ten Negro Artists from the United States (Dix artistes nègres de Etats-Unis)*, exh. cat. (Washington, D.C.: United States Commission for the First World Festival of Negro Arts, and National Collection of Fine Arts, Smithsonian Institution, 1966), p. 82, pl. 23 [20]; Romare Bearden and Harry Henderson, *Six Black Masters of American Art*, exh. cat. (New York: Doubleday, 1972), p. 115, ill. [6]; Elsa Honig Fine, *The Afro-American Artist: A Search for Identity* (New York: Hacker Art Books, 1973), p. 149, pl. 200; Brown 1974, p. 23, ill.; Ellen Sharp, *The Legend of John Brown*, exh. cat. (Detroit: The Detroit Institute of Arts, 1978); Wheat 1986, pp. 81–2, pls. 21–3 [6, 21, 22] and p. 211, ill. [4, 20, 22]; Powell 1992, n.p., ill. [21]; Ellen Sharp, "The Legend of John Brown and the Series by Jacob Lawrence," *Bulletin of the DIA* 67, 4 (1993), pp. 14–35, ill. [1]; Romare Bearden and Harry Henderson, *A History of African-American Artists from 1972 to Present* (New York: Pantheon Books, 1993), p. 304, ill. [6]; Peter T. Nesbett, with an essay by Patricia Hills, *Jacob Lawrence: Thirty Years of Prints (1963–1993), A Catalogue Raisonné* (Seattle: Francine Seders Gallery in association with University of Washington Press, 1994), p. 3, fig. 3 [22]; Stephen Wallis, "Jacob Lawrence: Portrait of a Serial Painter," *Art and Antiques* 19, 11 (December 1996), pp. 58–64, ill. [23].

Remarks: Painted in New Orleans during the fall of 1941.

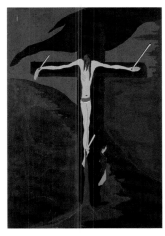

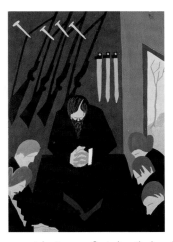

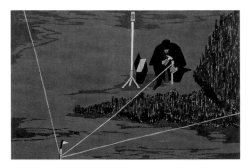

3. For 12 years, John Brown engaged in land speculations and wool merchandising. All this to make some money for his greater work which was the abolishment of slavery.

1. John Brown, a man who had a fanatical belief that he was chosen by God to overthrow black slavery in America.

2. For 40 years, John Brown reflected on the hopeless and miserable condition of the slaves.

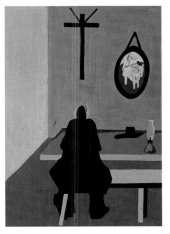

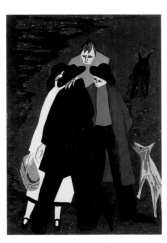

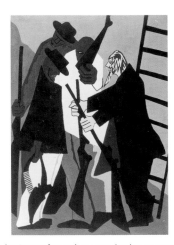

4. His ventures failing him, he accepted poverty.

5. John Brown, while tending his flock in Ohio, first communicated with his sons and daughters his plans of attacking slavery by force.

6. John Brown formed an organization among the colored people of the Adirondack woods to resist the capture of any fugitive slave.

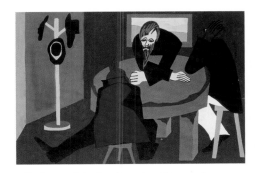

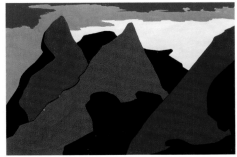

7. To the people he found worthy of his trust, he communicated his plans.

8. John Brown's first thought of the place where he would make his attack came to him while surveying land for Oberlin College in West Virginia, 1840.

9. Kansas was now the skirmish ground of the Civil War.

10. Those pro-slavery were murdered by those anti-slavery.

11. John Brown took to guerilla warfare.

12. John Brown's victory at Black Jack drove those pro-slavery to new fury, and those who were anti-slavery to new efforts.

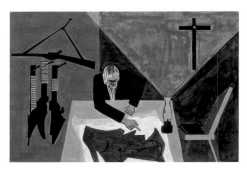

13. John Brown, after long meditation, planned to fortify himself somewhere in the mountains of Virginia or Tennessee and there make raids on the surrounding plantations, freeing slaves.

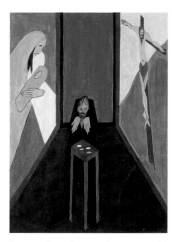

14. John Brown collected money from sympathizers and friends to carry out his plans.

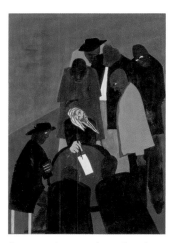

15. John Brown made many trips to Canada organizing for his assault on Harpers Ferry.

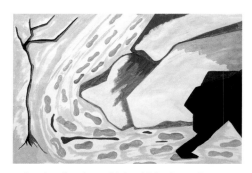

16. In spite of a price on his head, John Brown, in 1859, liberated 12 Negroes from a Missouri plantation.

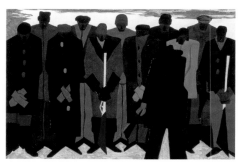

17. John Brown remained a full winter in Canada, drilling Negroes for his coming raid on Harpers Ferry.

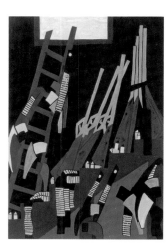

18. July 3, 1859, John Brown stocked an old barn with guns and ammunitions. He was ready to strike his first blow at slavery.

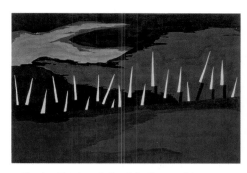

19. Sunday, October 16, 1859, John Brown with a company of 21 men, white and black, marched on Harpers Ferry.

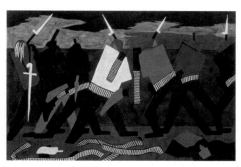

20. John Brown held Harpers Ferry for 12 hours. His defeat was a few hours off.

21. After John Brown's capture, he was put to trial for his life in Charles Town, Virginia.

22. John Brown was found "guilty of treason and murder in the 1st degree. He was hanged in Charles Town, Virginia on December 2, 1859."

P42-01
Diners
1942
gouache on paper
14 × 19¾ in. (35.6 × 50.20 cm)
signed and dated upper left "J. LAWRENCE 42"

Collection: The University of Arizona Museum of Art. Gift of C. Leonard Pfeiffer.

Provenance: [The Downtown Gallery, New York]; C. Leonard Pfeiffer.

Exhibitions: The Downtown Gallery, New York, *Spring Exhibition*, April 7–May 2, 1942; The Metropolitan Museum of Art, New York, *An Exhibition of Contemporary American Paintings from the Collection of the University of Arizona*, April 7–27, 1943, no. 85 (as *Café Scene*); American Federation of Arts, New York, *A University Collects—Arizona*, 1952–3; Olin Art Gallery, Whitman College, Walla Walla, Wash., *Inaugural Exhibition*, September 30–October 24, 1972; Whitney 1974–5, no. 85 (as *Café Scene*); Seattle 1986–7, no. 54; Arizona Bank Galleria, Phoenix, *Artists of the Black Community/USA*, May 26–August 19, 1988; Edith C. Blum Art Institute, Bard College, Annandale-on-Hudson, N.Y., *Art What Thou Eat: Images of Food in American Art*, September 2–November 18, 1990; Henry Art Gallery 1998.

References: Elizabeth McCausland, "Jacob Lawrence," *Magazine of Art* 38, 7 (November 1945), p. 252, ill. (as *Café Scene*); Alan Gruskin, *Painting in the U.S.A.* (New York: Doubleday & Co., 1946), p. 83, ill.; "Arizona Art Collection: University Gets One Hundred U.S. Paintings," *Life* 20, 7 (February 18, 1946), p. 77, ill. (as *Café Scene*); *The University of Arizona Collection of American Art* (Tucson, Ariz.: University of Arizona, 1947), no. 58, ill.; Matthew Baigell, *The American Scene: American Painting of the 1930s* (New York: Praeger Publishers, 1974), p. 196, fig. 112; *Paintings and Sculpture in the Permanent Collection* (Tucson, Ariz.: University of Arizona, 1983), p. 258, ill.; Wheat 1986, p. 211, ill.; *Artists of the Black Community/USA*, exh. cat. (Phoenix: The Arizona Bank Galleria, 1988), n.p., ill.; Antonello Negri, *Tendenze del Realismo Nel Ventesimo Secolo* (Bari, Italy: Laterza, 1992).

P42-02
Alley
1942
gouache on composition board
27⅝ × 24 in. (70.2 × 61 cm)
signed and dated lower right "J. LAWRENCE 42"

Collection: Clark Atlanta University Art Collections. Gift of David Levy.

Provenance: [The Downtown Gallery, New York]; Mr. and Mrs. David Levy.

P42-03
Interior
1942
gouache on paper
30¼ × 32½ in. (76.8 × 82.6 cm)
signed and dated lower right "J. LAWRENCE 42"

Collection: The Art Institute of Chicago. Earle Ludgin Bequest.

Provenance: [The Downtown Gallery, New York]; Earle Ludgin, Chicago, Ill.

Exhibitions: The Downtown Gallery, New York, *Spring Exhibition*, April 7–May 2, 1942; The Art Institute of Chicago, *Since the Harlem Renaissance: Sixty Years of African-American Art*, May 18–August 25, 1996.

P42-04
Spring Plowing
1942
gouache and tempera on composition board
19½ × 23¾ in. (49.5 × 60.3 cm)
signed and dated upper right "J. Lawrence 42"

Collection: Greenville County Museum of Art. Museum purchase with funds donated by the Arthur and Holly Magill Foundation.

Provenance: [The Downtown Gallery, New York]; Mr. and Mrs. Mackinley Helm, New York; [Parke Bernet Galleries, New York, December 13–14, 1973, lot 176]; Mr. and Mrs. Fred D. Rudin, Atlantic City, New Jersey; [Richard York Gallery, New York].

Exhibitions: The Institute for Modern Art, Boston, *Paintings and Sculpture by American Negro Artists*, 1943, no. 20; Whitney 1974–5, no. 80 (as *The Plowman*).

References: *An American Gallery: Volume VI* (New York: Richard York Gallery, 1990), no. 41, ill.; Martha R. Severens, *Greenville County Museum of Art: The Southern Collection*, exh. cat. (New York: Hudson Hills Press, 1995), pp. 186–7.

Remarks: Executed in Lenexa, Virginia, during the spring of 1942. The artist and his wife have expressed doubt regarding the authenticity of this painting.

P42-05
Trees
1942
gouache and tempera on paper
sight: 37 × 29 in. (94 × 73.7 cm)
signed and dated lower right "J. Lawrence 42"

Collection: Howard University Gallery of Art, Washington, D.C.

Provenance: [The Downtown Gallery, New York].

References: "New Gallery Emphasizes Negro Art," *Washington Post*, October 31, 1943, sec. V, p. 8.

Remarks: Executed in Lenexa, Virginia, during the winter or spring of 1942.

P42-06
Firewood
1942
gouache, ink, and watercolor on paper
22¾ × 31 in. (57.8 × 78.7 cm)
signed and dated lower left "J. Lawrence 42"; inscribed bottom left in margin "Firewood #55"

Collection: National Museum of American Art, Smithsonian Institution. Transfer from United States Information Agency.

Provenance: [The Downtown Gallery, New York]; United States Information Agency Exhibits Division.

Exhibitions: The Albright Gallery, Buffalo, February 1944; University Art Galleries, University of Nebraska, Lincoln, *Fifty-Fourth Annual Exhibition of Contemporary Art*, March 1944; The Art Institute of Chicago, *The Fifty-Fifth Annual American Exhibition: Water Colors and Drawings*, June 8–August 20, 1944, no. 247; Musee d'Art Moderne, Paris, *Exposition internationale d'art moderne*, November–December 1946; Municipal Arts Gallery, Philadelphia Civic Center, *Afro-American Artists: 1800–1969*, December 5–29, 1969, no. 129; Whitney 1974–5, no. 78; Henry Art Gallery 1998.

References: Alain Locke, ed., "How We Live in South and North: Paintings by Jacob Lawrence," *Survey Graphic* 31, 11 (November 1942), p. 478, ill.; James A. Porter, *Modern Negro Art* (New York: The Dryden Press, 1943), p. 242, ill.; Dan West, "I Love the South," *New Masses* 59, 9 (May 28, 1946), p. 3, ill.; Oliver W. Larkin, *Art and Life in America* (New York: Rinehart & Company, 1950), p. 436.

Remarks: Executed in Lenexa, Virginia, during the winter of 1942.

P42-07
Wash Day
1942
gouache on paper
28½ × 20¼ in. (72.4 × 51.4 cm)
signed and dated upper right "J. Lawrence 42"

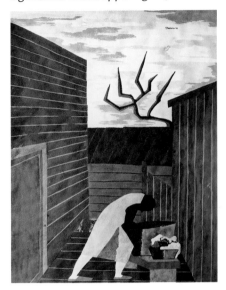

Collection: Private collection.

Provenance: [The Downtown Gallery, New York]; Marvin Small, New York; [ACA Gallery, New York]; Sidney L. Bergen, New York; [ACA Gallery, New York].

Exhibitions: The Brooklyn Museum, *International Watercolor Exhibition, Twelfth Biennial*, April 9–May 23, 1943, no. 79; Whitney 1974–5, no. 79 (Whitney only); ACA Galleries, New York, *Social Art in America, 1930–1945*, November 6–28, 1981, no. 37.

References: Milton W. Brown, *Social Art in America, 1930–1945*, exh. cat. (New York: ACA Galleries, 1981), p. 41, ill.; Barbara Gallati, "Social Art in America, 1930–1945," *Arts* 56, 3 (November 1981), p. 7, ill.

Remarks: Executed in Lenexa, Virginia, during the winter or spring of 1942.

P42-08
Drawing Water
1942
gouache on paper
28 × 20 in. (71 × 50.8 cm)
signed and dated lower right "J. Lawrence 42"

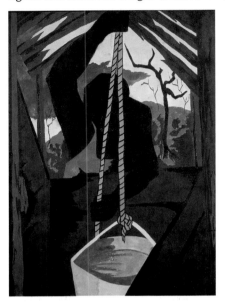

Collection: C. Bruce and Shahara Llewellyn, New York.

Provenance: ?; David Frank, Roslyn Heights, New York; [Terry Dintenfass Inc., New York].

Exhibitions: Kennedy Galleries, New York, *Artists Salute Skowhegan*, December 8–21, 1977; Stockton State 1983, no. 10.

References: *Artists Salute Skowhegan*, exh. cat. (New York: Kennedy Galleries, 1977), ill.; Wheat 1986, p. 65.

Remarks: Executed in Lenexa, Virginia, during the winter or spring of 1942.

P42-09
Untitled [*Rural Scene*]
1942, 1960
oil and egg tempera on hardboard
18 × 12 in. (45.7 × 30.5 cm)
signed and dated lower right "Jacob Lawrence 1941–60"

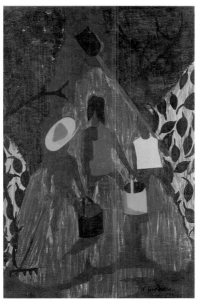

Collection: Anacostia Museum and Center for African American History and Culture, Washington, D.C.

Provenance: Jacob and Gwendolyn Knight Lawrence, New York; ?; [Forum Gallery, New York]; Museum of African Art, Washington, D.C.

Remarks: This is one of only a few known works on which the artist experimented with oil paint. It was probably started while the artist was in Lenexa, Virginia, during the winter months in early 1942, though it appears as if the shadowing and modeling of the figures was added later with tempera, perhaps ca. 1960. The work was signed and dated by the artist in the early 1960s.

P42-10
Reflection
1942
gouache on paper
image: 27¾ × 20½ in. (70.5 × 52.1 cm)
inscription unknown

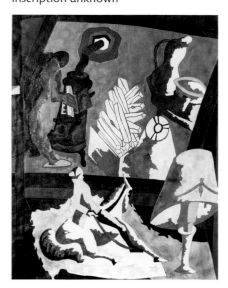

Collection: Current location unknown.

Provenance: [The Downtown Gallery, New York]; Lawrence Allan, New York; [The Alan Gallery, New York]; First Pennsylvania Bank, Philadelphia.

Exhibitions: The Downtown Gallery, New York, *Spring 1944: New Important Paintings and Sculpture by Leading Americans*, April 11–May 6, 1944, no. 7; City Art Museum, Saint Louis, *Thirty-Eighth Annual Exhibition: American Painting of Today*, February 10–May 12, 1945, no. 40; Fine Arts Gallery of San Diego, *Paintings by Matisse, Tom Lewis, Chester Hayes; Watercolor Paintings by Jacob Lawrence and Willing Howard*, April 1946; AFA 1960–2, no. 10 (as *Reflections*); Whitney 1974–5, no. 81 (as *Reflections*).

References: Henry McBride, "Attractions in the Galleries," *New York Sun*, April 22, 1944; Saarinen 1960, p. 25, ill.

Remarks: Executed in Lenexa, Virginia, during the winter or spring of 1942.

P42-11
Woman with Grocery Bags
1942
gouache on paper
29¾ × 21 in. (75.6 × 53.3 cm)
signed and dated upper right "J. LAWRENCE 42" [vertical]

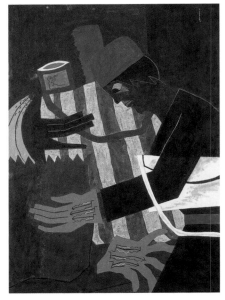

Collection: Mr. and Mrs. Charles Gwathmey, New York.

Provenance: [The Downtown Gallery, New York]; Robert and Rosalee Gwathmey, New York.

Exhibitions: Whitney 1974–5, no. 91; Seattle 1986–7, no. 65; Midtown Payson 1995a; Henry Art Gallery 1998.

References: Wheat 1986, p. 87, pl. 30.

Remarks: A.k.a. *Groceries* and *Grocery Bags*.

P42-12
The Photographer
1942
gouache on paper
22 × 29½ in. (55.9 × 74.9 cm)
signed and dated lower right "J. LAWRENCE 42"

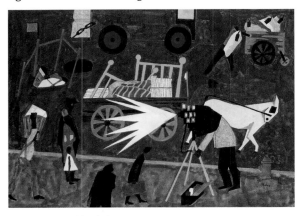

Collection: Ms. Abby Shahn.

Provenance: [The Downtown Gallery, New York]; Ben Shahn, New York.

Exhibitions: The Museum of Modern Art, New York, *Christmas Sale of Paintings under $75,* December 8, 1943–January 9, 1944; Salem College, Winston-Salem, N.C., January 1946; Black Mountain College, Asheville, N.C., July 2–August 28, 1946 (as *Photographer*); Coliseum, New York, *Art: USA: 59, A Force, A Language, A Frontier,* April 3–19, 1959, no. 125a; The Art Museum, Princeton University, N.J., *Fragments of American Life, An Exhibition of Paintings: Romare Bearden, Joseph Delaney, Rex Gorleigh, Lois Mailou Jones, Jacob Lawrence, Hughie Lee-Smith, Hale Woodruff,* January 25–March 28, 1976; Katonah 1992; Midtown Payson 1995a.

Remarks: A.k.a. *Street Photographer*.

P42-13
Pool Parlor
1942
gouache and watercolor on paper
31 × 22¾ in. (78.7 × 57.8 cm)
signed and dated lower right "J. Lawrence 42"; inscribed bottom left in margin "POOL PARLOR"

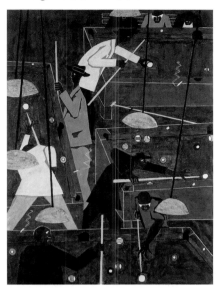

Collection: The Metropolitan Museum of Art. Arthur Hoppock Hearn Fund, 1942, 42.167.

Provenance: [The Downtown Gallery, New York].

Exhibitions: The Metropolitan Museum of Art, New York, *Artists for Victory: An Exhibition of Contemporary Art*, December 7, 1942–February 22, 1943; Albany Institute of History and Art, *The Negro Artist Comes of Age*, January 3–February 11, 1945, no. 42; The Institute for Modern Art, Boston, *Four Modern American Painters: Peter Blume, Stuart Davis, Marsden Hartley, Jacob Lawrence*, March 2–April 1, 1945, no. 43; The Downtown Gallery, New York, *All-Loan Exhibition of Outstanding Examples of American Progressive Art*, October 9–27, 1945, no. 9; Phillips Memorial Gallery, Washington, D.C., *Three Negro Artists: Horace Pippin, Jacob Lawrence, Richmond Barthé*, December 14, 1946–January 6, 1947, no. 33; The Museum of Modern Art, New York, *The City*, 1951–4; Whitney 1974–5, no. 82; Midtown Payson 1995a.

References: *Artists for Victory: An Exhibition of Contemporary American Art*, exh. cat. (New York: Metropolitan Museum of Art, 1942), p. 17; "Artists for Victory Score Victory in Metropolitan Exhibition," *Art Digest* 17, 6 (December 15, 1942), p. 6; James A. Porter, *Modern Negro Art* (New York: The Dryden Press, 1943), p. 265, ill. (as *Pool Room*); "Survey of the Month: Two Negro Artists Win Awards in Artists for Victory Exhibition," *Opportunity* 21, 1 (January 1943), p. 18, ill.; Alfred M. Frankfurter, "The Artists for Victory Exhibition: The Paintings," *ARTnews* 41, 16 (January 1–14, 1943), p. 8, ill.; Alain Locke, *The Negro Artist Comes of Age*, exh. cat. (New York: Albany Institute, 1945); Ben Wolf, "Edith Halpert, Art Crusader, Marks Two Decades of Success," *Art Digest* 20, 2 (October 15, 1945); Elizabeth McCausland, "Jacob Lawrence," *Magazine of Art* 38, 7 (November 1945), p. 253, ill.; *Three Negro Artists: Horace Pippin, Jacob Lawrence, Richmond Barthé*, exh. cat. (Washington, D.C.: Phillips Memorial Gallery and Catholic Inter-Racial Council, 1946), n.p., ill.; Fernando Puma, *Modern Art Looks Ahead* (New York: Beechhurst, 1947); "Jacob Lawrence," *Magazine of Art: Flint Institute Edition* (May 1947), p. 3, ill.; Edmund Burke Feldman, *Art as Image and Idea* (Englewood Cliffs, N.J.: Prentice-Hall, 1967), p. 49; Edmund Burke Feldman, *Becoming Human through Art* (Englewood Cliffs, N.J.: Prentice-Hall, 1970), p. 259; Elsa Honig Fine, *The Afro-American Artist: A Search for Identity* (New York: Hacker Art Books, 1973), p. 96; *Selected Work by Black Artists from the Collection of The Metropolitan Museum of Art*, exh. cat. (New York: Bedford-Stuyvesant Restoration Corporation, 1976); Edmund Burke Feldman, *Varieties of Visual Experience* (New York: Harry N. Abrams, 1980), pp. 51, 63, ill.; Lowery S. Sims, *The Artist Celebrates New York: Selected Paintings from The Metropolitan Museum of Art*, exh. brch. (New York: Metropolitan Museum of Art, 1985); Wheat 1986, p. 84, pl. 25; James A. Porter, *Modern Negro Art* (Washington, D.C.: Howard University, 1992), p. 267, ill.

Remarks: This painting won a $500 purchase prize (sixth prize) in the Metropolitan Museum of Art's *Artists for Victory* exhibition in 1942–3.

P42-14
Play Street
1942
gouache on paper
30⅞ × 22⅜ in. (78.4 × 56.8 cm)
signed and dated lower left "J. Lawrence 42" [vertical]; inscribed bottom left in margin "PLAY STREET"

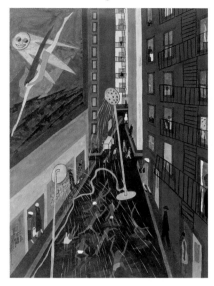

Collection: Dr. and Mrs. Fredric Newman.

Provenance: [The Barnett Aden Gallery, Washington, D.C.]; Dr. Richard Long, Atlanta; [Terry Dintenfass Inc., New York].

Exhibitions: The Art Institute of Chicago, *The Twenty-Second International Exhibition of Watercolors*, May 13–August 22, 1943, no. 247; Fine Arts Gallery of San Diego, *Paintings by Matisse, Tom Lewis, and Chester Hayes; Watercolor Paintings by Jacob Lawrence and Willing Howard*, April 1946; Wichita Art Museum, Kans., *American Art and the Great Depression: Two Sides of the Coin*, October 27–December 1, 1985; Katonah 1992.

References: Howard E. Wooden, *American Art and the Great Depression: Two Sides of the Coin*, exh. cat. (Wichita, Kans.: Wichita Art Museum, 1985), p. 108, fig. 76.

P42-15
Tombstones
1942
gouache on paper
28¾ × 22½ in. (73 × 57.2 cm)
signed and dated upper left "J. Lawrence 42"

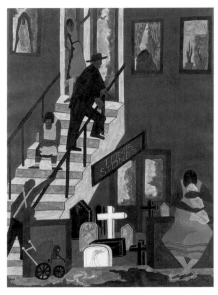

Collection: Whitney Museum of American Art, New York. Purchase.

Provenance: [The Downtown Gallery, New York].

Exhibitions: The Downtown Gallery, New York, *Opening Exhibition: New Paintings and Sculpture*, September 22–October 10, 1942, no. 7; University Art Galleries, University of Nebraska, Lincoln, *Fifty-Third Annual Exhibition of Contemporary Art*, March 7–April 4, 1943, no. 39; Whitney Museum of American Art, New York, *1943–44 Annual Exhibition of Contemporary American Art: Sculpture, Paintings, Watercolors, and Drawings*, November 23, 1943–January 4, 1944, no. 158; Phillips Memorial Gallery, Washington, D.C., *Three Negro Artists: Horace Pippin, Jacob Lawrence, Richmond Barthé*, December 14, 1946–January 6, 1947, no. 31; Whitney Museum of American Art, New York, *Juliana Force and American Art: A Memorial*, September 24–October 30, 1949, no. 138; São Paulo, *I Bienal do Museum de Arte Moderna de São Paulo*, October–December 1951, no. 35; Whitney Museum of American Art, New York, *Sixty Years of American Art*, September 16–October 20, 1963; Whitney Museum of American Art, New York, *Art of the United States: 1670–1966*, September 28–November 27, 1966, no. 170; La Jolla Museum of Art, Calif., *Dimensions of Black*, February 14–March 29, 1970, no. 191; Whitney 1974–5, no. 83; Los Angeles County Museum of Art, *Two Centuries of Black American Art*, September 30–November 21, 1976, no. 161; The Emerson Gallery, Hamilton College, Clinton, N.Y., *The Re-gentrified Jungle*, January–February 1983; Seattle 1986–7, no. 55; Katonah 1992; Whitney Museum of American Art at Champion Plaza, Stamford, Conn., *Spheres of Influence: Artists and Their Students in the Permanent Collection of the Whitney Museum of American Art*, October 1–November 20, 1993; Whitney Museum of American Art, New York, *An American Story*, March 20–October 6, 1996.

References: "Group Shows All Worth While," *New York World-Telegram*, September 26, 1942; Alain Locke, ed., "How We Live in South and North: Paintings by Jacob Lawrence," *Survey Graphic* 31, 11 (November 1942), p. 479, ill.; Rosamund Frost, "Encore by Popular Demand: The Whitney," *ARTnews* 42, 14 (December 1–14, 1943), p. 22, ill.; "The Whitney Buys," *Art Digest* 18, 13 (April 1, 1944), p. 14; "Whitney Buys for Solid Worth," *ARTnews* 43, 5 (April 15–30, 1944), p. 22; Bernard S. Myers, *Encyclopedia of Painting* (New York: Crown Publishers, 1955), p. 297, ill.; John I. H. Baur, ed., *New Art in America: Fifty Painters of the Twentieth Century* (Greenwich, Conn.: New York Graphic Society, 1957), p. 272, ill.; Cedric Dover, *American Negro Art* (Greenwich, Conn.: New York Graphic Society, 1960), p. 163, pl. 83.; William H. Pierson, Jr., and Martha Davidson, eds., *Arts of the United States: A Pictorial Survey* (New York: McGraw-Hill, 1960), p. 349, ill.; Albert Ten Eyck Gardner, *History of Water Color Painting in America* (New York: Reinhold Publishing, 1966), p. 156, ill.; Marion E. Brown, "Negro in the Fine Arts," in *The American Negro Reference Book*, edited by John Preston Davis (Englewood Cliffs, N.J.: Prentice-Hall, 1966), p. 744, ill.; Harry A. Ploski and Roscoe C. Brown, *The Negro Almanac* (New York: Bellwether, 1967), p. 628, ill.; Jehanne Teihet, ed., *Dimensions of Black*, exh. cat. (La Jolla, Calif.: La Jolla Museum of Art, 1970), p. 103, fig. 191; Harry A. Ploski and Ernest Kaiser,

Afro USA (New York: Bellwether, 1971), p. 717, ill.; Harry A. Ploski and Ernest Kaiser, *The Negro Almanac*, rev. ed. (New York: Bellwether, 1971), p. 717, ill.; Harry A. Ploski, Otto J. Lindenmayer, and Ernest Kaiser, *Reference Library of Black America*, Vol. 4 (New York: Bellwether, 1971), p. 87, ill.; John W. McCoubrey, *American Painting 1900–1970* (New York: Time-Life Books, 1971), ill.; Elsa Honig Fine, *The Afro-American Artist: A Search for Identity* (New York: Hacker Art Books, 1973), p. 146, pl. 194; Brown 1974, p. 17, ill.; *Catalogue of the Collection* (New York: Whitney Museum of American Art, 1974), p. 99, ill.; Pat Mainardi, "Review of Exhibitions: Jacob Lawrence at the Whitney," *Art in America* 62, 4 (July–August 1974), p. 84, ill.; Emma Lila Fundaburk and Thomas G. Davenport, *Art in Public Places in the United States* (Bowling Green, Ohio: Bowling Green University Popular Press, 1975), n.p., pl. 170; Richard Watkins, "Jacob Lawrence: The Famous Artist Who Chronicles Major Black Events in American History Says He Is Motivated and Inspired by the Black Experience," *Black Enterprise* 6, 5 (December 1975), p. 66; David C. Driskell, *Two Centuries of Black American Art*, exh. cat. (Los Angeles: Los Angeles County Museum of Art, 1976), p. 109, ill.; Harry A. Ploski and Warren Marr II, *The Negro Almanac: A Reference Work on the Afro American*, 3rd ed. (New York: Bellwether, 1976), p. 773, ill.; David C. Driskell, "Art by Blacks: Its Vital Role in U.S. Culture," *Smithsonian* 7, 7 (October 1976), p. 93, ill.; Leonard Simon, "The American Presence of the Black Artist," *American Art Review* 3 (November–December 1976), p. 116, ill.; "Art Across North America: Outstanding Exhibitions," *Apollo* 104 (December 1976), p. 511, ill.; Donelson Hoopes, Jr., *American Watercolor Painting* (New York: Watson-Guptill, 1977), p. 188, ill.; Mary Rickie, "The Art of Black America," *Eastern Review* 2 (January 1977), p. 22, ill.; Lewis and Sullivan 1982, p. 15, ill.; Wheat 1986, p. 83, pl. 24.; Catherine Fox, "Jacob Lawrence, Artist Lifted Beauty from Jaws of Waiting American Nightmare," *The Atlanta Journal and Constitution*, December 14, 1986, p. J1, ill.; Jane Addams Allen, "Famed Artist Paints Niche in History," *Washington Times*, April 2, 1987, p. C1, ill.; Robert Wernick, "Jacob Lawrence: Art As Seen through a People's History," *Smithsonian* 18, 3 (June 1987), p. 56, ill.; Harry A. Ploski and James Williams, *The Negro Almanac: A Reference Work on African Americans* (New York: Gale Research, 1989), p. 1051, ill.; Powell 1992, n.p., pl. 5; C. Roznoy, *Spheres of Influence: Artists and Their Students in the Permanent Collection of the Whitney Museum of American Art*, exh. cat. (New York: Whitney Museum of American Art, 1993), ill.

P42-16
Bar-b-que
1942
gouache on paper
30¾ × 22⅜ in. (78.1 × 56.8 cm)
signed and dated lower right "J. LAWRENCE 42"

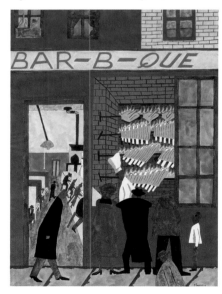

Collection: Owens-Dewey Fine Art, Santa Fe, New Mexico.

Provenance: [The Downtown Gallery, New York]; Oscar Serlin; Private collection; [Sotheby's, New York, May 27, 1999, lot 145].

Exhibitions: The Downtown Gallery, New York, *Spring Exhibition*, March 31–April 24, 1943.

P43-02

Most of the People Are Very Poor Rent Is High Food Is High
1943
gouache on paper
22¾ × 15¼ in. (57.8 × 38.7 cm)
signed and dated upper left "J. Lawrence 43"; inscribed bottom left
in margin "Low Incomes"

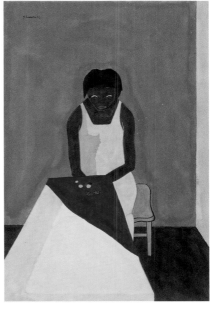

Collection: Marjorie Belluschi, Portland, Oregon.

Provenance: [The Downtown Gallery, New York]; Pietro Belluschi, Portland, Ore.

Exhibitions: Downtown 1943, no. 2; The Institute for Modern Art, Boston, *Four Modern American Painters: Peter Blume, Stuart Davis, Marsden Hartley, Jacob Lawrence*, March 2–April 1, 1945, no. 45; AFA 1960–2, no. 12; Whitney 1974–5, no. 86; Santa Monica 1982; Northwest Art 1997.

References: "Art: Harlem in Color," *Newsweek* 21, 23 (June 7, 1943), p. 100; Meyer Symason, "Canvas and Film: The Young Negro Artist Jacob Lawrence Depicts Harlem in a Series of Paintings," *New Masses* 47, 10 (June 8, 1943), p. 29, ill.; Patrick Pacheco, "Artist in Harlem," *Vogue* 102 (September 15, 1943), p. 94, ill.; Thomas B. Hess, "Veterans: Then and Now," *ARTnews* 45, 3 (May 1946), p. 45, ill. (as *Harlem, 1942*); Oliver W. Larkin, *Art and Life in America* (New York: Rinehart & Company, 1950), p. 437, ill.; Saarinen 1960, p. 25, ill.; Margaret Rigg, "Jacob Lawrence: Painter," *Motive* (April 1962), p. 17, ill.; Lewis and Hewitt 1982, n.p., ill.; Lewis and Sullivan 1982, p. 19, ill. (as *Coins*); Wheat 1986, p. 85, ill.; Kristin Bumiller, *The Civil Rights Society: The Social Construction of Victims* (Baltimore: The John Hopkins University Press, 1988), cvr., ill.

Remarks: A.k.a. *Low Incomes*.

P43-03

They Live in Old and Dirty Tenement Houses
1943
gouache on paper
22½ × 15⅜ in. (57.2 × 39 cm)
signed and dated upper right "J. Lawrence 43"; inscribed bottom left
in margin "Bad Housing"

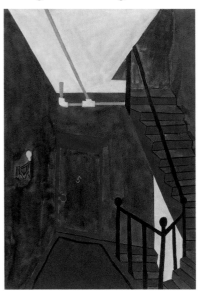

Collection: Portland Art Museum, Portland, Oregon. Helen Thurston Ayer Fund.

Provenance: [The Downtown Gallery, New York].

Exhibitions: Downtown 1943; Lewis and Clark College, Portland, Ore., February 9–16, 1969; Lewis and Clark College, Portland, Ore., March 26–April 8, 1979; Northwest Art 1997.

References: "Five Paintings Purchased," *Portland Museum Bulletin* 5, 3 (November 1943), p. 3.

Remarks: A.k.a. *Bad Housing*.

P43-04
They Live in Fire Traps
1943
gouache on paper
22½ × 15⅜ in. (57.2 × 39.1 cm)
signed and dated lower right "J Lawrence 43"; inscribed bottom left in margin "After the Fire" [partially erased]; inscribed bottom right in margin "M"

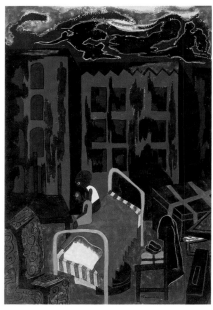

Collection: Worcester Art Museum, Worcester, Massachusetts. Museum purchase.

Provenance: [The Downtown Gallery, New York].

Exhibitions: Downtown 1943, no. 4.

References: "Attractions in the Galleries," *New York Sun*, May 14, 1943, p. 26; Patrick Pacheco, "Artist in Harlem," *Vogue* 102 (September 15, 1943), p. 94, ill. (as *The people live in firetraps*); Susan E. Strickler, ed., *American Traditions in Watercolor: The Worcester Art Museum Collection* (New York: Abbeville Press, 1987), pp. 40, 210, ill.; Peter Conn, *Literature in America: An Illustrated History* (New York and London: Cambridge University Press, 1989), ill.

Remarks: A.k.a. *After the Fire.*

P43-05
Often Three Families Share One Toilet
1943
gouache on paper
image: 21¼ × 14¼ in. (54 × 36.2 cm)
signed and dated lower right "J Lawrence 43"

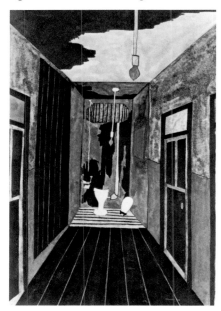

Collection: Current location unknown.

Provenance: [The Downtown Gallery, New York]; Mrs. J. P. Warburg, Greenwich, Conn.; ?; Stephen V. Baldwin; [June Kelly Gallery, New York].

Exhibitions: Downtown 1943, no. 5; Phillips Memorial Gallery, Washington, D.C., *Three Negro Artists: Horace Pippin, Jacob Lawrence, Richmond Barthé,* December 14, 1946– January 6, 1947, no. 26; Whitney 1974–5, no. 87; The Center Gallery, Bucknell University, Lewisburg, Pa., *Since the Harlem Renaissance: Fifty Years of Afro-American Art,* April 13– June 6, 1984.

References: Margaret Rigg, "Jacob Lawrence: Painter," *Motive* (April 1962), p. 23, ill.; *Since the Harlem Renaissance: Fifty Years of Afro-American Art,* exh. cat. (Lewisburg, Pa.: The Center Gallery of Bucknell University, 1984), p. 82, no. 47, ill.

Remarks: A.k.a. *Three Family Toilet.* Offered for sale at Christie Manson and Woods on December 6, 1991 (lot 211), but unsold.

P43-06
This Is a Family Living in Harlem
1943
gouache and ink on paper
22⅝ × 15⅝ in. (57.5 × 39.7 cm)
signed and dated lower right "J. Lawrence 43"; inscribed bottom left in margin "A Family"; inscribed top right in margin "47" [vertical]

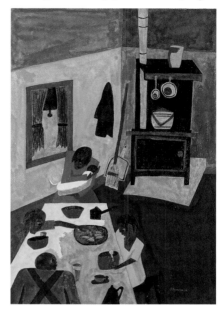

Collection: The Museum of Modern Art, New York. Gift of Mrs. Maurice Blin, 1971.

Provenance: [The Downtown Gallery, New York]; Mrs. Maurice Blin, New York.

Exhibitions: Downtown 1943, no. 6; The Museum of Modern Art, New York, *Drawn in America, 1898–1945*, November 1, 1990–March 5, 1991.

Remarks: A.k.a. *A Family.*

P43-07
The Mother and Father Go to Work
1943
gouache on paper
image: 21½ × 14½ in. (54.6 × 36.8 cm)
signed and dated lower right "J. Lawrence 43"

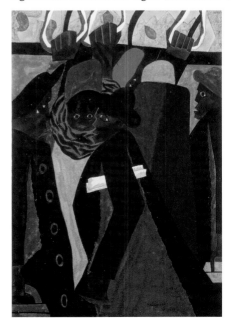

Collection: Albright-Knox Art Gallery, Buffalo, New York. Room of Contemporary Art Fund, 1944.

Provenance: [The Downtown Gallery, New York].

Exhibitions: Downtown 1943, no. 7; Museum of Art, Rhode Island School of Design, Providence, *A Selection of American Paintings from the Present Day,* January 1944; Kitchener-Waterloo Art Gallery, Kitchener, Ontario, *Contemporary American Painters: From the Albright-Knox Gallery, Buffalo, New York,* February 19–March 28, 1965, no. 10; African Cultural Center, Inc., Buffalo, December 19, 1971–January 19, 1972; Albright-Knox Art Gallery, Buffalo, *American Art in Upstate New York: Drawings, Watercolors and Small Sculpture from Public Collections in Albany, Buffalo, Ithaca, Rochester, Syracuse and Utica,* July 12–August 25, 1974; Albright-Knox Art Gallery, Buffalo, *The American Scene—Selections from the Permanent Collection,* January 17–March 2, 1986; Albright-Knox Art Gallery, Buffalo, *Intimate Gestures, Realized Visions: Masterworks on Paper from the Collection of the Albright-Knox Art Gallery,* December 11, 1987–January 31, 1988; Albright-Knox Art Gallery, Buffalo, *A View of the Ordinary,* January 31–April 2, 1989; Albright-Knox Art Gallery, Buffalo, *African-American Art from the Permanent Collection,* March 15–April 28, 1991.

References: Gallery Notes: Albright Art Gallery 10, 2 (June 1943–December 1944), ill.

Remarks: A.k.a. *Going to Work.*

P43-08
The Children Go to School
1943
gouache on paper
14¼ × 21¼ in. (36.2 × 54 cm)
signed and dated upper left "J. Lawrence 43"

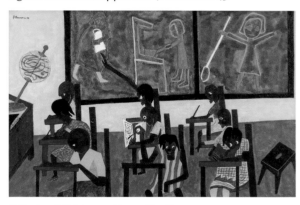

Collection: C. H. Tinsman, Kansas City, Kansas.

Provenance: [The Downtown Gallery, New York]; Davidson Taylor, New York; [Terry Dintenfass Inc., New York]; Mr. and Mrs. Arthur Steel, New York; [Terry Dintenfass Inc., New York].

Exhibitions: Downtown 1943, no. 8; Whitney Museum of American Art, New York, *1943–44 Annual Exhibition of Contemporary American Art: Sculpture, Paintings, Watercolors, and Drawings,* November 23, 1943–January 4, 1944; Phillips Memorial Gallery, Washington, D.C., *Three Negro Artists: Horace Pippin, Jacob Lawrence, Richmond Barthé,* December 14, 1946–January 6, 1947, no. 30; Whitney 1974–5, no. 88; Seattle 1986–7, no. 57.

References: Virginius Dabney, "Negro Migrations," *New York Times Review of Books,* June 10, 1945, p. 4, ill.; Margaret Rigg, "Jacob Lawrence: Painter," *Motive* (April 1962), p. 18, ill.; Wheat 1986, p. 211, ill.

Remarks: A.k.a. *A School Room.*

P43-09

If the Family Can Afford It, Their Baby Is Sent to One of the Few Day Nurseries Available

1943

gouache on paper

sight: 13½ × 21½ in. (34.3 × 54.6 cm)

signed and dated upper left "J Lawrence 43"

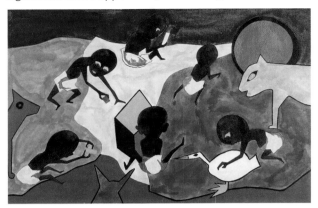

Collection: Private collection, New York.

Provenance: [The Downtown Gallery, New York]; Mrs. Eugene Davidson, New York; [The Modern Poetry Association Dinner and Literary Auction, The Arts Club Chicago, November 18, 1978, lot 31].

Exhibitions: Downtown 1943, no. 9.

Remarks: A.k.a. *A Day Nursery.*

P43-10

In the Evening the Mother and Father Come Home from Work

1943

gouache on paper

15⅜ × 22⅞ in. (39.1 × 58.1 cm)

signed lower center/right "J. Lawrence"

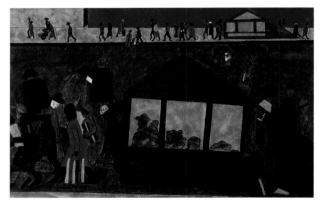

Collection: Virginia Museum of Fine Arts, Richmond. Gift of the Alexander Shilling Fund.

Provenance: [The Downtown Gallery, New York].

Exhibitions: Downtown 1943, no. 10; Museum of Art, Rhode Island School of Design, Providence, *A Selection of American Paintings from the Present Day*, January 1944; Mint Museum of Art, Charlotte, N.C., *American Painting and Sculpture 1900–1945*, November 12–December 23, 1978; Chrysler 1979a.

References: *American Painting and Sculpture 1900–1945*, exh. cat. (Raleigh, N.C.: Mint Museum of Art, 1978), p. 29, ill.; *The Chrysler Museum Bulletin* 8, 9 (October 1979), ill.

Remarks: A.k.a. *Subway—Home from Work.*

P43-11

There Are Many Churches in Harlem The People Are Very Religious

1943

watercolor and gouache on paper

15½ × 22½ in. (39.4 × 57.2 cm)

signed and dated upper left "J. Lawrence 43"; inscribed top center in margin "CHURCH. OF. GOD"; inscribed bottom left in margin "CHURCH"

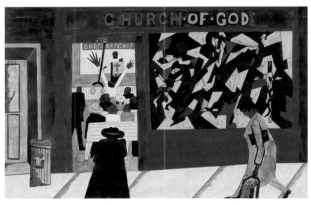

Collection: Amon Carter Museum, Fort Worth, Texas.

Provenance: [The Downtown Gallery, New York]; Dr. Harry Austin Blutman, New York; ?; Robert A. M. Peterson, New Lebanon, N.J.; [Terry Dintenfass Inc., New York].

Exhibitions: Downtown 1943, no. 13; Terry Dintenfass Inc., New York, *A Point of View*, October 2–29, 1987; Amon Carter Museum, Fort Worth, *Revealed Treasures: Watercolors and Drawings*, July 30–October 16, 1994.

References: "Art: Harlem in Color," *Newsweek* 21, 23 (June 7, 1943), p. 100; Donald Barr, "Guilt Was Everywhere," *New York Times Book Review*, May 17, 1953, p. 5, ill. (as *Storefront Church in Harlem*).

Remarks: A.k.a. *Church of God.*

P43-12

There Is an Average of Four Bars to Every Block

1943

gouache on paper

15⁹⁄₁₆ × 22½ in. (39.5 × 57.2 cm)

signed and dated lower right "J. Lawrence 43"; signed and dated bottom right in margin "Jacob Lawrence 1943"

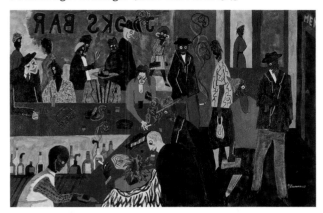

Collection: Museum of Art, Rhode Island School of Design, Providence. Mary B. Jackson Fund, 43.565.

Provenance: [The Downtown Gallery, New York].

Exhibitions: Downtown 1943, no. 14; United Modern Art in Boston, *Art Panorama*, January 22–February 25, 1945; Art Department, Providence Public Library, R.I., *The Negro in Literature and Art*, April 6–May 1, 1945; The Museum of Art, Rhode Island School of Design, Providence, *Four Generations of African-American Art from the Permanent Collection*, November 17, 1994–February 19, 1995.

References: "Art: Harlem in Color," *Newsweek* 21, 23 (June 7, 1943), p. 100.

Remarks: A.k.a. *Bar*.

P43-13

You Can Buy Bootleg Whiskey for Twenty-Five Cents a Quart

1943

gouache on paper

15¼ x 22⅝ in. (38.7 x 57.5 cm)

signed and dated upper left "J. Lawrence 43"

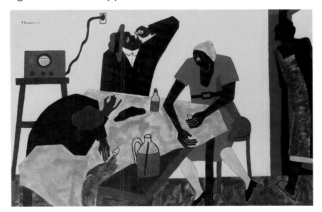

Collection: Portland Art Museum, Portland, Oregon. Helen Thurston Ayer Fund.

Provenance: [The Downtown Gallery, New York].

Exhibitions: Downtown 1943, no. 15; Lewis and Clark College, Portland, Ore., February 9–16, 1969; Lewis and Clark College, Portland, Ore., March 26–April 8, 1979; Seattle 1986–7, no. 58; Whitney Museum of American Art, New York, *New York, New York: City of Ambition*, July 3–October 27, 1996.

References: "Art: Harlem in Color," *Newsweek* 21, 23 (June 7, 1943), p. 100, ill.; "Five Paintings Purchased," *Portland Museum Bulletin* 5, 3 (November 1943), p. 3; Ralph M. Pearson, *The Modern Renaissance in American Art: Presenting the Work and Philosophy of Fifty-Four Distinguished Artists* (New York: Harper & Brothers, 1954), p. 164, ill.; Margaret Rigg, "Jacob Lawrence: Painter," *Motive* (April 1962), p. 19, ill.; Wheat 1986, p. 211, ill.; Avis Berman, "Commitment on Canvas," *Modern Maturity* (August–September 1986), p. 71, ill. (as *Bootleg Whiskey*).

P43-14

The Rooftops Seem to Spread for Miles

1943

gouache on paper

14 × 21¾ in. (35.6 × 55.2 cm)

signed and dated lower center/right "J. Lawrence 43"

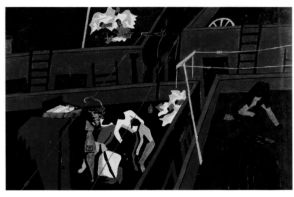

Collection: The Carl Van Vechten Gallery of Fine Arts, Fisk University, Nashville, Tennessee.

Provenance: [The Downtown Gallery, New York]; Peggy Illunstuley; ?; Dr. Hugo Munsterburg.

Exhibitions: Downtown 1943, no. 16; Museum of Art, Rhode Island School of Design, Providence, *A Selection of American Paintings from the Present Day*, January 1944; Department of Fine Art, Fisk University, Nashville, *Amistad II: Afro-American Art*, 1975, no. 50; American Federation of Arts, New York, *In the Spirit of Resistance: African-American Modernists and the Mexican Muralist School*, 1996–8.

References: James A. Porter, *Modern Negro Art* (Washington, D.C.: Howard University, 1992), p. 204, ill.

Remarks: A.k.a. *Roof Tops*.

P43-15
At Times It Is Hard to Get a Table in a Pool Room
1943
gouache on paper
21½ × 14½ in. (54.6 × 36.8 cm)
signed and dated lower right "J. Lawrence 43"

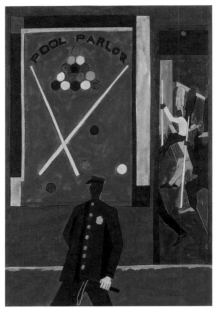

Collection: Private collection, New York.

Provenance: [The Downtown Gallery, New York]; Dr. and Mrs. Michael Watter, Philadelphia; [The Alan Gallery, New York].

Exhibitions: Downtown 1943, no. 17; Katonah 1992.

References: Patrick Pacheco, "Artist in Harlem," *Vogue* 102 (September 15, 1943), p. 94, ill.

Remarks: A.k.a. *Pool Parlor*; edges have been trimmed.

P43-16
Many Whites Come to Harlem to Watch the Negroes Dance
1943
gouache on paper
14 × 21 in. (35.6 × 53.3 cm)
signed and dated lower right "J. Lawrence 43"

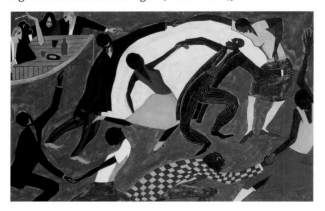

Collection: Private collection.

Provenance: [The Downtown Gallery, New York]; Edith G. Halpert, New York; Nathalie Baum, New York.

Exhibitions: Downtown 1943, no. 18; California Palace of the Legion of Honor, San Francisco, *Contemporary American Painting*, May 17–June 17, 1945; Phillips Memorial Gallery, Washington, D.C., *Three Negro Artists: Horace Pippin, Jacob Lawrence, Richmond Barthé*, December 14, 1946–January 6, 1947, no. 25; UCLA Art Galleries, Dickson Art Center, Los Angeles, *The Negro in American Art*, September 11–October 16, 1966.

References: James A. Porter, *Modern Negro Art* (New York: The Dryden Press, 1943), p. 266, ill.; Ralph M. Pearson, "A Modernist Explains Modern Art," *New York Times Magazine*, September 1, 1946, p. 21, ill.; Elsa Honig Fine, *The Afro-American Artist: A Search for Identity* (New York: Hacker Art Books, 1973), p. 148, pl. 199; James A. Porter, *Modern Negro Art* (Washington, D.C.: Howard University, 1992), p. 268, ill.

Remarks: A.k.a. *Dancing at the Savoy.*

P43-17
And Harlem Society Looks On
1943
gouache on paper
16 × 22½ in. (40.6 × 57.2 cm)
signed and dated upper left "J. Lawrence 43"; inscribed bottom left in margin "HARLEM SOCIETY" and bottom right in margin "TR"

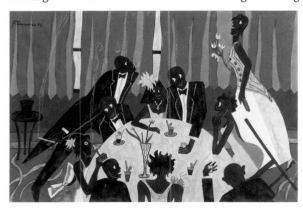

Collection: Portland Art Museum, Portland, Oregon. Helen Thurston Ayer Fund.

Provenance: [The Downtown Gallery, New York].

Exhibitions: Downtown 1943, no. 19; Lewis and Clark College, Portland, Ore., February 9–16, 1969; Henry Art Gallery, University of Washington, Seattle, *Art of the Thirties: The Pacific Northwest*, April 1–30, 1972, no. 19; Lewis and Clark College, Portland, Ore., March 26–April 8, 1979; Seattle 1986–7, no. 59; Whitney Museum of American Art, New York, *New York, New York: City of Ambition*, July 3–October 27, 1996; Henry Art Gallery 1998.

References: "Five Paintings Purchased," *Portland Museum Bulletin* 5, 3 (November 1943), p. 3; Martha Kingsbury, *Art of the Thirties: The Pacific Northwest*, exh. cat. (Seattle: University of Washington Press, 1972), p. 46, pl. 20 (as *Harlem Society*); Wheat 1986, p. 212, ill.

P43-18

In the Evening Evangelists Preach and Sing on Street Corners

1943

gouache on paper

25 × 17 in. (63.5 × 43.2 cm)

signed and dated lower right "J. Lawrence 43"

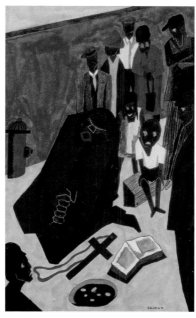

Collection: Neuberger Museum of Art, Purchase College, State University of New York. Gift of Roy R. Neuberger.

Provenance: [The Downtown Gallery, New York]; Mr. and Mrs. Roy Neuberger, New York.

Exhibitions: Downtown 1943, no. 20; Samuel M. Kootz Gallery, New York, *Modern American Paintings from the Collection of Mr. and Mrs. Roy R. Neuberger*, April 15–May 4, 1946; Walker Art Center, Minneapolis, *Contemporary American Painting and Sculpture: Collection of Mr. and Mrs. Roy R. Neuberger*, May 24–August 10, 1952, no. 63; Whitney Museum of American Art, New York, *Roy and Marie Neuberger Collection: Modern American Painting and Sculpture*, November 17–December 19, 1954, no. 59; American Federation of Arts, New York, *Executive View, Art in the Office*, 1956–8, no. 21; Fort Wayne Museum of Art, Ind., *Twenty-Four Paintings by Contemporary American Artists from the Collection of Mr. and Mrs. Roy R. Neuberger of New York City*, September 13–October 20, 1959, no. 14; Museum of Art, University of Michigan, Ann Arbor, *Contemporary American Painting: Selections from the Collection of Mr. and Mrs. Roy R. Neuberger*, October 21–November 18, 1962, no. 25; Katonah 1992; Mount Holyoke College Art Museum, South Hadley, Mass., *Collective Pursuits: Mount Holyoke Investigates Modernism*, April 3–May 30, 1993; American Federation of Arts, New York, *In the Spirit of Resistance: African-American Modernists and the Mexican Muralist School*, 1996–8.

References: Cedric Dover, *American Negro Art* (Greenwich, Conn.: New York Graphic Society, 1960), p. 129, pl. 55.; *Contemporary American Painting: Selections from the Neuberger Collection*, exh. cat. (Ann Arbor, Mich.: University of Michigan, 1962); Daniel Robbins, ed., *The Neuberger Collection: An American Collection*, exh. cat. (Providence, R.I.: Museum of Art, Rhode Island School of Design, 1968), pp. 308, 310, ill.

Remarks: A.k.a. *Evangelist.*

P43-19

Peddlers Reduce Their Prices in the Evening to Get Rid of Their Perishables

1943

gouache on paper

15⅛ × 22⅝ in. (38.4 × 57.5 cm)

signed lower right "J. Lawrence"; inscribed bottom left in margin "FRUIT and Vegetable Peddlers"

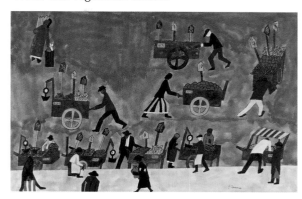

Collection: Hampton University Museum, Hampton, Virginia.

Provenance: [The Downtown Gallery, New York]; Countee and Ida Cullee, New York.

Exhibitions: Downtown 1943, no. 22.

Remarks: A.k.a. *Peddlers* and *Fruit and Vegetable Peddlers.*

P43-20

Harlem Hospital's Free Clinic Is Crowded with Patients Every Morning and Evening

1943

gouache on paper

21³⁄₁₆ x 29⅛ in. (53.8 × 74 cm)

signed and dated lower center "J. Lawrence 43"

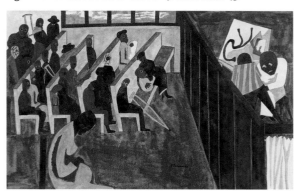

Collection: Portland Art Museum, Portland, Oregon. Helen Thurston Ayer Fund.

Provenance: [The Downtown Gallery, New York].

Exhibitions: Downtown 1943, no. 23; Lewis and Clark College, Portland, Ore., February 9–16, 1969; Lewis and Clark College, Portland, Ore., March 26–April 8, 1979; Seattle 1986–7, no. 60; Whitney Museum of American Art, New York, *New York, New York: City of Ambition*, July 3–October 27, 1996; Henry Art Gallery 1998.

References: "Five Paintings Purchased," *Portland Museum Bulletin* 5, 3 (November 1943), p. 3; Wheat 1986, p. 212, ill.

Remarks: A.k.a. *Free Clinic.*

P43-21

The Undertakers Do a Good Business

1943

gouache on paper

22 x 13½ in. (55.9 × 34.3 cm)

signed and dated lower right "J. Lawrence 43"

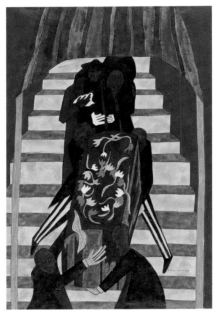

Collection: Portland Art Museum, Portland, Oregon. Helen Thurston Ayer Fund.

Provenance: [The Downtown Gallery, New York].

Exhibitions: Downtown 1943, no. 24; Northwest Art 1997.

References: "Attractions in the Galleries," *New York Sun*, May 14, 1943, p. 26; "Five Paintings Purchased," *Portland Museum Bulletin* 5, 3 (November 1943), p. 3.

Remarks: A.k.a. *A Funeral*.

P43-22

When It Is Warm the Parks Are Filled with People

1943

gouache on paper

22½ × 15½ in. (57.2 × 39.4 cm)

signed and dated upper left "J. Lawrence 43"

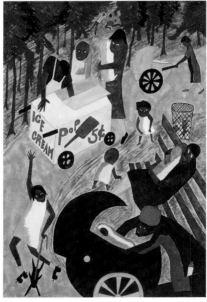

Collection: Hirshhorn Museum and Sculpture Garden, Smithsonian Institution. Gift of Joseph H. Hirshhorn, 1966.

Provenance: [The Downtown Gallery, New York]; John Rawling, New York; [The Alan Gallery, New York]; Joseph H. Hirshhorn, New York.

Exhibitions: Downtown 1943, no. 25; Hirshhorn Museum and Sculpture Garden, Smithsonian Institution, Washington, D.C., *Kin and Communities: Selected Works from the Hirshhorn Museum Collection*, June 14–August 23, 1977; Chrysler 1979a; Smithsonian Institution Traveling Exhibition Service, Washington, D.C., *Genre Scenes*, 1985–7; Henry Art Gallery 1998.

Remarks: A.k.a. *An Afternoon in the Park* and *Park Scene*.

P43-23

Mothers and Fathers Work Hard to Educate Their Children

1943

gouache on paper

15⅜ × 22½ in. (39.1 × 57.2 cm)

signed and dated lower center "J. Lawrence 43"

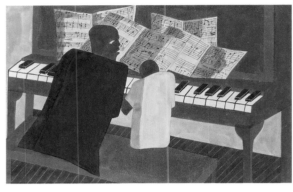

Collection: New Jersey State Museum, Trenton. Gift of the Association for the Arts of the New Jersey State Museum, FA1973.19.

Provenance: [The Downtown Gallery, New York]; Edith G. Halpert, New York; [Parke Bernet Galleries, New York, March 14–5, 1973, lot 174].

Exhibitions: Downtown 1943, no. 27; Museum of Art, Rhode Island School of Design, Providence, *A Selection of American Paintings from the Present Day*, January 1944; The Downtown Gallery, New York, *Group Exhibition*, February 1–12, 1944; Albany Institute of History and Art, *The Negro Artist Comes of Age*, January 3–February 11, 1945, no. 41; The Institute for Modern Art, Boston, *Four Modern American Painters: Peter Blume, Stuart Davis, Marsden Hartley, Jacob Lawrence*, March 2–April 1, 1945, no. 44; Phillips Memorial Gallery, Washington, D.C., *Three Negro Artists: Horace Pippin, Jacob Lawrence, Richmond Barthé*, December 14, 1946–January 6, 1947, no. 23; Smith Music Hall, University of Illinois, Urbana-Champaign, *Music in Art*, February 1950; The Corcoran Gallery of Art, Washington, D.C., *The Edith Gregor Halpert Collection*, January 16–February 28, 1960, no. 47 (as *Piano*); National Collection of Fine Art, Washington, D.C., *Edith Gregor Halpert Memorial Exhibition*, April 1972; Whitney 1974–5, no. 89; New Jersey State Museum, Trenton, *Six Black Americans: Benny Andrews, Romare Bearden, Sam Gilliam, Richard Hunt, Jacob Lawrence, Betye Saar*, January 26–March 30, 1980, no. 3; Stockton State 1983, no. 11; Seattle 1986–7, no. 61; New Jersey State Museum, Trenton, and Prefecture of Fukui, Japan, *Dream Singers, Storytellers: An African-American Presence*, 1992–4, no. 138; New Jersey State Museum, Trenton, *One Hundredth Anniversary Exhibition*, January 21–December 31, 1995; New Jersey State Museum, Trenton, *Art by African Americans in the Collection of the New Jersey State Museum*, September 19–December 31, 1998.

References: "*Harlem*" *by Jacob Lawrence: Exhibition of Paintings in Gouache*, exh. brch. (New York: Downtown Gallery, 1943), n.p., ill.; Maude Riley, "Effective Protests by Lawrence of Harlem," *Art Digest* 17, 16 (May 15, 1943), p. 7, ill.; Patrick Pacheco, "Artist in Harlem," *Vogue* 102 (September 15, 1943), p. 94, ill.; "The Passing Shows," *ARTnews* (February 15, 1944), p. 22 (as *They Educate Their Children*); Alain Locke, *The Negro Artist Comes of Age*, exh. cat. (New York: Albany Institute of History and Art, 1945), n.p., ill.; Ben Wolf, "Negro Art Scores without Double Standards," *Art Digest* 19, 9 (February 1, 1945), p. 8, ill.; Elizabeth McCausland, "Jacob Lawrence," *Magazine of Art* 38, 7 (November 1945), p. 252, ill.; "Jacob Lawrence," *Magazine of Art: Flint Institute Edition* (May 1947), p. 3, ill.; Brown 1974, p. 26, ill.; Jefferson Eugene Grisby, Jr., *Art and Ethics: Background for Teaching Youth in a Pluralistic Society* (Dubuque, Iowa: William C. Brown, 1977), p. 48, ill.; *Six Black Americans: Benny Andrews, Romare Bearden, Sam Gilliam, Richard Hunt,*

Jacob Lawrence, Betye Saar, exh. cat. (Trenton, N.J.: New Jersey State Museum, 1980), ill.; Lewis and Sullivan 1982, p. 18, ill. (as *Harlem series #27*); Lemakis 1983, p. 2, ill.; Wheat 1986, p. 212, ill.; Alison Weld and Sadao Serikawa, *Dream Singers, Storytellers: An African-American Presence*, exh. cat. (Trenton, N.J.: New Jersey State Museum; Fukui, Japan: Fukui Fine Arts Museum, 1992), p. 131, ill.; Weld, Alison, ed., *Art by African Americans in the Collection of the New Jersey State Museum* (Trenton, N.J.: New Jersey State Museum, 1998), p. 75, ill.

Remarks: A.k.a. *Teacher and Student*, *At the Piano*, and *The Music Lesson*.

P43-24
The Libraries Are Appreciated
1943
gouache on paper
14¹¹⁄₁₆ × 21⅝ in. (37.3 × 54.9 cm)
signed and dated upper right "J. Lawrence 43"

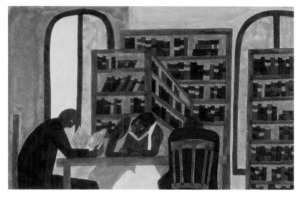

Collection: Philadelphia Museum of Art. The Louis E. Stern Collection.

Provenance: [The Downtown Gallery, New York]; Louis E. Stern, Philadelphia.

Exhibitions: Downtown 1943, no. 28; The Institute for Modern Art, Boston, *Four Modern American Painters: Peter Blume, Stuart Davis, Marsden Hartley, Jacob Lawrence*, March 2–April 1, 1945; The Brooklyn Museum, *The Louis E. Stern Collection*, September 25, 1962–March 10, 1963; Philadelphia Museum of Art, *American Watercolors and Drawings from the Museum Collection*, October 4–December 10, 1974; Philadelphia Museum of Art, *Selection of African American Works from the Collections*, February 1–April 9, 1989; Philadelphia Museum of Art, *African American Art from the Collection*, January 20–April 1, 1990.

References: R. Sturgis Ingersoll, *The Louis E. Stern Collection* (Philadelphia: Philadelphia Museum of Art, 1964), pp. 78, 189, ill.; David R. Brigham, "Bridging Identities: Dox Thrash as African American and Artist," *Smithsonian Studies in American Art* 4, 2 (spring 1990), p. 35, ill.; Glenn C. Tomlinson, "Jacob Lawrence," *Philadelphia Museum of Art Bulletin* 90 (winter 1995), p. 19, ill.

Remarks: A.k.a. *Students in a Library.*

P43-25
Ironers
1943
gouache on paper
21½ × 29½ in. (54.6 × 74.9 cm)
signed and dated lower right "J. Lawrence 43"

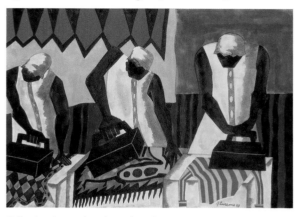

Collection: Ann and Andrew Dintenfass.

Provenance: ?; Jerome Zipkin; [Terry Dintenfass Inc., New York].

Exhibitions: ACA Galleries, New York, *Social Art in America, 1930–1945*, November 6–28, 1981, no. 36; Seattle 1986–7, no. 63; The Corcoran Gallery of Art, Washington, D.C., *Facing History: The Black Image in American Art, 1710–1940*, January 13–March 25, 1990, no. 115; Katonah 1992.

References: Romare Bearden and Harry Henderson, *Six Black Masters of American Art* (Garden City, N.Y.: Doubleday, 1972), p. 114, ill.; Milton W. Brown, *Social Art in America, 1930–1945*, exh. cat. (New York: ACA Galleries, 1981), p. 41, ill.; Deborah Soloman, "The Book of Jacob," *New York Daily News Magazine*, September 27, 1987, p. 19, ill.; John Russell, "Art View: The Epic of a People Writ Large on Canvas," *New York Times*, October 11, 1987, sec. 2, p. 39, ill.; Kay Larson, "Bound for Glory," *New York* 20, 41 (October 19, 1987), p. 112, ill.; Amy Fine Collins, "Jacob Lawrence: Art Builder," *Art in America* 76, 2 (February 1988), p. 132, ill.; Guy C. McElroy, *Facing History: The Black Image in American Art, 1710–1940*, exh. cat. (San Francisco: Bedford Arts Publishers in association with The Corcoran Gallery of Art, 1990), p. 129, ill.

P43-26
Sidewalk Drawings
1943
gouache on paper
22⅜ × 29½ in. (56.8 × 74.9 cm)
signed and dated upper left "J. LAWRENCE 43"

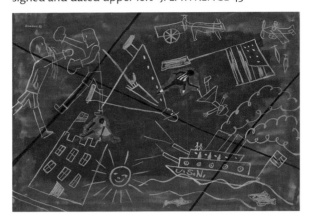

Collection: C. Bruce and Shahara Llewellyn, New York.

Provenance: [The Downtown Gallery, New York]; Mr. and Mrs. Jan de Graaff, New York; ?; [70th Art Gallery, New York].

Exhibitions: The Downtown Gallery, New York, *Eighteenth Annual Exhibition: New Paintings and Sculpture by Leading American Artists*, October 5–30, 1943, no. 8; Phillips Memorial Gallery, Washington, D.C., *Three Negro Artists: Horace Pippin, Jacob Lawrence, Richmond Barthé*, December 14, 1946–January 6, 1947, no. 20; AFA 1960–2, no. 13; Whitney 1974–5, no. 90; Seattle 1986–7, no. 64.

References: Saarinen 1960, p. 26, ill.; Wheat 1986, p. 212, ill.

P43-27
The Apartment
1943
gouache on paper
21¼ × 29¼ in. (54 × 74.3 cm)
signed and dated lower right "J. Lawrence 43"

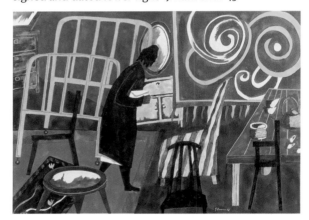

Collection: Hunter Museum of American Art, Chattanooga, Tennessee. Museum purchase with funds provided by the Benwood Foundation and the 1982 Collectors' Group.

Provenance: [The Downtown Gallery, New York]; Dorothy Dodge; Daphne Dodge Hunter; [Terry Dintenfass Inc., New York].

Exhibitions: Seattle 1986–7, no. 62 (Seattle; Oakland; Atlanta; Washington, D.C.); San Antonio 1996; Henry Art Gallery 1998.

References: "Negro Artists: Their Works Win Top U.S. Honors," *Life* 21 (July 22, 1946), p. 65, ill.; William Henning, Jr., *Recent Acquisitions* (Chattanooga, Tenn.: Hunter Museum, 1982), ill.; Carol Lawson, "A Group Shopping Spree Stocks a Museum with Art," *New York Times*, June 20, 1982, p. H28; Avis Berman, "Jacob Lawrence and the Making of Americans," *ARTnews* 83, 2 (February 1984), p. 81, ill.; Carolyn Mitchell, "The Hunter Museum: A Showcase for Modern American Art in Chattanooga," *Southern Accents* 7, 3 (May–June 1984), ill.; Wheat 1986, p. 87, pl. 31; Esther Mumford, "Jacob Lawrence: In Retrospect," *Northwest Art Paper* (August 15–September 15, 1986), p. 4, ill.; Ellen Harkins Wheat, *Portraits: The Lives and Works of Eminent Artists* 2, 3 (1992), ill.; John Duggleby, *Story Painter: The Life of Jacob Lawrence* (San Francisco: Chronicle Books, 1998), p. 14, ill.; Keith Raether, "'Landscapes' of a Painter's Life," *News Tribune*, July 2, 1998, p. 3, ill.; Regina Hackett, "Jacob Lawrence: A Life in Art," *Seattle Post-Intelligencer*, July 2, 1998, p. D1, ill.; Robin Updike, "Jacob Lawrence," *The Seattle Times*, July 2, 1998, p. E1, ill.; Tom McTaggart, "'Life' Has Its Ups and Downs," *Seattle Weekly*, July 9, 1998, p. 22, ill.

P43-28
Harlem Scene (The Butcher Shop)
ca. 1943
gouache on paper
20 × 25¾ in. (50.8 × 65.4 cm)
signed and dated lower right "Jacob Lawrence 38"

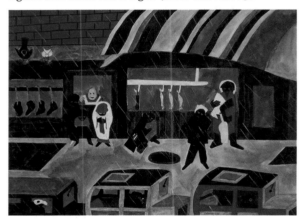

Collection: T. W. Wood Art Gallery, Montpelier, Vermont.

Provenance: WPA Federal Art Project, New York; Henry Schnakenberg, New York.

Remarks: Dated 1938 but probably executed ca. 1942–3. This painting is a copy by the artist of an earlier work (P38-17). Paper is high quality, medium weight wove—a more expensive paper than that used for the earlier work. Both the medium and stylistic details suggest the later dating. WPA records note that a painting titled *The Butcher Shop* was on long-term loan to the T. W. Wood Gallery in the late 1930s. According to the Wood Gallery, they received this painting as a gift from Henry Schnakenberg, an artist who was also in the WPA, was a friend of Lawrence's, and had a residence in Vermont. It is probable that the earlier painting was lent from the WPA to the Wood Gallery, that the work was damaged in some manner, and that through Mr. Schnakenberg, the artist agreed to take the work back and paint a replacement painting. The artist did this on several occasions later in his career.

P44-01

Captain Skinner

1944

gouache on composition board

29⅛ × 21⅛ in. (74 × 53.7 cm)

signed, dated, and inscribed upper right "Jacob Lawrence 1944 / U.S.C.G." [vertical]

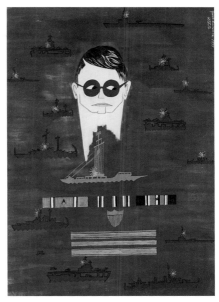

Collection: National Museum of American Art, Smithsonian Institution. Gift of Carlton Skinner.

Provenance: Jacob and Gwendolyn Knight Lawrence, New York; Governor Carlton Skinner, San Francisco.

Exhibitions: National Museum of American Art, Smithsonian Institution, Washington, D.C., *Recent Acquisitions in Graphic Arts*, October 4, 1991–February 2, 1992; Henry Art Gallery 1998.

References: Wheat 1986, p. 90, pl. 34; Lt. Charles H. Hollingsworth, Jr., "Jacob Armstead Lawrence, Famous Artist Served on Active Duty as CG Reservist from '43–'45," *Coast Guard Reservist* (February 1994), p. 4, ill.

P44-02

No. 2 Main Control Panel, Nerve Center of Ship

1944

watercolor and gouache on paper

20 × 24 in. (50.8 × 61 cm)

signed, dated, and inscribed lower right "J. Lawrence 1944 / U.S.C.G."

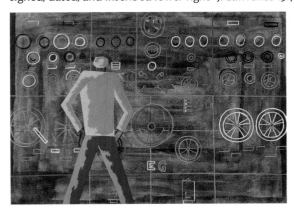

Collection: United States Coast Guard Museum, New London, Connecticut.

Provenance: United States Coast Guard, Washington, D.C.

Exhibitions: Henry Art Gallery 1998.

P44-03

Decommissioning the Sea Cloud

1944

gouache on paper

22¾ × 31 in. (57.8 × 78.7 cm)

signed, dated, and inscribed lower right "J. Lawrence 1944 / U.S.C.G."

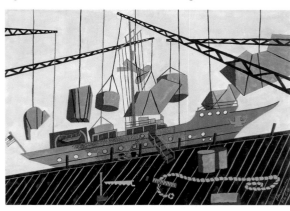

Collection: Santa Barbara Museum of Art. Gift of Mr. and Mrs. Burton Tremaine, Jr., 1947.14.

Provenance: United States Coast Guard, Washington, D.C.; ?; Mr. and Mrs. Burton Tremaine.

Exhibitions: Peppers Art Center Gallery, University of Redlands, Calif., *Selections of Drawings and Watercolors from the Santa Barbara Museum of Art*, February 4–27, 1966; Exhibits USA, Mid-America Arts Alliance, Kansas City, Mo., *Bold Strokes and Quiet Gestures: Twentieth-Century Drawings and Watercolors from the Santa Barbara Museum of Art*, 1992–4; Henry Art Gallery 1998.

References: Susan C. Larsen, *Bold Strokes and Quiet Gestures: Twentieth-Century Drawings and Watercolors from the Santa Barbara Museum of Art* (Kansas City, Mo.: Mid-America Arts Alliance, 1992), p. 83, ill. (as *United States Coast Guard Boat*).

P44-04
Painting the Bilges
1944
gouache on paper
30⅞ × 22⅝ in. (78.4 × 57.5 cm)
signed, dated, and inscribed lower right "J. Lawrence 1944 / U.S.C.G.";
verso: inscribed "Painting the Bilges"

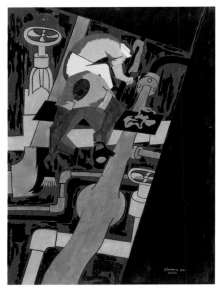

Collection: Hirshhorn Museum and Sculpture Garden, Smithsonian Institution. Bequest of Joseph H. Hirshhorn, 1986.

Provenance: [The Downtown Gallery, New York]; O'Donnell Iselin, New York; [Parke Bernet Galleries, New York, December 13, 1972, Sale 3454, lot 161]; Joseph H. Hirshhorn, New York.

Exhibitions: The Brooklyn Museum, *International Watercolor Exhibition, Thirteenth Biennial*, March 8–April 29, 1945, no. 95.

References: Wheat 1986, p. 88, pl. 32.

Remarks: A.k.a. *Engine Room Maintenance*.

P44-05
Prayer
1944
gouache and watercolor on paper
20¾ × 29 in. (52.7 × 73.7 cm)
signed, dated, and inscribed lower right "J. Lawrence 1944 / U.S.C.G."

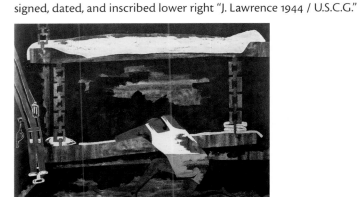

Collection: Current location unknown.

Provenance: United States Coast Guard, Washington, D.C.

Exhibitions: MoMA 1944; The Institute for Modern Art, Boston, *Four Modern American Painters: Peter Blume, Stuart Davis, Marsden Hartley, Jacob Lawrence*, March 2–April 1, 1945, no. 51.

References: Aline B. Louchheim, "Lawrence: Quiet Spokesman," *ARTnews* 43, 13 (October 15–31, 1944), p. 15, ill.

P44-06
General Quarters
1944
gouache and watercolor on paper
38 × 28½ in. (96.5 × 72.4 cm)
signed, dated, and inscribed lower right "J. Lawrence 1944 / U.S.C.G."

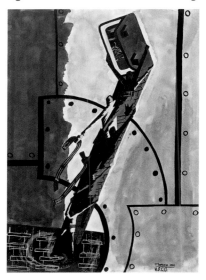

Collection: Current location unknown.

Provenance: United States Coast Guard, Washington, D.C.

Exhibitions: MoMA 1944.

P44-07
Chipping the Mast
1944
gouache on paper
29 × 20 in. (73.7 × 50.8 cm)
signed, dated, and inscribed lower right "J. Lawrence / 1944 / U.S.C.G."

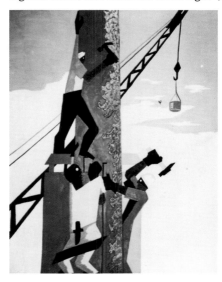

Collection: Current location unknown.

Provenance: United States Coast Guard, Washington, D.C.; [The Downtown Gallery, New York]; Tel Aviv Museum of Art, Israel.

Exhibitions: The Downtown Gallery, New York, *Nineteenth Annual Spring Exhibition: Important New Paintings and Sculpture by Leading American Artists*, May 1–26, 1945, no. 10; Whitney Museum of American Art, New York, *1946 Annual Exhibition of Contemporary American Sculpture, Watercolors, and Drawings*, February 5–March 13, 1946, no. 106; Black Mountain College, Asheville, N.C., July 2–August 28, 1946; Salem College, Winston-Salem, N.C., March 1947; Illinois Wesleyan University, Bloomington, October 1947.

References: Margaret Breuning, "Sound Painting by the Downtown Group," *Art Digest* 19, 16 (May 15, 1945), p. 18; Wheat 1986, p. 89, pl. 33; Lt. Charles H. Hollingsworth, Jr., "Jacob Armstead Lawrence, Famous Artist Served on Active Duty as CG Reservist from '43–'45," *Coast Guard Reservist* (February 1994), p. 5, ill.

P44-08
Holystoning the Deck
1944
watercolor and gouache on paper
32⅝ × 36⅞ in. (82.9 × 93.7 cm)
signed, dated, and inscribed upper right "J. Lawrence 1944 / U.S.C.G."

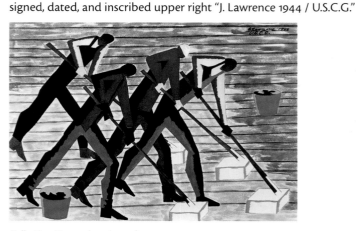

Collection: Current location unknown.

Provenance: United States Coast Guard, Washington, D.C.; Lt. Lothar Wolff, New York; The Museum of Modern Art, New York.

Exhibitions: MoMA 1944; The Institute for Modern Art, Boston, *Four Modern American Painters: Peter Blume, Stuart Davis, Marsden Hartley, Jacob Lawrence*, March 2–April 1, 1945, no. 50 (as *Holystoning Detail*).

References: Elizabeth McCausland, "Jacob Lawrence," *Magazine of Art* 38, 7 (November 1945), p. 251, ill.; "Jacob Lawrence," *Magazine of Art: Flint Institute of Arts Edition* (May 1947), p. iv, ill.; Vivian Campbell, "American Negro Art," *The Woman's Press* (November 1947), p. 9, ill.; Brown 1974, p. 27, ill.

P44-09
Signal Practice
1944
watercolor and gouache on paper
28⅝ × 20¼ in. (72.7 × 51.4 cm)
signed, dated, and inscribed upper right "J. Lawrence 1944 / U.S.C.G."

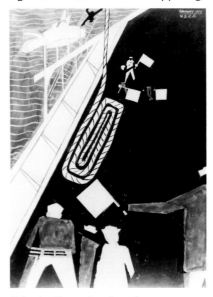

Collection: Current location unknown.

Provenance: United States Coast Guard, Washington, D.C.

Exhibitions: MoMA 1944.

Remarks: A.k.a. *Flag Drill*.

P44-10
Officer's Steward
1944
watercolor and gouache on paper
29⅛ × 20¾ in. (74 × 52.7 cm)
signed, dated, and inscribed upper left "J. Lawrence 1944 / U.S.C.G."

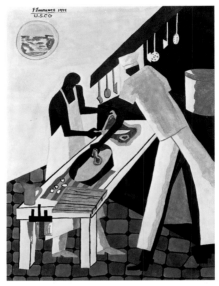

Collection: Current location unknown.
Provenance: United States Coast Guard, Washington, D.C.
Exhibitions: MoMA 1944.

P44-11
Recreation
1944
gouache on paper
32⅞ × 25¾ in. (83.5 × 65.4 cm)
signed, dated, and inscribed upper left "J. Lawrence 1944 / U.S.C.G."

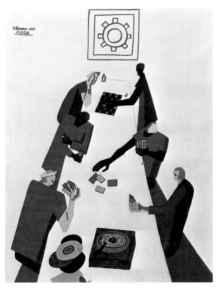

Collection: Current location unknown.
Provenance: United States Coast Guard, Washington, D.C.; Lt. Lothar Wolff, New York.
Exhibitions: MoMA 1944.
References: Marjorie E. Greene, "Jacob Lawrence," *Opportunity* 23, 1 (January–March 1945), pp. 26–7, ill.

P44-12
Recreation (Boxing)
1944
watercolor and gouache on paper
20¾ × 29 in. (52.7 × 73.7 cm)
signed, dated, and inscribed lower right "J. Lawrence 1944 / U.S.C.G."

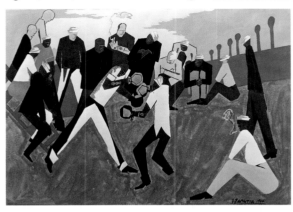

Collection: Current location unknown.
Provenance: United States Coast Guard, Washington, D.C.
Exhibitions: MoMA 1944.

P44-13
The Helmsman
1944
gouache on paper
25¾ × 33½ in. (65.4 × 85.1 cm)
signed, dated, and inscribed lower right "J. Lawrence / 1944 / U.S.C.G."

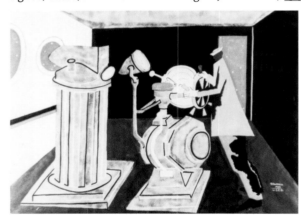

Collection: Current location unknown.
Provenance: United States Coast Guard, Washington, D.C.; Lt. Lothar Wolff, New York.
Exhibitions: MoMA 1944.

P44-14
Memory Training
1944
gouache on paper
dimensions unknown
signed, dated, and inscribed upper left "J. Lawrence 1944 / U.S.C.G."

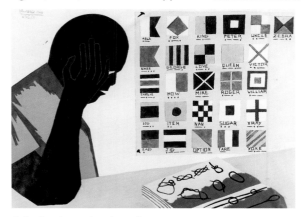

Collection: Current location unknown.
Provenance: United States Coast Guard, Washington, D.C.
Remarks: A.k.a. *Seamanship.*

P44-15
Tattoos
1944
gouache on paper
dimensions unknown
signed, dated, and inscribed upper left "Jacob Lawrence 1944 / U.S.C.G."

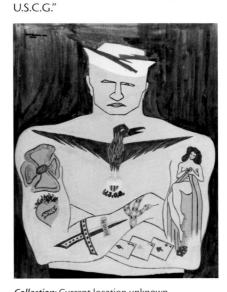

Collection: Current location unknown.
Provenance: United States Coast Guard, Washington, D.C.

P44-16
Cmbar Katian
1944
watercolor and gouache on paper
22½ × 31 in. (57.2 × 78.7 cm)
signed, dated, and inscribed lower right "J. Lawrence / 1944 / U.S.C.G."; verso: signed and inscribed "Cmbar Katian" / Jacob Lawrence / SP. PR 3/c / U.S.C.G."

Collection: United States Coast Guard Museum, New London, Connecticut.
Provenance: United States Coast Guard, Washington, D.C.
Exhibitions: Henry Art Gallery 1998.

P44-17
Lookout from the Gun Platform . . .
1944
gouache on paper
dimensions unknown
signed, dated, and inscribed lower right "J. Lawrence 1944 / U.S.C.G."

Collection: Current location unknown.
Provenance: United States Coast Guard, Washington, D.C.

P44-18
Untitled [*The Big Gun*]
1944
gouache on paper
dimensions unknown
signed, dated, and inscribed lower right "J. Lawrence 1944 / U.S.C.G."

Collection: Current location unknown.

P45-01
Anchor on Cart
1945
gouache on paper
dimensions unknown
inscription unknown

Collection: Current location unknown.

Provenance: United States Coast Guard, Washington, D.C.; [The Downtown Gallery, New York]; Jack Sharp; Senator William Benton (Encyclopedia Britannica collection); Spelman College, Atlanta.

Exhibitions: Whitney Museum of American Art, New York, *1945 Annual Exhibition of Contemporary American Sculpture, Watercolors, and Drawings*, January 3–February 8, 1945, no. 115; The Downtown Gallery, New York, *1945: New Painting and Sculpture by Leading American Artists*, November 6–December 1, 1945, no. 11; University Art Galleries, University of Nebraska, Lincoln, *Fifty-Sixth Annual Exhibition of Contemporary Art*, March 3–31, 1946, no. 78; The Museum of the National Center of Afro-American Artists, Roxbury, Mass., *Five Famous Black Artists: Romare Bearden, Jacob Lawrence, Horace Pippin, Charles White, Hale Woodruff*, February 9–March 10, 1970 (as *Anchor and Cart*).

References: Margaret Breuning, "This Is Their Best," *Art Digest* 20, 4 (November 15, 1945), p. 31; Jo Gibbs, "Britannica Inaugurates a Rotating Annual," *Art Digest* 21, 1 (October 1, 1946), p. 14, ill.

Remarks: Lent by Spelman College to *Five Famous Black Artists* exhibition in 1970, and then returned to Spelman following the exhibition.

P45-02
Bakers
1945
gouache on paper
dimensions unknown
signed, dated, and inscribed upper right "Jacob Lawrence 1945 / U.S.C.G."

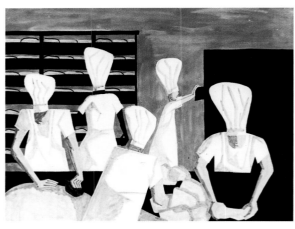

Collection: Current location unknown.

Provenance: United States Coast Guard, Washington, D.C.

References: Elizabeth McCausland, "Jacob Lawrence," *Magazine of Art* 38, 7 (November 1945), p. 250, ill.

P45-03
Lifeboat
1945
gouache on paper
23⅛ × 30⅞ in. (58.7 × 78.4 cm)
signed, dated, and inscribed lower right "Jacob Lawrence 1945 / U.S.C.G."

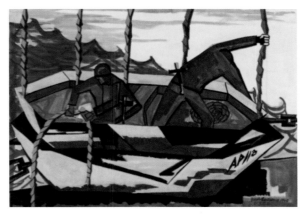

Collection: The Baltimore Museum of Art. Gift of the Art Committee of the Women's Cooperative Civic League, BMA 1946.135.

Provenance: United States Coast Guard, Washington, D.C.; [The Downtown Gallery, New York].

Exhibitions: Fine Arts Gallery of San Diego, *Paintings by Matisse, Tom Lewis, and Chester Hayes; Watercolor Paintings by Jacob Lawrence and Willing Howard*, April 1946; The Baltimore Museum of Art, *Baltimore-Owned Paintings by Equity Artists*, summer 1950; The Baltimore Museum of Art, *African-American Art from the Museum's Collection*, January 21–March 18, 1990.

P45-04
Seaman's Belt
1945
gouache and watercolor on paper
image: 21 × 29 in. (53 × 73.7 cm)
signed, dated, and inscribed upper right "J. Lawrence / U.S.C.G. / 1945"

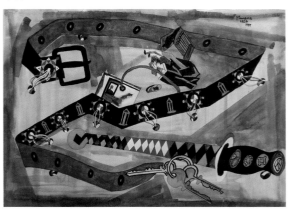

Collection: Albright-Knox Art Gallery, Buffalo, New York. Gift of Mr. and Mrs. David K. Anderson to the Martha Jackson Collection, 1974.

Provenance: United States Coast Guard, Washington, D.C.; [The Downtown Gallery, New York]; Mrs. Martha Jackson, New York; [Martha Jackson Gallery, New York].

Exhibitions: The University of Maryland Art Gallery, Baltimore, *The Private Collection of Martha Jackson*, June 22–September 30, 1973, no. 141; Whitney 1974–5, no. 93; Albright-Knox Art Gallery, Buffalo, *American Art in Upstate New York: Drawings, Watercolors and Small Sculpture from Public Collections in Albany, Buffalo, Ithaca, Rochester, Syracuse and Utica*, July 12–August 25, 1974; Albright-Knox Art Gallery, Buffalo, *The Martha Jackson Collection at the Albright-Knox Art Gallery*, November 21, 1975–January 4, 1976; Albright-Knox Art Gallery, Buffalo, *The American Scene—Selections from the Permanent Collection*, January 17–March 2, 1986; Seattle 1986–7, no. 66 (Seattle, Oakland, Brooklyn); Albright-Knox Art Gallery, Buffalo, *Intimate Gestures, Realized Visions: Masterworks on Paper from the Collection of the Albright-Knox Art Gallery*, December 11, 1987–January 31, 1988; Albright-Knox Art Gallery, Buffalo, *African-American Art from the Permanent Collection*, March 15–April 28, 1991.

References: Brown 1974, p. 27, ill.; Harry Rand, *The Martha Jackson Memorial Collection*, exh. cat. (Washington, D.C.: Smithsonian Institution Press, 1985), p. 39; Wheat 1986, p. 212, ill.

P45-05
U.S.O. "Show"
1945
gouache and watercolor on paper
21 × 29 in. (53.3 × 73.7 cm)
signed, dated, and inscribed lower right "Jacob Lawrence 1945 /
U.S.C.G."; verso: signed and inscribed center "U.S.O. 'Show' / Jacob
Lawrence / SP. PR 3/c / U.S.C.G."

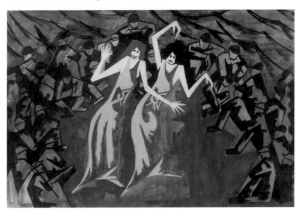

Collection: Irene and Mark Kauffman.

Provenance: United States Coast Guard, Washington, D.C.; ?; Margit Chanin, New York;
[Sid Deutsch Gallery, New York].

Exhibitions: The Art Museum, Princeton University, N.J., *Fragments of American Life, An
Exhibition of Paintings: Romare Bearden, Joseph Delaney, Rex Gorleigh, Lois Mailou Jones,
Jacob Lawrence, Hughie Lee-Smith, Hale Woodruff,* January 25–March 28, 1976; Fine Arts
Museum of Long Island, Hempstead, N.Y., *Celebrating Contemporary American Black
Artists,* March 13–May 1, 1983.

References: John Ralph Willis, *Fragments of American Life: An Exhibition of Paintings,*
exh. cat. (Princeton, N.J.: Princeton University, 1976), p. 51.

Remarks: A.k.a. *Entertaining the Troops.* The artist and his wife have expressed doubt
regarding the authenticity of this painting.

P45-06
Television
1945
gouache on paper
13 × 10¼ in. (33 × 26 cm)
signed and dated lower left "Jacob Lawrence 1945"

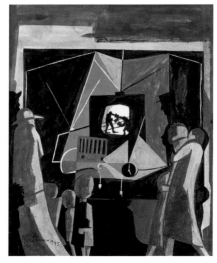

Collection: Private collection.

Provenance: Jacob and Gwendolyn Knight Lawrence, New York and Seattle;
[DC Moore Gallery, New York].

P45-07
Home Chores
1945
gouache on paper
29½ × 21¹/₁₆ in. (74.9 × 53.5 cm)
signed and dated upper right "Jacob Lawrence 1945 ©"

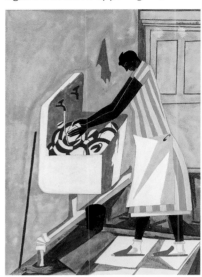

Collection: The Nelson-Atkins Museum of Art, Kansas City, Missouri. Anonymous gift.

Provenance: [The Downtown Gallery, New York]; IBM Corporation, Armonk, N.Y.;
Private collection.

Exhibitions: The Downtown Gallery, New York, *Six Artists out of Uniform,* May 7–25,
1946, no. 4; AFA 1960–2, no. 14.

References: "In the Art Galleries," *New York Herald Tribune,* May 12, 1946; "Art: The Lost
and Found," *Newsweek* (May 20, 1946), p. 102; Saarinen 1960, p. 26, ill.; Henry Adams,
Margaret Stenz, Jan M. Marsh, et al., *American Drawings and Watercolors from the Kan-
sas City Region* (Kansas City, Mo.: The Nelson-Atkins Museum of Art, 1992), p. 265, ill.

P45-08
End of the Day
1945
gouache on paper
20 × 29½ in. (50.8 × 74.9 cm)
signed and dated upper left "Jacob Lawrence 1945"

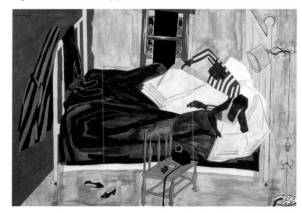

Collection: Lauron K. Gibbs, Kenneth D. Gibbs.

Provenance: [The Downtown Gallery, New York]; Mr. and Mrs. Edward and Helga
Kook.

Exhibitions: Phillips Memorial Gallery, Washington, D.C., *Three Negro Artists: Horace
Pippin, Jacob Lawrence, Richmond Barthé,* December 14, 1946–January 6, 1947, no. 37;
Whitney 1974–5, no. 92 (Whitney only).

P45-09
The Shoemaker
1945
gouache and watercolor on paper
22⅝ × 30⅞ in. (57.5 × 78.4 cm)
signed and dated lower right "Jacob Lawrence 1945"; verso: signed, dated, and inscribed "The Shoemaker / 1946 / Jacob Lawrence"

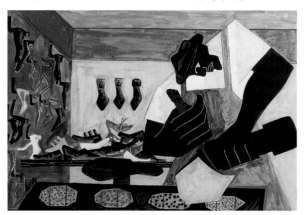

Collection: The Metropolitan Museum of Art. George A. Hearn Fund, 1946, 46.73.2.

Provenance: [The Downtown Gallery, New York].

Exhibitions: The Metropolitan Museum of Art, New York, *Two Hundred Years of Watercolor Painting in America*, December 8, 1966–January 29, 1967, no. 238; Bedford-Stuyvesant Restoration Corporation, Brooklyn, *Selected Works by Black Artists from the Collection of The Metropolitan Museum of Art*, April 14–June 14, 1976; Pushkin Museum, Moscow, *Representations of America*, December 15, 1977–February 15, 1978; New Jersey State Museum, Trenton, *Six Black Americans: Benny Andrews, Romare Bearden, Sam Gilliam, Richard Hunt, Jacob Lawrence, Betye Saar*, January 26–March 30, 1980, no. 4; American Federation of Arts, New York, *The Figure in Twentieth-Century American Art: Selections from The Metropolitan Museum of Art*, 1985–6; Katonah 1992; The Metropolitan Museum of Art, New York, *I Tell My Heart: The Art of Horace Pippin*, February 1–April 30, 1995.

References: Two Hundred Years of Watercolor Painting in America (New York: The Metropolitan Museum of Art, 1966), p. 34.; *Six Black Americans: Benny Andrews, Romare Bearden, Sam Gilliam, Richard Hunt, Jacob Lawrence, and Betye Saar*, exh. cat. (Trenton, N.J.: New Jersey State Museum, 1980), n.p., ill.; Lowery Stokes Sims, *The Figure in Twentieth Century American Art: Selections from The Metropolitan Museum of Art* (New York: The Metropolitan Museum of Art, 1984), p. 89, ill.; Wheat 1986, p. 94, pl. 38; Patterson Sims, *Jacob Lawrence: The Early Decades, 1935–1950*, exh. brch. (Katonah, N.Y.: The Katonah Museum of Art, 1992), p. 2, ill.; Kathy Grantham, "Jacob Lawrence in Retrospect," *North County News* (March 25–31, 1992), p. vi, ill.; William Zimmer, "A Painterly Storyteller Takes Black America as His Subject," *New York Times*, April 5, 1992, p. WC20, ill.

Remarks: This painting was probably completed, signed, and dated by the artist late in 1945 and inscribed on the verso in early 1946.

P46-01
Watchmaker
1946
gouache and chalk on paper
30 × 21½ in. (76.2 × 54.6 cm)
signed and dated lower right "Jacob Lawrence / 1946"

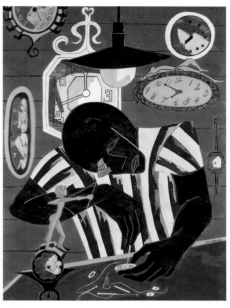

Collection: Hirshhorn Museum and Sculpture Garden, Smithsonian Institution. Gift of Joseph H. Hirshhorn, 1966.

Provenance: [The Downtown Gallery, New York]; Joseph H. Hirshhorn, New York.

Exhibitions: The Downtown Gallery, New York, *The Twenty-First Annual Fall Exhibition: New Paintings and Sculpture by Leading American Artists*, September 24–October 19, 1946, no. 10; Phillips Memorial Gallery, Washington, D.C., *Three Negro Artists: Horace Pippin, Jacob Lawrence, Richmond Barthé*, December 14, 1946–January 6, 1947, no. 38; The American Academy of Arts and Letters, New York, *Exhibition of Work by Newly Elected Members, Recipients of Honors, and Childe Hassam Fund Purchases*, May 28–June 28, 1953, no. 38 (as *The Watchmaker*); Abraham Shapiro Athletic Center, Brandeis University, Waltham, Mass., *Third Festival of the Creative Arts: Three Collections*, June 1–17, 1955, no. 25; Tweed Gallery, University of Minnesota, Duluth, *Paintings from the Collection of Joseph H. Hirshhorn*, April 1956; National Gallery of Canada, Ottawa, *Some American Paintings from the Collection of Joseph H. Hirshhorn*, January 10–31, 1957, no. 44; AFA 1960–2, no. 24; Brandeis 1965, no. 2; The Museum of the National Center of Afro-American Artists, Roxbury, Mass., *Five Famous Black Artists: Romare Bearden, Jacob Lawrence, Horace Pippin, Charles White, Hale Woodruff*, February 9–March 10, 1970; Alexandria Museum of Art, La., *The Rhythm of Life: Selected Works by Bearden, Gwathmey, and Lawrence*, January 25–March 30, 1984.

References: "Reviews and Previews: Progressive Moderns," *ARTnews* 45, 8 (October 1946), pp. 57–8; Ben Wolf, "New at Downtown," *Art Digest* 21, 1 (October 1, 1946), p. 17; Hugh Thomson, "Pictures Must Excite Me Twice," *Star Weekly Magazine*, May 18, 1957, p. 17, ill.; Saarinen 1960, p. 33, ill.; Ulli Beier, "Two American Negro Painters: Jacob Lawrence and William H. Johnson," *Black Orpheus* (Ibadan, Nigeria) 11 (1962), p. 27, ill.; Jane H. Kay, "Lawrence Retrospective: Capsulating a Career," *Christian Science Monitor*, March 26, 1965, p. 4; *Five Famous Black Artists: Romare Bearden, Jacob Lawrence, Horace Pippin, Charles White, Hale Woodruff*, exh. cat. (Roxbury, Mass.: Museum of the National Center of Afro-American Artists, 1970), n.p., ill.

Remarks: A.k.a. *Watch Repairs*.

P46-02
Cabinet Makers
1946
gouache on paper
22 × 30¹⁄₁₆ in. (55.9 × 76.4 cm)
signed and dated lower right "Jacob Lawrence / 1946"

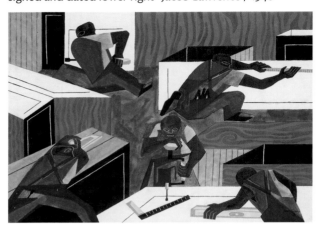

Collection: Hirshhorn Museum and Sculpture Garden, Smithsonian Institution. Gift of Joseph H. Hirshhorn, 1966.

Provenance: [The Downtown Gallery, New York]; Joseph H. Hirshhorn, New York.

Exhibitions: AFA 1960–2, no. 21 (as *Cabinet Makers*); Hirshhorn Museum and Sculpture Garden, Smithsonian Institution, Washington, D.C., *Inaugural Exhibition*, October 1, 1974–September 15, 1975; District 1199 Cultural Center, New York, *The Working American*, October 18–November 24, 1979, no. 20 (New York only); Henry Art Gallery 1998.

References: Saarinen 1960, p. 31, ill.; "'Narrative Painter' Lawrence's Works to Be Exhibited at Allegheny College," *Meadville Tribune* (Pa.), February 17, 1961; Abram Lerner, ed., *The Hirshhorn Museum and Sculpture Garden* (New York: Harry N. Abrams, 1974), p. 484, ill.; Emma L. Fundaburk and Mary Douglass Foreman, *Art in the Environment in the U.S.* (Luverne, Ala.: E. L. Fundaburk, 1975), pl. 290; Jean Lipman and Helen M. Franc, *Bright Stars: American Painting and Sculpture Since 1976* (New York: E. P. Dutton, 1976), p. 121, ill.; Shirley Glubak, *The Art of America Since World War II* (New York: Macmillan, 1976), p. 9, ill.; Patricia Hills and Abigail Booth Gerdts, *The Working American*, exh. cat. (Washington, D.C.: Smithsonian Institution Traveling Exhibition Service, 1979), p. 39, ill.; Carter Ratcliff, "Packaging the American Worker," *Art in America* 68, 2 (February 1980), pp. 14–5; *Federal Bar News and Journal* 28, 9 (September 1980), cvr., ill.; James M. Carpenter, *Visual Art: A Critical Introduction* (New York: Harcourt Brace Jovanovich, 1982), ill.; Lewis and Sullivan 1982, p. 22, ill.; "Art/Work: Jacob Lawrence, Artist," *Personnel Journal* 64 (August 1985), p. 128, ill.; Wheat 1986, p. 156, pl. 75.

P46-03
Steelworkers
1946
gouache on paper
14 × 21 in. (35.6 × 53.3 cm)
signed and dated lower right "Jacob Lawrence 1946"

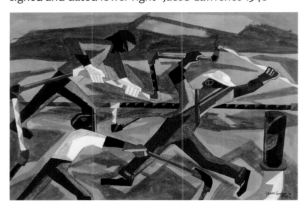

Collection: Edith and Emil Oxfeld.

Provenance: ?; [ACA Gallery, New York].

P46-04
Radio Repairs
1946
gouache on paper
21½ × 29½ in. (54.6 × 74.9 cm)
signed and dated lower right "Jacob Lawrence 1946"

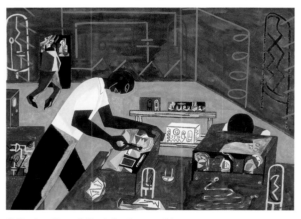

Collection: Mr. and Mrs. Julius Rosenwald.

Provenance: [The Downtown Gallery, New York].

Exhibitions: The Downtown Gallery, New York, *Spring 1947*, April 1–26, 1947, no. 10; Boris Mirski Art Gallery, Boston, *Boston/New York: First Exchange Exhibition*, April 29–May 17, 1947, no. 11; Carnegie Institute, Pittsburgh, *Painting in the United States, 1947*, October 9–December 7, 1947, no. 152; Indiana University, Bloomington, March 1948; AFA 1960–2, no. 25.

References: "Group Show by Americans," *New York Herald Tribune*, April 6, 1947; Margaret Breuning, "Vernal Preview," *Art Digest* 21, 14 (April 15, 1947), p. 21, ill.; Dorothy Adlow, "Boston and New York Exchange Art Shows: Manhattan Painters Exhibit Works at Mirski Gallery," *Christian Science Monitor*, May 12, 1947, p. 4, ill.; Saarinen 1960, p. 33, ill.

P46-05
Stenographers
1946
gouache on paper
21½ × 29½ in. (54.6 × 74.9 cm)
signed and dated lower right "Jacob Lawrence / 1946"

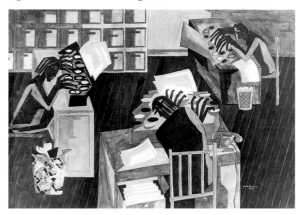

Collection: Current location unknown.

Provenance: [The Downtown Gallery, New York]; Benedict College, Columbia, S.C.

Exhibitions: The Brooklyn Museum, *International Watercolor Exhibition, Fourteenth Biennial*, April 16–June 8, 1947, no. 36; The Downtown Gallery, New York, *American Art 1800–1947*, June 10–August 8, 1947; The Downtown Gallery, New York, *Twentieth-Century American Watercolors*, September 3–27, 1947, no. 9; Van Bark Studios, Studio City, Calif., October 1947; Brooks Memorial Art Gallery, Memphis, April 1948; Evanston Art Center, Ill., October 1948; Stephens College Art Gallery, Columbia, Mo., March 1949.

References: *International Watercolor Exhibition, Fourteenth Biennial*, exh. cat. (Brooklyn: The Brooklyn Museum, 1947), ill.; "New Paintings," *ARTnews* 46, 5 (July 1947); "Reviews and Previews: American Watercolors," *ARTnews* 46, 7 (September 1947).

P46-06
Barber Shop
1946
gouache on paper
21⅛ × 29⅜ in. (53.7 × 74.6 cm)
signed and dated lower left "Jacob Lawrence 1946 ©"

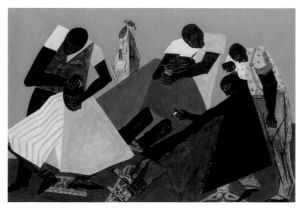

Collection: The Toledo Museum of Art. Purchased with funds from the Libbey Endowment. Gift of Edward Drummond Libbey.

Provenance: [The Downtown Gallery, New York]; Charles Alan, New York; Mrs. G. Richard Davis, New York; [Terry Dintenfass Inc., New York].

Exhibitions: Black Mountain College, Asheville, N.C., July 2–August 28, 1946; Phillips Memorial Gallery, Washington, D.C., *Three Negro Artists: Horace Pippin, Jacob Lawrence, Richmond Barthé*, December 14, 1946–January 6, 1947, no. 34; University of Iowa, Iowa City, *Third Summer Exhibition of Contemporary Art*, June 15–July 30, 1947; The Art Gallery of Toronto, *Contemporary Paintings from Great Britain, the United States and France, with Sculptures from the United States*, October 1949, no. 99; AFA 1960–2, no. 22; Whitney 1974–5, no. 95; Kennedy Galleries, New York, *One Hundred Artists Associated with the Art Students League of New York*, March 6–29, 1975; The Museum of the National Center of Afro-American Artists and the Museum of Fine Arts, Roxbury, Mass., *Jubilee: Afro-American Artists on Afro-America*, November 13, 1975–January 4, 1976; Seattle 1986–7, no. 68 (Seattle; Oakland; Atlanta; Washington, D.C.; Dallas; Brooklyn).

References: Leo Lerman, "The American Eye," *House and Garden* 90 (December 1946), p. 120, ill.; Edmund Barry Gaither, *Jubilee: Afro-American Artists on Afro-America*, exh. cat. (Roxbury, Mass.: Museum of Fine Arts in cooperation with the Museum of the National Center of Afro-American Artists, 1975), p. 42, ill.; *The Kennedy Galleries Are Host to the Hundredth Anniversary Exhibition of Paintings and Sculptures by One Hundred Artists Associated with the Art Students League of New York*, exh. brch. (New York: Kennedy Galleries, 1975), p. 151, ill.; Susan E. Strickler, *The Toledo Museum of Art: American Paintings* (Toledo, Ohio: Toledo Museum of Art, 1979), p. 78, pl. 225; Wheat 1986, pp. 71–2, pl. 37; Bill Woodward, "Strides Toward Freedom," *Kansas Alumni Magazine* 90, 4 (July–August 1992), p. 22, ill.; Henry Sayre, *A World of Art* (Upper Saddle River, N.J.: Prentice-Hall, 1997), p. 168, fig. 226.

P46-07
The Seamstress
1946
gouache on paper
21⅝ × 29⅞ in. (54.9 × 75.9 cm)
signed and dated lower right "Jacob Lawrence / 1946"

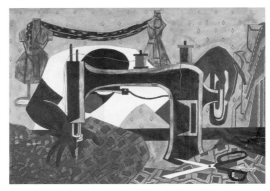

Collection: Southern Illinois University Museum at Carbondale.

Provenance: [The Downtown Gallery, New York]; The American Academy of Arts and Letters, New York.

Exhibitions: Whitney Museum of American Art, New York, *1947 Annual Exhibition of Contemporary American Sculpture, Watercolors, and Drawings*, March 11–April 17, 1947, no. 113; Boris Mirski Art Gallery, Boston, *Boston/New York: First Exchange Exhibition*, April 29–May 17, 1947; Carnegie Institute, Pittsburgh, *Painting in the United States, 1947*, October 9–December 7, 1947; The American Academy of Arts and Letters, New York, *Exhibition of Work by Newly Elected Members, Recipients of Academy and Institute Honors, and Pictures Purchased from the Childe Hassam Fund*, May 22–June 30, 1948, no. 11; AFA 1960–2, no. 26 (as *Seamstress*); Whitney 1974–5, no. 94; Seattle 1986–7, no. 71.

References: *1947 Annual Exhibition of Contemporary American Sculpture, Watercolors, and Drawings*, exh. cat. (New York: Whitney Museum of American Art, 1947), n.p., ill.; Vivian Campbell, "American Negro Art," *The Woman's Press* (February 1947), p. 7, ill.; "Academic Activities and Awards," *ARTnews* 46, 4 (summer 1948), p. 64, ill.; John I. H. Baur, ed., *New Art in America: Fifty Painters of the Twentieth Century* (Greenwich, Conn.: New York Graphic Society, 1957), p. 274, ill.; Saarinen 1960, p. 33, ill.; Vivien Raynor, "In the Galleries: Jacob Lawrence," *Arts* 35, 4 (January 1961), p. 54; Wheat 1986, p. 91, pl. 35; Les Payne, "A Great Creator of Movement in Paint," *Newsday*, October 18, 1987, Ideas sec., p. 5, ill.

P46-08
Winter
1946
gouache on paper
29½ × 21 in. (74.9 × 53.3 cm)
signed and dated lower right "Jacob Lawrence 46"

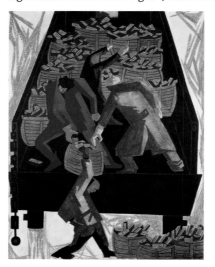

Collection: Private collection, New Jersey.

Provenance: [The Downtown Gallery, New York]; Benjamin Tepper; [Terry Dintenfass Inc., New York].

Exhibitions: The Downtown Gallery, New York, *Six Artists out of Uniform*, May 7–25, 1946, no. 5; Phillips Memorial Gallery, Washington, D.C., *Three Negro Artists: Horace Pippin, Jacob Lawrence, Richmond Barthé*, December 14, 1946–January 6, 1947, no. 24; Katonah 1992.

References: Thomas B. Hess, "Veterans: Then and Now," *ARTnews* 45, 3 (May 1946), p. 45, ill.; "The War's Effect on Artists: A Heightening of Their Talents Is Noted," *Pictures on Exhibit* 8, 8 (May 1946), p. 14; Elizabeth McCausland, "Postwar Paintings by Modern Artists," *Springfield Sunday Union and Republican*, May 12, 1946, ill.; Robert M. Coates, "The Art Galleries," *The New Yorker* (May 18, 1946), p. 79.

P46-09
New Jersey
1946
gouache and watercolor on paper
24⅛ × 20 1/16 in. (61.3 × 51 cm)
signed and dated lower right "Jacob / Lawrence / 1946"

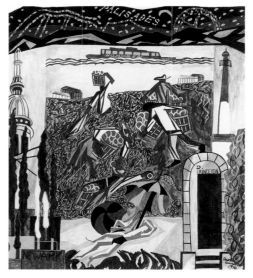

Collection: National Museum of American Art, Smithsonian Institution. Gift of the Container Corporation of America.

Provenance: Jacob and Gwendolyn Knight Lawrence, New York; Container Corporation of America, Chicago.

References: [Container Corporation advertisement], *Time* (November 11, 1946), p. 69, ill.; John D. Morse, "Americans Abroad," *Magazine of Art* 40, 1 (January 1947), p. 25, ill.

Remarks: Commissioned by the Container Corporation of America for a series called "The United States Series."

P46-10
African Gold Miners
1946
gouache on paper
26¾ × 21⁹⁄₁₆ in. (68 × 54.8 cm)
signed and dated lower left "Jacob / Lawrence / 46"

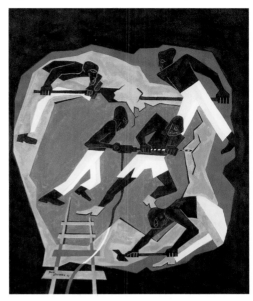

Collection: Hirshhorn Museum and Sculpture Garden, Smithsonian Institution. Gift of Joseph H. Hirshhorn, 1966.

Provenance: [The Downtown Gallery, New York]; Joseph H. Hirshhorn, New York.

Exhibitions: Exhibition Center, Time-Life Building, New York, Fortune: *Art in World Business*, September 14–October 7, 1967.

References: Fortune 34 (October 1946), cvr., ill.

Remarks: A.k.a. *African Gold Rush*. Commissioned by *Fortune* magazine as cover design for the October 1946 issue containing an article on South African gold mines.

P46-11
South African Gold Mines
1946
gouache on paper
20¼ × 19½ in. (51.4 × 49.5 cm)
signed and dated lower left "Jacob Lawrence / 46"

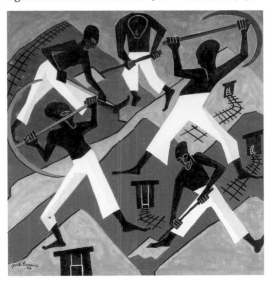

Collection: Flint Institute of Arts, Flint, Michigan. Purchased with Funds from the Harvey J. Mallery Charitable Trust, 1991.23.

Provenance: Jacob and Gwendolyn Knight Lawrence, New York; Mr. and Mrs. Daniel Geller, Pittsboro, N.C.; [Terry Dintenfass Inc., New York].

References: Annual Report, 1991–2 (Flint, Mich.: Flint Institute of Arts, 1992), cvr., ill.

Remarks: A.k.a. *Untitled (Men Working)*.

P46-12
The Lecture
1946
gouache on paper
22 × 29½ in. (55.9 × 74.9 cm)
signed and dated lower right "Jacob Lawrence / 1946"

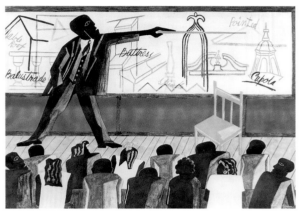

Collection: Current location unknown.

Provenance: [The Downtown Gallery, New York]; Museum of Modern Art, São Paulo, Brazil; [Terry Dintenfass Inc., New York]; Davidson Taylor, New York.

Remarks: A.k.a. *A School Room*.

P46-13
Funeral Sermon
1946
gouache and watercolor on paper
29⅜ × 21⅛ in. (74.6 × 53.7 cm)
signed and dated lower right "Jacob Lawrence 1946 ©"

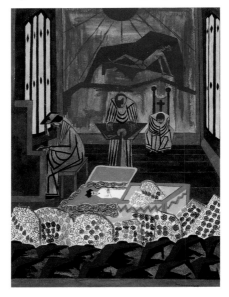

Collection: Brooklyn Museum of Art. Anonymous gift, 48.24.

Provenance: [The Downtown Gallery, New York]; Edith G. Halpert, New York.

Exhibitions: The Downtown Gallery, New York, *Six Artists out of Uniform*, May 7–25, 1946, no. 7; Black Mountain College, Asheville, N.C., July 8–August 28, 1946; Phillips Memorial Gallery, Washington, D.C., *Three Negro Artists: Horace Pippin, Jacob Lawrence, Richmond Barthé*, December 14, 1946–January 6, 1947, no. 35; University of Iowa, Iowa City, *Third Summer Exhibition of Contemporary Art*, June 15–July 30, 1947, no. 62; The Brooklyn Museum, *Thirty-Second Annual Exhibition: The Brooklyn Society of Artists*, February 4–March 7, 1948, no. 75 [watercolor prize winner]; University of Iowa, Iowa City, *Fourth Summer Exhibition of Contemporary Art*, June–July 1948, no. 62; The Detroit Institute of Arts, *Little Show of Work in Progress: Paintings by Robert Gwathmey and Jacob Lawrence, Ceramics by Edwin and Mary Sheier*, January 24–February 19, 1950; The Brooklyn Museum, *Listening to Pictures*, 1968, no. 48; The Brooklyn Museum, *American Watercolors and Pastels from the Museum Collection*, July 3–September 19, 1976; The Morris Museum, Morristown, N.J., *American Realism of the Twentieth Century*, April 14–May 31, 1980; Katonah 1992; Midtown Payson 1995a; Brooklyn Museum of Art, *Masters of Color and Light: Homer, Sargent and the American Watercolor Movement*, March 20–July 5, 1998, no. 130.

References: "The War's Effect on Artists: A Heightening of Their Talents Is Noted," *Pictures on Exhibit* 8, 8 (May 1946), p. 14; A. E. Kruse, "At the Galleries: The Downtown Gallery," *Brooklyn Eagle*, May 12, 1946, p. 30; Howard Devree, "By Groups and One by One," *New York Times*, May 12, 1946; "In the Art Galleries," *New York Herald Tribune*, May 12, 1946; "Art: The Lost and Found," *Newsweek* (May 20, 1946), p. 102; "Reviews and Previews: The Brooklyn Society of Artists," *ARTnews* 44, 1 (March 1948), p. 48; Wheat 1986, p. 92, pl. 36.

P46-14
Going Home
1946
gouache on paper
22 × 30¼ in. (55.9 × 76.8 cm)
signed and dated lower right "Jacob Lawrence / 1946"

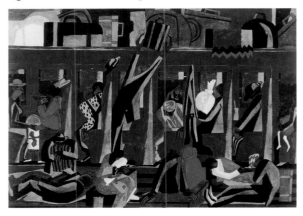

Collection: Jules and Connie Kay.

Provenance: [The Downtown Gallery, New York]; Hale Woodruff, New York; IBM International Foundation, Armonk, New York; [Sotheby's, New York, May 25, 1995, Sale 6713, lot 107].

Exhibitions: Venice, *La Ventiquarto Biennale di Venezia*, 1948, June–December 1948; IBM traveling exhibition, *Contemporary Paintings: Twenty-Five Americans*, August 1949–July 1956; AFA 1960–2, no. 22; IBM Corporation, New York, *Crosscurrents in American Art: Twenty-Five Americans*, September–October 1965; Student Center, Baruch School, City College of New York, April–May 1966; National Collection of Fine Art, Smithsonian Institution, Washington, D.C., March–October 1968; IBM International Foundation, Armonk, N.Y., *People and Places*, January–March 1969; Whitney 1974–5, no. 99; New Muse Community Museum, Brooklyn, *Black Artists of the WPA 1933–1943: An Exhibition of Drawings, Paintings and Sculpture*, February 15–March 30, 1976; Stockton State 1983, no. 13; IBM Gallery of Science and Art, New York, *American Images: Selections from the IBM Collection*, June–July 1984; Seattle 1986–7, no. 69; American Federation of Arts, New York, *In the Spirit of Resistance: African-American Modernists and the Mexican Muralist School*, 1996–8.

References: "Revolt from Victorian Prettiness," *ARTnews Annual* 18 (1948), p. 111, ill.; "The Americans at Venice," *ARTnews* 47, 5 (September 1948), p. 25; Saarinen 1960, p. 31, ill.; Lindsay Patterson, *International Library of Negro Life and History: The Negro in Music and Art* (New York: Publishers Company, 1967), p. 238, ill.; Edmund Burke Feldman, *The Artist* (Englewood Cliffs, N.J.: Prentice-Hall, 1982), p. 214, ill.; Wheat 1986, p. 212, ill.; Christine Lindey, *Art in the Cold War: From Vladivostok to Kalamazoo, 1945–1962* (New York: New Amsterdam Books, 1990), p. 87, ill.; Lizzetta Lefalle-Collins, *In the Spirit of Resistance: African-American Modernists and the Mexican Muralist School* (New York: American Federation of Arts, 1996), p. 31, ill.; Richard J. Powell, *Black Art and Culture in the Twentieth Century* (London: Thames and Hudson, 1997), p. 91, pl. 54.

P46-15
Accident
1946
gouache and watercolor on paper
image: 21½ × 29 in. (54.6 × 73.7 cm)
signed and dated upper left "Jacob Lawrence / 1946"

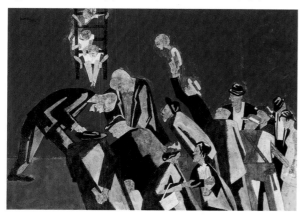

Collection: Gibbes Museum of Art/Carolina Art Association. Museum Purchase with funds provided by the NEA Living Artist Fund, 74.01.

Provenance: [The Downtown Gallery, New York]; Irving Levick, Buffalo; [Terry Dintenfass Inc., New York].

Exhibitions: Whitney 1974–5, no. 98; South Carolina State University, Orangeburg, *South Carolina Collects: Watercolors at S.C. State Museum,* June–September 1997.

References: Norman Lundin, "Jacob Lawrence," *Artweek* (December 7, 1974), p. 1, ill.

P46-16
Antiques
1946
gouache on paper
22 × 30 in. (55.9 × 76.2 cm)
signed and dated lower right "Jacob Lawrence / 1946"

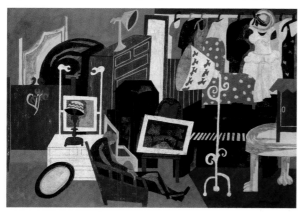

Collection: Susan and Alan Patricof.

Provenance: [The Barnett Aden Gallery, Washington, D.C.]; Charles Sheeler; Estate of Charles Sheeler; [Terry Dintenfass Inc., New York].

Exhibitions: Seattle 1986–7, no. 67.

References: Wheat 1986, p. 212, ill.

Remarks: A.k.a. *Second Hand Shop.*

P46-17
Blind Flower Vendor
1946
watercolor on paper
29½ × 35½ in. (74.9 × 90.2 cm)
signed and dated lower right "Jacob Lawrence 1946"

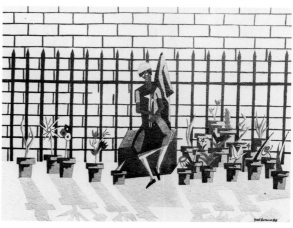

Collection: Black Entertainment Television Holdings, Washington, D.C.

Provenance: [The Barnett Aden Gallery, Washington, D.C.]; Museum of African American Art, Tampa, Fla.

Exhibitions: Walker Art Center, Minneapolis, *One Hundred Thirty-Six American Artists: The Third Annual Purchase Exhibition,* August 25–September 22, 1946, no. 68; Phillips Memorial Gallery, Washington, D.C., *Three Negro Artists: Horace Pippin, Jacob Lawrence, Richmond Barthé,* December 14, 1946–January 6, 1947, no. 32; Associated Artists' Gallery, Washington, D.C., *Exhibition of Contemporary Artists' Works Assembled in Tribute to The Barnett Aden Gallery,* March 8–April 2, 1961, no. 16 (as *Blind Florist*); Anacostia Neighborhood Museum, Smithsonian Institution, Washington, D.C., *The Barnett-Aden Collection,* January 20–May 6, 1974, no. 74; The Art Museum, Princeton University, N.J., *Fragments of American Life, An Exhibition of Paintings: Romare Bearden, Joseph Delaney, Rex Gorleigh, Lois Mailou Jones, Jacob Lawrence, Hughie Lee-Smith, Hale Woodruff,* January 25–March 28, 1976; Frick Fine Arts Museum, University of Pittsburgh, *Black American Art from the Barnett-Aden Collection,* September 17–October 23, 1977.

References: *The Barnett-Aden Collection,* exh. cat. (Washington, D.C.: Smithsonian Institution, 1974), pp. 14, 106, ill.; John Ralph Willis, *Fragments of American Life: An Exhibition of Paintings,* exh. cat. (Princeton, N.J.: Princeton University, 1976), p. 51, ill.; *Black American Art from the Barnett-Aden Collection,* exh. cat. (Pittsburgh: Frick Fine Arts Museum, University of Pittsburgh, 1977), p. 14, pl. 74.

Remarks: A.k.a. *The Blind Florist.*

P46-18
Juke Box
1946
gouache and tempera on paper
image: 29½ × 21⅛ in. (74.9 × 53.7 cm)
unsigned

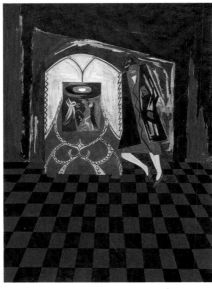

Collection: The Detroit Institute of Arts. Gift of Dr. D. T. Burton, Dr. M. E. Fowler, Dr. J. B. Greene, and Mr. J. J. White.

Provenance: [The Downtown Gallery, New York].

Exhibitions: The Downtown Gallery, New York, *New Important Paintings by Leading Americans*, June 4–29, 1946, no. 10; Van Bark Studios, Studio City, Calif., *American Art by Leading American Progressive Contemporaries from The Downtown Gallery*, October 7–November 2, 1946; Wilmington Society of Arts, Delaware, March 1947; Randolph-Macon Women's College, Ashland, Va., April 1947; Saint Paul Gallery, September 1947; University of Wisconsin, Madison, March 1948; The Downtown Gallery, New York, *Art and/or Money, Part III*, August 2–19, 1949, no. 11; The Detroit Institute of Arts, *Little Show of Work in Progress: Paintings by Robert Gwathmey and Jacob Lawrence, Ceramics by Edwin and Mary Sheier*, January 24–February 19, 1950; Northside Art Center, New York, May 1952; Florida Gulf Coast Circuit, *Fourteenth Southeastern Exchange*, 1953, no. 18; The Detroit Institute of Arts, *American Heritage—People and Places*, June 1964; Hope College, Holland, Mich., *Fine Arts Festival Exhibition*, April 24–May 17, 1965; Eastern Michigan University, Ypsilanti, *Contemporary Afro-American Artists*, October 19–November 20, 1970.

References: "This Week in Art: Crawford Off to Bikini," *New York World-Telegram*, June 15, 1946; Margaret Lowengrund, "Paintings for $250," *Art Digest* 23, 19 (August 1, 1949), p. 15, ill.; "Accessions: January 1, 1953–December 31, 1953," *Bulletin of the DIA* 33, 1 (1953–4), p. 51; "Accessions: Pittsburgh and Elsewhere," *Art Digest* 27, 16 (May 15, 1953), p. 21, ill.; *Twenty-Five Years of American Painting 1933–1958*, exh. cat. (Göteborg, Sweden: Göteborgs Konstmuseum, 1959), no. 37, ill.; Wheat 1986, p. 95, pl. 40.

P46-19
The Lovers
1946
gouache on paper
21½ × 30 in. (54.6 × 76.2 cm)
signed and dated lower right "Jacob Lawrence 1946"

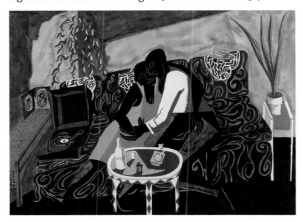

Collection: Mrs. Harpo Marx. Courtesy of Seattle Art Museum.

Provenance: [The Downtown Gallery, New York].

Exhibitions: AFA 1960–2, no. 23 (as *Lovers*); Whitney 1974–5, no. 96; Santa Monica 1982; Seattle 1986–7, no. 70; Northwest Art 1997; Henry Art Gallery 1998.

References: Saarinen 1960, p. 32, ill.; Clifford Smith, "Bright Sorrow," *Time* 77 (February 24, 1961), p. 62, ill.; Brown 1974, p. 29, ill.; Lewis and Sullivan 1982, p. 23, ill.; Wheat 1986, p. 94, pl. 39; Catherine Fox, "Jacob Lawrence, Artist Lifted Beauty from Jaws of Waiting American Nightmare," *Atlanta Journal and Constitution*, December 14, 1986, p. J1, ill.; Ellen Harkins Wheat, "Jacob Lawrence: American Painter," *American Visions* (1987), p. 54, ill.; Ellen Harkins Wheat, "Jacob Lawrence: Chronicler of the Black Experience," *American Visions* 2, 1 (February 1987), p. 34, ill.; bell hooks, *Outlaw Culture: Resisting Representation* (New York: Routledge, 1994), p. 2.

P46-20
The Masked Ball
1946
gouache on paper
19½ × 29½ in. (49.5 × 74.9 cm)
signed and dated upper right "Jacob Lawrence © / 1946"

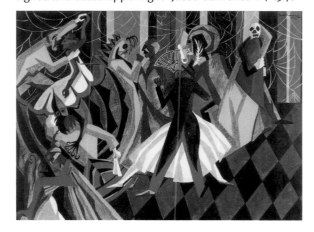

Collection: Blanche and Bud Blank.

Provenance: [The Downtown Gallery, New York]; Dr. and Mrs. Michael Watter, Philadelphia; [Sotheby's, New York, May 25, 1995, Sale 6713, lot 108].

Exhibitions: The Downtown Gallery, New York, *Six Artists out of Uniform*, May 7–25, 1946, no. 6; Phillips Memorial Gallery, Washington, D.C., *Three Negro Artists: Horace Pippin, Jacob Lawrence, Richmond Barthé*, December 14, 1946–January 6, 1947, no. 36; Philadelphia Museum of Art, *The Sonia and Michael Watter Collection*, June 13–October 5, 1958.

References: Thomas B. Hess, "Veterans: Then and Now," *ARTnews* 45, 3 (May 1946), p. 71; A. E. Kruse, "At the Galleries: The Downtown Gallery," *Brooklyn Eagle*, May 12, 1946, p. 30; Howard Devree, "By Groups and One by One," *New York Times*, May 12, 1946; "Art: The Lost and Found," *Newsweek* (May 20, 1946), p. 102.

P46-21
Shooting Gallery
1946
gouache, watercolor, and ink on paper
21¾ × 29½ in. (55.2 × 74.9 cm)
signed and dated lower right "Jacob Lawrence / 1946"

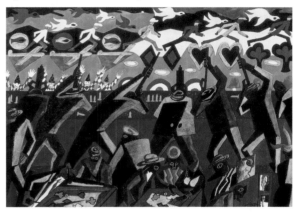

Collection: Walker Art Center, Minneapolis. Gift of Dr. and Mrs. Malcolm McCannel.

Provenance: [The Downtown Gallery, New York]; Mr. and Mrs. Daniel S. Defenbacher.

Exhibitions: American Federation of Arts, New York, *The Second Exhibition of the La Tausca Art Competition*, 1947–8, no. 58; The Minneapolis Institute of Arts, *Watercolor and Drawings from Twin Cities Collections*, July 1–October 1, 1950; Whitney 1974–5, no. 97; Dintenfass 1978; Seattle 1986–7, no. 72.

References: Brown 1974, p. 30, ill.; Wheat 1986, p. 213, ill.

P46-22
Harlem
1946
watercolor and gouache on paper
30½ × 22⁷⁄₁₆ in. (77.5 × 57 cm)
signed and dated lower right "Jacob Lawrence 1946"; inscribed bottom left in margin "Because of the many unwritten covenants that exist in N.Y.C. Decent living quarters come high to thoes [*sic*] Harlemites who can afford to pay."

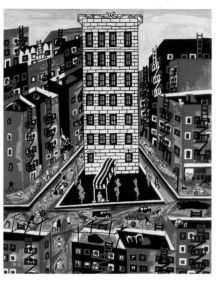

Collection: Auburn University, Auburn, Alabama.

Provenance: War Assets Administration, Washington, D.C.; Alabama Polytechnic Institute (now Auburn University).

Exhibitions: Whitney Museum of American Art, New York, *One Hundred Seventeen Oil and Water Color Originals by Leading American Artists*, May 21–June 18, 1948, no. 104; Union Gallery, Auburn University, Ala., *Advancing American Art, 1946–47: An Exhibition of British and American Paintings*, April 11–30, 1976; Montgomery Museum of Fine Arts, Ala., *Advancing American Art*, January 10–March 4, 1984, no. 49.

References: Bucklin Moon, "The Harlem Nobody Knows," *Glamour* (July 1946), p. 68, ill.; *Catalog of One Hundred Seventeen Oil and Water Color Originals by Leading American Artists*, exh. cat. (Washington, D.C.: War Assets Administration, 1948), no. 104; Margaret Lynne Ausfeld and Virginia M. Mecklenburg, *Advancing American Art: Politics and Aesthetics in the State Department Exhibition 1946–48*, exh. cat. (Montgomery, Ala.: Montgomery Museum of Fine Arts, 1984), p. 84, fig. 41.

P47-01
War
1946–7
egg tempera on hardboard (14 panels)
16 × 20 in. (40.6 × 50.8 cm) // 20 × 16 in. (50.8 × 40.6 cm)

Collection: Whitney Museum of American Art, New York. Gift of Mr. and Mrs. Roy R. Neuberger.

Provenance: [The Downtown Gallery, New York]; Mr. and Mrs. Roy R. Neuberger.

Exhibitions: New Jersey State Museum, Trenton, *Jacob Lawrence: The War Series*, November 2–23, 1947; The Downtown Gallery, New York, *War: Fourteen Paintings in Tempera by Jacob Lawrence*, December 2–27, 1947; Pennsylvania Academy of the Fine Arts, Philadelphia, *The One Hundred Forty-Third Annual Exhibition of Painting and Sculpture*, January 25–February 19, 1948, no. 127 [6]; Smith College Museum of Art, Northampton, Mass., *Jacob Lawrence: The War Series*, April 7–28, 1948; AFA 1960–2, nos. 28–31 [2, 6, 8, 12]; Whitney Museum of American Art, New York, *American Art from the Twentieth Century: Selections from the Permanent Collection*, June 30–September 24, 1967 [4]; The Museum of the National Center of Afro-American Artists, Roxbury, Mass., *Five Famous Black Artists: Romare Bearden, Jacob Lawrence, Horace Pippin, Charles White, Hale Woodruff*, February 9–March 10, 1970 [12 as *Coming Home*]; Whitney 1974–5, nos. 103–8 [1, 2, 3, 6, 8, 12]; Los Angeles County Museum of Art, *Two Centuries of Black American Art*, September 30–November 21, 1976, no. 162 [1]; Whitney Museum of American Art, New York, *Thirty Years of American Art: Selections from the Permanent Collection*, May 6–July 24, 1977 [13]; Whitney Museum of American Art, New York, *Introduction to Twentieth-Century American Art: Selections from the Permanent Collection*, September 16–October 10, 1977 [8]; Montgomery Museum of Fine Arts, Ala., *American Art, 1934–1956: Selections from the Whitney Museum of American Art*, April 26–June 11, 1978, nos. 25–7 [3, 6, 13]; New Jersey State Museum, Trenton, *Six Black Americans: Benny Andrews, Romare Bearden, Sam Gilliam, Richard Hunt, Jacob Lawrence, Betye Saar*, January 26–March 30, 1980, no. 5; Whitney Museum of American Art, New York, *The Figurative Tradition and the Whitney Museum of American Art: Paintings and Sculpture from the Permanent Collection*, June 25–September 28, 1980 [8, 13]; Whitney Museum of American Art, New York, *Decade of Transition: 1940–1950, Selections from the Permanent Collection*, April 30–July 12, 1981; Rutgers University Art Gallery, New Brunswick, N.J., *Realism and Realities: The Other Side of American Painting, 1940–1960*, January 17–March 26, 1982, nos. 90–1 [8, 13]; Seattle 1986–7, nos. 73–6 [2, 3, 12, 13]; Neuberger Museum of Art, Purchase College, State University of New York, *Roy R. Neuberger: Patron of the Arts*, April 25–July 25, 1993, nos. 35–8 [4, 5, 9, 12]; Whitney Museum of American Art at Philip Morris, New York, *Jacob Lawrence: The War Series*, January 11–March 24, 1995; Henry Art Gallery 1998 [2, 3, 7, 8, 11, 12, 13]; Whitney Museum of American Art, New York, *The American Century: Art and Culture 1900–2000, Part 1: 1900–1950*, April 23–August 22, 1999 [13].

References: *War: Fourteen Paintings in Tempera by Jacob Lawrence*, exh. brch. (New York: The Downtown Gallery, 1947), n.p., ill. [6]; "Promises of the New Season in New York," *ARTnews* 46, 8 (October 1947), p. 18, ill. [12]; "Exhibit to Open," *New York Times*, November 2, 1947, p. 6; Alfredo Valente, "Jacob Lawrence," *Promenade* (December 1947), p. 44, ill. [3]; Charles Z. Offin, "Gallery Previews in New York," *Pictures on Exhibit* 10, 3 (December 1947), p. 33, ill. [8]; M. A. Wilder, "New Yorkers to See Jacob Lawrence Exhibition Christmas Week," *Design* 49, 4 (December 1947), p. 15; "Reviews and Previews: Jacob Lawrence," *ARTnews* 46, 10 (December 1947), p. 44, ill. [2]; Helen Carlson, "Inness and Some Moderns," *New York Sun*, December 5, 1947, p. 27 [1]; Dorothy Adlow, "Jacob Lawrence's War Pictures," *Christian Science Monitor*, December 6, 1947, p. 18; Emily Genauer, "Jacob Lawrence War Paintings Are Tragic," *New York World-Telegram*, December 6, 1947, p. 4; Carlyle Burrows, "In the Art Galleries," *New York Herald Tribune*, December 7, 1947, sec. 6, p. 4; Howard Devree, "An Annual Round-Up: Jacob Lawrence," *New York Times*, December 7, 1947, p. 16, ill. [8]; Jo Gibbs, "Lawrence Uses War for New

'Sermon in Paint,'" *Art Digest* 22, 6 (December 15, 1947), p. 10, ill. [12]; "Art: Strike Fast," *Time* 50 (December 22, 1947), p. 61, ill. [6]; "In the World of Books—The Men of World War II Are Now Speaking Out," *Christian Science Monitor*, September 16, 1948, p. 15, ill. [8]; Aline B. Louchheim, "An Artist Reports on the Troubled Mind," *New York Times Magazine*, October 15, 1950, p. 15, ill. [8]; Patricia Blake, "A Sprinkler on the Lawn," *New York Times Book Review*, September 20, 1953, p. 26, ill. [6]; Ralph M. Pearson, *The Modern Renaissance in American Art: Presenting the Work and Philosophy of Fifty-Four Distinguished Artists* (New York: Harper & Brothers, 1954), p. 168; Saarinen 1960, pp. 34–5, ill. [2, 6, 8, 12]; William H. Pierson, Jr. and Martha Davidson, eds. *Arts of the United States: A Pictorial Survey* (New York: McGraw-Hill, 1960), p. 349, ill. [3]; Lloyd Goodrich and John I. H. Baur, *American Art of Our Century* (New York: Frederick A. Praeger, 1961), p. 161, ill. [2, 3]; Vivien Raynor, "In the Galleries: Jacob Lawrence," *Arts* 35, 4 (January 1961), p. 55 [2]; Margaret Rigg, "Jacob Lawrence: Painter," *Motive* (April 1962), p. 23, ill. [6, 8]; *Five Famous Black Artists: Romare Bearden, Jacob Lawrence, Horace Pippin, Charles White, Hale Woodruff*, exh. cat. (Roxbury, Mass.: Museum of the National Center of Afro-American Artists, 1970), n.p., ill.; Lillian Freedgood, *An Enduring Image: American Painting from 1665* (New York: Crowell, 1970), p. 320, ill. [3]; Virginia Lee, "Jacob Lawrence—Story Teller," *Northwest Art News and Views* 1 (March–April 1970), p. 20, ill. [12]; Elsa Honig Fine, *The Afro-American Artist: A Search for Identity* (New York: Hacker Art Books, 1973), p. 147, ill. [1]; Brown 1974, p. 31, ill. [12]; Diane J. Gingold, *American Art, 1934–1956: Selections from the Whitney Museum of American Art*, exh. cat. (Montgomery, Ala.: Montgomery Museum of Fine Arts, 1978), p. 32, ill. [13]; Patricia Hills and Roberta K. Tarbell, *The Figurative Tradition and the Whitney Museum of American Art: Paintings and Sculpture from the Permanent Collection*, exh. cat. (New York: Whitney Museum of American Art, 1980), figs. 99–100 [8, 13]; Patterson Sims, *Decade of Transition, 1940–1950*, exh. brch. (New York: Whitney Museum of American Art, 1981), n.p.; Peter Selz, *Art in Our Times: A Pictorial History 1890–1980* (New York: Harry N. Abrams, 1981), p. 357, pl. 956; Greta Berman and Jeffrey Wechsler, *Realism and Realities: The Other Side of American Painting, 1940–1960*, exh. cat. (New Brunswick, N.J.: Rutgers University Art Gallery, State University of New Jersey, 1982), pp. 34–5, ill. [8, 13]; Lewis and Sullivan 1982, pp. 27–8, ill. [3 as *Shipping Out*; 12 as *Soldiers in Bunk*]; Wheat 1986, pp. 96–8, pls. 41–3 [2, 11, 12]; Irving Sandler, *Roy R. Neuberger: Patron of the Arts*, exh. cat. (Purchase, N.Y.: Neuberger Museum of Art, 1993), p. 59, ill. [12]; Beth Venn, *American Art 1940–1965, Traditions Reconsidered: Selections from the Permanent Collection of the Whitney Museum*, exh. brch. (San Jose, Calif.: San Jose Museum of Art, 1995), p. 3, ill. [8]; Roberta Smith, "Art Review: The Migration from the South in Sixty Images," *New York Times*, January 13, 1995, p. C29, ill. [2]; Barbara Haskell, *The American Century: Art and Culture, 1900–1950*, exh. cat. (New York: Whitney Museum of American Art, 1999), p. 318, ill. [14].

Remarks: Lawrence conceived of this series during his service in World War II, receiving a Guggenheim Fellowship in 1946 for its execution. This is the first series completed by the artist since the *John Brown* series in 1941. Unlike the earlier series, these fourteen paintings were completed one at a time between 1946 and late 1947. Two of the panels are dated "1948" indicating that Lawrence may have made minor changes to those works after they were originally exhibited, or that these two panels were exhibited undated and he added the inscription in 1948. The order in which the panels were originally exhibited establishes a chronological narrative, though the artist did not paint them in that order. The panels are presented here in the order in which they were first exhibited at the New Jersey State Museum and the Downtown Gallery.

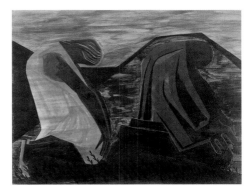

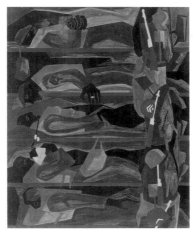

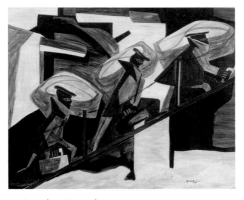

1. *Prayer*
1947
signed and dated lower right "Jacob Lawrence 1947"

2. *Shipping Out*
1947
signed and dated lower right "Jacob Lawrence / 1947"

3. *Another Patrol*
1946
signed and dated lower right "Jacob Lawrence / 1946"

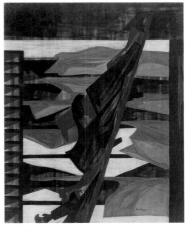

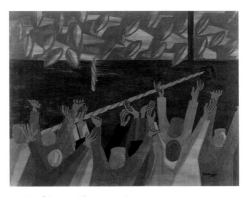

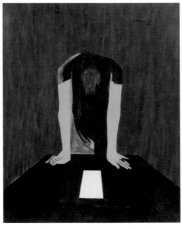

4. *Alert*
1947
signed and dated lower right "Jacob Lawrence 1947"

5. *Docking—Cigarette Joe?*
1947
signed and dated lower right "Jacob Lawrence 1947"

6. *The Letter*
1946
signed and dated upper right "Jacob Lawrence 1946"

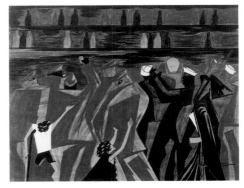

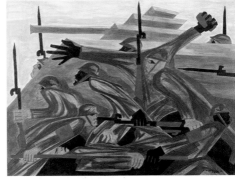

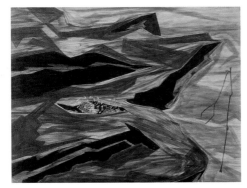

7. *On Leave*
1947
signed and dated lower right "Jacob Lawrence 1947"

8. *Beachhead*
1947
signed and dated lower right "Jacob Lawrence 1947"

9. *How Long?*
1947
signed and dated lower right "Jacob Lawrence 1947"

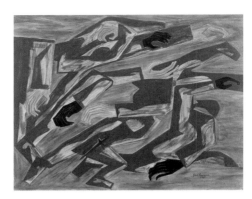

10. *Purple Hearts*
1947
signed and dated lower right "Jacob Lawrence 1947"

11. *Casualty—The Secretary of War Regrets*
1947
signed and dated lower right "Jacob / Lawrence / 1947"

12. *Going Home*
1947
signed and dated lower right "Jacob Lawrence / 1947"

13. *Reported Missing*
1948
signed and dated lower right "Jacob Lawrence / 1948"

14. *Victory*
1948
signed and dated lower right "Jacob Lawrence 1948"

P47-02
Victory
1947
gouache and ink on paper
21¾ × 17 in. (55.2 × 43.2 cm)
signed and inscribed lower right "VICTORY" / Jacob Lawrence";
inscribed top left in margin "14"

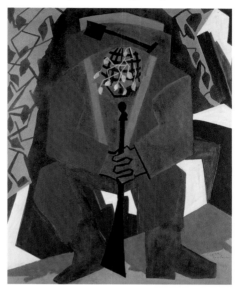

Collection: Ernest P. Bynum and Dennis M. Costin.

Provenance: ?; [Sid Deutsch Gallery, New York]; Aaron Payne, New York.

Remarks: This is a study for *Victory,* panel no. 14 in the *War* series.

P47-03
Men at War
1947
gouache on paper
16 × 20 in. (40.6 × 50.8 cm)
signed and dated lower right "Jacob Lawrence / 1947"

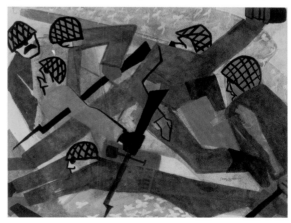

Collection: The Butler Museum of American Art, Youngstown, Ohio. Gift of Marvin Small, 1948.

Provenance: [The Downtown Gallery, New York]; Marvin Small, New York.

Exhibitions: The Butler Institute of American Art, Youngstown, Ohio, *Fifty-Four Paintings, Drawings, Prints by Contemporary Americans Acquired during the Past Year by The Butler Institute,* November 12–December 12, 1948, no. 18; Henry Art Gallery 1998.

P47-04
Untitled [*Sailors at a Bar*]
1947
tempera on paper
15½ × 19¾ in. (39.4 × 50.2 cm)
signed and dated lower right "JACOB / LAWRENCE / 1947"

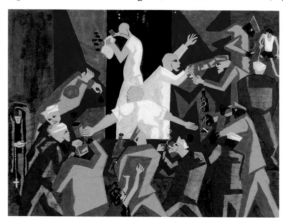

Collection: Dr. Meredith F. and Gail Wright Sirmans.

Provenance: ?; [Luise Ross Gallery, New York].

Exhibitions: Bellevue Art Museum, Wash., *Hidden Heritage: Afro-American Art, 1800–1950,* September 14–November 10, 1985, no. 79.

References: David C. Driskell, *Hidden Heritage: Afro-American Art, 1800–1950,* exh. cat. (San Francisco: Art Museums Association of America, 1985), p. 78, fig. 49.

P47-05
Naples—1944
1947
egg tempera on hardboard
16 × 20 in. (40.6 × 50.8 cm)
signed and dated lower right "Jacob Lawrence / 1947"

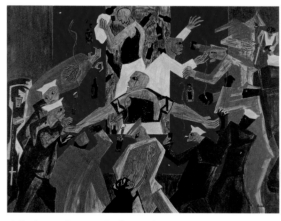

Collection: Paula Granoff, Palm Beach.

Provenance: The Downtown Gallery, New York; Arthur B. Spingarn, New York; [Sotheby Parke Bernet, New York, May 24, 1972, lot 184]; Dr. John J. McDonough, Youngstown, Ohio; [Sotheby Parke Bernet, New York, March 22, 1978, Sale 4098, lot 62].

Exhibitions: New Orleans Museum of Art, *A Panorama of American Painting: The John J. McDonough Collection,* April–June 1975, no. 30.

References: Edward Alden Jewell, "Art: Examples of Modernism in New Shows," *New York Times,* September 28, 1947, sec. 2, p. 7; John E. Bullard, *A Panorama of American Painting: The John J. McDonough Collection,* exh. cat. (New Orleans: New Orleans Museum of Art, 1975), p. 38, p. 116, pl. 58; Fran Preisman, "The John J. McDonough Collection," *Artweek* (July 26, 1975), p. 4, ill. (as *Drama—Halloween Party*).

P47-06
Letter from Home
1947
egg tempera on hardboard
19¾ × 15¹⁵⁄₁₆ in. (50.2 × 40.5 cm)
signed and dated lower right "Jacob Lawrence / 1947"; verso:
inscribed upper left "#162 / Letter from Home"

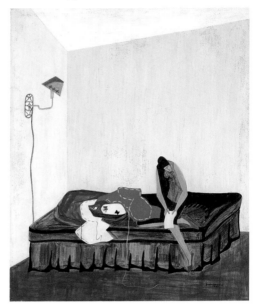

Collection: Michael Rosenfeld Gallery, New York.
Provenance: [The Downtown Gallery, New York]; Alan Brandt, New York.
Remarks: A.k.a. *Letter from Europe.*

P47-07
Dancing Doll
1947
egg tempera on hardboard
20¼ × 24⅛ in. (51.4 × 61.3 cm)
signed and dated lower right "Jacob Lawrence / 1947"

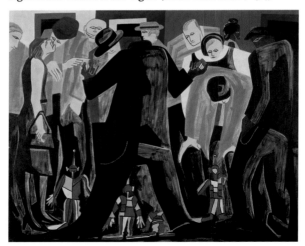

Collection: Frederick R. Weisman Art Museum at the University of Minnesota. Bequest of Hudson Walker from the Ione and Hudson Walker Collection.
Provenance: [The Downtown Gallery, New York]; Ione and Hudson Walker, Minneapolis.
Exhibitions: The University Gallery, University of Minnesota, Minneapolis, *Selected Works from the Collection of Ione and Hudson Walker,* 1959; The University Gallery, University of Minnesota, Minneapolis, *Art and the University of Minnesota,* September–November 1961; The University Gallery, University of Minnesota, Minneapolis, *Hudson D. Walker: Patron and Friend, Collector of Twentieth-Century American Art,* 1977, no. 46; Special Collections and Rare Books, University of Minnesota Libraries, Minneapolis, *Witnessing Afro-American Life, Literature, and Achievement: The Archie Givens, Sr. Collection,* October 24–December 19, 1986; Henry Art Gallery 1998.
References: Percy North, *Hudson D. Walker: Patron and Friend, Collector of Twentieth Century American Art,* exh. cat. (Minneapolis: University Gallery, 1977), p. 36, ill.; *American Paintings and Sculpture in the University Art Museum Collection* (Minneapolis: University of Minnesota, 1986), pp. 258–9; p. 260, ill.
Remarks: In a letter to Mark R. Kriss, a researcher at the Weisman Museum in 1978, Jacob Lawrence stated: "This is a street scene of peddlers selling dolls which dance. The doll dances as it is manipulated by an invisible string."

P47-08
Children at Play
1947
tempera on hardboard
20 × 24 in. (50.8 × 61 cm)
signed and dated lower right "Jacob Lawrence / 1947"

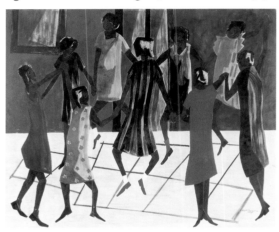

Collection: Georgia Museum of Art, University of Georgia. Eva Underhill Holbrook Memorial Collection of American Art. Gift of Alfred H. Holbrook, 47.178.
Provenance: [The Downtown Gallery, New York].
Exhibitions: Georgia Museum of Art, University of Georgia, Athens, *Holbrook Collection: New Acquisitions,* January 19–February 5, 1948, no. 25; Georgia Museum of Art, University of Georgia, Athens, *Dedication Exhibition,* January 28–February 22, 1958, no. 57; Georgia Museum of Art, University of Georgia, Athens, *A University Collects: Georgia Museum of Art,* November 8–30, 1969, no. 28; The Tampa Museum, Fla., *Games Kids Play,* July 1–September 10, 1982, no. 23; Georgia Museum of Art, University of Georgia, Athens, *Hidden Masterpieces,* June 16–September 11, 1983; Georgia Museum of Art, University of Georgia, Athens, *Through the Eyes of Artists: Portrayals of Blacks from the Collection of the University of Georgia,* February 2–March 10, 1991; Samuel P. Harn Museum of Art, University of Florida, Gainesville, *America's Mirror: Painting in the United States, 1850–1950 from the Collection of The Georgia Museum of Art, the University of Georgia,* November 26, 1994–March 15, 1995; Radford Study Collection Gallery, Georgia Museum of Art, University of Georgia, Athens, *Inspirations: Four Twentieth-Century African-American Artists,* January 17–February 16, 1997.
References: *The Eva Underhill Holbrook Memorial Collection of the Georgia Museum of Art,* exh. cat. (Athens, Ga.: Georgia Museum of Art, University of Georgia, 1953), p. 24, no. 151, ill.; [Catalogue of the Georgia Museum of Art Collection] (Athens, Ga.: Georgia Museum of Art, University of Georgia, 1969), no. 28, ill.

P47-09
The Checker Players
1947
egg tempera on hardboard
20 × 24 in. (50.8 × 61 cm)
signed and dated lower left "Jacob Lawrence / 1937" [*sic*]; verso: inscribed top left "MATEL" [vertical] and "Jacob Lawrence #178 / The Checker Players"

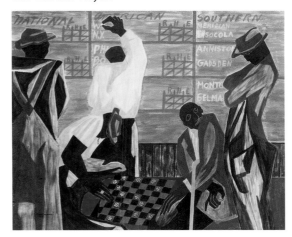

Collection: Worcester Art Museum, Worcester, Massachusetts. Gift of Saundra B. Lane in memory of her husband William H. Lane and purchase through the Stoddard Acquisition Fund.

Provenance: [The Downtown Gallery, New York]; Selden Rodman, Oakland, N.J.; [Terry Dintenfass Inc., New York]; Mr. and Mrs. William H. Lane, Leominster, Mass.

Exhibitions: University Art Galleries, University of Nebraska, Lincoln, *Fifty-Eighth Annual Exhibition of Contemporary Art*, February 29–March 28, 1948, no. 125; Evanston Art Center, Ill., October 1948; Stephens College Art Gallery, Columbia, Mo., March 1949; The William Benton Museum of Art, University of Connecticut, Storrs, *Selections from the William H. Lane Foundation*, May 17–May 25, 1975, no. 48; The William Benton Museum of Art, University of Connecticut, Storrs, *Selections from The William H. Lane Foundation: Part II*, January 22–March 11, 1979, no. 63.

References: Romare Bearden and Harry Henderson, *Six Black Masters of American Art* (Garden City, N.Y.: Doubleday, 1972), p. 101, ill.

Remarks: Incorrectly dated "1937" by the artist in 1947.

P47-10
Playland
1947
egg tempera on hardboard
24 × 20 in. (61 × 50.8 cm)
signed and dated lower right "Jacob Lawrence / 1947"

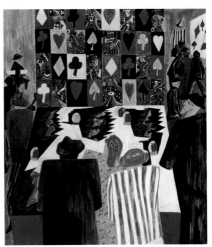

Collection: Clark Atlanta University. Collection of African American Art, First Atlanta University Purchase Award in Watercolor, 1948.

Provenance: [The Downtown Gallery, New York].

Exhibitions: California Palace of the Legion of Honor, San Francisco, October 1947; Atlanta University, *Seventh Annual Exhibition of Paintings, Sculptures, Prints by Negro Artists*, April 4–May 2, 1948, no. 31; High Museum of Art, Atlanta, *Highlights from the Atlanta University Collection of Afro-American Art*, November 11–December 9, 1973, no. 36; Whitney 1974–5, no. 110 (as *(Broadway) Playland*); Montgomery Museum of Fine Arts, Ala., *Turning Point: The Harlem Renaissance*, March 26–May 30, 1985; Addison Gallery of American Art, Phillips Academy, Andover, Mass., and The Studio Museum in Harlem, New York, *To Conserve a Legacy: American Art from Historically Black Colleges and Universities*, 1999–2001, no. 156.

References: *Highlights from the Atlanta University Collection of Afro-American Art*, exh. cat. (Atlanta: High Museum of Art, 1973), no. 36, ill.; Richard Powell and Jock Reynolds, *To Conserve a Legacy: American Art from Historically Black Colleges and Universities*, exh. cat. (Andover, Mass.: Addison Gallery of American Art; New York: The Studio Museum in Harlem, 1999), p. 210, ill.

Remarks: A.k.a. *(Broadway) Playland*; won first place purchase prize ($150) in Atlanta University Annual in 1948.

P47-11
Tailors
1947
egg tempera on hardboard
20 × 24 in. (50.8 × 61 cm)
signed and dated lower right "Jacob Lawrence / 1947"

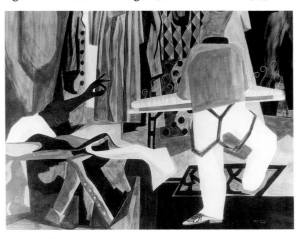

Collection: Current location unknown.

Provenance: [The Downtown Gallery, New York]; Mr. and Mrs. John Hay Whitney, New York.

Exhibitions: The Downtown Gallery, New York, *The Twenty-Second Annual Fall Exhibition: New Paintings and Sculpture by Leading American Artists*, September 23–October 18, 1947, no. 10.

References: Charles Z. Offin, "Gallery Previews in New York," *Pictures on Exhibit* 10, 1 (October 1947); "New Paintings," *ARTnews* 46, 8 (October 1947).

Remarks: This painting was last seen in the residence of John Hay Whitney when he was ambassador to Great Britain between 1957 and 1961.

In the Heart of the Black Belt

1947

In 1947, Walker Evans at *Fortune* magazine commissioned the artist to execute a number of paintings depicting the lives of African Americans in the southern Black Belt. Lawrence traveled to the Black Belt in June and July and painted the works upon his return to New York City. Three of the ten paintings Lawrence completed were reproduced in *Fortune* with text written by Walker Evans (only seven of these have been located). In the article, Evans describes the three paintings as part of a series. Lawrence has recently stated that he never considered the paintings as a series, but as a thematic group of individual works. As he did with the "Harlem" paintings (1943) and many of his series, the artist developed captions for the individual panels.

The artist has noted: "Most of my time was spent in the Mississippi Delta where cotton is still king and where Negroes outnumber whites everywhere and in some areas as much as two to one. For outnumbering the whites, the Negro pays dearly. He is denied first-class citizenship, and civil liberties are the properties of white men. A few Negroes have attained affluence by submitting to and using the feudal tradition of the South. A small minority are even upholding this tradition for the uncertainties it affords them. But there are other Negroes—teachers, lawyers, social scientists, farmers, and social workers—who are working hard to obtain equality of economic, educational, and social status, which has been denied several millions of Negroes for over three hundred years. These are the men and women who are optimistic, and rightfully so, concerning the Negroes future not only in the South but in the United States."

P47-12
In the Heart of the Black Belt
1947
egg tempera on hardboard
20 × 24 in. (50.8 × 61 cm)
signed and dated lower right "Jacob Lawrence 1947"

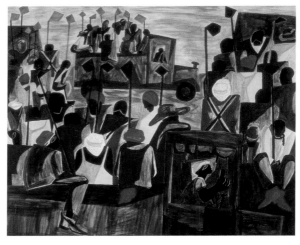

Collection: Orange County Museum of Art, Newport Beach, California. Bequest of Betty Jane Cook.

Provenance: [The Downtown Gallery, New York]; Paul M. Cook; Betty Jane Cook.

Exhibitions: Virginia Museum of Fine Arts, Richmond, *The Sixth Biennial Exhibition of Contemporary American Paintings*, February 1948; Carnegie Institute, Pittsburgh, *Painting in the United States, 1948*, October 14–December 12, 1948, no. 123; Stephens College Art Gallery, Columbia, Mo., March 1949; Pennsylvania Academy of the Fine Arts, Philadelphia, *The Forty-Eighth Annual Philadelphia Water Color and Print Exhibition*, October 28–November 26, 1950, no. 279.

References: Walker Evans, "In the Heart of the Black Belt," *Fortune* 37, 2 (August 1948), p. 88, ill.

Caption: Within a one hundred mile radius of Memphis, Tennessee, there are approximately four million Negroes—or one third the entire Negro population of the United States.

P47-13
Beer Hall
1947
egg tempera on hardboard
19½ × 23⅜ in. (49.5 × 59.4 cm)
signed and dated lower right "Jacob Lawrence 1949"

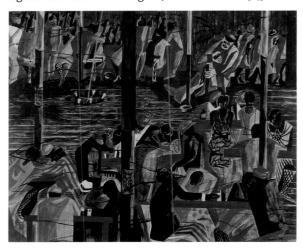

Collection: Lorraine Gordon, New York.

Provenance: [The Downtown Gallery, New York]; Mr. and Mrs. Max Gordon, New York.

Exhibitions: Whitney 1974–5, no. 100; Seattle 1986–7, no. 77.

References: Wheat 1986, p. 213, ill.

Remarks: A.k.a. *Southern Café—Beer Hall*. This painting appears to be dated 1949 by the artist but it was painted in 1947.

Caption: "There is no villain, no idiot, no saint. There are just men; men who crave ease and power, men who know want and hunger, men who have crawled. They all dream and strive with ecstasy of fear and strain of effort, balked of hope and hate." —W. E. Burghardt DuBois, *Black Reconstruction*

P47-14
Cat Fish Row
1947
egg tempera on hardboard
18½ × 23½ in. (47 × 59.7 cm)
signed and dated lower right "Jacob Lawrence / 1947"

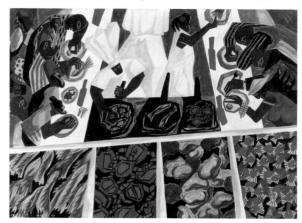

Collection: Susie Ruth Powell and Franklin R. Anderson.

Provenance: [The Downtown Gallery, New York]; Dr. and Mrs. Robert D. Straus, Houston; [Francine Seders Gallery, Seattle].

Exhibitions: AFA 1960–2, no. 31; Whitney 1974–5, no. 101; Seattle 1986–7, no. 79; Henry Art Gallery 1998.

References: Ralph M. Pearson, *The Modern Renaissance in American Art: Presenting the Work and Philosophy of Fifty-Four Distinguished Artists* (New York: Harper & Brothers, 1954), p. 166, fig. 99, ill.; Saarinen 1960, p. 36, ill.; Brown 1974, p. 32, ill.; Wheat 1986, p. 213, no. 79, ill.

Caption: "The Great Mississippi Delta begins at the lobby of the Peabody Hotel in Memphis, Tennessee, and ends on Cat Fish Row in Vicksburg, Mississippi."—Folk Saying

P47-15
Red Earth—Georgia
1947
egg tempera on hardboard
20 × 24 in. (50.8 × 61 cm)
signed and dated lower right "Jacob Lawrence / 1947"

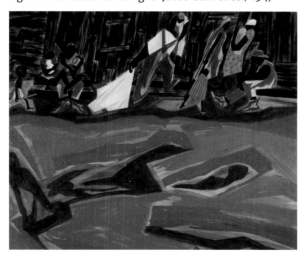

Collection: Private collection, Palm Springs.

Provenance: [The Downtown Gallery, New York]; Robert Blackburn, New York; [The Downtown Gallery, New York].

Exhibitions: The Detroit Institute of Arts, *Little Show of Work in Progress: Paintings by Robert Gwathmey and Jacob Lawrence, Ceramics by Edwin and Mary Sheier*, January 24–February 19, 1950; Watkins Gallery, American University, Washington, D.C., *Objective and Non-Objective*, April 16–May 5, 1950; Whitney 1974–5, no. 102 (Whitney only).

References: Wheat 1986, p. 99, pl. 44.

Caption: Within the black belt can be found most of the Negro wealth in the United States. There are palatial homes, palatial funeral parlors, rich insurance companies and a few banks—but the great mass of people are poor.

P47-16
July 4th, Independence Day, Vicksburg, Mississippi
1947
egg tempera on hardboard
20 × 24 in. (50.8 × 61 cm)
signed and dated lower right "Jacob Lawrence 1947"

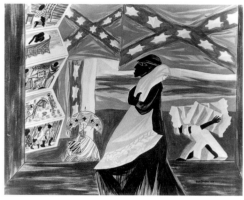

Collection: Current location unknown.

Provenance: [The Downtown Gallery, New York].

Caption: "Suffering is not to be measured so much by outward circumstances as by inward emotions."—Henri Taine

P47-17
Migration
1947
egg tempera on hardboard
20 × 24 in. (50.8 × 61 cm)
signed and dated lower right "Jacob Lawrence 1947"

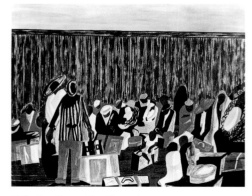

Collection: Current location unknown.

Provenance: [The Downtown Gallery, New York].

Caption: Newer farm machinery that can do the work of many hands, along with racial disturbances, are the causes of a perennial migration of the southern Negro from rural to urban communities within the south and from southern to northern communities within the country.

P47-18
Gee's Bend
1947
egg tempera on hardboard
20 × 24 in. (50.8 × 61 cm)
signed and dated lower right "Jacob Lawrence / 1947"

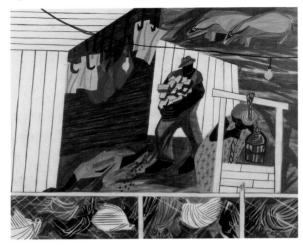

Collection: Evansville Museum of Arts and Science, Evansville, Indiana.

Provenance: [The Downtown Gallery, New York]; Mrs. Katherine Owen, Houston, Tex. and New Harmony, Ind.; Jane Blaffer Owen.

Exhibitions: Paducah Art Guild, Ky., December 1977–February 1978.

References: Walker Evans, "In the Heart of the Black Belt," *Fortune* 37, 2 (August 1948), p. 89, ill.; Ben Richardson, *Great American Negros* (New York: Crowell, 1956), p. 109; Myron Schwartzman, *Romare Bearden: His Life and Art* (New York: Harry N. Abrams, 1990), p. 100, ill.

Caption: "On May 3rd, 1943, William E. Street, Field Representative for Region Five of the F.S.A., took me to Gee's Bend, one of the projects of the Farm Security Administration in Wilcox County, Alabama, in order that I might see the wonders that have been wrought since this bureau took over Gee's Bend in 1936. As we neared the place I could see that it really was not the Gee's Bend of forty years ago. I saw beautifully built homes, fine pigs running around in the lots, hundreds of chickens on each yard, and above all, the gardens full of different types of vegetables."—From *In this Gee's Bend of Forty Years Ago* by S. B. Coles

P47-19
The Builders
1947
egg tempera on hardboard
19¼ × 23½ in. (48.9 × 59.7 cm)
signed and dated lower right "Jacob Lawrence / 1947"

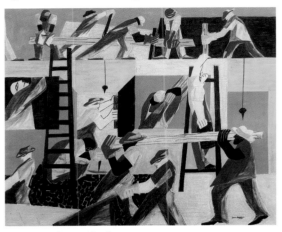

Collection: Private collection.

Provenance: [The Downtown Gallery, New York].

Exhibitions: Williams College, Williamstown, Mass., *Second Williams Alumni Art Show*, May 9–June 13, 1976; Seattle 1986–7, no. 78; Williams College, Williamstown, Mass., *Third Williams Alumni Loan Exhibition*, June 12–November 28, 1993.

References: Wheat 1986, p. 213, ill.

Caption: In New Orleans, Louisiana, the Negro has made his greatest step toward economic security. He has large membership in trade unions (A.F.L. and C.I.O.) and representation on the executive board of the Louisiana State Federation of Labor.

P47-20
A Class in Shoemaking
1947
egg tempera on hardboard
20 × 24 in. (50.8 × 61 cm)
signed and dated lower right "Jacob Lawrence / 1947"

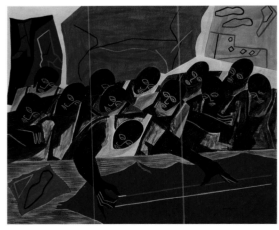

Collection: Carnegie Mellon University, Pittsburgh.

Provenance: [The Downtown Gallery, New York]; Mr. and Mrs. Carl Norden, Pittsburgh.

References: Aline B. Louchheim, "An Artist Reports on the Troubled Mind," *New York Times Magazine*, October 15, 1950, p. 35, ill.; Louise Elliot Rago, "A Welcome for Jacob Lawrence," *School Arts* (February 1963), pp. 31–2.

Caption: Knowing the value of an industrial skill as well as an academic education the Negro, for many years, has worked hard to obtain both.

P47-21
The Businessmen
1947
egg tempera on hardboard
20 × 24 in. (50.8 × 61 cm)
signed and dated upper right "Jacob Lawrence / 1947"

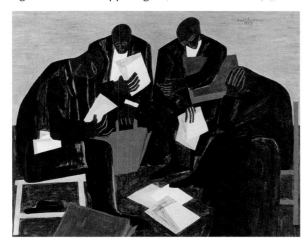

Collection: Current location unknown.

Provenance: [The Downtown Gallery, New York]; William Keighley, Los Angeles.

Exhibitions: Whitney Museum of American Art, New York, *1948 Annual Exhibition of Contemporary American Sculpture, Watercolors, and Drawings*, January 31–March 21, 1948, no. 115; University of Iowa, Iowa City, *Fourth Summer Exhibition of Contemporary Art*, June–July 1948, no. 60.

References: Thomas B. Hess, "Pity the Poor Sculptor," *ARTnews* 47, 1 (March 1948), p. 56; Walker Evans, "In the Heart of the Black Belt," *Fortune* 37, 2 (August 1948), p. 89, ill.; Herbert Matter, "Fifty-Three Living American Artists," *Vogue* 115, 2 (February 1, 1950), p. 151, ill.

Caption: "Whereas church leadership in the Negro community was once dominant, such leadership now has to share its influence with publicly financed institutions whose emphases are secular."—Dr. Quarles, Dean, Dillard University, New Orleans

P48-01
Woman Sewing
1948
egg tempera on hardboard
17⅞ × 23⅞ in. (45.4 × 60.6 cm)
signed and dated lower right "Jacob Lawrence 48"

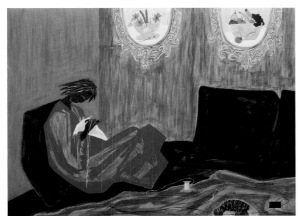

Collection: Private collection.

Provenance: [The Downtown Gallery, New York]; Private collection, Houston.

P48-02
Flower Woman
1948
egg tempera on hardboard
20 × 24 in. (50.8 × 61 cm)
signed and dated lower center/right "Jacob Lawrence 48"

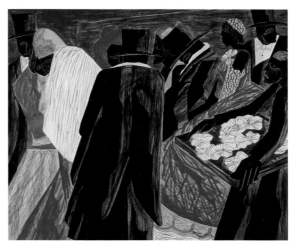

Collection: Mary P. Hines, Winnetka, Illinois.

Provenance: [The Downtown Gallery, New York]; Mrs. Francis W. Pick, Glencoe, Ill.

Exhibitions: The Downtown Gallery, New York, *Christmas 1948*, December 7–31, 1948.

References: Romare Bearden and Carl Holty, *The Painter's Mind* (New York: Crown Publishers, 1967), p. 209, ill.

P48-03
Kibitzers
1948
egg tempera on hardboard
20 × 24 in. (50.8 × 61 cm)
signed and dated upper left "Jacob Lawrence 48"

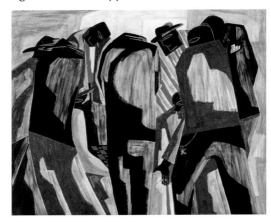

Collection: Addison Gallery of American Art, Phillips Academy, Andover, Massachusetts. Gift of the Childe Hassam Fund of the American Academy of Arts and Letters.

Provenance: [The Downtown Gallery, New York]; The American Academy of Arts and Letters, New York.

Exhibitions: Pennsylvania Academy of the Fine Arts, Philadelphia, *The Forty-Seventh Annual Water Color and Print Exhibition*, October 29–December 4, 1949, no. 609; The Thompson Gallery, Massachusetts College of Art, Boston, *Jacob Lawrence*, January 20–February 15, 1984; Addison Gallery of American Art, Phillips Academy, Andover, Mass., *The American City*, January 18–March 10, 1991; Addison Gallery of American Art, Phillips Academy, Andover, Mass., *American Abstraction at the Addison Gallery of American Art*, April 18–July 31, 1991; Addison Gallery of American Art, Phillips Academy, Andover, Mass., *Addison Gallery of American Art: Sixty-Five Years*, April 13–July 31, 1996; Addison Gallery of American Art, Phillips Academy, Andover, Mass., *Form and Structure: Twentieth-Century Work from the Addison Collection*, December 28, 1998–April 25, 1999.

References: "Watercolors at Philadelphia: A Preview of Pennsylvania Academy's Forty-Seventh Annual Exhibition," *Pictures on Exhibit* 12, 2 (November 1949), p. 5, ill.; Powell 1992, n.p., pl. 7.

P48-04
Rummage Sale
1948
egg tempera on hardboard
24 × 20 in. (61 × 50.8 cm)
signed and dated lower right "Jacob Lawrence 48"

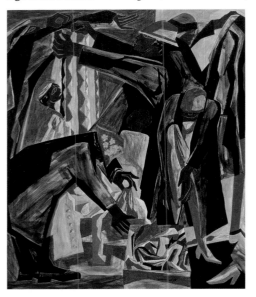

Collection: Private collection.

Provenance: [The Downtown Gallery, New York]; Nelson A. Rockefeller, New York.

References: Dorothy Drummond, "Watercolor Annual at Pennsylvania Academy," *Art Digest* 23, 4 (November 15, 1948), p. 26.

P48-05
Ambulance Call
1948
egg tempera on hardboard
24 × 20 in. (61 × 50.8 cm)
signed and dated lower right "Jacob Lawrence 48"

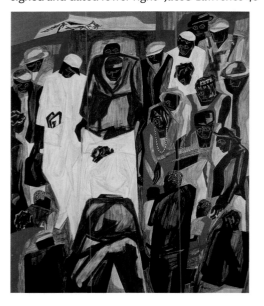

Collection: Private collection.

Provenance: The Downtown Gallery, New York; [Carlen Galleries, Philadelphia]; Dr. and Mrs. Bernard J. Ronis, Philadelphia.

Exhibitions: Pennsylvania Academy of the Fine Arts, Philadelphia, *The Forty-Sixth Annual Philadelphia Water Color and Print Exhibition*, November 7–December 12, 1948, no. 249.

References: Cedric Dover, *American Negro Art* (Greenwich, Conn.: New York Graphic Society, 1960), p. 25, ill.; Clifford Wright, "Jacob Lawrence," *The Studio* 161 (January 1961), pp. 26–8, ill.

P48-06
Summer Street Scene
1948
tempera on hardboard
20⅜ × 24¼ in. (51.8 × 61.6 cm)
signed and dated lower right "Jacob Lawrence / 48"

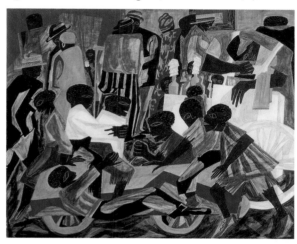

Collection: Memorial Art Gallery of the University of Rochester. Marion Stratton Gould Fund.

Provenance: [The Downtown Gallery, New York]; Alfred E. Jones, New York; [Vanderwoude Tananbaum Gallery, New York].

Exhibitions: California Palace of the Legion of Honor, San Francisco, *Third Annual Exhibition of Painting*, December 1, 1948–January 16, 1949; AFA 1960–2, no. 32; Whitney 1974–5, no. 109.

References: Saarinen 1960, p. 37, ill.; Brown 1974, p. 32, ill.

Remarks: A.k.a. *Summer Street Scene in Harlem*. Memorial Art Gallery notes that the medium is not egg tempera.

P48-07
Shoe-Shine Boys
1948
egg tempera on hardboard
20 × 24 in. (50.8 × 61 cm)
signed and dated lower right "Jacob Lawrence 48"

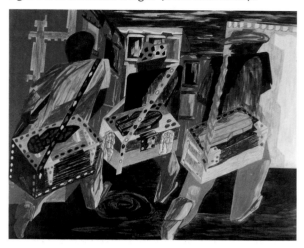

Collection: Mrs. Patricia Burrows, Connecticut.

Provenance: [The Downtown Gallery, New York]; Mrs. Enid Bassett; [Parke Bernet Galleries, New York, December 12, 1974, Sale 3706, lot 2]; Mr. and Mrs. Selig Burrows, Palm Beach, Fla.

Exhibitions: The Downtown Gallery, New York, *The Twenty-Third Annual Exhibition: New Paintings and Sculpture by Leading American Artists*, September 28–October 2, 1948, no. 10; The American Academy of Arts and Letters, New York, *Exhibition of Work by Newly Elected Members, Recipients of Honors, and Childe Hassam Fund Purchases*, May 28–June 28, 1953, no. 41; Seattle 1986–7, no. 80; Katonah 1992; Michael Rosenfeld Gallery, New York, *African-American Art: Twentieth Century Masterworks II*, February 1–April 8, 1995, no. 14.

References: Margaret Breuning, "Downtown's Annual," *Art Digest* 23, 2 (October 15, 1948); Wheat 1986, p. 213, no. 80, ill.; Richard J. Powell, *African-American Art: Twentieth Century Masterworks II*, exh. cat. (New York: Michael Rosenfeld Gallery, 1995), p. 41, ill.

P48-08
The Wedding
1948
egg tempera on hardboard
20 × 24 in. (50.8 × 61 cm)
signed and dated lower right "Jacob Lawrence 48"

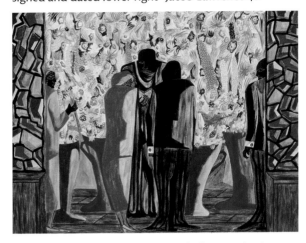

Collection: The Art Institute of Chicago. Gift of Mary P. Hines in memory of her mother Frances W. Pick, 1993.258.

Provenance: [The Downtown Gallery, New York]; Mrs. Frederick Forsythe, Ann Arbor; Mr. and Mrs. Franklin Forsythe, Laguna Beach, Calif.; [Terry Dintenfass Inc., New York]; Dr. Daniel J. Whitner, Atlanta; [Christie, Manson & Woods, New York, September 28, 1989, lot 346]; Mr. and Mrs. John Whitney Payson, Hobe Sound, Fla.; [Midtown Payson Galleries, New York].

Exhibitions: The Downtown Gallery, New York, *The Artist Speaks*, April 5–23, 1949, no. 10; Carnegie Institute, Pittsburgh, *Painting in the United States, 1949*, October 13– December 11, 1949, no. 51; AFA 1960–2, no. 33; The Corcoran Gallery of Art, Washington, D.C., *National Conference on the Arts Honors Ten African-American Artists*, March 14– April 16, 1980; Thomas J. Walsh Gallery, Fairfield University, Conn., *Human Conditions: American Twentieth-Century Paintings and Drawings*, February 7–March 7, 1992; The Art Institute of Chicago, *Spiritual Expressions: Art for Private Contemplation and Public Celebration*, November 22, 1995–March 17, 1996.

References: "Art: Questions and Answers," *Time* 53 (April 11, 1949), p. 57, ill.; Margaret Breuning, "Carnegie Presents Last and Best Alt American Annual," *Art Digest* 24, 2 (October 15, 1949), pp. 7–9; Saarinen 1960, p. 37, ill.; Wheat 1986, p. 100, pl. 46.

P48-09
Gypsies
1948
egg tempera on hardboard
20 × 24 in. (50.8 × 61 cm)
signed and dated lower right "Jacob Lawrence 1948"

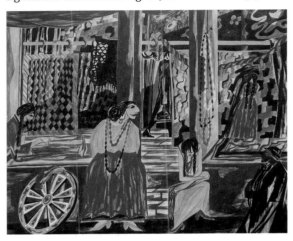

Collection: Bennett College, Greensboro, North Carolina.
Provenance: [The Downtown Gallery, New York].

P48-10
Saturday Night
1948
egg tempera on hardboard
21¼ × 24¾ in. (54 × 62.9 cm)
signed and dated lower right "Jacob Lawrence 48"

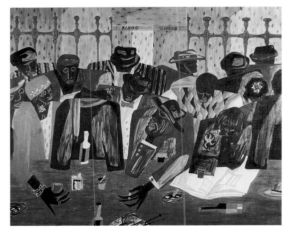

Collection: Clark Atlanta University Art Collections. Gift of Chauncey and Catherine Waddell.

Provenance: [The Downtown Gallery, New York].

Exhibitions: Worcester Art Museum, Mass. [Biennial Exhibition], December 1948– January 1949; University Art Galleries, University of Nebraska, Lincoln, *NAA Fifty-Ninth Annual Exhibition of Contemporary Art*, March 6–April 3, 1949; Whitney Museum of American Art, New York, *1949 Annual Exhibition of Contemporary American Sculpture, Watercolors, and Drawings*, April 2–May 8, 1949, no. 115; Worcester Art Museum, Mass., *American Painting since the Armory Show from the William H. Lane Foundation*, July 1– September 10, 1957; High Museum of Art, Atlanta, *Highlights from the Atlanta University Collection of Afro-American Art*, November 11–December 9, 1973, no. 37; High Museum of Art, Atlanta, *African-American Art in Atlanta: Public and Corporate Collections*, May 11–June 17, 1984.

References: "Worcester Biennial Holds Public Interest," *Art Digest* 23, 6 (December 15, 1948), p. 14; *Highlights from the Atlanta University Collection of Afro-American Art*, exh. cat. (Atlanta: High Museum of Art, 1973), no. 37.

P48-11
Birth
1948
egg tempera on hardboard
20 × 16 in. (50.8 × 40.6 cm)
signed and dated lower right "Jacob Lawrence 48"

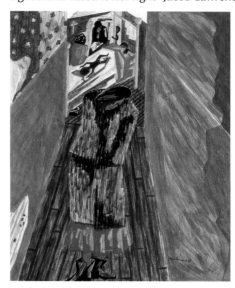

Collection: Patrick and Beatrice Haggerty Museum of Art, Marquette University, Milwaukee. Museum Purchase, The Mary B. Finnigan Art Endowment Fund.

Provenance: Jacob and Gwendolyn Knight Lawrence, New York; Pinelas Family Collection; Joel Levy, New York; [Michael Rosenfeld Gallery, New York].

Exhibitions: Michael Rosenfeld Gallery, New York, *African-American Art: Twentieth Century Masterworks*, November 18, 1993–February 12, 1994; Henry Art Gallery 1998; The Patrick and Beatrice Haggerty Museum of Art, Marquette University, Milwaukee, *Children in Art: A Century of Change*, February 12–May 23, 1999.

References: Beryl J. Wright, *African-American Art: Twentieth Century Masterworks*, exh. cat. (New York: Michael Rosenfeld Gallery, 1993), p. 13, ill.

Remarks: One of two paintings commissioned by *Seventeen* magazine in 1948, this work was never published. The artist completed this work first, then executed *The Fur Coat*, which contains the same subject matter but reverses the foreground and background elements. *The Fur Coat* has not been located.

P49-01
Paper Boats
1949
egg tempera on hardboard
17⅞ × 23⅞ in. (45.4 × 60.6 cm)
signed and dated upper right "Jacob Lawrence / 1949"

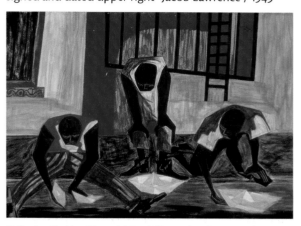

Collection: Sheldon Memorial Art Gallery and Sculpture Garden, University of Nebraska, Lincoln.

Provenance: [The Downtown Gallery, New York].

Exhibitions: University Art Galleries, University of Nebraska, Lincoln, *NAA Fifty-Ninth Annual Exhibition of Contemporary Art*, March 6–April 3, 1949, no. 60; The Detroit Institute of Arts, *Little Show of Work in Progress: Paintings by Robert Gwathmey and Jacob Lawrence, Ceramics by Edwin and Mary Sheier*, January 24–February 19, 1950; Denver Art Academy, *Sixteen Leading American Painters*, 1952; University Art Galleries, University of Nebraska, Lincoln, *Twenty-Fifth Anniversary Exhibition of the Frank M. Hall Bequest*, 1953, no. 144; Contemporary Arts Museum, Houston, *Modern Painting: Ways and Means*, January 25–February 15, 1953; Des Moines Art Center, *The Kirsch Years, 1936–1958*, January 7–February 10, 1974, no. 38; The Art Museum, Princeton University, N.J., *Fragments of American Life, An Exhibition of Paintings: Romare Bearden, Joseph Delaney, Rex Gorleigh, Lois Mailou Jones, Jacob Lawrence, Hughie Lee-Smith, Hale Woodruff*, January 25–March 28, 1976.

References: Norman Geske and Karen O. Janovy, *The American Painting Collection of the Sheldon Memorial Art Gallery* (Lincoln, Nebr.: University of Nebraska Press, 1988) pp. 108, 293, ill.

Remarks: A.k.a. *Paper Sail Boats*.

P49-02
The Marble Players
1949
egg tempera on hardboard
20 × 24 in. (50.8 × 61 cm)
signed and dated lower right "Jacob Lawrence 49"

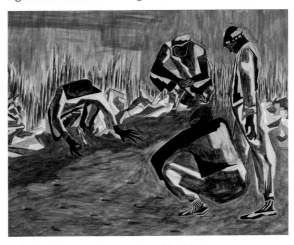

Collection: Thomas and Sue Pick, Northfield, Illinois.

Provenance: [The Downtown Gallery, New York]; Mrs. Francis W. Pick, Glencoe, Ill.

Exhibitions: Fine Arts Gallery of San Diego, *Paintings by Matisse, Tom Lewis, and Chester Hayes; Watercolor Paintings by Jacob Lawrence and Willing Howard*, April 1946; The Brooklyn Museum, *International Watercolor Exhibition, Fifteenth Biennial*, May 4–June 19, 1949, no. 175; The Detroit Institute of Arts, *Little Show of Work in Progress: Paintings by Robert Gwathmey and Jacob Lawrence, Ceramics by Edwin and Mary Sheier*, January 24–February 19, 1950; The Downtown Gallery, New York, *Art for 13,000,000*, June 6–30, 1950; Fort Wayne Museum of Art, Ind., *Selections from the Sara Roby Foundation*, September 4–November 1, 1981.

P49-03
The Long Stretch
1949
egg tempera on hardboard
20 × 24 in. (50.8 × 61 cm)
signed and dated lower right "J. Lawrence / 1949"; verso: inscribed "The Long Stretch"

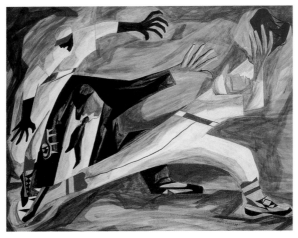

Collection: Private collection, London.

Provenance: [The Downtown Gallery, New York]; Berenice Judas; [Terry Dintenfass Inc., New York]; Robert Simpson, New York; [ACA Gallery, New York].

Exhibitions: The Downtown Gallery, New York, *The Twenty-Fourth Annual Exhibition: New Paintings and Sculpture by Leading American Artists*, October 3–22, 1949, no. 10; The Art Museum, Princeton University, N.J., *Fragments of American Life, An Exhibition of Paintings: Romare Bearden, Joseph Delaney, Rex Gorleigh, Lois Mailou Jones, Jacob Lawrence, Hughie Lee-Smith, Hale Woodruff*, January 25–March 28, 1976.

References: Dorothy Seckler, "Reviews and Previews: New Paintings," *ARTnews* 48, 6 (October 1949); John Ralph Willis, *Fragments of American Life: An Exhibition of Paintings*, exh. cat. (Princeton, N.J.: The Art Museum, Princeton University, 1976), p. 53.

Remarks: Lawrence has noted in an undated statement in the Terry Dintenfass Papers (Archives of American Art) that this painting was inspired by Jackie Robinson, the Brooklyn Dodger who was also the first African American player in the major leagues.

P49-04
Strike
1949
tempera on hardboard
20 × 24 in. (50.8 × 61 cm)
signed and dated lower right "Jacob Lawrence 49"

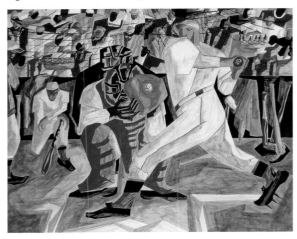

Collection: Howard University Gallery of Art, Washington, D.C.

Provenance: [The Downtown Gallery, New York]; Mark Robson, Beverly Hills, Calif.

Exhibitions: Boris Mirski Art Gallery, Boston, October 1949; Pennsylvania Academy of the Fine Arts, Philadelphia, *One Hundred Forty-Third Annual Exhibition of Painting and Sculpture*, January 22–February 26, 1950, no. 225; Howard University Gallery of Art, Washington, D.C., *New Vistas in American Art*, March–April 1961; American Federation of Arts, New York, *American Painting: The 1940s*, 1967, no. 36; New York State Museum, Albany, and Smithsonian Institution Traveling Exhibition Service, *Diamonds Are Forever: Artists and Writers on Baseball*, May 16–July 5, 1987; Addison Gallery of American Art, Phillips Academy, Andover, Mass., and The Studio Museum in Harlem, New York, *To Conserve a Legacy: American Art from Historically Black Colleges and Universities*, 1999–2001, no. 157.

References: Wheat 1986, p. 99, pl. 45; Peter H. Gordon, ed., with Sydney Waller and Paul Weinman, *Diamonds Are Forever: Artists and Writers on Baseball*, exh. cat. (San Francisco: Chronicle Books, 1987), p. 119, ill.; Duncan Christy, "The Art of Baseball," *M: The Civilized Man* 5, 7 (April 1988), p. 98, ill; Kathleen M. Burke, "From Albany, A Feast for Fans," *Smithsonian* (April 1988), p. 184, ill.; Richard J. Powell and Jock Reynolds, *To Conserve a Legacy: American Art from Historically Black Colleges and Universities*, exh. cat. (Andover, Mass.: Addison Gallery of American Art; New York: The Studio Museum in Harlem, 1999), p. 83, ill.

P49-05
Psychiatric Therapy
1949
casein tempera on paper
18⅜ × 23⅜ in. (46.7 × 59.4 cm)
signed and dated lower center "Jacob Lawrence 49"

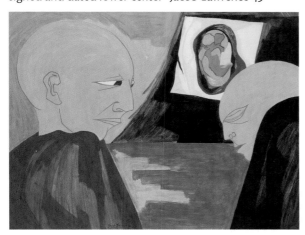

Collection: Hillside Hospital North Shore—Long Island Jewish Health System.

Provenance: [The Downtown Gallery, New York].

Exhibitions: Downtown 1950, no. 1; Texas Christian University, Fort Worth, April 1952; Katonah 1992.

References: "Jacob Lawrence: New Paintings Portraying Life in Insane Asylum Project Him into Top Ranks of U.S. Artists," *Ebony* (April 1951), p. 74, ill.; Ralph M. Pearson, *The Modern Renaissance in American Art: Presenting the Work and Philosophy of Fifty-Four Distinguished Artists* (New York: Harper & Brothers, 1954), p. 167.

P49-06
Creative Therapy
1949
casein tempera on paper
22 × 30 in. (55.9 × 76.2 cm)
signed and dated lower right "Jacob Lawrence / 49"

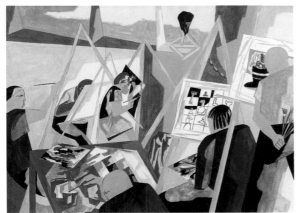

Collection: The Cleveland Museum of Art. Delia E. Holden Fund, 1994.2.

Provenance: [The Downtown Gallery, New York]; Mr. and Mrs. Irwin Zlowe; [Terry Dintenfass Inc., New York]; Andrew and Ann Dintenfass, Pacific Palisades, Calif.; [Terry Dintenfass Inc., New York].

Exhibitions: Downtown 1950, no. 4; The Cleveland Museum of Art, *Recent Acquisitions: Prints, Drawings, Photographs*, September 13–November 27, 1994.

References: Ralph M. Pearson, *The Modern Renaissance in American Art: Presenting the Work and Philosophy of Fifty-Four Distinguished Artists* (New York: Harper & Brothers, 1954), p. 167.

P49-07
Recreational Therapy
1949
casein tempera on paper
dimensions unknown
signed and dated lower right "Jacob Lawrence 1949" [?]

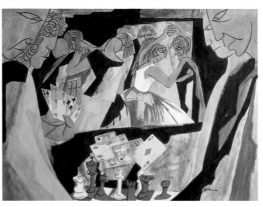

Collection: Current location unknown.

Provenance: [The Downtown Gallery, New York]; Frank Hurd, Irvine, Calif.

Exhibitions: Downtown 1950, no. 3; The Art Museum, Princeton University, N.J., *Fragments of American Life, An Exhibition of Paintings: Romare Bearden, Joseph Delaney, Rex Gorleigh, Lois Mailou Jones, Jacob Lawrence, Hughie Lee-Smith, Hale Woodruff*, January 25–March 28, 1976.

References: Ralph M. Pearson, *The Modern Renaissance in American Art: Presenting the Work and Philosophy of Fifty-Four Distinguished Artists* (New York: Harper & Brothers, 1954); John Ralph Willis, *Fragments of American Life, An Exhibition of Paintings: Romare Bearden, Joseph Delaney, Rex Gorleigh, Lois Mailou Jones, Jacob Lawrence, Hughie Lee-Smith, Hale Woodruff*, exh. cat. (Princeton, N.J.: The Art Museum, Princeton University, 1976), p. 53, ill.

P49-08
Occupational Therapy No. 1
1949
casein tempera on paper
23¾ × 31¾ in. (60.3 × 80.6 cm)
signed and dated lower right "Jacob Lawrence 1949"

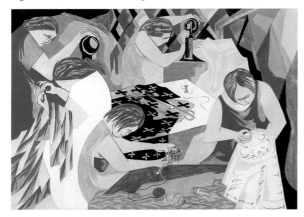

Collection: Private collection.

Provenance: [The Downtown Gallery, New York].

Exhibitions: The Downtown Gallery, New York, *In 1950: New Paintings and Sculpture by Leading American Artists*, April 25–May 13, 1950, no. 11 (as *Occupational Therapy*); Downtown 1950, no. 2.

References: Dorothy Seckler, "Reviews and Previews: Jacob Lawrence," *ARTnews* 49, 7 (November 1950), p. 65, ill. (as *Occupational Therapy*); "Jacob Lawrence: New Paintings Portraying Life in Insane Asylum Project Him into Top Ranks of U.S. Artists," *Ebony* (April 1951), pp. 73–8, ill.

P50-01
Occupational Therapy No. 2
1950
casein tempera on paper
23¾ × 31¾ in. (60.3 × 80.6 cm)
signed and dated lower center/right "Jacob Lawrence / 1950"

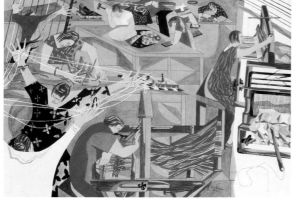

Collection: Herbert F. Johnson Museum, Cornell University, Ithaca, New York. Dr. and Mrs. Milton Lurie Kramer (Class of 1936) Collection. Bequest of Helen Kroll Kramer.

Provenance: [The Downtown Gallery, New York]; Helen Kramer (Handwoven Fabrics Inc.).

Exhibitions: Albright-Knox Art Gallery, Buffalo, *American Art in Upstate New York: Drawings, Watercolors and Small Sculpture from Public Collections in Albany, Buffalo, Ithaca, Rochester, Syracuse and Utica*, July 12–August 25, 1974; Herbert F. Johnson Museum of Art, Cornell University, Ithaca, N.Y., *Directions in Afro-American Art*, September 18–October 27, 1974, no. 119; Herbert F. Johnson Museum of Art, Cornell University, Ithaca, N.Y., *American Watercolors, 1855–1955*, May 17–July 3, 1977; Seattle 1986–7, no. 82; Herbert F. Johnson Museum of Art, Cornell University, Ithaca, N.Y., *Afro-American Art from the Herbert F. Johnson Collection*, March 28–April 16, 1988; Henry Art Gallery 1998.

References: Ralph M. Pearson, *The Modern Renaissance in American Art: Presenting the Work and Philosophy of Fifty-Four Distinguished Artists* (New York: Harper & Brothers, 1954), p. 167; *American Watercolors, 1855–1955*, exh. cat. (Ithaca, N.Y.: Herbert F. Johnson Museum of Art, Cornell University, 1977); Wheat 1986, p. 213, ill.

Remarks: A.k.a. *Weaving*.

P50-02
Drama—Hallowe'en Party
1950
casein tempera on paper
21½ × 29½ in. (54.6 × 74.9 cm)
signed and dated lower right "Jacob Lawrence / 1950"; verso: inscribed "Halloween Play" [?]

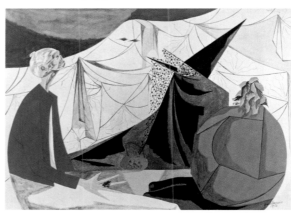

Collection: Current location unknown.

Provenance: [The Downtown Gallery, New York]; Edith G. Halpert, New York; Estate of Edith Gregor Halpert, New York; [Parke Bernet Galleries, New York, March 14–5, 1973, lot 194]; Dr. John J. McDonough, Youngstown, Ohio; [Sotheby Parke Bernet, New York, March 22, 1978, lot 61].

Exhibitions: The Downtown Gallery, New York, *Aquamedia*, February 21–March 11, 1950, no. 12; Virginia Museum of Fine Arts, Richmond, *American Painting 1950*, April 22–June 4, 1950; Downtown 1950; The American Academy of Arts and Letters, New York, *Exhibition of Work by Newly Elected Members, Recipients of Honors, and Childe Hassam Fund Purchases*, May 28–June 28, 1953, no. 42 (as *Halloween Party*); The Downtown Gallery, New York, *Aquamedia—Modern Masters*, January 1964; Amon Carter Museum, Fort Worth, *Image to Abstraction*, September 14–November 19, 1967, no. 39; New Orleans Museum of Art, *A Panorama of American Painting: The John J. McDonough Collection*, April–June 1975, no. 59.

References: James Johnson Sweeney, "Sweeney Setting His American Scene," *ARTnews* 49, 3 (May 1950), p. 18, ill. (as *Drama—Hallowe'en*); Leslie Cheek, Jr., "One-Man Direction Gives Cast to Virginia's Biennial Show," *Art Digest* 24, 15 (May 1, 1950), p. 7, ill.; Ralph M. Pearson, *The Modern Renaissance in American Art: Presenting the Work and Philosophy of Fifty-Four Distinguished Artists* (New York: Harper & Brothers, 1954), p. 167; John E. Bullard, *A Panorama of American Painting: The John J. McDonough Collection*, exh. cat. (New Orleans: New Orleans Museum of Art, 1975), pp. 38–9; p. 117, pl. 59; Fran Preisman, "The John J. McDonough Collection," *Artweek* (July 26, 1975).

P50-03
Square Dance
1950
casein tempera on paper
21⅝ × 29⅝ in. (54.9 × 75.2 cm)
signed and dated lower right "Jacob / Lawrence / 1950"

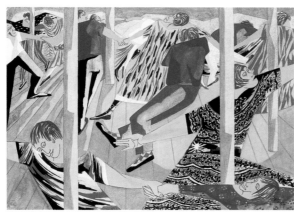

Collection: Williams College Museum of Art. Bequest of Leonard B. Schlosser, Class of 1946.

Provenance: [The Downtown Gallery, New York]; Leonard B. Schlosser, New York.

Exhibitions: Whitney Museum of American Art, New York, *1950 Annual Exhibition of Contemporary American Sculpture, Watercolors, and Drawings*, April 1–May 28, 1950, no. 110; Downtown 1950, no. 6; AFA 1960–2, no. 37; Whitney 1974–5, no. 113; Seattle 1986–7, no. 81.

References: Ralph M. Pearson, *The Modern Renaissance in American Art: Presenting the Work and Philosophy of Fifty-Four Distinguished Artists* (New York: Harper & Brothers, 1954), p. 167; Saarinen 1960, p. 39, ill.; Wheat 1986, p. 213, ill.; Robert Wernick, "Jacob Lawrence: Art As Seen through a People's History," *Smithsonian* 18, 3 (June 1987), p. 61, ill.

P50-04
In the Garden
1950
casein tempera on paper
22³⁄₁₆ × 30¹⁄₁₆ in. (56.4 × 76.4 cm)
signed and dated lower right "Jacob Lawrence / 1950"

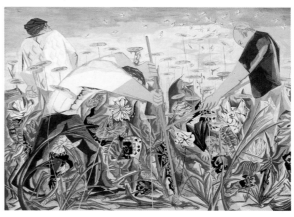

Collection: Private collection.

Provenance: [The Downtown Gallery, New York]; Dr. Abram Kanof, Raleigh, N.C.

Exhibitions: Downtown 1950, no. 11; AFA 1960–2, no. 35; Whitney 1974–5, no. 114 (Whitney only).

References: Helen Carlson, "Gallery Previews," *Pictures on Exhibit* 13, 2 (November 1950), p. 33, ill.; Ralph M. Pearson, *The Modern Renaissance in American Art: Presenting the Work and Philosophy of Fifty-Four Distinguished Artists* (New York: Harper & Brothers, 1954), p. 167; Saarinen 1960, p. 38, ill.; Wheat 1986, p. 118, pl. 48; Ron Glowen, "Jacob Lawrence: A Living History," *Artweek* 17, 28 (August 23, 1986), p. 1, ill.; Romare Bearden and Harry Henderson, *A History of African-American Artists from 1972 to Present* (New York: Pantheon Books, 1993), p. 306, ill.

P50-05
Sedation
1950
casein tempera on paper
30⅞ × 22¾ in. (78.4 × 57.8 cm)
signed and dated lower right "Jacob Lawrence / 1950"

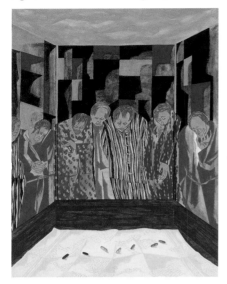

Collection: The Museum of Modern Art, New York. Gift of Mr. and Mrs. Hugo Kastor, 1951.

Provenance: [The Downtown Gallery, New York]; Mr. and Mrs. Hugo Kastor.

Exhibitions: Downtown 1950, no. 9; The Museum of Modern Art, New York, *Recent Accessions*, February 13–May 13, 1951; São Paulo, *I Bienal do Museum de Arte Moderna de São Paulo*, October–December 1951, no. 36; The American Academy of Arts and Letters, New York, *Works by Candidates for Grants in Art for the Year 1953*, February 9–March 4, 1953; The Museum of Modern Art, New York, *Twenty-Fifth Anniversary Exhibition*, October 19, 1954–January 2, 1955; AFA 1960–2, no. 38; Brandeis 1965, no. 3; The American Academy of Arts and Letters, New York, *Exhibition of Work by Newly Elected Members and Recipients of Honors and Awards*, May 20–August 29, 1965, no. 11; Forum Gallery, New York, *The Portrayal of Negroes in American Painting: United Negro College Fund Exhibition*, September 25–October 6, 1967; Lake Forest College, Ill., *Soul Week 1968: The Negro in American Culture*, January 22–February 3, 1968; Whitney 1974–5, no. 111; Seattle 1986–7, no. 83; Katonah 1992.

References: James Fitzsimmons, "Lawrence Documents," *Art Digest* 25, 3 (November 1, 1950), p. 16, ill.; Belle Krasne, "Modern's Purchases," *Art Digest* 25, 11 (March 1, 1951), p. 11; "Painting and Sculpture in The Museum of Modern Art," *MoMA Supplement 1952 Bulletin* 19, 3 (spring 1952), p. 22, ill.; Ralph M. Pearson, *The Modern Renaissance in American Art: Presenting the Work and Philosophy of Fifty-Four Distinguished Artists* (New York: Harper & Brothers, 1954), p. 167; Alfred H. Barr, Jr., *Painting and Sculpture in The Museum of Modern Art* (New York: The Museum of Modern Art, 1958); Martha Davidson and William H. Pierson, Jr., eds., *Arts of the United States: A Pictorial Survey* (New York: McGraw-Hill, 1960), p. 349, ill.; Saarinen 1960, p. 39, ill.; Vivien Raynor, "In the Galleries: Jacob Lawrence," *Arts* 35, 4 (January 1961), p. 55; *The Portrayal of Negroes in American Painting*, exh. cat. (New York: Forum Gallery, 1967), pl. 25; Virginia Lee, "Jacob Lawrence—Story Teller," *Northwest Art News and Views* 1 (March–April 1970), p. 21, ill.; Brown 1974, p. 33, ill.; Ruth Berenson, "Art: A Different American Scene," *National Review* 26, 33 (August 16, 1974), p. 930; Alfred H. Barr, Jr., *Painting and Sculpture in The Museum of Modern Art, 1929–1967* (New York: The Museum of Modern Art, 1977), p. 558, no. 278, ill.; Lewis and Sullivan 1982, p. 30, ill.; Wheat 1986, p. 214, ill.

P50-06
Depression
1950
casein tempera on paper
22 × 30½ in. (55.9 × 77.5 cm)
signed and dated lower right "Jacob Lawrence 1950"

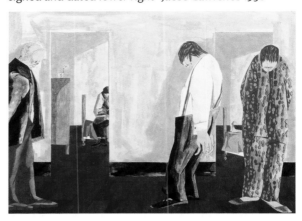

Collection: Whitney Museum of American Art, New York. Gift of David M. Solinger.

Provenance: [The Downtown Gallery, New York]; Mr. David M. Solinger, New York.

Exhibitions: Downtown 1950, no. 10; The American Academy of Arts and Letters, New York, *Exhibition of Work by Newly Elected Members, Recipients of Honors, and Childe Hassam Fund Purchases*, May 28–June 28, 1953, no. 37; The Downtown Gallery, New York, *Skowhegan School of Painting and Sculpture: A Benefit Exhibition by Its Faculty and Visiting Artists for the Scholarship Fund*, November 9–20, 1954, no. 17; Whitney Museum of American Art, New York, *The Museum and Its Friends: Twentieth-Century American Art from Collections of the Friends of the Whitney Museum*, April 30–June 15, 1958, no. 95; AFA 1960–2, no. 34; Whitney 1974–5, no. 112; Stockton State 1983, no. 14; Seattle 1986–7, no. 84; Katonah 1992; Henry Art Gallery 1998.

References: Aline B. Louchheim, "An Artist Reports on the Troubled Mind," *New York Times Magazine*, October 15, 1950, p. 15, ill.; "Jacob Lawrence: New Paintings Portraying Life in Insane Asylum Project Him into Top Ranks of U.S. Artists," *Ebony* (April 1951), p. 74, ill.; Ralph M. Pearson, *The Modern Renaissance in American Art: Presenting the Work and Philosophy of Fifty-Four Distinguished Artists* (New York: Harper & Brothers, 1954), p. 167; John I. H. Baur, ed., *New Art in America: Fifty Painters of the Twentieth Century* (Greenwich, Conn.: New York Graphic Society, 1957), p. 275, ill.; Saarinen 1960, p. 38, ill.; Lewis and Sullivan 1982, p. 31, ill.; Wheat 1986, p. 117, pl. 47; Deborah Solomon, "The Book of Jacob," *New York Daily News Magazine*, September 27, 1987, p. 18, ill.; Ellen Harkins Wheat, *Portraits: The Lives and Works of Eminent Artists* 2, 3 (1992), ill.

P50-07
The Dilemma of an Aging Population
1950
casein tempera on paper
24 × 16 in. (61 × 40.6 cm)
signed and dated lower left "Jacob Lawrence / 1950"

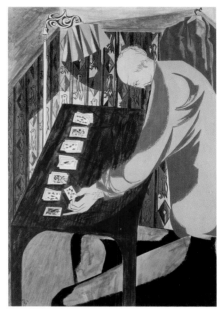

Collection: Private collection, Seattle.

Provenance: ?; Dr. and Mrs. Emanuel Klein, New York; [Terry Dintenfass Inc., New York]; Dr. and Mrs. Isaac Taylor, Boston; [DC Moore Gallery, New York].

Exhibitions: American Federation of Arts, New York, *World at Work, 1930–1955: An Exhibition of Paintings and Drawings Commissioned by* Fortune, *Presented on the Occasion of the Magazine's Twenty-Fifth Anniversary*, 1955–6, no. 28; Henry Art Gallery 1998.

References: "U.S.A.: Permanent Revolution, Part Three: The Problems of Free Men," *Fortune* (February 1951), p. 111, ill.

Remarks: A.k.a. *Solitaire*; commissioned in 1950 by *Fortune* magazine.

P50-08
Slums
1950
casein tempera on paper
25 × 21½ in. (63.5 × 54.6 cm)
signed and dated lower center/right "Jacob Lawrence 50"

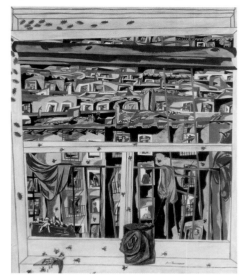

Collection: Elizabeth Marsteller Gordon, San Francisco.

Provenance: [The Downtown Gallery, New York]; Mr. and Mrs. William Marsteller, Chicago.

Exhibitions: The Brooklyn Museum, *International Watercolor Exhibition, Sixteenth Biennial*, May 9–June 24, 1951, no. 177; São Paulo, *I Bienal do Museum de Arte Moderna de São Paulo*, October–December 1951; Perls Gallery, New York, *Paintings of New York*, April 1952; Philadelphia Art Alliance, December 22, 1954–January 3, 1955; Whitney Museum of American Art, New York, *Business Buys American Art: Third Loan Exhibition by the Friends of the Whitney Museum of American Art*, March 17–April 24, 1960; AFA 1960–2, no. 36; Whitney 1974–5, no. 115; Chrysler 1979a; The Katonah Museum of Art, N.Y., *In Good Conscience: The Radical Tradition in Twentieth-Century American Illustration*, August 16–September 27, 1992.

References: Robert M. Coates, "In the Galleries," *The New Yorker* 19, 15 (May 29, 1943), p. 15; Belle Krasne, "Brooklyn Biennial Surveys Watercolors," *Art Digest* 25, 16 (May 15, 1951), p. 13; Howard Devree, "Boston's Festival: Exhibitions in the Open and at Brandeis," *New York Times*, June 13, 1954, sec. 2, p. 7, ill.; John I. H. Baur, ed., *New Art in America: Fifty Painters of the Twentieth Century* (Greenwich, Conn.: New York Graphic Society, 1957), p. 273, ill.; Saarinen 1960, p. 39, ill.; Bayard Rustin, "The Role of the Artist in the Freedom Struggle," *Crisis* 77, 7 (August–September 1970); Jacob Lawrence, "The Artist Responds," *Crisis* 77, 7 (August–September 1970); Brown 1974, p. 39, ill.; Lewis and Sullivan 1982, p. 29, ill.; Wheat 1986, p. 103, fig. 48; Carey Lovelace, "Looking at Art: The Artist's Eye, Jacob Lawrence," *ARTnews* 95, 11 (December 1996), p. 79.

P50-09
The Concert
1950
casein tempera on paper
22 × 30 in. (55.9 × 76.2 cm)
signed and dated lower right "Jacob Lawrence / 1950"

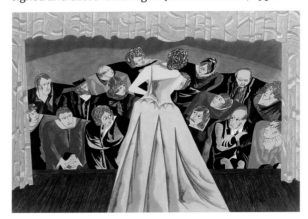

Collection: Wichita Art Museum, Wichita, Kansas. The Roland P. Murdock Collection.

Provenance: [The Downtown Gallery, New York].

Exhibitions: The Downtown Gallery, New York, *Twenty-Fifth Annual Exhibition*, September 26–October 21, 1950, no. 8; Downtown 1950, no. 7.

References: Howard Devree, "Modern Panorama: Four New Group Shows Reveal Breadth and Variety of Contemporary Art," *New York Times*, October 1, 1950, sec. 2, p. 9; Margaret Breuning, "Downtown Gallery Young at Twenty-Five," *Art Digest* 25, 1 (October 1, 1950), p. 10; "Jacob Lawrence: New Paintings Portraying Life in Insane Asylum Project Him into Top Ranks of U.S. Artists," *Ebony* (April 1951), p. 75, ill.; Ralph M. Pearson, *The Modern Renaissance in American Art: Presenting the Work and Philosophy of Fifty-Four Distinguished Artists* (New York: Harper & Brothers, 1954), p. 167.

P51-01
Bullfighters
1951
casein tempera on paper
22 × 30 in. (55.9 × 76.2 cm)
signed and dated lower right "Jacob Lawrence / 1951 ©"

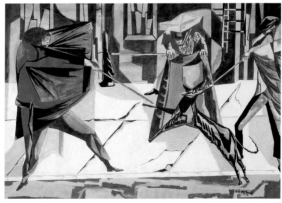

Collection: Collection of Emmanuel Schilling.

Provenance: [The Alan Gallery, New York]; Downtown Community School, New York; [Terry Dintenfass Inc., New York]; Mr. and Mrs. Richard Fried, New York; [DC Moore Gallery, New York].

Exhibitions: The Brooklyn Museum, *Brooklyn Artists Biennial Exhibition*, April 23–June 1, 1952, no. 50.

P51-02
Strong Man
1951
casein tempera and gouache on paper
22 × 17 in. (55.9 × 43.2 cm)
signed and dated lower right "Jacob Lawrence 51"

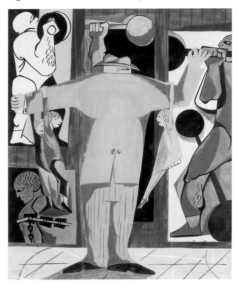

Collection: The Harmon and Harriet Kelley Foundation for the Arts.

Provenance: Jacob and Gwendolyn Knight Lawrence, New York and Seattle; [Francine Seders Gallery, Seattle].

Exhibitions: USIA Caribbean 1989; Francine Seders Gallery, Seattle, *Twenty-Fifth Anniversary Exhibition: The Middle Years*, June 7–July 7, 1991; San Antonio Museum of Art, *The Harmon and Harriet Kelley Collection of African American Art*, February 4–April 3, 1994, no. 70; David Winston Bell Gallery, Brown University, Providence, R.I., *The Harmon and Harriet Kelley Collection of African American Art*, April 18–May 31, 1998.

References: Lewis and Hewitt 1989, p. 32, ill.; *Harmon and Harriet Kelley Collection of African American Art*, exh. cat. (San Antonio: San Antonio Museum of Art, 1994); Diane M. Bolz, "A Kaleidoscope of Black Culture," *Smithsonian* 26, 4 (July 1995), p. 26, ill.

P51-03
Photos
1951
watercolor and gouache on paper
23 × 32 in. (58.4 × 81.3 cm)
signed and dated lower right "Jacob Lawrence 1951 ©"

Collection: Milwaukee Art Museum. Gift of Milprint, Inc., A Division of Philip Morris Industrial, M1971.1.

Provenance: Jacob and Gwendolyn Knight Lawrence, New York; [Terry Dintenfass Inc., New York].

Exhibitions: The Downtown Gallery, New York, *Twenty-Fifth Annual Fall Exhibition: Paintings and Sculpture by Leading American Artists*, October 2–27, 1951, no. 11; Philadelphia Art Alliance, December 22, 1954–January 3, 1955; Coliseum, New York, *Art: USA: 59, A Force, A Language, A Frontier*, April 3–19, 1959; The Minneapolis Institute of Arts in association with Ruder & Finn Fine Arts, *Thirty Contemporary Black Artists*, October 17–November 24, 1968; Milwaukee Art Museum, September 27–October 27, 1970; Whitney 1974–5, no. 116.

References: Howard Devree, "Group Annual," *New York Times*, October 7, 1951, sec. 2, p. 9; Margaret Breuning, "Birthday Downtown," *Art Digest* 26, 2 (October 15, 1951); *Contemporary Black Artists*, exh. cat. (New York: Ruder & Finn Fine Arts, 1969), ill.; Robert P. Johnston, "Six Major Figures in Afro-American Art," *Michigan Academician* 3 (spring 1971), p. 54; Wheat 1986, p. 119, pl. 49; *Black Artists and Images* (Milwaukee: Milwaukee Art Museum, 1988), n.p., ill. (as *Photographer's Shop*).

P51-04
Magic on Broadway
1951
gouache on paper
30¼ × 22⅛ in. (76.8 × 56.2 cm)
signed and dated lower right "Jacob / Lawrence / 51"

Collection: Ellen L. Roach.

Provenance: Jacob and Gwendolyn Knight Lawrence, New York; Evelyn S. Cohen, New York.

Exhibitions: The Downtown Gallery, New York, *Spring 1951: New Paintings and Sculpture*, April 3–28, 1951, no. 10; Great Neck Education Association, New York, *Art in America: Twentieth Century*, March 1–14, 1953; John Herron Art Museum, Indianapolis, *Contemporary American Watercolors*, December 27, 1953–January 31, 1954, no. 43; Philadelphia Art Alliance, December 22, 1954–January 3, 1955; Seattle 1986–8, no. 86.

References: Wheat 1986, p. 214, ill.

P51-05
Tie Rack
1951
egg tempera on hardboard
29¾ × 19¼ in. (75.6 × 48.9 cm)
signed and dated lower right "Jacob Lawrence / 51"

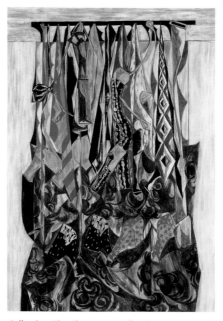

Collection: The Thompson Collection.

Provenance: Jacob and Gwendolyn Knight Lawrence, New York and Seattle; [Midtown Payson Galleries, New York].

Exhibitions: The Downtown Gallery, New York, *Annual Spring Exhibition: New Paintings and Sculpture by Leading American Artists*, April 1–19, 1952; Philadelphia Art Alliance, December 22, 1954–January 3, 1955; The Pyramid Club, Philadelphia, *The Third Annual Review of Painting and Sculpture: 1957, In the United States*, October 25–November 30, 1957; Seattle 1986–7, no. 85; Midtown Payson 1995a.

References: Wheat 1986, p. 214, no. 85, ill.; Midtown Payson 1995b, p. 6, ill.

P51-06
Chess on Broadway
1951
watercolor and gouache on paper
21½ × 29½ in. (54.6 × 74.9 cm)
signed and dated lower right "Jacob Lawrence 1951"

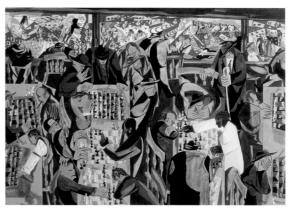

Collection: Private collection.

Provenance: [The Downtown Gallery, New York]; William Riesenfeld, New York.

Exhibitions: Whitney Museum of American Art, New York, *1951 Annual Exhibition of Contemporary American Sculpture, Watercolors and Drawings*, March 17–May 6, 1951, no. 103; Artists Equity, New York, *Founding Members Exhibition*, May 1952, no. 35; La Biennale di Venezia, *Esposizione Internazionale d'Art, 1956: American Artists Paint the City*, June–November 1956; Whitney 1974–5, no. 117 (Whitney only).

References: *Twenty-Eighth Venice Biennale: American Artists Paint the City*, exh. cat. (Chicago: The Art Institute of Chicago, 1956), p. 9, pl. 3.; Wheat 1986, p. 120, pl. 50.

P51-07
Vaudeville
1951
egg tempera on hardboard
29⅞ × 19¹⁵⁄₁₆ in. (75.9 × 50.6 cm)
signed and dated lower right "Jacob Lawrence 51"

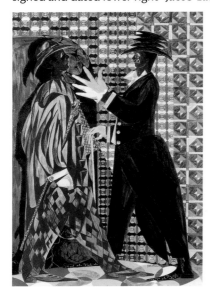

Collection: Hirshhorn Museum and Sculpture Garden, Smithsonian Institution. Gift of Joseph H. Hirshhorn, 1966.

Provenance: [The Downtown Gallery, New York]; Joseph H. Hirshhorn, New York.

Exhibitions: Downtown 1953, no. 8; Abraham Shapiro Athletic Center, Brandeis University, Waltham, Mass., *Festival of the Creative Arts: The Comic Spirit, An Exhibition,* June 10–4, 1953, no. 84; Phil Art 1955; AFA 1960–2, no. 39; Whitney 1974–5, no. 118 (Whitney only); Alexandria Museum of Art, La., *The Rhythm of Life: Selected Works by Bearden, Gwathmey, and Lawrence,* January 25–March 30, 1984.

References: Quick (January 26, 1953), ill.; F[airfield] P[orter], "Reviews and Previews: Jacob Lawrence," *ARTnews* 51, 10 (February 1953), p. 73; Ralph M. Pearson, *The Modern Renaissance in American Art: Presenting the Work and Philosophy of Fifty-Four Distinguished Artists* (New York: Harper & Brothers, 1954), p. 167, fig. 100.; Alexander Eliot, *Three Hundred Years of American Painting* (New York: Time, 1957), p. 260, ill.; Joseph Littell, ed., *The Language of Man* (Geneva, Ill.: McDougal, Littell & Co., 1971), ill.; Elsa Honig Fine, *The Afro-American Artist: A Search for Identity* (New York: Hacker Art Books, 1973), p. 150; p. 161, ill.; Marshall B. Davidson, *The Artist's America* (New York: American Heritage, 1973), ill.; Brown 1974, p. 35, ill.; Robert Wernick, "Jacob Lawrence: Art As Seen through a People's History," *Smithsonian* 18, 3 (June 1987), p. 61, ill.; Cynthia Colbert and Martha Taunton, *Discover Art: Kindergarten* (Worcester, Mass.: Davis Publications, 1990), p. 49, ill.; Milo Wold, *An Introduction to Music and Art in the Western World,* 9th ed. (Dubuque, Iowa: W. C. Brown, 1990), pl. 91; Jamake Highwater, "Stripping Art of Elitism," *Christian Science Monitor,* April 23, 1990, p. 16, ill.; Charles Sullivan, ed., *Children of Promise* (New York: Harry N. Abrams, 1991), p. 112, ill.; Ellen Harkins Wheat, *Portraits: The Lives and Works of Eminent Artists* 2, 3 (1992), fig. 6; Donald Herberholz and Barbara Herberholz, *Artworks for Elementary Teachers,* 7th ed. (Madison, Wis.: Brown and Benchmark, 1994), p. 108, ill.; Edward Lucie-Smith, *Race, Sex, and Gender in Contemporary Art* (New York: Harry N. Abrams, 1994), p. 22, ill.

P52-01
Billboards
1952
egg tempera on hardboard
36 × 24 in. (91.4 × 61 cm)
signed and dated lower center "Jacob / Lawrence / 52"

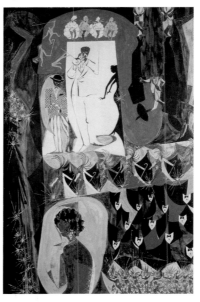

Collection: Private collection.

Provenance: [The Downtown Gallery, New York]; Helen Grayson, New York; [Parke Bernet Galleries, New York, October 24, 1968, lot 81].

Exhibitions: The Downtown Gallery, New York, *The Twenty-Fifth Anniversary Exhibition,* October 1952; Downtown 1953; Terry Dintenfass Inc., New York, *Skowhegan School of Painting and Sculpture: Fifth Annual Art Exhibition and Sale,* October 22–October 25, 1969, no. 54A; Smithsonian Institution Traveling Exhibition Service, Washington, D.C., *Louis Armstrong: A Cultural Legacy,* 1994–6.

References: Chris Ritter, "Fifty-Seventh Street in Review: Downtown Group," *Art Digest* 27, 2 (October 15, 1952), p. 16; Mark H. Miller, ed., *Louis Armstrong: A Cultural Legacy,* exh. cat. (New York: Queens Museum of Art, 1994), ill.

P52-02
Marionettes
1952
egg tempera on hardboard
18¼ × 24½ in. (46.4 × 62.2 cm)
signed and dated lower left "Jacob Lawrence 52"

Collection: High Museum of Art, Atlanta. Purchase with funds from the National Endowment for the Arts and Edith G. and Philip A. Rhodes, 1980.224.

Provenance: [The Downtown Gallery, New York]; Mrs. Emma Little, Pittsburgh; [Terry Dintenfass Inc., New York]; Dr. Marvin Radoff, Yardley, Pa.; [Terry Dintenfass Inc., New York].

Exhibitions: Downtown 1953, no. 7; The Corcoran Gallery of Art, Washington, D.C., *National Conference on the Arts Honors Ten African-American Artists,* March 14–April 16, 1980; High Museum of Art, Atlanta, *African-American Art in Atlanta: Public and Corporate Collections,* May 11–June 17, 1984, no. 36; Seattle 1986–7, no. 88 (Seattle; Oakland; Atlanta; Washington, D.C.; Dallas; Brooklyn).

References: Chris Ritter, "Fifty-Seventh Street in Review: Downtown Group," *Art Digest* 27, 5 (December 1, 1952), p. 18; Sidney Geist, "Fifty-Seventh Street in Review: Jacob Lawrence," *Art Digest* 27, 9 (February 1, 1953), p. 17; *African-American Art in Atlanta: Public and Corporate Collections,* exh. cat. (Atlanta: High Museum of Art, 1984), p. 8, ill.; Wheat 1986, p. 214, ill.; *Selected Works: Outstanding Painting, Sculpture, and Decorative Art from the Permanent Collection* (Atlanta: High Museum of Art, 1987), p. 55, ill.; Powell 1992, pl. 8; Kelly Morris, ed., *Highlights from the Collection: Selected Paintings, Sculpture, Photographs, and Decorative Art from the Permanent Collection* (Atlanta: High Museum of Art, 1994), p. 76, ill.

P52-03
Christmas Pageant
1952
egg tempera on hardboard
24 × 28½ in. (61 × 72.4 cm)
signed and dated lower right "Jacob Lawrence / 52"

Collection: Collection Neuberger Museum of Art, Purchase College, State University of New York. Gift of Roy R. Neuberger.

Provenance: [The Downtown Gallery, New York]; Mr. and Mrs. Roy Neuberger, New York.

Exhibitions: Downtown 1953, no. 5; Whitney Museum of American Art, New York, *Roy and Marie Neuberger Collection: Modern American Painting and Sculpture,* November 17–December 19, 1954, no. 58; The Institute of Contemporary Art, Boston, *Twentieth-Century American Paintings from the Collection of Mr. and Mrs. Roy R. Neuberger,* March 13–April 8, 1956; Whitney 1974–5; The Chrysler Museum of Art, Norfolk, Va., *American Figure Painting, 1950–1980,* October 1–December 5, 1980.

References: Roy Neuberger, "Collecting American Art," *Art in America* 42, 4 (December 1954), p. 287, ill.; Daniel Robbins, ed., *The Neuberger Collection: An American Collection,* exh. cat. (Providence, R.I.: Museum of Art, Rhode Island School of Design, 1968), p. 309; Thomas W. Styron, *American Figure Painting 1950–1980,* exh. cat. (Norfolk, Va.: The Chrysler Museum, 1980), p. 93, ill.

P52-04
Makeup
1952
egg tempera on hardboard
20 × 24 in. (50.8 × 61 cm)
signed and dated lower right "Jacob Lawrence 52"

Collection: Elisabeth and William M. Landes, Chicago.

Provenance: [The Alan Gallery, New York]; Herbert Gladstone, New York; [ACA Gallery, New York].

Exhibitions: Downtown 1953, no. 3; Whitney Museum of American Art, New York, *1953 Annual Exhibition of Contemporary American Sculpture, Watercolors, and Drawings,* April 9–May 29, 1953, no. 103; Virginia Museum of Fine Arts, Richmond, *American Painting 1954,* February 26–March 21, 1954; The Alan Gallery, New York, *From Museum Walls . . .,* June 15–August 20, 1954, no. 11; Philadelphia Art Alliance, December 22, 1954–January 3, 1955; Coliseum, New York, *Art: USA: 59, A Force, A Language, A Frontier,* April 3–19, 1959, no. 125; The Brooklyn Museum, *Herbert A. Goldstone Collection of American Art,* May 15–September 12, 1965, no. 54.

References: Fred Mitchell, "Gallery Previews in New York," *Pictures on Exhibit* 15, 5 (February 1953), p. 33, ill.; Saarinen 1960, p. 40, ill.; *Herbert A. Goldstone Collection of American Art,* exh. cat. (Brooklyn: The Brooklyn Museum, 1965).

Remarks: A.k.a. *Dressing Room.*

P52-05
Night after Night
1952
egg tempera on hardboard
24 × 18 in. (61 × 45.7 cm)
signed and dated lower right "Jacob Lawrence 52"

Collection: Private collection, New York.

Provenance: [Terry Dintenfass Inc., New York].

Exhibitions: Downtown 1953, no. 4; The American Academy of Arts and Letters, New York, *Exhibition of Work by Newly Elected Members, Recipients of Honors, and Childe Hassam Fund Purchases*, May 28–June 28, 1953, no. 40; The Downtown Gallery, New York, *International Exhibition: American, Belgian, British, Canadian, French, Italian, Mexican Painters under Forty*, February 2–27, 1954, no. 16; Whitney Museum of American Art, New York, *1954 Annual Exhibition of Contemporary American Sculpture, Watercolors, and Drawings*, March 17–April 18, 1954, no. 110; AFA 1960–2, no. 42; Whitney 1974–5, no. 110.

References: Stuart Preston, "Recent Works by Stevens, David Smith, Lawrence," *New York Times*, February 1, 1953, sec. 2, p. 8, ill.; Saarinen 1960, p. 41, ill.; Clifford Wright, "Jacob Lawrence," *The Studio* 161 (January 1961), p. 26, ill.; Lewis and Sullivan 1982, p. 32, ill. (as *Back Stage*).

P52-06
Curtain
1952
egg tempera on hardboard
20 × 24 in. (50.8 × 61 cm)
inscription unknown

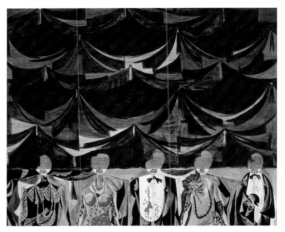

Collection: Private collection, Beverly Hills.

Provenance: [The Alan Gallery, New York]; Joseph Strick, Santa Monica, Calif.; [Herbert Palmer Gallery, Los Angeles]; Dr. Leon Banks, Los Angeles; [Alitash Kebede Contemporary Art, Los Angeles].

Exhibitions: Downtown 1953, no. 11; Pennsylvania Academy of the Fine Arts, Philadelphia, *The One Hundred Forty-Ninth Annual Exhibition of Paintings and Sculpture*, January 24–February 28, 1954, no. 36 (as *The Curtain*); Watkins Gallery, American University, Washington, D.C., *Art and Theater*, April 8–May 13, 1956; The Museum of African-American Art, Los Angeles, *Los Angeles Collects: Works by over Thirty Artists from Fifteen Private Collections*, October 9–December 27, 1987.

References: F[airfield] P[orter], "Reviews and Previews: Jacob Lawrence," *ARTnews* 51, 10 (February 1953), p. 73, ill.; Sidney Geist, "Fifty-Seventh Street in Review: Jacob Lawrence," *Art Digest* 27, 9 (February 1, 1953), p. 17.

P52-07
Ventriloquist
1952
egg tempera on hardboard
19⅞ × 24 in. (50.5 × 61 cm)
signed and dated lower right "Jacob Lawrence 52"

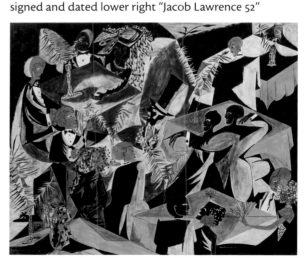

Collection: Joanne Stern, New York.

Provenance: [The Alan Gallery, New York].

Exhibitions: Downtown 1953.

Remarks: A.k.a. *Harlem Nightclub.*

P52-08
Fantasy
1952
egg tempera on hardboard
24 × 30 in. (61 × 76.2 cm)
signed and dated lower right "Jacob Lawrence 52"

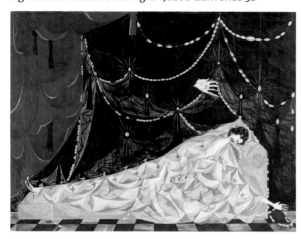

Collection: The Baltimore Museum of Art. The Edward Joseph Gallagher III Memorial Fund, 1991.12.

Provenance: Edith G. Halpert, New York; [Parke Bernet Galleries, New York, March 15, 1973, lot 199]; [Terry Dintenfass Inc., New York]; Private collection, New York; [Terry Dintenfass Inc., New York].

Exhibitions: The American Academy of Arts and Letters, New York, *Works by Candidates for Grants in Art for the Year 1953*, February 9–March 4, 1953, no. 39; The American Academy of Arts and Letters, New York, *Exhibition of Work by Newly Elected Members, Recipients of Honors, and Childe Hassam Fund Purchases*, May 28–June 28, 1953, no. 39; The Downtown Gallery, New York, *Aquamedia—Modern Masters*, February 1961; The Corcoran Gallery of Art, Washington, D.C., *The Edith Gregor Halpert Collection*, September 28–November 11, 1962.

P52-09
Concert
1952
egg tempera on hardboard
22¾ × 31¾ in. (57.8 × 80.6 cm)
signed and dated lower right "Jacob Lawrence 52"

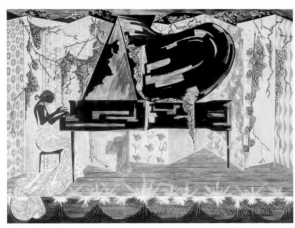

Collection: Herbert F. Johnson Museum, Cornell University, Ithaca, New York. Gift of Dr. and Mrs. Emanuel Klein, Class of 1924.

Provenance: [The Downtown Gallery, New York]; Dr. and Mrs. Emanuel Klein, New York.

Exhibitions: Downtown 1953, no. 6; AFA 1960–2, no. 41; Henry Art Gallery 1998.

References: Saarinen 1960, p. 41, ill.

P52-10
Tragedy and Comedy
1952
egg tempera on hardboard
24 × 32 in. (61 × 81.3 cm)
signed and dated lower right "Jacob Lawrence 52"

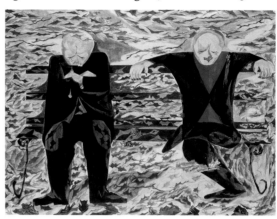

Collection: Michael and Elizabeth Rea, Connecticut.

Provenance: [The Downtown Gallery, New York]; Private collection; [Midtown Payson Galleries, New York].

Exhibitions: Downtown 1953, no. 2; The Brooklyn Museum, *International Watercolor Exhibition, Seventeenth Biennial*, May 13–June 21, 1953, no. 156; AFA 1960–2, no. 40 (as *Comedy and Tragedy*); Brandeis 1965, no. 4; Whitney 1974–5, no. 119; Seattle 1986–7, no. 87.

References: F[airfield] P[orter], "Reviews and Previews: Jacob Lawrence," *ARTnews* 51, 10 (February 1953), p. 73; Saarinen 1960, p. 41, ill.; Brown 1974, p. 39, ill.; Ruth Berenson, "Art: A Different American Scene," *National Review* 26, 33 (August 16, 1974), p. 930; Wheat 1986, p. 120, pl. 51.

P52-11
Strength
1952
casein tempera on paper
22 × 17½ in. (55.9 × 44.5 cm)
signed and dated lower right "Jacob Lawrence 52"

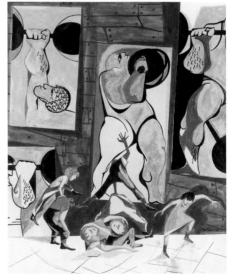

Collection: Private collection. Courtesy of DC Moore, New York.

Provenance: [The Alan Gallery, New York]; Private collection, New York; [DC Moore Gallery, New York].

Exhibitions: DC Moore Gallery, New York, *Inaugural Exhibition*, November 16–December 30, 1995; Henry Art Gallery 1998.

P52-12
Construction
1952
casein tempera on brown paperboard
23¼ × 29¾ in. (59 × 75.6 cm)
signed and dated lower right "Jacob Lawrence 52"

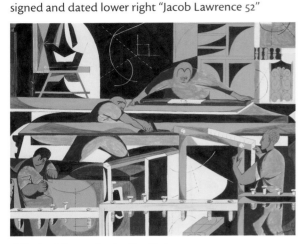

Collection: Private collection, New York.

Provenance: [The Alan Gallery, New York]; Downtown Community School, New York; [?].

Exhibitions: Virginia Museum of Fine Arts, Richmond, *Watercolors U.S. 1956*, July 1956.

P53-01
Wedding Party
1953
tempera on hardboard
9 × 12 in. (22.9 × 30.5 cm)
signed and dated lower right "Jacob Lawrence 53"

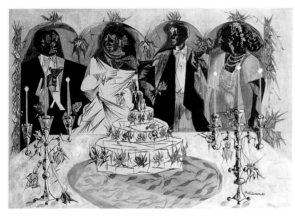

Collection: The Thompson Collection.

Provenance: [The Alan Gallery, New York]; Frederick C. Tobler, Princeton, N.J.; [Sotheby's, New York, December 1, 1999, Sale 7397, lot 215].

P53-02
Surgery, Harlem Hospital
1953
egg tempera on hardboard
20 × 24 in. (50.8 × 61 cm)
signed and dated lower right "Jacob Lawrence 53"

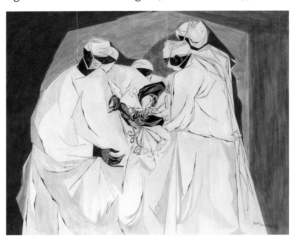

Collection: Michael Rosenfeld Gallery, New York.

Provenance: Jacob and Gwendolyn Knight Lawrence, New York; Cyril and Jean Olliviere, New York; Dr. Arthur Olliviere, San Francisco.

Exhibitions: Whitney 1974–5, no. 121.

References: Brown 1974, p. 38, ill.; Robert Pincus-Witten, "Jacob Lawrence: Carpenter Cubism," *Artforum* 13, 66 (September 1974), p. 67, ill.

P53-03
Card Game
1953
egg tempera on hardboard
19 × 23½ in. (48.3 × 59.7 cm)
signed and dated lower right "Jacob Lawrence 53"

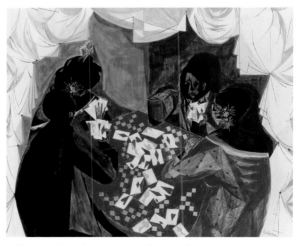

Collection: The Walter O. Evans Collection of African American Art.

Provenance: [The Alan Gallery, New York]; Private collection, New York; [Terry Dintenfass Inc., New York].

Exhibitions: AFA 1960–2, no. 43; Whitney 1974–5, no. 122; Chrysler 1979a; Beach Institute/King-Tisdell Museum, Savannah, Ga., *The Walter O. Evans Collection of African-American Art*, 1991–2000.

References: Saarinen 1960, p. 42, ill.; Chrysler 1979b; Shirley Woodson, ed., *The Walter O. Evans Collection of African-American Art* (Savannah, Ga.: King-Tisdell Foundation, 1991), p. 64, ill.

Remarks: A.k.a. *The Card Game*.

P53-04
Champions
1953
egg tempera on hardboard
19¾ × 24 in. (50.2 × 61 cm)
signed and dated lower right "Jacob Lawrence 53"

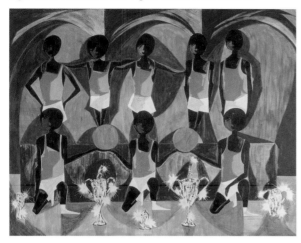

Collection: The University of Michigan Museum of Art. Gift of Dr. James and Vivian Curtis.

Provenance: [The Alan Gallery, New York]; Dr. James and Vivian Curtis, St. Albans, N.Y.

Exhibitions: The Alan Gallery, New York, *Opening Exhibition*, September 29–October 24, 1953, no. 11; The Brooklyn Museum, *Brooklyn Artists Biennial Exhibition*, January 18–February 19, 1956, no. 52; AFA 1960–2, no. 44.

References: Saarinen 1960, p. 43, ill.

P54-01
Pool
1954
tempera on hardboard
9⅞ × 13⅞ in. (25.1 × 35.2 cm)
signed and dated lower right "Jacob Lawrence 54"

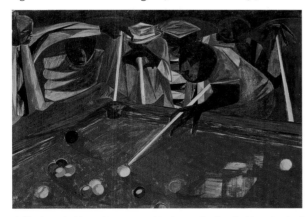

Collection: Hirshhorn Museum and Sculpture Garden, Smithsonian Institution. Gift of Joseph H. Hirshhorn, 1966.

Provenance: [The Alan Gallery, New York]; Joseph H. Hirshhorn, New York.

Exhibitions: Charles-Fourth Gallery, New Hope, Pa., *The Alan Gallery of New York*, May 31–September 26, 1954; Whitney 1974–5, no. 124.

References: Clifford Wright, "Jacob Lawrence," *The Studio* 161 (January 1961), p. 26, ill.

P54-02
A Game of Chance
1954
egg tempera on hardboard
18 × 24 in. (45.7 × 61 cm)
signed and dated lower right "Jacob Lawrence 54"

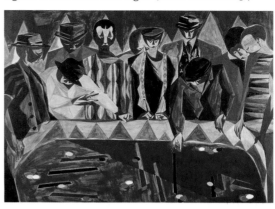

Collection: Private collection. Courtesy of Michael Rosenfeld Gallery, New York.

Provenance: [The Alan Gallery, New York]; Eric Sternberg, Boston; [Michael Rosenfeld Gallery, New York].

P54-03
Gamblers
1954
tempera on hardboard
9 × 12 in. (22.9 × 30.5 cm)
signed and dated lower left "Jacob Lawrence 54"

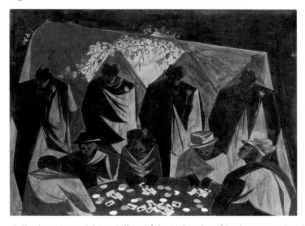

Collection: Memorial Art Gallery of the University of Rochester. Marion Stratton Gould Fund.

Provenance: [The Alan Gallery, New York]; ?; [Parke Bernet Galleries, New York, March 21, 1974, Sale 3617, lot 105].

Remarks: Memorial Art Gallery notes that the medium is not egg tempera.

P54-04
Chess Players
1954
egg tempera on hardboard
17⁷⁄₁₆ × 21⁷⁄₁₆ in. (44.3 × 54.5 cm)
signed and dated lower left "Jacob Lawrence 54"

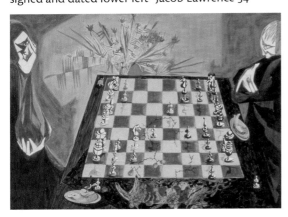

Collection: The Baltimore Museum of Art. Bequest of Saidie A. May, by exchange, 1990.78.

Provenance: [The Alan Gallery, New York]; Titan Industrial; [Christie, Manson & Woods, New York, May 23, 1990, Sale 7082, lot 247].

P54-05
Man with Flowers
1954
egg tempera on hardboard
15¾ × 11¾ in. (40 × 29.8 cm)
signed and dated lower right "Jacob Lawrence 54"

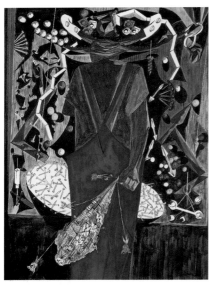

Collection: Norton Museum of Art, West Palm Beach, Florida.

Provenance: Jacob and Gwendolyn Knight Lawrence, New York; Leonard and Ruth Bocour; [Midtown Payson Galleries, New York].

Exhibitions: Whitney 1974–5, no. 125; Midtown Payson 1995a.

References: "Jacob Lawrence at Midtown Payson Galleries, The Art Show," *Artfair Magazine* 2, 2 (December 1994–February 1995), p. 13, ill.; Midtown Payson 1995b, p. 7, ill.; Sharon Fitzgerald, "The Homecoming of Jacob Lawrence," *American Visions* 10 (April–May 1995), p. 22, ill.

P54-06
The Prayer
1954
egg tempera on hardboard
7⅞ × 10 in. (20 × 25.4 cm)
signed and dated lower left "Jacob Lawrence / 54"

Collection: Collection of AXA Financial.

Provenance: [The Downtown Gallery, New York]; Private collection; Robert Leeds, Clearwater, Fla.; [Mary Ryan Gallery, New York].

Exhibitions: Henry Art Gallery 1998.

References: Robin Updike, "Jacob Lawrence," *Seattle Times*, July 2, 1998, p. E1, ill.

P54-07
Nativity
1954
egg tempera on hardboard
9 × 12 in. (22.9 × 30.5 cm)
signed and dated lower right "Jacob Lawrence / 54"

Collection: Nathan and Karrie Polowetzky Collection, New York.

Provenance: [The Alan Gallery, New York].

P54-08
Still Life with Grapes and Roses
1954
egg tempera on hardboard
17¾ × 23⅞ in. (45.1 × 60.6 cm)
signed and dated lower right "Jacob Lawrence / 1954"

Collection: Private collection. Courtesy of DC Moore Gallery, New York.

Provenance: Jacob and Gwendolyn Knight Lawrence, New York; Mrs. Herman Stoute, Brooklyn; Jacob and Gwendolyn Knight Lawrence, New York and Seattle; [DC Moore Gallery, New York].

P54-09
Masks
1954
egg tempera on hardboard
24 × 17¾ in. (61 × 45.1 cm)
signed and dated lower right "Jacob Lawrence 54"

Collection: Elizabeth Marsteller Gordon, San Francisco.

Provenance: [The Alan Gallery, New York]; Mr. and Mrs. William Marsteller, Chicago.

Exhibitions: The Alan Gallery, New York, *Opening Exhibition: 1954–1955*, September 9–October 2, 1954, no. 9; University of Illinois, Urbana-Champaign, *Contemporary American Painting and Sculpture*, February 27–April 3, 1955, no. 75.

References: S. P., "About Art and Artists: Group Shows at Two Galleries Open Local Season with Varied Works," *New York Times*, September 13, 1954, p. 18; *Contemporary American Painting and Sculpture*, exh. cat. (Urbana-Champaign, Ill.: University of Illinois, 1955), pl. 14, ill.; Wheat 1986, p. 122, pl. 53.

P54-10
Village Quartet
1954
egg tempera on hardboard
9 × 12 in. (22.9 × 30.5 cm)
signed and dated lower right "Jacob Lawrence 54"

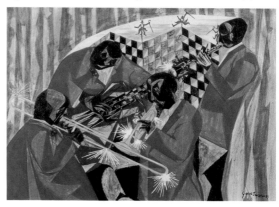

Collection: Private collection.

Provenance: [The Alan Gallery, New York]; John Denman, Bellevue, Wash.

Exhibitions: The Alan Gallery, New York, *The Denman Collection: Loan Exhibition*, February 15–March 5, 1955, no. 14; Whitney 1974–5, no. 123; Seattle 1986–7, no. 90.

References: *The Denman Collection: Loan Exhibition*, exh. brch. (New York: The Alan Gallery, 1955), ill.; Howard Devree, "About Art and Artists: John Piper Blends Traditional English Romantic Landscape with Abstraction," [includes review of Denman exhibition at The Downtown Gallery], *New York Times*, February 17, 1955, p. 25; Gretchen T. Munson, "The Denman Collection," *ARTnews* 54, 1 (March 1955), p. 52; Fred Grunfeld, "Strange Rhythms and a Peculiar Lilt," *New York Times Book Review*, April 3, 1955, p. 7, ill. (as *Pounding at a Beat*); Aline B. Saarinen, "A Pilot's World Famous Art Collection," *Cosmopolitan* 139, 1 (July 1955), p. 67, ill.; Brown 1974, p. 36, ill.; Wheat 1986, p. 125, pl. 57; *Arts Line* 4, 3 (July 1986), cvr., ill.

P54-11
The Masquerade
1954
egg tempera on hardboard
8⅞ × 11⅞ in. (22.5 × 30.1 cm)
signed and dated lower right "Jacob Lawrence 54"

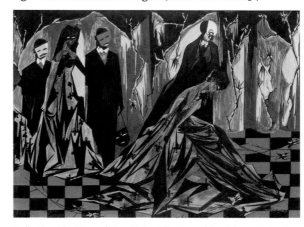

Collection: The State of New York; Collection of the Adam Clayton Powell Jr. State Office Building, New York.

Provenance: [The Alan Gallery, New York]; George Baxt, New York; ?; Selma Smith, Swarthmore, Pa.; [Terry Dintenfass Inc., New York].

P54-12
Celebration
1954
egg tempera on hardboard
23⅞ × 17⅛ in. (60.6 × 43.5 cm)
signed and dated lower right "Jacob Lawrence 54"

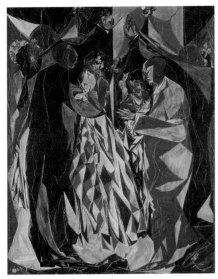

Collection: Hirshhorn Museum and Sculpture Garden, Smithsonian Institution. Gift of Joseph H. Hirshhorn, 1966.

Provenance: [The Alan Gallery, New York]; Joseph H. Hirshhorn, New York.

Exhibitions: The Alan Gallery, New York, *Opening Exhibition: 1955–1956*, September 8–October 1, 1955, no. 10; Henry Art Gallery 1998.

P55-01
Procession
1955
egg tempera on hardboard
16 × 12 in. (40.6 × 30.5 cm)
signed and dated lower right "Jacob Lawrence 55"

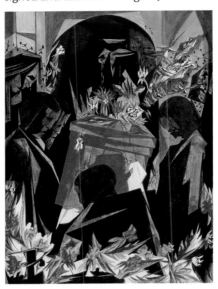

Collection: Minnesota Museum of American Art, Saint Paul. Katherine G. Ordway Fund Purchase.

Provenance: [Perls Gallery, New York]; Private collection; [Fran B. Horowitz Fine Arts, Minneapolis].

Exhibitions: Minnesota Museum of American Art, Saint Paul, *From the American Collection*, September 19–November 28, 1993.

References: Saarinen 1960, p. 46, ill.

P55-02
The Evangelist
1955
tempera on hardboard
12 × 8¾ in. (30.5 × 22.2 cm)
signed and dated lower right "Jacob Lawrence 55"

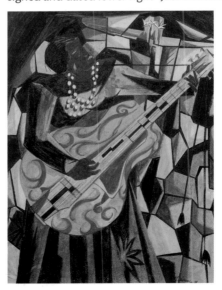

Collection: Private collection. Courtesy of DC Moore Gallery, New York.

Provenance: [The Alan Gallery, New York]; Frank Picarello, Jr., New York.

P55-03
Life, Death, and Resurrection
1955
egg tempera on hardboard
12 × 9 in. (30.5 × 22.9 cm)
signed and dated lower right "Jacob Lawrence 55"; verso: inscribed
"Life, Death + Resurrection"

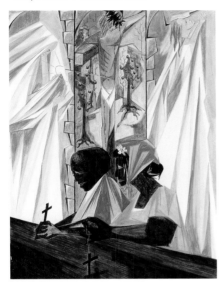

Collection: The Lane Collection, Boston.

Provenance: [The Alan Gallery, New York].

Exhibitions: De Cordova Museum and Sculpture Park, Lincoln, Mass., *American Painters: 1955*, October 9–November 4, 1955; Worcester Art Museum, Mass., *American Painting since the Armory Show from the William H. Lane Foundation*, July 1–September 10, 1957.

P55-04
Study for United Nations Mural
1955
casein tempera on paper
29 × 72 in. (73.7 × 182.9 cm)
unsigned

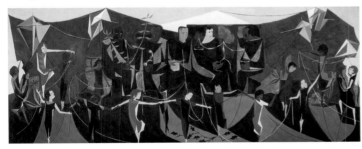

Collection: Mr. and Mrs. Sherle Wagner.

Provenance: [The Alan Gallery, New York].

Exhibitions: Whitney Museum of American Art, New York, *Mural Sketches and Sculpture Models*, October 25–November 5, 1955, no. 6; Whitney 1974–5, no. 126 (Whitney only).

Remarks: This painting was the artist's entry for a mural at the United Nations in New York. Though the painting won first prize (shared with Stuart Davis), the mural was never executed.

P55-05
Time
1955
casein tempera on paper
17⅞ × 23⅞ in. (45.4 × 60.6 cm)
signed and dated lower right "Jacob Lawrence 1953"

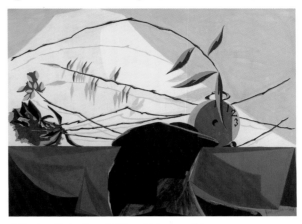

Collection: Elisabeth and William M. Landes, Chicago.

Provenance: Jacob and Gwendolyn Knight Lawrence, New York and Seattle; [DC Moore Gallery, New York].

Remarks: This painting was postdated "1953" by the artist in the mid-1990s; however, stylistically it is closer to work created in 1955.

P56-01
The Cue and the Ball
1956
casein tempera on paper
30½ × 22½ in. (77.5 × 57.2 cm)
signed and dated lower right "Jacob Lawrence 56"

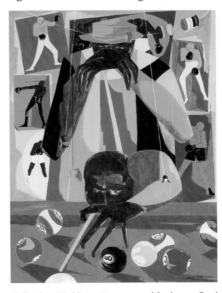

Collection: Hirshhorn Museum and Sculpture Garden, Smithsonian Institution. Gift of Joseph H. Hirshhorn, 1966.

Provenance: [The Alan Gallery, New York]; Joseph H. Hirshhorn, New York.

Exhibitions: The Alan Gallery, New York, *Opening Exhibition: 1956–1957*, September 5–29, 1956, no. 9.

References: Clifford Wright, "Jacob Lawrence," *The Studio* 161 (January 1961), p. 26, ill.; Wheat 1986, p. 157, pl. 74b.

P56-02
Palm Sunday
1956
casein tempera on paper
30¼ × 22½ in. (76.8 × 57.2 cm)
signed and dated lower right "Jacob Lawrence 56"

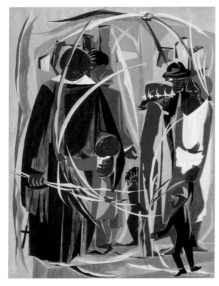

Collection: North Carolina Central University Art Museum, Durham. Friends of the Museum Fund and the National Endowment for the Arts.

Provenance: [The Alan Gallery, New York]; Mr. and Mrs. David Harris, New York; [Parke Bernet Galleries, New York, December 13, 1973, lot 174]; Alfred Giardino, New York; [Terry Dintenfass Inc., New York].

Exhibitions: Washington Federal Savings and Loan Association of Miami Beach, *Jacob Lawrence Painting Exhibition*, October 16–November 22, 1961; Gallery 62, National Urban League, New York, *Golden Opportunity*, September 18–November 30, 1978; Addison Gallery of American Art, Phillips Academy, Andover, Mass., and The Studio Museum in Harlem, New York, *To Conserve a Legacy: American Art from Historically Black Colleges and Universities*, 1999–2001.

References: Powell 1992, pl. 9; Richard Powell and Jock Reynolds, *To Conserve a Legacy: American Art from Historically Black Colleges and Universities*, exh. cat. (Andover, Mass.: Addison Gallery of American Art; New York: The Studio Museum in Harlem, 1999), p. 2, ill.

P56-03
Struggle . . . From the History of the American People
1954–6
egg tempera on hardboard (30 panels)

In 1954, Lawrence began research for a new series of paintings on the history of the United States. His original conception of sixty paintings included captions written by his friend Jay Leyda. The goal was to publish the series in book format. He conducted research at The Schomburg Library and completed the first thirty paintings by the end of 1956. These works were exhibited at The Alan Gallery in 1956 and again in 1958. Lawrence never painted the remaining thirty panels, but in 1959 the first thirty panels were purchased by a collector who sold the panels individually over several decades. Twenty-one of these panels were consigned to the Martin Gallery, New York, in February 1966, where they were exhibited.

Lawrence did not work on all thirty panels at once, as he had done with *The Migration of the Negro* (1941), instead he worked on the panels individually or in groups. The panels are presented here in the order in which they were first exhibited. Because the series is considered to be a single artwork (regardless of the fact that the panels are in numerous collections), cataloguing data is included for each panel, even if no image exists.

1. *. . . is life so dear or peace so sweet as to be purchased at the price of chains and slavery?*
—PATRICK HENRY, 1775
1955
12 × 16 in. (30.5 × 40.6 cm)
signed and dated upper left "Jacob Lawrence 55"

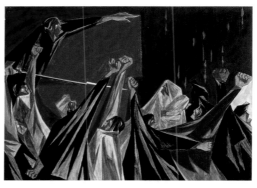

Collection: Susan and Alan Patricof.

Provenance: [The Alan Gallery, New York]; William Meyers, New York; [Terry Dintenfass Inc., New York].

Exhibitions: Alan 1956, no. 1; Alan 1958, no. 1; AFA 1960–2, no. 45.

References: Saarinen 1960, p. 44, ill.

Remarks: A.k.a. *Prophecy (Patrick Henry)*.

2. *Massacre in Boston*
1955
12 × 16 in. (30.5 × 40.6 cm)
signed and dated lower left "Jacob Lawrence 55"

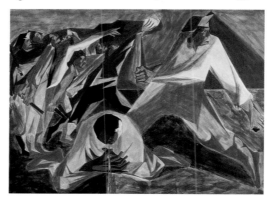

Collection: Mr. and Mrs. Harvey Ross.

Provenance: [The Alan Gallery, New York]; William Meyers, New York; [The Martin Gallery, New York]; Janet Lehr, New York; [ACA Gallery, New York].

Exhibitions: Alan 1956, no. 2; Alan 1958, no. 2; The Minneapolis Institute of Arts in association with Ruder & Finn Fine Arts, New York, *Thirty Contemporary Black Artists*, October 17–November 24, 1968; Whitney 1974–5, no. 127; Stockton State 1983, no. 15; Midtown Payson 1995a.

References: Al Newbill, "Gallery Previews in New York," *Pictures on Exhibit* 20, 4 (January 1957), p. 23; Wheat 1986, p. 123, ill.

Remarks: A.k.a. *Massacre in Boston* and *Incident (Boston Massacre).*

3. Rally Mohawks! bring out your axes, and tell King George we'll pay no taxes on his foreign tea . . .
—A SONG OF 1773
1955
12 × 16 in. (30.5 × 40.6 cm)
inscription unknown

Collection: Current location unknown.

Provenance: [The Alan Gallery, New York]; William Meyers, New York.

Exhibitions: Alan 1956, no. 3; Alan 1958, no. 3.

Remarks: A.k.a. *Masquerade (Boston Tea-Party).*

4. I alarmed almost every house till I got to Lexington.
—PAUL REVERE
1954
12 × 16 in. (30.5 × 40.6 cm)
signed and dated lower left "Jacob Lawrence 54"

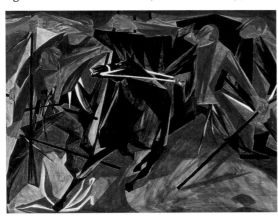

Collection: Allan and Mary Kollar, Seattle.

Provenance: [The Alan Gallery, New York]; William Meyers, New York; [Terry Dintenfass Inc., New York]; Private collection, Washington, D.C.; [Terry Dintenfass Inc., New York].

Exhibitions: Alan 1956, no. 4; Alan 1958, no. 4; Seattle 1986–7, no. 91; Springfield Museum of Art, Ohio, and the Riffe Gallery, Ohio Arts Council, Columbus, *Masterworks by Twentieth Century African-American Artists*, January 17–June 13, 1998.

References: Wheat 1986, p. 214, no. 91, ill.; *Masterworks by Twentieth Century African-American Artists*, exh. cat. (Springfield, Ohio: Springfield Museum of Art, 1998), ill.

Remarks: A.k.a. *The Night Rider* and *Night Rider (Paul Revere).*

5. We have no property! We have no wives! No children! We have no city! No country!
—PETITION OF MANY SLAVES, 1773
1955
16 × 12 in. (40.6 × 30.5 cm)
signed and dated lower left "Jacob Lawrence 55"

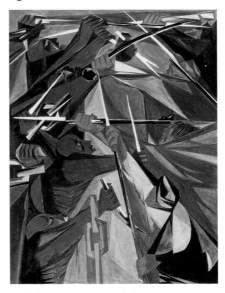

Collection: The Thompson Collection.

Provenance: William Meyers, New York; [The Alan Gallery, New York]; Mr. and Mrs. Oscar Rosen; Private collection, Washington, D.C.; [Midtown Payson Galleries, New York].

Exhibitions: Alan 1956, no. 5; Alan 1958, no. 5; The Museum of the National Center of Afro-American Artists, Roxbury, Mass., *Five Famous Black Artists: Romare Bearden, Jacob Lawrence, Horace Pippin, Charles White, Hale Woodruff*, February 9–March 10, 1970 (as *Battling Slaves*); Whitney 1974–5; Seattle 1986–7, no. 92.

References: *Five Famous Black Artists: Romare Bearden, Jacob Lawrence, Horace Pippin, Charles White, Hale Woodruff*, exh. cat. (Roxbury, Mass.: Museum of the National Center of Afro-American Artists, 1970), n.p., ill.; Brown 1974; Wheat 1986, p. 215, ill.; Midtown Payson 1995b, p. 9, ill.

Remarks: A.k.a. *Slave Revolt* and *Men in Chains.*

6. *... we mutually pledge to each other our Lives, our Fortunes, and our sacred Honour.*
—*4 JULY 1776*
1955
16 × 12 in. (40.6 × 30.5 cm)
signed and dated lower right "Jacob Lawrence 55"

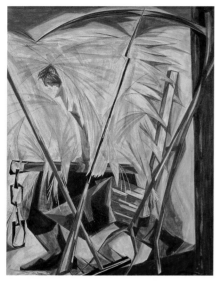

Collection: Professor and Mrs. David Driskell.

Provenance: [The Alan Gallery, New York]; William Meyers, New York; [Terry Dintenfass Inc., New York]; Mr. and Mrs. Louis Harrow, White Plains, N.Y.; [Luise Ross Gallery, New York].

Exhibitions: Alan 1956, no. 6; Alan 1958, no. 6; Whitney 1974–5, no. 129 (Whitney only); Midtown Payson 1995a.

References: Terry Gips, ed., *Narratives of African-American Art and Identity: The David C. Driskell Collection*, exh. cat. (College Park, Md.: University of Maryland, 1998).

Remarks: A.k.a. *Independence.*

7. *The summer soldier and the sunshine patriot will, in this crisis, shrink from the service of his country.*
—*THOMAS PAINE, 1776*
1956
12 × 15½ in. (30.5 × 39.4 cm)
signed and dated lower right "Jacob Lawrence 56"

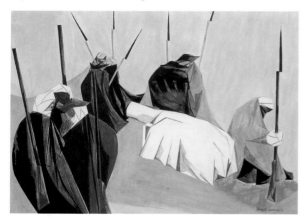

Collection: Renee and Chaim Gross Foundation.

Provenance: [The Alan Gallery, New York]; William Meyers, New York; ?; Edward Halpern.

Exhibitions: Alan 1956, no. 7; Alan 1958, no. 7.

References: Howard Devree, "Personal Visions: Work by Five Artists in Modes of Today," *New York Times*, May 11, 1958, sec. 2, p. 15, ill. (as *Valley Forge*).

8. *... again the rebels rushed furiously on our men.*
—*A HESSIAN SOLDIER*
1954
12 × 15½ in. (30.5 × 39.4 cm)
signed and dated lower right "Jacob Lawrence 1954"

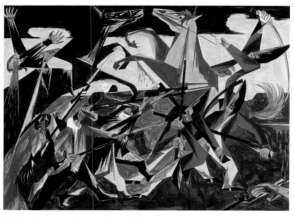

Collection: Mr. and Mrs. Harvey Ross.

Provenance: [The Alan Gallery, New York]; William Meyers, New York; [The Bernhardt Crystal Gallery, New York]; Private collection; [Terry Dintenfass Inc., New York]; Bernard King; [DC Moore Gallery, New York].

Exhibitions: Alan 1956, no. 8; Alan 1958, no. 8; The Center Gallery, Bucknell University, Lewisburg, Pa., *Since the Harlem Renaissance: Fifty Years of Afro-American Art*, April 13–June 6, 1984.

Remarks: A.k.a. *Red Coats* and *Red Coats (Bennington).*

9. *Defeat*
1954
12 × 16 in. (30.5 × 40.6 cm)
signed and dated lower left "Jacob Lawrence 1954"

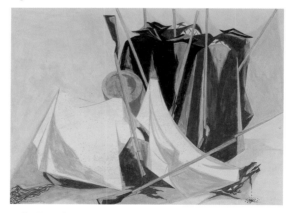

Collection: John Hope Franklin.

Provenance: [The Alan Gallery, New York]; William Meyers, New York; ?; Dr. Robert Aaron; [Terry Dintenfass Inc., New York].

Exhibitions: Alan 1956, no. 9; Alan 1958, no. 9; Whitney 1974–5.

10. *We crossed the River at McKonkey's Ferry 9 miles above Trenton . . . the night was excessively severe . . . which the men bore without the least murmur . . .*
—TENCH TILGHMAN, 27 DECEMBER 1776
1954
12 × 16 in. (30.5 × 40.6 cm)
signed and dated lower right "Jacob Lawrence 54"

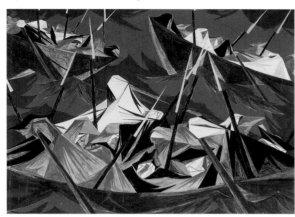

Collection: Private collection.

Provenance: [The Alan Gallery, New York]; William Meyers, New York; [The Martin Gallery, New York]; Irwin Bogen, New York.

Exhibitions: Alan 1956, no. 10; Alan 1958, no. 10; AFA 1960–2, no. 46; Midtown Payson 1995a.

References: J. R. M., "In the Galleries: Jacob Lawrence," *Arts* 31, 4 (January 1957), p. 53, ill.; "American Struggle: Three Paintings," *Vogue* 130 (July 1957), p. 66, ill.; Saarinen 1960, p. 45, ill.; Midtown Payson 1993b, p. 11; Romare Bearden and Harry Henderson, *A History of African-American Artists from 1972 to Present* (New York: Pantheon Books, 1993), p. 308, ill.

Remarks: A.k.a. *Washington Crossing the Delaware* and *River.*

11. *120.9.14.286.9.33-ton 290.9.27 be at 153.9.28.110.8.17.255.9.29 evening 178.9.8 . . .*
—AN INFORMER'S CODED MESSAGE
1955
15 ¹⁵⁄₁₆ × 11 ¹⁵⁄₁₆ in. (40.5 × 30.3 cm)
signed and dated upper right "Jacob Lawrence 55"; verso: inscribed center "Rebel or Loyalist?"

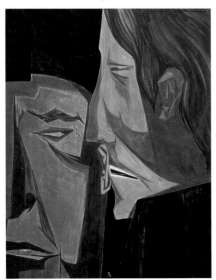

Collection: Private collection, New York.

Provenance: [The Alan Gallery, New York]; William Meyers, New York; [The Martin Gallery, New York].

Exhibitions: Alan 1956, no. 11; Alan 1958, no. 11.

References: "Birth of a Nation," *Time* 69 (January 14, 1957), p. 82, ill.; Wheat 1986, p. 123, pl. 55.

Remarks: A.k.a. *Espionage, Rebel or Loyalist?, The Secret,* and *An Informer.*

12. *And a Woman Mans a Cannon*
1955
16 × 12 in. (40.6 × 30.5 cm)
signed and dated lower right "Jacob Lawrence 55"

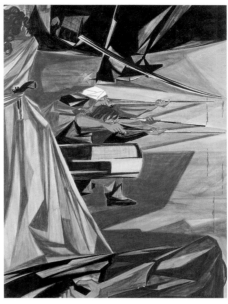

Collection: Dr. Kenneth Clark.

Provenance: [The Alan Gallery, New York]; William Meyers, New York; [Terry Dintenfass Inc., New York]; Dr. Michael Moses, New York; [Terry Dintenfass Inc., New York].

Exhibitions: Alan 1956, no. 12; Alan 1958, no. 12; Midtown Payson 1995a.

Remarks: A.k.a. *Woman at War.*

13. *Victory and Defeat*
1955
12 × 16 in. (30.5 × 40.6 cm)
signed and dated lower right "Jacob / Lawrence 55"

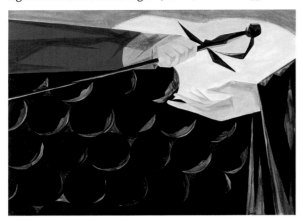

Collection: Private collection, Seattle.

Provenance: [The Alan Gallery, New York]; William Meyers, New York; [Harvey Lubitz, New York]; Michael Kapon, New York; [DC Moore Gallery, New York].

Exhibitions: Alan 1956, no. 13; Alan 1958, no. 13; Midtown Payson 1995a.

Remarks: A.k.a. *Passing the Sword of Freedom* and *Sword (Yorktown)*.

14. *Peace*
1955
12 × 16 in. (30.5 × 40.6 cm)
inscription unknown

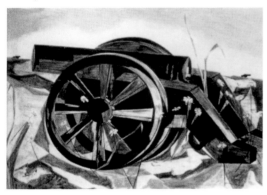

Collection: Current location unknown.

Provenance: [The Alan Gallery, New York]; William Meyers, New York.

Exhibitions: Alan 1956, no. 14; Alan 1958, no. 14; AFA 1960–2, no. 47.

References: Saarinen 1960, p. 45, ill.; William Berkson, "In the Galleries," *Arts* 40, 7 (May 1966), p. 66; Carlos Baker, "Many Wars Ago," *New York Times Book Review*, April 14, 1968, p. 5, ill. (as *Hollow Victories*); Romare Bearden and Harry Henderson, *A History of African-American Artists from 1972 to Present* (New York: Pantheon Books, 1993), p. 308, ill.

Remarks: A.k.a. *Idle Cannon*.

15. *We, the people of the United States, in order to form a more perfect Union, establish justice, insure domestic tranquility . . .*
—17 September 1787
1955
12 × 16 in. (30.5 × 40.6 cm)
signed and dated lower left "Jacob Lawrence 55"; verso: inscribed center "CREATION"

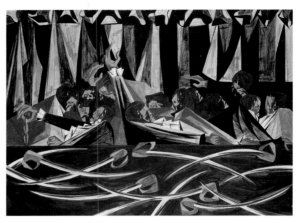

Collection: Fogg Art Museum, Harvard University Art Museums. Anonymous fund in memory of Henry Berg, Henry George Berg Bequest, Richard Norton, and Alpheus Hyatt Fund.

Provenance: [The Alan Gallery, New York]; William Meyers, New York; ?; Mr. and Mrs. Sidney Sass; [G. W. Eisenstein & Co., New York].

Exhibitions: Alan 1956, no. 15; Alan 1958, no. 15; Whitney 1974–5; Midtown Payson 1995a.

References: "American Struggle: Three Paintings," *Vogue* 130 (July 1957), p. 67, ill.; Midtown Payson 1995b, cvr., ill.

Remarks: A.k.a. *Creation, Creation (Constitutional Convention)*, and *We the People*.

16. *There are combustibles in every State, which a spark might set fire to.*
—Washington, 26 December 1786
1956
dimensions unknown
inscription unknown

Collection: Current location unknown.

Provenance: [The Alan Gallery, New York]; William Meyers, New York.

Exhibitions: Alan 1956, no. 16; Alan 1958, no. 16.

Remarks: A.k.a. *Discontent Within (Shay's Rebellion)*.

17. *I shall hazard much and can possibly gain nothing by the issue of this interview . . .*
—HAMILTON BEFORE HIS DUEL WITH BURR, 1804
1956
12 × 16 in. (30.5 × 40.6 cm)
signed and dated lower left "Jacob Lawrence 56"

Collection: Mr. and Mrs. Harvey Ross.

Provenance: [The Alan Gallery, New York]; William Meyers, New York; [Harvey Lubitz, New York]; Michael Kapon, New York; [DC Moore Gallery, New York].

Exhibitions: Alan 1956, no. 17; Alan 1958, no. 17; Midtown Payson 1995a.

Remarks: A.k.a. *The Death of Alexander Hamilton* and *Politics (Hamilton-Burr Duel).*

18. *In all your intercourse with the natives, treat them in the most friendly and conciliatory manner which their own conduct will admit . . .*
—JEFFERSON TO LEWIS & CLARK, 1803
1956
16 × 12 in. (40.6 × 30.5 cm)
signed and dated lower center "Jacob Lawrence 56"

Collection: Dr. Kenneth Clark.

Provenance: [The Alan Gallery, New York]; William Meyers, New York; [Terry Dintenfass Inc., New York]; Dr. Michael Moses, New York; [Terry Dintenfass Inc., New York].

Exhibitions: Alan 1956, no. 18; Alan 1958, no. 18; AFA 1960–2, no. 48; Midtown Payson 1995a.

References: Virginia Lee, "Jacob Lawrence—Story Teller," *Northwest Art News and Views* 1 (March–April 1970), p. 20; Elsa Honig Fine, *The Afro-American Artist: A Search for Identity* (New York: Hacker Art Books, 1973), p. 150, pl. 201.

Remarks: A.k.a. *Exploration of the West, Exploration (Lewis & Clark),* and *The Expedition of Lewis and Clark.*

19. *Thousands of American citizens have been torn from their country and from everything dear to them: they have been dragged on board ships of war of a foreign nation.*
—MADISON, 1 JUNE 1812
1956
16 × 12 in. (40.6 × 30.5 cm)
signed and dated lower right "Jacob Lawrence 56"

Collection: Current location unknown.

Provenance: [The Alan Gallery, New York]; William Meyers, New York.

Exhibitions: Alan 1956, no. 19; Alan 1958, no. 19.

Remarks: A.k.a. *Impressment.*

20. *Spindles*
1956
egg tempera on hardboard
dimensions unknown
inscription unknown

Collection: Current location unknown.

Provenance: [The Alan Gallery, New York]; William Meyers, New York.

Exhibitions: Alan 1956, no. 20; Alan 1958, no. 20.

21. *Listen, Father! The Americans have not yet defeated us by land; neither are we sure they have done so by water—we therefore wish to remain here and fight our enemy . . .*
—Tᴇᴄᴜᴍsᴇʜ ᴛᴏ ᴛʜᴇ Bʀɪᴛɪsʜ, Tɪᴘᴘᴇᴄᴀɴᴏᴇ, 1811
1956
16 × 12 in. (40.6 × 30.5 cm)
signed and dated lower right "Jacob Lawrence 56"

Collection: Mr. and Mrs. Harvey Ross.

Provenance: [The Alan Gallery, New York]; William Meyers, New York; [Harvey Lubitz, New York]; Michael Kapon, New York; [DC Moore Gallery, New York].

Exhibitions: Alan 1956, no. 21; Alan 1958, no. 21; AFA 1960–2, no. 49; Midtown Payson 1995a.

References: Saarinen 1960, pp. 2, 46, ill.

Remarks: A.k.a. *Tippecanoe.*

22. *Trappers*
1956
16 × 11⅞ in. (40.6 × 30.1 cm)
signed and dated lower right "Jacob Lawrence 56"

Collection: Dr. Kenneth Clark.

Provenance: [The Alan Gallery, New York]; William Meyers, New York; [Terry Dintenfass Inc., New York]; Dr. Michael Moses, New York; [Terry Dintenfass Inc., New York].

Exhibitions: Alan 1956, no. 22; Alan 1958, no. 22; Midtown Payson 1995a.

Remarks: A.k.a. *Bitter Root Trail.*

23. *. . . if we fail, let us fail like men, and expire together in one common struggle . . .*
—Hᴇɴʀʏ Cʟᴀʏ, 1813
1956
16 × 12 in. (40.6 × 30.5 cm)
signed and dated lower left "Jacob Lawrence 56"

Collection: Dr. Kenneth Clark.

Provenance: [The Alan Gallery, New York]; William Meyers, New York; [Terry Dintenfass Inc., New York]; Dr. Michael Moses, New York; [Terry Dintenfass Inc., New York].

Exhibitions: Alan 1956, no. 23; Alan 1958, no. 23; AFA 1960–2, no. 50; Midtown Payson 1995a.

References: Saarinen 1960, p. 46, ill.

Remarks: A.k.a. *Battle of Lake Erie* and *Inland Sea (Battle of Lake Erie).*

24. *Of the Senate House, the President's Palace, the barracks, the dockyard . . . nothing could be seen except heaps of smoking ruins . . .*
—*A British officer at Washington, 1814*
1956
12 × 16 in. (30.5 × 40.6 cm)
signed and dated upper right "Jacob Lawrence 56"

Collection: Dr. Kenneth Clark.

Provenance: [The Alan Gallery, New York]; William Meyers, New York; [Terry Dintenfass Inc., New York]; Dr. Michael Moses, New York; [Terry Dintenfass Inc., New York].

Exhibitions: Alan 1956, no. 24; Alan 1958, no. 24; Whitney 1974–5, no. 133; Midtown Payson 1995a.

References: Brown 1974, p. 37.

Remarks: A.k.a. *A British Officer at Washington* and *Invasion (Destruction of Washington)*.

25. *I cannot speak sufficiently in praise of the firmness and deliberation with which my whole line received their approach . . .*
—*Andrew Jackson, New Orleans, 1815*
1956
12 × 16 in. (30.5 × 40.6 cm)
signed and dated lower left "Jacob Lawrence 56"

Collection: Private collection.

Provenance: [The Alan Gallery, New York]; William Meyers, New York; [Terry Dintenfass Inc., New York].

Exhibitions: Alan 1956, no. 25; Alan 1958, no. 25; Midtown Payson 1995a.

Remarks: A.k.a. *Battle after Peace (New Orleans)*.

26. *Peace*
1956
11¾ × 15¾ in. (29.8 × 40 cm)
signed and dated lower right "Jacob Lawrence 56"

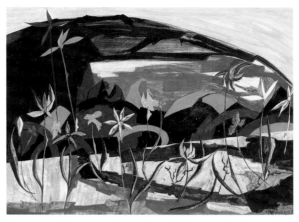

Collection: Francine Seders, Seattle.

Provenance: [The Alan Gallery, New York]; William Meyers, New York.

Exhibitions: Alan 1956, no. 26; Alan 1958, no. 26; Midtown Payson 1995a; Henry Art Gallery 1998.

Remarks: A.k.a. *Peace (Ghent)*.

27. *. . . for freedom we want and will have, for we have served this cruel land long enuff . . .*
—*A Georgia slave, 1810*
1956
11¾ × 15⅝ in. (29.8 × 39.7 cm)
signed and dated lower left "Jacob Lawrence 56"

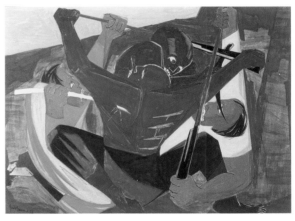

Collection: Howard Phil Welt and Norma Crampton.

Provenance: [The Alan Gallery, New York]; William Meyers, New York; ?; Jacob and Gwendolyn Knight Lawrence, Seattle; [Francine Seders Gallery, Seattle].

Exhibitions: Alan 1956, no. 27; Alan 1958, no. 27; Seattle 1986–7, no. 93; Midtown Payson 1995a; Henry Art Gallery 1998.

References: Lewis and Sullivan 1982, p. 26, ill. (as *Rebellion*); Wheat 1986, p. 124, pl. 56.

Remarks: A.k.a. *Slave Rebellion* and *Slave Rebellion (Boxley)*.

28. *Immigrants admitted from all countries: 1820 to 1840—115,773*
1956
16 × 12 in. (40.6 × 30.5 cm)
signed and dated upper left "Jacob Lawrence 56"

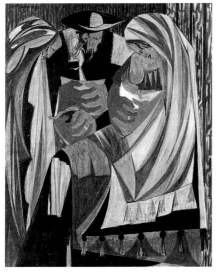

Collection: Current location unknown.

Provenance: [The Alan Gallery, New York]; William Meyers, New York.

Exhibitions: Alan 1956, no. 28; Alan 1958, no. 28.

Remarks: A.k.a. *Immigrants.*

29. *A cent and a half a mile, a mile and a half an hour.*
—*SLOGAN OF THE ERIE CANAL BUILDERS*
1956
11⅞ × 15⅞ in. (30.1 × 40.3 cm)
signed and dated lower left "Jacob Lawrence / 56"; verso: inscribed upper left "The Builders"

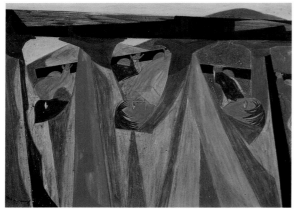

Collection: Private collection.

Provenance: [The Alan Gallery, New York]; William Meyers, New York; [Metropolitan Music School, New York, Benefit Sale, January 1961].

Exhibitions: Alan 1956, no. 29; Alan 1958, no. 29, Syracuse University, N.Y., *Jacob Lawrence: A Continuing Presence, An Exhibition of His Work from Private Collections,* February 15–March 11, 1989.

Remarks: A.k.a. *The Builders.*

30. *Old America seems to be breaking up and moving Westward . . .*
—*AN ENGLISH IMMIGRANT, 1817*
1956
11⅞ × 15⅞ in. (30.1 × 40.3 cm)
signed and dated lower left "Jacob Lawrence 56"; verso: inscribed upper left "Wagon West"; inscribed lower left "#29"

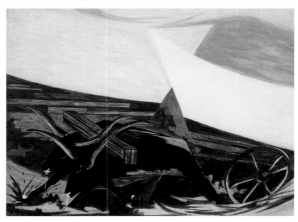

Collection: Private collection, New York.

Provenance: [The Alan Gallery, New York]; William Meyers, New York; [The Martin Gallery, New York].

Exhibitions: Alan 1956, no. 30; Alan 1958, no. 30; AFA 1960–2, no. 51.

References: Saarinen 1960, p. 47, ill.; Wheat 1986, p. 104.

Remarks: A.k.a. *Wagons West, Westward,* and *Moving Westward.*

P57-01
The Street
1957
casein tempera on paper
30½ × 22¼ in. (77.5 × 56.5 cm)
signed and dated lower right "Jacob Lawrence 57"

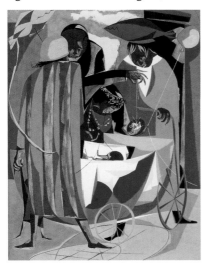

Collection: The Butler Institute of American Art, Youngstown, Ohio. Museum purchase, 1986.

Provenance: [The Alan Gallery, New York]; Harris A. Melasky, Tyler, Tex.; [Terry Dintenfass Inc., New York].

Exhibitions: The Alan Gallery, New York, *Opening Exhibition: 1957–1958*, September 10–28, 1957, no. 11; Fine Arts Museum of Long Island, Hempstead, N.Y., *Celebrating Contemporary American Black Artists*, March 13–May 1, 1983; Columbus Museum of Art, Ohio, *A Nature's Legacy: One Hundred Fifty Years of American Art*, January 19–October 5, 1992; Springfield Museum of Art, Ohio, and the Riffe Gallery, Ohio Arts Council, Columbus, *Masterworks by Twentieth Century African-American Artists*, January 17–June 13, 1998.

References: [Review of the Alan Gallery exhibition], *New York Herald Tribune*, September 15, 1957; Eleanor Flomenhaft, *Celebrating Contemporary American Black Artists*, exh. cat. (Hempstead, N.Y.: Fine Arts Museum of New York, 1983), n.p., ill.; Wheat 1986, p. 128, pl. 59; Irene S. Sweetkind, ed., *Master Paintings from the Butler Institute of Art* (New York: Harry N. Abrams, 1994), p. 276, ill.

P57-02
Playroom
1957
egg tempera on hardboard
20 × 16 in. (50.8 × 40.6 cm)
signed and dated lower right "Jacob Lawrence 57"

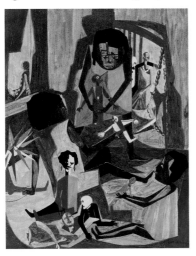

Collection: The William H. Lane Collection, Boston.

Provenance: [The Alan Gallery, New York]; Mr. and Mrs. William H. Lane, Boston.

Exhibitions: The Currier Gallery of Art, Manchester, N.H., *American Art from the William H. Lane Foundation*, November 1–December 14, 1958; Slater Memorial Museum, Norwich Free Academy, Conn., *William H. Lane Foundation Exhibition*, November 2–22, 1960; Whitney 1974–5, no. 135.

P57-03
Cabinet Maker
1957
casein tempera on paper
30½ × 22½ in. (77.5 × 57.2 cm)
signed and dated lower right "Jacob Lawrence 57"

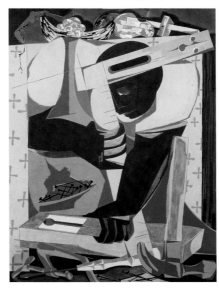

Collection: Hirshhorn Museum and Sculpture Garden, Smithsonian Institution. Gift of Joseph H. Hirshhorn, 1966.

Provenance: [The Alan Gallery, New York]; Joseph H. Hirshhorn, New York.

Exhibitions: AFA 1960–2, no. 52; Whitney 1974–5, no. 134 (Whitney only); Chrysler 1979a; Henry Art Gallery 1998.

References: Saarinen 1960, p. 48, ill.; "'Narrative Painter' Lawrence's Works to Be Exhibited at Allegheny College," *Meadville Tribune*, February 17, 1961; Romare Bearden and Harry Henderson, *Six Black Masters of American Art* (Garden City, N.Y.: Doubleday, 1972), pl. 21; Tom Williams, ed., "Exhibitions: Jacob Lawrence in Retrospect," *The Saint Louis Art Museum Bulletin* (July–August 1974), ill.; Milton Williams, "America's Top Black Artist," *Sepia* 23, 8 (August 1974), p. 77, ill.; Chrysler 1979b; Deloris Tarzan, "SAM Celebrates Lawrence," *Seattle Times*, July 9, 1986, p. C1, ill.; Robert Wernick, "Jacob Lawrence: Art As Seen through a People's History," *Smithsonian* 18, 3 (June 1987), p. 67, ill.; Kay Larson, "Museums: Jacob Lawrence," *New York* 20, 37 (September 21, 1987), p. 66, ill.; Deborah Solomon, "The Book of Jacob," *New York Daily News Magazine*, September 27, 1987, p. 21, ill.; Amy Fine Collins, "Jacob Lawrence: Art Builder," *Art in America* 76, 2 (February 1988), p. 133, ill.; "A Cubist of Today," *Scholastic: Art and Man* 19 (September–October 1988), p. 11, ill.; Pamela Mills, "Always Reaching for a New Dimension Defines Lawrence's Fifty-Year Career," *People's Daily World*, March 22, 1989, ill.; "Jacob Lawrence," *Scholastic: Art* 25 (April–May 1995), p. 2, ill.; p. 3.

P57-04
Cafe Comedian
1957
casein tempera on paper
23 × 29 in. (58.4 × 73.7 cm)
signed and dated lower right "Jacob Lawrence 57"

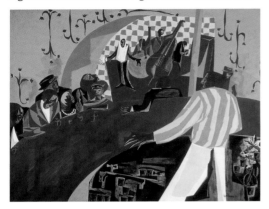

Collection: Museum of Fine Arts, Boston. Gift of Mr. and Mrs. William H. Lane and Museum Purchase, 1990.378.

Provenance: [The Alan Gallery, New York]; Mr. and Mrs. William H. Lane, Boston.

Exhibitions: Whitney Museum of American Art, New York, *1957 Annual Exhibition: Sculpture—Paintings—Watercolors*, November 20, 1957–January 12, 1958, no. 109; Des Moines Art Center, *Art To-Day*, February 2–March 2, 1958; The Currier Gallery of Art, Manchester, N.H., *American Art from the William H. Lane Foundation*, November 1–December 14, 1958; Fitchburg Art Museum, Mass., *American Art from the William H. Lane Foundation*, February 20–April 1, 1959; Mount Holyoke College Art Museum, South Hadley, Mass., *American Paintings Lent by the William H. Lane Foundation*, October 10–November 2, 1959; AFA 1960–2, no. 53; University Art Galleries, University of New Hampshire, Durham, *An Exhibition of Paintings from the William H. Lane Foundation*, February 13–March 15, 1963; De Cordova Museum, Lincoln, Mass., *Paintings from the William H. Lane Foundation*, November 23–December 29, 1963; Radcliffe College Graduate Center, Cambridge, Mass., *Paintings from the William H. Lane Foundation*, February 26–March 26, 1964; AMSAC 1964; George Walter Vincent Smith Art Museum, Springfield, Mass., *Twentieth-Century American Paintings Lent by the William H. Lane Foundation*, November 8–December 6, 1964; UCLA Art Galleries, Dickson Art Center, Los Angeles, *The Negro in American Art*, September 11–October 16, 1966; Mead Art Museum, Amherst College, Mass., *Twentieth-Century American Art from the William H. Lane Foundation*, October 10–November 11, 1973; Addison Gallery of American Art, Phillips Academy, Andover, Mass., *William H. Lane Foundation Exhibition*, November 20, 1973–January 24, 1974; The William Benton Museum of Art, University of Connecticut, Storrs, *Selections from the William H. Lane Foundation*, May 17–25, 1975, no. 49; Danforth Museum of Art, Framingham, Mass., *American Art: Selections from the William H. Lane Foundation*, March 21–June 4, 1978; The William Benton Museum of Art, University of Connecticut, Storrs, *Selections from The William H. Lane Foundation: Part II*, January 22–March 11, 1979, no. 65; Museum of Fine Arts, Boston, *The Lane Collection: Twentieth-Century Paintings in the American Tradition*, April 13–August 28, 1983, no. 99; Museum of Fine Arts, Boston, *Awash in Color: Homer, Sargent, and the Great American Watercolor*, April 28–August 15, 1993.

References: Saarinen 1960, p. 48, ill.; Margaret Rigg, "Jacob Lawrence: Painter," *Motive* (April 1962), p. 22, ill.; James A. Porter, *The Negro in American Art*, exh. cat. (Los Angeles: UCLA Art Galleries, Dickson Art Center, 1966), p. 31, ill.; Theodore E. Stebbins, Jr., and Carol Troyen, *The Lane Collection: Twentieth-Century Paintings in the American Tradition* (Boston: Museum of Fine Arts, 1983), p. 158, ill.; Carol Troyen and Sue Welsh Reed, *Awash in Color: Homer, Sargent, and the Great American Watercolor*, exh. cat. (Boston: Museum of Fine Arts, 1993), no. 125.

P58-01
Men exist for the sake of one another. Teach them then or bear with them.
—MARCUS ANTONIUS, MEDITATIONS, VIII: 59
1958
egg tempera on hardboard
20¾ × 16¾ in. (52.7 × 42.5 cm)
signed and dated lower right "Jacob Lawrence 58"

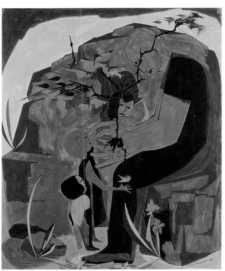

Collection: National Museum of American Art, Smithsonian Institution. Gift of the Container Corporation of America.

Provenance: [Terry Dintenfass Inc., New York]; Container Corporation of America, Chicago.

Exhibitions: Time-Life Exhibition Gallery, New York, *Great Ideas of Western Man—Art and Ideas in Mass Communication*, September 28–October 27, 1963; National Museum of American Art, Washington, D.C., *Art, Design, and the Modern Corporation*, October 24, 1985–January 19, 1986, no. 111.

References: Walter Herdeg, ed., *59/60 Graphis Annual 99* (1959), p. 86, ill.; [Container Corporation advertisement], *Time* (April 13, 1959), p. 119, ill.; [Container Corporation advertisement], *Newsweek* (April 20, 1959), p. 108, ill.; Martina Roudabush Norelli, *Art, Design, and the Modern Corporation: The Collection of the Container Corporation of America, A Gift to the National Museum of American Art*, exh. cat. (Washington, D.C.: Smithsonian Institution Press, 1985), p. 107, ill.

P58-02
Brownstones
1958
egg tempera on hardboard
31½ × 37¼ in. (80 × 94.6 cm)
signed and dated lower right "Jacob Lawrence 58"

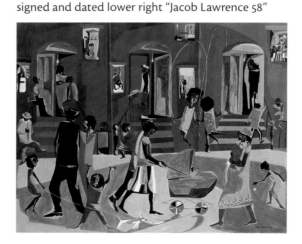

Collection: Clark Atlanta University Art Collections. Gift of Chauncey and Catherine Waddell.

Provenance: [The Alan Gallery, New York]; Mr. and Mrs. Chauncey L. Waddell, New York.

Exhibitions: High Museum of Art, Atlanta, *African-American Art in Atlanta: Public and Corporate Collections*, May 11–June 17, 1984, no. 33; Addison Gallery of American Art, Phillips Academy, Andover, Mass., and The Studio Museum in Harlem, New York, *To Conserve a Legacy: American Art from Historically Black Colleges and Universities*, 1999–2001, no. 152.

References: *Contemporary Art Collection* (Atlanta: Atlanta University, 1959), p. 17, ill.; Richard J. Powell and Jock Reynolds, *To Conserve a Legacy: American Art from Historically Black Colleges and Universities*, exh. cat. (Andover, Mass.: Addison Gallery of American Art; New York: The Studio Museum in Harlem, 1999).

P58-03
Fulton and Nostrand
1958
egg tempera on hardboard
24 × 30 in. (61 × 76.2 cm)
signed and dated lower right "Jacob Lawrence 58"

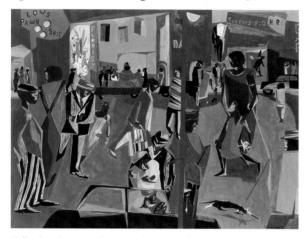

Collection: George and Joyce Wein, New York.

Provenance: [The Alan Gallery, New York]; Mr. and Mrs. Alexander Rittmaster, Woodmere, N.Y.; [Sotheby Parke Bernet, New York, May 29, 1981, lot 182]; ?; [Terry Dintenfass Inc., New York].

Exhibitions: Whitney Museum of American Art, New York, *1958 Annual Exhibition: Sculpture, Paintings, Watercolors, Drawings*, November 19, 1958–January 4, 1959, no. 106; The Pushkin Museum of Fine Arts, Moscow, *American Sculpture and Painting: American National Exhibition in Moscow*, July 25–September 5, 1959, no. 45; Whitney Museum of American Art, New York, *Between the Fairs: Twenty-Five Years of American Art, 1939–1964*, June 24–September 23, 1964, no. 71; Wollman Hall, New School Art Center, New School for Social Research, New York, *Contemporary Urban Visions*, January 25–February 24, 1966, no. 27; Neuberger Museum of Art, Purchase College, State University of New York, *Crossing State Lines: Twentieth-Century Art from Private Collections in Westchester and Fairfield Counties*, March 26–June 18, 1995.

References: *1958 Annual Exhibition: Sculpture, Paintings, Watercolors, Drawings*, exh. cat. (New York: Whitney Museum of American Art, 1958), ill.; Hilton Kramer, "In the Museums," *Art in America* 52, 2 (March 1964), p. 42, ill.; Victor S. Navasky, "With Malice toward All," *New York Times Book Review*, February 27, 1966, p. 4, ill. (as *Surreal Subworld*); Seymour Chwast and Steven Heller, eds., *The Art of New York* (New York: Harry N. Abrams, 1983), p. 76, ill.; Avis Berman, "Jacob Lawrence and the Making of Americans," *ARTnews* 83, 2 (February 1984), p. 82, ill. (as *Fulton and North Strand*); Wheat 1986, p. 129, pl. 60; Robert A. M. Stern, Thomas Mellins, and David Fishman, *New York 1960: Architecture and Urbanism between the Second World War and the Bicentennial* (New York: Monacelli Press, 1995), p. 1164, ill.

Remarks: Fulton and Nostrand Streets constitute one of the main intersections in the Bedford-Stuyvesant neighborhood of New York City, where the artist was living at that time.

P58-04
Two Comedians and a Dancer
1958
tempera on hardboard
18 × 24 in. (45.7 × 61 cm)
signed and dated lower right "J. Lawrence 58"

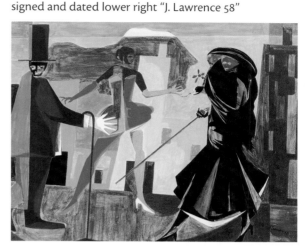

Collection: Private collection, New York.

Provenance: [The Alan Gallery, New York]; Flora Whitney Miller, New York; Estate of Flora Whitney Miller; [Sotheby's, New York, May 28, 1987, lot 328]; [Terry Dintenfass Inc., New York]; Andrew and Ann Dintenfass, Pacific Palisades, Calif.; [Terry Dintenfass Inc., New York].

Exhibitions: Whitney 1974–5, no. 136.

P58-05
Dominoes
1958
egg tempera on hardboard
24½ × 19¾ in. (62.2 × 50.2 cm)
signed and dated lower right "Jacob Lawrence / 58"

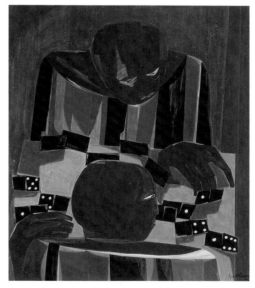

Collection: Private collection.

Provenance: [The Alan Gallery, New York]; Walter Werner, Redding, Conn.

Exhibitions: AFA 1960–2, no. 54.

References: Saarinen 1960, p. 49, ill.

P58-06
Magic Man
1958
egg tempera on hardboard
20 × 24 in. (50.8 × 61 cm)
signed and dated lower right "Jacob Lawrence 58"

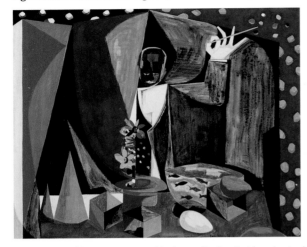

Collection: Hirshhorn Museum and Sculpture Garden, Smithsonian Institution. Gift of Mr. and Mrs. Henry Folkerson, 1981.

Provenance: [The Alan Gallery, New York]; Vincent Price Collection; Mr. and Mrs. Henry Folkerson, Fort Lauderdale, Fla.

Exhibitions: The Alan Gallery, New York, *Fifth Anniversary Exhibition: New Paintings and Sculpture*, September 8–27, 1958, no. 11; University of Illinois, Urbana-Champaign, *Contemporary American Painting and Sculpture*, March 1–April 5, 1959, no. 68; City Art Museum, Saint Louis, April 1959; Downtown Contemporary Gallery, Atlantic City, N.J., February 1961; Washington Federal Savings and Loan Association of Miami Beach, *Jacob Lawrence Painting Exhibition*, October 16–November 22, 1961.

References: *Contemporary American Painting and Sculpture*, exh. cat. (Urbana-Champaign, Ill.: University of Illinois, 1959, p. 235, pl. 77; *Jacob Lawrence: Painting Exhibition*, exh. brch. (Miami Beach: Washington Federal Savings and Loan Association, 1961), n.p., ill.

P59-01
The Architect
1959
egg tempera on hardboard
11¾ × 16 in. (29.8 × 40.6 cm)
signed and dated lower right "Jacob / Lawrence 59"

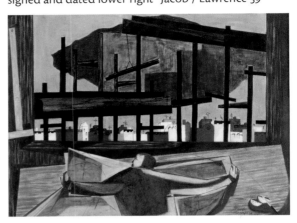

Collection: The Studio Museum in Harlem. Gift of Mr. and Mrs. James Harithas.

Provenance: ?; [Terry Dintenfass Inc., New York]; Mr. and Mrs. James Harithas.

References: *The Permanent Collection of the Studio Museum in Harlem* (New York: The Studio Museum in Harlem, 1983), p. 16, ill.

P59-02
Subway Acrobats
1959
egg tempera on hardboard
20 × 24 in. (50.8 × 61 cm)
signed and dated lower right "Jacob Lawrence 59"

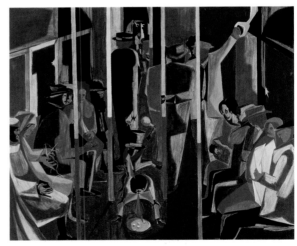

Collection: Private collection, New York.

Provenance: The Alan Gallery, New York; Maurice Cohen, Woodmere, N.Y.; [Terry Dintenfass Inc., New York]; Dr. Richard Simms, Los Angeles; [Heritage Gallery, Los Angeles].

Exhibitions: Los Angeles County Museum of Art, *Two Centuries of Black American Art*, September 30–November 21, 1976, no. 163.

References: "New Work at Alan Gallery," *Apollo* 70, 106 (October 1959), p. 106; Richard A. Simms, "Collector's Column," *Black Art* 1, 2 (winter 1976), p. 26, ill.; Lewis and Sullivan 1982, p. 33, ill.; Samella Lewis, "Beyond Traditional Boundaries: Collecting Black Art for Museums," *Museum News* 60, 3 (January–February 1982), p. 44, ill.

P59-03
Harlem Street Scene
1959
egg tempera on hardboard
16 × 11 in. (40.6 × 27.9 cm)
signed and dated lower right "Jacob Lawrence 59"

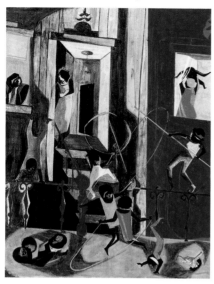

Collection: Private collection, New York.

Provenance: ?; [Terry Dintenfass Inc., New York].

P59-04
The Brown Angel
1959
egg tempera on hardboard
24 × 20 in. (61 × 50.8 cm)
signed and dated lower right "Jacob Lawrence 59"

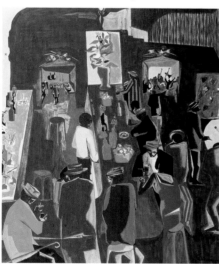

Collection: Private collection. Courtesy of F. B. Horowitz Fine Art, Hopkins, Minnesota.

Provenance: The Alan Gallery, New York; Mr. and Mrs. Irving Levick, Buffalo; [Sotheby Parke Bernet, New York, June 4, 1982, Sale 4880, lot 182]; [Terry Dintenfass Inc., New York].

Exhibitions: Seattle 1986–7, no. 95; Catherine G. Murphy Gallery, College of Saint Catherine, Saint Paul, *American Scene Painting*, February 4–March 3, 1995.

References: Michael David Zellman, *American Art Analog, Volume III, 1874–1930* (New York: Chelsea House Publishers in association with American Art Analog, 1986), p. 1005; Wheat 1986, p. 215, ill.

P59-05
The Visitors
1959
egg tempera on hardboard
20 × 24 in. (50.8 × 61 cm)
signed and dated lower right "Jacob Lawrence 59"

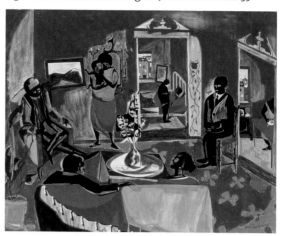

Collection: Dallas Museum of Art. General Acquisitions Fund.

Provenance: [The Downtown Gallery, New York]; William Zierler, New York; [Terry Dintenfass Inc., New York]; Keith Baker, Oshkosh, Wis.; [Terry Dintenfass Inc., New York].

Exhibitions: AFA 1960–2, no. 57; Seattle 1986–7, no. 97.

References: Saarinen 1960, p. 50, ill.; Wheat 1986, p. 215, ill.

P59-06
Street Shadows
1959
egg tempera on hardboard
24 × 30 in. (61 × 76.2 cm)
signed and dated lower right "Jacob Lawrence / 59"

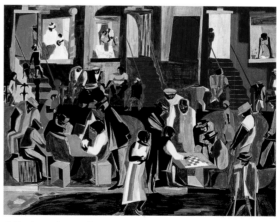

Collection: Private collection, New York.

Provenance: Jacob and Gwendolyn Knight Lawrence, New York; [Postgraduate Center for Psychotherapy, New York, Benefit Auction, January 1960]; Mr. and Mrs. Lewis Garlick, Southampton, N.Y.

Exhibitions: AFA 1960–2, no. 56; Indiana University Museum of Art, Bloomington, *The American Scene, 1900–1970: An Exhibition of Twentieth-Century Painting Held in Honor of the Sesquicentennial of Indiana University*, April 6–May 17, 1970; Whitney 1974–5, no. 137; Seattle 1986–7, no. 96.

References: Saarinen 1960, p. 15, ill.; Henry Radford Hope, *The American Scene 1900–1970*, exh. cat. (Bloomington, Ind.: Indiana University Art Museum, 1970), n.p., pl. 67; Shirley Glubak, "American Paintings," in *Freedom's Ground*, edited by Bernard J. Weiss and Lyman C. Hunt (New York: Holt, 1973), p. 326; Wheat 1986, p. 215, ill.

P59-07
Fruits and Vegetables
1959
egg tempera on hardboard
20 × 24 in. (50.8 × 61 cm)
signed and dated lower right "Jacob Lawrence 59"

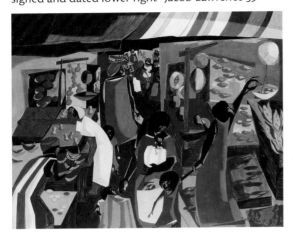

Collection: Private collection, New York.

Provenance: The Alan Gallery, New York; Mr. Irving Weisner, New York; [Five Towns Music and Art Foundation, Woodmere, N.Y.].

Exhibitions: AFA 1960–2, no. 55.

References: Saarinen 1960, p. 50, ill.

P60-01
All Hallow's Eve
1960
tempera on hardboard
24 × 30 in. (61 × 76.2 cm)
signed and dated lower right "J. Lawrence 1960"

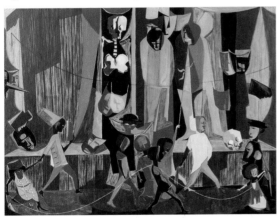

Collection: Ann and Walter Nathan, Chicago.

Provenance: The Alan Gallery, New York; Mr. and Mrs. Arthur Dintenfass; [Terry Dintenfass Inc., New York].

Exhibitions: The Alan Gallery, New York, *New Work IV*, June 1–30, 1960, no. 1; The Alan Gallery, New York, *New Work*, May 8–26, 1961, no. 13; Washington Federal Savings and Loan Association of Miami Beach, *Jacob Lawrence: Painting Exhibition*, October 16– November 22, 1961; Pennsylvania Academy of the Fine Arts, Philadelphia, *The One Hundred Fifty-Eighth Annual Exhibition: Water Colors, Prints and Drawings*, January 18– March 3, 1963, no. 316; Dintenfass 1963, no. 6.

References: Barry Schwartz, *The New Humanism: Art in a Time of Change* (New York: Praeger, 1974), p. 45, ill.

P60-02
Ices I
1960
egg tempera on hardboard
24 × 30 in. (61 × 76.2 cm)
signed and dated lower right "Jacob Lawrence 1960"

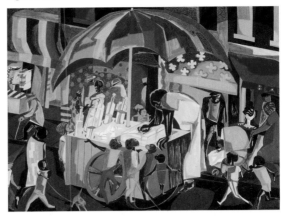

Collection: The Walter O. Evans Collection of African American Art.

Provenance: The Alan Gallery, New York; Alvin Boretz, New York; [Sotheby's, New York, September 21, 1994, lot 188].

Exhibitions: Krannert Art Museum, University of Illinois, Urbana-Champaign, *Contemporary American Painting and Sculpture*, February 26–April 2, 1961, no. 70; The Alan Gallery, New York, *New Work*, May 8–26, 1961, no. 11.

References: *Contemporary American Painting and Sculpture*, exh. cat. (Urbana-Champaign, Ill.: University of Illinois, 1961), p. 113, ill.

P60-03
Ices II
1960
egg tempera on hardboard
30 × 23⅞ in. (76.2 × 60.6 cm)
signed and dated lower right "Jacob Lawrence 60"

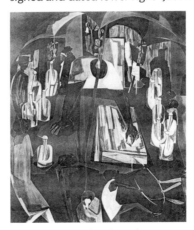

Collection: Current location unknown.

Provenance: [Five Towns Music and Arts Foundation, Woodmere, N.Y.]; Paula Singer, Hewlett Harbor, N.Y.; Jacob and Gwendolyn Knight Lawrence, Seattle.

Exhibitions: The Alan Gallery, New York, *New Work*, May 8–26, 1961, no. 12.

Remarks: This painting disappeared from the artist's apartment in Seattle in 1999.

P60-04
Parade
1960
tempera on hardboard
23⅞ × 30⅛ in. (60.6 × 76.5 cm)
signed and dated lower right "Jacob Lawrence 60"

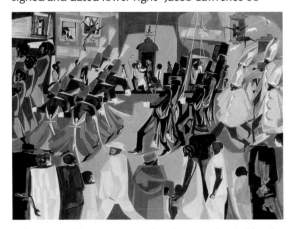

Collection: Hirshhorn Museum and Sculpture Garden, Smithsonian Institution. Gift of Joseph H. Hirshhorn, 1966.

Provenance: The Alan Gallery, New York; Joseph H. Hirshhorn, New York.

Exhibitions: Washington Federal Savings and Loan Association of Miami Beach, *Jacob Lawrence: Painting Exhibition*, October 16–November 22, 1961; The Museum of the National Center of Afro-American Artists and Museum of Fine Arts, Roxbury, Mass., *Jubilee: Afro-American Artists on Afro-America*, November 13, 1975–January 4, 1976; Los Angeles County Museum of Art, *Two Centuries of Black American Art*, September 30–November 21, 1976, no. 164; Alexandria Museum of Art, La., *The Rhythm of Life: Selected Works by Bearden, Gwathmey, and Lawrence*, January 25–March 30, 1984; Seattle 1986–7, no. 100.

References: John Gordon and L. Rust Hills, *New York, New York* (New York: Shorecrest, 1965), p. 403, ill.; Romare Bearden and Harry Henderson, *Six Black Masters of American Art* (Garden City, N.Y.: Doubleday, 1972), p. 57, ill.; Edmund Barry Gaither, *Jubilee: Afro-American Artists on Afro-America*, exh. cat. (Roxbury, Mass.: Museum of Fine Arts in cooperation with the Museum of the National Center of Afro-American Artists, 1975), p. 15, ill.; David C. Driskell, *Two Centuries of Black American Art*, exh. cat. (Los Angeles: Los Angeles County Museum of Art, 1976), p. 75, ill.; Judith Wilson, "Main Events: Art," *Essence* 10 (September 1979), p. 12, ill.; Wheat 1986, p. 130, pl. 61; Shirley Haley-James, *English* (Boston: Houghton Mifflin, 1990), p. 329, ill.; Romare Bearden and Harry Henderson, *A History of African-American Artists from 1972 to Present* (New York: Pantheon Books, 1993), p. 313, ill.

P60-05
The Library
1960
tempera on hardboard
24 × 29⅞ in. (61 × 75.9 cm)
signed and dated lower center/right "Jacob Lawrence 60"

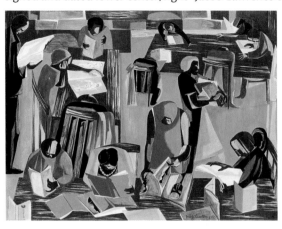

Collection: National Museum of American Art, Smithsonian Institution. Gift of S. C. Johnson & Sons, Inc.

Provenance: The Alan Gallery, New York; ?; S. C. Johnson & Sons, Inc.

Exhibitions: The Alan Gallery, New York, *New Work IV*, June 1–30, 1960, no. 2; The Alan Gallery, New York, *New Work*, May 8–26, 1961, no. 10; Washington Federal Savings and Loan Association of Miami Beach, *Jacob Lawrence: Painting Exhibition*, October 16–November 22, 1961; Johnson Collection of Contemporary Paintings, Chicago, *Art: USA*, 1965–7, no. 68; National Collection of Fine Art, Smithsonian Institution, Washington, D.C., *Art by Black Americans: 1930–1950*, October 19–December 6, 1971; National Museum of American Art, Washington, D.C., *Art, Design, and the Modern Corporation: The Collection of the Container Corporation of America, A Gift to the National Museum of American Art*, October 24, 1985–January 19, 1986; National Museum of American Art, Smithsonian Institution, Washington, D.C., *Free within Ourselves: African-American Artists in the Collection of the National Museum of American Art*, 1992–4; Henry Art Gallery 1998.

References: Lee Nordness, ed., *Art: USA Now*, exh. cat. (Lucerne, Switzerland: C. J. Bucher, 1962), p. 323, ill.; Margaret Rigg, "Jacob Lawrence: Painter," *Motive* (April 1962), p. 23, ill.; Howard VanderBeak, *Thought and Phrase* (Cedar Falls, Iowa: University of Northern Iowa, 1974); William Kloss, *Treasures from the National Museum of American Art* (Washington, D.C.: National Museum of American Art and Smithsonian Press, 1985), p. 156, ill.; Regenia A. Perry, *Free within Ourselves: African-American Artists in the Collection of the National Museum of American Art*, exh. cat. (Washington, D.C.: National Museum of American Art, Smithsonian Institution in association with Pomegranate Art Books, 1992), bk. cvr., ill.

P60-06
Library II
1960
egg tempera on hardboard
23½ × 29½ in. (59.7 × 74.9 cm)
signed and dated lower right "Jacob Lawrence 60"

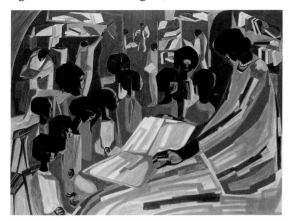

Collection: Mr. and Mrs. Michael Cherkasky, New York.

Provenance: The Alan Gallery, New York; Mr. and Mrs. Arthur Dintenfass; [Terry Dintenfass Inc., New York]; Martin and Sarah Cherkasky, New York.

Exhibitions: AFA 1960–2, no. 58; Pennsylvania Academy of the Fine Arts, Philadelphia, *The One Hundred Fifty-Eighth Annual Exhibition: Water Colors, Prints and Drawings,* January 18–March 3, 1963, no. 315; Dintenfass 1963, no. 3; Brandeis 1965, no. 5; Whitney 1974–5, no. 140 (New York only).

References: Saarinen 1960, p. 51, ill.; Brown 1974, p. 40, ill.; Milton Williams, "America's Top Black Artist," *Sepia* 23, 8 (August 1974), p. 76, ill.

P60-07
Library III
1960
egg tempera on hardboard
30 × 24 in. (76.2 × 61 cm)
signed and dated lower right "Jacob Lawrence 60"

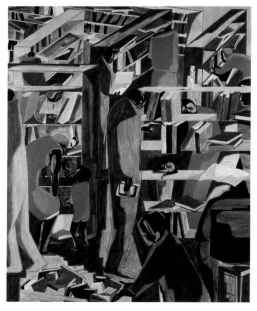

Collection: Collection of Citigroup.

Provenance: [Terry Dintenfass Inc., New York]; Litton Industries, New York; [Terry Dintenfass Inc., New York].

Exhibitions: Washington Federal Savings and Loan Association of Miami Beach, *Jacob Lawrence: Painting Exhibition,* October 16–November 22, 1961; Dintenfass 1963, no. 7; Brandeis 1965, no. 6; UCLA Art Galleries, Dickson Art Center, Los Angeles, *The Negro in American Art,* September 11–October 16, 1966; Whitney 1974–5, no. 141 (Whitney only); Stockton State 1983, no. 16; Seattle 1986–7, no. 99.

References: Edward Alden Jewell, "Art: New Group and One-Man Exhibits," *New York Times,* September 27, 1942, sec. 8, p. 5; James A. Porter, *The Negro in American Art,* exh. cat. (Los Angeles: UCLA Art Galleries, Dickson Art Center, 1966), cvr., ill.; Wheat 1986, p. 215, no. 99, ill.

P61-01
Four Students
1961
tempera on hardboard
30 × 22 in. (76.2 × 55.9 cm)
inscription unknown

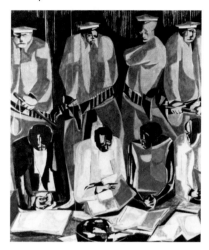

Collection: Current location unknown.

Provenance: [The Alan Gallery, New York]; ?; [Terry Dintenfass Inc., New York]; Maurice Saltzman.

Exhibitions: The Alan Gallery, New York, *61/62 Opening Exhibition: From 1700 to 1961,* September 1961, no. 15 (ill. in brochure); Whitney Museum of American Art, New York, *Annual Exhibition 1961: Contemporary American Painting,* December 13, 1961–February 4, 1962, no. 70; Whitney Museum of American Art, New York, *Annual Exhibition 1963: Contemporary American Painting,* December 1963–January 1964; Brandeis 1965, no. 7.

References: *1961 Annual Exhibition: Contemporary American Painting,* exh. cat. (New York: Whitney Museum of American Art, 1961), n.p., ill.; Margaret Rigg, "Jacob Lawrence: Painter," *Motive* (April 1962), p. 24, ill.; Jane H. Kay, "Lawrence Retrospective: Capsulating a Career," *Christian Science Monitor,* March 26, 1965, p. 4.

P61-02
Playthings
1961
tempera on hardboard
16 × 20 in. (40.6 × 50.8 cm)
signed and dated lower right "Jacob Lawrence 61"

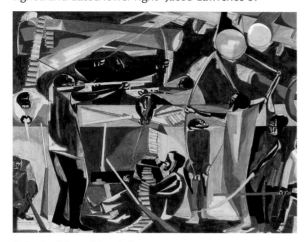

Collection: Jules and Connie Kay.
Provenance: ?; [Forum Gallery, New York].
Exhibitions: Midtown Payson 1995a.

P61-03
The Travelers
1961
tempera on hardboard
11½ × 8½ in. (29.2 × 21.6 cm)
inscription is illegible

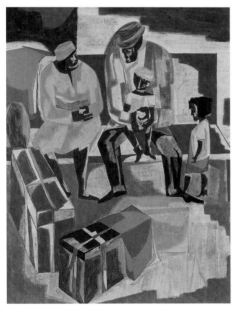

Collection: Professor and Mrs. David C. Driskell.
Provenance: [Terry Dintenfass Inc., New York]; Mr. and Mrs. Norman Greenfield; [Terry Dintenfass Inc., New York].
Exhibitions: Washington Federal Savings and Loan Association of Miami Beach, *Jacob Lawrence: Painting Exhibition*, October 16–November 22, 1961; Dintenfass 1963, no. 8; Midtown Payson 1995a.
References: Terry Gips, ed., *Narratives of African-American Art and Identity: The David C. Driskell Collection*, exh. cat. (College Park, Md.: University of Maryland, 1998), ill.

P61-04
Untitled [*Children Playing*]
1961
gouache on paper
image: 6⅝ × 5 in. (16.8 × 12.7 cm)
signed and dated lower right "Jacob Lawrence 61"

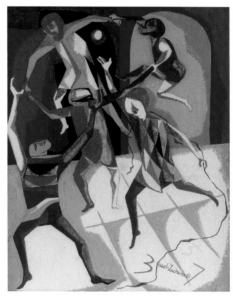

Collection: Jack and Jackie Friedman.
Provenance: Jacob and Gwendolyn Knight Lawrence, New York.
Remarks: One of two paintings commissioned by Jack and Jackie Friedman while the artist was on the faculty at the Five Towns Music and Arts Foundation; see P61-05.

P61-05
Untitled [*Children Playing*]
1961
gouache on paper
image: 6⅝ × 5 in. (16.8 × 12.7 cm)
signed and dated lower right "Jacob Lawrence 61"

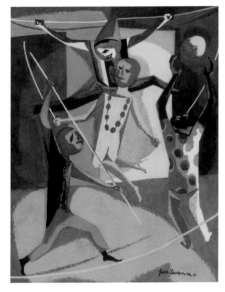

Collection: Jack and Jackie Friedman.
Provenance: Jacob and Gwendolyn Knight Lawrence, New York.

P61-06
Street Scene
1961
tempera on hardboard
12 × 16 in. (30.5 × 40.6 cm)
signed and dated lower right "Jacob Lawrence 61"

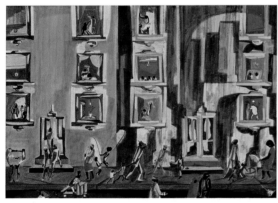

Collection: Private collection.
Provenance: [The Downtown Gallery, New York]; ?; [Terry Dintenfass Inc., New York]; Private collection.
Exhibitions: Southern Christian Leadership Council, Atlanta, *Black Motion*, 1972; New York Cultural Center, New York, *Blacks: USA: 1973*, September 26–November 15, 1973.
References: *Black Motion*, exh. brch. (Atlanta: Southern Christian Leadership Conference, 1972), ill.; Benny Andrews, *Blacks: USA: 1973*, exh. cat. (New York: New York Cultural Center, 1973), n.p., ill.

P61-07
Morning Still Life
1961
watercolor and gouache on paper
23¹¹⁄₁₆ × 17¾ in. (60.2 × 45.1 cm)
signed and dated lower right "Jacob Lawrence 61"

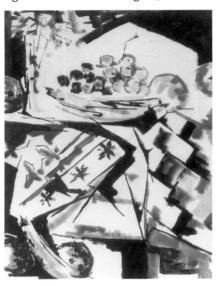

Collection: The Newark Museum. Gift of Diana Bonner Lewis, 86.43.
Provenance: Jacob and Gwendolyn Knight Lawrence, New York; [Parke Bernet Galleries, New York, Benefit Sale for Northside Center for Child Development, May 23, 1961, lot 94]; Jacob and Gwendolyn Knight Lawrence, New York; Diana Bonner Lewis, New York.

P61-08
Untitled [*The Checker Players*]
1961
egg tempera on hardboard
8¾ × 11⅝ in. (22.2 × 29.5 cm)
signed and dated lower right "Jacob Lawrence 61"

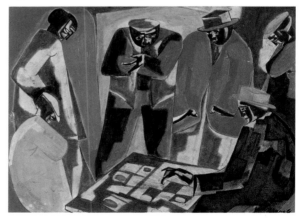

Collection: Elizabeth and Steven Roose, Scarsdale, New York.
Provenance: Jacob and Gwendolyn Knight Lawrence, New York; Judith Golden, New York.

P62-01
Praying Ministers
1962
tempera on hardboard
23 × 38 in. (58.4 × 96.5 cm)
signed and dated lower right "Jacob Lawrence 62"

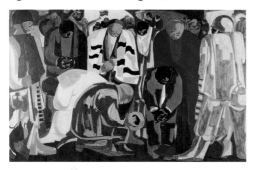

Collection: Spelman College, Atlanta.

Provenance: [Terry Dintenfass Inc., New York]; Mrs. Adolph Berle; [CORE Benefit Auction, dates unknown]; ?.

Exhibitions: Great Hall, City College of New York, The Evolution of Afro-American Artists: 1800–1950, October 15–November 8, 1967; Municipal Arts Gallery, Philadelphia Civic Center, Afro-American Artists: 1800–1969, December 5–29, 1969, no. 130; The Museum of the National Center of Afro-American Artists, Roxbury, Mass., Five Famous Black Artists: Romare Bearden, Jacob Lawrence, Horace Pippin, Charles White, Hale Woodruff, February 9–March 10, 1970 (as The Praying Minister); The Museum of the National Center of Afro-American Artists, Roxbury, Mass., School of the Museum of Fine Arts, and Museum of Fine Arts, Boston, Afro-American Artists, New York and Boston, May 19–June 23, 1970; High Museum of Art, Atlanta, African-American Art in Atlanta: Public and Corporate Collections, May 11–June 17, 1984, no. 35.

References: James H. Beck, "Jacob Lawrence," ARTnews 62, 2 (April 1963), p. 13, ill.; V[ivien] R[aynor], "In the Galleries: Jacob Lawrence," Arts 37, 9 (May 1963), p. 112; Romare Bearden and Carroll Greene, Jr., The Evolution of Afro-American Artists: 1800–1950, exh. cat. (New York: City University of New York in cooperation with Harlem Cultural Council and New York Urban League, 1967), p. 33, ill.; Carroll Greene, Jr., "Afro-American Artists: Yesterday and Now," The Humble Way (3rd Quarter 1968), p. 13, ill.; Virginia Lee, "Jacob Lawrence—Story Teller," Northwest Art News and Views 1 (March–April 1970), p. 19, ill.; Carroll Greene, Jr., "Perspective: The Black Artist in America," Art Gallery 13, 7 (April 1970), p. 8, ill.; David Schapiro, ed., Social Realism: Art as Weapon (New York: Patrick Ungar Publishing Company, 1973), p. 247, ill.; Wheat 1986, p. 133, pl. 64; Ellen Harkins Wheat, "Jacob Lawrence: American Painter," American Visions, 1987, p. 53, ill.; Ellen Harkins Wheat, "Jacob Lawrence: Chronicler of the Black Experience," American Visions 2, 1 (February 1987), p. 33, ill.

P62-02
Northbound
1962
tempera on hardboard
24 × 40 in. (61 × 101.6 cm)
signed and dated lower right "Jacob Lawrence 62"

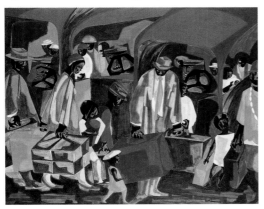

Collection: Mr. Merrill C. Berman, New York.

Provenance: [Terry Dintenfass Inc., New York]; Dr. and Mrs. Leo Stoll; [Sotheby's, New York, September 24, 1992, Sale 6336, lot 189]; John Horton, Kintnersville, Pa.; [Michael Rosenfeld Gallery, New York].

Exhibitions: The Alan Gallery, New York, 61/62 Opening Exhibition: From 1700 to 1961, September 1961, no. 14; The Alan Gallery, New York, 62/63: Tenth Anniversary Season: Opening Exhibition, September 25–October 13, 1962, no. 14; Dintenfass 1963, no. 11; James A. Michener Art Museum, Doylestown, Pa., A Collector's Eye: Depression-Era Paintings from the Collection of John Horton, December 10, 1994–January 22, 1995; Michael Rosenfeld Gallery, New York, African-American Art: Twentieth Century Masterworks IV, January 24–March 26, 1997.

References: 62/63: Tenth Anniversary Season: Opening Exhibition, exh. brch. (New York: The Alan Gallery, 1962), ill.; Jacob Lawrence, exh. brch. (New York: Terry Dintenfass Inc., 1963), ill.; "Art: Black Mirror," Newsweek 61, 15 (April 15, 1963), p. 100; Jefferson Eugene Grisby, Jr., Art and Ethics: Background for Teaching Youth in a Pluralistic Society (Dubuque, Iowa: William C. Brown, 1977), p. 43; A Collector's Eye: Depression-Era Paintings from the Collection of John Horton, exh. cat. (Doylestown, Pa.: James A. Michener Art Museum, 1994), pp. 12, 23; p. 17, ill.; African-American Art: Twentieth Century Masterworks IV, exh. cat. (New York: Michael Rosenfeld Gallery, 1997), p. 40, ill.

P62-03
Street Scene (Boy with Kite)
1962
egg tempera on hardboard
23⅞ × 30 in. (60.6 × 76.2 cm)
signed and dated lower right "Jacob Lawrence 62"

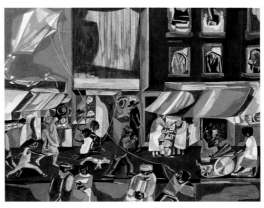

Collection: Conservation Center of the Institute of Fine Arts, New York University.

Provenance: [Terry Dintenfass Inc., New York]; Judith Golden, New York.

Exhibitions: Dintenfass 1963, no. 13.

References: Doris Athineos, "Eternity Is Delusional," Forbes (June 16, 1997), p. 288, ill.

P62-04
Playing Card (Joker)
1962
tempera on paper
22⁷⁄₁₆ × 15⅛ in. (57 × 38.4 cm)
signed and dated lower right "Jacob Lawrence 62"; inscribed
"J O K E R" [reversed, from bottom right edge, upwards]

Collection: Hirshhorn Museum and Sculpture Garden, Smithsonian Institution. Gift of Joseph H. Hirshhorn, 1966.

Provenance: [Terry Dintenfass Inc., New York]; Joseph H. Hirshhorn, New York.

Exhibitions: Temple Emanu-El, Yonkers, N.Y., May 16–29, 1965.

References: Jean Lipman, *What Is American in American Art?* (New York: McGraw-Hill, 1963), p. 173, ill.; A. Hyatt Major, "Painters' Playing Cards," *Art in America* 51, 2 (April 1963), p. 41, ill.

P62-05
Playing Card (Jack)
1962
tempera on paper
22½ × 15⅛ in. (57.2 × 38.4 cm)
signed and dated lower right "Jacob Lawrence 62"

Collection: Hirshhorn Museum and Sculpture Garden, Smithsonian Institution. Gift of Joseph H. Hirshhorn, 1966.

Provenance: [Terry Dintenfass Inc., New York]; Joseph H. Hirshhorn, New York.

Exhibitions: Temple Emanu-El, Yonkers, N.Y., May 16–29, 1965.

References: Jean Lipman, *What Is American in American Art?* (New York: McGraw-Hill, 1963), p. 173, ill.; A. Hyatt Major, "Painters' Playing Cards," *Art in America* 51, 2 (April 1963), p. 41, ill.

P62-06
Playing Card (Queen)
1962
tempera on paper
22¼ × 15 in. (56.5 × 38.1 cm)
signed and dated lower right "Jacob Lawrence 62"

Collection: Hirshhorn Museum and Sculpture Garden, Smithsonian Institution. Gift of Joseph H. Hirshhorn, 1966.

Provenance: [Terry Dintenfass Inc., New York]; Joseph H. Hirshhorn, New York.

Exhibitions: Temple Emanu-El, Yonkers, N.Y., May 16–29, 1965.

References: Jean Lipman, *What Is American in American Art?* (New York: McGraw-Hill, 1963), p. 173, ill.; A. Hyatt Major, "Painters' Playing Cards," *Art in America* 51, 2 (April 1963), p. 41, ill.

P62-07
Playing Card (King)
1962
tempera on paper
22⁵/₁₆ × 15⅛ in. (56.7 × 38.4 cm)
signed and dated lower right "Jacob Lawrence 62"

Collection: Hirshhorn Museum and Sculpture Garden, Smithsonian Institution. Gift of Joseph H. Hirshhorn, 1966.

Provenance: [Terry Dintenfass Inc., New York]; Joseph H. Hirshhorn, New York.

Exhibitions: Temple Emanu-El, Yonkers, N.Y., May 16–29, 1965.

References: Jean Lipman, *What Is American in American Art?* (New York: McGraw-Hill, 1963), p. 173, ill.; A. Hyatt Major, "Painters' Playing Cards," *Art in America* 51, 2 (April 1963), p. 41, ill.

P62-08
Vegetable Stand
1962
gouache and watercolor on paper
38¼ × 30 in. (97.2 × 76.2 cm)
signed and dated lower right "Jacob Lawrence 62"

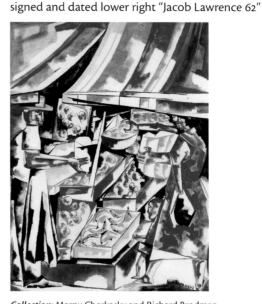

Collection: Marny Cherkasky and Richard Brodman.

Provenance: [Terry Dintenfass Inc., New York]; Martin and Sarah Cherkasky, New York.

P62-09
Soldiers and Students
1962
gouache on paper
22½ × 30½ in. (57.2 × 77.5 cm)
signed and dated lower right "Jacob Lawrence 62"

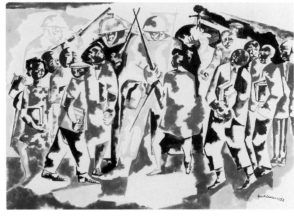

Collection: Hood Museum of Art, Dartmouth College, Hanover, New Hampshire. Bequest of Jay R. Wolf, Class of 1951.

Provenance: [Terry Dintenfass Inc., New York]; Julius R. Wolf, New York.

Exhibitions: Dintenfass 1963, no. 12; Wollman Hall, New School Art Center, New School for Social Research, New York, *Protest and Hope: An Exhibition of Contemporary American Art*, October 24–December 2, 1967, no. 28.

References: *Protest and Hope: An Exhibition of Contemporary American Art*, exh. cat. (New York: New School Art Center, 1967), p. 38, ill.

P62-10
Cabaret
1962
watercolor and gouache on paper
22 × 30 in. (55.9 × 76.2 cm)
signed and dated lower right "Jacob Lawrence 62"

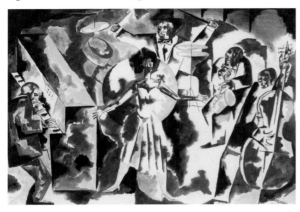

Collection: Current location unknown.

Provenance: [Terry Dintenfass Inc., New York]; Mr. and Mrs. Samuel Korman; [Sotheby's, New York, December 1, 1988, Sale 5787, lot 322].

Exhibitions: Dintenfass 1963, no. 2.

P63-01
Fish Market
1963
gouache and watercolor on paper
22½ × 30½ in. (57.2 × 77.5 cm)
signed and dated lower right "Jacob Lawrence 63"

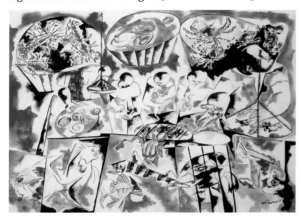

Collection: Private collection, New York.

Provenance: [Terry Dintenfass Inc., New York].

Exhibitions: Saint Paul Gallery and School of Art, *Drawings: USA*, 1962–3, no. 144.

P63-02
Dolls on Display
1963
gouache and watercolor on paper
31 × 22¾ in. (78.7 × 57.8 cm)
signed and dated lower right "Jacob Lawrence 63"

Collection: Private collection.

Provenance: [Terry Dintenfass Inc., New York].

Exhibitions: Wollman Hall, New School Art Center, New School for Social Research, New York, *By the Faculty of the Art Workshops*, January 16–26, 1967, no. 19.

P63-03
Taboo
1963
egg tempera on hardboard
19⅞ × 23⅞ in. (50.5 × 60.6 cm)
signed and dated lower right "Jacob Lawrence 63"

Collection: Mrs. Josef Jaffe.

Provenance: [Terry Dintenfass Inc., New York]; Martin Gordon, New York; [?]; Josef Jaffe, Philadelphia.

Exhibitions: Dintenfass 1963, no. 4; Wollman Hall, New School Art Center, New School for Social Research, New York, *The American Conscience: An Exhibition of Contemporary Paintings*, March 3–April 4, 1964, no. 26 (as *Social Dilemma*); Whitney Museum of American Art, New York, *The Friends Collect: Recent Acquisitions by Members of the Friends of the Whitney Museum of American Art, Seventh Friends Loan Exhibition*, May 8–June 16, 1964, no. 89; Brandeis 1965, no. 8; Michael Rosenfeld Gallery, New York, *African-American Art: Twentieth Century Masterworks III*, February 1–April 6, 1996.

References: Saarinen 1960, p. 48, ill.; *Art Students League: Centennial Decade, 1967–68* (New York: The Art Students League of New York, 1967), p. 52, ill.; Wheat 1986, p. 109; *African-American Art: Twentieth Century Masterworks III* (New York: Michael Rosenfeld Gallery, 1996), p. 32, ill.

Remarks: A.k.a. *Social Dilemma* and *The Wedding*.

P63-04
Ordeal of Alice
1963
egg tempera on hardboard
24 × 20 in. (61 × 50.8 cm)
signed and dated lower right "Jacob Lawrence 63"

Collection: Private collection, New York.

Provenance: [Terry Dintenfass Inc., New York].

Exhibitions: Dintenfass 1963, no. 10; Brandeis 1965, no. 9; Whitney 1974–5, no. 142.

References: "Art: Black Mirror," *Newsweek* 61, 15 (April 15, 1963), p. 100, ill.; V[ivien] R[ay-nor], "In the Galleries: Jacob Lawrence," *Arts* 37, 9 (May 1963), p. 112; Walker Percy, "The Doctor Listened," *New York Times Book Review*, June 25, 1967, p. 7, ill.; Lewis and Waddy 1969, p. 82, ill.; Edmund Burke Feldman, *Becoming Human through Art* (Englewood Cliffs, N.J.: Prentice-Hall, 1970), p. 42 (as *The Terrors of Alice*); Elton C. Fax, *Seventeen Black Artists* (New York: Dodd, Mead and Co., 1971), pp. 163–4; Brown 1974, p. 41, ill; Lewis and Sullivan 1982, p. 54, ill.; Wheat 1986, pp. 18, 23, 109, 134, pl. 66; John Russell, "Art View: The Epic of a People Writ Large on Canvas," *New York Times*, October 11, 1987, sec. 2, p. 39.

P63-05
American Revolution
1963
gouache and tempera on paper
23 × 15 in. (58.4 × 38.1 cm)
signed and dated lower right "Jacob Lawrence 63"

Collection: Private collection. Courtesy of Peg Alston Fine Arts, New York.

Provenance: [Terry Dintenfass Inc., New York]; Dr. and Mrs. Ira Janow, New York; [Peg Alston Fine Arts, New York].

Exhibitions: ACA Galleries, New York, *Voices of Conscience: Then and Now*, July 3–October 27, 1996.

References: *Motive* 24, 1 (October 1963), cvr., ill.; Wheat 1986, p. 199, fn. 37.

Remarks: Commissioned for and used by *Motive* magazine for its October 1963 issue. Text on the frontispiece reads: "As a Negro, Mr. Lawrence understands the meaning of the struggle for freedom . . . Mr. Lawrence graciously consented to paint this cover especially for *Motive* to help underscore the urgency of our times and expose the raw face of hatred and evil and oppression."

P63-06

Invisible Man among the Scholars

1963

tempera on hardboard

24 × 35¼ in. (61 × 89.5 cm)

signed and dated lower right "Jacob Lawrence 63"

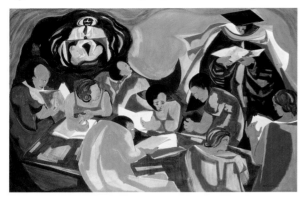

Collection: Mr. and Mrs. Harold A. Sorgenti.

Provenance: [Skowhegan School of Painting and Sculpture, Fourth Annual Exhibition and Sale, October 3, 1968]; Robert J. Gurney, New York; [Sid Deutsch Gallery, New York]; ARCO Chemical.

Exhibitions: Dintenfass 1963, no. 1; The Brooklyn Museum, *Art Festival for NAACP Legal Defense*, September 11–22, 1963, no. 173; Pennsylvania Academy of the Fine Arts, Philadelphia, *The One Hundred Fifty-Ninth Annual Exhibition of American Paintings and Sculpture*, January 25–March 1, 1964, no. 177; American Society of Contemporary Artists, New York, *American Painting Today: Pavilion of Fine Arts, New York World's Fair 1964–65*, June 15–October 22, 1964; Grand Rapids Art Museum, Mich., December 1964; Wollman Hall, New School Art Center, New School for Social Research, New York, *By the Faculty of the Art Workshops*, January 16–26, 1967, no. 18; Hood Museum of Art, Dartmouth College, Hanover, N.H., *Six Black Artists*, January 10–31, 1968.

References: Wheat 1986, p. 109, ill.

P63-07

Two Rebels

1963

egg tempera on hardboard

23¼ × 19¼ in. (59 × 48.9 cm)

signed and dated lower right "Jacob Lawrence 63"

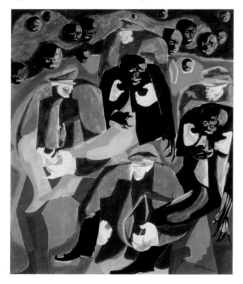

Collection: The Harmon and Harriet Kelley Foundation for the Arts.

Provenance: Jacob and Gwendolyn Knight Lawrence, New York and Seattle; [Francine Seders Gallery, Seattle].

Exhibitions: The American Academy of Arts and Letters, New York, *Exhibition of Work by Newly Elected Members, Recipients of Honors, and Childe Hassam Fund Purchases*, May 28–June 28, 1953, no. 10; Dintenfass 1963, no. 5; Realisti Americani Galleria/ACA, Rome, November 9–December 14, 1963, no. 11; Wollman Hall, New School Art Center, New School for Social Research, New York, *The American Conscience: An Exhibition of Contemporary Paintings*, March 3–April 4, 1964, no. 27; YM-YWHA Essex County, West Orange, N.J., *WPA Artists: Then and Now*, October 29–November 28, 1967, no. 46; Hood Museum of Art, Dartmouth College, Hanover, N.H., *Six Black Artists*, January 10–31, 1968; The American Academy of Arts and Letters, New York, *Paintings by Members*, October 25–December 22, 1968, no. 33; The Studio Museum in Harlem, New York, *Tradition and Conflict: Images of a Turbulent Decade, 1963–1973*, January 27–June 30, 1985; Arizona State 1990; The Jewish Museum, New York, *Bridges and Boundaries: African Americans and American Jews*, 1992–4; Bellevue Art Museum, Wash., *Jacob Lawrence: Thirty Years of Prints (1963–1993)*, September 24–November 27, 1994 (Bellevue only); San Antonio 1996.

References: *Tradition and Conflict: Images of a Turbulent Decade, 1963–1973*, exh. cat. (New York: The Studio Museum in Harlem, 1985), p. 46, ill.; Peter Nesbett, with an essay by Patricia Hills, *Jacob Lawrence: Thirty Years of Prints (1963–1993), A Catalogue Raisonné* (Seattle: Francine Seders Gallery in association with University of Washington Press, 1994), p. 10, fig. 1; Patrick Pacheco, "Giving Black Artists Their Due: Harmon and Harriet Kelley," *Art and Antiques* 19, 3 (March 1996), p. 72, ill. (as *The Rebels*).

P63-08

Clown

1963

tempera on hardboard

24⁵⁄₁₆ × 20³⁄₁₆ in. (61.8 × 51.3 cm)

signed and dated lower right "Jacob Lawrence 1963"

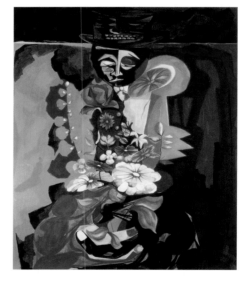

Collection: The Newark Museum. Anonymous gift, 91.177.

Provenance: The Alan Gallery, New York; Henry Ploch, Clifton, N.J.; [Terry Dintenfass Inc., New York]; Mr. and Mrs. Garson Heller.

Exhibitions: Whitney Museum of American Art, New York, *Annual Exhibition 1963: Contemporary American Painting,* December 1963–January 1964, no. 73; Whitney Museum of American Art, New York, *1964 Annual Exhibition,* December 1964–January 1965; The Museum of the National Center of Afro-American Artists, Roxbury, Mass., *Five Famous Black Artists: Romare Bearden, Jacob Lawrence, Horace Pippin, Charles White, Hale Woodruff,* February 9–March 10, 1970; The Art Museum, Princeton University, N.J., *Fragments of American Life, An Exhibition of Paintings: Romare Bearden, Joseph Delaney, Rex Gorleigh, Lois Mailou Jones, Jacob Lawrence, Hughie Lee-Smith, Hale Woodruff,* January 25–March 28, 1976; Jamaica Arts Center, New York, *Jacob Lawrence: Fifty Years of His Work,* December 8, 1984–January 30, 1985.

References: 1963 Annual Exhibition: Contemporary American Painting, exh. cat. (New York: Whitney Museum of American Art, 1963), n.p., ill.; Lucille Roberts, "The Gallery of Eight," *Topic* 5 (1966), p. 25, ill.; Carroll Greene, Jr., "The Afro-American Artist," *The Art Gallery* 11, 7 (April 1968), p. 17, ill.; *Five Famous Black Artists: Romare Bearden, Jacob Lawrence, Horace Pippin, Charles White, Hale Woodruff,* exh. cat. (Roxbury, Mass.: Museum of the National Center of Afro-American Artists, 1970), n.p., ill.; John Ralph Willis, *Fragments of American Life: An Exhibition of Paintings,* exh. cat. (Princeton, N.J.: The Art Museum, Princeton University, 1976), p. 54, ill.

P63-09
All Hallow's Eve
1963
tempera and gouache on paper
16 × 12 in. (40.6 × 30.5 cm)
signed and dated lower right "Jacob Lawrence 63"

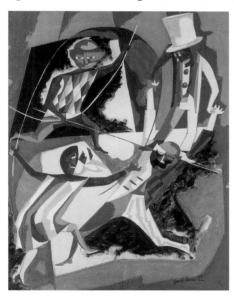

Collection: Fine Arts Museums of San Francisco, Achenbach Foundation for the Graphic Arts. Gift of Raymond Saunders, 1993.54.

Provenance: [Terry Dintenfass Inc., New York]; Raymond Saunders, Oakland, Calif.

Exhibitions: Henry Art Gallery 1998.

P64-01
The Family
1964
egg tempera on hardboard
24 × 20 in. (61 × 50.8 cm)
signed and dated lower right "Jacob Lawrence 64"

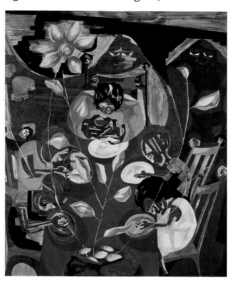

Collection: Peggy and David Shiffrin.

Provenance: [Terry Dintenfass Inc., New York]; Mr. and Mrs. Arthur Kobacker, Steubenville, Ohio.

Exhibitions: Dintenfass 1965; UCLA Art Galleries, Dickson Art Center, Los Angeles, *The Negro in American Art,* September 11–October 16, 1966, no. 3; Whitney 1974–5; Seattle 1986–7, no. 101; Springfield Museum of Art, Ohio, and the Riffe Gallery, Ohio Arts Council, Columbus, *Masterworks by Twentieth Century African-American Artists,* January 17–June 13, 1998.

References: Wheat 1986, p. 215, ill.

P64-02
Meat Market
1964
tempera and gouache on paper
30¾ × 22 in. (78.1 × 55.9 cm)
signed and dated lower right "Jacob Lawrence / 64"

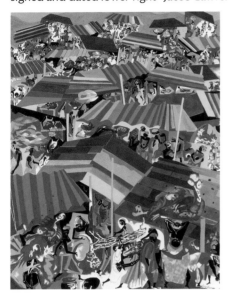

Collection: Judith Golden, New York.

Provenance: [Terry Dintenfass Inc., New York].

Exhibitions: AMSAC 1964, no. 2; Dintenfass 1965; Brandeis 1965, no. 11; The Museum of the National Center of Afro-American Artists, Roxbury, Mass., *Five Famous Black Artists: Romare Bearden, Jacob Lawrence, Horace Pippin, Charles White, Hale Woodruff*, February 9–March 10, 1970; Whitney 1974–5, no. 146; Seattle 1986–7, no. 105; Midtown Payson 1995a.

References: Jane H. Kay, "Lawrence Retrospective: Capsulating a Career," *Christian Science Monitor*, March 26, 1965, p. 4; Edmund Barry Gaither, *Five Famous Black Artists: Romare Bearden, Jacob Lawrence, Horace Pippin, Charles White, Hale Woodruff*, exh. cat. (Roxbury, Mass.: Museum of the National Center of Afro-American Artists, 1970), n.p., ill.; Wheat 1986, p. 131, pl. 62.

P64-03
Street to Mbari
1964
tempera, gouache, and graphite on paper
22¼ × 30⅞ in. (56.5 × 78.4 cm)
signed and dated lower right "Jacob Lawrence / 64"; verso: inscribed upper left in graphite "Street to MBari / 30¾ × 22"

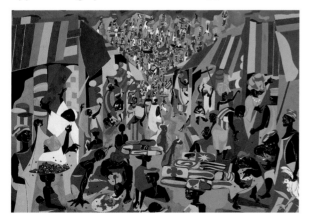

Collection: National Gallery of Art, Washington, D.C. Gift of Mr. and Mrs. James T. Dyke.

Provenance: [Terry Dintenfass Inc., New York]; Dr. and Mrs. Marvin L. Radoff; [Terry Dintenfass Inc., New York]; Mr. and Mrs. James T. Dyke.

Exhibitions: AMSAC 1964, no. 3; Dintenfass 1965; Morgan State 1965, no. 10 (as *Street to N'Bari*); The Butler Institute of American Art, Youngstown, Ohio, *The Forty-Seventh Annual Mid-Year Show*, August 1983; Seattle 1986–7.

References: "Lawrence Exhibit at Morgan," *The Sun*, March 7, 1965, p. D4, ill.; Elton C. Fax, "The American Negro Artist, 1968," in *Black America: 1968—The Year of Awakening*, edited by Patricia Romero (Washington, D.C.: Publishers Company, 1969), p. 229; Evelyn Stevenson, "The Artist as Social Commentator," *Christian Science Monitor*, August 7, 1973, p. 19, ill.; Wheat 1986, p. 132, pl. 63; Robert Wernick, "Jacob Lawrence: Art As Seen through a People's History," *Smithsonian* 18, 3 (June 1987), p. 63, ill.; Robin Updike, "A Modern Master," *Seattle Times*, June 28, 1998, *Pacific Northwest* magazine, p. 19, ill.

P64-04
Three Red Hats
1964
tempera and gouache on paper
22 × 30¾ in. (55.9 × 78.1 cm)
signed and dated lower right "Jacob Lawrence 64"

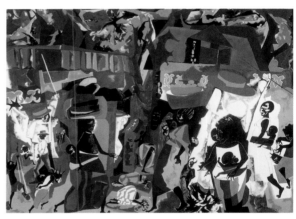

Collection: Dr. and Mrs. Fredric Newman.

Provenance: [Terry Dintenfass Inc., New York]; Mrs. Joel E. Spingarn, Philadelphia; Honor Tranum, Saint Thomas, V.I.; [Terry Dintenfass Inc., New York].

Exhibitions: AMSAC 1964, no. 5; Dintenfass 1965; Brandeis 1965, no. 10; Whitney 1974–5, no. 143; Seattle 1986–7, no. 107.

References: Brown 1974, p. 43, ill.; Lawrence Campbell, "Reviews: Jacob Lawrence, *ARTnews* 73, 7 (September 1974), p. 112; Wheat 1986, p. 216, ill.

P64-05
Four Sheep
1964
tempera and gouache on paper
22 × 30¾ in. (55.9 × 78.1 cm)
signed and dated lower right "Jacob Lawrence 64"

Collection: Mr. and Mrs. Harry Schaeffer.

Provenance: [Terry Dintenfass Inc., New York]; Mr. and Mrs. Lawrence Appel, New York.

Exhibitions: Dintenfass 1965; Morgan State 1965, no. 8; Seattle 1986–7, no. 103.

References: Wheat 1986, p. 216, no. 103, ill.

P64-06
Roosters
1964
tempera and gouache on paper
30¾ × 22 in. (78.1 × 55.9 cm)
signed and dated lower right "Jacob Lawrence / 64"

Collection: Mr. and Mrs. Sherle Wagner.

Provenance: [Terry Dintenfass Inc., New York].

Exhibitions: AMSAC 1964, no. 1; Dintenfass 1965; Brandeis 1965, no. 12; Great Hall, City College of New York, *The Evolution of Afro-American Artists: 1800–1950*, October 15–November 8, 1967.

References: Rosalind Browne, "Reviews and Previews: Jacob Lawrence," *ARTnews* 63, 10 (February 1965), p. 17, ill. (as *Market*).

P64-07
Antiquities
1964
tempera and gouache on paper
30¾ × 22 in. (78.1 × 55.9 cm)
signed and dated lower left "Jacob Lawrence 64"

Collection: The James E. Lewis Museum of Art, Morgan State University, Baltimore, Maryland.

Provenance: [Terry Dintenfass Inc., New York].

Exhibitions: Dintenfass 1965; Morgan State 1965, no. 7; Municipal Arts Gallery, Philadelphia Civic Center, *Afro-American Artists: 1800–1969*, December 5–29, 1969; Archer M. Huntington Art Gallery, University of Texas at Austin, *Afro-American Artists Abroad*, March 29–May 3, 1970; Whitney 1974–5, no. 144 (Whitney only); Goucher College, Baltimore, *Afro-American Artists Exhibition*, February 1981; Eubie Blake Cultural Center, Baltimore, *African-American Artists*, February 1982; Bowie State University, Md., *Great American Artists*, September 2–October 2, 1983; The Baltimore Life Insurance Company Gallery, *The Remarkable Morgan State Collection*, February 1984; The Montpelier Cultural Center, Laurel, Md., *Morgan State University Collection*, February 1985; U.S. Department of Transportation, Washington, D.C., *Black History Month Celebration, The James E. Lewis Museum of Art Collection Exhibition*, February 1995.

References: James E. Lewis, *Afro-American Artists Abroad*, exh. cat. (Austin, Tex.: The University of Texas, 1970), ill.

P64-08
Street Scene
1964
tempera and gouache on paper
29½ × 21¾ in. (74.9 × 55.2 cm)
signed and dated lower right "Jacob Lawrence 64"; verso: inscribed
"Street Scene"

Collection: Blanche and Bud Blank.

Provenance: [Terry Dintenfass Inc., New York]; Esther Rabinowitz, New York;
[Sotheby's, New York, May 24, 1989, Sale 5860, lot 237].

Exhibitions: AMSAC 1964, no. 6; Dintenfass 1965; Morgan State 1965, no. 9.

P64-09
Iyo
1964
gouache on paper
22½ × 30¼ in. (57.2 × 76.8 cm)
signed and dated lower right "Jacob Lawrence 64"

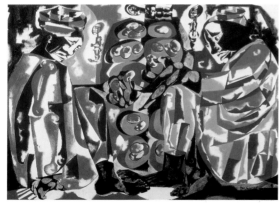

Collection: Joslyn Art Museum, Omaha, Nebraska. Collectors' Choice 1966.

Provenance: [Terry Dintenfass Inc., New York]; Dr. and Mrs. Max Ronis, Philadelphia;
[Terry Dintenfass Inc., New York].

Exhibitions: Dintenfass 1965; Morgan State 1965, no. 11; Henry Art Gallery 1998.

P64-10
Untitled [*Woman Sewing*]
1964
watercolor and gouache on paper
9 × 8 in. (22.9 × 20.3 cm)
signed and dated lower right "Jacob Lawrence 64"

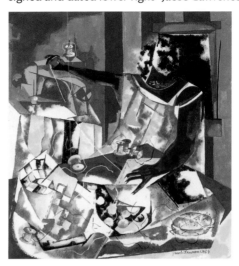

Collection: High Museum of Art, Atlanta. Gift of Thelma Rodbell, 1991.262.

Provenance: ?; Thelma Rodbell.

P64-11
Menagerie
1964
watercolor and gouache on paper
21½ × 30¼ in. (54.6 × 76.8 cm)
signed and dated lower right "Jacob Lawrence 64"

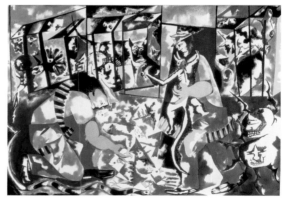

Collection: Emmanuel Schilling.

Provenance: [Terry Dintenfass Inc., New York]; Private collection; [DC Moore Gallery,
New York].

P65-01

Dreams No. 1

1965

gouache on paper

31 × 22½ in. (78.7 × 57.2 cm)

signed and dated lower right "Jacob Lawrence 65"

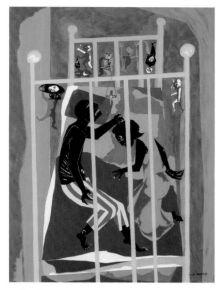

Collection: New Britain Museum of American Art, New Britain, Connecticut. Charles F. Smith Fund.

Provenance: Jacob and Gwendolyn Knight Lawrence, New York; [Terry Dintenfass Inc., New York]; Ruth and Jack Wexler, Kings Point, N.Y.; [Terry Dintenfass Inc., New York].

Exhibitions: Whitney Museum of American Art, New York, *1965 Annual Exhibition: Contemporary American Painting*, December 8, 1965–January 30, 1966, no. 72 (as *Dreams*); Whitney 1974–5, no. 148; Seattle 1986–7, no. 108.

References: 1965 Annual Exhibition: Contemporary American Painting, exh. cat. (New York: Whitney Museum of American Art, 1965), n.p., ill.; Harry Roskolenko, "Junkie's Homecoming," *New York Times Book Review,* September 10, 1967, p. 56, ill.; Brown 1974, p. 42, ill.; Milton Williams, "America's Top Black Artist," *Sepia* 23, 8 (August 1974), p. 76, ill.; Wheat 1986, p. 216, no. 108, ill.; Ron Glowen, "Jacob Lawrence: A Living History," *Artweek* 17, 28 (August 23, 1986), p. 1, ill.

P65-02

Dreams No. 2: Memories

1965

tempera on hardboard

35¾ × 24 in. (90.8 × 61 cm)

signed and dated lower right "Jacob Lawrence 65"

Collection: National Museum of American Art, Smithsonian Institution. Gift of the Sara Roby Foundation.

Provenance: [Terry Dintenfass Inc., New York]; Sara Roby Foundation.

Exhibitions: Pennsylvania Academy of the Fine Arts, Philadelphia, *One Hundred Sixty-First Annual Exhibition of American Painting and Sculpture,* January 21–March 6, 1966, no. 169; American Federation of Arts, New York, *Realism and Surrealism in American Art: From the Sara Roby Foundation Collection,* 1971–5, no. 18; Fort Wayne Museum of Art, Ind., *Selections from the Sara Roby Foundation,* September 4–November 1, 1981, no. 20; Danforth Museum of Art, Framingham, Mass., *Selections from the Sara Roby Foundation Collection,* February–July 1982, no. 14; Mary and Leigh Block Gallery, Northwestern University, Evanston, Ill., *Selections from the Sara Roby Foundation Collection,* March 24–July 3, 1983; Cedar Rapids Art Center, Iowa, *Selections from the Sara Roby Foundation Collection,* August 21–December 31, 1983; Alexandria Museum of Art, La., *Selections from the Sara Roby Foundation Collection,* March–June 1984, no. 34; Huntsville Museum of Art, Ala., *Selections from the Sara Roby Foundation Collection,* September 2–December 30, 1984, no. 31; North Carolina Museum of Art, Raleigh, *Selections from the Sarah Roby Foundation,* February 1–April 27, 1986; National Museum of American Art, Washington, D.C., *Modern American Realism: The Sara Roby Foundation Collection,* January 30–August 16, 1987; National Museum of American Art, Smithsonian Institution, *Free within Ourselves: African-American Artists in the Collection of the National Museum of American Art,* 1992–4.

References: Powell 1992, n.p., pl. 10.

Remarks: A.k.a. *Memories.*

P65-03
The Journey
1965
tempera and gouache on paper
21¾ × 29½ in. (55.2 × 74.9 cm)
signed and dated lower right "Jacob Lawrence 65"

Collection: Private collection.

Provenance: Jacob and Gwendolyn Knight Lawrence, New York; Mrs. Joel E. Spingarn, Philadelphia; Honor Tranum, Saint Thomas, V.I.; Joel Tranum, Wellesley, Mass.; [Sotheby's, New York, December 1, 1999, Sale 7397, lot 221].

Exhibitions: Whitney 1974–5; Seattle 1986–7, no. 104.

References: Wheat 1986, p. 216, no. 107, ill.

P66-01
Marketplace
1966
tempera and gouache on paper
10½ × 14¾ in. (26.7 × 37.5 cm)
signed and dated lower right "Jacob Lawrence 66"

Collection: Mr. and Mrs. John Whitney Payson.

Provenance: [Terry Dintenfass Inc., New York]; Sidney and Jean Frauwirth, New Bedford, Mass.; [Midtown Payson Galleries, New York].

Remarks: A.k.a. *Market Place No. 1* and *Market Place*.

P66-02
Market Scene
1966
tempera and gouache on paper
10⅝ × 14½ in. (27 × 36.8 cm)
signed and dated lower right "Jacob Lawrence 66"

Collection: Collection of a private family, Massachusetts.

Provenance: Jacob and Gwendolyn Knight Lawrence, New York and Seattle; [DC Moore Gallery, New York].

P66-03
Street Scene in Lagos
1966
tempera and gouache on paper
10½ × 14¾ in. (26.7 × 37.5 cm)
signed and dated lower right "Jacob Lawrence 66"

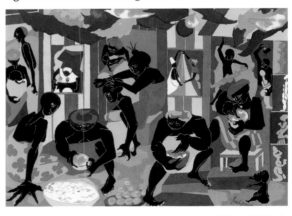

Collection: Ed and Carolyn Lewis. Courtesy of Michael Rosenfeld Gallery, New York.

Provenance: [Terry Dintenfass Inc., New York]; Sidney and Jean Frauwirth, New Bedford, Mass.; [Terry Dintenfass Inc., New York]; Robert Nowinski, Seattle; [Michael Rosenfeld Gallery, New York].

Exhibitions: Michael Rosenfeld Gallery, New York, *African-American Art: Twentieth Century Masterworks IV*, January 24–March 26, 1997.

References: *African-American Art: Twentieth Century Masterworks IV*, exh. cat. (New York: Michael Rosenfeld Gallery, 1997), p. 21, ill.

Remarks: A.k.a. *Nigerian Theme: Meat Market*. In a letter from the artist to Sidney Frauwirth dated March 29, 1966, he wrote: "The painting 'Street Scene in Lagos' is something of what we saw from the back of our house while living in Lagos. We found it very exciting—being in the heart of the city."

P66-04
Typists
1966
tempera and gouache on paper
22 × 29¼ in. (55.9 × 74.3 cm)
signed and dated lower right "Jacob Lawrence 66"

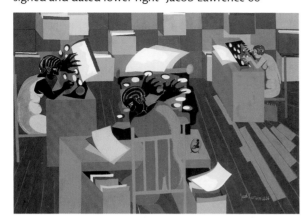

Collection: Herbert F. Johnson Museum of Art, Cornell University. Gift of Isabel Berley, Class of 1945, and William Berley, Class of 1947.

Provenance: [Terry Dintenfass Inc., New York]; William and Isabel Berley, New York.

Exhibitions: Seattle 1986–7, no. 109; Herbert F. Johnson Museum, Cornell University, Ithaca, N.Y., *Cornell Collects: A Celebration of American Art from the Collections of Alumni and Friends*, September 1990, no. 93; Herbert F. Johnson Museum of Art, Cornell University, Ithaca, N.Y., *Exhibition of the Collection of William and Isabel Berley*, April 14–June 11, 1995; Michael Rosenfeld Gallery, New York, *African-American Art: Twentieth Century Masterworks V*, January 22–March 21, 1998.

References: Wheat 1986, p. 216, no. 109, ill.; Leslie King-Hammond, *African-American Art: Twentieth Century Masterworks V*, exh. cat. (New York: Michael Rosenfeld Gallery, 1998).

Remarks: A.k.a. *The Typists* and *The Office Place*.

P66-05
Students with Books
1966
egg tempera on hardboard
23⅞ × 35⅞ in. (60.6 × 91.1 cm)
signed and dated lower right "Jacob Lawrence 66"

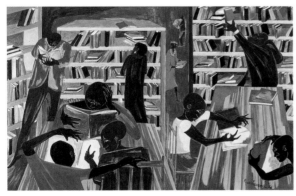

Collection: Mr. Merrill C. Berman, New York.

Provenance: [Terry Dintenfass Inc., New York]; Sidney Frauwirth, New Bedford, Mass.; Mrs. Francis Levin, New Bedford, Mass.; [Tibor de Nagy Gallery, New York].

P66-06
Courtyard Library
1966
tempera and gouache on paper
15½ × 19½ in. (39.4 × 49.5 cm)
signed and dated lower right "Jacob Lawrence 66"

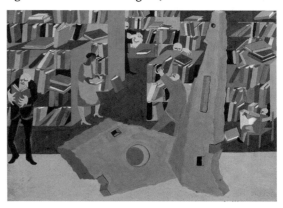

Collection: Private collection.

Provenance: [Terry Dintenfass Inc., New York].

Remarks: A.k.a. *Court Yard Library*.

P66-07
The Library
1966
tempera and gouache on paper
image: 10¼ × 14¼ in. (26 × 36.2 cm)
signed and dated lower right "Jacob Lawrence 66"

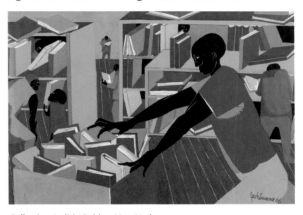

Collection: Judith Golden, New York.

Provenance: Jacob and Gwendolyn Knight Lawrence, New York.

P66-08
Dreams No. 3: Toreador
1966
tempera on paper
22½ × 30½ in. (57.2 × 77.5 cm)
signed and dated lower right "Jacob Lawrence 66"

Collection: Private collection, New York.
Provenance: [Terry Dintenfass Inc., New York].
Remarks: A.k.a. *Street Scene—Children and White Dog.*

P66-09
Dreams No. 4: Railroad Station
1966
tempera and gouache on paper
21½ × 30 in. (54.6 × 76.2 cm)
signed and dated lower right "Jacob Lawrence 66"

Collection: Private collection, New Jersey.
Provenance: [Terry Dintenfass Inc., New York]; Sarah Sidon; Estate of Sarah Sidon; [Terry Dintenfass Inc., New York].
Exhibitions: Pennsylvania Academy of the Fine Arts, Philadelphia, *One Hundred Sixty-Second Annual Exhibition: Water Colors, Prints and Drawings,* January 20–March 5, 1967.
Remarks: A.k.a. *Untitled (Migrants Arriving).*

P66-10
Family
1966
tempera and gouache on paper
11¾ × 11⅝ in. (29.8 × 29.5 cm)
signed and dated lower right "Jacob Lawrence 66"

Collection: Francine Seders, Seattle.
Provenance: [Terry Dintenfass Inc., New York]; Bobbie Goldberg; Elizabeth Zutt; [Michael Rosenfeld Gallery, New York]; ?; James A. Shamp, Durham, N.C.
Exhibitions: Great Hall, City College of New York, *The Evolution of Afro-American Artists: 1800–1950,* October 15–November 8, 1967; Northwest Art 1997; Henry Art Gallery 1998; Tacoma Art Museum, Wash., *American People, America Places,* January 30–March 28, 1999.

P67-01

Harriet and the Promised Land

1967

gouache and tempera on paper (17 paintings)

In 1967, the artist was commissioned by Windmill Books, Simon & Schuster to create a series of works for publication as a children's book. He completed a series of twenty paintings, but only seventeen were included in the final publication. One of the images was excluded by the editor because it included an image of Harriet Tubman with a gun. The series is presented here as it was originally published in 1968.

1. *Birth 1822*

13 × 12 in. (33 × 30.5 cm)

signed and dated lower right "Jacob Lawrence 67"

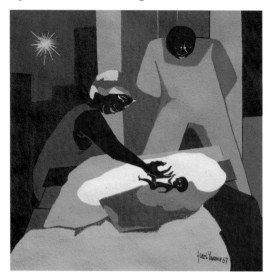

Collection: Bette Crouse.

Provenance: [Terry Dintenfass Inc., New York].

Exhibitions: Dintenfass 1968; Marymount College, Tarrytown, N.Y., *Focus: The Black Artist,* February 12–14, 1969.

References: Lawrence 1968, ill.; Ralph Pomeroy, "Reviews and Previews: Jacob Lawrence," *ARTnews* 66, 9 (January 1968), p. 15; Lawrence 1993, n.p., ill.

2. *The Family*

image: 25½ × 30½ in. (64.8 × 77.5 cm)

signed and dated lower right "Jacob Lawrence 67"

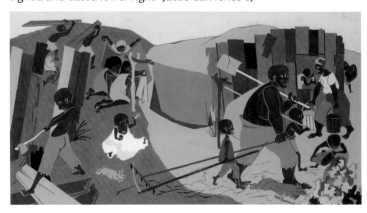

Collection: Private collection, Connecticut.

Provenance: [Terry Dintenfass Inc., New York]; Frederick C. Tobler, Princeton, N.J.; [DC Moore Gallery, New York].

Exhibitions: Dintenfass 1968.

References: Lawrence 1968, ill.; Gerald Dorset, "In the Galleries: Jacob Lawrence," *Arts* 42, 4 (February 1968), p. 65; Lawrence 1993, n.p., ill.

3. *Lullaby*

12½ × 12½ in. (31.8 × 31.8 cm)

signed and dated lower right "Jacob Lawrence 67"

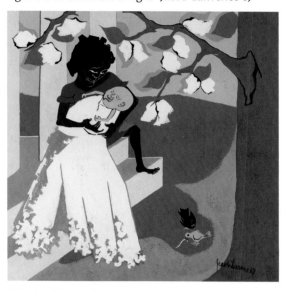

Collection: Private collection.

Provenance: Jacob and Gwendolyn Knight Lawrence, New York; [Art Students League, New York, Benefit Auction, dates unknown]; Herbert Neubauer, New York.

Exhibitions: Dintenfass 1968.

References: Lawrence 1968, ill.; Lawrence 1993, n.p., ill.

4. *A Mother Tells the Story of Moses*

11½ × 11¼ in. (29.2 × 28.6 cm)

signed and dated lower right "Jacob Lawrence 67"

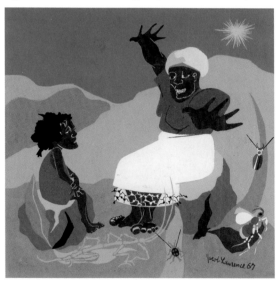

Collection: Private collection.

Provenance: [Terry Dintenfass Inc., New York].

Exhibitions: Dintenfass 1968.

References: Lawrence 1968, ill.; Lawrence 1993, n.p., ill.

5. *Prayer*

11½ × 11 in. (29.2 × 27.9 cm)
signed and dated lower right "Jacob Lawrence 67"

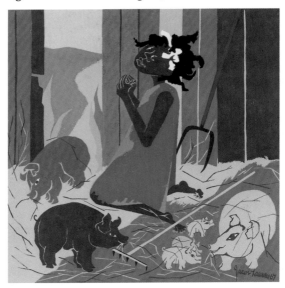

Collection: Ms. Mildred Beatty Smith, Flint.

Provenance: [Terry Dintenfass Inc., New York].

Exhibitions: Dintenfass 1968.

References: Lawrence 1968, ill.; Gerald Dorset, "In the Galleries: Jacob Lawrence," *Arts* 42, 4 (February 1968), p. 65; Lawrence 1993, n.p., ill.

6. *A Slave at Work*

17 × 9 in. (43.2 × 22.9 cm)
inscription unknown

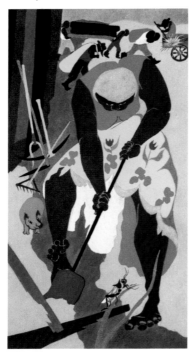

Collection: Current location unknown.

Provenance: [Terry Dintenfass Inc., New York].

Exhibitions: Dintenfass 1968; Marymount College, Tarrytown, N.Y., *Focus: The Black Artist,* February 12–14, 1969.

References: Lawrence 1968, ill.; Lawrence 1993, n.p., ill.

Remarks: This painting was stolen while on view at Marymount College in 1969.

7. *Labor*

11¼ × 11 in. (28.6 × 27.9 cm)
signed and dated lower right "Jacob Lawrence 67"

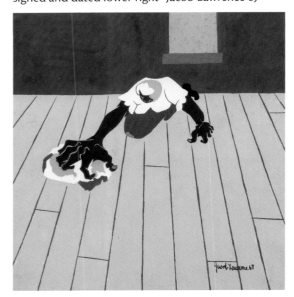

Collection: Mr. and Mrs. Paul Schmid III.

Provenance: [Terry Dintenfass Inc., New York]; [Sid Deutsch Gallery, New York]; [Terry Dintenfass Inc., New York]; Mr. and Mrs. Warren Shapleigh.

Exhibitions: Dintenfass 1968; Whitney 1974–5, no. 150.

References: Lawrence 1968, ill.; Lawrence 1993, n.p., ill.

8. *A Plan to Escape*

14¼ × 13 in. (36.2 × 33 cm)
signed and dated lower right "Jacob Lawrence 67"

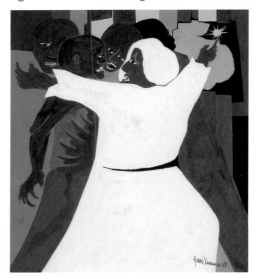

Collection: Private collection, Seattle.

Provenance: [Terry Dintenfass Inc., New York]; Morton and Betty Yarmon, New York; [Sotheby Parke Bernet, New York, April 21, 1977, lot 220]; ?; [Midtown Payson Galleries, New York].

Exhibitions: Dintenfass 1968; Midtown Payson 1995a; Henry Art Gallery 1998.

References: Lawrence 1968, ill.; Lawrence 1993, ill.; Jennifer P. Borum, "Reviews: New York, Jacob Lawrence," *Artforum* 33, 9 (May 1995), p. 101, ill.; Lawrence 1993, n.p., ill.

9. *Walking by Night, Sleeping by Day*
16¼ × 23¼ in. (41.3 × 59.1 cm)
signed and dated lower right "Jacob Lawrence 67"

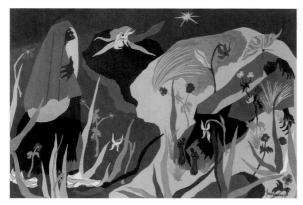

Collection: Private collection.

Provenance: [Terry Dintenfass Inc., New York]; Mrs. David Ross, Fort Lee, N.J.; [Terry Dintenfass Inc., New York].

Exhibitions: Dintenfass 1968; Whitney 1974–5, no. 151; Fine Arts Museum of Long Island, Hempstead, N.Y., *Celebrating Contemporary Black American Artists*, March 13–May 1, 1983 (as *Walking by Day, Sleeping by Night*); Seattle 1986–7, no. 110; The Jewish Museum, New York, *Bridges and Boundaries: African Americans and American Jews*, 1992–4.

References: Lawrence 1968, ill.; Wheat 1986, p. 216, no. 110, ill.; Donna Alverman, ed., *Rare as Hen's Teeth* (Lexington, Mass.: Heath & Co. 1989), pp. 454–5, ill.; Lawrence 1993, n.p., ill.

10. *Through Forests, Through Rivers, Up Mountains*
15⅝ × 26¾ in. (39.7 × 67.9 cm)
signed and dated lower right "Jacob Lawrence 67"

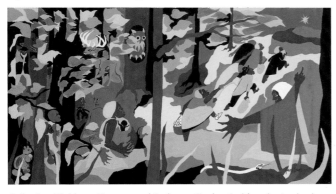

Collection: Hirshhorn Museum and Sculpture Garden, Smithsonian Institution. Bequest of Joseph H. Hirshhorn, 1986.

Provenance: [Terry Dintenfass Inc., New York]; Joseph H. Hirshhorn, New York.

Exhibitions: Dintenfass 1968.

References: Lawrence 1968, ill.; Gerald Dorset, "In the Galleries: Jacob Lawrence," *Arts* 42, 4 (February 1968), p. 65; Lawrence 1993, n.p., ill.

11. *The North Star*
dimensions unknown
inscription unknown

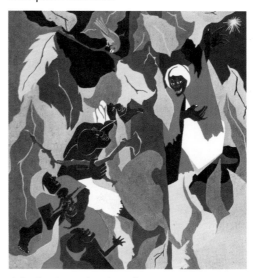

Collection: Current location unknown.

Provenance: [Terry Dintenfass Inc., New York]; Helen Cranswick.

Exhibitions: Dintenfass 1968.

References: Lawrence 1968, ill.; Lawrence 1993, n.p., ill.

12. *Fugitives*
17 × 9 in. (43.2 × 22.9 cm)
signed and dated lower right "Jacob Lawrence 67"

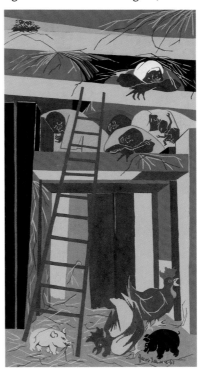

Collection: Ms. Mildred Beatty Smith, Flint.

Provenance: [Terry Dintenfass Inc., New York].

Exhibitions: Dintenfass 1968; Seattle 1986–7, no. 111.

References: Lawrence 1968, ill.; Wheat 1986, p. 216, no. 111, ill.; Stephanie Stokes Oliver, "Jacob Lawrence," *Essence* (November 1986), p. 91, ill.; Jim Quinn, "Hanging Out with the Potamkins," *Philadelphia* (July 1989), p. 61, ill.; Lawrence 1993, n.p., ill.

13. *An Underground Railroad*
14¼ × 13 in. (36.2 × 33 cm)
signed and dated lower right "Jacob Lawrence 67"

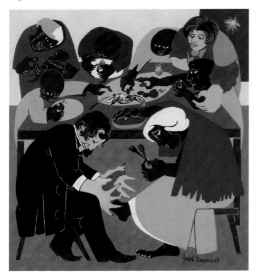

Collection: Marylin Bender Altschul, New York.

Provenance: [Terry Dintenfass Inc., New York].

Exhibitions: Dintenfass 1968; Chrysler 1979a.

References: Lawrence 1968, ill.; Lawrence 1993, n.p., ill.

14. *Flight II*
15½ × 13⅞ in. (39.4 × 35.2 cm)
signed and dated lower right "Jacob Lawrence 67"

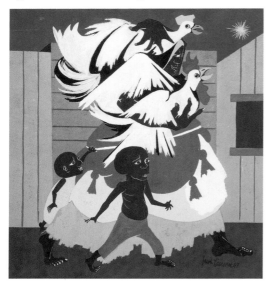

Collection: Hood Museum of Art, Dartmouth College, Hanover, New Hampshire. Bequest of Jay R. Wolf, Class of 1951.

Provenance: [Terry Dintenfass Inc., New York]; Julius R. Wolf, New York.

Exhibitions: Dintenfass 1968; Beaumont-May Gallery, Hopkins Center, Dartmouth College, Hanover, N.H., *The Jay Wolf Bequest of Contemporary Art*, June 24–August 28, 1977.

References: Lawrence 1968, ill.; Lawrence 1993, n.p., ill.

15. *Canada Bound*
16½ × 28¼ in. (41.9 × 71.8 cm)
signed and dated lower right "Jacob Lawrence 67"

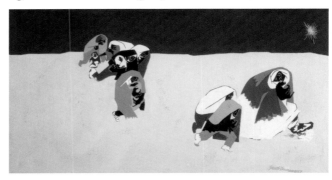

Collection: The University of Michigan Art Museum. Gift of Dr. James and Vivian Curtis.

Provenance: [Terry Dintenfass Inc., New York]; Dr. James and Vivian Curtis, St. Albans, N.Y.

Exhibitions: Dintenfass 1968; Whitney 1974–5, no. 152; Seattle 1986–7, no. 112.

References: Lawrence 1968, ill.; Brown 1974, p. 44, ill.; Wheat 1986, p. 137, pl. 70; Lawrence 1993, n.p., ill.

16. *Flight III*
17 × 9 in. (43.2 × 22.9 cm)
signed and dated lower right "Jacob Lawrence 67"

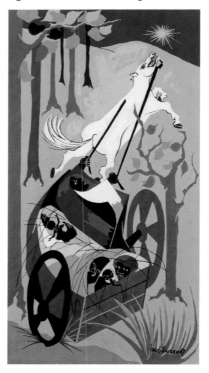

Collection: Allan and Nenette Harvey.

Provenance: [Terry Dintenfass Inc., New York].

Exhibitions: Dintenfass 1968.

References: Lawrence 1968, ill.; Lawrence 1993, n.p., ill.

17. *The Last Journey*

15⅝ × 26¾ in. (39.7 × 67.9 cm)

signed and dated lower right "Jacob Lawrence 67"; inscribed bottom right in margin "20"

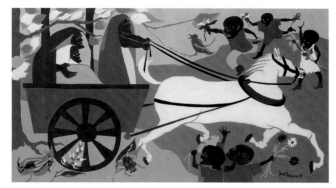

Collection: Private collection, New York.

Provenance: [Terry Dintenfass Inc., New York].

Exhibitions: Dintenfass 1968.

References: Lawrence 1968, ill.; Ralph Pomeroy, "Reviews and Previews: Jacob Lawrence," *ARTnews* 66, 9 (January 1968), p. 15 (as *End of the Journey*); Lawrence 1993, n.p., ill.

P67-02

Prayer

1967

gouache on paper

11¾ × 11½ in. (29.8 × 29.2 cm)

signed and dated lower right "Jacob Lawrence 67"

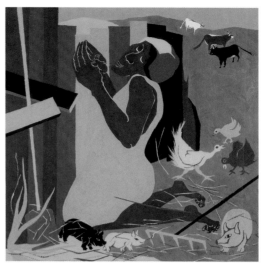

Collection: Private collection.

Provenance: [Terry Dintenfass Inc., New York]; Saul Miller, Va.

Exhibitions: Great Hall, City College of New York, *The Evolution of Afro-American Artists: 1800–1950*, October 15–November 8, 1967.

P67-03

Rural Scene

1967

tempera and gouache on paper

image: 14½ × 25¾ in. (36.8 × 65.4 cm)

signed and dated lower left "Jacob Lawrence 67"

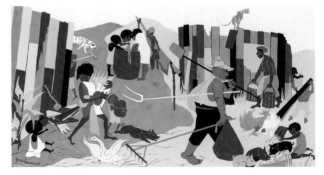

Collection: The Thompson Collection.

Provenance: [Terry Dintenfass Inc., New York]; Private collection, New York; [William Doyle Galleries, New York, November 17, 1998, lot 48].

P67-04
Over the Line
1967
gouache on paper
14 × 13 in. (35.6 × 33 cm)
signed and dated lower right "Jacob Lawrence 67"

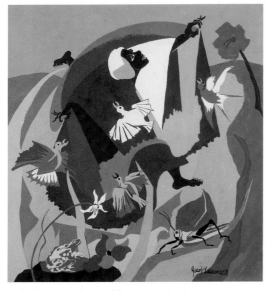

Collection: Mr. and Mrs. Richard H. Markowitz.
Provenance: [Terry Dintenfass Inc., New York].

P67-05
Another Journey Ended
1967
gouache on paper
10 × 11 in. (25.4 × 27.9 cm)
signed and dated lower right "Jacob Lawrence 67"

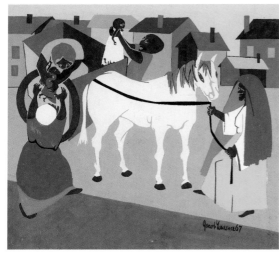

Collection: Susie Ruth Powell and Franklin R. Anderson.
Provenance: Jacob and Gwendolyn Knight Lawrence, New York and Seattle; [Francine Seders Gallery, Seattle].
Exhibitions: USIA Caribbean 1989, no. 14; Whitney Museum of American Art at Champion Plaza, Stamford, Conn., *Fables, Fantasies and Everyday Things*, October 14, 1994–January 30, 1995; Henry Art Gallery 1998.
References: Lewis and Hewitt 1989, p. 34, ill.

P67-06
Flight No. 1
1967
gouache on paper
17½ × 9 in. (44.5 × 22.9 cm)
signed and dated lower right "Jacob Lawrence 67"

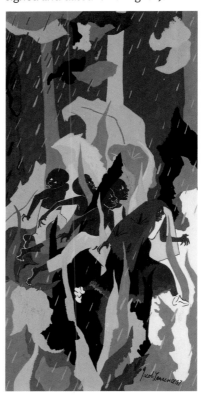

Collection: Alitash Kebede Contemporary Art Gallery, Los Angeles.
Provenance: [Terry Dintenfass Inc., New York]; Andrew and Elena Ismail, N.J.
Remarks: A.k.a. *Walking in the Rain.*

P67-07
Daybreak—A Time to Rest
1967
egg tempera on hardboard
31⅞ × 24⅞ in. (81 × 63.2 cm)
signed and dated lower right "Jacob Lawrence 67"

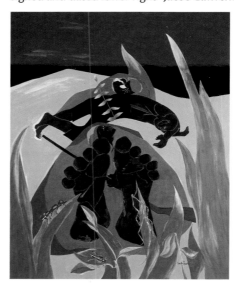

Collection: National Gallery of Art, Washington, D.C. Anonymous gift, 1973.8.1.

Provenance: [Terry Dintenfass Inc., New York].

Exhibitions: The Museum of the National Center of Afro-American Artists, Roxbury, Mass., *Five Famous Black Artists: Romare Bearden, Jacob Lawrence, Horace Pippin, Charles White, Hale Woodruff*, February 9–March 10, 1970; United States embassy residence, Bonn, West Germany, long-term loan, 1981–5; Seattle 1986–7, no. 113.

References: Judith Wragg Chase, *Afro-American Art and Craft* (New York: Van Nostrand, 1971), p. 122, ill.; Dorothy B. Rennie, "Three Black Artists," *North Carolina Museum of Art Bulletin* 10, 4 (June 1971), p. 7; *American Painting: An Illustrated Catalogue* (Washington, D.C.: National Gallery of Art, 1980), p. 193, ill.; John Wilmerding, *American Masterpieces from the National Gallery* (New York: Hudson Hills Press, 1980), pl. 60; Wheat 1986, p. 139, pl. 72; Ellen Harkins Wheat, "Jacob Lawrence: Chronicler of the Black Experience," *American Visions* 2, 1 (February 1987), p. 35, ill.; *American Paintings: An Illustrated Catalogue*, Washington, D.C.: National Gallery of Art, 1992, p. 225, ill.; H. H. Arnason, Marla F. Prather, and Daniel Wheeler, *History of Modern Art* (New York: Harry N. Abrams, 1998), p. 428, fig. 500.

P67-08
A Foothold on the Rocks
1967
egg tempera on hardboard
30 × 24 in. (76.2 × 61 cm)
signed and dated lower right "Jacob Lawrence 67"

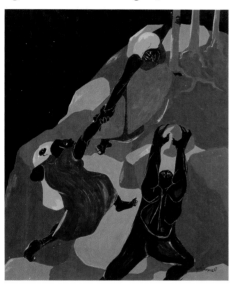

Collection: Mr. and Mrs. Murray Handwerker.

Provenance: [Terry Dintenfass Inc., New York].

Exhibitions: Whitney 1974–5, no. 153; The Art Museum, Princeton University, N.J., *Fragments of American Life, An Exhibition of Paintings: Romare Bearden, Joseph Delaney, Rex Gorleigh, Lois Mailou Jones, Jacob Lawrence, Hughie Lee-Smith, Hale Woodruff*, January 25–March 28, 1976; Seattle 1986–7, no. 115.

References: Ben Wolf, "Six Artists Return from the War," *Art Digest* 20, 16 (May 15, 1946), p. 13; Dorothy B. Rennie, "Three Black Artists," *North Carolina Museum of Art Bulletin* 10, 4 (June 1971), p. 6, ill.; John Ralph Willis, *Fragments of American Life: An Exhibition of Paintings*, exh. cat. (Princeton, N.J.: The Art Museum, Princeton University, 1976), p. 54; Lewis and Hewitt 1982, cvr., ill. (as *Harriet Tubman*); Wheat 1986, no. 115, ill.

P67-09
Forward
1967
egg tempera on hardboard
23⅞ × 35¹⁵⁄₁₆ in. (60.6 × 91.3 cm)
signed and dated lower right "Jacob Lawrence 67"

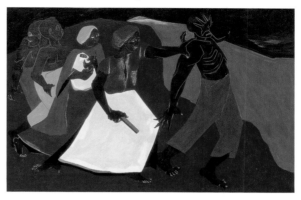

Collection: North Carolina Museum of Art, Raleigh. Purchase with funds from the State of North Carolina.

Provenance: [Terry Dintenfass Inc., New York].

Exhibitions: Dintenfass 1968; The Minneapolis Institute of Arts in association with Ruder & Finn Fine Arts, New York, *Thirty Contemporary Black Artists*, October 17–November 24, 1968; Colorado Springs Fine Arts Center, *New Accessions USA*, July–September 1970, no. 21; Seattle 1986–7, no. 114.

References: "The Black Artists: A Unique Observation," *Tuesday* 4 (February 1969), p. 16, ill.; Dorothy B. Rennie, "Three Black Artists," *North Carolina Museum of Art Bulletin* 10, 4 (June 1971), cvr., ill.; William Germain Dooley, "Home Forum," *Christian Science Monitor*, April 24, 1972, p. 8, ill.; Norman Prendergraft, "Tracing the Rise of the Afro-American Artist in North Carolina," *Art Voices/South* 1 (March–April 1978), p. 76, ill.; Wheat 1986, p. 138, pl. 71; Regina Hackett, "Gone to Gotham, Seattle Art Holds Its Own in New York," *Seattle Post-Intelligencer*, October 26, 1987, p. C5, ill.; Marian E. Barnes and Linda Goss, eds., *Talk That Talk: An Anthology of African American Storytelling* (New York: Simon & Schuster, 1989), cvr., ill.; Huston Paschal, "Rethinking Familiar Images," *North Carolina Museum of Art Preview* (autumn 1991), p. 4; *Introduction to the Collections* (Raleigh, N.C.: North Carolina Museum of Art, 1992, rev. ed.), p. 278, ill.; Larry Silver, *Art in History* (Englewood Cliffs, N.J.: Prentice-Hall, 1993), pp. 454–5, fig. 10.29; Rebecca Martin Nagy, ed., *North Carolina Museum of Art: Handbook of the Collections* (Raleigh, N.C.: North Carolina Museum of Art, 1998), p. 235, ill.

P67-10
Ten Fugitives
1967
egg tempera on hardboard
24½ × 36½ in. (62.2 × 92.7 cm)
signed and dated lower right "Jacob Lawrence 67"

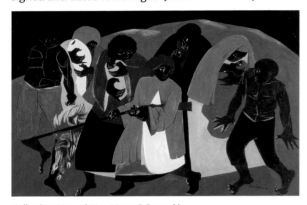

Collection: Mr. and Mrs. Meyer P. Potamkin.

Provenance: [Terry Dintenfass Inc., New York].

Exhibitions: Dintenfass 1968; National Academy of Design, New York, *Skowhegan School of Painting and Sculpture: Annual Art Exhibition and Sale*, October 4–13, 1968, no. 88; James B. Duke Library, Johnson C. Smith University, Charlotte, N.C., *Encounters: An Exhibit in Celebration of the Charlotte-Mecklenberg Bi-Centennial*, November–December 1968, no. 37; Terry Dintenfass Inc., New York, *Concern*, June 9–26, 1970, no. 12; William Penn Memorial Museum, Harrisburg, Pa., *An Alumnus Salutes Dickinson College's Two Hundredth Anniversary*, November 19, 1972–January 3, 1973; United States Information Agency, Washington, D.C., *Two Hundred Years of American Painting, 1776–1976*, 1976–7, no. 53; Seattle 1986–7, no. 116; Pennsylvania Academy of the Fine Arts, Philadelphia, *American Art from the Collection of Vivian and Meyer P. Potamkin*, June 10–October 1, 1989; Hampton University Museum, Va., *Jacob Lawrence: The Frederick Douglass and Harriet Tubman Series of 1938–40*, 1991–8 (Philadelphia only).

References: Eugene Grigsby, *Encounters: An Exhibit in Celebration of the Charlotte-Mecklenberg Bi-Centennial*, exh. cat. (Charlotte, N.C.: Johnson C. Smith University, 1968), p. 13, ill.; Dorothy B. Rennie, "Three Black Artists," *North Carolina Museum of Art Bulletin* 10, 4 (June 1971), p. 5, fig. 2; Wheat 1986, p. 217, ill.; Susan Danly, *American Art from the Collection of Vivian and Meyer P. Potamkin*, exh. cat. (Philadelphia: Pennsylvania Academy of Fine Arts, 1989), p. 7, ill.

P67-11
Brooklyn Stoop
1967
casein tempera on illustration board
29⅛ × 20⅛ in. (74 × 51.1 cm)
signed and dated lower right "Jacob Lawrence 67"

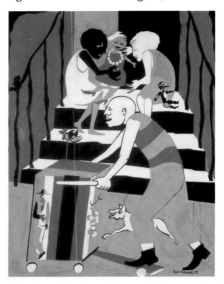

Collection: Collection of Tacoma Art Museum. Purchased with Acquisition Funds.

Provenance: Jacob and Gwendolyn Knight Lawrence, New York and Seattle; [Francine Seders Gallery, Seattle].

Exhibitions: The Detroit Institute of Arts, *The John Brown Series by Jacob Lawrence*, October 14–November 26, 1978; USIA Caribbean 1989, no. 8; Tacoma Art Museum, Wash., *Recent Acquisitions to the Permanent Collection*, February 15–March 31, 1991; Hampton University Museum, Va., *Jacob Lawrence: The Frederick Douglass and Harriet Tubman Series of 1938–40*, 1991–8 (Tacoma only); Tacoma Art Museum, Wash., *Twentieth-Century American Painting*, August 22–October 20, 1991; Tacoma Public Library, Wash., *Northwest Black Pioneers*, March 16–April 1, 1992; Tacoma Art Museum, Wash., *Collections on Paper: Recent Acquisitions*, November 13, 1992–February 7, 1993; Seafirst Gallery, Seattle, *Tacoma Art Museum: Selections from the Northwest Collection*, September 2–October 20, 1994; Northwest Art 1997; Henry Art Gallery 1998.

References: Wheat 1986, p. 140, pl. 73; Lewis and Hewitt 1989, p. 33, ill.

Remarks: Commissioned as a poster design for Goddard Art Center, New York.

P67-12
Dreams No. 5: The Library
1967
egg tempera on hardboard
24 × 35⅞ in. (61 × 91.1 cm)
signed and dated lower right "Jacob Lawrence 67"

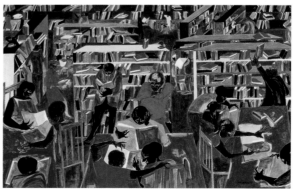

Collection: The Pennsylvania Academy of the Fine Arts, Philadelphia. Funds provided by the National Endowment for the Arts, the Collector's Circle, and the Henry D. Gilpin and John Lambert Funds.

Provenance: [Terry Dintenfass Inc., New York]; Dr. and Mrs. Robert Aaron, Great Neck, N.Y.; [Terry Dintenfass Inc., New York].

Exhibitions: Carnegie Institute, Pittsburgh, *The Pittsburgh International Exhibition of Contemporary Painting and Sculpture*, October 27, 1967–January 7, 1968, no. 274; The Butler Institute of American Art, Youngstown, Ohio, *Fiftieth National Midyear Exhibition*, June 29–August 24, 1986; Terry Dintenfass Inc., New York, *A Point of View*, October 2–29, 1987; Philadelphia Museum of Art, *Rolywholyover: A Circus*, May 21–July 30, 1995.

References: *The Pittsburgh International Exhibition of Contemporary Painting and Sculpture*, exh. cat. (Pittsburgh: Carnegie Institute, 1967), p. 274, ill.; Nancy Fresella-Lee, *The American Paintings in the Pennsylvania Academy of the Fine Arts* (Philadelphia: Pennsylvania Academy of the Fine Arts in association with University of Washington Press, 1989), p. 80, no. 777, ill.

P67-13
Portrait of Stokely Carmichael
1967
casein tempera, gouache, and brush and ink on paper
22⅜ × 14½ in. (56.8 × 36.8 cm)
signed lower center "Jacob Lawrence"

Collection: National Portrait Gallery, Smithsonian Institution, Washington, D.C.

Provenance: Time-Life Incorporated, New York; [Terry Dintenfass Inc., New York].

References: Wheat 1986, p. 141.

Remarks: Commissioned by *Time* magazine for use as a cover image, but never published. Lawrence traveled to Atlanta to meet Carmichael at the SNCC Headquarters shortly before Carmichael stepped down as chairman. Lawrence made several preparatory studies for this portrait.

P67-14
Black Cowboys
ca. 1967
casein tempera on illustration board
20 × 30 in. (50.8 × 76.2 cm)
signed lower right "Jacob Lawrence"

Collection: Edwin A. Ulrich Museum of Art, Wichita State University, Wichita, Kansas. Endowment Association Art Collection.

Provenance: Jacob and Gwendolyn Knight Lawrence, New York and Seattle; [DC Moore Gallery, New York].

Exhibitions: Savannah 1998, no. 2.

References: Cynda L. Benson, *Jacob Lawrence*, exh. cat. (Savannah, Ga.: Savannah College of Art and Design, 1998), p. 5, fig. 2.

Remarks: Signed by the artist in the mid-1990s.

P67-15
Generations
1967
gouache and tempera on paper
dimensions unknown
signed and dated lower left "Jacob Lawrence 67"

Collection: Current location unknown.

References: Wheat 1986, p. 136, pl. 68, ill.

P68-01

Untitled [Skowhegan School Exhibition and Sale]

1968

gouache on paper

29 × 20 in. (73.7 × 50.8 cm)

signed and dated lower right "Jacob Lawrence 68"

Collection: Private collection, New York.

Provenance: Jacob and Gwendolyn Knight Lawrence, New York; Skowhegan School of Painting and Sculpture, Maine; ?; [Terry Dintenfass Inc., New York].

P68-02

Wounded Man

1968

gouache on paper

29½ × 22 in. (74.9 × 55.9 cm)

signed and dated lower right "Jacob Lawrence 68"

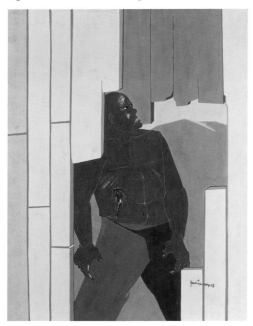

Collection: The Walter O. Evans Collection of African American Art.

Provenance: Jacob and Gwendolyn Knight Lawrence, New York and Seattle; [Francine Seders Gallery, Seattle].

Exhibitions: Seattle 1986–7, no. 117; Henry Art Gallery 1998.

References: Wheat 1986, p. 135, pl. 67; Amy Fine Collins, "Jacob Lawrence: Art Builder," *Art in America* 76, 2 (February 1988), p. 130, ill.; Robin Updike, "A Modern Master," *Seattle Times*, June 28, 1998, *Pacific Northwest* magazine, p. 16, ill.; Ron Glowen, "Art Reflects Black History and Struggle," *Bellingham Herald*, July 10, 1998, p. 3, ill.; Peter T. Nesbett, "An IFAR Evening: The Jacob Lawrence Catalogue Raisonné Project," *International Foundation for Art Research Journal* 2, 2 (spring 1999), p. 11, ill.

P68-03

Builders No. 1

1968

gouache and tempera on paper

30½ × 22 in. (77.5 × 55.9 cm)

signed and dated lower right "Jacob Lawrence 68"

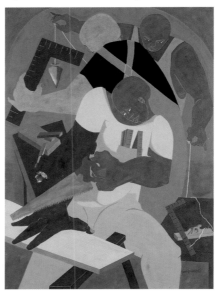

Collection: Private collection.

Provenance: [Terry Dintenfass Inc., New York]; Mr. George Perutze; [Terry Dintenfass Inc., New York]; Mr. and Mrs. Sidney Sass, North Calwell, N.J.

Exhibitions: The Museum of Modern Art, New York, *In Honor of Dr. Martin Luther King Jr.: Contemporary American Painting and Sculpture Donated by Artists to Be Sold for the Benefit of the Southern Christian Leadership Foundation*, October 30–November 3, 1968; Illinois Bell Telephone, Chicago, *Black American Artists 71*, January 12–February 5, 1971, no. 71; Dintenfass 1973, no. 1.

References: Alma Murray and Robert Thomas, eds., *Black Perspectives* (New York: Scholastic Book Service, 1971), p. 157, ill.; Robert H. Glauber, *Black American Artists / 71*, exh. cat. (Chicago: Illinois Bell Telephone, 1971); Evelyn Stevenson, "The Artist as Social Commentator," *Christian Science Monitor*, August 7, 1973, p. 19.

P68-04
Builders No. 2
1968
gouache and tempera on paper
30 × 21¼ in. (76.2 × 54 cm)
signed and dated lower right "Jacob Lawrence 68"

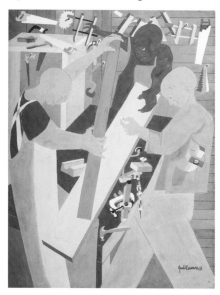

Collection: Reynolda House, Museum of American Art, Winston-Salem, North Carolina.

Provenance: [Terry Dintenfass Inc., New York]; Barbara Lassiter Millhouse.

Exhibitions: Dintenfass 1973, no. 2.

References: Barbara Millhouse, with Robert Workman, *American Originals: Selections from Reynolda House, Museum of American Art* (New York: American Federation of Arts and Abbeville Press, 1990), p. 129, ill.

P68-05
Lieutenant Colonel Chukwuemeka Odumegwa Ojukwu of Biafra
1968
tempera and watercolor on paper
26¾ × 19¾ in. (67.9 × 50.2 cm)
signed lower left "Jacob Lawrence"

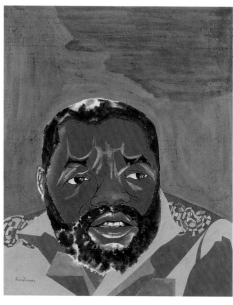

Collection: National Portrait Gallery, Smithsonian Institution, Washington, D.C.

Provenance: Time-Life Incorporated, New York.

References: *Time* (August 23, 1968), cvr., ill.

Remarks: Commissioned by *Time* magazine.

P69-01
Builders No. 1
1969
gouache and tempera on paper
22 × 30½ in. (55.9 × 77.5 cm)
signed and dated lower right "Jacob Lawrence 69"

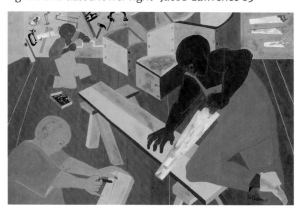

Collection: Ann and James Harithas.

Provenance: [Terry Dintenfass Inc., New York].

Exhibitions: Dintenfass 1973, no. 3; Terry Dintenfass Inc., New York, *Stars from the Lone Star State*, June 1994.

References: Virginia Lee, "Jacob Lawrence—Story Teller," *Northwest Art News and Views* 1 (March–April 1970), p. 21, ill.; Wheat 1986, p. 159, pl. 77.

P69-02
Builders No. 2
1969
gouache and tempera on paper
30 × 22 in. (76.2 × 55.9 cm)
signed and dated lower right "Jacob Lawrence 69"

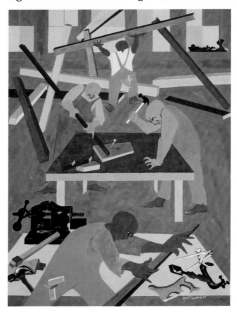

Collection: Dr. Mary Ronis, Philadelphia.

Provenance: [Terry Dintenfass Inc., New York]; Dr. and Mrs. Bernard Ronis, Philadelphia.

Exhibitions: Whitney Museum of American Art, New York, *1969 Annual Exhibition: Contemporary American Painting*, December 16, 1969–February 1, 1970, no. 67; Dintenfass 1973, no. 4; Whitney 1974–5, no. 154.

References: Brown 1974, p. 45, ill.; Avis Berman, "Jacob Lawrence and the Making of Americans," *ARTnews* 83, 2 (February 1984), pp. 78–86, ill.

P69-03
Protest Rally
1969
tempera and gouache on paper
21¾ × 16 in. (55.2 × 40.6 cm)
signed lower center "Jacob Lawrence"

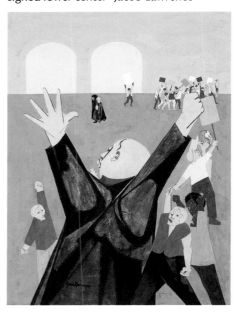

Collection: Colby College Museum of Art. Museum purchase with a grant from the Charles E. Merrill Trust.

Provenance: Jacob and Gwendolyn Knight Lawrence, New York; Time-Life Incorporated, New York; [Terry Dintenfass Inc., New York].

Exhibitions: Port Washington Public Library, N.Y., *One Hundred Years of American Art*, January 2–February 29, 1992.

References: *Colby Library Quarterly* 15, 4 (December 1979), p. 207.

P70-01
Portrait of Jesse Jackson
1970
tempera on composition board
23¾ × 17 in. (60.3 × 43.2 cm)
unsigned

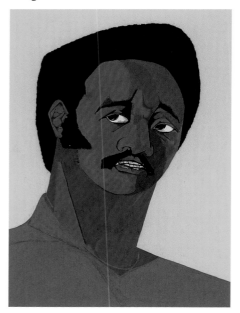

Collection: National Portrait Gallery, Smithsonian Institution, Washington, D.C.

Provenance: Time-Life Incorporated, New York.

Exhibitions: National Portrait Gallery, Washington, D.C., *Time of Our Lives*, May 1, 1978–June 30, 1979.

References: [Cover illustration depicting Jesse Jackson.] *Time* (April 6, 1970), cvr., ill.

Remarks: Commissioned by *Time* magazine.

P70-02
Builders No. 1
1970
gouache on paper
22 × 30 in. (55.9 × 76.2 cm)
signed and dated lower right "Jacob Lawrence 70"; verso: inscribed center "Jacob Lawrence The Builders—No. 1 1970"; inscribed lower center "gouache on paper"

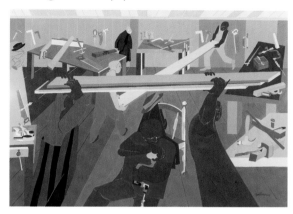

Collection: Henry Art Gallery, University of Washington, Seattle. Gift of the Artist.

Provenance: Jacob and Gwendolyn Knight Lawrence, Seattle.

Exhibitions: Henry Art Gallery, University of Washington, Seattle, *Jacob Lawrence: Work in Progress*, May 27–June 9, 1970; City of Auckland Art Gallery, New Zealand, *Pacific Cities Loan Exhibition*, March–May 1971; Afro-American Pavilion, Expo '74, Spokane, Wash., summer 1974; Francine Seders Gallery, Seattle, *Graphics by Jacob Lawrence*, October 15–November 3, 1976; Henry Art Gallery, University of Washington, Seattle, *Henry Art Gallery: Five Decades*, February 11–March 13, 1977; Seattle 1986–7, no. 118; Safeco Gallery, Safeco Insurance Companies, Seattle, *School of Art: 1960–1975*, June 3–July 29, 1988; Jacob Lawrence Gallery, University of Washington, Seattle, *Jacob Lawrence: Paintings 1971–1984, Inaugural Exhibition*, October 19–December 6, 1994; Henry Art Gallery 1998.

References: Wheat 1986, p. 160, pl. 78; "The Home Forum," *Christian Science Monitor*, August 28, 1986, p. 34, ill.; Stephanie Stokes Oliver, "Jacob Lawrence," *Essence* (November 1986), p. 90, ill.; Alice B. Skinner, "Spirit in Form," *Chrysalis* 11 (summer 1987), p. 149, ill.; Regina Hackett, "Jacob Lawrence: A Life in Art," *Seattle Post-Intelligencer*, July 2, 1998, p. D9, ill.

P70-03
The Pool Game
1970
gouache and tempera on paper
22 × 30 in. (55.9 × 76.2 cm)
signed and dated lower right "Jacob Lawrence 70"

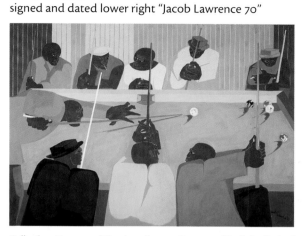

Collection: Museum of Fine Arts, Boston. Courtesy of Emily L. Ainsley Fund.

Provenance: [Terry Dintenfass Inc., New York].

Exhibitions: Whitney Museum of American Art, New York, *Contemporary Black Artists in America*, April 6–May 16, 1971, no. 34; Institute of Contemporary Art, Boston, *A Selection of American Art: The Skowhegan School 1946–1976*, June 16–September 5, 1976; Seattle 1986–7, no. 119.

References: Robert Doty, *Contemporary Black Artists in America*, exh. cat. (New York: Whitney Museum of American Art, 1971), p. 30, ill.; Malcolm Preston, "Art: Black Exhibit," *Boston Herald Traveler*, April 19, 1971, p. 17; Edgar J. Driscoll, Jr., "Blacks Duncanson, Bannister Honored in Fine Arts Exhibit," *Boston Globe*, January 16, 1972, p. A94; Lloyd Goodrich, *A Selection of American Art: The Skowhegan School 1946–1976*, exh. cat. (Boston: Institute for Contemporary Art, 1976), p. 109, ill.; Wheat 1986, p. 157, pl. 74c; Esther Mumford, "Jacob Lawrence: In Retrospect," *Northwest Art Paper* (August 15–September 15, 1986), p. 4, ill.

Remarks: A.k.a. *Pool Game* and *Pool Room*.

P71-01
Builders No. 1
1971
tempera and gouache on paper
30 × 22 in. (76.2 × 55.9 cm)
signed and dated lower right "Jacob Lawrence 1971"

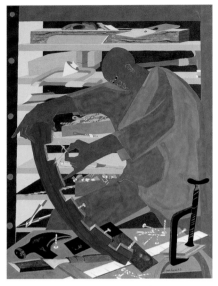

Collection: Birmingham Museum of Art. Museum purchase with funds provided by the Simpson Foundation, private contributors, and with Museum funds.

Provenance: [Terry Dintenfass Inc., New York].

Exhibitions: Birmingham Museum of Art, Ala., *American Watercolors: 1850–Present*, January 1972; Dintenfass 1973, no. 5; Whitney 1974–5, no. 156; Seattle 1986–7, no. 120.

References: Lewis and Waddy 1969, p. 81, ill. (as *The Builder*); *The Black Scholar* 9, 1 (September 1977), cvr., ill.; Wheat 1986, p. 217, no. 120, ill.; Stephen Wallis, "Jacob Lawrence: Portrait of a Serial Painter," *Art and Antiques* 19, 11 (December 1996), p. 63, ill.

P71-02
Builders No. 2
1971
tempera and gouache on paper
30 × 22 in. (76.2 × 55.9 cm)
signed and dated lower right "Jacob Lawrence 71"

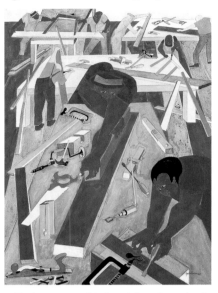

Collection: James and Barbara Palmer, Pennsylvania.

Provenance: [Terry Dintenfass Inc., New York]; Mr. and Mrs. Richard Nye, New York; [Terry Dintenfass Inc., New York].

Exhibitions: Whitney Museum of American Art, New York, *1972 Annual Exhibition: Contemporary American Painting*, January 25–March 19, 1972, no. 65; Dintenfass 1973, no. 6; Seattle 1986–7, no. 121; Midtown Payson 1995a; San Antonio 1996.

References: *1972 Annual Exhibition: Contemporary American Painting*, exh. cat. (New York: Whitney Museum of American Art, 1972), p. 36, ill.; Wheat 1986, p. 217, no. 121, ill.

P71-03
Builders No. 3
1971
tempera and gouache on paper
22 × 30 in. (55.9 × 76.2 cm)
signed and dated lower right "Jacob Lawrence 71"

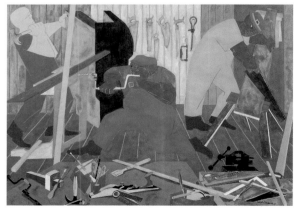

Collection: Johnson Publishing Company, Chicago.

Provenance: [Terry Dintenfass Inc., New York].

Exhibitions: Weatherspoon Art Gallery, University of North Carolina at Greensboro, *Art on Paper*, November–December 1971.

P71-04
Munich Olympic Games
1971
tempera and gouache on paper
39⅞ × 28¹⁵⁄₁₆ in. (101.3 × 73.5 cm)
signed lower right "Jacob Lawrence"

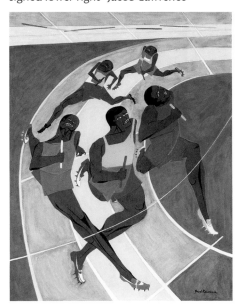

Collection: Seattle Art Museum. Purchased with funds from PONCHO.

Provenance: [Terry Dintenfass Inc., New York]; Mr. and Mrs. Joseph M. Erdelac, Cleveland; [Francine Seders Gallery, Seattle].

Exhibitions: Dintenfass 1973, no. 8; Museum of Art, Munson-Williams-Proctor Institute, Utica, N.Y., *The Olympics in Art: An Exhibition of Works of Art Related to Olympic Sports*, January 13–March 2, 1980, no. 81; Santa Monica 1982; Seattle 1986–7, no. 122; Jacob Lawrence Gallery, University of Washington, Seattle, *Jacob Lawrence: Paintings 1971–1984, Inaugural Exhibition*, October 19–December 6, 1994; Henry Art Gallery 1998.

References: Bernard Denvir, "London Letter," *Art International* 16, 5 (May 20, 1972), p. 42; Joseph S. Trovato, *The Olympics in Art: An Exhibition of Works of Art Related to Olympic Sports*, exh. cat. (Utica, N.Y.: Museum of Art, Munson-Williams-Proctor Institute, 1980), pp. 38, 142, ill.; Sally G. Devaney, "Utica's Olympus," *The Art Gallery* (January 1980), p. 25, ill.; Louis Louis, *Ten Seconds* (Saint Paul: Graywolf Press, 1991), cvr., ill.; Powell 1992, pl. 12; Gary Wills, "The Real Thing," *New York Review of Books* 41, 14 (August 11, 1994), p. 6, ill.; Tom Stabile, "Reconstructing Jacob Lawrence: A Scholarly Team Prepares the Master Catalog," *Humanities* 19, 6 (November–December 1998), p. 28, ill.

Remarks: Commissioned by Edition Olympia for translation into silk-screen prints on the occasion of the 1972 Munich Olympic Games.

P72-01
Builders No. 1
1972
gouache and watercolor on paper
22½ × 30¾ in. (57.2 × 78.1 cm)
signed and dated lower right "Jacob Lawrence 72"

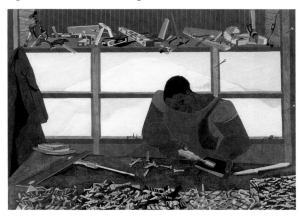

Collection: The Saint Louis Art Museum, Saint Louis, Missouri. The Eliza McMillan Fund.

Provenance: [Terry Dintenfass Inc., New York].

Exhibitions: Dintenfass 1973, no. 7; The Saint Louis Art Museum, *The Black Presence in Art*, October 3–November 10, 1975; The Museum of the National Center of Afro-American Artists and Museum of Fine Arts, Roxbury, Mass., *Jubilee: Afro-American Artists on Afro-America*, November 13, 1975–January 4, 1976; The Detroit Institute of Arts, *The John Brown Series by Jacob Lawrence*, October 14–November 26, 1978; Seattle 1986–7, no. 123; Henry Art Gallery 1998.

References: *The Saint Louis Art Museum Bulletin* 8, 4 (November–December 1972), p. 55, ill.; Wheat 1986, p. 161, pl. 79; Helen D. Hume, *A Survival Kit for the Secondary School Art Teacher* (West Nyack, N.Y.: Center for Applied Research in Education, 1990), p. 75, ill.; Mary Ann Steiner, ed., *The Saint Louis Art Museum Handbook of the Collection* (Saint Louis: The Saint Louis Art Museum, 1991), p. 150; Robin Updike, "A Modern Master," *Seattle Times*, June 28, 1998, *Pacific Northwest* magazine, p. 16, ill.

P73-01
Builders No. 1
1973
gouache and tempera on paper
28⅞ × 23⅞ in. (73.3 × 60.6 cm)
signed and dated lower right "Jacob Lawrence 73"

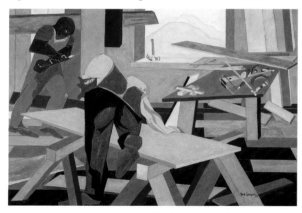

Collection: Private collection.

Provenance: [Sid Deutsch Gallery, New York].

Exhibitions: Dintenfass 1973, no. 9; Whitney 1974–5, no. 157.

References: "Eye on New York," *The Art Gallery* 17, 1 (October 1973), p. 83, ill.

P73-02
Builders No. 2
1973
gouache and tempera on paper
21⅞ × 29⅞ in. (55.5 × 75.9 cm)
signed and dated lower right "Jacob Lawrence / 73"

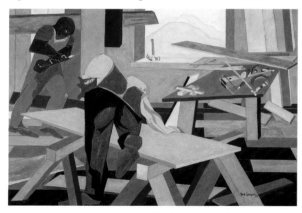

Collection: Tougaloo College Art Collection. NEA Purchase Grant, 73.063.

Provenance: [Terry Dintenfass Inc., New York].

Exhibitions: Dintenfass 1973, p. 10; Mississippi Museum of Art, Jackson, *Jacob Lawrence: The Builder*, January 24–March 14, 1982, no. 10; Henry Art Gallery 1998.

References: "Acquisitions: Tougaloo's Collections Grow," *Art Journal* 33, 4 (summer 1974), p. 351; Wheat 1986, p. 162, pl. 80.

P73-03
Builders No. 3
1973
gouache on paper
38¾ × 20 in. (98.4 × 50.8 cm)
signed and dated lower right "Jacob Lawrence 73"

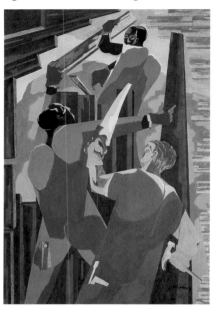

Collection: Private collection, New York.

Provenance: [Terry Dintenfass Inc., New York].

Exhibitions: Dintenfass 1973, no. 11.

References: Clarence Major, "Clarence Major Interviews: Jacob Lawrence, The Expressionist," *The Black Scholar* 9, 3 (November 1977), p. 26, ill.; Wheat 1986, p. 163, pl. 81.

P73-04
Builders No. 4
1973
gouache and tempera on paper
21½ × 30½ in. (54.6 × 77.5 cm)
signed and dated lower right "Jacob Lawrence 73"

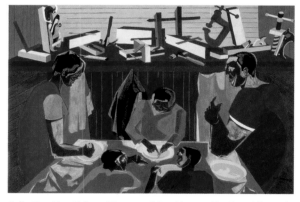

Collection: New Orleans Museum of Art. Museum Purchase, Women's Volunteer Committee Fund and matching funds from the National Endowment for the Arts.

Provenance: [Terry Dintenfass Inc., New York].

Exhibitions: Dintenfass 1973, no. 12; Whitney 1974–5, no. 158; Alexandria Museum of Art, La., *The Rhythm of Life: Selected Works by Bearden, Gwathmey, and Lawrence*, January 25–March 30, 1984.

References: "Art Gallery Scene, May 1975," *The Art Gallery* 18 (April 1975), p. 39, ill.; *The Rhythm of Life: Selected Works by Bearden, Gwathmey, and Lawrence*, exh. cat. (Alexandria, La.: Alexandria Museum of Art, 1984).

P73-05
George Washington Bush
1973
casein tempera and gouache on paperboard (5 paintings)
each panel signed and dated lower right "Jacob Lawrence 73"

Collection: Washington State Capitol Museum, Olympia.

Provenance: Jacob and Gwendolyn Knight Lawrence, Seattle.

Exhibitions: Tacoma Art Museum, Wash., *Jacob Lawrence: The Washington Years,* February 3–April 2, 1989; The Washington State Capitol Museum, Olympia, *In Retrospect: Twenty-Five Years: The Governor's Invitational Art Exhibition,* September 23–November 12, 1989; Whatcom 1992, nos. 2–4.

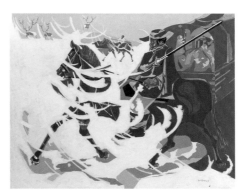

3. *The hardest part of the journey is yet to come—the Continental Divide, stunned by the magnitude of roaring rivers.*
31½ × 39½ in. (80 × 100.3 cm)

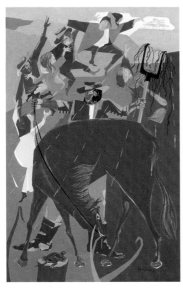

1. *On a fair May morning in 1844, George Washington Bush left Clark County, Missouri, in six Conestoga wagons.*
31½ × 19½ in. (80 × 49.5 cm)

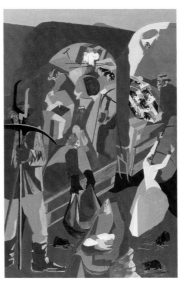

4. *Christmas, 1844—Fort Vancouver is a temporary halting place before they venture to Puget Sound country.*
31½ × 19½ in. (80 × 49.5 cm)

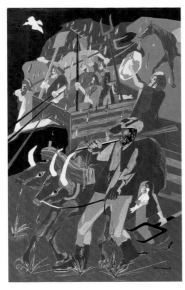

2. *In the Iowa Territory, they rendez-voused with a wagon train headed for the Oregon Trail.*
31½ × 19½ in. (80 × 49.5 cm)

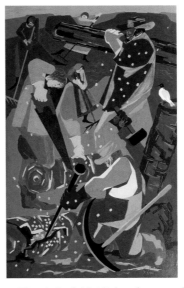

5. *Thank God All Mighty, home at last—the settlers erect shelter at Bush Prairie near what is now Olympia, Washington, November 1845.*
31½ × 19½ in. (80 × 49.5 cm)

P74-01
Builders No. 1
1974
gouache on paper
30 × 22 in. (76.2 × 55.9 cm)
signed and dated lower right "Jacob Lawrence 74"

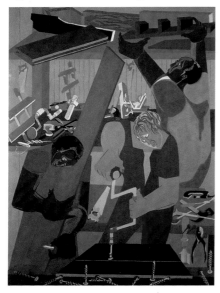

Collection: Collection of the Vatican Museum, Vatican City, Italy.

Provenance: Jacob and Gwendolyn Knight Lawrence, Seattle; Skowhegan School of Painting and Sculpture, Maine.

Exhibitions: Santa Monica 1982.

References: Jefferson Eugene Grisby, Jr., *Art and Ethics: Background for Teaching Youth in a Pluralistic Society* (Dubuque, Iowa: William C. Brown, 1977), p. 32, ill.; Lewis and Hewitt 1982, n.p., ill. (misdated 1976); Wheat 1986, p. 164, pl. 82; Powell 1992, n.p., ill.

P74-02
The 1920s . . . The Migrants Arrive and Cast Their Ballots
1974
gouache on paper
32 × 24½ in. (81.3 × 62.2 cm)
inscription unknown

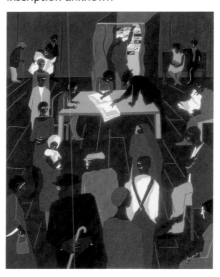

Collection: Herbert F. Johnson Museum of Art, Cornell University. Gift of Natalie and Dr. Marvin Gliedman.

Provenance: [Terry Dintenfass Inc., New York]; Dr. and Mrs. Marvin Gliedman, Atlantic Beach, N.Y.

Exhibitions: Dintenfass 1978, no. 12; Henry Art Gallery 1998.

P74-03
Builders No. 3
1974
gouache and tempera on paper
30 × 22 in. (76.2 × 55.9 cm)
signed and dated lower right "Jacob Lawrence 74"

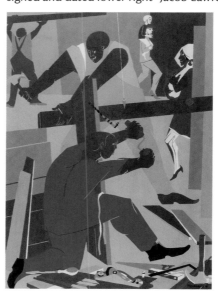

Collection: Private collection, New York.

Provenance: [Terry Dintenfass Inc., New York].

Exhibitions: Dintenfass 1978, no. 16.

P74-04
Poster Design . . . Whitney Exhibition
1974
gouache and tempera on paper
30 1/16 × 22 1/4 in. (76.4 × 56.5 cm)
signed and dated lower right "Jacob Lawrence 74"

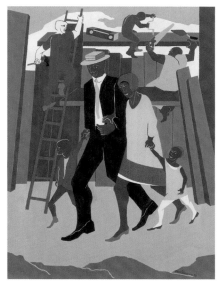

Collection: Private collection, New York.

Provenance: [Terry Dintenfass Inc., New York].

Exhibitions: Whitney 1974–5, no. 164.

References: Brown 1974, cvr., ill.; Jessica B. Harris, "The Prolific Palette of Jacob Lawrence," *Encore* (November 1974), pp. 52–3, ill.; Lewis and Sullivan 1982, p. 53, ill. (as *Builders*); Glory Jones, "Jacob Lawrence: The Master Nobody Knows," *Washington* (November–December 1984), p. 56, ill.; Wheat 1986, pp. 146–7; Theodore F. Wolff, "Touring Show Celebrates Jacob Lawrence's Style," *Christian Science Monitor*, August 4, 1986, p. 24, ill. (as *Builders-Family*).

P75-01
Confrontation at the Bridge
1975
gouache on paper
22 1/2 × 30 1/4 in. (57.2 × 76.8 cm)
signed and dated lower right "Jacob Lawrence 75"

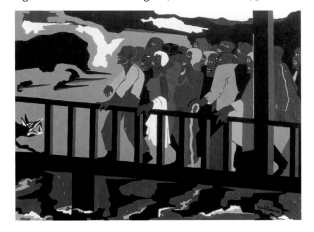

Collection: James and Barbara Palmer, Pennsylvania.

Provenance: [Terry Dintenfass Inc., New York]; Dr. and Mrs. Isaac Taylor, Boston; [Terry Dintenfass Inc., New York].

Exhibitions: Dintenfass 1978, no. 13; Seattle 1986–7, no. 126; Midtown Payson 1995a; San Antonio 1996.

References: Wheat 1986, p. 172, pl. 89; Avis Berman, "Commitment on Canvas," *Modern Maturity* (August–September 1986), p. 75, ill.; "Retrospective Exhibit on Afro-American Painter," *People's Daily World*, September 30, 1987, p. A11, ill.; John Russell, "Art View: The Epic of a People Writ Large on Canvas," *New York Times*, October 11, 1987, sec. 2, p. 39.

Remarks: Commissioned by Transworld Art, New York, on the occasion of the American Bicentennial, for translation into silk-screen prints. The prints were included in a portfolio entitled *Not Songs of Loyalty Alone: The Struggle for Personal Freedom* that accompanied the ten-volume *An American Portrait 1776–1976*.

P75-02
The Serengeti
1975
tempera and gouache on illustration board
17 1/2 × 26 in. (44.5 × 66 cm)
signed and dated lower right "Jacob Lawrence 75"

Collection: Collection of Champion International, Stamford, Connecticut.

Provenance: [Terry Dintenfass Inc., New York].

Exhibitions: Dintenfass 1978, no. 11.

References: Glory Jones, "Jacob Lawrence: The Master Nobody Knows," *Washington* (November–December 1984), pp. 56–7, ill.; Wheat 1986, p. 173, pl. 91.

Remarks: Commissioned by the Champion Paper Company for reproduction in a book on Africa.

P75-03
Other Rooms
1975
gouache and tempera on paper
24 × 18 in. (61 × 45.7 cm)
signed and dated lower right "Jacob Lawrence 75"

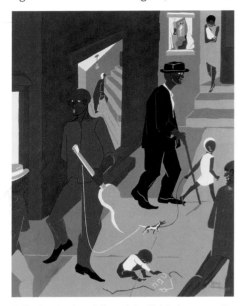

Collection: Jacob and Gwendolyn Knight Lawrence. Courtesy of Francine Seders Gallery, Seattle.

Exhibitions: Dintenfass 1978, no. 6; The Detroit Institute of Arts, *The John Brown Series by Jacob Lawrence*, October 14–November 26, 1978; Seattle 1986–7, no. 128; USIA Caribbean 1989, no. 21; Bellevue Art Museum, Wash., *Celebrations—No Place Like Home*, November 20, 1993–January 8, 1994; Tampa Museum of Art, Fla., *New York Realism: Past and Present*, 1994–5; Henry Art Gallery 1998.

References: Wheat 1986, p. 218, ill.; Ron Glowen, "Jacob Lawrence: A Living History," *Artweek* 17, 28 (August 23, 1986), p. 1, ill.; Stephanie Stokes Oliver, "Jacob Lawrence," *Essence* (November 1986), p. 91, ill.; "Jacob Lawrence: American Painter," *Dallas Weekly*, June 25–July 1, 1987, p. C1, ill.; Lewis and Hewitt 1989, p. 40, ill.

Remarks: A.k.a. *People in Other Rooms*; commissioned by the Harlem School of the Arts for translation into silk-screen prints.

P76-01
Bumbershoot '76
1976
gouache on paper
34¼ × 26½ in. (87 × 67.3 cm)
signed and dated lower right "Jacob Lawrence 76"

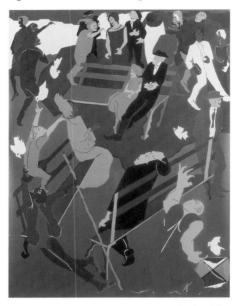

Collection: Seattle Arts Commission, Seattle City Light One Percent for Art Portable Works Collection.

Provenance: Jacob and Gwendolyn Knight Lawrence, Seattle.

Exhibitions: Seattle Art Museum, *Masters of the Northwest*, November 1976–January 1977; Jacob Lawrence Gallery, University of Washington, Seattle, *Jacob Lawrence: Paintings 1971–1984, Inaugural Exhibition*, October 19–December 6, 1994; Henry Art Gallery 1998.

References: Glory Jones, "Jacob Lawrence: The Master Nobody Knows," *Washington* (November–December 1984), p. 55, ill.

Remarks: Poster commission for Bumbershoot, an annual arts festival in Seattle, Washington.

P76-02

In a free government, the security of civil rights must be the same as that for religious rights. It consists in the one case in the multiplicity of interests, and in the other, the multiplicity of sects.
—JAMES MADISON, *1788*
1976
gouache on paper
30 × 22⅛ in. (76.2 × 56.2 cm)
signed and dated lower right "Jacob Lawrence 76"

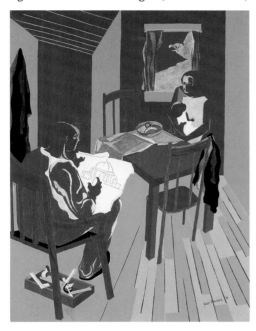

Collection: National Museum of American Art, Smithsonian Institution. Gift of the Container Corporation of America.

Provenance: [Terry Dintenfass Inc., New York]; Container Corporation of America, Chicago.

Exhibitions: Dintenfass 1978, no. 14; National Museum of American Art, Washington, D.C., *Art, Design, and The Modern Corporation, The Collection of the Container Corporation of America, A Gift to the National Museum of American Art*, October 24, 1985–January 19, 1986, no. 112.

References: [Container Corporation advertisement], *Business Week* (May 10, 1976), p. 123, ill.; Martina Roudabush Norelli, *Art, Design, and the Modern Corporation: The Collection of the Container Corporation of America, A Gift to the National Museum of American Art*, exh. cat. (Washington, D.C.: Smithsonian Institution Press, 1985), p. 108, ill.

Remarks: Commissioned by the Container Corporation of America for its "Great Ideas" series.

P76-03

Scraping the Ice
1976
gouache and tempera on paper
26½ × 24 in. (67.3 × 61 cm)
signed and dated lower right "Jacob Lawrence 1960–1976"

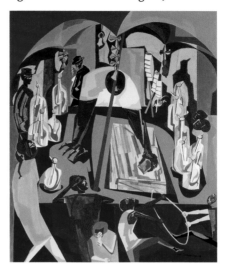

Collection: Midge Singer Korczak.

Provenance: Jacob and Gwendolyn Knight Lawrence, Seattle; Paula Singer, Hewlett Harbor, N.Y.

Remarks: Executed in 1976, based on a painting entitled *Ices II*, 1960 (egg tempera on hardboard). After the original painting suffered significant paint loss due, in part, to environmental conditions, the artist painted this work and traded it for the earlier painting.

P77-01
The Studio
1977
gouache and tempera on paper
30 × 22 in. (76.2 × 55.9 cm)
signed and dated lower right "Jacob Lawrence 1977"

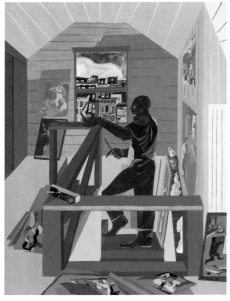

Collection: Seattle Art Museum. Partial gift of Gull Industries; John H. and Ann Hauberg; Links, Seattle; and gift by exchange from the estate of Mark Tobey.

Provenance: Jacob and Gwendolyn Knight Lawrence, Seattle; [Francine Seders Gallery, Seattle].

Exhibitions: Dintenfass 1978, no. 5; Santa Monica 1982; Seattle 1986–7, no. 130; USIA Caribbean 1989, no. 20; Jacob Lawrence Gallery, University of Washington, Seattle, *Jacob Lawrence: Paintings 1971–1984, Inaugural Exhibition*, October 19–December 6, 1994; Midtown Payson 1995a; Northwest Art 1997.

References: Clarence Major, "Clarence Major Interviews: Jacob Lawrence, The Expressionist," *The Black Scholar* 9, 3 (November 1977), p. 27, ill.; Lewis and Hewitt 1982, n.p., ill.; Lewis and Sullivan 1982, p. 2, ill. (as *Studio*); Ron Glowen, "Jacob Lawrence: A Living History," *Artweek* 17, 28 (August 23, 1986), cvr., ill.; Robert Wernick, "Jacob Lawrence: Art As Seen through a People's History," *Smithsonian* 18, 3 (June 1987), p. 66, ill.; Eleanor Heartney, "Reviews: Jacob Lawrence," *ARTnews* 86, 10 (December 1987), p. 143, ill.; Amy Fine Collins, "Jacob Lawrence: Art Builder," *Art in America* 76, 2 (February 1988), p. 131, ill.; Lewis and Hewitt 1989, p. 37, ill.; Powell 1992, n.p., pl. 13.

Remarks: This painting depicts the interior of the artist's studio, in the attic of his house, where he lived and worked from 1971 to 1996.

P77-02
Self-Portrait
1977
gouache and tempera on paper
23 × 31 in. (58.4 × 78.7 cm)
signed and dated lower right "Jacob Lawrence / 1977"

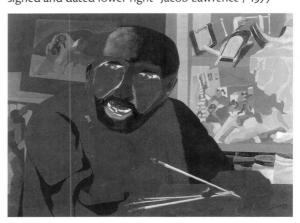

Collection: National Academy of Design, New York.

Provenance: Jacob and Gwendolyn Knight Lawrence, Seattle.

Exhibitions: Dintenfass 1978, no. 10; Seattle 1986–7, no. 129; Midtown Payson 1995a; Henry Art Gallery 1998.

References: Chrysler 1979b, ill. (not in exhibition); Lewis and Sullivan 1982, cvr., ill.; Avis Berman, "Jacob Lawrence and the Making of Americans," *ARTnews* 83, 2 (February 1984), p. 80, ill.; Wheat 1986, p. 175, pl. 93; Janet Kutner, "Powerful Folk Art, Lawrence's Paintings Celebrate Black Life," *Dallas Morning News*, June 30, 1987, p. C1, ill.

Remarks: Lawrence presented this painting to the National Academy in conjunction with his induction on December 5, 1977.

P77-03
University
1977
tempera and gouache on paper
32 × 24 in. (81.3 × 61 cm)
signed and dated lower right "Jacob Lawrence 1977"

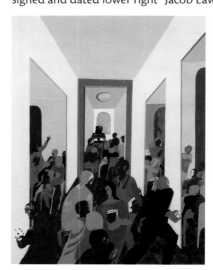

Collection: Private collection, New York.

Provenance: [Terry Dintenfass Inc., New York].

Exhibitions: Dintenfass 1978; Seattle 1986–7, no. 132.

References: Clarence Major, "Clarence Major Interviews: Jacob Lawrence, The Expressionist," *The Black Scholar* 9, 3 (November 1977), p. 26, ill.; Wheat 1986, p. 148; p. 174, pl. 92.

P77-04
The Swearing In No. 1
1977
gouache on paper
18 × 28 in. (45.7 × 72.1 cm)
signed and dated lower right "Jacob Lawrence 1977"

Collection: Jacob and Gwendolyn Knight Lawrence. Courtesy of Francine Seders Gallery, Seattle.

Exhibitions: Dintenfass 1978, no. 4; USIA Caribbean 1989, no. 7; Savannah 1998, no. 9; Henry Art Gallery 1998.

References: Clarence Major, "Clarence Major Interviews: Jacob Lawrence, The Expressionist," *The Black Scholar* 9, 3 (November 1977), p. 25, ill.; Lewis and Sullivan 1982, p. 56, ill.; Wheat 1986, p. 177, pl. 95; Lewis and Hewitt 1989, p. 36, ill.; Dan R. Goddard, "Stories Are Told through Artist's Works," *San Antonio Express-News*, March 30, 1996, p. G1, ill.; Cynda L. Benson, *Jacob Lawrence*, exh. cat. (Savannah, Ga.: Savannah College of Art and Design, 1998), p. 11, fig. 9.

Remarks: Commissioned by President Jimmy Carter's Inaugural Committee. Lawrence painted two versions; this version was translated to silk-screen prints as part of a portfolio entitled "Inaugural Impressions." The portfolio included prints by Roy Lichtenstein, Robert Rauschenberg, Andy Warhol, and Jamie Wyeth.

P77-05
The Swearing In No. 2
1977
gouache on paper
19½ × 29½ in. (49.5 × 74.9 cm)
signed and dated lower right "Jacob Lawrence 77"

Collection: Collection of Stephens Inc., Little Rock, Arkansas.

Provenance: Jacob and Gwendolyn Knight Lawrence, Seattle; [Terry Dintenfass Inc., New York].

Exhibitions: Dintenfass 1978, no. 1; Seattle 1986–7, no. 131.

References: Wheat 1986, p. 218, no. 131, ill.; Joanna Shaw-Eagle, "Jacob Lawrence, American Painter, at the Phillips Collection, April 4 through May 31," *Museum and Arts Washington* (March–April 1987), p. 10, ill.

P77-06
Carpenters
1977
gouache on paper
19 × 23⅛ in. (48.3 × 58.7 cm)
signed and dated lower right "Jacob Lawrence 77"

Collection: Jacob and Gwendolyn Knight Lawrence. Courtesy of Francine Seders Gallery, Seattle.

Exhibitions: Dintenfass 1978, no. 9; Santa Monica 1982; USIA Caribbean 1989, no. 10; Jacob Lawrence Gallery, University of Washington, Seattle, *Jacob Lawrence: Paintings 1971–1984, Inaugural Exhibition*, October 19–December 6, 1994; Savannah 1998, no. 1; Henry Art Gallery 1998.

References: Lewis and Hewitt 1982, n.p., ill.; Lewis and Hewitt 1989, p. 38, ill.; Cynda L. Benson, *Jacob Lawrence*, exh. cat. (Savannah, Ga.: Savannah College of Art and Design, 1998), cvr., ill.

Remarks: One of three paintings completed in late 1977 or early 1978, based on three lithographs the artist made at George C. Miller & Sons in 1977. The prints were drawn directly on aluminum plates; the paintings were created after the prints were pulled. The other two paintings are *Windows* and *Tools*.

P77-07
Windows
1977
gouache on paper
19¼ × 23 in. (48.9 × 58.4 cm)
signed and dated lower left "Jacob Lawrence 1977"

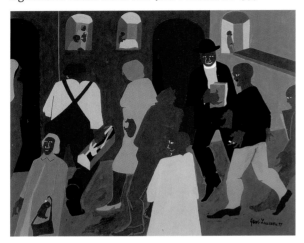

Collection: Jacob and Gwendolyn Knight Lawrence. Courtesy of Francine Seders Gallery, Seattle.

Exhibitions: Dintenfass 1978, no. 8; Santa Monica 1982; USIA Caribbean 1989, no. 5; United States embassy residence, Vienna, long-term loan, December 1993–7; Savannah 1998, no. 20; Henry Art Gallery 1998.

References: Lewis and Hewitt 1982, n.p., ill.; Lewis and Sullivan 1982, p. 57, ill.; Lewis and Hewitt 1989, p. 35, ill.; Cynda L. Benson, *Jacob Lawrence*, exh. cat. (Savannah, Ga.: Savannah College of Art and Design, 1998), p. 16, fig. 20.

P78-01
Tools
1978
gouache on paper
21¾ × 18½ in. (55.2 × 47 cm)
signed and dated lower right "Jacob Lawrence 78"

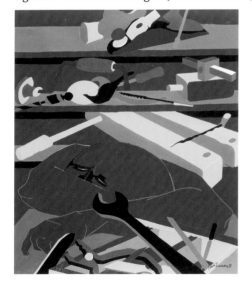

Collection: Detroit Institute of Arts. Founders Society Purchase with funds from the Friends of African American Art, Founders Junior Council, and the J. Lawrence Buell, Jr. Fund, Josephine and Ernest Kanzler Fund, Mr. and Mrs. Alvan Macauley, Jr. Fund, K. T. Keller Fund, Laura H. Murphy Fund.

Provenance: Jacob and Gwendolyn Knight Lawrence, Seattle; [Francine Seders Gallery, Seattle].

Exhibitions: Dintenfass 1978, no. 7; USIA Caribbean 1989, no. 6.

References: Wheat 1986, p. 165, pl. 83, ill.; Lewis and Hewitt 1989, cvr., ill.

P78-02
Man with Square
1978
gouache on paper
24⅝ × 16¼ in. (62.5 × 41.3 cm)
signed and dated lower right "Jacob Lawrence 1978"

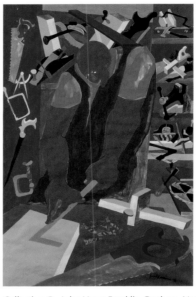

Collection: Dr. John Hope Franklin, Durham, North Carolina.

Provenance: [Terry Dintenfass Inc., New York].

Exhibitions: Dintenfass 1978, no. 18; The Corcoran Gallery of Art, Washington, D.C., *National Conference on the Arts Honors Ten African-American Artists*, March 14–April 16, 1980; Mississippi Museum of Art, Jackson, *Jacob Lawrence: The Builder*, January 24–March 14, 1982, no. 8; Fine Arts Museum of Long Island, Hempstead, N.Y., *Celebrating Contemporary Black American Artists*, March 13–May 1, 1983; Jamaica Arts Center 1984.

References: Liz M. Weiman, "Museum Notebook: The World of Jacob Lawrence," *Southwest Art* 16, 2 (July 1986), p. 80, ill.; Ellen Harkins Wheat, "Jacob Lawrence: Chronicler of the Black Experience," *American Visions* 2, 1 (February 1987), p. 35, ill.

P78-03
Man with Saw
1978
gouache on paper
24⅝ × 16¼ in. (62.5 × 41.3 cm)
signed and dated lower right "Jacob Lawrence 78"

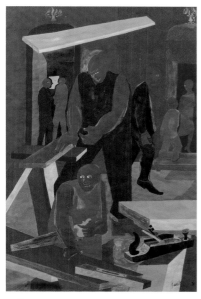

Collection: Private collection.

Provenance: [Terry Dintenfass Inc., New York].

Exhibitions: Dintenfass 1978, no. 17.

P78-04
The Workshop
1978
gouache on paper
27⅞ × 20 in. (70.8 × 50.8 cm)
signed and dated lower right "Jacob Lawrence 1978"

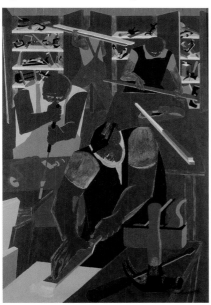

Collection: The Schoen Collection, Miami, Florida.

Provenance: Jacob and Gwendolyn Knight Lawrence, Seattle; [Terry Dintenfass Inc., New York].

Exhibitions: The Schomburg Center for Research in Black Culture, New York, *The Business of Slavery*, February 4–April 15, 1978; Dintenfass 1978, no. 2; New Jersey State Museum, Trenton, *Six Black Americans: Benny Andrews, Romare Bearden, Sam Gilliam, Richard Hunt, Jacob Lawrence, Betye Saar*, January 26–March 30, 1980, no. '6; CBS Broadcasting, New York, *Art NY*, March 1981; Rossi Gallery, Morristown, N.J., *American Image*, January 31–March 3, 1982; Alexandria Museum of Art, La., *The Rhythm of Life: Selected Works by Bearden, Gwathmey, and Lawrence*, January 25–March 30, 1984; Seattle 1986-7, no. 135; Pratt Manhattan Gallery, Pratt Institute, New York, *This Was Pratt*, March 12–April 16, 1988.

References: Wheat 1986, p. 219, ill.

P78-05
Games
1978
gouache on paper
24¼ × 51¾ in. (61.6 × 131.4 cm)
signed and dated lower right "Jacob Lawrence 1978"

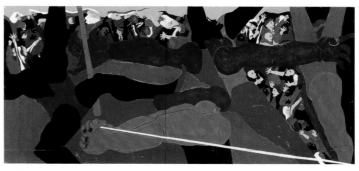

Collection: Howard Phil Welt and Norma Crampton.

Provenance: Jacob and Gwendolyn Knight Lawrence, Seattle; [Francine Seders Gallery, Seattle].

Exhibitions: Santa Monica 1982; Francine Seders Gallery, Seattle, *Studies for Murals and Sculpture*, July 8–27, 1986; Seattle 1986-7, no. 134; Wellington B. Gray Gallery, School of Art, East Carolina University, Greenville, N.C., *Jacob Lawrence: An American Master*, February 17–March 23, 1992; Oregon State University, Corvallis, *Jacob Lawrence*, April 1993; Jacob Lawrence Gallery, University of Washington, Seattle, *Jacob Lawrence: Paintings, 1971–1984, Inaugural Exhibition*, October 19–December 6, 1994; Seders 1998.

References: Nola Ahola, "Two Major Murals Dedicated February 27 at Kingdome," *The Arts: Newsletter of the King County Arts Commission, Washington* (January–February 1980), p. 1, ill.; Lewis and Hewitt 1982, n.p., ill.; Lewis and Sullivan 1982, p. 3, ill.; Wheat 1986, p. 219, no. 134, ill.; Avis Berman, "Commitment on Canvas," *Modern Maturity* (August–September 1986), pp. 70–1, ill.; Lewis and Hewitt 1989, n.p., ill.

Remarks: This work is the final maquette for the mural at Kingdome Stadium, Seattle; commissioned by the King County Arts Commission.

P79-01
Builders—19 Men
1979
gouache and tempera on paper
30 × 22 in. (76.2 × 55.9 cm)
signed and dated lower right "Jacob Lawrence 79"

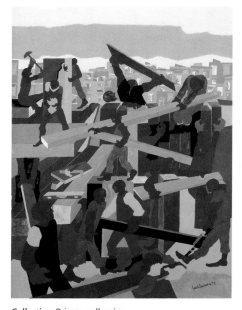

Collection: Private collection.

Provenance: [Terry Dintenfass Inc., New York].

P79-02
Builders (Red and Green Ball)
1979
gouache and tempera on paper
30 × 22 in. (76.2 × 55.9 cm)
signed and dated lower right "Jacob Lawrence 79"

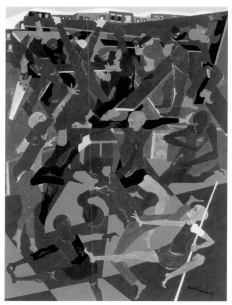

Collection: New Jersey State Museum Collection. Purchase, FA1987.28.

Provenance: [Francine Seders Gallery, Seattle].

Exhibitions: New Jersey State Museum, Trenton, and Prefecture of Fukui, Japan, *Dream Singers, Storytellers: An African-American Presence*, 1992–4.

References: Wheat 1986, p. 183, pl. 102.; Sadao Serikawa and Alison Weld, *Dream Singers, Storytellers: An African-American Presence*, exh. cat. (Trenton, N.J.: New Jersey State Museum; Fukui, Japan: Fukui Fine Arts Museum, 1992), p. 131, ill.

P80-01
Explorations
1980
gouache on bristol board
19¼ × 78 in. (48.9 × 198.1 cm)
signed and dated lower right "Jacob Lawrence 1980"

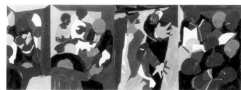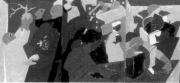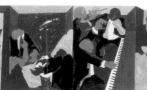

Collection: Howard University Gallery of Art, Washington, D.C.

Provenance: Jacob and Gwendolyn Knight Lawrence, Seattle.

References: Wheat 1986, pp. 180–1, pl. 98; Michelle-Lee White, "Common Directions, Epic Dimensions: Jacob Lawrence's Murals at Howard University," *International Review of African American Art* 12, 4 (1995), p. 32, ill.

Remarks: This is the maquette for the mural of the same title, commissioned by Howard University.

P80-02
Builders
1980
gouache on paper
34 × 25½ in. (86.4 × 64.8 cm)
signed and dated lower right "Jacob Lawrence / 1980"

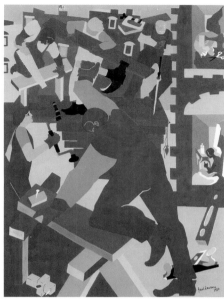

Collection: Collection of Safeco Corporation, Seattle.

Provenance: [Francine Seders Gallery, Seattle].

Exhibitions: Seders 1985; Tacoma Art Museum, Wash., *Jacob Lawrence: The Washington Years*, February 3–April 2, 1989; Northwest Art 1997; Henry Art Gallery 1998.

References: Wheat 1986, p. 178, pl. 96.

P80-03
Images of Labor
1980
gouache on paper
25 × 18½ in. (63.5 × 47 cm)
signed and dated lower right "Jacob Lawrence / 80"

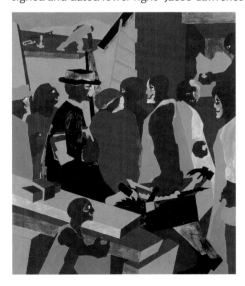

Collection: Lyondell Chemical, Newtown Square, Pennsylvania.

Provenance: Jacob and Gwendolyn Knight Lawrence, Seattle; [Francine Seders Gallery, Seattle].

Exhibitions: Washington State Capitol Museum, Olympia, *1981 Governor's Invitational Art Exhibition*, August 1981; Arizona State 1990; Philadelphia Art Alliance, *First in the Heart Is the Dream—African American Artists in the Twentieth Century: The Philadelphia Collection*, 1993.

References: Regina Hackett, "Jacob Lawrence's Latest Series Has Slowed to a Standstill," *Seattle Post-Intelligencer*, December 10, 1985, p. C5, ill.; Naomi Nelson, *First in the Heart Is the Dream—African American Artists in the Twentieth Century: The Philadelphia Connection*, exh. cat. (Philadelphia: The Philadelphia Art Alliance, 1993), n.p., ill.

P81-01
Pacific Northwest Arts and Crafts Fair
1981
tempera and gouache on paper
23 × 18½ in. (58.4 × 47 cm)
signed and dated lower right "Jacob Lawrence 1981"

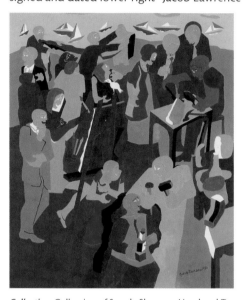

Collection: Collection of Seattle Sheraton Hotel and Towers.

Provenance: [Francine Seders Gallery, Seattle].

Exhibitions: Henry Art Gallery 1998.

References: Wheat 1986, p. 170, pl. 87.

Remarks: Poster design for Pacific Northwest Arts and Crafts Fair, Bellevue, Wash.

P82-01
Study for Eight Builders
1982–5
gouache on paper
22 × 29 in. (55.9 × 73.7 cm)
signed and dated lower right "Jacob Lawrence 1982–85"

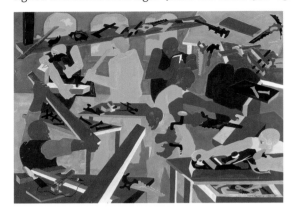

Collection: Portland Art Museum, Portland, Oregon. The Blanche Eloise Day Ellis and Robert Hale Ellis Memorial Collection.

Provenance: [Francine Seders Gallery, Seattle].

Exhibitions: Willamette 1989.

P82-02
Eight Builders
1982
gouache and tempera on paper
40 × 52 in. (101.6 × 132.1 cm)
signed and dated lower right "Jacob Lawrence 82"

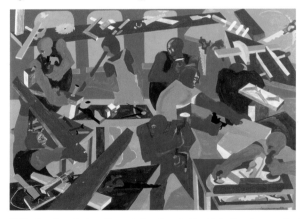

Collection: Seattle Arts Commission, Seattle City Light One Percent for Art Portable Works Collection.

Provenance: [Francine Seders Gallery, Seattle].

Exhibitions: Seattle 1986–7, no. 137; Henry Art Gallery 1998.

References: Sue Chin, "Jacob Lawrence: Expressing Life and Visions through Art," *Seattle Arts* 6, 4 (December 1982), p. 1, ill.; Bruce Guenther, *Fifty Northwest Artists: A Critical Selection of Painters and Sculptors Working in the Pacific Northwest* (San Francisco: Chronicle Books, 1983), p. 75, ill.; Deloris Tarzan, "Fifty Visions, There Is No Northwest Style, There Are Only Northwest Artists," *Seattle Times/Seattle Post-Intelligencer*, January 8, 1984, *Pacific* magazine, p. 1, ill.; Wheat 1986, p. 185, pl. 104.

Hiroshima paintings

These eight paintings were commissioned by Limited Edition Club, New York, for translation into silk-screen prints to accompany a limited-edition book of the artist's choosing. Lawrence chose John Hersey's *Hiroshima*, originally published in *The New Yorker* magazine, 1947.

P83-01
Farmers
1983
tempera and gouache on paper
23 × 17½ in. (58.4 × 44.5 cm)
signed and dated lower right "Jacob Lawrence 83"

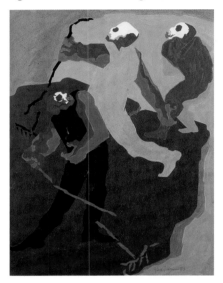

Collection: Jacob and Gwendolyn Knight Lawrence. Courtesy of Francine Seders Gallery, Seattle.

Exhibitions: Seattle 1986–7, no. 138; Tacoma Art Museum, Wash., *Jacob Lawrence: The Washington Years*, February 3–April 2, 1989; Arizona State 1990; Whatcom 1992; Midtown Payson 1993a; Jacob Lawrence Gallery, University of Washington, Seattle, *Jacob Lawrence: Paintings 1971–1984, Inaugural Exhibition*, October 19–December 6, 1994; Tyler 1996; Henry Art Gallery 1998.

References: John Hersey, with silk-screen prints by Jacob Lawrence, *Hiroshima* (New York: The Limited Editions Club, 1983); Wheat 1986, p. 219, ill.; Ellen Harkins Wheat, "Jacob Lawrence: Chronicler of the Black Experience," *American Visions* 2, 1 (February 1987), p. 35, ill.

P83-02

Family

1983

tempera and gouache on paper

23 × 17½ in. (58.4 × 44.5 cm)

signed and dated lower right "Jacob Lawrence 83"

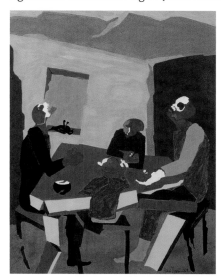

Collection: Jacob and Gwendolyn Knight Lawrence. Courtesy of Francine Seders Gallery, Seattle.

Exhibitions: Seattle 1986–7, no. 139; Tacoma Art Museum, Wash., *Jacob Lawrence: The Washington Years*, February 3–April 2, 1989; Arizona State 1990; Whatcom 1992; Midtown Payson 1993a; Jacob Lawrence Gallery, University of Washington, Seattle, *Jacob Lawrence: Paintings 1971–1984, Inaugural Exhibition*, October 19–December 6, 1994; Tyler 1996; Henry Art Gallery 1998.

References: John Hersey, with silk-screen prints by Jacob Lawrence, *Hiroshima* (New York: The Limited Editions Club, 1983); Avis Berman, "Jacob Lawrence and the Making of Americans," *ARTnews* 83, 2 (February 1984), p. 86, ill.; Wheat 1986, p. 219, ill.

P83-03

People in the Park

1983

tempera and gouache on paper

23 × 17½ in. (58.4 × 44.5 cm)

signed and dated lower right "Jacob Lawrence 83"

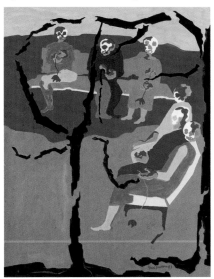

Collection: Jacob and Gwendolyn Knight Lawrence. Courtesy of Francine Seders Gallery, Seattle.

Exhibitions: Seattle 1986–7, no. 140; Tacoma Art Museum, Wash., *Jacob Lawrence: The Washington Years*, February 3–April 2, 1989; Whatcom 1992; Midtown Payson 1993a; Jacob Lawrence Gallery, University of Washington, Seattle, *Jacob Lawrence: Paintings 1971–1984, Inaugural Exhibition*, October 19–December 6, 1994; Tyler 1996; Henry Art Gallery 1998.

References: John Hersey, with silk-screen prints by Jacob Lawrence, *Hiroshima* (New York: The Limited Editions Club, 1983); Wheat 1986, p. 219, ill.; Esther Mumford, "Jacob Lawrence: In Retrospect," *Northwest Art Paper* (August 15–September 15, 1986), p. 5, ill.; Deborah Solomon, "The Book of Jacob," *New York Daily News Magazine*, September 27, 1987, p. 19, ill.

P83-04

Man with Birds

1983

tempera and gouache on paper

23 × 17½ in. (58.4 × 44.5 cm)

signed and dated lower right "Jacob Lawrence 83"

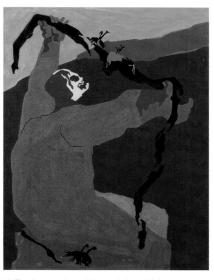

Collection: Jacob and Gwendolyn Knight Lawrence. Courtesy of Francine Seders Gallery, Seattle.

Exhibitions: Seattle 1986–7, no. 141; Tacoma Art Museum, Wash., *Jacob Lawrence: The Washington Years*, February 3–April 2, 1989; Whatcom 1992; Midtown Payson 1993a; Jacob Lawrence Gallery, University of Washington, Seattle, *Jacob Lawrence: Paintings 1971–1984, Inaugural Exhibition*, October 19–December 6, 1994; Tyler 1996; Henry Art Gallery 1998.

References: John Hersey, with silk-screen prints by Jacob Lawrence, *Hiroshima* (New York: The Limited Editions Club, 1983); Wheat 1986, p. 186, pl. 106; Stephen Wallis, "Jacob Lawrence: Portrait of a Serial Painter," *Art and Antiques* 19, 11 (December 1996), p. 64, ill.; Robin Updike, "A Modern Master," *Seattle Times*, June 28, 1998, *Pacific Northwest* magazine, p. 16, ill.; Shaniece A. Bell, "Art of the African World, Jacob Lawrence: One of the World's Most Preeminent Artists," *The Black Collegian* (October 1998), p. 12, ill.

P83-05
Street Scene
1983
tempera and gouache on paper
23 × 17½ in. (58.4 × 44.5 cm)
signed and dated lower right "Jacob Lawrence 83"

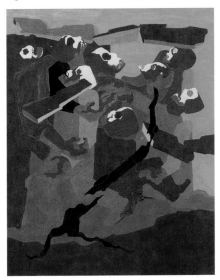

Collection: Jacob and Gwendolyn Knight Lawrence. Courtesy of Francine Seders Gallery, Seattle.

Exhibitions: Seattle 1986–7, no. 142; Tacoma Art Museum, Wash., *Jacob Lawrence: The Washington Years*, February 3–April 2, 1989; Whatcom 1992; Midtown Payson 1993a; Jacob Lawrence Gallery, University of Washington, Seattle, *Jacob Lawrence: Paintings 1971–1984, Inaugural Exhibition*, October 19–December 6, 1994; Tyler 1996; Henry Art Gallery 1998.

References: John Hersey, with silk-screen prints by Jacob Lawrence, *Hiroshima* (New York: The Limited Editions Club, 1983); Wheat 1986, p. 219, ill.; Shaniece A. Bell, "Art of the African World, Jacob Lawrence: One of the World's Most Preeminent Artists," *The Black Collegian* (October 1998), p. 13, ill.

P83-06
Playground
1983
tempera and gouache on paper
23 × 17½ in. (58.4 × 44.5 cm)
signed and dated lower right "Jacob Lawrence 83"

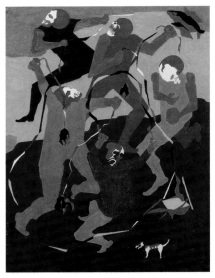

Collection: Jacob and Gwendolyn Knight Lawrence. Courtesy of Francine Seders Gallery, Seattle.

Exhibitions: Seattle 1986–7, no. 143; Tacoma Art Museum, Wash., *Jacob Lawrence: The Washington Years*, February 3–April 2, 1989; Whatcom 1992; Midtown Payson 1993a; Jacob Lawrence Gallery, University of Washington, Seattle, *Jacob Lawrence: Paintings 1971–1984, Inaugural Exhibition*, October 19–December 6, 1994; Tyler 1996; Henry Art Gallery 1998.

References: John Hersey, with silk-screen prints by Jacob Lawrence, *Hiroshima* (New York: The Limited Editions Club, 1983); Wheat 1986, p. 219, ill.; Shaniece A. Bell, "Art of the African World, Jacob Lawrence: One of the World's Most Preeminent Artists," *The Black Collegian* (October 1998), p. 13, ill.

P83-07
Boy with Kite
1983
tempera and gouache on paper
23 × 17½ in. (58.4 × 44.5 cm)
signed and dated lower right "Jacob Lawrence 83"

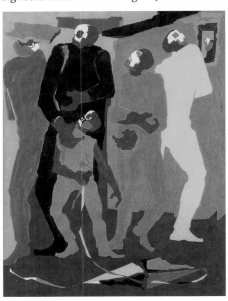

Collection: Jacob and Gwendolyn Knight Lawrence. Courtesy of Francine Seders Gallery, Seattle.

Exhibitions: Seattle 1986–7, no. 144; Tacoma Art Museum, Wash., *Jacob Lawrence: The Washington Years*, February 3–April 2, 1989; Whatcom 1992; Midtown Payson 1993a; Jacob Lawrence Gallery, University of Washington, Seattle, *Jacob Lawrence: Paintings 1971–1984, Inaugural Exhibition*, October 19–December 6, 1994; Tyler 1996; Henry Art Gallery 1998.

References: John Hersey, with silk-screen prints by Jacob Lawrence, *Hiroshima* (New York: The Limited Editions Club, 1983); Edmund Barry Gaither, "The Spiral of Afro-American Art," in *American Art Analog, Volume III, 1874–1930*, edited by Michael David Zellman (New York: Chelsea Home Publishers in association with American Art Analog, 1986), p. 408, ill.; Wheat 1986, p. 187, pl. 107; p. 220, ill.; Ron Glowen, "Jacob Lawrence: A Living History," *Artweek* 17, 28 (August 23, 1986), p. 1, ill.; Catherine Fox, "Jacob Lawrence, Artist Lifted Beauty from Jaws of Waiting American Nightmare," *Atlanta Journal and Constitution*, December 14, 1986, p. J1, ill.; Romare Bearden and Harry Henderson, *A History of African-American Artists from 1972 to Present* (New York: Pantheon Books, 1993), p. 313, ill.; Shaniece A. Bell, "Art of the African World, Jacob Lawrence: One of the World's Most Preeminent Artists," *The Black Collegian*, October 1998, p. 12, ill.

P83-08
Market
1983
tempera and gouache on paper
23 × 17½ in. (58.4 × 44.5 cm)
signed and dated lower right "Jacob Lawrence 83"

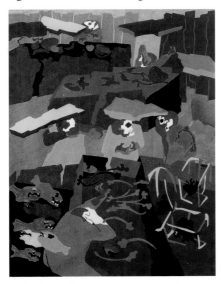

Collection: Jacob and Gwendolyn Knight Lawrence. Courtesy of Francine Seders Gallery, Seattle.

Exhibitions: Seattle 1986–7, no. 145; Tacoma Art Museum, Wash., *Jacob Lawrence: The Washington Years*, February 3–April 2, 1989; Whatcom 1992; Midtown Payson 1993a; Jacob Lawrence Gallery, University of Washington, Seattle, *Jacob Lawrence: Paintings 1971–1984, Inaugural Exhibition*, October 19–December 6, 1994; Tyler 1996; Henry Art Gallery 1998.

References: John Hersey, with silk-screen prints by Jacob Lawrence, *Hiroshima* (New York: The Limited Editions Club, 1983); Wheat 1986, p. 220, ill.

P84-01
Origins
1984
gouache on paper
12 × 79¾ in. (30.5 × 202.6 cm)
signed and dated lower right "Jacob Lawrence 1984"

Collection: Howard University Gallery of Art, Washington, D.C.

Provenance: Jacob and Gwendolyn Knight Lawrence, Seattle.

Exhibitions: Seattle 1986–7, no. 146.

References: Wheat 1986, pp. 180–1, pl. 99; Michelle-Lee White, "Common Directions, Epic Dimensions: Jacob Lawrence's Murals at Howard University," *International Review of African American Art* 12, 4 (1995), p. 32, ill.

Remarks: Maquette for the mural of the same title, commissioned by Howard University.

P84-02
Theater
1984
gouache on paper (two sheets)
each: 10½ × 41 in. (26.7 × 104.1 cm)

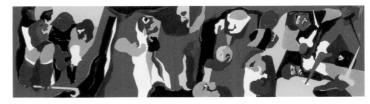

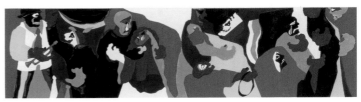

Collection: Jacob and Gwendolyn Knight Lawrence. Courtesy of Francine Seders Gallery, Seattle.

Exhibitions: USIA Caribbean 1989, no. 18; Francine Seders Gallery, Seattle, *Twenty-Fifth Anniversary Exhibition: The Middle Years*, June 7–July 7, 1991; Jacob Lawrence Gallery, University of Washington, Seattle, *Jacob Lawrence: Paintings 1971–1984, Inaugural Exhibition*, October 19–December 6, 1994; Seders 1998.

References: Regina Hackett, "A Master's Mural: Top Artist Does a Big Job for UW," *Seattle Post-Intelligencer*, August 19, 1985, p. C11, ill.; Regina Hackett, "The Public Side of Jacob Lawrence," *Seattle Post-Intelligencer*, July 17, 1998, p. 21, ill.

Remarks: Two-part maquette for the mural of the same title, commissioned by the University of Washington, Seattle.

P85-01
Bread, Fish, Fruit
1985
gouache on paper
30 × 22½ in. (76.2 × 57.2 cm)
signed and dated lower center/right "Jacob Lawrence / 1985"

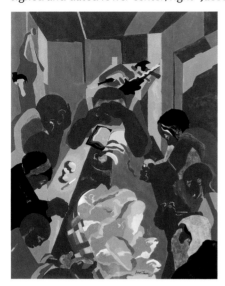

Collection: Private collection.

Provenance: [Francine Seders Gallery, Seattle]; Mr. and Mrs. Donald F. Imwalle, San Jose.

Exhibitions: Seattle 1986–7, no. 149; Henry Art Gallery 1998.

References: Wheat 1986, cvr., ill., p. 188, pl. 109; Bruce Nixon, "Artist Paints Pulse of Life," *Dallas Times Herald*, June 30, 1987, p. E2, ill.; Amy Fine Collins, "Jacob Lawrence: Art Builder," *Art in America* 76, 2 (February 1988), p. 135, ill.

Remarks: Commissioned as a poster design for 1986 retrospective at the Seattle Art Museum.

P85-02
Building No. 1
1985
gouache on paper
30 × 22 in. (76.2 × 55.9 cm)
signed and dated lower right "Jacob Lawrence 85"

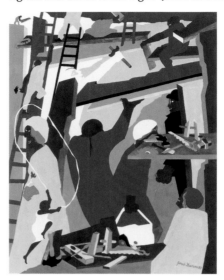

Collection: Les Payne, New York.

Provenance: [Francine Seders Gallery, Seattle].

Exhibitions: Seattle 1986–7, no. 148.

References: Ellen Harkins Wheat, "Jacob Lawrence and the Legacy of Harlem," *Archives of American Art Journal* 26, 1 (1986), p. 24, ill.; Wheat 1986, p. 220, no. 148, ill.

Remarks: Poster design for National Urban League's seventy-fifth birthday.

P85-03
Builders—Man on Scaffold
1985
gouache on paper
30 × 22¼ in. (76.2 × 56.5 cm)
signed and dated lower right "Jacob Lawrence 1985"

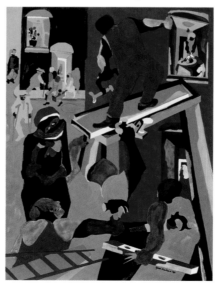

Collection: PACCAR Inc. Corporation Collection, Bellevue, Washington.

Provenance: [Francine Seders Gallery, Seattle].

Exhibitions: Tacoma Art Museum, Wash., *Jacob Lawrence: The Washington Years*, February 3–April 2, 1989; Northwest Art 1997.

References: Wheat 1986, p. 188, pl. 108.

Remarks: Commissioned by Francine Seders Gallery, Seattle, for translation into limited-edition prints.

P85-04
Street Scene
1985
gouache on paper
29½ × 21¾ in. (74.9 × 55.2 cm)
signed and dated lower right "Jacob Lawrence 85"

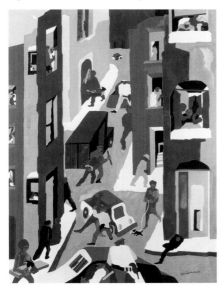

Collection: Terry and Eva Herndon.

Provenance: [Francine Seders Gallery, Seattle].

Exhibitions: Seattle 1986–7, no. 147; Palm Springs Desert Museum, Calif., *Northwest by Southwest: Painted Fictions*, 1990, no. 40; Museum of Our National Heritage, Lexington, Mass., *Art from the Driver's Seat: Americans and Their Cars—From the Collection of Terry and Eva Herndon*, August 1, 1993–January 2, 1994; Midtown Payson 1995a; Henry Art Gallery 1998.

References: Wheat 1986, p. 220, ill.; Lois Allan, *Contemporary Art in the Northwest* (North Ryden, Australia: Craftsman House Art Books, 1995), p. 138, ill.

P86-01
Schomburg Library
1986
gouache on paper
30 × 22 in. (76.2 × 55.9 cm)
signed and dated lower right "Jacob Lawrence 86"

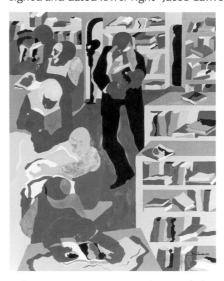

Collection: The Walter O. Evans Collection of African American Art.

Provenance: [Francine Seders Gallery, Seattle].

Exhibitions: Francine Seders Gallery, Seattle, *Selected Works in Celebration of Black History Month*, February 5–March 6, 1988; Palm Springs Desert Museum, Calif., *Northwest by Southwest: Painted Fictions*, 1990, no. 39; Beach Institute/King-Tisdell Museum, Savannah, Ga., *The Walter O. Evans Collection of African-American Art*, January–April 1991 (venues after Cincinnati).

References: Katherine Plake Hough, *Northwest by Southwest: Painted Fictions*, exh. cat. (Palm Springs, Calif.: Palm Springs Desert Museum, 1990), p. 77, ill.

Remarks: Commissioned by The Schomburg Center for Research in Black Culture, New York, for translation into limited-edition prints that were later sold to benefit the Center.

P86-02
Builders
1986
gouache on paper
31½ × 30 in. (80 × 76.2 cm)
signed and dated lower right "Jacob Lawrence 86"

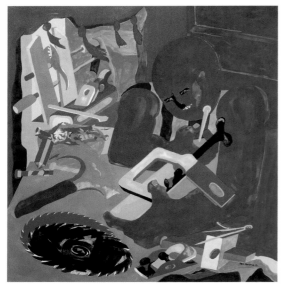

Collection: National Academy of Design, New York.
Provenance: Jacob and Gwendolyn Knight Lawrence, Seattle.
Exhibitions: Henry Art Gallery 1998.

P86-03
Community
1986
gouache on paper
30 × 22⅛ in. (76.2 × 56.2 cm)
signed and dated lower center/right "Jacob Lawrence 1986"

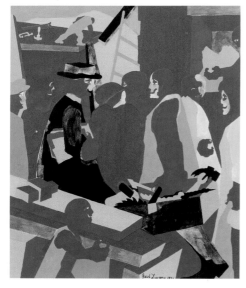

Collection: National Museum of American Art, Smithsonian Institution. Transfer from the United States General Services Administration, Art-in-Architecture Program.

Provenance: Jacob and Gwendolyn Knight Lawrence, Seattle; United States General Services Administration, Art-in-Architecture Program, Washington, D.C.

Exhibitions: Francine Seders Gallery, Seattle, *Selected Works in Celebration of Black History Month*, February 5–March 6, 1988; USIA Caribbean 1989, no. 17; National Building Museum, Washington, D.C., *GSA 1990 Design Excellence Awards*, November 26, 1990–January 4, 1991; National Museum of American Art, Washington, D.C., *Recent Acquisitions in Graphic Arts*, October 4, 1991–February 2, 1992; Henry Art Gallery 1998.

References: Lewis and Hewitt 1982, p. 39, ill. (as *Tools* and misdated 1982).

Remarks: Maquette for the mural of the same title, commissioned by the United States General Services Administration for the Jamaica Federal Building in New York City.

P87-01
Overtime
1987
gouache on paper
31⅝ × 23¾ in. (80.3 × 60.3 cm)
signed and dated lower right "Jacob Lawrence c 1987"

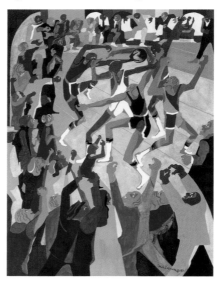

Collection: Mrs. Eunice W. Johnson, Chicago.
Provenance: [Francine Seders Gallery, Seattle].

Exhibitions: Francine Seders Gallery, Seattle, *Selected Works in Celebration of Black History Month*, February 5–March 6, 1988; The Washington State Capitol Museum, Olympia, *In Retrospect: Twenty-Five Years: The Governor's Invitational Art Exhibition*, September 23–November 12, 1989; Jon Taner Art Gallery, Montclair, N.J., February 1990; Washington State Convention and Trade Center, Seattle, *1991 National Governor's Invitational Art Exhibition*, August 1991; Wellington B. Gray Gallery, School of Art, East Carolina University, Greenville, N.C., *Jacob Lawrence: An American Master*, February 17–March 23, 1992 (first six venues).

P87-02
Time, Space, Energy
1987
tempera and gouache on paper (four sheets)
each: 16¾ × 23¾ in. (42.5 × 60.3 cm)
inscribed on the first sheet, bottom left in margin "1: TITLE: TIME, SPACE, ENERGY"; inscribed on the first sheet, center "SCALE: 3 INCHES = 1 FOOT"

Collection: Jacob and Gwendolyn Knight Lawrence. Courtesy of Francine Seders Gallery, Seattle.

Exhibitions: Seders 1998.

Remarks: Four-part maquette for the mural of the same title, commissioned by the Greater Orlando Aviation Authority. All sheets numbered bottom left.

P87-03
Debate I
1987
tempera and gouache on paper
47 × 31½ in. (119.4 × 80 cm)
signed and dated lower right "Jacob Lawrence c 1987"

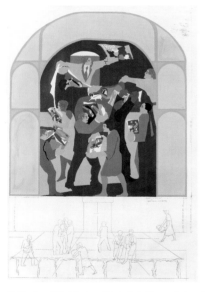

Collection: Washington State Arts Commission, Art in Public Places Program.

Provenance: Jacob and Gwendolyn Knight Lawrence, Seattle.

Exhibitions: Jacob Lawrence Gallery, University of Washington, Seattle, *Jacob Lawrence: Paintings 1971–1984, Inaugural Exhibition*, October 19–December 6, 1994; Seders 1998.

References: Mike Layton, "New Murals May Grace Capitol," *Seattle Post-Intelligencer*, February 27, 1987, p. E6; "Lawrence in Olympia," *Arts Line* 4, 11 (March 1987), pp. 3, 12; Deloris Tarzan, "Proposed Mural Touches Off New Debate on Art in Capitol, Is Jacob Lawrence Too Contemporary?" *Seattle Times*, March 13, 1987, ill.; Regina Hackett, "Art Again a Capitol Offense," *Seattle Post-Intelligencer*, March 14, 1987, p. A1, ill.

Remarks: Commissioned by Washington State Arts Commission. Artist completed maquettes but withdrew from the commission after murals by Michael Spafford, a friend and colleague on the art faculty of the University of Washington, were covered with a curtain.

P87-04
Debate II
1987
tempera and gouache on paper
47 × 31½ in. (119.4 × 80 cm)
signed and dated lower right "Jacob Lawrence c 1987"

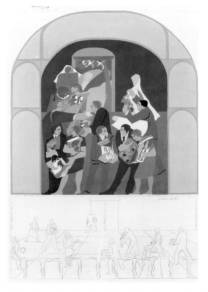

Collection: Washington State Arts Commission, Art in Public Places Program.

Provenance: Jacob and Gwendolyn Knight Lawrence, Seattle.

Exhibitions: Jacob Lawrence Gallery, University of Washington, Seattle, *Jacob Lawrence: Paintings 1971–1984, Inaugural Exhibition*, October 19–December 6, 1994; Seders 1998.

References: Mike Layton, "New Murals May Grace Capitol," *Seattle Post-Intelligencer*, February 27, 1987, p. E6; "Lawrence in Olympia," *Arts Line* 4, 11 (March 1987), pp. 3, 12; Deloris Tarzan, "Proposed Mural Touches Off New Debate on Art in Capitol, Is Jacob Lawrence Too Contemporary?" *Seattle Times*, March 13, 1987, ill.; Regina Hackett, "Art Again a Capitol Offense," *Seattle Post-Intelligencer*, March 14, 1987, p. A1, ill.

P88-01
Memorabilia
1988
gouache on paper
31½ × 23⅜ in. (80 × 59.4 cm)
signed and dated lower right "Jacob Lawrence 1988 ©"

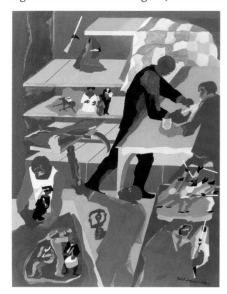

Collection: ArtColl Trust.

Provenance: [Francine Seders Gallery, Seattle]; Sidney and Diedre Green, Winter Springs, Fla.; [Francine Seders Gallery, Seattle].

Exhibitions: Arizona State 1990.

Remarks: Commissioned as a poster design for the twentieth anniversary of the African Studies Program at Vassar College, Poughkeepsie, N.Y.; translated into limited-edition prints in 1990 to fund the Jacob Lawrence Endowment at the University of Washington Press.

P89-01
Aspiration
1988–9
gouache on paper
31⅝ × 23½ in. (80.3 × 59.7 cm)
signed and dated lower right "Jacob Lawrence 88 ©"

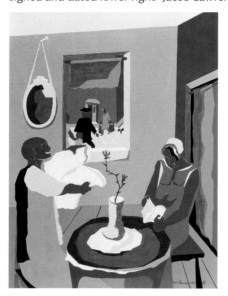

Collection: Paris and Charlene Qualles.

Provenance: [Francine Seders Gallery, Seattle].

Exhibitions: Willamette 1989.

Remarks: Commissioned by the NAACP Special Contribution Fund on the occasion of its eightieth anniversary; translated into lithographic prints that were sold to benefit the organization. The original painting was completed in 1988. Minor changes were made to the painting in 1989 by the artist after the prints were completed.

P89-02

Revolt on the Amistad

1989

gouache on paper

29¾ × 22 in. (75.6 × 55.9 cm)

signed and dated lower right "Jacob Lawrence 89 ©"

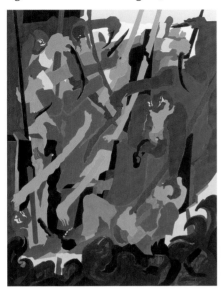

Collection: Paris and Charlene Qualles.

Provenance: [Francine Seders Gallery, Seattle].

Exhibitions: Oregon State University, Corvallis, *Jacob Lawrence*, April 1993; Midtown Payson 1993a; Bellevue Art Museum, Wash., *Jacob Lawrence: Thirty Years of Prints (1963–1993)*, September 24–November 27, 1994.

Remarks: Commissioned by the Aetna Life Insurance Company and Spradling-Ames, Key West, Fla., to commemorate the 150th anniversary of the Amistad incident; translated into limited-edition prints.

P89-03

To the Defense

1989

gouache on paper

31⅝ × 24⅛ in. (80.3 × 61.3 cm)

signed and dated lower right "Jacob Lawrence 1989 ©"

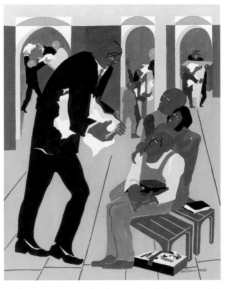

Collection: Private collection, Portland. Courtesy of Gordon Woodside/John Braseth Gallery, Seattle.

Provenance: [Alitash Kebede Contemporary Art, Los Angeles]; Robert C. and Faye Davidson, Los Angeles; [Gordon Woodside/John Braseth Gallery, Seattle].

Exhibitions: Michael Rosenfeld Gallery, New York, *African-American Art: Twentieth Century Masterworks VI*, January 14–March 6, 1999.

Remarks: Commissioned by the NAACP Legal Defense and Education Fund on the occasion of its fiftieth birthday.

P89-04

Eight Studies for the Book of Genesis

1989

gouache on paper (8 paintings)

29¾ × 22 in. (75.6 × 55.9 cm)

each painting signed and dated lower right "Jacob Lawrence 89 ©"

Collection: The Walter O. Evans Foundation for Art and Literature.

Provenance: [Francine Seders Gallery, Seattle].

Exhibitions: Beach Institute/King-Tisdell Museum, Savannah, Ga., *The Walter O. Evans Collection of African-American Art*, 1991–2000 (venues after Honolulu); Francine Seders Gallery, Seattle, *Twenty-Fifth Anniversary Exhibition: The Middle Years*, June 7–July 7, 1991; Wellington B. Gray Gallery, School of Art, East Carolina University, Greenville, N.C., *Jacob Lawrence: An American Master*, February 17–March 23, 1992; Mardigan

1. In the beginning, all was void.

2. And God brought forth the firmament and the waters.

3. And God said "Let the earth bring forth the grass, trees, fruits, and herbs."

4. And God created the day and the night, and God created and put the stars in the skies.

Library, University of Michigan, Dearborn, *Jacob Lawrence: The Genesis Series; Paintings on Loan from the Collection of Walter O. Evans, Detroit, Michigan*, February 3–March 3, 1994.

References: *Genesis* [King James version of the book of Genesis, illustrated with eight screen prints by Jacob Lawrence] (New York: The Limited Editions Club, 1990), ill. [1–8]; Regina Hackett, "Lawrence Explores New Territory," *Seattle Post-Intelligencer*, March 30, 1990, ill. [3]; Deloris Tarzan Ament, "Genesis from the Eighties," *Seattle Times*, April 1, 1990, p. L1, ill. [5]; Jennifer McLerran, "Aging and Pessimism," *Reflex* (May–June 1990), p. 22, ill. [8]; Sheila Farr, "Labors of Love: Jacob Lawrence at the Whatcom Museum of History and Art," *Artweek* 23, 12 (March 26, 1992), p. 9, ill.; *Jacob Lawrence: The Genesis Series; Paintings on Loan from the Collection of Walter O. Evans, Detroit, Michigan*, exh. brch. (Dearborn, Mich.: University of Michigan, 1994), ill.

Remarks: Commissioned by The Limited Editions Club, New York, for translation into silk-screen prints. No. 2 is signed and dated lower right "Jacob Lawrence 1989 ©"

5. And God created all the fowls of the air and the fishes of the seas.

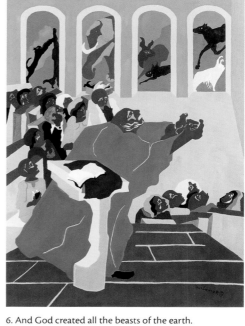

6. And God created all the beasts of the earth.

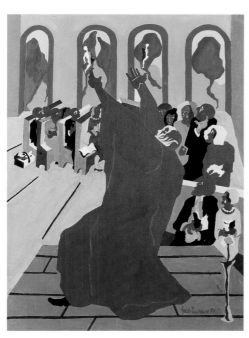

7. And God created man and woman.

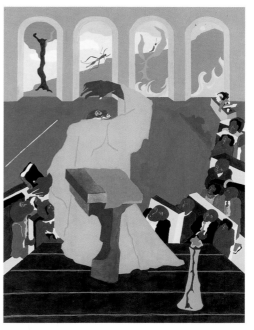

8. And creation was done—and all was well.

P90-01
On the Way
1990
gouache on paper
16 × 12 in. (40.6 × 30.5 cm)
signed and dated lower right "Jacob Lawrence 1990 ©"

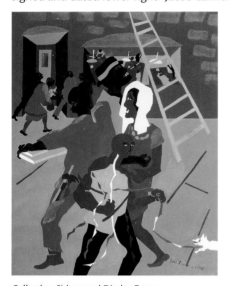

Collection: Sidney and Diedre Green.

Provenance: [Francine Seders Gallery, Seattle].

Remarks: Commissioned by the Resident Associate Program of the Smithsonian Institution on the occasion of its twenty-fifth anniversary.

P91-01
Celebration of Heritage
1991
gouache on paper
29¾ × 22¼ in. (75.6 × 56.5 cm)
signed and dated lower right "Jacob Lawrence 91"

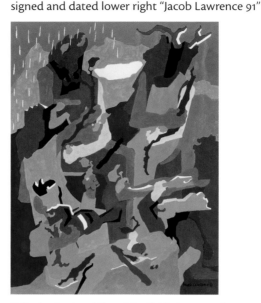

Collection: Jacob and Gwendolyn Knight Lawrence. Courtesy of Francine Seders Gallery, Seattle.

Exhibitions: Francine Seders Gallery, Seattle, *Twenty-Fifth Anniversary Exhibition: The Middle Years*, June 7–July 7, 1991; Midtown Payson 1995a; Savannah 1998, no. 17; Pinnacle Gallery, Savannah College of Art and Design, Ga., *Hindsight Is 20/20*, September 16, 1999–January 2, 2000.

References: Cynda L. Benson, *Jacob Lawrence*, exh. cat. (Savannah, Ga.: Savannah College of Art and Design, 1998), p. 23, fig. 17.

Remarks: Commissioned by the American Indian Heritage Foundation, Falls Church, Va., for translation into lithographic prints. Prints published to support the Indian Heritage Foundation.

P90-02
Events in the Life of Harold Washington
1990
gouache on paper
30½ × 49½ in. (77.5 × 125.7 cm)
inscribed top left in margin "Events in the Life of Harold Washington"; inscribed left center in margin "Proposal for Harold Washington Museum / 10 feet, 6 inches high, 15 feet, 3 inches depth, 2 inches = 1 foot / Medium: mosaic, Stephen Mitchell, (312) 744-7649, J.L. arrives in Chicago on Tues. August 28, presentation of proposal on Wednesday August 29, J.L. leaves Chicago on Thursday August 30, Palmer Hotel (312) 726-7500"; inscribed bottom in margin "The mayor as city planner, the mayor in his office, the mayor studies the city, Harold Washington campaigns, pens and papers, Harold Washington as lawyer, Harold Washington celebrates victory, to the capitol, the swearing in, Harold Washington in CCC camp, education, the war years, the athlete"

Collection: City of Chicago Public Art Collection.

Provenance: Jacob and Gwendolyn Knight Lawrence, Seattle.

Exhibitions: Richard J. Daley Center, Chicago, *Art in Public Places*, September 1995–January 1996.

Remarks: Maquette for a mural of the same title, commissioned by City of Chicago One Percent for Art Program.

P92-01
Woman with Flower
1992
gouache on paper
22⅛ × 15⅛ in. (56.2 × 38.4 cm)
signed and dated lower right "Jacob Lawrence 1992"

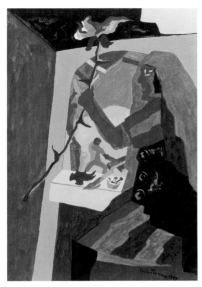

Collection: Susie Ruth Powell and Franklin R. Anderson.
Provenance: [Francine Seders Gallery, Seattle].

P92-02
Grand Performance
1992
gouache on paper
26½ × 20 in. (67.3 × 50.8 cm)
signed and dated lower right "Jacob Lawrence 1992"

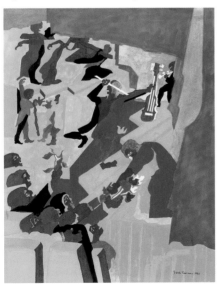

Collection: Mr. and Mrs. Daniel Baty, Seattle, Washington.
Provenance: [Francine Seders Gallery, Seattle].
References: Lois Allan, *Contemporary Art in the Northwest* (North Ryden, Australia: Craftsman House Art Books, 1995), p. 139, ill.
Remarks: Commissioned by Anheuser-Busch Companies, Saint Louis, on the occasion of the 1993 NAACP Image Awards Twenty-Fifth Anniversary celebration; translated into lithographic prints and posters that were distributed as part of the NAACP fundraiser for its Stay in School program.

P93-01
Builders in the Workshop
1993
gouache on paper
31½ × 22¼ in. (80 × 56.5 cm)
signed and dated lower right "Jacob Lawrence 93"

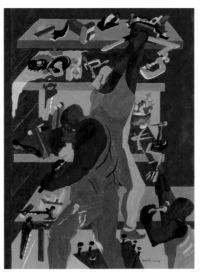

Collection: Martha A. and Robert S. Rubin.
Provenance: [Midtown Payson Galleries, New York].
Exhibitions: Midtown Payson 1993a.
References: Midtown Payson 1993b, cvr., ill.; "Jacob Lawrence at Midtown Payson Galleries," *ART NOW Gallery Guide: New York* (December 1993), cvr., ill.

P93-02
Lawyers and Clients
1993
gouache on paper
29¾ × 22 in. (75.6 × 55.9 cm)
signed and dated lower right "Jacob Lawrence 93"

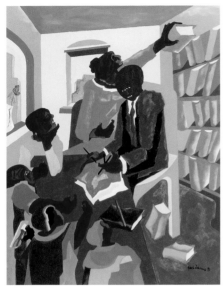

Collection: Sidney Mishkin Gallery at Baruch College.

Provenance: [Midtown Payson Galleries, New York].

References: Karen Wilkin, "At the Galleries," *Partisan Review* 1 (1994), p. 140, ill.

P93-03
The Builders Family
1993
gouache on paper
26 × 22¼ in. (66 × 56.5 cm)
signed and dated lower right "Jacob Lawrence 93"

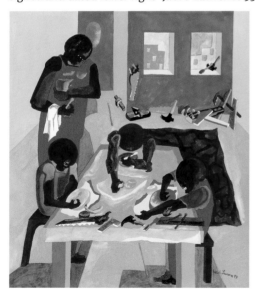

Collection: Francie Bishop Good and David Horvitz, Fort Lauderdale.

Provenance: [Midtown Payson Galleries, New York].

Exhibitions: Midtown Payson 1993a.

References: Steven Vincent, "Jacob Lawrence at Midtown Payson," *Art and Auction* (November 1993), p. 80, ill.; "Jacob Lawrence at Midtown Payson Galleries," *ART NOW Gallery Guide: New York* (December 1993), p. 10, ill.

P93-04
Builders in the City
1993
gouache on paper
19 × 28½ in. (48.3 × 72.4 cm)
signed and dated lower right "Jacob Lawrence 93"

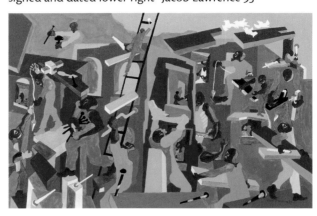

Collection: Courtesy of SBC Communications, Inc.

Provenance: [Midtown Payson Galleries, New York].

References: Michael Kimmelman, "A Sense of the Epic, A Love of the Ordinary," *New York Times*, November 14, 1993, sec. 2, p. 39, ill.; Karen Wilkin, "At the Galleries," *Partisan Review* 1 (1994), p. 139; Lois Allan, *Contemporary Art in the Northwest* (North Ryden, Australia: Craftsman House Art Books, 1995), p. 137, ill.

P94-01
The Cabinet Maker
1994
gouache on paper
29¾ × 22 in. (75.6 × 55.9 cm)
signed and dated lower right "Jacob Lawrence 1994"; verso: inscribed "The Cabinet Maker"

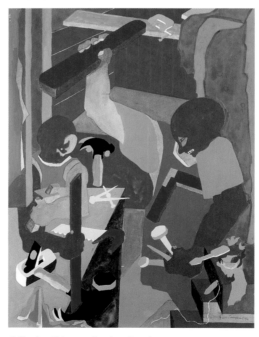

Collection: Private collection, Seattle.

Provenance: [DC Moore Gallery, New York].

Exhibitions: Midtown Payson 1995a; DC Moore Gallery, New York, *Inaugural Exhibition*, November 16–December 30, 1995.

P94-02
The Barefoot Prophet of Harlem
1994
gouache on paper
25¾ × 19⅝ in. (65.4 × 49.8 cm)
signed and dated lower right "Jacob Lawrence 1994"

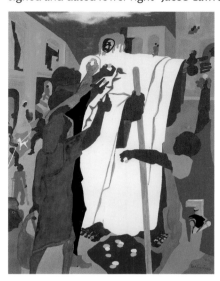

Collection: Jacob and Gwendolyn Knight Lawrence. Courtesy of DC Moore Gallery, New York.

Provenance: [DC Moore Gallery, New York].

Exhibitions: Midtown Payson 1995a; Pennsylvania Academy of the Fine Arts, Philadelphia, *Founder's Day Exhibition*, May 1997; Savannah 1998, no. 16.

References: Midtown Payson 1995b; Cynda L. Benson, *Jacob Lawrence*, exh. cat. (Savannah, Ga.: Savannah College of Art and Design, 1998), p. 22, fig. 16.

P94-03
Shopping Bags
1994
gouache on paper
19¾ × 25⅝ in. (50.2 × 65.1 cm)
signed and dated lower right "Jacob Lawrence 1994"; verso: inscribed "Shopping Bags"

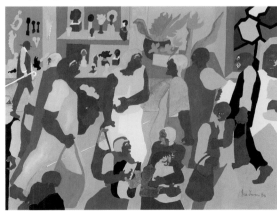

Collection: Muscarelle Museum of Art, College of William and Mary, Virginia. Museum Purchase, Gene A. (William and Mary 1952) and Mary A. Burns Art Acquisition Fund, E1997.115.

Provenance: [DC Moore Gallery, New York].

Exhibitions: Midtown Payson 1995a.

P94-04
Artist with Tools
1994
gouache on paper
25¾ × 19⅝ in. (65.4 × 49.8 cm)
signed and dated lower right "Jacob Lawrence 1994"; verso: inscribed "Artist with Tools"

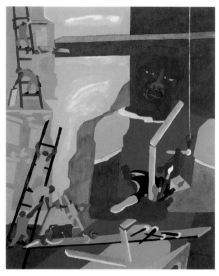

Collection: Peter and Susan Tuteur, Saint Louis.

Provenance: [Midtown Payson Galleries, New York].

Exhibitions: Midtown Payson 1995a.

References: Midtown Payson 1995b, cvr., ill.

P94-05
Supermarket—Tools
1994
gouache on paper
25½ × 19½ in. (64.8 × 49.5 cm)
signed and dated lower right "Jacob Lawrence / 1994"

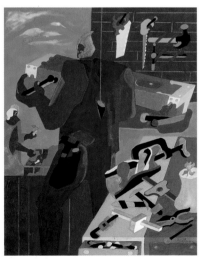

Collection: Private collection.

Provenance: [Francine Seders Gallery, Seattle]; Walter O. Evans, Detroit, Mich.; [Francine Seders Gallery, Seattle].

Exhibitions: Seders 1994; Henry Art Gallery 1998.

References: Regina Hackett, "Masters of Their Domain," *Seattle Post-Intelligencer*, May 27, 1996, p. D1, ill.; Janet Kutner, "Mast and Mentor," *Dallas Morning News*, October 25, 1996, p. C1, ill.

P94-06
Supermarket—Produce
1994
gouache on paper
25¾ × 19½ in. (65.4 × 49.5 cm)
signed and dated lower right "Jacob Lawrence / 1994"

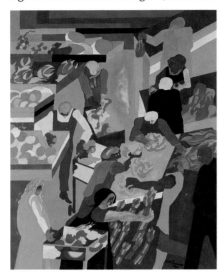

Collection: The Saint Louis Art Museum, Saint Louis, Missouri. Museum Minority Artist Purchase Fund and funds given by the Honorable Carole E. Jackson in memory of Dr. William Harrison.

Provenance: [Francine Seders Gallery, Seattle].

Exhibitions: Seders 1994.

P94-07
Supermarket—Celebration
1994
gouache on paper
26 × 20½ in. (66 × 52.1 cm)
signed and dated lower right "Jacob Lawrence 1994"

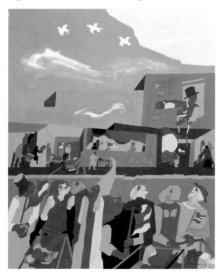

Collection: Private collection, Seattle.

Provenance: [Francine Seders Gallery, Seattle].

Exhibitions: Seders 1994; Midtown Payson 1995a.

References: Jacci Thompson Dodd, "Jacob Lawrence: Recent Work," *International Review of African American Art* 14, 1 (1997), ill.

P94-08
Supermarket—All Hallow's Eve
1994
gouache on paper
19⅝ × 25⅝ in. (49.8 × 65.1 cm)
signed and dated lower right "Jacob Lawrence 1994"

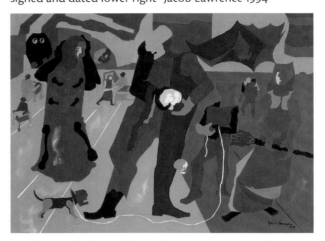

Collection: Jacob and Gwendolyn Knight Lawrence. Courtesy of Francine Seders Gallery, Seattle.

Exhibitions: Seders 1994; Northwest Art 1997.

P94-09
Supermarket—Flora
1994
gouache on paper
26 × 19⅝ in. (66 × 49.8 cm)
signed and dated lower right "Jacob Lawrence / 1994"

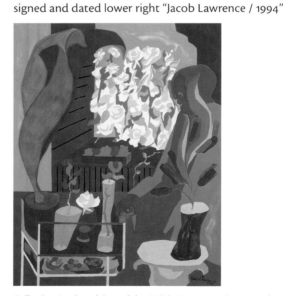

Collection: Jacob and Gwendolyn Knight Lawrence. Courtesy of Francine Seders Gallery, Seattle.

Exhibitions: Seders 1994; Meadows 1996; Savannah 1998, no. 18; Henry Art Gallery 1998.

References: Cynda L. Benson, *Jacob Lawrence*, exh. cat. (Savannah, Ga.: Savannah College of Art and Design, 1998), p. 24, fig. 18.

P94-10
Supermarket—Fishes
1994
gouache on paper
19½ × 25½ in. (49.5 × 64.8 cm)
signed and dated lower right "Jacob Lawrence 1994"

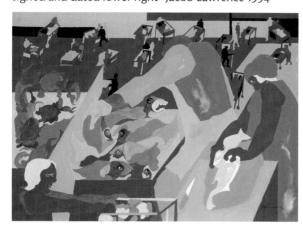

Collection: Private collection, Seattle.

Provenance: [Francine Seders Gallery, Seattle].

Exhibitions: Seders 1994; Savannah 1998, no. 4; Henry Art Gallery 1998.

References: Cynda L. Benson, *Jacob Lawrence*, exh. cat. (Savannah, Ga.: Savannah College of Art and Design, 1998), p. 7, fig. 4.

P94-11
Supermarket—Periodicals
1994
gouache on paper
19¾ × 25½ in. (50.2 × 64.8 cm)
signed and dated lower right "Jacob Lawrence 1994"

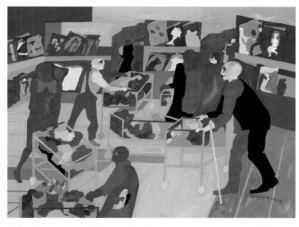

Collection: Jacob and Gwendolyn Knight Lawrence. Courtesy of Francine Seders Gallery, Seattle.

Exhibitions: Seders 1994; Meadows 1996; Northwest Art 1997; Savannah 1998, no. 3; The George D. and Harriet W. Cornell Fine Arts Museum, Winter Park, Fla., *Beyond the Veil: Art of African-American Artists at Century's End*, January 16–February 28, 1999.

References: *Jacob Lawrence: Paintings from Two Series, 1940 and 1994*, exh. brch. (Dallas: Meadows Museum, Owens Art Center, Southern Methodist University, 1996), p. 3, ill.; Jacci Thompson Dodd, "Jacob Lawrence: Recent Work," *International Review of African American Art* 14, 1 (1997), ill.; Cynda L. Benson, *Jacob Lawrence*, exh. cat. (Savannah, Ga.: Savannah College of Art and Design, 1998), p. 6, fig. 3.

P94-12
Supermarket—Meats
1994
gouache on paper
19½ × 25¾ in. (49.5 × 65.4 cm)
signed and dated lower right "Jacob Lawrence 1994"

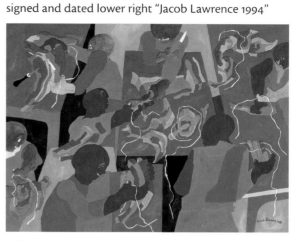

Collection: Jeremy and Linda Jaech, Seattle.

Provenance: [Francine Seders Gallery, Seattle].

Exhibitions: Seders 1994.

References: Robin Updike, "Lawrence Exhibit Is This Month's Star at Galleries," *Seattle Times*, December 14, 1994, p. F1, ill.; Jacci Thompson Dodd, "Jacob Lawrence: Recent Work," *International Review of African American Art* 14, 1 (1997), ill.

P94-13
Supermarket—Toys
1994
gouache on paper
25½ × 19 in. (64.8 × 48.3 cm)
signed and dated lower right "Jacob Lawrence 1994"

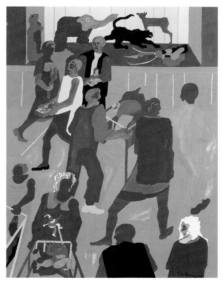

Collection: Jacob and Gwendolyn Knight Lawrence. Courtesy of Francine Seders Gallery, Seattle.

Exhibitions: Seders 1994; Midtown Payson 1995a; Pratt Manhattan Gallery, Pratt Institute, New York, *Jazz Y Son*, March 25–April 29, 1995; Meadows 1996; Northwest Art 1997; Savannah 1998, no. 19; Meridian International Center, Washington, D.C., *Outward Bound: American Art at the Brink of the Twenty-First Century*, May 20–June 11, 1999.

References: Cynda L. Benson, *Jacob Lawrence*, exh. cat. (Savannah, Ga.: Savannah College of Art and Design, 1998), p. 25, fig. 19.

P94-14
Supermarket—Gifts for the Homeless
1994
gouache on paper
29¾ × 19⅝ in. (75.6 × 49.8 cm)
signed and dated lower right "Jacob Lawrence 1994"

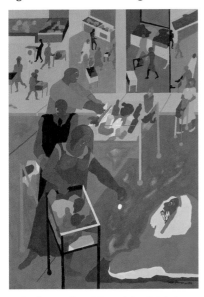

Collection: Jacob and Gwendolyn Knight Lawrence. Courtesy of Francine Seders Gallery, Seattle.

Exhibitions: Seders 1994; Meadows 1996; Northwest Art 1997; Henry Art Gallery 1998.

References: *Jacob Lawrence: Paintings from Two Series, 1940 and 1994,* exh. brch. (Dallas: Meadows Museum, Owens Art Center, Southern Methodist University, 1996), p. 9, ill.; Jacci Thompson Dodd, "Jacob Lawrence: Recent Work," *International Review of African American Art* 14, 1 (1997), ill.

P94-15
Supermarket—Checkout Counter
1994
gouache on paper
20 × 29¾ in. (50.8 × 75.6 cm)
signed and dated lower right "Jacob Lawrence 1994"

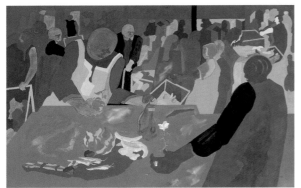

Collection: Jacob and Gwendolyn Knight Lawrence. Courtesy of Francine Seders Gallery, Seattle.

Exhibitions: Seders 1994; Meadows 1996; Northwest Art 1997.

References: *Jacob Lawrence: Paintings from Two Series, 1940 and 1994,* exh. brch. (Dallas: Meadows Museum, Owens Art Center, Southern Methodist University, 1996), cvr., ill.; Janet Kutner, "Mast and Mentor," *Dallas Morning News,* October 25, 1996, p. C1, ill.; Jacci Thompson Dodd, "Jacob Lawrence: Recent Work," *International Review of African American Art* 14, 1 (1997), ill.

P94-16
Supermarket—Used Books
1994
gouache on paper
31 × 25 in. (78.7 × 63.5 cm)
signed and dated lower right "Jacob Lawrence 1994"

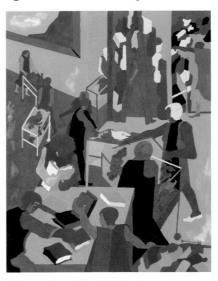

Collection: Ann P. Wyckoff, Seattle.

Provenance: [DC Moore Gallery, New York].

Exhibitions: Seders 1994; Midtown Payson 1995a; Henry Art Gallery 1998.

P94-17
From Field . . .
1994
gouache on paper
8½ × 11⅞ in. (21.6 × 30.1 cm)
signed and dated lower right "Jacob Lawrence 1994"

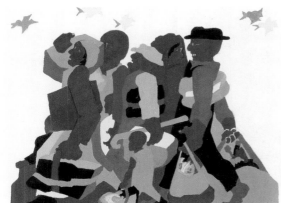

Collection: Private collection.

Provenance: [Francine Seders Gallery, Seattle].

Exhibitions: Savannah 1998, no. 12; Henry Art Gallery 1998.

References: Cynda L. Benson, *Jacob Lawrence*, exh. cat. (Savannah, Ga.: Savannah College of Art and Design, 1998), p. 14, fig. 12.

P94-18
. . . To Factory
1994
gouache on paper
8½ × 11⅝ in. (21.6 × 29.5 cm)
signed and dated lower right "Jacob Lawrence 1994"

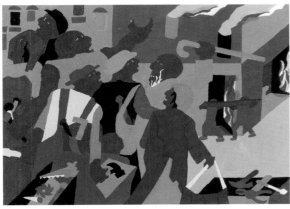

Collection: Private collection.

Provenance: [Francine Seders Gallery, Seattle].

Exhibitions: Savannah 1998, no. 13; Henry Art Gallery 1998.

References: Cynda L. Benson, *Jacob Lawrence*, exh. cat. (Savannah, Ga.: Savannah College of Art and Design, 1998), p. 15, fig. 13.

P94-19
Artist in Studio
1994
gouache on paper
26 × 19¾ in. (66 × 50.2 cm)
signed and dated lower right "Jacob Lawrence 1994"

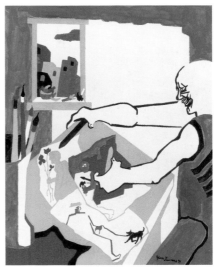

Collection: Jacob and Gwendolyn Knight Lawrence. Courtesy of Francine Seders Gallery, Seattle.

Exhibitions: Jacob Lawrence Gallery, University of Washington, Seattle, *Jacob Lawrence: Paintings 1971–1984, Inaugural Exhibition*, October 19–December 6, 1994; Midtown Payson 1995a; Northwest Art 1997; Savannah 1998, no. 14; Henry Art Gallery 1998; Pinnacle Gallery, Savannah College of Art and Design, Ga., *Hindsight Is 20/20*, September 16, 1999–January 2, 2000.

References: Cynda L. Benson, *Jacob Lawrence*, exh. cat. (Savannah, Ga.: Savannah College of Art and Design, 1998), p. 20, fig. 14.

Remarks: Commissioned for translation into lithographic prints to benefit the Jacob Lawrence Gallery Endowment at the University of Washington, Seattle.

P96-01

New York in Transit I

1996

gouache on paper

26¼ × 47¾ in. (66.7 × 121.3 cm)

signed and dated lower right "Jacob Lawrence 1996"; inscribed bottom right in margin "MURAL PROPOSAL FOR / TIMES SQUARE SUBWAY COMPLEX / TITLE: NEW YORK IN TRANSIT / MEDIUM: MOSAIC / SIZE: 6'2" × 21'3" / SCALE: 2"=1'"; inscribed bottom left in margin "SUZANNE RANDOLPH / RANDOLPH AND TATE ASSOCI-ATES / 155 WEST 72ND STREET / SUITE 501 / NEW YORK, N.Y. 10023 / (212) 595-6302"; inscribed top in margin "CHINESE SECTION" "BAS-KETBALL" "SUBWAY MAP" "AQUARIUM" "HIGHRISE" "SUBWAY TRAIN" "MUSIC"; inscribed bottom in margin "ART" "UNIVERSITY" "PARADE" "FOREST HILLS" "MENAGERIE" "THEATER" "WOMAN KNITTING" "HORSE RACING" "BASE BALL"

Collection: Jacob and Gwendolyn Knight Lawrence. Courtesy of Francine Seders Gallery, Seattle.

Exhibitions: Seders 1998.

Remarks: The first of two maquettes for a mural at Times Square Subway complex. A.k.a. *Maquette for "New York in Transit."*

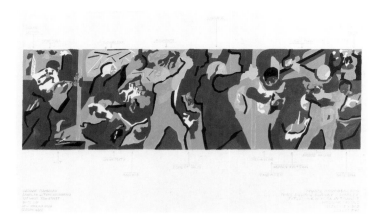

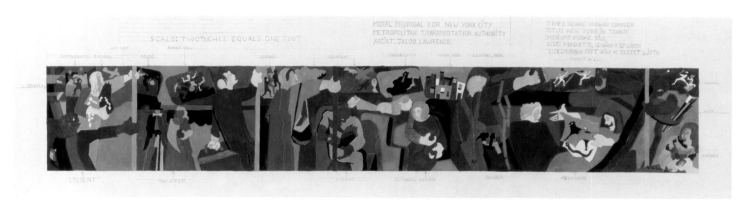

P97-01

New York in Transit II

1997

gouache on paper

21⅜ × 80 in. (54.3 × 203.2 cm)

signed and dated lower right "Jacob Lawrence 97"; inscribed top center in margin "MURAL PROPOSAL FOR THE NEW YORK CITY / METROPOLITAN TRANSPORTATION AUTHORITY / ARTIST: JACOB LAWRENCE"; inscribed top right in margin "TIMES SQUARE SUB-WAY COMPLEX / TITLE: NEW YORK IN TRANSIT / MEDIUM: MOSAIC TILE / SIZE: MAQUETTE, 12" HIGH × 72" WIDTH / SIZE: MURAL—6 FEET HIGH × 36 FEET WIDTH"; inscribed top left in margin "SCALE: TWO INCHES EQUALS ONE FOOT"; inscribed along the top in margin "RESTAURANT" "FASHION" "AIR PORT" "MUSIC" "BASKET BALL" "PARADE" "AQUARIUM" "UNIVERSITY" "HIGH RISE" "CENTRAL PARK" "FOREST HILLS"; inscribed left in margin "LIBRARY"; inscribed right in margin "BASEBALL" "ART" "PRODUCE"; inscribed along the bottom in margin "STUDENT" "THEATER" "FREIGHT" "BOTANICAL GARDEN" "BUILDER" "MENAGERIE"

Collection: Commissioned by the Metropolitan Transportation Authority Arts for Transit for installation at the Times Square Subway Station Complex of MTA New York City.

Provenance: Jacob and Gwendolyn Knight Lawrence, Seattle.

Exhibitions: Seders 1998.

Remarks: Second of two maquettes executed for Times Square Subway mural; this design was accepted for fabrication and installation. A.k.a. *Art in Transit.*

P98-01
Builders—Man in Blue Jacket
1998
gouache on paper
24 × 18 in. (61 × 45.7 cm)
signed and dated lower right "Jacob Lawrence 1998"

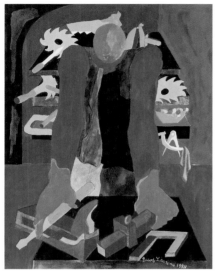

Collection: Private collection, Connecticut.

Provenance: [DC Moore Gallery, New York].

Exhibitions: DC Moore 1998a.

References: DC Moore 1998b, p. 4, ill.

P98-02
Builders—Stained Glass Windows
1998
gouache on paper
24 × 18 in. (61 × 45.7 cm)
signed and dated lower right "Jacob Lawrence 98"

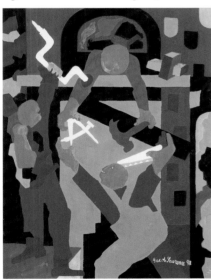

Collection: Jacob and Gwendolyn Knight Lawrence. Courtesy of DC Moore Gallery, New York.

Exhibitions: DC Moore 1998a; DC Moore Gallery, New York, *The Contemporary City: Red Grooms, Yvonne Jacquette, Jacob Lawrence, Philip Pearlstein, Paul Wonner,* March 3–27, 1999.

References: DC Moore 1998b, p. 25, ill.

P98-03
Builders—Builder with Pear
1998
gouache on paper
24 × 18 in. (61 × 45.7 cm)
signed and dated lower right "Jacob Lawrence / 1998"

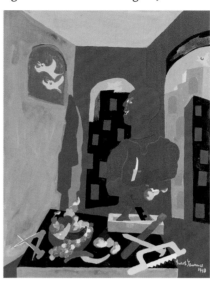

Collection: Jacob and Gwendolyn Knight Lawrence. Courtesy of DC Moore Gallery, New York.

Exhibitions: DC Moore 1998a.

References: DC Moore 1998b, p. 23, ill.

P98-04
Builders—Saw and Nails
1998
gouache on paper
24 × 18 in. (61 × 45.7 cm)
signed and dated lower right "Jacob Lawrence 1998"

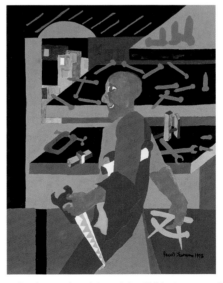

Collection: Jacob and Gwendolyn Knight Lawrence. Courtesy of DC Moore Gallery, New York.

Exhibitions: DC Moore 1998a.

References: DC Moore 1998b, p. 17, ill.

P98-05
Builders—Man with Still Life
1998
gouache on paper
24 × 18 in. (61 × 45.7 cm)
signed and dated lower right "Jacob Lawrence 1998"

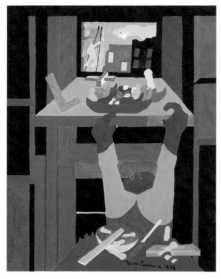

Collection: Private collection, Seattle.

Provenance: [DC Moore Gallery, New York].

Exhibitions: DC Moore 1998a.

References: DC Moore 1998b, p. 15, ill.; Christian Viveros-Faune, "New York: Jacob Lawrence at DC Moore," *Art in America* 87, 4 (April 1999), p. 143, ill.

P98-06
Builders—Green Hills
1998
gouache on paper
24 × 18 in. (61 × 45.7 cm)
signed and dated lower right "Jacob Lawrence 1998"

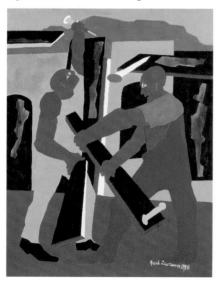

Collection: Private collection. Courtesy of DC Moore Gallery, New York.

Provenance: [DC Moore Gallery, New York].

Exhibitions: DC Moore 1998a.

References: DC Moore 1998b, p. 19, ill.

P98-07
Builders—Playroom
1998
gouache on paper
24 × 18 in. (61 × 45.7 cm)
signed and dated lower right "Jacob Lawrence 1998"

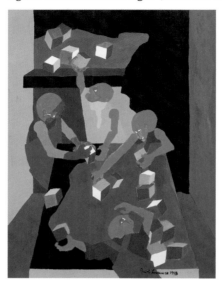

Collection: Jacob and Gwendolyn Knight Lawrence. Courtesy of DC Moore Gallery, New York.

Exhibitions: DC Moore 1998a.

References: DC Moore 1998b, p. 13, ill.

P98-08
Builders—Nine Windows
1998
gouache on paper
24 × 18 in. (61 × 45.7 cm)
signed and dated lower right "Jacob Lawrence 1998"

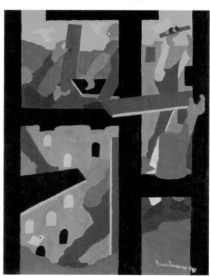

Collection: Jacob and Gwendolyn Knight Lawrence. Courtesy of DC Moore Gallery, New York.

Exhibitions: DC Moore 1998a.

References: DC Moore 1998b, p. 27, ill.

P98-09
Builders—Six Men with Beams
1998
gouache on paper
24 × 18 in. (61 × 45.7 cm)
signed and dated lower right "Jacob Lawrence 1998"

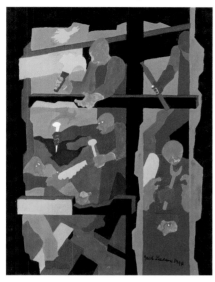

Collection: Jacob and Gwendolyn Knight Lawrence. Courtesy of DC Moore Gallery, New York.

Exhibitions: DC Moore 1998a; DC Moore Gallery, New York, *The Contemporary City: Red Grooms, Yvonne Jacquette, Jacob Lawrence, Philip Pearlstein, Paul Wonner,* March 3–27, 1999.

References: DC Moore 1998b, p. 21, ill.

P98-10
Builders—Man with Beard
1998
gouache on paper
24 × 18 in. (61 × 45.7 cm)
signed and dated lower right "Jacob Lawrence / 1998"

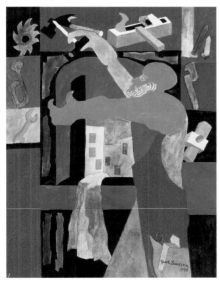

Collection: Private collection, New Jersey.
Provenance: [DC Moore Gallery, New York].
Exhibitions: DC Moore 1998a.
References: DC Moore 1998b, p. 7, ill.

P98-11
Builders—Four Men
1998
gouache on paper
24 × 18 in. (61 × 45.7 cm)
signed and dated lower right "Jacob Lawrence 98"

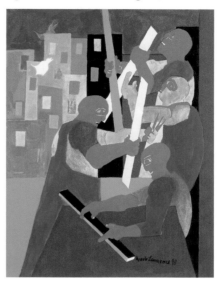

Collection: Private collection. Courtesy of DC Moore Gallery, New York.
Provenance: [DC Moore Gallery, New York].
Exhibitions: DC Moore 1998a.
References: DC Moore 1998b, p. 9, ill.

P98-12
Builders—Men on Ladders
1998
gouache on paper
24 × 18 in. (61 × 45.7 cm)
signed and dated lower right "Jacob Lawrence 98"

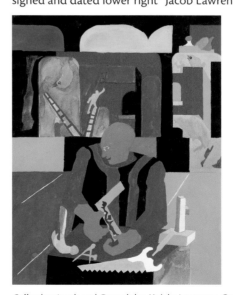

Collection: Jacob and Gwendolyn Knight Lawrence. Courtesy of DC Moore Gallery, New York.
Exhibitions: DC Moore 1998a.
References: DC Moore 1998b, p. 11, ill.

P99-01
Games—Curtain Time
1999
gouache on paper
24 × 18 in. (61 × 45.7 cm)
signed and dated lower center "Jacob Lawrence 99"

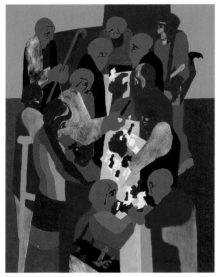

Collection: Jacob and Gwendolyn Knight Lawrence. Courtesy of Francine Seders Gallery, Seattle.

P99-02
Games—Chess
1999
gouache on paper
24 × 18 in. (61 × 45.7 cm)
signed and dated lower right "Jacob Lawrence 99"

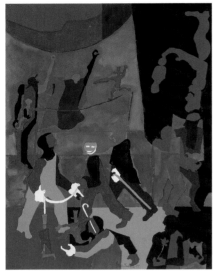

Collection: Private collection. Courtesy of Francine Seders Gallery, Seattle.

Provenance: [Francine Seders Gallery, Seattle].

P99-03
Games—Street Carnival
1999
gouache on paper
24 × 18 in. (61 × 45.7 cm)
signed and dated lower center/right "Jacob Lawrence 99"

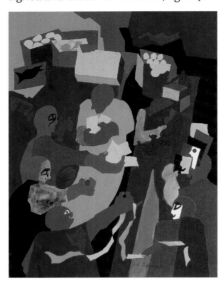

Collection: Jacob and Gwendolyn Knight Lawrence. Courtesy of Francine Seders Gallery, Seattle.

P99-04
Games—Eight Ball
1999
gouache on paper
24 × 18 in. (61 × 45.7 cm)
signed and dated lower right "Jacob Lawrence 99"

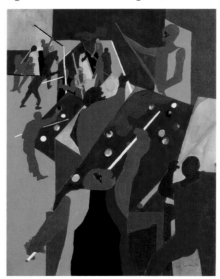

Collection: Jacob and Gwendolyn Knight Lawrence. Courtesy of Francine Seders Gallery, Seattle.

P99-05
Games—Pocket Pool
1999
gouache on paper
24 × 18 in. (61 × 45.7 cm)
signed and dated lower right "Jacob Lawrence 99"

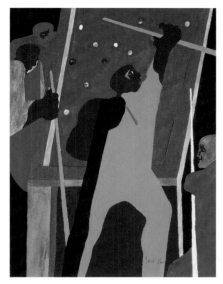

Collection: Private collection. Courtesy of Francine Seders Gallery, Seattle.
Provenance: [Francine Seders Gallery, Seattle].

P99-06
Games—Sleight of Hand
1999
gouache on paper
24 × 18 in. (61 × 45.7 cm)
signed and dated lower right "Jacob Lawrence 99"

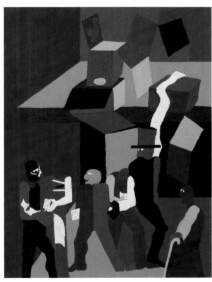

Collection: Jacob and Gwendolyn Knight Lawrence. Courtesy of Francine Seders Gallery, Seattle.
Remarks: A.k.a. *Games—Slight of Hand.*

P99-07
Games—A Bid of Four Hearts
1999
gouache on paper
24 × 18 in. (61 × 45.7 cm)
signed and dated lower center/right "Jacob Lawrence 99"

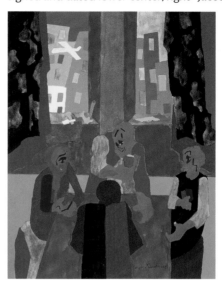

Collection: Private collection. Courtesy of Francine Seders Gallery, Seattle.
Provenance: [Francine Seders Gallery, Seattle].

P99-08
Games—Throwing the Dice
1999
gouache on paper
24 × 18 in. (61 × 45.7 cm)
signed and dated lower right "Jacob Lawrence 99"

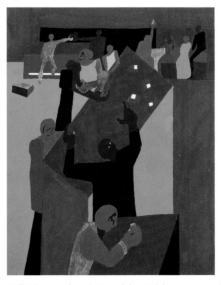

Collection: Jacob and Gwendolyn Knight Lawrence. Courtesy of Francine Seders Gallery, Seattle.

P99-09
Games—Checkers
1999
gouache on paper
24 × 18 in. (61 × 45.7 cm)
signed and dated lower right "Jacob Lawrence 99"

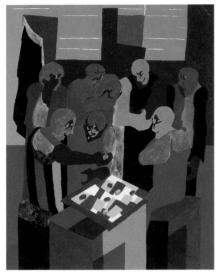

Collection: Private collection. Courtesy of Francine Seders Gallery, Seattle.
Provenance: [Francine Seders Gallery, Seattle].

P99-10
Games—Tossing Coins
1999
gouache on paper
24 × 18 in. (61 × 45.7 cm)
signed and dated lower center/right "Jacob Lawrence 99"

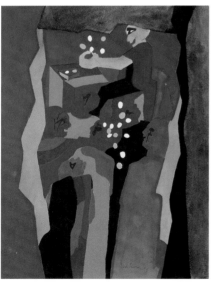

Collection: Jacob and Gwendolyn Knight Lawrence. Courtesy of Francine Seders Gallery, Seattle.

P99-11
Games—Five Card Stud
1999
gouache on paper
24 × 18 in. (61 × 45.7 cm)
signed and dated lower right "Jacob Lawrence 99"

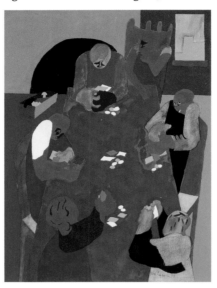

Collection: Paul C. Sprenger and Jane Lang, Washington, D.C.
Provenance: Jacob and Gwendolyn Knight Lawrence, Seattle; [Francine Seders Gallery, Seattle].

P99-12
Games—Three Card Monte
1999
gouache on paper
24 × 18 in. (61 × 45.7 cm)
signed and dated lower right "Jacob Lawrence 99"

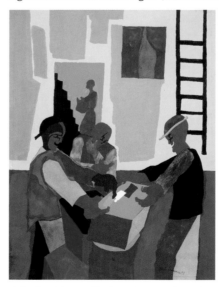

Collection: Private collection. Courtesy of Francine Seders Gallery, Seattle.
Provenance: [Francine Seders Gallery, Seattle].

Completed Drawings, Studies, and Sketches

D36-01
Chow
1936
graphite on paper
9 × 6 in. (22.9 × 15.2 cm)
signed and dated lower right "Lawrence 36"

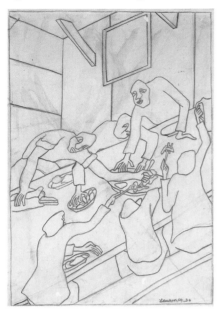

Collection: Spelman College, Atlanta.

Remarks: Executed by the artist while he was in the Civilian Conservation Corps in Middletown, New York.

D36-02
Infirmary
1936
graphite on paper
9 × 6 in. (22.9 × 15.2 cm)
signed and dated lower left "Lawrence 36"

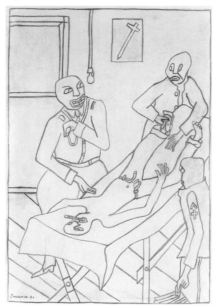

Collection: Spelman College, Atlanta.

Remarks: Executed by the artist while he was in the Civilian Conservation Corps in Middleton, New York.

D36-03
Sore Back
1936
graphite on paper
9 × 6 in. (22.9 × 15.2 cm)
signed and dated lower right "Lawrence 36"

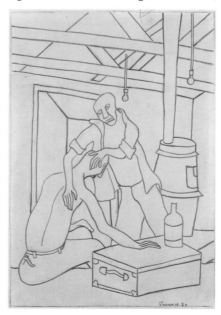

Collection: Spelman College, Atlanta.

Remarks: Executed by the artist while he was in the Civilian Conservation Corps in Middleton, New York.

D43-01

Killing the Incurable and Aged

1943

brush and ink on paper

10¾ × 13 in. (27.3 × 33 cm)

signed lower right "J. / LAWRENCE" [vertical]; inscribed bottom left in margin "#77", "Killing the Incurable and Aged"; verso: inscribed center "Death"

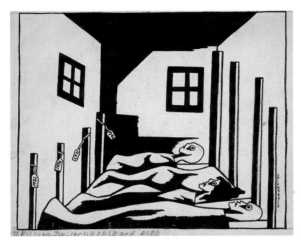

Collection: Private collection.

Provenance: Jacob and Gwendolyn Knight Lawrence, New York.

Remarks: One of an unknown number of drawings the artist executed while stationed with the Coast Guard at a white officers' training camp in St. Augustine, Fla., during the winter of 1943–4. At the time, Lawrence was working as a steward; he had not yet attained his Public Relations rating that allowed him to paint full-time.

In a letter from the artist to his dealer Edith Halpert in 1943, he comments on the deplorable social conditions for African Americans in the South and notes that he is working on a group of drawings to be titled "How the Negro Views the South" that he hopes to get published. The drawings were mailed to The Downtown Gallery but never published, and none are listed in gallery records as having sold. Only two, this drawing and *Starvation* (D43-02), are known to exist.

D43-02

Starvation

1943

brush and ink on paper

13 × 11 in. (33 × 27.9 cm)

signed lower right "J. LAWRENCE"; inscribed bottom left in margin "STARVATION" and illegible number; verso: inscribed center "Scavenger"

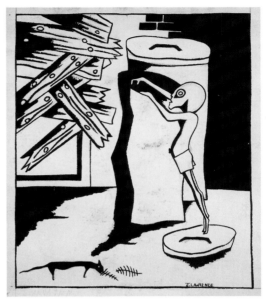

Collection: Private collection.

Provenance: Jacob and Gwendolyn Knight Lawrence, New York.

Remarks: Completed in St. Augustine, Fla., during the winter of 1943–4.

D45-01
Bombed Buildings—Southampton, England
1945
pen and ink on paper
11 × 16¾ in. (27.9 × 42.5 cm)
signed, dated, and inscribed lower right "Bombed Buildings / Southampton England / Jacob Lawrence 1945"

Collection: Dr. Blanche R. Brown.

Provenance: Jacob and Gwendolyn Knight Lawrence, New York; [Duncan Parrish Post of the American Legion, New York, Benefit Auction].

D45-02
From Naples to Pompeii, From Pompeii to Naples
1945
pen and ink on paper
13 × 20 in. (33 × 50.8 cm)
signed, dated, and inscribed upper right "'From Naples to Pompeii / From Pompeii to Naples' / Jacob Lawrence / 1945"

Collection: Private collection.

Provenance: Jacob and Gwendolyn Knight Lawrence, New York; Mitchell Siporin, Boston.

D45-03
Conversation with a Veteran
1945
pen and ink on paper
12 × 18 in. (30.5 × 45.7 cm)
signed, dated, and inscribed upper left "conversation with / a veteran / Jacob Lawrence / 1945"; inscribed lower left in pencil "#87"

Collection: Private collection.

Provenance: Jacob and Gwendolyn Knight Lawrence, New York.

D45-04
House in Italy—Naples
1945
pen and ink on paper
11⅞ × 18 in. (30.1 × 45.7 cm)
signed, dated, and inscribed lower right "House in Italy—Naples / Jacob Lawrence / 1945"; inscribed lower left "#89"

Collection: Jacob and Gwendolyn Knight Lawrence. Courtesy of Francine Seders Gallery, Seattle.

D45-05
Scramble for a Cigarette on a Dock in Naples
1945
pen and ink on paper
11⅞ × 18 in. (30.1 × 45.7 cm)
signed, dated, and inscribed lower right "Scramble for a cigarette on a / Dock in Naples / Jacob Lawrence / 1945"; inscribed lower left "#88"

Collection: Private collection.

Provenance: Jacob and Gwendolyn Knight Lawrence, New York and Seattle.

D45-06
Men on Watch in the North Atlantic
1945
pen and ink on paper
11⅞ × 18 in. (30.1 × 45.7 cm)
signed, dated, and inscribed lower right "MEN on Watch in / the North / Atlantic / Jacob Lawrence / 1945"; inscribed lower left "#86"

Collection: Jacob and Gwendolyn Knight Lawrence. Courtesy of DC Moore Gallery, New York.

Exhibitions: DC Moore 1996a.

D45-07
Priests and Nuns, Naples, Italy
1945
pen and ink on paper
11⅞ × 18 in. (30.1 × 45.7 cm)
signed, dated, and inscribed upper left "Priests and Nuns / Naples Italy / Jacob Lawrence / 1945"; inscribed lower left "#85"

Collection: Wolfgang Herz, New York.

Provenance: Jacob and Gwendolyn Knight Lawrence, New York and Seattle; [DC Moore Gallery, New York].

Exhibitions: DC Moore 1996a.

References: DC Moore 1996b, p. 7, ill.

D46-01
Man and Book
ca. 1946
pen and blue ink on paper
11¾ × 18 in. (29.8 × 45.7 cm)
signed lower right "Jacob Lawrence"

Collection: Private collection.

Provenance: Jacob and Gwendolyn Knight Lawrence, New York and Seattle; [DC Moore Gallery, New York].

Exhibitions: DC Moore 1996a.

References: DC Moore 1996b, p. 8, ill.

D46-02
Untitled [*Schomburg Library*]
1946
brush and ink on paper
12 × 18 in. (30.5 × 45.7 cm)
signed and inscribed lower right "To Ann With / Fondest Regards / Jacob Lawrence"

Collection: Bowdoin College Museum of Art. Gift of halley k. harrisburg '90 and Michael Rosenfeld, New York.

Provenance: ?; Ronald Brown, New York; [Michael Rosenfeld Gallery, New York].

Exhibitions: Michael Rosenfeld Gallery, New York, *African-American Art: Twentieth Century Masterworks V,* January 22–March 21, 1998.

References: Leslie King-Hammond, *African-American Art: Twentieth Century Masterworks V,* exh. cat. (New York: Michael Rosenfeld Gallery, 1998), p. 27, ill.

D46-03
Untitled [*Schomburg Library*]
1946
pen and ink on paper
18 × 11⅞ in. (45.7 × 30.1 cm)
signed and dated lower right "Jacob Lawrence / 1946"

Collection: Peter Rettman and Debra Portnoff Rettman, Seattle. Courtesy of Gordon Woodside/John Braseth Gallery, Seattle.

Provenance: Jacob and Gwendolyn Knight Lawrence, New York and Seattle; John Braseth, Seattle; [Gordon Woodside/John Braseth Gallery, Seattle].

Exhibitions: DC Moore 1996a; Henry Art Gallery 1998.

References: DC Moore 1996b, p. 10, ill. (as *Library*).

D47-01
Hot Summer's Night
1947
pen and ink on paper
11¾ × 17 in. (29.8 × 43.2 cm)
signed and dated lower right "Jacob Lawrence / 1947"

Collection: Jacob and Gwendolyn Knight Lawrence. Courtesy of DC Moore Gallery, New York.

Exhibitions: The Downtown Gallery, New York, *Important New Drawings,* February 4–March 1, 1947, no. 20; DC Moore 1996a; Henry Art Gallery 1998; DC Moore Gallery, New York, *The Reflective Image: American Drawings and Watercolors 1910–1960,* January 7–30, 1999.

References: "Reviews and Previews: Drawings," *ARTnews* 45, 12 (February 1947); Morris U. Schappes, "Myths about Anti-Semitism," *Masses and Mainstream* 1, 8 (October 1948), p. 54, ill.; DC Moore 1996b, p. 11, ill.

D47-02
Hot Summer
1947
pen and ink on paper
18 × 11½ in. (45.7 × 29.2 cm)
signed and dated lower right "Jacob Lawrence 1947"; verso: inscribed "Hot Summer"

Collection: Private collection. Courtesy of Peg Alston Fine Arts, New York.

Provenance: Jacob and Gwendolyn Knight Lawrence, New York and Seattle; [Peg Alston Fine Arts, New York].

Exhibitions: DC Moore 1996a.

References: DC Moore 1996b, p. 9, ill.

D47-03
Hot Summer's Night
1947
pen and ink on paper
12 × 18 in. (30.5 × 45.7 cm)
unsigned

Collection: Private collection.

Provenance: Jacob and Gwendolyn Knight Lawrence, New York and Seattle.

Remarks: A.k.a. *Sleeping on Fire Escapes.*

D47-04
Untitled [Lynchings]
1947
pen and ink on paper
dimensions unknown
inscription unknown

Collection: Current location unknown.

References: Henry Wallace, "Violence and Hope in the South," *New Republic* 117, 23 (December 8, 1947), p. 15, ill.

D48-01
Untitled [Man with Hat and Cigarette]
1948
pen and ink on paper
dimensions unknown
signed and dated lower right "J. Lawrence 48"

Collection: Current location unknown.

References: Richard Watts, Jr., "Books in Review: A Liberal View of the South," *New Republic* 118, 3 (January 19, 1948), p. 27, ill.

D48-02
Dixie Café
1948
brush and ink on paper
17 × 22¼ in. (43.2 × 56.5 cm)
signed and dated lower center/right "Jacob Lawrence 48"

Collection: Margaret and Michael Asch.

Provenance: [The Downtown Gallery, New York]; Moses Asch, New York.

References: Ira De A. Reid, "Walden the Democrat," *New Republic* 119, 16 (October 18, 1948), p. 13, ill.

D48-03
Graduation
1948
brush and ink on paper
22 × 16½ in. (55.9 × 41.9 cm)
signed and dated lower right "Jacob Lawrence 48"; inscribed bottom
left in margin "South Side, Chicago"

Collection: The Art Institute of Chicago.

Provenance: ?; Thurlow Tibbs; Estate of Thurlow Tibbs, Washington, D.C.

Exhibitions: The Sixth District Police Headquarters, Washington, D.C, *The Evans-Tibbs Collection, Selections from the Permanent Holdings: Nineteenth and Twentieth Century American Art*, August 25–31, 1985, no. 18; Smithsonian Institution Traveling Exhibition Service, Washington, D.C, *African-American Artists 1880–1987: Selections from the Evans-Tibbs Collection*, 1989–92, no. 27.

References: Langston Hughes, *One-Way Ticket* (New York: Alfred A. Knopf, 1948), p. 129, ill.; *Selections from the Permanent Holdings: Nineteenth and Twentieth Century American Art*, exh. cat. (Washington, D.C.: The Evans-Tibbs Collection, 1985), cvr., ill.; Guy C. McElroy, Richard J. Powell, and Sharon F. Patton, *African-American Artists 1880–1987: Selections from the Evans-Tibbs Collection*, exh. cat. (Washington, D.C.: Smithsonian Institution Traveling Exhibition Service, 1989), pp. 66, 70, fig. 38.

D48-04
Home in a Box
1948
brush and ink on paper
24⅜ × 16⅜ in. (61.9 × 41.6 cm)
signed and dated lower right "Jacob Lawrence 48"

Collection: June and Walter Christmas.

Provenance: ?; [The Walden School, New York, Benefit Auction].

References: Langston Hughes, *One-Way Ticket* (New York: Alfred A. Knopf, 1948), p. 117, ill.

D48-05
One-Way Ticket
1948
brush and ink on paper
24½ × 16 in. (62.2 × 40.6 cm)
signed and dated lower right "Jacob Lawrence 1948"; signed and dated bottom right in margin "Jacob Lawrence 1948"; inscribed bottom left in margin "One-Way Ticket"

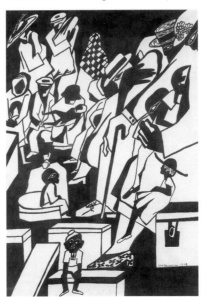

Collection: Private collection, Connecticut.

Provenance: Jacob and Gwendolyn Knight Lawrence, New York and Seattle; [DC Moore Gallery, New York].

Exhibitions: USIA Caribbean 1989, no. 22; The Phillips Collection, Washington, D.C., *Jacob Lawrence: The Migration Series*, September 23, 1993–January 9, 1994; DC Moore 1996a; Pennsylvania Academy of the Fine Arts, Philadelphia, *Founder's Day Exhibition*, May 1997; Savannah 1998, no. 5.

References: Langston Hughes, *One-Way Ticket* (New York: Alfred A. Knopf, 1948), p. 63, ill.; Wheat 1986, p. 74, fig. 4(a); Ellen Harkins Wheat, "Jacob Lawrence: American Painter," *American Visions* (1987), p. 74, ill.; Lewis and Hewitt 1989, p. 55, ill.; Elizabeth Hutton Turner, ed., *Jacob Lawrence: The Migration Series*, exh. cat. (Washington, D.C.: Rappahannock Press in association with the Phillips Collection, 1993), p. 12, ill.; DC Moore 1996b, p. 13, ill.; Cynda L. Benson, *Jacob Lawrence*, exh. cat. (Savannah, Ga.: Savannah College of Art and Design, 1998), p. 8, fig. 5.

Remarks: Commissioned by Langston Hughes and published in *One-Way Ticket*, a collection of his poems.

D48-06
Flight
1948
brush and ink on paper
24½ × 16 in. (62.2 × 40.6 cm)
signed and dated bottom right in margin "Jacob Lawrence 1948"

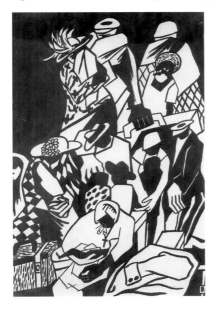

Collection: Private collection, Connecticut.

Provenance: Jacob and Gwendolyn Knight Lawrence, New York and Seattle; [DC Moore Gallery, New York].

Exhibitions: The Phillips Collection, Washington, D.C., *Jacob Lawrence: The Migration Series*, September 23, 1993–January 9, 1994; DC Moore 1996a; Savannah 1998, no. 6.

References: Langston Hughes, *One-Way Ticket* (New York: Alfred A. Knopf, 1948), p. 63, ill.; DC Moore 1996b, p. 15, ill. (as *One-Way Ticket II*); Cynda L. Benson, *Jacob Lawrence*, exh. cat. (Savannah, Ga.: Savannah College of Art and Design, 1998), p. 9, fig. 6.

Remarks: Commissioned by Langston Hughes and published in *One-Way Ticket*, a collection of his poems.

D48-07
Picket Line
1948
brush and ink on paper
17 × 22¼ in. (43.2 × 56.5 cm)
signed and dated upper right "Jacob Lawrence / 48"; inscribed bottom right in margin "Picket Line / 22¼ × 17"

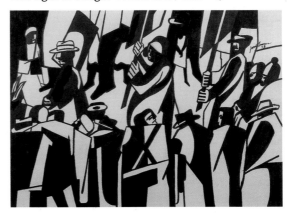

Collection: Private collection, Connecticut.

Provenance: [The Downtown Gallery, New York]; Jacob and Gwendolyn Knight Lawrence, New York and Seattle; [DC Moore Gallery, New York].

Exhibitions: The Phillips Collection, Washington, D.C., *Jacob Lawrence: The Migration Series*, September 23, 1993–January 9, 1994; DC Moore 1996a; Pennsylvania Academy of the Fine Arts, Philadelphia, *Founder's Day Exhibition*, May 1997.

References: DC Moore 1996b, p. 14, ill.

Remarks: Commissioned by Langston Hughes but not published in *One-Way Ticket*.

D48-08
Silhouette (The Lynching)
1948
brush and ink on paper
24½ × 16½ in. (62.2 × 41.9 cm)
signed and dated lower left "Jacob Lawrence 48"

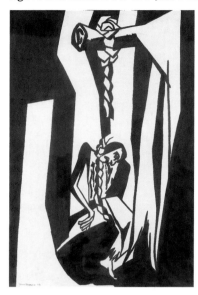

Collection: Private collection, Connecticut.

Provenance: Jacob and Gwendolyn Knight Lawrence, New York and Seattle; [DC Moore Gallery, New York].

Exhibitions: The Phillips Collection, Washington, D.C, *Jacob Lawrence: The Migration Series from The Phillips Collection*, 1996–7; DC Moore 1996a; Pennsylvania Academy of the Fine Arts, Philadelphia, *Founder's Day Exhibition*, May 1997.

References: Langston Hughes, *One-Way Ticket* (New York: Alfred A. Knopf, 1948), p. 57, ill.; DC Moore 1996b, p. 17, ill.

Remarks: Commissioned by Langston Hughes and published in *One-Way Ticket*, a collection of his poems.

D48-09
The Ballad of Margie Polite
1948
brush and ink on paper
24¾ × 16½ in. (62.9 × 41.9 cm)
signed and dated lower left "Jacob Lawrence 48"; signed and dated bottom right in margin "Jacob Lawrence 1948"; inscribed bottom left in margin "The Ballad of Margie Polite"

Collection: Private collection, Connecticut.

Provenance: Jacob and Gwendolyn Knight Lawrence, New York and Seattle; [DC Moore Gallery, New York].

Exhibitions: USIA Caribbean 1989, no. 32; The Phillips Collection, Washington, D.C., *Jacob Lawrence: The Migration Series*, September 23, 1993–January 9, 1994; DC Moore 1996a; Pennsylvania Academy of the Fine Arts, Philadelphia, *Founder's Day Exhibition*, May 1997.

References: Langston Hughes, *One-Way Ticket* (New York: Alfred A. Knopf, 1948), p. 77, ill.; Lewis and Hewitt 1989, p. 54, ill.; DC Moore 1996b, p. 16, ill.

Remarks: Commissioned by Langston Hughes and published in *One-Way Ticket*, a collection of his poems.

D48-10
New York Street Scene
1948
brush and ink on paper
17¼ × 22¼ in. (43.8 × 56.5 cm)
signed and dated lower right "Jacob Lawrence / 48"

Collection: Courtesy of Michael Rosenfeld Gallery, New York.

Provenance: [The Downtown Gallery, New York]; Jerome Zerkow, New Jersey.

Exhibitions: Michael Rosenfeld Gallery, New York, *African-American Art: Twentieth Century Masterworks VI*, January 14–March 6, 1999.

References: Horace Cayton, "Carey the Republican," *New Republic* 119, 16 (October 18, 1948), p. 11, ill.; *African-American Art: Twentieth Century Masterworks VI*, exh. cat. (New York: Michael Rosenfeld Gallery, 1999), p. 4, ill.

D48-11
The Preacher
1948
brush and ink on paper
21½ × 16¼ in. (54.6 × 41.3 cm)
signed and dated lower right "Jacob Lawrence / 1948"

Collection: Shirley Seligman, Brooklyn, New York.

Provenance: ?; [Terry Dintenfass Inc., New York].

D48-12
The Shrine
1948
brush and ink on paper
22 × 17 in. (55.9 × 43.2 cm)
signed and dated lower right "Jacob Lawrence / 1948"

Collection: The Walter O. Evans Collection of African American Art.

Provenance: Jacob and Gwendolyn Knight Lawrence, New York; Langston Hughes, New York; Adele Glasgow, New York.

Exhibitions: Beach Institute/King-Tisdell Museum, Savannah, Ga., *The Walter O. Evans Collection of African-American Art*, January–April 1991 (venues after Boston).

D48-13
Harriet Tubman
1948
brush and ink on paper
dimensions unknown
signed and dated lower center/right "Jacob Lawrence / 1948"

Collection: Current location unknown.

Remarks: Commissioned by *Masses and Mainstream*.

D48-14
Slave Rebellion
1948
brush and ink on paper
dimensions unknown
signed and dated lower right "Jacob Lawrence 198" [*sic*]

Collection: Current location unknown.
Remarks: Commissioned by *Masses and Mainstream*.

D48-15
Slave Trade
1948
brush and ink on paper
dimensions unknown
signed and dated lower right "Jacob Lawrence / 1948"

Collection: Current location unknown.
Remarks: Commissioned by *Masses and Mainstream*.

D48-16
Underground Railroad
1948
brush and ink on paper
dimensions unknown
signed and dated lower right "Jacob Lawrence 1948"

Collection: Current location unknown.
Remarks: Commissioned by *Masses and Mainstream*.

D48-17
Underground Railroad, Fording a Stream
1948
brush and ink on paper
16½ × 23 in. (41.9 × 58.4 cm)
signed and dated center "Jacob Lawrence / 1948"

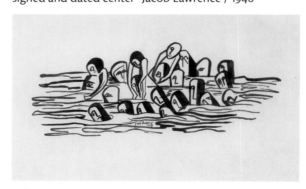

Collection: Blanche and Bud Blank.
Provenance: Graphic Arts Workshop, New York; [Terry Dintenfass Inc., New York]; Dr. and Mrs. Herbert Paskow; [Sotheby's Arcade, New York, December 18, 1991, lot 341].
Remarks: This work executed expressly for *Negro Artist U.S.A.*, a portfolio of works published by the Graphic Arts Workshop in December 1948. Other artists who contributed work included Antonio Frasconi, Robert Gwathmey, Charles White, and Leonard Baskin.

D48-18
Terror of the Klan
1948
brush and ink on paper
image: 14 × 20¾ in. (35.6 × 52.7 cm)
signed and dated lower right "Jacob Lawrence 48"; inscribed bottom
center in margin "TERROR OF THE KLAN"

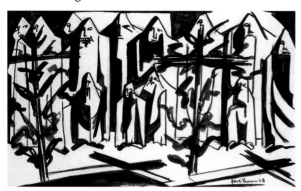

Collection: Private collection.

Provenance: Jacob and Gwendolyn Knight Lawrence, New York; Graphic Arts
Workshop, New York.

Remarks: Commissioned for but not used in *Negro Artist U.S.A.* (see D48-17).

D48-19
Untitled [*Sketches of Gwen*]
ca. 1948
brush and ink on cardboard
28 × 22 in. (71.1 × 55.9 cm)
unsigned

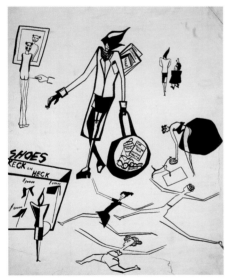

Collection: Private collection.

Provenance: Jacob and Gwendolyn Knight Lawrence, New York.

D49-01
Playing Records
1949
brush and ink on paper
22¼ × 17¼ in. (56.5 × 43.8 cm)
signed and dated lower left "Jacob Lawrence 49"

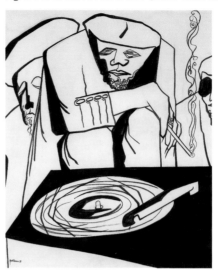

Collection: BankAmerica Corporation.

Provenance: Jacob and Gwendolyn Knight Lawrence, New York; Langston Hughes,
New York; Adele Glasgow, New York; John and Vivian Hewitt, New York.

Exhibitions: California Afro-American Museum, Los Angeles, *The Portrayal of the Black
Musician in American Art*, March 7–August 14, 1987; Smithsonian Institution Traveling
Exhibition Service, Washington, D.C., *Louis Armstrong: A Cultural Legacy*, 1994–6.

Remarks: A.k.a. *The Disc Jockey.*

D49-02
The Chess Players
ca. 1949
brush and ink on paper
16½ × 22½ in. (41.9 × 57.2 cm)
signed lower right "Jacob Lawrence"

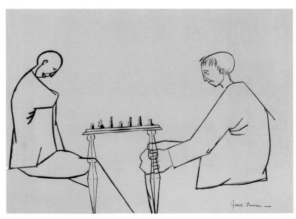

Collection: Jacob and Gwendolyn Knight Lawrence. Courtesy of Francine Seders
Gallery, Seattle.

Exhibitions: USIA Caribbean 1989, no. 34 (as c. 1947); Henry Art Gallery 1998.

References: Lewis and Hewitt 1989, p. 52, ill.

D49-03
The Psychiatrist
1949
brush and ink on paper
19 × 24 in. (48.3 × 61 cm)
signed and dated upper right "Jacob Lawrence 49"

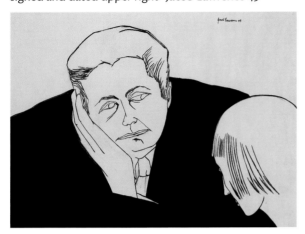

Collection: Billy Hodges, New York.

Provenance: ?; Steven Weinrath, New York; [Terry Dintenfass Inc., New York]; Myron Calhoun, Mobile, Ala.; [Terry Dintenfass Inc., New York].

D51-01
Three Judges
1951
brush and ink on paper
19 × 25½ in. (48.3 × 64.8 cm)
signed and dated lower right "Jacob Lawrence / 51"; signed and dated bottom right in margin "Jacob Lawrence 1951"; inscribed bottom left in margin "Three Judges"

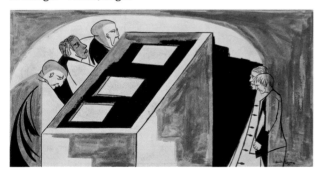

Collection: Private collection.
Provenance: Jacob and Gwendolyn Knight Lawrence, New York and Seattle.
Exhibitions: DC Moore 1996a.

D51-02
Untitled [*Still Life*]
1951
brush and ink on paper
15⅞ × 18½ in. (40.3 × 47 cm)
signed and dated lower right "Jacob Lawrence / 51"

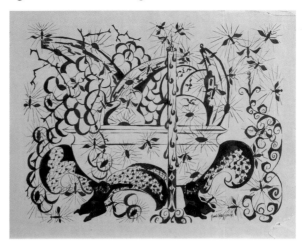

Collection: Wids and Peggy Jones DeLaCour.

Provenance: Jacob and Gwendolyn Knight Lawrence, New York and Seattle.

Exhibitions: Pennsylvania Academy of the Fine Arts, Philadelphia, *The Forty-Eighth Annual Philadelphia Water Color and Print Exhibition*, October 28–November 26, 1950.

D51-03
Untitled [*Dance A*]
1951
brush and ink on paper
9 × 21½ in. (22.9 × 54.6 cm)
signed lower right "Jacob Lawrence"

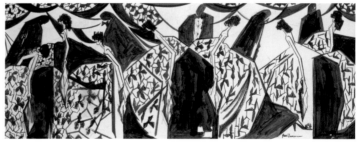

Collection: Private collection. Courtesy of Michael Rosenfeld Gallery, New York.

Provenance: ?; Michael Eisenberg, New York.

Exhibitions: Michael Rosenfeld Gallery, New York, *African-American Art: Twentieth Century Masterworks VI*, January 14–March 6, 1999, no. 34A.

References: *African-American Art: Twentieth Century Masterworks VI*, exh. cat. (New York: Michael Rosenfeld Gallery, 1999), p. 41, ill. (as *Dance A*).

D51-04
Untitled [Dance B]
1951
brush and ink on paper
9 × 21½ in. (22.9 × 54.6 cm)
signed and dated lower right "Jacob Lawrence / 51"

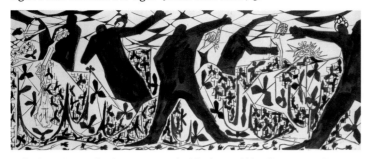

Collection: Private collection. Courtesy of Michael Rosenfeld Gallery, New York.

Provenance: ?; Michael Eisenberg, New York.

Exhibitions: Michael Rosenfeld Gallery, New York, *African-American Art: Twentieth Century Masterworks VI,* January 14–March 6, 1999, no. 34B.

References: *African-American Art: Twentieth Century Masterworks VI,* exh. cat. (New York: Michael Rosenfeld Gallery, 1999), p. 41, ill. (as *Dance B*).

D51-05
Westchester Graduation Ball
1951
brush and ink on paper
9⅛ × 21¾ in. (23.2 × 55.2 cm)
signed lower right "Jacob Lawrence"

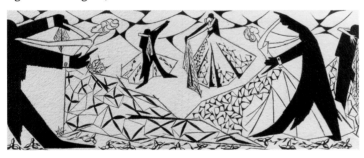

Collection: The Collection of Patricia Adams, the late Rev. Dr. Alger L. and Jessie M. Adams, Hastings-on-Hudson, New York.

Provenance: Jacob and Gwendolyn Knight Lawrence, New York; Rev. Dr. Alger L. and Jesse M. Adams, Hastings-on Hudson, New York.

Remarks: Used as the program cover for the graduation ball of Westchester High School, held at the Sarah Lawrence College in Bronxville, N.Y., June 13, 1951.

D53-01
Peeling an Apple
1953
brush and ink, and gouache on paper
14¾ × 12¼ in. (37.5 × 31.1 cm)
signed and dated lower right "Jacob Lawrence 53"

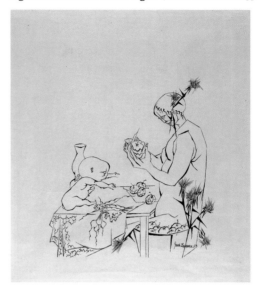

Collection: The Arkansas Arts Center, Little Rock. The Arkansas Arts Center Foundation Purchase, 1998.98.2.

Provenance: [The Alan Gallery, New York]; Harold Donahue; [Terry Dintenfass Inc., New York].

References: "Portrait," *Art Digest* 28, 3 (January 15, 1954), cvr., ill.

D55-01
Children at Play
ca. 1955
brush and ink on paper
18 × 22 in. (45.7 × 55.9 cm)
signed lower right "Jacob Lawrence"; verso: inscribed center
"CHILDREN AT PLAY"

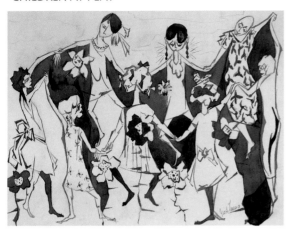

Collection: Private collection.

Provenance: Jacob and Gwendolyn Knight Lawrence, New York.

Remarks: Signed by the artist in the 1990s.

D56-01
Untitled [Seamstress]
ca. 1956
pen and ink, and crayon on paper
17 × 24 in. (43.2 × 61 cm)
signed lower right "Jacob Lawrence"

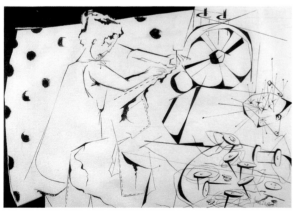

Collection: Private collection.

Provenance: Jacob and Gwendolyn Knight Lawrence, New York and Seattle.

D57-01
The Family
1957
graphite on paper
23 × 19½ in. (58.4 × 49.5 cm)
signed and dated lower right "Jacob Lawrence / 57"

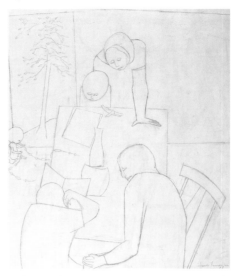

Collection: The Arkansas Arts Center Foundation Collection, Little Rock. The Museum Purchase Plan of the NEA and the Tabriz Fund, 74.11.b.

Provenance: [Terry Dintenfass Inc., New York].

Exhibitions: Oklahoma City Art Museum, *Forty Drawings from The Arkansas Arts Center Foundation Collection*, January 22–February 21, 1982; The Arkansas Arts Center, Little Rock, *Twentieth-Century American Drawings from The Arkansas Arts Center Foundation Collection*, 1984–7, no. 34; The Arkansas Arts Center, State Services Department, Little Rock, *African American Artists from The Arkansas Arts Center Foundation Collection*, 1990–6; The Arts and Science Center for Southeast Arkansas, Pine Bluff, *Drawings: A Survey of the Twentieth Century, Selections from The Arkansas Arts Center Foundation Collection*, September 6–October 14, 1990; DC Moore 1996a.

References: Townsend Wolfe, *Twentieth-Century American Drawings from the Arkansas Arts Center Foundation Collection* (Little Rock, Ark.: The Arkansas Arts Center, 1984), p. 41, ill.; DC Moore 1996b, p. 18, ill.

D58-01
Untitled [*Street Scene*]
1958
brush and ink on paper
22½ × 30½ in. (57.2 × 77.5 cm)
signed and dated lower right "Jacob Lawrence 58"

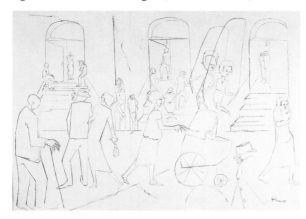

Collection: Ray Reider Golden and Robert Golden, Riverdale, New York.

Provenance: Jacob and Gwendolyn Knight Lawrence, New York; [Five Towns Music and Arts Foundation, Woodmere, N.Y.]; Judith Golden, New York.

D59-01
Scientist
1959, 1996
brush and ink on paper
22½ × 15¼ in. (57.2 × 38.7 cm)
signed and dated lower left "Jacob Lawrence 59"

Collection: Jacob and Gwendolyn Knight Lawrence. Courtesy of DC Moore Gallery, New York.

Exhibitions: DC Moore 1996a (New York only).

References: DC Moore 1996b, p. 19, ill. (as *Man with Skulls*).

Remarks: Shading added in 1996.

D59-02
Still Life with Masks
1959
brush and ink on paper
18 × 20¼ in. (45.7 × 51.4 cm)
signed and dated lower right "Jacob Lawrence 59"

Collection: Private collection.

Provenance: Jacob and Gwendolyn Knight Lawrence, New York.

D60-01
Untitled [*Still Life*]
1960
brush and ink on paper
17¾ × 23⅞ in. (45.1 × 60.6 cm)
signed and dated lower right "Jacob Lawrence / June 6/60"

Collection: Jacob and Gwendolyn Knight Lawrence. Courtesy of DC Moore Gallery, New York.

Exhibitions: DC Moore 1996a.

References: DC Moore 1996b, p. 26, ill. (as *Vases: Cubist Study*).

D60-02
Doll
1960
brush and ink on paper
17¾ × 20½ in. (45.1 × 52.1 cm)
signed and dated lower right "Jacob Lawrence / 26/60"

Collection: Jacob and Gwendolyn Knight Lawrence. Courtesy of DC Moore Gallery, New York.

Exhibitions: DC Moore 1996a.

References: DC Moore 1996b, p. 20, ill.

D60-03
Untitled
1960
brush and ink on paper
23 × 17½ in. (58.4 × 44.5 cm)
signed and dated lower right "Jacob Lawrence / May 26, 1960"

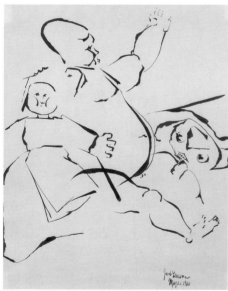

Collection: Elizabeth and Steven Roose, Scarsdale, New York.

Provenance: Jacob and Gwendolyn Knight Lawrence, New York; Judith Golden, New York.

D60-04
Cat (Le Chat Gris)
1960
brush and ink on paper
17¾ × 23¾ in. (45.1 × 60.3 cm)
signed and dated lower right "Jacob Lawrence 1960"

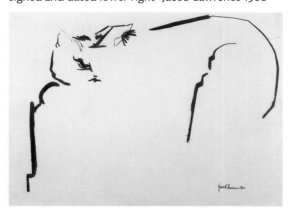

Collection: Jacob and Gwendolyn Knight Lawrence. Courtesy of DC Moore Gallery, New York.

Exhibitions: DC Moore 1996a.

References: DC Moore 1996b, p. 22, ill. (as *Cat*).

D60-05
Untitled
1960
gouache, colored crayon, and graphite on paper
8½ × 22¼ in. (21.6 × 56.5 cm)
unsigned

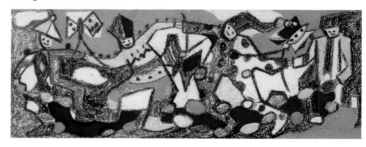

Collection: Daniel H. Golden, New York.

Provenance: Jacob and Gwendolyn Knight Lawrence, New York.

D60-06
Two Cats
1960
brush and ink on brown paper
20 × 24 in. (50.8 × 61 cm)
signed and dated upper left "Jacob Lawrence 1960"; verso: inscribed
"Two Cats"

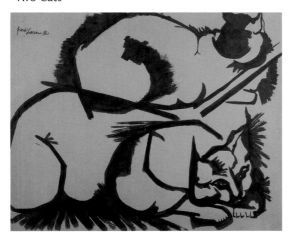

Collection: Jacob and Gwendolyn Knight Lawrence. Courtesy of DC Moore Gallery, New York.

Exhibitions: Atrium Gallery, Morristown, N.J., *This Is Why We Sing*, January 31–March 28, 1997.

D60-07
Untitled [*The Five Towns Music and Art Foundation*]
1960
brush and ink on paper
22⅝ × 15½ in. (57.5 × 39.4 cm)
signed and dated lower right "Jacob Lawrence 60"; inscribed lower
center "The Five Towns / Music and Art Foundation / Incorporated"

Collection: Ray Reider Golden and Robert Golden, Riverdale, New York.
Provenance: Jacob and Gwendolyn Knight Lawrence, New York and Seattle.

D60-08
Cat
ca. 1960
brush and ink on paper
10¾ × 14⅞ in. (27.3 × 37.8 cm)
signed upper left "Jacob Lawrence" [upside down]

Collection: Jacob and Gwendolyn Knight Lawrence. Courtesy of DC Moore Gallery, New York.

Exhibitions: DC Moore 1996a (Arkansas only).

References: DC Moore 1996b, p. 24, ill.

D60-09
Cat (Back View)
ca. 1960
brush and ink on paper
10¾ × 14¾ in. (27.3 × 37.5 cm)
signed twice, lower right "Jacob Lawrence" and upper right "Jacob
Lawrence" [vertical]

Collection: Jacob and Gwendolyn Knight Lawrence. Courtesy of DC Moore Gallery, New York.

Exhibitions: Atrium Gallery, Morristown, N.J., *This Is Why We Sing*, January 31–March 28, 1997.

D60-10
Cat with Gwen
ca. 1960
brush and ink on paper
17¾ × 33⅞ in. (45.1 × 86 cm)
signed lower right "Jacob Lawrence"; verso: inscribed "GWEN WITH CAT"

Collection: Private collection.

Provenance: Jacob and Gwendolyn Knight Lawrence, New York and Seattle.

D61-01
Untitled
1961
brush and ink on paper
23¾ × 17¾ in. (60.3 × 45.1 cm)
signed and dated lower right "Jacob Lawrence 61"

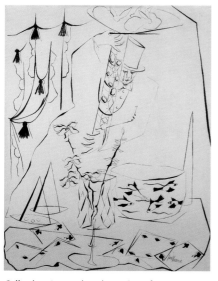

Collection: Ann and Andrew Dintenfass.

Provenance: [Terry Dintenfass Inc., New York].

D61-02
Chess on Broadway
1961
brush and ink on paper
18 × 23 in. (45.7 × 58.4 cm)
signed and dated lower right "Jacob Lawrence 61"

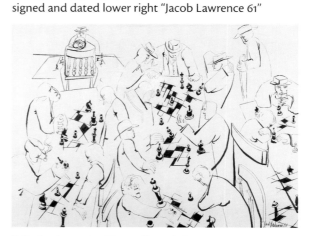

Collection: Leonard and Eleanor Flomenhaft.

Provenance: [Terry Dintenfass Inc., New York].

D61-03
Still Life
ca. 1961
brush and ink on paper
15¼ × 22½ in. (38.7 × 57.2 cm)
signed lower right "Jacob Lawrence"

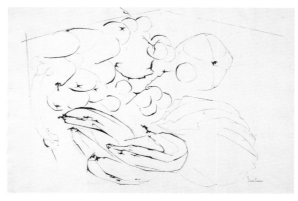

Collection: Jacob and Gwendolyn Knight Lawrence. Courtesy of DC Moore Gallery, New York.

Exhibitions: Atrium Gallery, Morristown, N.J., *This Is Why We Sing*, January 31–March 28, 1997.

D61-04
Untitled
1961
brush and ink on paper
17 × 23½ in. (43.2 × 59.7 cm)
signed and dated lower right "Jacob Lawrence 1961"

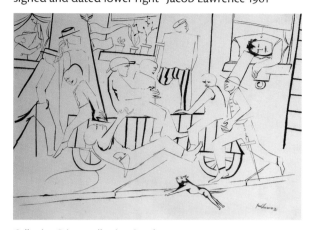

Collection: Private collection, Seattle.

Provenance: [Terry Dintenfass Inc., New York]; Elsie Niedenberg, New York; [Gordon Woodside/John Braseth Gallery, Seattle].

Exhibitions: DC Moore 1996a.

References: DC Moore 1996b, p. 29, ill.

D62-01
Untitled [*Marketplace*]
1962
brush and ink on paper
dimensions unknown
signed and dated lower right "Jacob Lawrence / 1962"

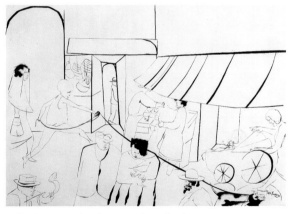

Collection: Nam-Hi and Yoon T. Kim Collection.

Provenance: ?; Aaron Payne, New York; [Fran B. Horowitz Fine Arts, Minneapolis].

D64-01
Untitled [*Ink Drawing No. 1*]
1964
brush and ink on paper
30¾ × 22 in. (78.1 × 55.9 cm)
signed and dated lower right "Jacob Lawrence 64"

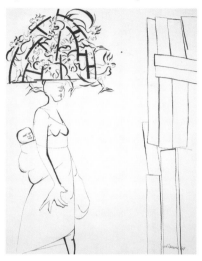

Collection: Private collection.

Provenance: [Terry Dintenfass Inc., New York]; Saul Miller, Arlington, Va.

Exhibitions: Morgan State 1965, no. 3.

D64-02
Untitled [*Ink Drawing No. 3*]
ca. 1964
brush and ink on paper
30¾ × 22 in. (78.1 × 55.9 cm)
signed and dated lower right "Jacob Lawrence 65"

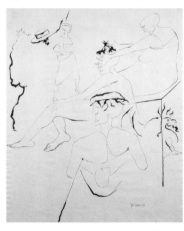

Collection: James E. Lewis Museum of Art, Morgan State University, Baltimore, Maryland. Purchased with funds from the Hendler Foundation.

Provenance: [Terry Dintenfass Inc., New York].

Exhibitions: Morgan State 1965, no. 5; Municipal Arts Gallery, Philadelphia Civic Center, *Afro-American Artists: 1800–1969*, December 5–29, 1969, no. 131; Archer M. Huntington Art Gallery, The University of Texas at Austin, *Afro-American Artists Abroad*, March 29–May 3, 1970; Bowie State University, Md., *The Black Heritage: A Look at Two Continents*, February 15–March 5, 1982; The Montpelier Cultural Center, Laurel, Md., *Morgan State University Collection*, February 1985.

References: *The Cross Section of the Gallery of Art* (Baltimore: Morgan State University, 1976).

Remarks: A.k.a. *Study of Three Red Hats*. Probably executed in 1964 and postdated to 1965.

D64-03
Untitled [*Market Woman*]
1964
brush and ink on paper
30 × 21¹¹⁄₁₆ in. (76.2 × 55.1 cm)
signed and dated lower right "Jacob Lawrence 64"

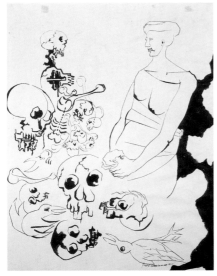

Collection: Jacob and Gwendolyn Knight Lawrence, Seattle.

Remarks: Drawing on verso depicts a woman with skulls, bones, and small standing figure.

D64-04
Untitled [*Crayon Drawing No. 1*]
1964
crayon on paper
8 × 10 in. (20.3 × 25.4 cm)
signed and dated lower right "Jacob Lawrence 64"

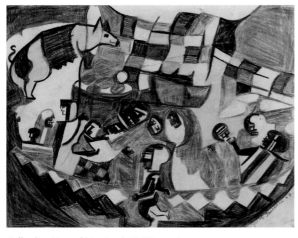

Collection: Mr. and Mrs. Lewis M. Warren, Jr.

Provenance: [Terry Dintenfass Inc., New York].

Exhibitions: AMSAC 1964; Morgan State 1965; Mississippi Museum of Art, Jackson, *Jacob Lawrence: The Builder*, January 24–March 14, 1982, no. 9.

Remarks: A.k.a. *Untitled* [*Crayon Drawing No. 2*]. Lawrence completed at least five colored crayon drawings in Nigeria in 1964, only three of which have been located. There is contradictory evidence that refers to this drawing as both *No. 1* and *No. 2*.

D64-05
Untitled [*Crayon Drawing No. 3*]
1964
crayon on paper
10¾ × 14¾ in. (27.3 × 37.5 cm)
signed lower right "Jacob Lawrence"

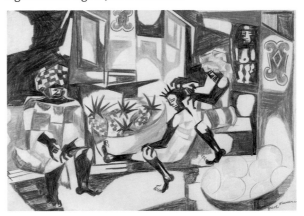

Collection: Michael and Josephine Clement Smart.

Provenance: Jacob and Gwendolyn Knight Lawrence, New York; Mrs. J. E. Spingarn, Philadelphia; [Terry Dintenfass Inc., New York]; Seth Taffae and Merton D. Simpson, New York.

Exhibitions: AMSAC 1964; Morgan State 1965, no. 2.

D64-06
Untitled [*Crayon Drawing No. ?*]
1964
crayon on paper
10 × 14 in. (25.4 × 35.6 cm)
signed and dated lower right "Jacob Lawrence 64"

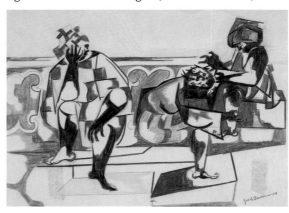

Collection: Margaret and Michael Asch.

Provenance: [Terry Dintenfass Inc., New York]; Moses Asch, New York.

Exhibitions: Morgan State 1965.

Remarks: A.k.a. *Untitled* [*Market*]. One of at least five colored crayon drawings executed in Nigeria in 1964.

D64-07
Draped Figure
ca. 1964
pastel on paper
23¾ × 18 in. (60.3 × 45.7 cm)
signed twice, lower right "Jacob Lawrence"

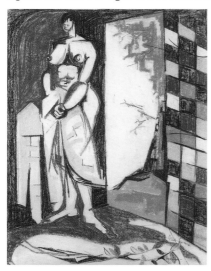

Collection: Jacob and Gwendolyn Knight Lawrence. Courtesy of DC Moore Gallery, New York.

Exhibitions: DC Moore Gallery, New York, *Pastels by Ten Contemporary Artists*, September 10–October 5, 1996; DC Moore 1996a.

References: DC Moore 1996b, p. 25, ill.

Remarks: Signed by the artist ca. 1995.

D64-08
Figure Study
ca. 1964
pastel on paper
23¼ × 18 in. (59.1 × 45.7 cm)
signed lower right "Jacob / Lawrence"

Collection: Jacob and Gwendolyn Knight Lawrence. Courtesy of DC Moore Gallery, New York.

Exhibitions: DC Moore Gallery, New York, *Pastels by Ten Contemporary Artists*, September 10–October 5, 1996; DC Moore 1996a (Arkansas only); Savannah 1998, no. 7.

References: DC Moore 1996b, p. 23, ill.; Cynda L. Benson, *Jacob Lawrence*, exh. cat. (Savannah, Ga.: Savannah College of Art and Design, 1998), p. 10, fig. 7.

D64-09
Figure Study—Blue
ca. 1964
blue pastel on paper
23¾ × 18 in. (60.3 × 45.7 cm)
signed lower right "Jacob Lawrence"

Collection: Jacob and Gwendolyn Knight Lawrence. Courtesy of DC Moore Gallery, New York.

Exhibitions: DC Moore Gallery, New York, *Pastels by Ten Contemporary Artists*, September 10–October 5, 1996; DC Moore 1996a (Arkansas only).

References: DC Moore 1996b, p. 21, ill. (as ca. 1960).

D65-01
Market—West Africa
1965
brush and ink on paper
25¼ × 20⅛ in. (64.1 × 51.1 cm)
signed and dated lower right "Jacob Lawrence 1965"

Collection: Private collection. Courtesy of DC Moore Gallery, New York.

Provenance: Jacob and Gwendolyn Knight Lawrence, New York and Seattle; [DC Moore Gallery, New York].

Exhibitions: DC Moore 1996a; DC Moore Gallery, New York, *Food for Thought: A Visual Banquet*, June 24–August 12, 1998.

D65-02
Confrontation
1965
brush and ink on paper
24 × 17½ in. (61 × 44.5 cm)
signed and dated lower right "Jacob Lawrence 65"

Collection: Private collection, Connecticut.

Provenance: [Terry Dintenfass Inc., New York]; Private collection; [DC Moore Gallery, New York].

Exhibitions: DC Moore 1996a; Savannah 1998, no. 8.

References: DC Moore 1996b, p. 27, ill.; Stephen Wallis, "Jacob Lawrence: Portrait of a Serial Painter," *Art and Antiques* 19, 11 (December 1996), p. 62, ill.; Cynda L. Benson, *Jacob Lawrence*, exh. cat. (Savannah, Ga.: Savannah College of Art and Design, 1998), p. 10, fig. 8.

D65-03
Struggle (Drawing for)
1965
graphite on paper
21⅜ × 15¾ in. (54.3 × 40 cm)
unsigned

Collection: Jacob and Gwendolyn Knight Lawrence. Courtesy of Francine Seders Gallery, Seattle.

Exhibitions: USIA Caribbean 1989, no. 31.

References: Lewis and Hewitt 1989, p. 57, ill.

D65-04
Struggle (Drawing for)
1965
graphite on paper
21½ × 15⅞ in. (54.6 × 40.3 cm)
unsigned

Collection: Jacob and Gwendolyn Knight Lawrence. Courtesy of Francine Seders Gallery, Seattle.

Exhibitions: USIA Caribbean 1989, no. 30.

References: Lewis and Hewitt 1989, p. 56, ill.

D65-05
Study for "Struggle III—Assassination"
1965
graphite on paper
20 × 26 in. (50.8 × 66 cm)
unsigned, dated lower center/right "1965"

Collection: Private collection.

Provenance: Jacob and Gwendolyn Knight Lawrence, New York and Seattle.

D65-06
Struggle I
1965
brush and ink, and gouache on paper
22½ × 31 in. (57.2 × 78.7 cm)
signed and dated lower right "Jacob Lawrence 65"

Collection: Blanche and Bud Blank.

Provenance: [Terry Dintenfass Inc., New York]; Mr. W. Spivak; [Terry Dintenfass Inc., New York]; Martha Gibbel; [Christie's East, New York, March 16, 1990, Sale 7020, lot 367].

Exhibitions: The Arkansas Arts Center, Little Rock, *Annual Collectors Show*, December 4, 1981–January 3, 1982; Edwin W. Voller Gallery, Paul Robeson Cultural Center, The Pennsylvania State University, University Park, *Prints: Romare Bearden and Jacob Lawrence*, April 4–30, 1982; Stockton State 1983; Fine Arts Museum of Long Island, Hempstead, N.Y., *Celebrating Contemporary American Black Artists*, March 13– May 1, 1983.

D65-07
Struggle II—Man On Horseback
1965
brush and ink, and gouache on paper
22¼ × 30¾ in. (56.5 × 78.1 cm)
signed and dated lower right "Jacob Lawrence 65"

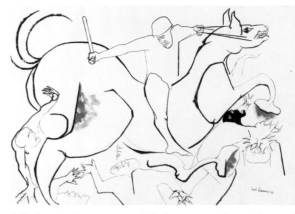

Collection: Seattle Art Museum. Gift of anonymous donors in honor of the Museum's fiftieth year.

Provenance: [Annual Exhibition and Sale presented by Lenox Hill Hospital and Skowhegan School of Painting and Sculpture, November 12, 1967, no. 78]; ?; [Terry Dintenfass Inc., New York]; Mr. and Mrs. Philip J. Schiller, Highland Park, Ill.; [Terry Dintenfass Inc., New York].

Exhibitions: The Arkansas Arts Center, Little Rock, *Annual Collectors Show*, December 4, 1981–January 3, 1982; Edwin W. Voller Gallery, Paul Robeson Cultural Center, The Pennsylvania State University, University Park, *Prints: Romare Bearden and Jacob Lawrence*, April 4–30, 1982; Stockton State 1983; Fine Arts Museum of Long Island, Hempstead, N.Y., *Celebrating Contemporary American Black Artists*, March 13–May 1, 1983 (as *Struggle Series No. 2*); Seattle Art Museum, *Recent Modern Acquisitions*, August 27–October 18, 1987; The Katonah Museum of Art, N.Y., *In Good Conscience: The Radical Tradition in Twentieth-Century American Illustration*, August 16–September 27, 1992; Henry Art Gallery 1998.

References: Lemakis 1983, cvr., ill.; Ellen Harkins Wheat, "Jacob Lawrence and the Legacy of Harlem," *Archives of American Art Journal* 26, 1 (1986), p. 23, ill.; Wheat 1986, p. 133, pl. 65; Chris Williams, "His Vision Is Universal," *People's Daily World*, April 13, 1989, p. 13, ill.; Ellen Harkins Wheat, *Portraits: The Lives and Works of Eminent Artists* 2, 3 (1992), fig. 7.

Remarks: A.k.a. *Struggle No. 2.*

D65-08
Struggle III—Assassination
1965
brush and ink, and gouache on paper
22 × 30½ in. (55.9 × 77.5 cm)
signed and dated lower right "Jacob Lawrence 65"

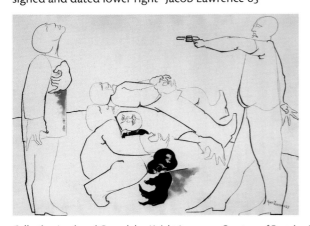

Collection: Jacob and Gwendolyn Knight Lawrence. Courtesy of Francine Seders Gallery, Seattle.

Exhibitions: USIA Caribbean 1989, no. 12; The Katonah Museum of Art, N.Y., *In Good Conscience: The Radical Tradition in Twentieth-Century American Illustration*, August 16–September 27, 1992.

References: Lewis and Hewitt 1989, p. 31, ill. (as *Struggle 3*).

D65-09
Struggle IV
1965
brush and ink, and gouache on paper
22 × 30 in. (55.9 × 76.2 cm)
signed and dated lower right "Jacob Lawrence 65"

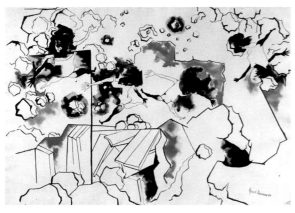

Collection: Current location unknown.

Provenance: [Terry Dintenfass Inc., New York]; Ben Weiss, New York.

D65-10
Self-Portrait
1965
brush and ink on paper
18 × 14½ in. (45.7 × 36.8 cm)
signed and dated lower right "Jacob Lawrence 65"

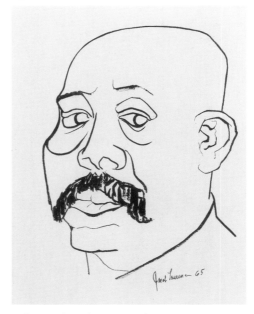

Collection: The Butler Institute of American Art, Youngstown, Ohio. Gift of Youngstown Chapter of Links, Inc., 1984.

Provenance: Jacob and Gwendolyn Knight Lawrence, New York; Private collection; [Sotheby's, New York, January 27, 1984, lot 601]; Youngstown Chapter of Links, Ohio.

Exhibitions: Henry Art Gallery 1998.

D65-11
Self-Portrait
1965
brush and ink on paper
15¼ × 11⅝ in. (38.7 × 29.5 cm)
signed and dated lower center "Jacob Lawrence 65"

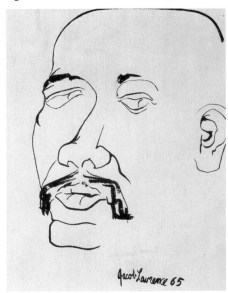

Collection: Jacob and Gwendolyn Knight Lawrence. Courtesy of Francine Seders Gallery, Seattle.

Exhibitions: USIA Caribbean 1989, no. 25; Henry Art Gallery 1998.

References: Lewis and Hewitt 1989, p. 49, ill.

D66-01
Massachusetts Textile Mill Study I
ca. 1966
crayon on paper
17 × 14 in. (43.2 × 35.6 cm)
unsigned

Collection: Private collection.

Provenance: Jacob and Gwendolyn Knight Lawrence, New York and Seattle.

Remarks: One of at least four sketches done on location at Sidney Frauwirth's textile mill in Bedford, Massachusetts.

D66-02
Massachusetts Textile Mill Study II
ca. 1966
crayon on paper
14 × 17 in. (35.6 × 43.2 cm)
unsigned

Collection: Private collection.

Provenance: Jacob and Gwendolyn Knight Lawrence, New York and Seattle.

D66-03
Massachusetts Textile Mill Study III [Two Figures]
ca. 1966
crayon on paper
14 × 17 in. (35.6 × 43.2 cm)
unsigned

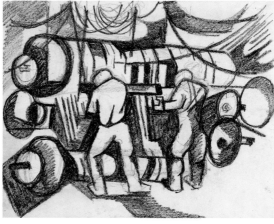

Collection: Private collection.

Provenance: Jacob and Gwendolyn Knight Lawrence, New York and Seattle.

D66-04
Massachusetts Textile Mill Study IV [One Figure]
ca. 1966
crayon on paper
14 × 17 in. (35.6 × 43.2 cm)
unsigned

Collection: Private collection.

Provenance: Jacob and Gwendolyn Knight Lawrence, New York and Seattle.

D66-05
All Hallow's Eve
1966
brush and ink on paper
14¾ × 22¼ in. (37.5 × 56.5 cm)
signed and dated lower right "Jacob Lawrence 66"

Collection: Mr. and Mrs. R. Hutchinson, New York.

Provenance: Jacob and Gwendolyn Knight Lawrence, New York; [Terry Dintenfass Inc., New York]; Private collection.

D66-06
Boys at Play
1966
brush and ink on paper
22½ × 30½ in. (57.2 × 77.5 cm)
signed and dated lower right "Jacob Lawrence 66"

Collection: Herbert F. Johnson Museum of Art, Cornell University. Gift of Isabel Berley, Class of 1945, and William Berley, Class of 1947.

Provenance: [Terry Dintenfass Inc., New York]; William and Isabel Berley, New York.

Exhibitions: Pennsylvania Academy of the Fine Arts, Philadelphia, *One Hundred Sixty-Second Annual Exhibition: Water Colors, Prints and Drawings*, January 20–March 5, 1967; Herbert F. Johnson Museum of Art, Cornell University, Ithaca, N.Y., *Exhibition of the Collection of William and Isabel Berley*, April 14–June 11, 1995.

References: Wheat 1986, p. 116.

D67-01
Rural Scene
1967
brush and ink on paper
22 × 29⅜ in. (55.9 × 74.6 cm)
signed and dated lower right "Jacob Lawrence / 67"

Collection: American Academy of Arts and Letters, New York. Gift of the Artist.

Provenance: Jacob and Gwendolyn Knight Lawrence, New York.

Exhibitions: American Academy of Arts and Letters, New York, *Drawings by Members*, November 17, 1967–February 4, 1968, no. 101.

D67-02
Escape
1967
brush, pen and ink, and crayon on paper
22¹⁄₁₆ × 29⁹⁄₁₆ in. (56 × 75.1 cm)
signed and dated lower right "Jacob Lawrence 67"

Collection: National Museum of American Art, Smithsonian Institution. Gift of the Sara Roby Foundation.

Provenance: [Terry Dintenfass Inc., New York]; A. Edelston, New York; [Terry Dintenfass Inc., New York]; Sara Roby Foundation.

Exhibitions: American Academy of Arts and Letters, New York, *Drawings by Members*, November 17, 1967–February 4, 1968, no. 100; Fort Wayne Museum of Art, Ind., *Selections from the Sara Roby Foundation*, September 4–November 1, 1981; Owensboro Museum of Fine Art, Ky., *Selections from the Sara Roby Foundation Collection*, September–December 1982; Mary and Leigh Block Gallery, Northwestern University, Evanston, Ill., *Selections from the Sara Roby Foundation Collection*, March 24–July 3, 1983; National Museum of American Art, Washington, D.C, *Modern American Realism: The Sara Roby Foundation Collection*, January 30–August 16, 1987; Henry Art Gallery 1998.

D67-03
Study for Portrait of Stokely Carmichael
1967
brush and ink on paper
12 × 12 in. (30.5 × 30.5 cm)
unsigned

(verso)

(recto)

Collection: Private collection.

Provenance: Jacob and Gwendolyn Knight Lawrence, New York and Seattle.

D68-01
Nude Study
ca. 1968–9
litho crayon on paper
18 × 24 in. (45.7 × 61 cm)
unsigned

Collection: Jacob and Gwendolyn Knight Lawrence. Courtesy of Francine Seders Gallery, Seattle.

References: Wheat 1986, p. 149, fig. 69.

Aesop's Fables

In 1969, Windmill Books, a division of Simon & Schuster, commissioned the artist to create drawings for the book *Aesop's Fables*. Lawrence completed twenty-three drawings for the commission, eighteen of which were published the following year. In 1997, the University of Washington Press republished the book, including all twenty-three original drawings.

D69-01
The Lion and the Other Beasts Go Hunting
1969
brush and ink on paper
17⅝ × 11³⁄₁₆ in. (44.8 × 28.4 cm)
unsigned

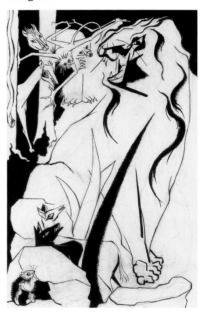

Collection: Private collection.

Provenance: Jacob and Gwendolyn Knight Lawrence, New York and Seattle; [Francine Seders Gallery, Seattle].

Exhibitions: USIA Africa 1989–90, no. 12; Seders 1998–2000.

References: Lawrence 1970; Lewis and Hewitt 1988, p. 44, ill.; Lawrence 1997, p. 11, ill.

D69-02
The Fox and the Goat
1969
brush and ink on paper
19¾ × 10⅛ in. (50.2 × 25.7 cm)
unsigned

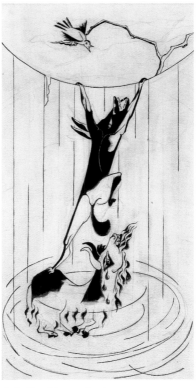

Collection: Private collection.

Provenance: Jacob and Gwendolyn Knight Lawrence, New York and Seattle; [Francine Seders Gallery, Seattle].

Exhibitions: USIA Caribbean 1989, no. 28; Shippensburg 1994; Shasta College 1994; Seders 1998–2000.

References: Lawrence 1970; Lewis and Hewitt 1989, p. 46, ill.; Lawrence 1997, p. 15, ill.

D69-03
The Council of Mice
1969
brush and ink on paper
15⅞ × 14½ in. (40.3 × 36.8 cm)
unsigned

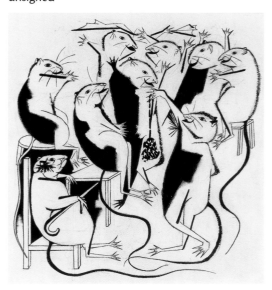

Collection: Private collection.

Provenance: Jacob and Gwendolyn Knight Lawrence, New York and Seattle; [Francine Seders Gallery, Seattle].

Exhibitions: USIA Africa 1989–90, no. 2; Shippensburg 1994; Shasta College 1994; Seders 1998–2000.

References: Lawrence 1970; Lewis and Hewitt 1988, p. 43, ill. (as *The Mice in Council*); Lewis and Hewitt 1989, p. 43, ill.; Lawrence 1997, p. 19, ill.

D69-04
The Monkey and the Camel
1969
brush and ink on paper
17⅝ × 27⅞ in. (44.8 × 70.8 cm)
unsigned

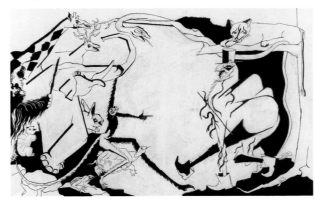

Collection: Private collection.

Provenance: Jacob and Gwendolyn Knight Lawrence, New York and Seattle; [Francine Seders Gallery, Seattle].

Exhibitions: USIA Africa 1989–90, no. 14; Whatcom 1992; Seders 1998–2000.

References: Lawrence 1970; Lewis and Hewitt 1988, p. 37, ill.; Lawrence 1997, p. 21, ill.

D69-05
The Lioness
1969
brush and ink on paper
19 × 11⅝ in. (48.3 × 29.5 cm)
unsigned

Collection: Private collection.

Provenance: Jacob and Gwendolyn Knight Lawrence, New York and Seattle; [Francine Seders Gallery, Seattle].

Exhibitions: USIA Africa 1989–90, no. 7; Shippensburg 1994; Shasta College 1994; Seders 1998–2000.

References: Lawrence 1970; Lewis and Hewitt 1988, p. 39, ill.; Lawrence 1997, p. 13, ill.

D69-06
The Ant and the Grasshopper
1969
brush and ink on paper
15½ × 14½ in. (39.3 × 36.8 cm)
unsigned

Collection: Private collection.

Provenance: Jacob and Gwendolyn Knight Lawrence, New York and Seattle; [Francine Seders Gallery, Seattle].

Exhibitions: USIA Africa 1989–90, no. 5; Seders 1998–2000.

References: Lawrence 1970; Lewis and Hewitt 1988, p. 35, ill.; Lewis and Hewitt 1989, p. 45, ill.; Lawrence 1997, p. 23, ill.

D69-07
The Fox and the Crow
1969
brush and ink on paper
17⁵⁄₁₆ × 8¹³⁄₁₆ in. (44 × 22.4 cm)
unsigned

Collection: Private collection.

Provenance: Jacob and Gwendolyn Knight Lawrence, New York and Seattle; [Francine Seders Gallery, Seattle].

Exhibitions: USIA Africa 1989–90, no. 8; Galerie de l'École des Beaux-Arts de Lorient, France, *Le Temps d'un dessin*, March 16–April 6, 1994; Whitney Museum of American Art at Champion Plaza, Stamford, Conn., *Fables, Fantasies and Everyday Things*, October 14, 1994–January 30, 1995; Seders 1998–2000.

References: Lawrence 1970; Lewis and Hewitt 1988, p. 48, ill.; Lawrence 1997, p. 25, ill.

D69-08
The Ass and the Grasshoppers
1969
brush and ink on paper
12¾ × 11¼ in. (32.4 × 28.6 cm)
unsigned

Collection: Private collection.

Provenance: Jacob and Gwendolyn Knight Lawrence, New York and Seattle; [Francine Seders Gallery, Seattle].

Exhibitions: USIA Caribbean 1989, no. 23; Whatcom 1992; Bellevue Art Museum, Wash., *Jacob Lawrence: Thirty Years of Prints (1963–1993)*, September 24–November 27, 1994; Shasta College 1994; Seders 1998–2000.

References: Lawrence 1970; Lewis and Hewitt 1989, p. 45, ill.; Sheila Farr, "Labors of Love: Jacob Lawrence at the Whatcom Museum of History and Art," *Artweek* 23, 12 (March 26, 1992), p. 9, ill.; Lawrence 1997, p. 27, ill.

D69-09
The Hares and the Frogs
1969
brush and ink on paper
16⁵⁄₁₆ × 29⅝ in. (41.4 × 75.2 cm)
unsigned

Collection: Private collection.

Provenance: Jacob and Gwendolyn Knight Lawrence, New York and Seattle; [Francine Seders Gallery, Seattle].

Exhibitions: USIA Africa 1989–90, no. 15; Whitney Museum of American Art at Champion Plaza, Stamford, Conn., *Fables, Fantasies and Everyday Things*, October 14, 1994–January 30, 1995; Seders 1998–2000.

References: Lawrence 1970; Lewis and Hewitt 1988, p. 36, ill.; Lawrence 1997, p. 31, ill.

D69-10
The Dog and the Bone
1969
brush and ink on paper
18 × 8⅞ in. (45.7 × 22.5 cm)
unsigned

Collection: Private collection.

Provenance: Jacob and Gwendolyn Knight Lawrence, New York and Seattle; [Francine Seders Gallery, Seattle].

Exhibitions: Seattle 1986–7; USIA Africa 1989–90, no. 9; Whatcom 1992; Pratt 1993; Seders 1998–2000.

References: Lawrence 1970; Wheat 1986, p. 142, fig. 61; Lewis and Hewitt 1988, p. 45, ill.; Lawrence 1997, p. 33, ill.

D69-11
The Angler and the Little Fish
1969
brush and ink on paper
12⅞ × 11¼ in. (32.7 × 28.6 cm)
unsigned

Collection: Private collection.

Provenance: Jacob and Gwendolyn Knight Lawrence, New York and Seattle; [Francine Seders Gallery, Seattle].

Exhibitions: USIA Caribbean 1989, no. 26; Pratt 1993, no. 8; Shippensburg 1994; Shasta College 1994; Seders 1998–2000.

References: Lawrence 1970; Lewis and Hewitt 1989, p. 50, ill.; Lawrence 1997, p. 35, ill.

D69-12
The Donkey in Lion's Skin
1969
brush and ink on paper
16⅜ × 14⅝ in. (41.6 × 37.1 cm)
unsigned

Collection: Private collection.

Provenance: Jacob and Gwendolyn Knight Lawrence, New York and Seattle; [Francine Seders Gallery, Seattle].

Exhibitions: USIA Africa 1989–90, no. 6; Shippensburg 1994; Shasta College 1994; Seders 1998–2000.

References: Lawrence 1970; Lewis and Hewitt 1988, p. 47, ill.; Lawrence 1997, p. 39, ill.

D69-13
The Thief and the Dog
1969
brush and ink on paper
18 × 11¼ in. (45.7 × 28.6 cm)
unsigned

Collection: Private collection.

Provenance: Jacob and Gwendolyn Knight Lawrence, New York and Seattle; [Francine Seders Gallery, Seattle].

Exhibitions: USIA Caribbean 1989, no. 29; Pratt 1993, no. 2; Shippensburg 1994; Shasta College 1994; Seders 1998–2000.

References: Lawrence 1970; Lewis and Hewitt 1989, p. 51, ill.; Lawrence 1997, p. 41, ill.

D69-14
The Bull and the Goat
1969
brush and ink on paper
14⅜ × 14¼ in. (36.5 × 36.2 cm)
unsigned

Collection: Private collection.

Provenance: Jacob and Gwendolyn Knight Lawrence, New York and Seattle; [Francine Seders Gallery, Seattle].

Exhibitions: USIA Caribbean 1989, no. 24; Pratt 1993; Shasta College 1994; Seders 1998–2000.

References: Lawrence 1970; Lewis and Hewitt 1989, p. 47, ill.; Lawrence 1997, p. 45, ill.

D69-15
The Bundle of Sticks
1969
brush and ink on paper
19 × 30 in. (48.3 × 76.2 cm)
unsigned; inscribed lower left "BUNDLE OF STICKS"

Collection: Private collection.

Provenance: Jacob and Gwendolyn Knight Lawrence, New York and Seattle; [Francine Seders Gallery, Seattle].

Exhibitions: USIA Caribbean 1989, no. 33; Seders 1998–2000.

References: Lawrence 1970; Lewis and Hewitt 1989, p. 53, ill.; Lawrence 1997, p. 47, ill.

D69-16
The Wolf in Sheep's Clothing
1969
brush and ink on paper
15 × 14⅜ in. (38.1 × 36.5 cm)
unsigned

Collection: Private collection.

Provenance: Jacob and Gwendolyn Knight Lawrence, New York and Seattle; [Francine Seders Gallery, Seattle].

Exhibitions: USIA Africa 1989–90, no. 3; Whatcom 1992; Shippensburg 1994; Shasta College 1994; Seders 1998–2000.

References: Lawrence 1970; Lewis and Hewitt 1988, p. 46, ill.; Lawrence 1997, p. 49, ill.

D69-17
The Fighting Cocks and the Eagle
1969
brush and ink on paper
16 × 13¾ in. (40.6 × 34.9 cm)
unsigned

Provenance: Private collection.

Collection: Jacob and Gwendolyn Knight Lawrence, New York and Seattle; [Francine Seders Gallery, Seattle].

Exhibitions: USIA Africa 1989–90, no. 11; Shasta College 1994; Seders 1998–2000.

References: Lawrence 1970; Lewis and Hewitt 1988, p. 42, ill.; Lawrence 1997, p. 51, ill.

D69-18
The Hare and the Tortoise
1969
brush and ink on paper
16¾ × 29¾ in. (42.5 × 75.6 cm)
unsigned

Collection: Private collection.

Provenance: Jacob and Gwendolyn Knight Lawrence, New York and Seattle; [Francine Seders Gallery, Seattle].

Exhibitions: USIA Africa 1989–90, no. 1; Whatcom 1992; Shippensburg 1994; Shasta College 1994; Seders 1998–2000.

References: Lawrence 1970; Lewis and Hewitt 1988, p. 40, ill.; Lawrence 1997, p. 55, ill. (as *The Tortoise and the Hare*).

D69-19
The Lion and the Three Bulls
1969
brush and ink on paper
17¾ × 29⅝ in. (45.1 × 75.2 cm)
unsigned

Collection: Private collection.

Provenance: Jacob and Gwendolyn Knight Lawrence, New York and Seattle; [Francine Seders Gallery, Seattle].

Exhibitions: USIA Africa 1989–90, no. 13; Seders 1998–2000.

References: Lewis and Hewitt 1988, p. 41, ill. (as *The Lion and the Bulls*); Lawrence 1997, p. 29, ill.

D69-20
The Birds, the Beasts, and the Bat
1969
brush and ink on paper
15 × 14½ in. (38.1 × 36.8 cm)
unsigned

Collection: Private collection.

Provenance: Jacob and Gwendolyn Knight Lawrence, New York and Seattle; [Francine Seders Gallery, Seattle].

Exhibitions: USIA Africa 1989–90, no. 10; Seders 1998–2000.

References: Lawrence 1997, p. 17, ill.

D69-21
The Raven and the Swan
1969
brush and ink on paper
17⅞ × 9¾ in. (45.4 × 24.8 cm)
unsigned

Collection: Private collection.

Provenance: Jacob and Gwendolyn Knight Lawrence, New York and Seattle; [Francine Seders Gallery, Seattle].

Exhibitions: USIA Caribbean 1989, no. 27; Pratt 1993; Bellevue Art Museum, Wash., *Jacob Lawrence: Thirty Years of Prints (1963–1993),* September 24–November 27, 1994; Shasta College 1994; Seders 1998–2000.

References: Lewis and Hewitt 1989, p. 48, ill.; Lawrence 1997, p. 43, ill.

D69-22
The Porcupine and the Snakes
1969
brush and ink on paper
15¾ × 14½ in. (40 × 36.8 cm)
unsigned

Collection: Private collection.

Provenance: Jacob and Gwendolyn Knight Lawrence, New York and Seattle; [Francine Seders Gallery, Seattle].

Exhibitions: USIA Africa 1989–90, no. 4; Whatcom 1992; Shasta College 1994; Seders 1998–2000.

References: Lewis and Hewitt 1988, p. 49, ill.; Lawrence 1997, p. 37, ill.

D69-23
The Two Frogs
1969
brush and ink on paper
15 × 14 in. (38.1 × 35.6 cm)
unsigned

Collection: Private collection.

Provenance: Jacob and Gwendolyn Knight Lawrence, New York and Seattle; [Francine Seders Gallery, Seattle].

Exhibitions: Seders 1998–2000.

References: Lawrence 1997, p. 53, ill.

D70-01
Untitled [*Chess Players*]
1970
graphite on paper
17½ × 23 in. (44.5 × 58.4 cm)
signed and dated lower right "Jacob Lawrence 70"

Collection: Ms. Ray Golden, New York.

Provenance: Jacob and Gwendolyn Knight Lawrence, New York.

D70-02
Traveling Man
1970, 1996
crayon and graphite on paper
23¾ × 18 in. (60.3 × 45.7 cm)
signed lower right "Jacob Lawrence"

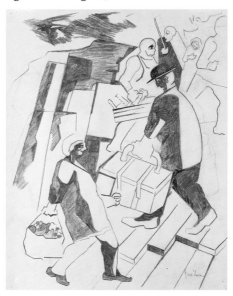

Collection: John and Heidi Rabel, Seattle.

Provenance: Jacob and Gwendolyn Knight Lawrence, Seattle; [Francine Seders Gallery, Seattle].

Exhibitions: Henry Art Gallery 1998.

References: DC Moore 1996b, p. 46, ill.

D72-01
Untitled [*Study for The Ring Cycle*]
ca. 1972
graphite on paper
24 × 18 in. (61 × 45.7 cm)
unsigned

Collection: Private collection.

Provenance: Jacob and Gwendolyn Knight Lawrence, Seattle.

Remarks: Study for a commission from the Seattle Opera. The commission was cancelled before the artist completed any paintings on the subject.

D72-02
Study for Builders
1972, 1996
crayon and graphite on paper
22¼ × 17⅝ in. (56.5 × 44.8 cm)
signed and dated lower right "Jacob Lawrence 1972"; verso: inscribed "Study for Builders"

Collection: Private collection. Courtesy of Conner-Rosencranz, New York.

Provenance: Jacob and Gwendolyn Knight Lawrence, Seattle; [Conner-Rosencranz Gallery, New York].

Exhibitions: DC Moore 1996a.

References: DC Moore 1996b, p. 41, ill.

D73-01
Builders
1973
brush and ink on paper
30½ × 22 in. (77.5 × 55.9 cm)
signed and dated lower right "Jacob Lawrence 73"

Collection: Private collection.

Provenance: [Terry Dintenfass Inc., New York].

Exhibitions: Dintenfass 1973, no. 13; Moravian College, Bethlehem, Pa., *American Concerns, The Humanist View: Selected Works on Paper*, February 9–March 4, 1976, no. 13.

References: Moravian College, *American Concerns, The Humanist View: Selected Works on Paper*, exh. cat. (Charlottesville, Va.: University of Virginia Press, 1976), ill.

D73-02
Untitled [*Men Working*]
1973
brush and ink on paper
30 × 22 in. (76.2 × 55.9 cm)
signed and dated lower right "Jacob Lawrence 1973"

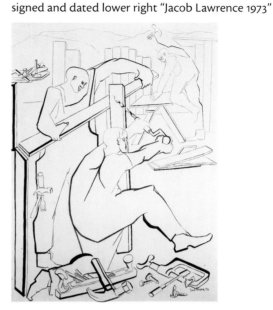

Collection: Mary Ann Odegaard Quarton. Gift of Charles E. Odegaard.

Provenance: Jacob and Gwendolyn Knight Lawrence, Seattle; Dr. Charles E. Odegaard, Seattle.

D73-03
Untitled [*Study for George Washington Bush Series*]
1973
graphite on paper
18 × 12⅝ in. (45.7 × 32.1 cm)
unsigned

Collection: Private collection.

Provenance: Jacob and Gwendolyn Knight Lawrence, Seattle.

D73-04
Untitled [Study for George Washington Bush Series]
1973
graphite on paper
18 × 12½ in. (45.7 × 31.8 cm)
unsigned; inscribed bottom left in margin "SPRING"

Collection: Private collection.
Provenance: Jacob and Gwendolyn Knight Lawrence, Seattle.

D74-01
Builders No. 1
1974
brush and ink on paper
26 × 20 in. (66 × 50.8 cm)
signed and dated lower right "Jacob Lawrence 74"

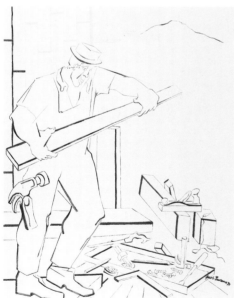

Collection: Private collection, Arkansas.
Provenance: [Terry Dintenfass Inc., New York].
Exhibitions: Oklahoma City Art Museum, *Mid-America Collects*, October 23–November 27, 1977; DC Moore 1996a.
References: Lewis and Sullivan 1982, p. 52, ill. (as *The Builders*); DC Moore 1996b, p. 40, ill.

D74-02
Builders No. 2
1974
brush and ink on paper
26 × 20 in. (66 × 50.8 cm)
signed and dated lower right "Jacob Lawrence 74"

Collection: Private collection.
Provenance: [Terry Dintenfass Inc., New York].
Exhibitions: Oklahoma City Art Museum, *Mid-America Collects*, October 23–November 27, 1977; DC Moore 1996a.
References: DC Moore 1996b, p. 28, ill.

D74-03
Untitled [Two Builders]
ca. 1974
graphite on paper
30 × 22 in. (76.2 × 55.9 cm)
unsigned

Collection: Private collection.
Provenance: Jacob and Gwendolyn Knight Lawrence, Seattle.

D74-04
Windows
1974, 1996
graphite and crayon on paper
30 × 22 in. (76.2 × 55.9 cm)
signed lower right "Jacob Lawrence"

Collection: Jacob and Gwendolyn Knight Lawrence. Courtesy of DC Moore Gallery, New York.

Exhibitions: DC Moore 1996a.

References: DC Moore 1996b, p. 43, ill.

D75-01
Track Meet
1975, 1996
brush and ink, crayon, and graphite on paper
22¼ × 30 in. (56.5 × 76.2 cm)
signed and dated lower right "Jacob Lawrence—1975"

Collection: Francine Seders, Seattle.

Provenance: Jacob and Gwendolyn Knight Lawrence, Seattle; [DC Moore Gallery, New York]; Carol Bennett, Seattle.

Exhibitions: DC Moore 1996a; Henry Art Gallery 1998.

References: DC Moore 1996b, p. 42, ill.

D75-02
Harriet Tubman
1975, 1996
brush and ink, crayon, and graphite on paper
27 × 22 in. (68.6 × 55.9 cm)
signed, dated, and inscribed lower right "'Harriet Tubman' / Jacob Lawrence 1975"

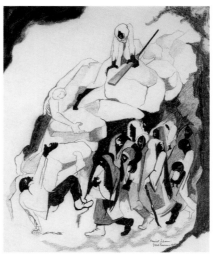

Collection: Janet B. Fudala and John Fudala.

Provenance: [Terry Dintenfass Inc., New York]; Jacob and Gwendolyn Knight Lawrence, Seattle; [Francine Seders Gallery, Seattle].

Exhibitions: Henry Art Gallery 1998.

D75-03
Back to Africa Movement
1975, 1996
graphite and crayon on paper
21½ × 16 in. (54.6 × 40.6 cm)
signed lower right "Jacob Lawrence"; verso: inscribed "Back to Africa Movement"

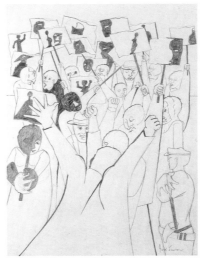

Collection: Private collection. Courtesy of DC Moore Gallery, New York.

Provenance: Jacob and Gwendolyn Knight Lawrence, Seattle; [DC Moore Gallery, New York].

Exhibitions: DC Moore 1996a; Mary Ryan Gallery, New York, *Civil Progress: Images of Black America*, February 12–March 15, 1997; DC Moore Gallery, New York, *Revealing Images: Selected Works on Paper*, October 7–November 1, 1997.

References: DC Moore 1996b, p. 2, ill.

D75-04
Untitled [*Crawling Cat*]
ca. 1975
graphite on paper
12 × 18 in. (30.5 × 45.7 cm)
unsigned

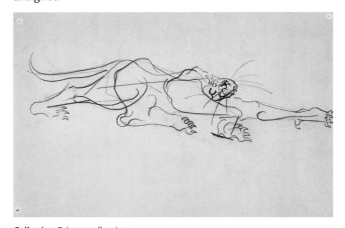

Collection: Private collection.

Provenance: Jacob and Gwendolyn Knight Lawrence, Seattle.

D75-05
Untitled [*Head Study after Bridgman, ¾ View*]
ca. 1975
charcoal on paper
24 × 18 in. (61 × 45.7 cm)
unsigned

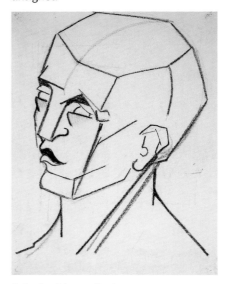

Collection: Private collection.

Provenance: Jacob and Gwendolyn Knight Lawrence, Seattle.

D75-06
Untitled [*Head Study after Bridgman, Profile*]
ca. 1975
charcoal on paper
24 × 18 in. (61 × 45.7 cm)
unsigned

Collection: Private collection.

Provenance: Jacob and Gwendolyn Knight Lawrence, Seattle.

D75-07
Untitled [*Head Study after Bridgman, ¾ View*]
ca. 1975
charcoal on paper
24 × 18 in. (61 × 45.7 cm)
unsigned

Collection: Private collection.

Provenance: Jacob and Gwendolyn Knight Lawrence, Seattle.

D75-08
Untitled [*Head Study after Bridgman, ¾ View*]
ca. 1975
charcoal on paper
24 × 18 in. (61 × 45.7 cm)
unsigned

Collection: Private collection.

Provenance: Jacob and Gwendolyn Knight Lawrence, Seattle.

D75-09
Untitled [*Head Study after Bridgman, Frontal*]
ca. 1975
crayon on paper
24 × 18 in. (61 × 45.7 cm)
unsigned

Collection: Private collection.

Provenance: Jacob and Gwendolyn Knight Lawrence, Seattle.

D75-10
Untitled [*Skeletal Torso*]
ca. 1975
graphite on paper
12 × 7⅛ in. (30.5 × 18.1 cm)
unsigned

Collection: Private collection.

Provenance: Jacob and Gwendolyn Knight Lawrence, Seattle.

D76-01
University
1976, 1996
gouache, graphite, and crayon on paper
30 × 22¼ in. (76.2 × 56.5 cm)
signed lower right "Jacob Lawrence"

Collection: Private collection. Courtesy of DC Moore Gallery, New York.

Provenance: Jacob and Gwendolyn Knight Lawrence, Seattle; [DC Moore Gallery, New York].

Exhibitions: DC Moore 1996a; Henry Art Gallery 1998.

References: DC Moore 1996b, p. 48, ill.

D78-01
Untitled
1978
colored pencil and crayon on paper
15½ × 12½ in. (39.4 × 31.8 cm)
signed and dated lower center/right "Jacob Lawrence 78"; inscribed bottom left in margin "To Liz and Steve"

Collection: Elizabeth and Steven Roose, Scarsdale, New York.

Provenance: Jacob and Gwendolyn Knight Lawrence, Seattle.

D78-02
Untitled [*Street Scene with Workers*]
1978
crayon and colored pencil on paper
15 × 12 in. (38.1 × 30.5 cm)
signed and dated lower center/right "Jacob Lawrence 78"; inscribed bottom left in margin "To Eric Monroe Golden"

Collection: Eric Monroe Golden, Riverdale, New York.

Provenance: Jacob and Gwendolyn Knight Lawrence, Seattle.

D78-03
Untitled [*Street Scene*]
1978
graphite on paper
15½ × 13 in. (39.4 × 33 cm)
signed and dated lower right "Jacob Lawrence / 1978"

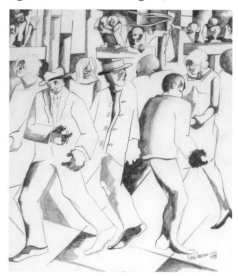

Collection: Burton and Norita Robbins.

Provenance: Jacob and Gwendolyn Knight Lawrence, Seattle.

D79-01
Untitled [*To Matthew Monroe Roose*]
1979
colored pencil, crayon, and graphite on paper
image: 13½ × 10 in. (34.3 × 25.4 cm)
signed and dated lower right "Jacob / Lawrence / 79"; inscribed
bottom left in margin "To Matthew Monroe Roose From Jake
and Gwen"

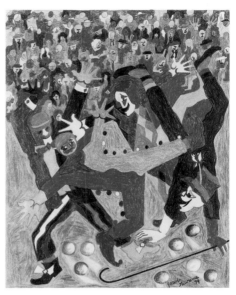

Collection: Matthew Monroe Roose, Scarsdale, New York.
Provenance: Jacob and Gwendolyn Knight Lawrence, Seattle.

D79-02
Untitled [*Builders*]
1979
brush and ink on paper
17 × 14 in. (43.2 × 35.6 cm)
signed and dated lower right "Jacob Lawrence 79"

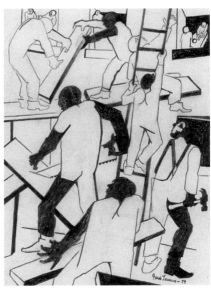

Collection: Current location unknown.
Provenance: [Francine Seders Gallery, Seattle]; Harry Farr, Seattle.

D80-01
Builders No. 1
1980
crayon and graphite on paper
17 × 13⅞ in. (43.2 × 35.2 cm)
signed and dated lower right "Jacob Lawrence 1980"

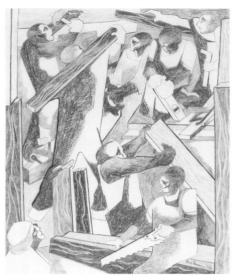

Collection: Seattle Art Museum, Purchased with funds from PONCHO.
Provenance: [Francine Seders Gallery, Seattle].

D80-02
Builders No. 2
1980
crayon and graphite on paper
17 × 13¾ in. (43.2 × 34.9 cm)
signed and dated lower right "Jacob Lawrence 1980"

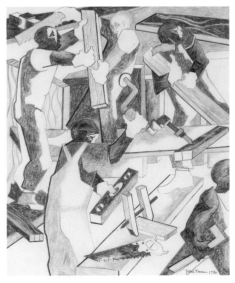

Collection: Edward and Susan Hilpert, Seattle.
Provenance: [Francine Seders Gallery, Seattle].
Exhibitions: Henry Art Gallery 1998.

D80-03
Thomas (The Artist's Cat)
1980
graphite on paper
5⅛ × 18¾ in. (13 × 47.6 cm)
signed and dated lower right "Jacob Lawrence 1980"

Collection: Private collection.

Provenance: Jacob and Gwendolyn Knight Lawrence, Seattle; [DC Moore Gallery, New York].

Exhibitions: DC Moore 1996a (Arkansas only).

D81-01
Carpenters No. 1
1981
graphite on paper
23¹³⁄₁₆ × 18 in. (60.5 × 45.7 cm)
signed and dated lower right "Jacob Lawrence 1981"

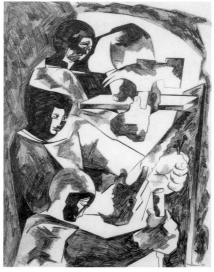

Collection: Steven Adam Brown, Seattle.

Provenance: [Francine Seders Gallery, Seattle].

Exhibitions: Dintenfass 1983; Arizona State 1990.

References: Lewis and Hewitt 1982, n.p., ill. (as *The Builders*); Lewis and Sullivan 1982, p. 38, ill. (as *The Builders*); Lewis and Hewitt 1989.

Remarks: A.k.a. *Carpenters Series #01* and *Builders Series #01.*

D81-02
Carpenters No. 2
1981
graphite on paper
23½ × 17¾ in. (59.7 × 45.1 cm)
signed and dated lower right "Jacob Lawrence 1981"

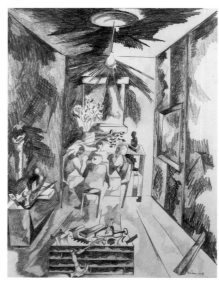

Collection: The Arkansas Arts Center Foundation Collection, Little Rock. The Barrett Hamilton Acquisition Fund, 1987.87.4.

Provenance: [Terry Dintenfass Inc., New York]; Bernard and Tilly Ronis, Philadelphia; [Terry Dintenfass Inc., New York].

Exhibitions: Santa Monica 1982; Dintenfass 1983; The Arkansas Arts Center, Little Rock, *Works by Artists Who Are Black*, January 30–March 4, 1987; The Arkansas Arts Center, State Services Department, Little Rock, *African American Artists from The Arkansas Arts Center Foundation Collection*, 1990–6.

References: Lewis and Hewitt 1982, n.p., ill. (as *The Builders*); Lewis and Sullivan 1982, p. 43, ill. (as *The Builders*).

Remarks: A.k.a. *Builders Series #02* and *Carpenters Series #02.*

D81-03
Carpenters No. 3
1981
graphite on paper
23⅞ × 18 in. (60.6 × 45.7 cm)
signed and dated lower right "Jacob Lawrence 1981"

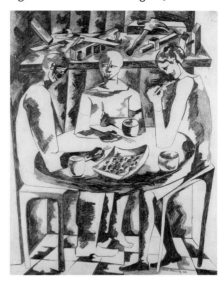

Collection: Private collection, New York.

Provenance: Jacob and Gwendolyn Knight Lawrence, Seattle.

Exhibitions: Dintenfass 1983.

References: Lewis and Hewitt 1982, n.p., ill. (as *The Builders*); Lewis and Sullivan 1982, p. 40, ill. (as *The Builders*).

Remarks: A.k.a. *Carpenters Series #03* and *Builders Series #03*.

D81-04
Carpenters No. 4
1981
graphite on paper
23¾ × 17¾ in. (60.3 × 45.1 cm)
signed and dated lower right "Jacob Lawrence 1981"

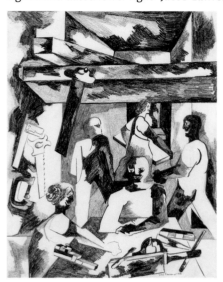

Collection: Steven Adam Brown.

Provenance: Jacob and Gwendolyn Knight Lawrence, Seattle; [Francine Seders Gallery, Seattle].

Exhibitions: Santa Monica 1982; Dintenfass 1983; Tacoma Art Museum, Wash., *Jacob Lawrence: The Washington Years*, February 3–April 2, 1989; Arizona State 1990; Whatcom 1992, no. 10 (as *Builders Series #4*); Henry Art Gallery 1998.

References: Lewis and Hewitt 1982, n.p., ill. (as *The Builders*); Lewis and Sullivan 1982, p. 42, ill. (as *The Builders*).

Remarks: A.k.a. *Carpenters Series #04* and *Builders Series #04*.

D81-05
Carpenters No. 5
1981
graphite on paper
26 × 20 in. (66 × 50.8 cm)
signed and dated lower right "Jacob Lawrence 1981"

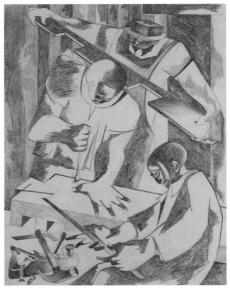

Collection: Ellen B. and William R. Hazzard, Lewisville, North Carolina.

Provenance: [Francine Seders Gallery, Seattle].

Exhibitions: Santa Monica 1982.

References: Lewis and Hewitt 1982, n.p., ill. (as *The Builders*); Lewis and Sullivan 1982, p. 37, ill. (as *The Builders*); Lewis and Hewitt 1989, n.p., ill.

Remarks: A.k.a. *Carpenters Series #05* and *Builders Series #05.*

D81-06
Carpenters No. 6
1981
graphite on paper
23¾ × 17½ in. (60.3 × 44.5 cm)
signed and dated lower right "Jacob Lawrence 1981"

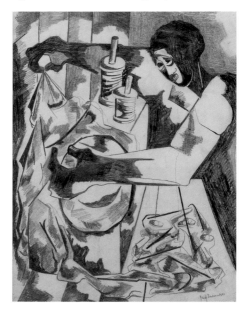

Collection: Private collection.

Provenance: [Francine Seders Gallery, Seattle]; Alpha Rodgers, Park Forest, Ill.; [Terry Dintenfass Inc., New York].

Exhibitions: Santa Monica 1982; Dintenfass 1983.

References: Lewis and Hewitt 1982, n.p., ill. (as *The Builders*); Lewis and Sullivan 1982, p. 39, ill. (as *The Builders*); Wheat 1986, p. 156, fig. 77.

Remarks: A.k.a. *Carpenters Series #06* and *Builders Series #06.*

D81-07
Carpenters No. 7
1981
graphite on paper
22 × 18 in. (55.9 × 45.7 cm)
signed and dated lower right "Jacob Lawrence 81"

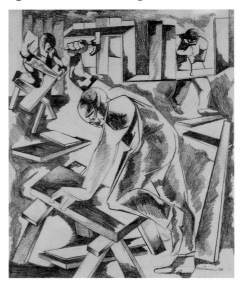

Collection: Ronald and Cynthia Thompson.

Provenance: Jacob and Gwendolyn Knight Lawrence, Seattle; [Francine Seders Gallery, Seattle]; Phillips Design Masters, New York; ?.

Exhibitions: Santa Monica 1982; Dintenfass 1983; Tacoma Art Museum, Wash., *Jacob Lawrence: The Washington Years*, February 3–April 2, 1989.

References: Lewis and Hewitt 1982, n.p., ill. (as *The Builders*); Lewis and Sullivan 1982, p. 41, ill. (as *The Builders*).

Remarks: A.k.a. *Carpenters Series #07* and *Builders Series #07.*

D81-08
Carpenters No. 8
1981
graphite on paper
22 × 12 in. (55.9 × 30.5 cm)
signed and dated lower right "Jacob Lawrence 1981"

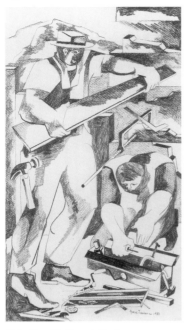

Collection: Mr. Kerry L. Davis.

Provenance: [Francine Seders Gallery, Seattle].

Exhibitions: Santa Monica 1982; Evans-Tibbs Collection, Washington, D.C., *Aesthetics of the American Northwest*, April–June 1987; Tacoma Art Museum, Wash., *Jacob Lawrence: The Washington Years*, February 3–April 2, 1989.

References: Lewis and Hewitt 1982, n.p., ill. (as *The Builders*); Lewis and Sullivan 1982, p. 36, ill. (as *The Builders*).

Remarks: A.k.a *Carpenters Series #08* and *Builders Series #08*.

D81-09
Carpenters No. 9
1981
graphite on paper
16 × 14 in. (40.6 × 35.6 cm)
signed and dated lower right "Jacob Lawrence 1981"

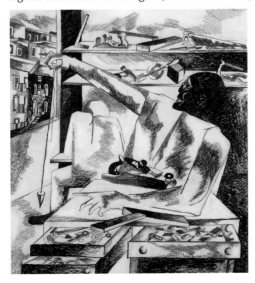

Collection: Francine Seders, Seattle.

Provenance: Jacob and Gwendolyn Knight Lawrence, Seattle; [Francine Seders Gallery, Seattle].

Exhibitions: Santa Monica 1982; Whatcom 1992, no. 11; Henry Art Gallery 1998.

References: Lewis and Hewitt 1982, n.p., ill. (as *The Builders*); Lewis and Sullivan 1982, p. 45, ill. (as *The Builders*); Wheat 1986, p. 156, fig. 76.; Lewis and Hewitt 1989, n.p., ill.

Remarks: A.k.a *Carpenters Series #09* and *Builders Series #09*.

D81-10
Carpenters No. 10
1981
graphite on paper
14¾ × 15¾ in. (37.5 × 40 cm)
signed and dated lower right "Jacob Lawrence 1981"

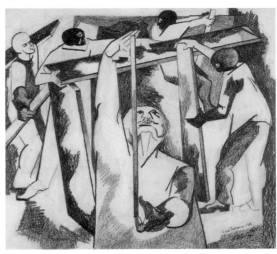

Collection: Donald Hardy and P. Bruce Marine.

Provenance: Jacob and Gwendolyn Knight Lawrence, Seattle; [Midtown Payson Galleries, New York].

Exhibitions: Santa Monica 1982; Seders 1982; Dintenfass 1983; Tacoma Art Museum, Wash., *Jacob Lawrence: The Washington Years*, February 3–April 2, 1989; Midtown Payson 1993a.

References: Lewis and Hewitt 1982, n.p., ill. (as *The Builders*); Lewis and Sullivan 1982, p. 44, ill. (as *The Builders*); Lewis and Hewitt 1989.

Remarks: A.k.a. *Carpenters Series #10* and *Builders Series #10*.

D81-11
Untitled
1981
colored pencil, graphite, and crayon on paper
14⁵⁄₁₆ × 13¹⁄₁₆ in. (36.4 × 33.2 cm)
signed and dated bottom right in margin "Jacob Lawrence, November 1981"; inscribed bottom left in margin "To Rachel Esther Golden"

Collection: Rachel Esther Golden, Riverdale, New York.
Provenance: Jacob and Gwendolyn Knight Lawrence, Seattle.

D82-01
Untitled [To Kathryn Sara Roose]
1982
crayon and colored pencil on paper
15½ × 13 in. (39.4 × 33 cm)
signed and dated lower right "Jacob Lawrence 1982"; inscribed and dated bottom left in margin "To Kathryn Sara Roose 6/82"

Collection: Kathryn Sara Roose, Scarsdale, New York.
Provenance: Jacob and Gwendolyn Knight Lawrence, Seattle.

D82-02
Street Scene 1982
1982
crayon and graphite on paper
19 × 16 in. (48.3 × 40.6 cm)
signed and dated lower right "Jacob Lawrence / 1982"; inscribed and dated bottom left in margin "Street Scene 1982"

Collection: Daniel H. Golden, New York.
Provenance: Jacob and Gwendolyn Knight Lawrence, Seattle.

D85-01
Builders No. 1
1985
colored pencil, brush and ink, and graphite on paper
20 × 13 in. (50.8 × 33 cm)
signed and dated lower center/right "Jacob Lawrence / 1985"

Collection: Charles Mansfield, Seattle.
Provenance: [Francine Seders Gallery, Seattle].
Exhibitions: Seders 1985.
Remarks: A.k.a. *Builders 1985, cd 01.*

D85-02
Builders No. 2
1985
colored pencil, brush and ink, and graphite on paper
13 × 20 in. (33 × 50.8 cm)
signed and dated lower right "Jacob Lawrence 1985"

Collection: Mr. and Mrs. John E. Branch.

Provenance: [Francine Seders Gallery, Seattle].

Exhibitions: Seders 1985; Evans-Tibbs Collection, Washington, D.C., *Aesthetics of the American Northwest*, April–June 1987.

Remarks: A.k.a. *Builders 1985, cd 02.*

D85-03
Builders No. 3
1985
colored pencil, brush and ink, and graphite on paper
20 × 13 in. (50.8 × 33 cm)
signed and dated lower right "Jacob Lawrence 1985"

Collection: Mr. and Mrs. Robert M. Sarkis, Seattle.

Provenance: [Francine Seders Gallery, Seattle].

Exhibitions: Seders 1985; Tacoma Art Museum, Wash., *Jacob Lawrence: The Washington Years*, February 3–April 2, 1989; Whatcom 1992, no. 12 (as *Builders #3*); Henry Art Gallery 1998.

Remarks: A.k.a. *Builders 1985, cd 03.*

D85-04
Builders No. 4
1985
colored pencil, brush and ink, and graphite on paper
13 × 20 in. (33 × 50.8 cm)
signed and dated lower right "Jacob Lawrence 1985"

Collection: Mr. and Mrs. Robert M. Sarkis, Seattle.

Provenance: [Francine Seders Gallery, Seattle].

Exhibitions: Seders 1985; Tacoma Art Museum, Wash., *Jacob Lawrence: The Washington Years*, February 3–April 2, 1989; Henry Art Gallery 1998.

Remarks: A.k.a. *Builders 1985, cd 04.*

D85-05
Builders No. 5
1985
colored pencil, brush and ink, and graphite on paper
13 × 20 in. (33 × 50.8 cm)
signed and dated lower right "Jacob Lawrence 1985"

Collection: John and Heidi Rabel, Seattle.

Provenance: [Francine Seders Gallery, Seattle].

Exhibitions: Seders 1985; Evans-Tibbs Collection, Washington, D.C., *Aesthetics of the American Northwest*, April–June 1987; Willamette 1989; Arizona State 1990; Henry Art Gallery 1998.

Remarks: A.k.a. *Builders 1985, cd 05.*

D85-06
Builders No. 6
1985
colored pencil, brush and ink, and graphite on paper
20 × 13 in. (50.8 × 33 cm)
signed and dated lower right "Jacob Lawrence 1985"

Collection: Maggie McKee Dorsey.

Provenance: [Francine Seders Gallery, Seattle].

Exhibitions: Seders 1985; Henry Art Gallery 1998.

Remarks: A.k.a. *Builders 1985, cd 06.*

D85-07
Builders No. 7
1985
colored pencil, brush and ink, and graphite on paper
20 × 13 in. (50.8 × 33 cm)
signed and dated lower right "Jacob Lawrence 1985"

Collection: Charles and Janice Helming, Seattle.

Provenance: [Francine Seders Gallery, Seattle].

Exhibitions: Seders 1985.

Remarks: A.k.a. *Builders 1985, cd 07.*

D85-08
Builders No. 8
1985
colored pencil, brush and ink, and graphite on paper
20 × 13 in. (50.8 × 33 cm)
signed and dated lower center/right "Jacob Lawrence 1985"

Collection: James O. Eggerman and Judith Robb Eggerman, Seattle.

Provenance: [Francine Seders Gallery, Seattle].

Exhibitions: Seders 1985; Tacoma Art Museum, Wash., *Jacob Lawrence: The Washington Years*, February 3–April 2, 1989.

References: Wheat 1986, p. 184, pl. 103.

Remarks: A.k.a. *Builders 1985, cd 08.*

D85-09
Builders No. 9
1985
colored pencil, brush and ink, and graphite on paper
13 × 20 in. (33 × 50.8 cm)
signed and dated lower right "Jacob Lawrence 1985"

Collection: Martin and Mimi Siegel, Bellevue, Washington.

Provenance: [Francine Seders Gallery, Seattle].

Exhibitions: Seders 1985; Tacoma Art Museum, Wash., *Jacob Lawrence: The Washington Years*, February 3–April 2, 1989.

Remarks: A.k.a. *Builders 1985, cd 09.*

D85-10
Builders No. 10
1985
colored pencil, brush and ink, and graphite on paper
20 × 13 in. (50.8 × 33 cm)
signed and dated lower right "Jacob Lawrence 1985"

Collection: Dr. and Mrs. Charles Nolan.
Provenance: [Francine Seders Gallery, Seattle].
Exhibitions: Seders 1985.
Remarks: A.k.a. *Builders 1985, cd 10.*

D85-11
Builders No. 11
1985
colored pencil, brush and ink, and graphite on paper
20 × 13 in. (50.8 × 33 cm)
signed and dated lower center/right "Jacob Lawrence 1985"

Collection: Private collection, New York.
Provenance: [Francine Seders Gallery, Seattle].
Exhibitions: Seders 1985.
Remarks: A.k.a. *Builders 1985, cd 11.*

D85-12
Builders No. 12
1985
colored pencil, brush and ink, and graphite on paper
13 × 20 in. (33 × 50.8 cm)
signed and dated lower right "Jacob Lawrence 1985"

Collection: Alitash Kebede Contemporary Art, Los Angeles.
Provenance: [Francine Seders Gallery, Seattle].
Exhibitions: Seders 1985.
References: Lewis and Hewitt 1989, p. 41, ill.
Remarks: A.k.a. *Builders 1985, cd 12.*

D85-13
Builders No. 13
1985
colored pencil, brush and ink, and graphite on paper
20 × 13 in. (50.8 × 33 cm)
signed and dated lower right "Jacob Lawrence 85"

Collection: Judith Peters, Seattle.
Provenance: [Francine Seders Gallery, Seattle].
Exhibitions: Seders 1985; Tacoma Art Museum, Wash., *Jacob Lawrence: The Washington Years*, February 3–April 2, 1989.
Remarks: A.k.a. *Builders 1985, cd 13.*

D85-14
Builders No. 14
1985
colored pencil, brush and ink, and graphite on paper
20 × 13 in. (50.8 × 33 cm)
signed and dated lower right "Jacob Lawrence 85"

Collection: Judith Peters, Seattle.

Provenance: [Francine Seders Gallery, Seattle].

Exhibitions: Seders 1985; Tacoma Art Museum, Wash., *Jacob Lawrence: The Washington Years*, February 3–April 2, 1989.

Remarks: A.k.a. *Builders 1985, cd 14.*

D85-15
Builders No. 15
1985
colored pencil, brush and ink, and graphite on paper
20 × 12½ in. (50.8 × 31.8 cm)
signed and dated lower right "Jacob Lawrence 1985"

Collection: Marsha Wolf and Ken Linkhart, Seattle.

Provenance: [Francine Seders Gallery, Seattle].

Exhibitions: Seders 1985; Evans-Tibbs Collection, Washington, D.C., *Aesthetics of the American Northwest*, April–June 1987; Willamette 1989.

Remarks: A.k.a. *Builders 1985, cd 15.*

D85-16
Builders No. 16
1985
colored pencil, brush and ink, and graphite on paper
20 × 13 in. (50.8 × 33 cm)
signed and dated lower right "Jacob Lawrence / 1985"

Collection: Paul B. Brown and Margaret A. Watson.

Provenance: [Francine Seders Gallery, Seattle].

Exhibitions: Seders 1985; Evans-Tibbs Collection, Washington, D.C., *Aesthetics of the American Northwest*, April–June 1987.

Remarks: A.k.a. *Builders 1985, cd 16.*

D85-17
Builders No. 17
1985
colored pencil, brush and ink, and graphite on paper
20 × 13 in. (50.8 × 33 cm)
signed and dated lower right "Jacob Lawrence 1985"

Collection: Michael C. Spafford and Elizabeth Sandvig.

Provenance: [Francine Seders Gallery, Seattle].

Exhibitions: Seders 1985; Tacoma Art Museum, Wash., *Jacob Lawrence: The Washington Years*, February 3–April 2, 1989; Henry Art Gallery 1998.

Remarks: A.k.a. *Builders 1985, cd 17.*

D85-18
Builders No. 18
1985
colored pencil, brush and ink, and graphite on paper
13 × 20 in. (33 × 50.8 cm)
signed and dated lower right "Jacob Lawrence /1985"

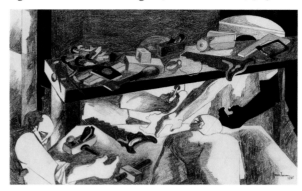

Collection: Drs. James and Caryn Hobbs, Los Angeles.

Provenance: [Alitash Kebede Contemporary Art, Los Angeles].

Exhibitions: Seders 1985.

Remarks: A.k.a. *Builders 1985, cd 18*.

D85-19
Study for Painting—The Builders
1985
crayon and graphite on paper
24 × 18 in. (61 × 45.7 cm)
signed and dated lower right "Jacob Lawrence / 1985"; verso:
inscribed "Study for Painting—The Builders"

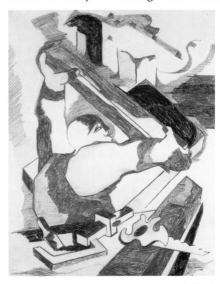

Collection: The Arkansas Arts Center Foundation Collection, Little Rock. The '96 Tabriz Fund, 97.7.

Provenance: Jacob and Gwendolyn Knight Lawrence, New York; [DC Moore Gallery, New York].

Exhibitions: DC Moore 1996a.

References: DC Moore 1996b, p. 47, ill.

D85-20
Study for Painting—The Builders
ca. 1985
gouache, crayon, and graphite on paper
23⅞ × 18 in. (60.6 × 45.7 cm)
signed and dated lower right "Jacob Lawrence 1985"

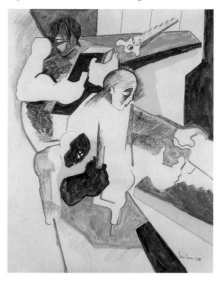

Collection: Greg Kucera and Larry Yocom, Seattle.

Provenance: Jacob and Gwendolyn Knight Lawrence, Seattle; [Francine Seders Gallery, Seattle].

Exhibitions: DC Moore 1996a; Henry Art Gallery 1998.

Remarks: Postdated by the artist after January 1996.

D85-21
Study for Builder—Man with Hammer
1985, 1996
graphite and crayon on paper
24 × 18 in. (61 × 45.7 cm)
signed lower right "Jacob Lawrence"; verso: inscribed "Study for Builder—Man with Hammer"

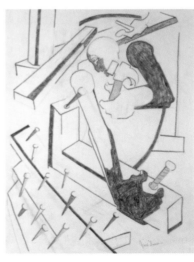

Collection: Jacob and Gwendolyn Knight Lawrence. Courtesy of DC Moore Gallery, New York.

Exhibitions: DC Moore 1996a.

References: DC Moore 1996b, p. 39, ill.

P85-22
Study for Painting
1985
tempera on paper
23⅝ × 18 in. (60 × 45.7 cm)
signed and dated lower center/right "Jacob Lawrence 1985"

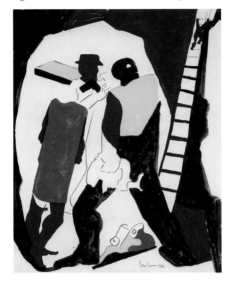

Collection: Dr. Daniel and Nancy Cook.

Provenance: Jacob and Gwendolyn Knight Lawrence, Seattle; [Francine Seders Gallery, Seattle].

Exhibitions: DC Moore Gallery, New York, *Jacob Lawrence: Drawings, 1945 to 1996*, October 9–November 9, 1996.

References: DC Moore 1996b, p. 45, ill.

D91-01
Untitled
1991
crayon and graphite on paper
9¾ × 8½ in. (24.8 × 21.6 cm)
signed and dated lower right "Jacob Lawrence 1991"; inscribed lower left "Happy Birthday JUDITH / Love, JAKE AND GWEN"

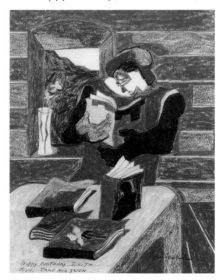

Collection: Judith Golden, New York.

Provenance: Jacob and Gwendolyn Knight Lawrence, Seattle.

D91-02
Cinque Aboard the Amistad
1991
brush and ink on paper
8 × 6 in. (20.3 × 15.2 cm)
signed lower left "Jacob Lawrence"

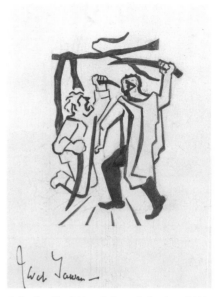

Collection: The Walter O. Evans Collection of African American Art.

Provenance: Jacob and Gwendolyn Knight Lawrence, Seattle.

References: John Henrik Clarke, *The Middle Passage: Our Holocaust* (Detroit: Dr. Walter O. Evans, 1991).

Remarks: Commissioned by Dr. Walter O. Evans for the booklet *The Middle Passage: Our Holocaust*, which includes an essay and speech by John Henrik Clarke.

D92-01
Fantasy: At the Controls of a Jumbo Jet
1992
colored pencil and graphite on paper
22 × 17 in. (55.9 × 43.2 cm)
signed and dated lower right "Jacob Lawrence 92"

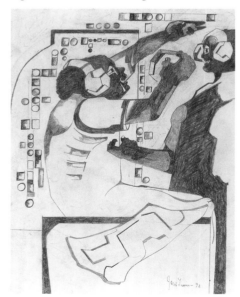

Collection: V. L. and Robyn Woolston, Seattle.

Provenance: [Francine Seders Gallery, Seattle].

D92-02
Fantasy: The Admiral
1992
colored pencil and graphite on paper
14¾ × 18 in. (37.5 × 45.7 cm)
signed and dated lower right "Jacob Lawrence 92"

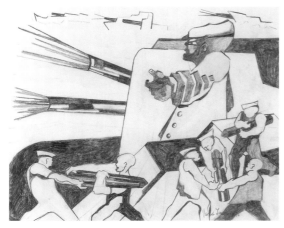

Collection: Armon Gilliam.

Provenance: [Francine Seders Gallery, Seattle]; Steven Adam Brown, Seattle; [Francine Seders Gallery, Seattle].

D92-03
Fantasy: Stretched Limousine
1992
colored pencil and graphite on paper
14½ × 22 in. (36.8 × 55.9 cm)
signed and dated lower right "Jacob Lawrence 92"

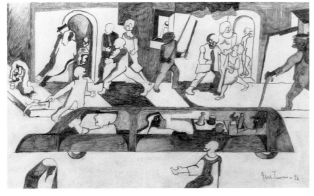

Collection: Mr. and Mrs. John Whitney Payson, New York.

Provenance: [Francine Seders Gallery, Seattle].

Exhibitions: Midtown Payson 1993a.

D92-04
Fantasy: New All Time World's Record
1992
colored pencil and graphite on paper
15 × 16 in. (38.1 × 40.6 cm)
signed and dated lower right "Jacob Lawrence 92"

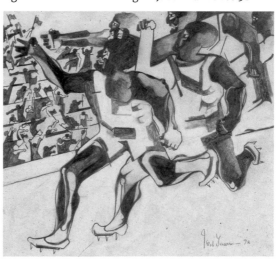

Collection: Armon Gilliam.

Provenance: [Francine Seders Gallery, Seattle].

Exhibitions: Francine Seders Gallery, Seattle, *Twenty-Fifth Anniversary Exhibition: The Middle Years*, June 7–July 7, 1991; Midtown Payson 1995a.

D92-05
Centennial Birthday Card
1992
colored pencil on paper
11 × 8½ in. (27.9 × 21.6 cm)
signed and dated lower right "Jacob Lawrence / 11/13/92"; inscribed upper right "To: / The Denver / Art Museum / Happy / Birthday"

Collection: Denver Art Museum. Gift of the artist in honor of the Denver Art Museum Centennial.

Provenance: Jacob and Gwendolyn Knight Lawrence, Seattle.

D93-01
Self-Portrait
1993
brush and ink on paper
11¼ × 9¾ in. (28.6 × 24.8 cm)
signed lower right "Jacob Lawrence"

Collection: Twentieth Century American Self-Portraiture. Collection of Ruth Bowman and Harry Kahn.

Provenance: [Midtown Payson Galleries, New York].

Exhibitions: National Academy of Design, New York, *Powerful Expressions: Recent American Drawings*, October 16, 1996–January 5, 1997.

References: *The New Yorker* 54, 44 (December 27, 1993), p. 30, ill.; Jack Flam, *Powerful Expressions: Recent American Drawings*, exh. cat. (New York: National Academy of Design, 1996), p. 83.

Remarks: Commissioned by *The New Yorker* magazine.

D95-01
Untitled
1995
colored pencil and crayon on paper
21¾ × 17⅞ in. (55.2 × 45.4 cm)
signed and dated lower center/right "Jacob Lawrence 1995"

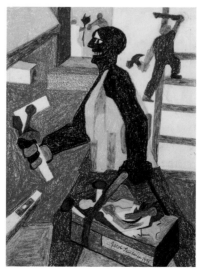

Collection: Private collection.

Provenance: Jacob and Gwendolyn Knight Lawrence, Seattle.

Remarks: Created specifically for the Studio in a School Association Benefit that took place on May 25, 1995, at Cartier's in New York City.

D95-02
Builders
1995
gouache on paper
18 × 24 in. (45.7 × 61 cm)
signed and dated lower right "Jacob Lawrence 1995"

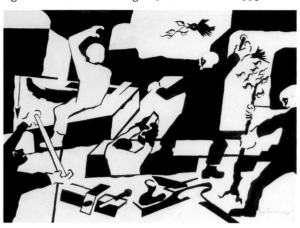

Collection: Jacob and Gwendolyn Knight Lawrence. Courtesy of Francine Seders Gallery, Seattle.

Exhibitions: Henry Art Gallery 1998.

Remarks: Commissioned by the National Academy of Design for translation into limited-edition prints.

D96-01
Self-Portrait
1965, 1996
brush and ink, and gouache on paper
19 × 12 in. (48.3 × 30.5 cm)
signed lower right "Jacob Lawrence"

Collection: National Portrait Gallery, Smithsonian Institution, Washington, D.C.

Provenance: Jacob and Gwendolyn Knight Lawrence, Seattle; [DC Moore Gallery, New York].

Exhibitions: DC Moore 1996a.

References: DC Moore 1996b, p. 5, ill.

Remarks: This drawing was extensively reworked in 1996.

D96-02
Ten Builders
1996
graphite on paper
11 × 14 in. (27.9 × 35.6 cm)
unsigned

Collection: Private collection
Provenance: Jacob and Gwendolyn Knight Lawrence, Seattle.

D96-03
Five Builders with Tool Box
1996
graphite on paper
11 × 14 in. (27.9 × 35.6 cm)
unsigned

Collection: Private collection
Provenance: Jacob and Gwendolyn Knight Lawrence, Seattle.

D96-04
Two Builders Playing Chess
1996
graphite on paper
11 × 14 in. (27.9 × 35.6 cm)
unsigned

Collection: Private collection.
Provenance: Jacob and Gwendolyn Knight Lawrence, Seattle.

D97-01
Worker with Tools
1997
crayon on paper
16 × 13 in. (40.6 × 33 cm)
signed and dated lower right "Jacob Lawrence 1997"

Collection: Mr. and Mrs. Arnold Newman.
Provenance: Jacob and Gwendolyn Knight Lawrence, Seattle.

D99-01
Lift Every Voice and Sing
1999
gouache on paper
24 × 18 in. (61 × 45.7 cm)
signed and dated lower left "Jacob Lawrence 99"; inscribed center
right "Lift / Every / Voice and / Sing"

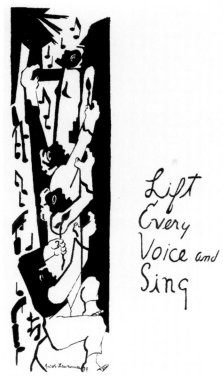

Collection: The Walter O. Evans Foundation for Art and Literature.

Provenance: Jacob and Gwendolyn Knight Lawrence, Seattle.

References: Lift Every Voice and Sing: One Hundred Years, One Hundred Voices, edited by Julian Bond and Sondra Kathryn Wilson (New York: Random House, 2000), ill.

Remarks: Commissioned by Dr. Walter O. Evans.

*Figure Studies after Vesalius
(1968–96)*

V-01
"Human Figure" after Vesalius
1968
graphite on paper
23⅞ × 18 in. (60.6 × 45.7 cm)
signed, dated, and inscribed lower right "'Human Figure' /
after Vesalius / Jacob Lawrence 1968"

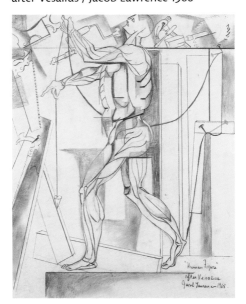

Collection: Private collection, New York.
Provenance: Jacob and Gwendolyn Knight Lawrence, Seattle.
References: Wheat 1986, pp. 147–8, fig. 67.

V-02
Figure Study after Vesalius [*Profile*]
N.D.
graphite on paper
24 × 18 in. (61 × 45.7 cm)
unsigned

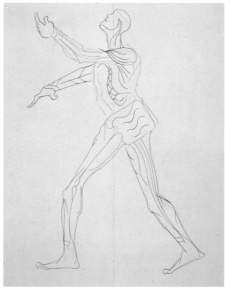

Collection: Private collection.
Provenance: Jacob and Gwendolyn Knight Lawrence, Seattle.

V-03
Figure Study after Vesalius [*Profile with Rocks*]
N.D.
graphite on paper
24 × 18 in. (61 × 45.7 cm)
unsigned

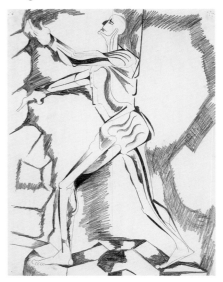

Collection: Private collection.
Provenance: Jacob and Gwendolyn Knight Lawrence, Seattle.

V-04
Figure Study after Vesalius [*Profile with Shading*]
1977
graphite on paper
11 × 8½ in. (27.9 × 21.6 cm)
unsigned

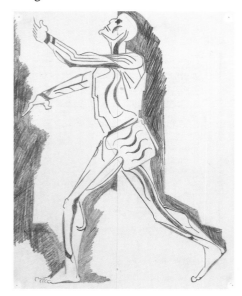

Collection: Private collection.
Provenance: Jacob and Gwendolyn Knight Lawrence, Seattle.

V-05

Figure Study after Vesalius [*Profile with Window*]
ca. 1977, 1996
graphite on paper
11 × 8½ in. (27.9 × 21.6 cm)
signed and dated lower right "Jacob Lawrence 1996"

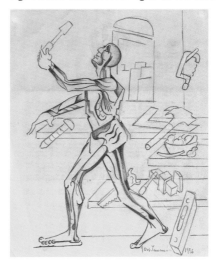

Collection: The Walter O. Evans Collection of African American Art.

Provenance: Jacob and Gwendolyn Knight Lawrence, Seattle; [Francine Seders Gallery, Seattle].

Exhibitions: Southern Methodist 1996, no. 13.

References: Van Keuren 1996, no. 13, ill.

V-06

Figure Study after Vesalius [*Profile with Boards*]
ca. 1975
graphite on paper
8½ × 5½ in. (21.6 × 14 cm)
initialed lower right "J.L."

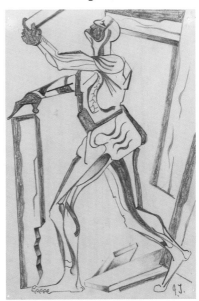

Collection: The Walter O. Evans Collection of African American Art.

Provenance: Jacob and Gwendolyn Knight Lawrence, Seattle; [Francine Seders Gallery, Seattle].

Exhibitions: Southern Methodist 1996, no. 16.

References: Van Keuren 1996, no. 16, ill.

V-07

Figure Study after Vesalius [*Profile with Plumb Bob*]
1996
graphite on paper
9½ × 6½ in. (24.1 × 16.5 cm)
signed lower center "Jacob Lawrence"

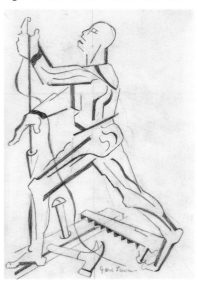

Collection: Jacob and Gwendolyn Knight Lawrence. Courtesy of DC Moore Gallery, New York.

Exhibitions: DC Moore 1996a; The Aldrich Museum of Contemporary Art, Ridgefield, Conn., *The Nude in Contemporary Art*, June 6–September 12, 1999.

References: DC Moore 1996b, p. 35, ill. (as *Standing Man with Plumb-Bob*).

V-08

Figure Study after Vesalius [*Profile with Tool Box*]
1996
graphite on paper
9½ × 6½ in. (24.1 × 16.5 cm)
signed and dated lower center/right "Jacob Lawrence 1996"

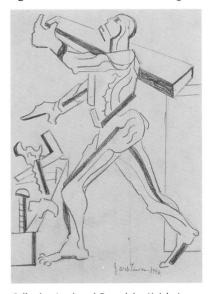

Collection: Jacob and Gwendolyn Knight Lawrence. Courtesy of Francine Seders Gallery, Seattle.

Exhibitions: Southern Methodist 1996, no. 10.

References: Van Keuren 1996, no. 10, ill.

V-09
Figure Study after Vesalius [*Frontal with Arc*]
N.D.
graphite on paper
11 × 8½ in. (27.9 × 21.6 cm)
unsigned

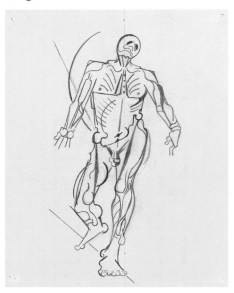

Collection: Private collection.
Provenance: Jacob and Gwendolyn Knight Lawrence, Seattle.

V-10
Figure Study after Vesalius [*Frontal*]
N.D.
graphite on paper
8½ × 5 in. (21.6 × 12.7 cm)
unsigned

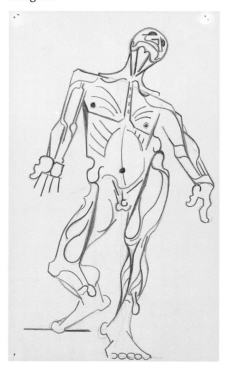

Collection: Private collection.
Provenance: Jacob and Gwendolyn Knight Lawrence, Seattle.

V-11
Figure Study after Vesalius [*Frontal with Block*]
ca. 1980
graphite on paper
24 × 18 in. (61 × 45.7 cm)
signed lower center/right "Jacob Lawrence"

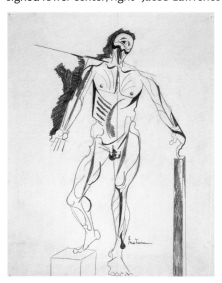

Collection: Private collection.
Provenance: Jacob and Gwendolyn Knight Lawrence, Seattle.

V-12
Figure Study after Vesalius [*Frontal with Shading*]
N.D.
graphite on paper
9½ × 4½ in. (24.1 × 11.4 cm)
unsigned

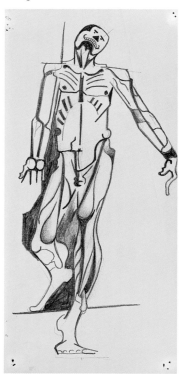

Collection: Private collection.
Provenance: Jacob and Gwendolyn Knight Lawrence, Seattle.

V-13

Figure Study after Vesalius [*Frontal with Horizontal Board*]
1980
graphite on paper
24 × 18 in. (61 × 45.7 cm)
signed and dated lower right "Jacob Lawrence 1980"

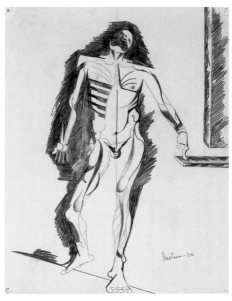

Collection: Private collection.

Provenance: Jacob and Gwendolyn Knight Lawrence, Seattle.

V-14

Figure Study after Vesalius [*Frontal with Crate*]
ca. 1970
graphite on paper
8 × 6 in. (20.3 × 15.2 cm)
signed lower left "Jacob Lawrence"

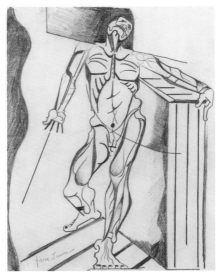

Collection: Jacob and Gwendolyn Knight Lawrence. Courtesy of DC Moore Gallery, New York.

Exhibitions: DC Moore 1996a; DC Moore Gallery, New York, *Revealing Images: Selected Works on Paper*, October 7–November 1, 1997; The Aldrich Museum of Contemporary Art, Ridgefield, Conn., *The Nude in Contemporary Art*, June 6–September 12, 1999.

References: DC Moore 1996b, p. 31, ill. (as *Figure Study after Vesalius*).

V-15

Figure Study after Vesalius [*Frontal with Compass and Staff*]
1979, 1996
graphite on paper
8½ × 6½ in. (21.6 × 16.5 cm)
signed lower right "Jacob Lawrence"

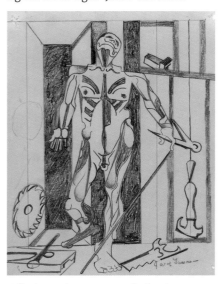

Collection: Burl J. F. Moone III, Pittsburgh.

Provenance: Jacob and Gwendolyn Knight Lawrence, Seattle; [Francine Seders Gallery, Seattle].

Exhibitions: Southern Methodist 1996, no. 14.

References: Van Keuren 1996, no. 14, ill.

V-16

Figure Study after Vesalius [*Frontal with Wrench*]
ca. 1975
graphite on paper
9 × 6 in. (22.9 × 15.2 cm)
signed lower right "Jacob Lawrence"

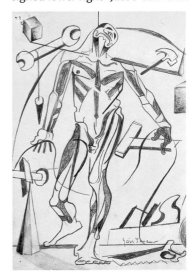

Collection: Jacob and Gwendolyn Knight Lawrence. Courtesy of Francine Seders Gallery, Seattle.

Exhibitions: Southern Methodist 1996, no. 11.

References: Van Keuren 1996, no. 11, ill.

V-17

Figure Study after Vesalius [**Frontal with Tools**]
1979, 1996
graphite on paper
8 × 6 in. (20.3 × 15.2 cm)
initialed lower right "J.L."

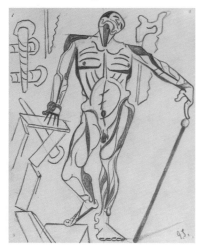

Collection: The Walter O. Evans Collection of African American Art.

Provenance: Jacob and Gwendolyn Knight Lawrence, Seattle; [Francine Seders Gallery, Seattle].

Exhibitions: Southern Methodist 1996, no. 1.

References: Van Keuren 1996, no. 1, ill.

V-18

Figure Study after Vesalius [**Frontal with Hammer and Plane**]
1996
graphite on paper
9½ × 6½ in. (24.1 × 16.5 cm)
signed lower center/right "Jacob Lawrence"

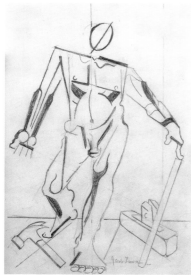

Collection: Jacob and Gwendolyn Knight Lawrence. Courtesy of DC Moore Gallery, New York.

Exhibitions: DC Moore 1996a; The Aldrich Museum of Contemporary Art, Ridgefield, Conn., *The Nude in Contemporary Art*, June 6–September 12, 1999.

References: DC Moore 1996b, p. 37, ill.

Remarks: A.k.a. *Standing Male Nude with Hammer and Plane.*

V-19

Figure Study after Vesalius [**Frontal with Right Arm Raised**]
N.D.
pen and ink on paper
5¾ × 4⅞ in. (14.6 × 12.4 cm)
unsigned

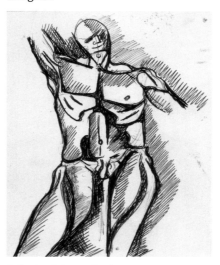

Collection: Private collection.

Provenance: Jacob and Gwendolyn Knight Lawrence, Seattle.

V-20

Figure Study after Vesalius [**Frontal**]
ca. 1970
brush and ink on paper
24 × 18 in. (61 × 45.7 cm)
signed lower right "Jacob Lawrence"; verso: inscribed "Figure Study"

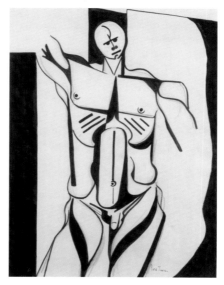

Collection: Jacob and Gwendolyn Knight Lawrence. Courtesy of DC Moore Gallery, New York.

Exhibitions: DC Moore 1996a.

References: DC Moore 1996b, p. 33, ill. (as *Figure Study*).

Remarks: Signed by the artist in the mid-1990s.

V-21
Figure Study after Vesalius [Frontal with Saw and Compass]
1996
graphite on paper
9½ × 6½ in. (24.1 × 16.5 cm)
signed lower right "Jacob Lawrence"

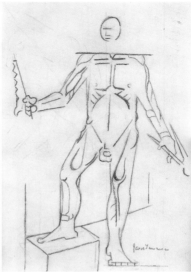

Collection: Jacob and Gwendolyn Knight Lawrence. Courtesy of DC Moore Gallery, New York.

Exhibitions: DC Moore 1996a (Arkansas only).

References: DC Moore 1996b, p. 34, ill. (as *Standing Man with Saw and Compass*).

V-22
Figure Study after Vesalius [Frontal with Table]
1996
graphite on paper
8½ × 6½ in. (21.6 × 16.5 cm)
signed lower right "Jacob Lawrence"

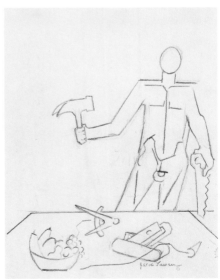

Collection: The Walter O. Evans Collection of African American Art.

Provenance: Jacob and Gwendolyn Knight Lawrence, Seattle; [Francine Seders Gallery, Seattle].

Exhibitions: Southern Methodist 1996, no. 20; Henry Art Gallery 1998.

References: Van Keuren 1996, no. 20, ill.

Remarks: A.k.a. *Standing Figure with Hammer and Saw.*

V-23
Figure Study after Vesalius [¾ Frontal]
1976
graphite on paper
11 × 8½ in. (27.9 × 21.6 cm)
unsigned

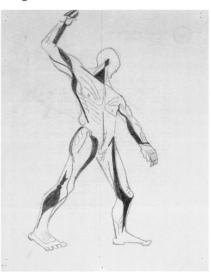

Collection: Private collection.

Provenance: Jacob and Gwendolyn Knight Lawrence, Seattle.

V-24
Figure Study after Vesalius [¾ Frontal without Shading]
N.D.
graphite on paper
24 × 18 in. (61 × 45.7 cm)
unsigned

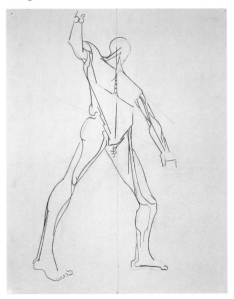

Collection: Private collection.

Provenance: Jacob and Gwendolyn Knight Lawrence, Seattle.

V-25

Figure Study after Vesalius [¾ *Frontal with Shading*]
N.D.
graphite on paper
24 × 18 in. (61 × 45.7 cm)
unsigned

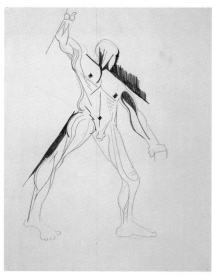

Collection: Private collection.
Provenance: Jacob and Gwendolyn Knight Lawrence, Seattle.

V-26

Figure Study after Vesalius [¾ *Frontal with Tools*]
1979, 1996
graphite on paper
8⅝ × 6 in. (21.9 × 15.2 cm)
signed lower right "Jacob Lawrence"

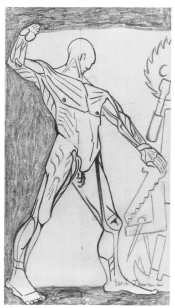

Collection: The Walter O. Evans Collection of African American Art.
Provenance: Jacob and Gwendolyn Knight Lawrence, Seattle; [Francine Seders Gallery, Seattle].
Exhibitions: Southern Methodist 1996, no. 18; Henry Art Gallery 1998.
References: Van Keuren 1996, no. 18, ill.

V-27

Figure Study after Vesalius [¾ *Frontal with Silhouette*]
ca. 1974
graphite on paper
8½ × 5¾ in. (21.6 × 14.6 cm)
signed lower center/right "Jacob Lawrence"

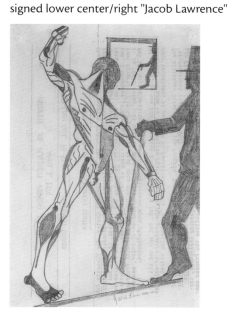

Collection: Carol Bennett.
Provenance: Jacob and Gwendolyn Knight Lawrence, Seattle; [Francine Seders Gallery, Seattle].
Exhibitions: DC Moore 1996a.
References: DC Moore 1996b, p. 30, ill.

V-28

Figure Study after Vesalius [¾ *Frontal with Lines*]
1996
graphite on paper
9½ × 6½ in. (24.1 × 16.5 cm)
signed lower center/right "Jacob Lawrence"

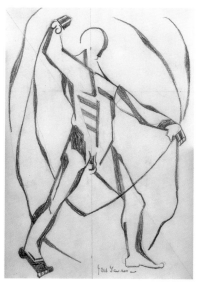

Collection: Jacob and Gwendolyn Knight Lawrence. Courtesy of DC Moore Gallery, New York.
Exhibitions: DC Moore 1996a.
References: DC Moore 1996b, p. 38, ill. (as *Standing Nude Study*).

V-29
Figure Study after Vesalius [*Leaning*]
N.D.
graphite on paper
8½ × 11 in. (21.6 × 27.9 cm)
unsigned

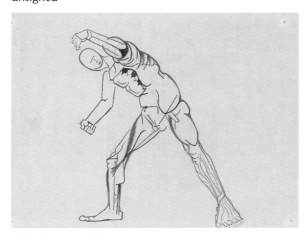

Collection: Private collection.

Provenance: Jacob and Gwendolyn Knight Lawrence, Seattle.

V-30
Figure Study after Vesalius [*Leaning*]
N.D.
graphite on paper
8½ × 11 in (21.6 × 27.9 cm)
unsigned

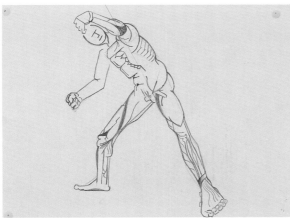

Collection: Private collection.

Provenance: Jacob and Gwendolyn Knight Lawrence, Seattle.

V-31
Figure Study after Vesalius [*Leaning with Diagonal Line*]
N.D.
graphite on paper
9¾ × 12¼ in. (24.8 × 31.1 cm)
unsigned

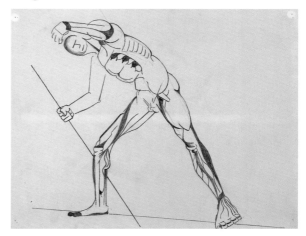

Collection: Private collection.

Provenance: Jacob and Gwendolyn Knight Lawrence, Seattle.

V-32
Figure Study after Vesalius [*Leaning with Arc*]
N.D.
graphite on paper
18 × 24 in. (45.7 × 61 cm)
unsigned

Collection: Private collection.

Provenance: Jacob and Gwendolyn Knight Lawrence, Seattle.

V-33

Figure Study after Vesalius [*Leaning with Vertical Line*]
ca. 1977
graphite on paper
11 × 8½ in. (27.9 × 21.6 cm)
unsigned

Collection: Private collection.

Provenance: Jacob and Gwendolyn Knight Lawrence, Seattle.

V-34

Figure Study after Vesalius [*Leaning with Bird Staff*]
1979
graphite on paper
8½ × 11 in. (21.6 × 27.9 cm)
initialed and dated lower right "J.L. 1979"

Collection: Private collection.

Provenance: Jacob and Gwendolyn Knight Lawrence, Seattle.

V-35

Figure Study after Vesalius [*Leaning with Plumb Bob*]
1979, 1996
graphite on paper
8½ × 7½ in. (21.6 × 19.1 cm)
signed lower right "Jacob Lawrence"

Collection: Ida Cole, Seattle.

Provenance: Jacob and Gwendolyn Knight Lawrence, Seattle; [Francine Seders Gallery, Seattle].

Exhibitions: Southern Methodist 1996, no. 19; Henry Art Gallery 1998.

References: Van Keuren 1996, no. 19, ill.

V-36

Figure Study after Vesalius [*Leaning*]
N.D.
graphite on paper
18 × 24 in. (45.7 × 61 cm)
unsigned

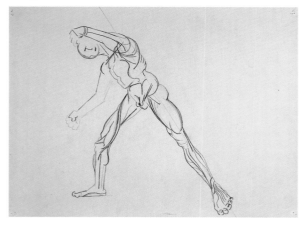

Collection: Private collection.

Provenance: Jacob and Gwendolyn Knight Lawrence, Seattle.

V-37
Figure Study after Vesalius [*Leaning Holding Diagonal Line*]
N.D.
graphite on paper
18 × 24 in. (45.7 × 61 cm)
unsigned

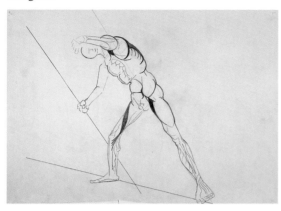

Collection: Private collection.

Provenance: Jacob and Gwendolyn Knight Lawrence, Seattle.

V-38
Figure Study after Vesalius [*Leaning Standing on Two Diagonal Lines*]
N.D.
graphite on paper
18 × 24 in. (45.7 × 61 cm)
unsigned

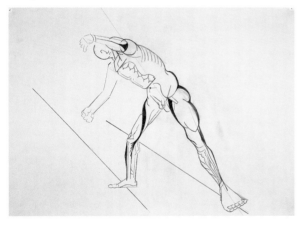

Collection: Private collection.

Provenance: Jacob and Gwendolyn Knight Lawrence, Seattle.

V-39
Figure Study after Vesalius [*Leaning with Tool Shelf*]
1979, 1996
graphite on paper
8½ × 6½ in. (21.6 × 16.5 cm)
unsigned; dated lower center/right "Sept. 1st 79"

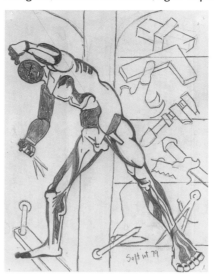

Collection: The Walter O. Evans Collection of African American Art.

Provenance: Jacob and Gwendolyn Knight Lawrence, Seattle; [Francine Seders Gallery, Seattle].

Exhibitions: Southern Methodist 1996, no. 8.

References: Van Keuren 1996, no. 8, ill.

V-40
Figure Study after Vesalius [*Leaning with Tool Shelf and Bowl of Fruit*]
1979, 1996
graphite on paper
8 × 10½ in. (20.3 × 26.7 cm)
initialed and dated lower center "J.L. 79"

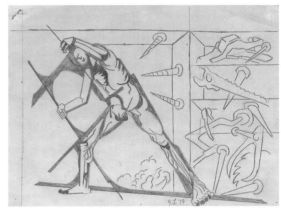

Collection: The Walter O. Evans Collection of African American Art.

Provenance: Jacob and Gwendolyn Knight Lawrence, Seattle; [Francine Seders Gallery, Seattle].

Exhibitions: Southern Methodist 1996, no. 3.

References: Van Keuren 1996, no. 3, ill.

V-41
Figure Study after Vesalius [¾ *Back*]
1979
graphite on paper
11 × 8½ in. (27.9 × 21.6 cm)
initialed and dated lower center "J.L. 1979"

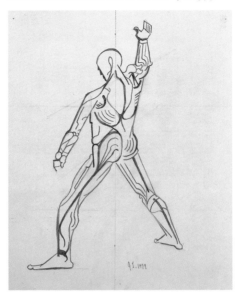

Collection: Private collection.
Provenance: Jacob and Gwendolyn Knight Lawrence, Seattle.

V-42
Figure Study after Vesalius [¾ *Back Standing on Line*]
N.D.
graphite on paper
12¼ × 10 in. (31.1 × 25.4 cm)
unsigned

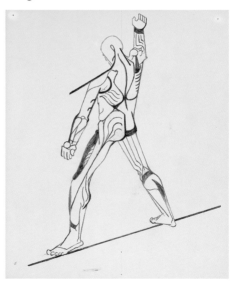

Collection: Private collection.
Provenance: Jacob and Gwendolyn Knight Lawrence, Seattle.

V-43
Figure Study after Vesalius [¾ *Back with Shading*]
1979
graphite on paper
11 × 7½ in. (27.9 × 19.1 cm)
initialed and dated lower center "J.L. 79"

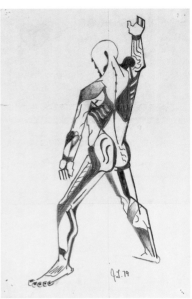

Collection: Private collection.
Provenance: Jacob and Gwendolyn Knight Lawrence, Seattle.

V-44
Figure Study after Vesalius [¾ *Back*]
ca. 1980
graphite on paper
24 × 18 in. (61 × 45.7 cm)
unsigned

Collection: Private collection.
Provenance: Jacob and Gwendolyn Knight Lawrence, Seattle.

V-45
Figure Study after Vesalius [¾ *Back with Line*]
1980
graphite on paper
24 × 18 in. (61 × 45.7 cm)
signed and dated lower right "Jacob Lawrence 1980"

Collection: Private collection.

Provenance: Jacob and Gwendolyn Knight Lawrence, Seattle.

V-46
Figure Study after Vesalius [¾ *Back with Line and Shading*]
1980
graphite on paper
24 × 18 in. (61 × 45.7 cm)
signed and dated lower right "Jacob Lawrence 1980"

Collection: Private collection.

Provenance: Jacob and Gwendolyn Knight Lawrence, Seattle.

V-47
Figure Study after Vesalius [¾ *Back with Coat at Left*]
1979, 1996
graphite on paper
9½ × 6½ in. (24.1 × 16.5 cm)
signed lower right "Jacob Lawrence"

Collection: The Walter O. Evans Collection of African American Art.

Provenance: Jacob and Gwendolyn Knight Lawrence, Seattle; [Francine Seders Gallery, Seattle].

Exhibitions: Southern Methodist 1996, no. 2.

References: Van Keuren 1996, no. 2, ill.

V-48
Figure Study after Vesalius [¾ *Back with Coat at Right*]
N.D.
graphite on paper
8½ × 5½ in. (21.6 × 14 cm)
signed lower right "Jacob Lawrence"

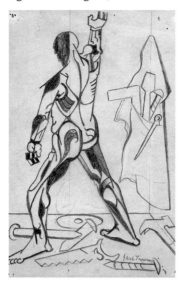

Collection: Jacob and Gwendolyn Knight Lawrence. Courtesy of Francine Seders Gallery, Seattle.

Exhibitions: Southern Methodist 1996, no. 12.

References: Van Keuren 1996, no. 12, ill.

V-49
Figure Study after Vesalius [¾ *Back with Open Door*]
1979, 1996
graphite on paper
8½ × 5½ in. (21.6 × 14 cm)
signed lower center "Jacob Lawrence"

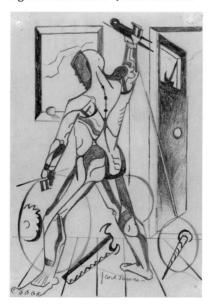

Collection: Carol Bennett, Seattle.

Provenance: Jacob and Gwendolyn Knight Lawrence, Seattle; [Francine Seders Gallery, Seattle].

Exhibitions: Southern Methodist 1996, no. 4.

References: Van Keuren 1996, no. 4, ill.

V-50
Figure Study after Vesalius [¾ *Back with Sinuous Line*]
1979
graphite on paper
9 × 6 in. (22.9 × 15.2 cm)
signed lower center "Jacob Lawrence"

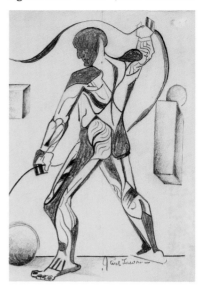

Collection: Carol Bennett, Seattle.

Provenance: Jacob and Gwendolyn Knight Lawrence, Seattle; [Francine Seders Gallery, Seattle].

Exhibitions: Southern Methodist 1996, no. 7.

References: Van Keuren 1996, no. 7, ill.

V-51
Figure Study after Vesalius [¾ *Back with Tools and Bowl of Fruit*]
1979, 1996
graphite on paper
8 × 8 in. (20.3 × 20.3 cm)
signed lower right "Jacob / Lawrence"

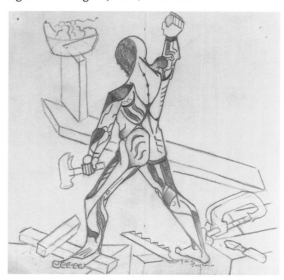

Collection: The Walter O. Evans Collection of African American Art.

Provenance: Jacob and Gwendolyn Knight Lawrence, Seattle; [Francine Seders Gallery, Seattle].

V-52
Figure Study after Vesalius [*Back*]
N.D.
graphite on paper
24 × 18 in. (61 × 45.7 cm)
unsigned

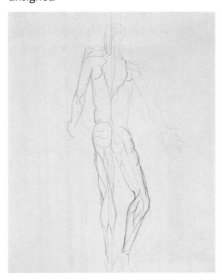

Collection: Private collection.

Provenance: Jacob and Gwendolyn Knight Lawrence, Seattle.

V-53
Figure Study after Vesalius [*Back with Lines and Shading*]
N.D.
graphite on paper
24 × 18 in. (61 × 45.7 cm)
unsigned

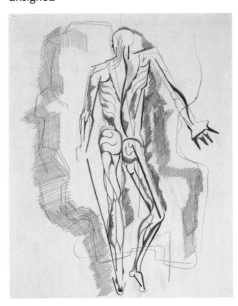

Collection: Private collection.

Provenance: Jacob and Gwendolyn Knight Lawrence, Seattle.

V-54
Figure Study after Vesalius [*Back with Rectangle and Shading*]
N.D.
graphite on paper
8 × 6 in. (20.3 × 15.2 cm)
unsigned

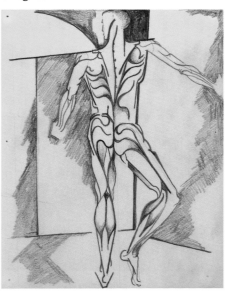

Collection: Private collection.

Provenance: Jacob and Gwendolyn Knight Lawrence, Seattle.

V-55
Figure Study after Vesalius [*Back with Cue*]
N.D.
graphite on paper
8½ × 6 in. (21.6 × 15.2 cm)
initialed lower right "J. L."

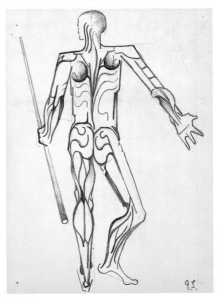

Collection: Private collection.

Provenance: Jacob and Gwendolyn Knight Lawrence, Seattle.

V-71
Figure Studies after Vesalius [*Back*]
N.D.
graphite on paper
18 × 24 in. (45.7 × 61 cm)
unsigned

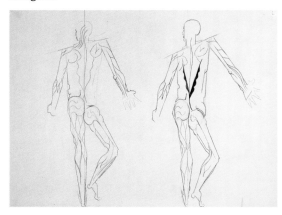

Collection: Private collection.

Provenance: Jacob and Gwendolyn Knight Lawrence, Seattle.

V-72
Figure Studies after Vesalius [*Frontal, Back*]
1980
graphite on paper
dimensions unknown
signed and dated lower right "Jacob Lawrence 1980"

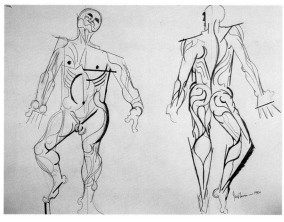

Collection: Current location unknown.

V-73
Figure Studies after Vesalius [*Back, Back, Back*]
N.D.
graphite on paper
24 × 18 in. (61 × 45.7 cm)
unsigned

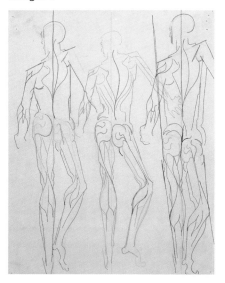

Collection: Private collection.

Provenance: Jacob and Gwendolyn Knight Lawrence, Seattle.

V-74
Figure Studies after Vesalius [*Frontal, Back, Profile*]
N.D.
graphite on paper
18 × 24 in. (45.7 × 61 cm)
unsigned

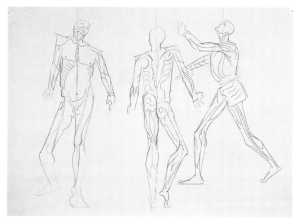

Collection: Private collection.

Provenance: Jacob and Gwendolyn Knight Lawrence, Seattle.

V-52
Figure Study after Vesalius [*Back*]
N.D.
graphite on paper
24 × 18 in. (61 × 45.7 cm)
unsigned

Collection: Private collection.

Provenance: Jacob and Gwendolyn Knight Lawrence, Seattle.

V-53
Figure Study after Vesalius [*Back with Lines and Shading*]
N.D.
graphite on paper
24 × 18 in. (61 × 45.7 cm)
unsigned

Collection: Private collection.

Provenance: Jacob and Gwendolyn Knight Lawrence, Seattle.

V-54
Figure Study after Vesalius [*Back with Rectangle and Shading*]
N.D.
graphite on paper
8 × 6 in. (20.3 × 15.2 cm)
unsigned

Collection: Private collection.

Provenance: Jacob and Gwendolyn Knight Lawrence, Seattle.

V-55
Figure Study after Vesalius [*Back with Cue*]
N.D.
graphite on paper
8½ × 6 in. (21.6 × 15.2 cm)
initialed lower right "J. L."

Collection: Private collection.

Provenance: Jacob and Gwendolyn Knight Lawrence, Seattle.

V-56

Figure Study after Vesalius [**Back with Window and Bowl**]
N.D.
graphite on paper
dimensions unknown
unsigned

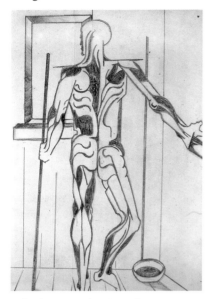

Collection: Current location unknown.

V-57

Figure Study after Vesalius [**Back with Plumb Bob**]
1979, 1996
graphite on paper
9½ × 6½ in. (24.1 × 16.5 cm)
signed lower right "Jacob Lawrence"

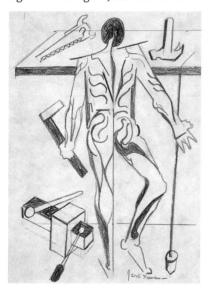

Collection: Jacob and Gwendolyn Knight Lawrence. Courtesy of Francine Seders Gallery, Seattle.
Exhibitions: Southern Methodist 1996, no. 5.
References: Van Keuren 1996, no. 5, ill.

V-58

Figure Study after Vesalius [**Back with Tools and Steps**]
1979, 1996
graphite on paper
8½ × 5½ in. (21.6 × 14 cm)
signed lower right "Jacob Lawrence"

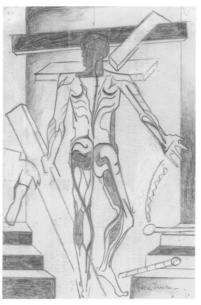

Collection: The Walter O. Evans Collection of African American Art.
Provenance: Jacob and Gwendolyn Knight Lawrence, Seattle; [Francine Seders Gallery, Seattle].
Exhibitions: Southern Methodist 1996, no. 9; Henry Art Gallery 1998.
References: Van Keuren 1996, no. 9, ill.

V-59

Figure Study after Vesalius [*Back with Hanging Saw*]

ca. 1975

graphite on paper

9⅝ × 6⅜ in. (24.4 × 16.2 cm)

signed lower right "Jacob Lawrence"

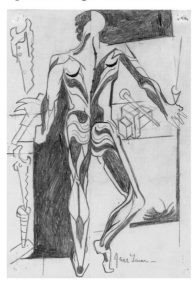

Collection: Ida Cole, Seattle.

Provenance: Jacob and Gwendolyn Knight Lawrence, Seattle; [Francine Seders Gallery, Seattle].

Exhibitions: Southern Methodist 1996, no. 17.

References: Van Keuren 1996, no. 17, ill.

V-60

Figure Study after Vesalius [*Back with Hammer and Saw*]

ca. 1975

graphite on paper

9½ × 5⅛ in. (24.1 × 13 cm)

signed lower right "Jacob Lawrence"

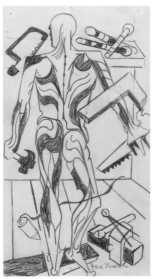

Collection: Ida Cole, Seattle.

Provenance: Jacob and Gwendolyn Knight Lawrence, Seattle; [Francine Seders Gallery, Seattle].

Exhibitions: Southern Methodist 1996, no. 6.

References: Van Keuren 1996, no. 6, ill.

V-61

Figure Study after Vesalius [*Back*]

N.D.

pen and ink on paper

6 × 4⅝ in. (15.2 × 11.7 cm)

unsigned

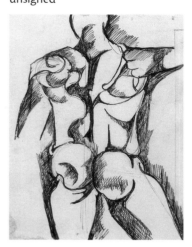

Collection: Private collection.

Provenance: Jacob and Gwendolyn Knight Lawrence, Seattle.

V-62

Figure Study after Vesalius [*Back with Right Angle*]

1996

graphite on paper

9½ × 6½ in. (24.1 × 16.5 cm)

signed lower right "Jacob Lawrence"

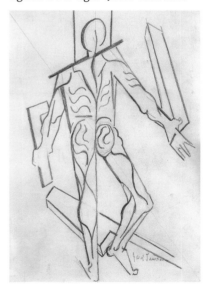

Collection: Jacob and Gwendolyn Knight Lawrence. Courtesy of DC Moore Gallery, New York.

Exhibitions: DC Moore 1996a (Little Rock only); The Aldrich Museum of Contemporary Art, Ridgefield, Conn., *The Nude in Contemporary Art*, June 6–September 12, 1999.

References: DC Moore 1996b, p. 32, ill. (as *Standing Man with Right Angle*).

V-63
Figure Study after Vesalius [Back with Hat and Cane]
1996
graphite on paper
9½ × 6½ in. (24.1 × 16.5 cm)
signed lower right "Jacob Lawrence"

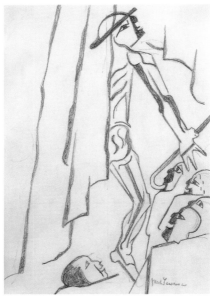

Collection: Jacob and Gwendolyn Knight Lawrence. Courtesy of DC Moore Gallery, New York.

Exhibitions: DC Moore 1996a.

References: DC Moore 1996b, p. 36, ill. (as *Stage Performer*).

V-64
Figure Studies after Vesalius [Leaning and Frontal with Shading]
N.D.
graphite on paper
18 × 24 in. (45.7 × 61 cm)
unsigned

Collection: Private collection.

Provenance: Jacob and Gwendolyn Knight Lawrence, Seattle.

V-65
Figure Studies after Vesalius [Leaning and Frontal with Lines]
1986
graphite on paper
18 × 24 in. (45.7 × 61 cm)
signed and dated lower right "Jacob Lawrence 1986"

Collection: Private collection.

Provenance: Jacob and Gwendolyn Knight Lawrence, Seattle.

V-66
Figures Studies after Vesalius [¾ Back and ¾ Frontal]
N.D.
graphite on paper
18 × 24 in. (45.7 × 61 cm)
unsigned

Collection: Private collection.

Provenance: Jacob and Gwendolyn Knight Lawrence, Seattle.

V-67
Figure Studies after Vesalius [*¾ Back and ¾ Frontal*]
N.D.
graphite on paper
18 × 24 in. (45.7 × 61 cm)
unsigned

Collection: Private collection.
Provenance: Jacob and Gwendolyn Knight Lawrence, Seattle.

V-68
Figure Studies after Vesalius [*Back and ¾ Back with Tools*]
1979, 1996
graphite on paper
8½ × 11 in. (21.6 × 27.9 cm)
signed lower right "Jacob Lawrence"

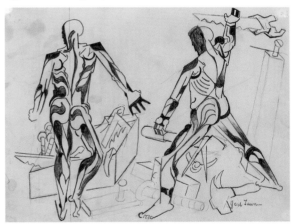

Collection: Jacob and Gwendolyn Knight Lawrence. Courtesy of Francine Seders Gallery, Seattle.
Exhibitions: Southern Methodist 1996, no. 15; Henry Art Gallery 1998.
References: Van Keuren 1996, no. 15, ill.

V-69
Figure Studies after Vesalius [*¾ Frontal and ¾ Back with Dog*]
N.D.
graphite on paper
18 × 24 in. (45.7 × 61 cm)
unsigned

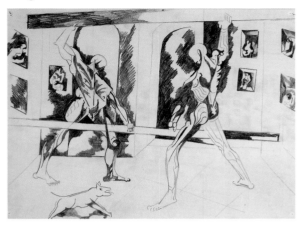

Collection: Private collection.
Provenance: Jacob and Gwendolyn Knight Lawrence, Seattle.

V-70
Figure Studies after Vesalius [*Back and ¾ Back*]
N.D.
graphite on paper
24 × 18 in. (61 × 45.7 cm)
unsigned

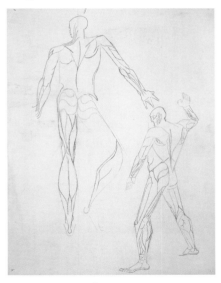

Collection: Private collection.
Provenance: Jacob and Gwendolyn Knight Lawrence, Seattle.

V-71
Figure Studies after Vesalius [*Back*]
N.D.
graphite on paper
18 × 24 in. (45.7 × 61 cm)
unsigned

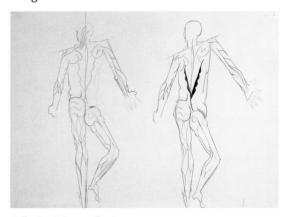

Collection: Private collection.

Provenance: Jacob and Gwendolyn Knight Lawrence, Seattle.

V-72
Figure Studies after Vesalius [*Frontal, Back*]
1980
graphite on paper
dimensions unknown
signed and dated lower right "Jacob Lawrence 1980"

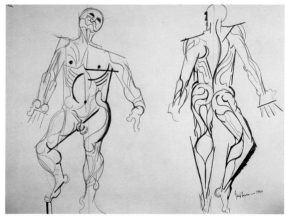

Collection: Current location unknown.

V-73
Figure Studies after Vesalius [*Back, Back, Back*]
N.D.
graphite on paper
24 × 18 in. (61 × 45.7 cm)
unsigned

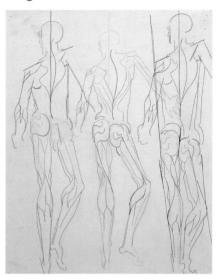

Collection: Private collection.

Provenance: Jacob and Gwendolyn Knight Lawrence, Seattle.

V-74
Figure Studies after Vesalius [*Frontal, Back, Profile*]
N.D.
graphite on paper
18 × 24 in. (45.7 × 61 cm)
unsigned

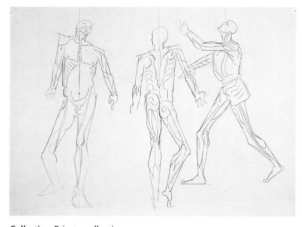

Collection: Private collection.

Provenance: Jacob and Gwendolyn Knight Lawrence, Seattle.

V-75
Figure Studies after Vesalius [*Back, ¾ Frontal, ¾ Back*]
N.D.
graphite on paper
18 × 24 in. (45.7 × 61 cm)
unsigned

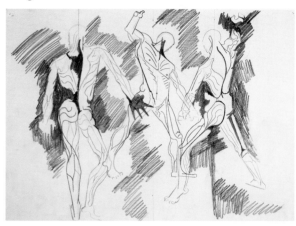

Collection: Private collection.

Provenance: Jacob and Gwendolyn Knight Lawrence, Seattle.

V-76
Figure Studies after Vesalius [*¾ Back, ¾ Frontal, Frontal*]
N.D.
pastel and charcoal on paper
18 × 24 in. (45.7 × 61 cm)
unsigned

Collection: Private collection.

Provenance: Jacob and Gwendolyn Knight Lawrence, Seattle.

Murals

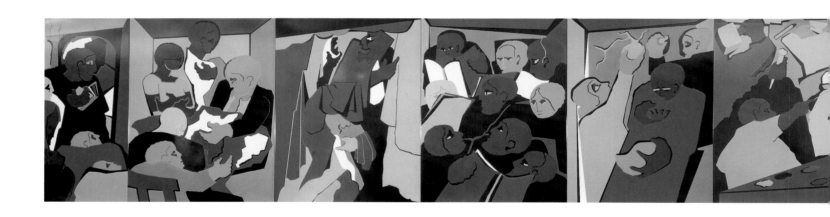

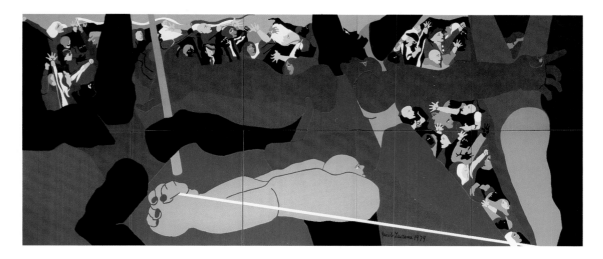

M79-01
Games
1979
porcelain enamel on steel
90 × 115 × 1 in. (228.6 × 292.1 × 2.5 cm)
signed and dated lower center/right "Jacob Lawrence 1979"

Collection: King County Public Art Program, Seattle.

References: Joan Mann, "Artist Jacob Lawrence Commissioned by KCAC to Create His First Mural This Fall at King County Domed Stadium," *The Arts: Newsletter of the King County Arts Commission, Washington* (February 1978), pp. 1–2.

Remarks: Commissioned by the King County One Percent for Art Collection for installation in the Kingdome, Seattle. Relocated in 2000 to Washington State Convention Center, Seattle.

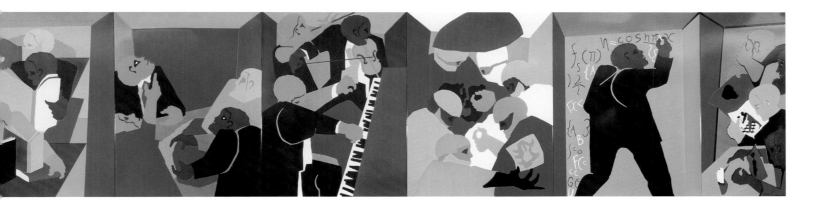

M80-01
Explorations
1980
porcelain enamel on steel
56 × 471 × 1 in. (142.2 × 1196.3 × 2.5 cm)
signed and dated lower right "Jacob Lawrence 1980"

Collection: Howard University Gallery of Art, Washington, D.C.

References: Paul Richard, "The Artist's Universe: Jacob Lawrence's Mural Unveiled at Howard," *Washington Post*, December 4, 1980, p. D1, ill.; Lewis and Sullivan 1982, pp. 24–5, ill.; Michelle-Lee White, "Common Directions, Epic Dimensions: Jacob Lawrence's Murals at Howard University," *International Review of African American Art* 12, 4 (1995), pp. 33–5, ill.

Remarks: Commissioned by Howard University and located in the Armour J. Blackburn University Center, Washington, D.C.

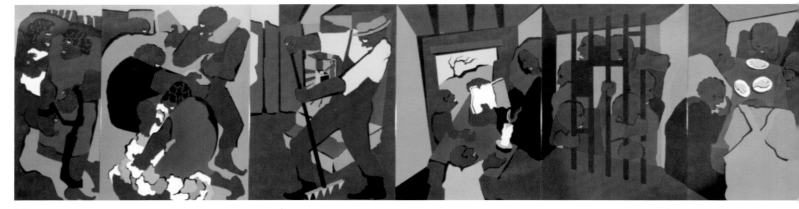

M84-01

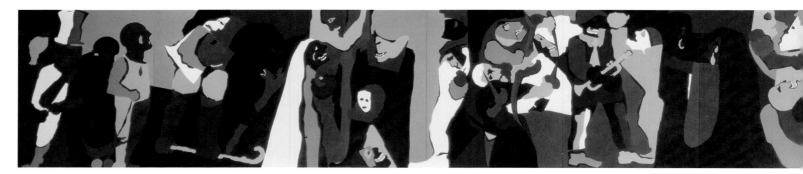

M84-02

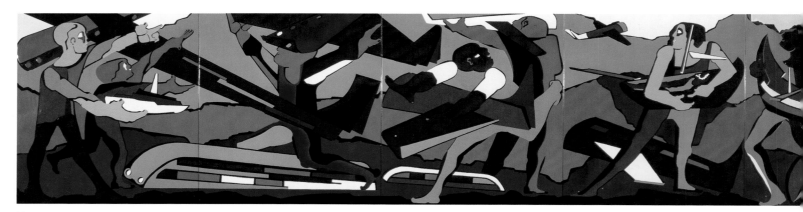

M88-02

M84-01
Origins
1984
porcelain enamel on steel
56 × 471 × 1 in. (142.2 × 1196.3 × 2.5 cm)
signed and dated lower right "Jacob Lawrence 1984"

Collection: Howard University Gallery of Art, Washington, D.C.

References: Michelle-Lee White, "Common Directions, Epic Dimensions: Jacob Lawrence's Murals at Howard University," *International Review of African American Art* 12, 4 (1995), p. 36, ill.

Remarks: Commissioned by Howard University and located in the Armour J. Blackburn University Center, Washington, D.C.

M84-02
Theater
1984
porcelain enamel on steel
51 × 498 × 1½ in. (129.5 × 1264.9 × 3.8 cm)
signed and dated lower right "Jacob Lawrence 1984"

Collection: University of Washington, Campus Art Collection.

References: Wheat 1986, p. 182, pl. 100.

Remarks: Commissioned by the University of Washington and located in the foyer of Meany Hall, a performance theater at the University of Washington, Seattle.

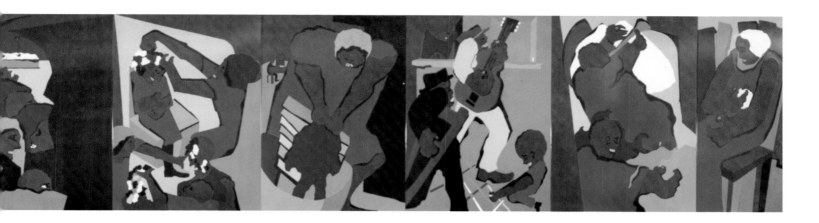

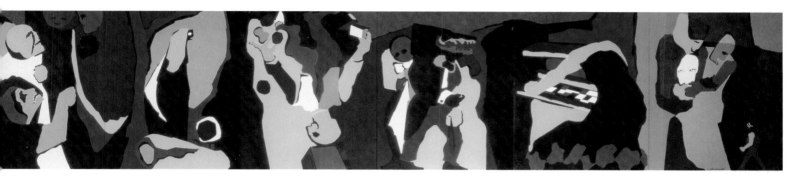

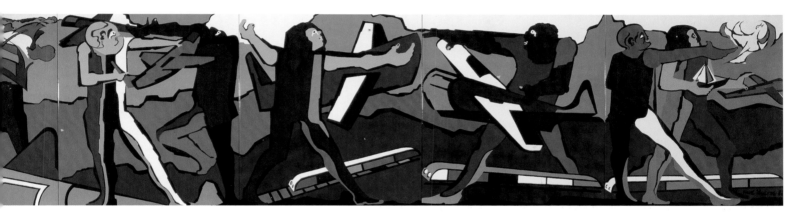

M88-02
Space, Time, Energy
1988
porcelain enamel on steel
42½ × 432 × 2 in. (108 × 1097.3 × 5.1 cm)
signed and dated lower right "Jacob Lawrence 88"

Collection: Commissioned by Greater Orlando Aviation Authority, Orlando International Airport, Florida.

M88-01
Community
1988
fired ceramic tile
141 × 116½ × ¾ in. (358.1 × 295.9 × 1.9 cm)
signed and dated lower right "Jacob Lawrence 88"

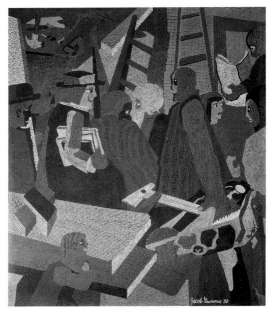

Collection: Commissioned under the Art-In-Architecture Program, General Services Administration, United States Government.

References: Michael Orenson, "Review/Art: Public Art at New Federal Building in Queens," *New York Times*, March 24, 1989, p. C32; Regina Hackett, "Borough of Queens Is a New Outpost of Contemporary Public Art," *Seattle Post-Intelligencer*, July 18, 1989, p. C5, ill.

Remarks: Located in the lobby of the Joseph P. Addabbo Federal Building in New York City.

M91-01
Events in the Life of Harold Washington
1991
fired ceramic tile
126 × 183 × ¾ in. (320 × 464.8 × 1.9 cm)
signed and dated lower right "Jacob Lawrence / 1991"

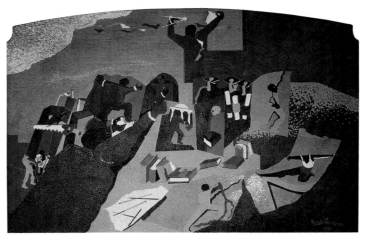

Collection: City of Chicago Public Art Collection.

References: Powell 1992, n.p., ill.; "Jacob Lawrence: Greatest Living Black Painter," *Ebony* (September 1992), p. 66, ill.; *A Guide to the Public Art Collection of the Harold Washington Library Center* (Chicago: Department of Public Affairs, 1993), inside cvr., ill.

Remarks: Commissioned by the City of Chicago Public Art Program and located in the main stairwell of the Harold Washington Library Center.

Abbreviations

AFA 1960–2
American Federation of Arts, New York, *Jacob Lawrence*, 1960–2.

Alan 1956
The Alan Gallery, New York, *Jacob Lawrence: Struggle . . . From the History of the American People,* December 28, 1956–January 19, 1957.

Alan 1958
The Alan Gallery, New York, *Jacob Lawrence: Struggle . . . From the History of the American People,* May 5–24, 1958.

American Artists School 1939
American Artists School, New York, *Jacob Lawrence and Samuel Wechsler,* February 1939.

AMSAC 1964
American Society of African Culture, Lagos, Nigeria, *Jacob Lawrence and Gwendolyn Lawrence,* November 1964.

Arizona State 1990
University Art Museum, Nelson Fine Arts Center, Arizona State University, Tempe, *Jacob Lawrence: Paintings and Prints,* January 21–February 25, 1990.

Brandeis 1965
Rose Art Museum, Brandeis University, Waltham, Mass., *Jacob Lawrence,* March 14–31, 1965.

Brown 1974
Milton W. Brown, *Jacob Lawrence,* exh. cat. (New York: Whitney Museum of American Art, 1974).

Chrysler 1979a
The Chrysler Museum of Art, Norfolk, Va., *Jacob Lawrence: Paintings and Graphics from 1936 to 1978,* October 11–November 18, 1979.

Chrysler 1979b
Jacob Lawrence: Paintings and Graphics from 1936 to 1978, exh. cat. (Norfolk, Va.: The Chrysler Museum of Art, 1979).

DC Moore 1996a
DC Moore Gallery, New York, *Jacob Lawrence: Drawings, 1945 to 1996,* October 9–November 9, 1996 (trav. exh., 1996–7).

DC Moore 1996b
Townsend Wolfe, *Jacob Lawrence: Drawings, 1945 to 1996,* exh. cat. (New York and Little Rock, Ark.: DC Moore Gallery and Arkansas Arts Center, 1996).

DC Moore 1998a
DC Moore Gallery, New York, *Jacob Lawrence: The Builders,* November 18–December 30, 1998.

DC Moore 1998b
Peter T. Nesbett, *Jacob Lawrence: The Builders,* exh. cat. (New York: DC Moore Gallery, 1998).

Dintenfass 1963
Terry Dintenfass Inc., New York, *Jacob Lawrence,* March 25–April 20, 1963.

Dintenfass 1965
Terry Dintenfass Inc., New York, *Jacob Lawrence Paintings,* January 5–30, 1965.

Dintenfass 1968
Terry Dintenfass Inc., New York, *Jacob Lawrence: Paintings for Harriet and the Promised Land,* January 2–20, 1968.

Dintenfass 1973
Terry Dintenfass Inc., New York, *Builders: Jacob Lawrence Paintings,* October 16–November 3, 1973.

Dintenfass 1978
Terry Dintenfass Inc., New York, *Jacob Lawrence: Paintings—Lithographs,* March 4–24, 1978.

Dintenfass 1979
Terry Dintenfass Inc., New York, *Jacob Lawrence: Builders,* October 16–November 3, 1979.

Dintenfass 1983
Terry Dintenfass Inc., New York, *Jacob Lawrence: Recent Drawings,* January 29–February 24, 1983.

Downtown 1943
The Downtown Gallery, New York, *"Harlem" by Jacob Lawrence: Exhibition of Paintings in Gouache,* May 11–29, 1943.

Downtown 1950
The Downtown Gallery, New York, *Jacob Lawrence,* October 24–November 11, 1950.

Downtown 1953
The Downtown Gallery, New York, *Performance: A Series of New Paintings in Tempera by Jacob Lawrence,* January 27–February 14, 1953.

Henry Art Gallery 1998
Henry Art Gallery, University of Washington, Seattle, *Jacob Lawrence: Painting Life,* July 2–September 27, 1998.

Jamaica Arts Center 1984
Jamaica Arts Center, New York, *Jacob Lawrence: Fifty Years of His Work,* December 8, 1984–January 30, 1985.

Katonah 1992
The Katonah Museum of Art, N.Y., *Jacob Lawrence: The Early Decades, 1935–1950,* March 1–April 19, 1992.

Lawrence 1968
Jacob Lawrence, with verses by Robert Kraus, *Harriet and the Promised Land* (New York: Windmill Books, Simon & Schuster, 1968).

Lawrence 1970
Aesop's Fables, with illustrations by Jacob Lawrence (New York: Windmill Books, Simon & Schuster, 1970).

Lawrence 1993
Jacob Lawrence, *Harriet and the Promised Land* (New York: Simon & Schuster, 1993).

Lawrence 1997
Aesop's Fables, with illustrations by Jacob Lawrence (Seattle: University of Washington Press, 1997).

Lemakis 1983
Emmanuel Lemakis, *Jacob Lawrence: An Exhibition of His Work*, exh. cat. (Pomona, N.J.: Art Gallery, Stockton State College, 1983).

Lewis and Hewitt 1982
Samella Lewis with Mary Jane Hewitt, *Jacob Lawrence*, exh. cat. (Santa Monica, Calif.: Santa Monica College, 1982).

Lewis and Hewitt 1988
Samella Lewis with Mary Jane Hewitt, *Jacob Lawrence: Drawings and Prints, Desenhos e Fotografias, Dessins et Gravures*, exh. cat. (Claremont, Calif.: Scripps College of the Claremont Colleges, 1988).

Lewis and Hewitt 1989
Samella Lewis with Mary Jane Hewitt, *Jacob Lawrence: Paintings and Drawings, Pinturas y Dibujos*, exh. cat. (Claremont, Calif.: Scripps College of the Claremont Colleges, 1989).

Lewis and Sullivan 1982
Samella Lewis and Lester Sullivan, "Jacob Lawrence Issue," *Black Art* (New York) 5, 3 (1982).

Lewis and Waddy 1969
Samella Lewis and Ruth G. Waddy, *Black Artists on Art* (Los Angeles: Contemporary Crafts Publishers, 1969).

Meadows 1996
Meadows Museum, Owens Art Center, Southern Methodist University, Dallas, *Jacob Lawrence: Paintings from Two Series, 1940 and 1994*, October 25–December 8, 1996.

Midtown Payson 1993a
Midtown Payson Galleries, New York, *Jacob Lawrence: Paintings, Drawings, and Prints*, November 17, 1993–January 14, 1994.

Midtown Payson 1993b
Jacob Lawrence: Paintings, Drawings, and Prints, exh. cat. (New York: Midtown Payson Galleries, 1993).

Midtown Payson 1995a
Midtown Payson Galleries, New York, *Jacob Lawrence, An Overview: Paintings from 1936–1994*, January 6–February 25, 1995.

Midtown Payson 1995b
Leslie King-Hammond, *Jacob Lawrence, An Overview: Paintings from 1936–1994*, exh. cat. (New York: Midtown Payson Galleries, 1995).

MoMA 1944
The Museum of Modern Art, New York, *Paintings by Jacob Lawrence: Migration of the Negro and Works Made in U.S. Coast Guard*, October 10–November 5, 1944.

Morgan State 1965
Carl Murphy Fine Arts Center Gallery, Morgan State College, Baltimore, *Exhibition of Paintings, Drawings, and Crayons by Jacob Lawrence: Works from a Recent Nigerian Trip*, March 7–April 9, 1965.

Northwest Art 1997
Museum of Northwest Art, La Conner, Wash., *Jacob Lawrence, An American Vision: Paintings and Prints 1942–1996*, March 15–July 2, 1997.

Phil Art 1955
Philadelphia Art Alliance, *Reuben Tam and Jacob Lawrence*, January 3–24, 1955.

Powell 1992
Richard J. Powell, *Jacob Lawrence* (New York: Rizzoli Art Series, 1992).

Pratt 1993
The Rubelle and Norman Schafler Gallery, Pratt Institute, Brooklyn, *Jacob Lawrence: An Exhibition Presented by the Black Alumni of Pratt Institute*, May 15–June 14, 1993.

Saarinen 1960
Aline B. Saarinen, *Jacob Lawrence*, exh. cat. (New York: American Federation of Arts, 1960).

San Antonio 1996
San Antonio Museum of Art, *Jacob Lawrence: An American Society in Transition*, March 28–June 6, 1996.

Santa Monica 1982
The Museum of African-American Art, Santa Monica College, Calif., *Jacob Lawrence*, April 1982.

Savannah 1998
Pinnacle Gallery, Savannah College of Art and Design, Ga., *Jacob Lawrence*, January 8–March 1, 1998.

Scripps 1982
Clark Humanities Museum, Scripps College, Claremont, Calif., *Jacob Lawrence and Gwendolyn Knight*, March 1982.

Seattle 1986–7
Seattle Art Museum, *Jacob Lawrence: American Painter*, July 10–September 7, 1986 (trav. exh., 1986–7).

Seders 1982
Francine Seders Gallery, Seattle, *Jacob Lawrence: Works on Paper*, August 20–September 19, 1982.

Seders 1985
Francine Seders Gallery, Seattle, *Jacob Lawrence: Works on Paper*, December 6–29, 1985.

Seders 1994
Francine Seders Gallery, Seattle, *Jacob Lawrence: New Paintings*, December 2, 1994–January 15, 1995.

Seders 1996
Francine Seders Gallery, Seattle, *Jacob Lawrence: Aesop's Fables*, July 13–August 4, 1996.

Seders 1998
Francine Seders Gallery, Seattle, *Jacob Lawrence as Muralist*, July 2–August 2, 1998.

Seders 1998–2000
Francine Seders Gallery, Seattle, *Jacob Lawrence: Aesop's Fables* (trav. exh., 1998–2000).

Shasta College 1994
Shasta College Gallery, Shasta College, Redding, Calif., *Jacob Lawrence: Prints and Drawings*, October 4–November 8, 1994.

Shippensburg 1994
Kauffman Gallery, Huber Art Center, Shippensburg University of Pennsylvania, *Jacob Lawrence: Works on Paper*, April 4–22, 1994.

Southern Methodist 1996
The Pollock Gallery, Hughes-Trigg Student Center, Southern Methodist University, Dallas, *After Vesalius: Drawings by Jacob Lawrence*, October 21–December 8, 1996.

Stockton State 1983
Art Gallery, Stockton State College, Pomona, N.J., *Jacob Lawrence: An Exhibition of His Work*, February 8–25, 1983.

Tyler 1996
Tyler Museum of Art, Tex., *Jacob Lawrence: The Hiroshima Paintings*, October 5–December 1, 1996.

USIA Africa 1989–90
Arts America Program, United States Information Agency, Washington, D.C., *Jacob Lawrence: Drawings and Prints* (trav. exh., 1989–90).

USIA Caribbean 1989
Arts America Program, United States Information Agency, Washington, D.C., *Jacob Lawrence: Paintings and Drawings* (trav. exh., 1989).

Van Keuren 1996
Philip Van Keuren, *After Vesalius, Drawings by Jacob Lawrence*, exh. cat. (Dallas: Division of Art, Southern Methodist University, 1996).

Whatcom 1992
Whatcom Museum of History and Art, Bellingham, Wash., *Jacob Lawrence*, January 25–April 19, 1992.

Wheat 1986
Ellen Harkins Wheat, *Jacob Lawrence: American Painter*, exh. cat. (Seattle: Seattle Art Museum, 1986).

Whitney 1974–5
Whitney Museum of American Art, New York, *Jacob Lawrence*, May 16–July 7, 1974 (trav. exh., 1974–5).

Willamette 1989
Hallie Brown Ford Gallery, Art Department, Willamette University, Salem, Ore., *Jacob Lawrence: Drawings and Prints*, November 6–December 1, 1989.

Exhibition Chronology

This chronology contains all of the known exhibitions that included paintings or drawings between 1935 and 1999. Incomplete entries have been included with the assumption that even partial data contributes to a more accurate understanding of the contexts in which Lawrence's work was exhibited, and with the hope that future scholarship will locate the missing information. Exhibitions that consisted exclusively of limited-edition prints are not included.

The chronology is organized by exhibition type (solo or group), then by year, then by starting date within each year. Exhibitions for which specific months are not known are grouped at the end of each year.

SOLO EXHIBITIONS

1936
Alston-Bannarn Studios, New York.

1938
135th Street YMCA, New York, *Presenting Jacob Lawrence in an Exhibition of Paintings* (February).

1939
De Porres Interracial Center, New York, *Jacob Lawrence* (May 22–June 5) [*The Life of Toussaint L'Ouverture*].

1940
Columbia University Art Gallery, New York (November 15, 1940–February 1, 1941) [*The Life of Toussaint L'Ouverture*, concurrent with an exhibition of Hokusai's prints].

Southside Community Art Center, Chicago, *Jacob Lawrence: Life of Harriet Tubman.*

1941
The Downtown Gallery, New York, *Jacob Lawrence: The Migration of the Negro* (November) [in conjunction with publication of series in *Fortune* magazine].

1942
Phillips Memorial Gallery, Washington, D.C., *Jacob Lawrence: The Migration of the Negro* (February 14–March 3).

The Museum of Modern Art, New York, *Jacob Lawrence: The Migration Series* (1942–4). Traveled to Vassar College, Poughkeepsie, N.Y. (October 1–22); Kalamazoo Institute, Mich. (November 1–22); The Currier Gallery of Art, Manchester, N.H. (December 1–22); Addison Gallery of American Art, Andover, Mass. (January 1–31, 1943); Wheaton College, Norton, Mass. (March 12–April 2, 1943); California Palace of the Legion of Honor, San Francisco (April 16–May 7, 1943); Portland Art Museum, Ore. (May 17–June 7, 1943); Crocker Art Gallery, Sacramento, Calif. (September 3–24, 1943); Music Town Gallery, Los Angeles (December 1–29, 1943); The Principia, Saint Louis (January 21–February 5, 1944); Indiana University, Bloomington (February 14–March 6, 1944); West Virginia State College, Institute (March 20–April 10, 1944); Lyman Allyn Art Museum, New London, Conn. (April 24–May 15, 1944); Harvard University, Cambridge, Mass. (May 29–June 19, 1944); The Museum of Modern Art, New York (October 10–November 5, 1944).

1943
The Downtown Gallery, New York, *"Harlem" by Jacob Lawrence: Exhibition of Paintings in Gouache* (May 11–29).

1944
The Museum of Modern Art, New York, *Paintings by Jacob Lawrence: Migration of the Negro and Works Made in U.S. Coast Guard* (October 10–November 5).

1945
The Downtown Gallery, New York, *Jacob Lawrence: John Brown, A Series of Twenty-Two Paintings in Gouache* (December 4–29).

1946
American Federation of Arts, New York, *The Life of John Brown by Jacob Lawrence* (1946–7). Traveled to Y.M.C.A., Pittsburgh (March 10–31); Arts and Crafts Center, Pittsburgh (April 15–May 12); The Art Institute of Chicago (as part of *The Fifty-Seventh Annual American Exhibition of Water Colors and Drawings;* June 6–August 18, 151–72 only); The Barnett Aden Gallery, Washington, D.C. (October 1–13); University of Nebraska, Lincoln (November 6–27); Akron Art Institute, Ohio (December 8–29); Central College, Pella, Iowa (January 8–29, 1947); Massillon Museum, Ohio (February 9–March 2, 1947); Allen Memorial Art Museum, Oberlin College, Ohio (March 12–April 1, 1947); Flint Institute of Arts, Mich. (April 11–21, 1947); Drew Fine Arts Center, Hamline University, Saint Paul (May 4–June 1, 1947), Wichita Art Association, Kans. (June 22–July 13, 1947); Portland Art Museum, Ore. (July 27–August 17, 1947); Allied Arts League, Los Angeles (October 5–26, 1947); State College of Washington, Pullman (November 9–30, 1947).

1947
New Jersey State Museum, Trenton, *Jacob Lawrence: The War Series* (November 2–23).

The Downtown Gallery, New York, *War: Fourteen Paintings in Tempera by Jacob Lawrence* (December 2–27).

1948
Smith College Museum of Art, Northampton, Mass., *Jacob Lawrence: The War Series* (April 7–28).

1950
The Downtown Gallery, New York, *Jacob Lawrence* (October 24–November 11).

1953
The Downtown Gallery, New York, *Performance: A Series of New Paintings in Tempera by Jacob Lawrence* (January 27–February 14).

1956
The Alan Gallery, New York, *Jacob Lawrence: Struggle . . . From the History of the American People* (December 28, 1956–January 19, 1957).

1958
The Alan Gallery, New York, *Jacob Lawrence: Struggle . . . From the History of the American People* (May 5–24).

1960
American Federation of Arts, New York, *Jacob Lawrence* (1960–2). Traveled to The Brooklyn Museum (November 22, 1960–January 2, 1961); Art Department, Skidmore College, Saratoga Springs, N.Y. (January 15–February 5, 1961); Allegheny College, Meadville, Pa. (February 19–March 26, 1961); Department of Art, Howard University, Washington, D.C. (April 1–30, 1961); Antioch College, Yellow Springs, Ohio (May 14–June 4, 1961); Art Department, Indiana State College, Terre Haute (July 23–August 20, 1961); Andrew Dickson White Museum, Cornell University, Ithaca, N.Y. (September 5–24, 1961); Art Department, Eastern Tennessee State College, Johnson City (October 8–29, 1961); College of Arts and Sciences, Florida A & M University, Tallahassee (November 12–December 3, 1961); Arkansas College, Fayetteville (December 17, 1961–February 11, 1962); Department of Art, Alabama College, Montealo (February 25–March 18, 1962); Department of Art, Talladega College, Ala. (April 1–22, 1962); Department of Art,

North Carolina Central University, Durham (May 6–27, 1962); Winston-Salem Public Library, N.C. (June 10–July 1, 1962); College of Education, State University of New York at Oneonta (August 19–September 9, 1962); Art Department, Wabash College, Crawfordsville, Ind. (September 23–October 14, 1962); Department of Art, Hampton Institute, Va. (October 28–November 18, 1962).

1961

Washington Federal Savings and Loan Association of Miami Beach, *Jacob Lawrence: Painting Exhibition* (October 16–November 22).

1962

West African Cultural Center, American Society of African Culture, Lagos, Nigeria, *Jacob Lawrence* (October). Traveled to Mbari Artists' and Writers' Club Cultural Center, Ibadan, Nigeria.

The Phillips Collection, Washington, D.C., *Jacob Lawrence: The Migration Series* (December).

1963

Terry Dintenfass Inc., New York, *Jacob Lawrence* (March 25–April 20).

1965

Terry Dintenfass Inc., New York, *Jacob Lawrence Paintings* (January 5–30).

Carl Murphy Fine Arts Center Gallery, Morgan State College, Baltimore, *Exhibition of Paintings, Drawings, and Crayons by Jacob Lawrence: Works from a Recent Nigerian Trip* (March 7–April 9).

Rose Art Museum, Brandeis University, Waltham, Mass., *Jacob Lawrence* (March 14–31).

1966

Martin Gallery, New York, *Jacob Lawrence: The Struggle Series* (February 28–March 12) [21 panels].

1968

Terry Dintenfass Inc., New York, *Jacob Lawrence: Paintings for Harriet and the Promised Land* (January 2–20).

The Art Gallery, Fisk University, Nashville, *Jacob Lawrence: The Toussaint L'Ouverture Series* (December 8–30).

1969

The Studio Museum in Harlem, New York, *Jacob Lawrence: The Toussaint L'Ouverture Series* (November 2, 1969–January 4, 1970).

Art Center at Hargate, Saint Paul's School, Concord, N.H., *Jacob Lawrence: The Migration Series* (November 14–December 7).

1970

Henry Art Gallery, University of Washington, Seattle, *Jacob Lawrence: Work in Progress* (May 27–June 9).

1971

The Detroit Institute of Arts, *Jacob Lawrence: John Brown Series* (May 4–June 6).

1972

The Phillips Collection, Washington, D.C., *Jacob Lawrence: The Migration Series* (September 10–October 23).

1973

Terry Dintenfass Inc., New York, *Builders: Jacob Lawrence Paintings* (October 16–November 3).

1974

Whitney Museum of American Art, New York, *Jacob Lawrence* (May 16–July 7). Traveled to The Saint Louis Art Museum (August 1–September 1); Birmingham Museum of Art, Ala. (September 23–October 23); Seattle Art Museum (November 15–December 15); William Rockhill Nelson Gallery of Art, Kansas City, Mo. (January 6–February 6, 1975); New Orleans Museum of Art (February 27–March 27, 1975).

1976

Francine Seders Gallery, Seattle, *Graphics by Jacob Lawrence* (October 15–November 3).

1978

Spelman College, Atlanta, *Jacob Lawrence* (March 4–24).

Terry Dintenfass Inc., New York, *Jacob Lawrence: Paintings—Lithographs* (March 4–24).

The Detroit Institute of Arts, *The John Brown Series by Jacob Lawrence* (October 14–November 26).

1979

The Chrysler Museum of Art, Norfolk, Va., *Jacob Lawrence: Paintings and Graphics from 1936 to 1978* (October 11–November 18).

Terry Dintenfass Inc., New York, *Jacob Lawrence: Builders* (October 16–November 3).

1981

Portsmouth Community Art Center, Va. (January 31–March 1) [*The Life of Frederick Douglass* and *The Life of Harriet Tubman*].

1982

Mississippi Museum of Art, Jackson, *Jacob Lawrence: The Builder* (January 24–March 4).

The Museum of African-American Art, Santa Monica College, Calif., *Jacob Lawrence* (April).

Francine Seders Gallery, Seattle, *Jacob Lawrence: Works on Paper* (August 20–September 19).

Conference for the Council of Churches, New York, *Jacob Lawrence: Toussaint L'Ouverture Series* (September).

U.S. Army Transportation Museum, Fort Eustis, Va., *Jacob Lawrence: The Frederick Douglass Series* (September 3–18).

Lowe Art Museum, University of Miami, Coral Gables, Fla., *Jacob Lawrence: Toussaint L'Ouverture Series* (December 8, 1982–January 16, 1983).

1983

Terry Dintenfass Inc., New York, *Jacob Lawrence: Recent Drawings* (January 29–February 24).

Art Gallery, Stockton State College, Pomona, N.J., *Jacob Lawrence: An Exhibition of His Work* (February 8–25).

Howard University Gallery of Art, Washington, D.C., *Jacob Lawrence: Toussaint L'Ouverture Series* (October–November).

Faculty Club, University of Washington, Seattle, *A Black Experience: Paintings, Drawings, and Prints by Professor Jacob A. Lawrence* (October 5–November 23).

Hampton University Museum, Va., *Jacob Lawrence: Toussaint L'Ouverture Series* (November–December).

1984

The Thompson Gallery, Massachusetts College of Art, Boston, *Jacob Lawrence* (January 20–February 15).

Portland Art Museum, Ore., *Jacob Lawrence: Toussaint L'Ouverture Series* (September 11–November 4).

Jamaica Arts Center, New York, *Jacob Lawrence: Fifty Years of His Work* (December 8, 1984–January 30, 1985).

1985

Francine Seders Gallery, Seattle, *Jacob Lawrence: Works on Paper* (December 6–29).

1986

Albright-Knox Art Gallery, Buffalo, *Jacob Lawrence: The Harriet Tubman Series* (January 18–March 2).

Seattle Art Museum, *Jacob Lawrence: American Painter* (July 10–September 7). Traveled to The Oakland Museum, Calif. (September 26–November 30); High Museum of Art, Atlanta (December 16, 1986–March 1, 1987); The Phillips Collection, Washington, D.C. (April 3–June 1, 1987); Dallas Museum of Art (July 19–September 6, 1987); The Brooklyn Museum (October 1–December 1, 1987).

1989

Arts America Program, United States Information Agency, Washington, D.C., *Jacob Lawrence: Drawings and Prints* (1989–90). Traveled to National Gallery of Zimbabwe, Harare (January 1–23); Johannesburg Art Foundation (February 10–March 3); Markerere Art Gallery, Kampala, Uganda (April 10–May 10); American Cultural Center, Dakar, Senegal (June); USIS Cultural Center, Abidjan, Ivory Coast (September); National Museum of Liberia, Monrovia (November); National Museum, Lagos, Nigeria (January–February, 1990); Brazzaville, Republic of Congo (March 15–April 15, 1990).

Arts America Program, United States Information Agency, Washington, D.C., *Jacob Lawrence: Paintings and Drawings* (1989). Traveled to Bank of Nova Scotia, Port of Spain, Trinidad and Tobago (February); Museo de Arte Contemporáneo de Caracas, Venezuela (April); Queens Park Gallery, Bridgetown, Barbados (May–June); National Gallery of Jamaica, Kingston (October–November).

Tacoma Art Museum, Wash., *Jacob Lawrence: The Washington Years* (February 3–April 2).

Syracuse University, N.Y., *Jacob Lawrence: A Continuing Presence, An Exhibition of His Work from Private Collections* (February 15–March 11).

Hallie Brown Ford Gallery, Art Department, Willamette University, Salem, Ore., *Jacob Lawrence: Drawings and Prints* (November 6–December 1).

1990

Aetna Gallery, Hartford, Conn., *Jacob Lawrence: Toussaint L'Ouverture Series* (January 4–March 4).

University Art Museum, Nelson Fine Arts Center, Arizona State University, Tempe, *Jacob Lawrence: Paintings and Prints* (January 21–February 25).

1991

New Orleans Contemporary Arts Center, *Jacob Lawrence: Toussaint L'Ouverture Series* (January–March).

Hampton University Museum, Va., *Jacob Lawrence: The Frederick Douglass and Harriet Tubman Series of 1938–40* (1991–8). Traveled to Memorial Art Gallery of the University of Rochester, N.Y. (February 16–April 14); Philadelphia Museum of Art (May 4–June 30); The Studio Museum of Harlem, New York (August 1–November 5); The Baltimore Museum of Art (November 26, 1991–February 23, 1992); Delaware Art Museum, Wilmington (March 6–April 2, 1992); The Art Institute of Chicago (May 13–August 2, 1992); The Museum of Fine Arts, Houston (September 13–November 29, 1992); Joslyn Art Museum, Omaha (February 13–April 18, 1993); Los Angeles County Museum of Art (June 10–August 22, 1993); The Fine Arts Museums of San Francisco (September 15, 1993–January 2, 1994); Tacoma Art Museum, Wash. (March 8–May 29, 1994); Hampton University Museum, Va. (January 16–July 31, 1995); Virginia Museum of Fine Arts, Richmond (November 16, 1996–January 19, 1997); Greenville County Museum of Art, S.C. (March 8–May 29, 1997); The Minneapolis Institute of Arts (February 22–May 3, 1998); New Bedford Art Museum, Mass. (July 31–November 1, 1998).

1992

Whatcom Museum of History and Art, Bellingham, Wash., *Jacob Lawrence* (January 25–April 19).

Wellington B. Gray Gallery, School of Art, East Carolina University, Greenville, N.C., *Jacob Lawrence: An American Master* (February 17–March 23). Traveled to Grandview Gallery, West Virginia University, Morgantown (November 17–December 14); Diggs Gallery at Winston-Salem State University, N.C. (April 21–June 14, 1993); The Afro-American Cultural Center, Charlotte, N.C. (July 1–August 30, 1993); St. John's Museum of Art, Wilmington, N.C. (September 18–November 29, 1993); The Hickory Museum of Art, N.C. (January 1–February 28, 1994); Schneider Museum of Art, Southern Oregon State College, Ashland (March 11–April 23, 1994); Fairbanks Gallery, Oregon State University, Corvallis (May 3–26, 1994).

The Katonah Museum of Art, N.Y., *Jacob Lawrence: The Early Decades, 1935–1950* (March 1–April 19).

1993

Oregon State University, Corvallis, *Jacob Lawrence* (April).

The Rubelle and Norman Schafler Gallery, Pratt Institute, Brooklyn, *Jacob Lawrence: An Exhibition Presented by the Black Alumni of Pratt Institute* (May 15–June 14).

The Phillips Collection, Washington, D.C., *Jacob Lawrence: The Migration Series* (September 23, 1993–January 9, 1994). Traveled to Milwaukee Art Museum (January 28–March 20, 1994); Portland Art Museum, Ore. (April 19–June 12, 1994); The Saint Louis Art Museum (September 30–November 27, 1994); The Museum of Modern Art, New York (January 11–April 11, 1995); High Museum of Art, Atlanta (April 25–June 27, 1995); Denver Art Museum (July 15–September 9, 1995); Chicago Historical Society (September 22–November 26, 1995).

Midtown Payson Galleries, New York, *Jacob Lawrence: Paintings, Drawings, and Prints* (November 17, 1993–January 14, 1994).

1994

Mardigan Library, University of Michigan, Dearborn, *Jacob Lawrence: The Genesis Series; Paintings on Loan from the Collection of Walter O. Evans, Detroit, Michigan* (February 3–March 3).

Kauffman Gallery, Huber Art Center, Shippensburg University of Pennsylvania, *Jacob Lawrence: Works on Paper* (April 4–22).

Bellevue Art Museum, Wash., *Jacob Lawrence: Thirty Years of Prints (1963–1993)* (September 24–November 27).

Shasta College Gallery, Shasta College, Redding, Calif., *Jacob Lawrence: Prints and Drawings* (October 4–November 8).

Jacob Lawrence Gallery, University of Washington, Seattle, *Jacob Lawrence: Paintings 1971–1984, Inaugural Exhibition* (October 19–December 6).

Francine Seders Gallery, Seattle, *Jacob Lawrence: New Paintings* (December 2, 1994–January 15, 1995).

1995

Midtown Payson Galleries, New York, *Jacob Lawrence, An Overview: Paintings from 1936–1994* (January 6–February 25).

Whitney Museum of American Art at Phillip Morris, New York, *Jacob Lawrence: The War Series* (January 11–March 24).

1996

San Antonio Museum of Art, *Jacob Lawrence: An American Society in Transition* (March 28–June 6).

Francine Seders Gallery, Seattle, *Jacob Lawrence: Aesop's Fables* (July 13–August 4).

The Phillips Collection, Washington, D.C., *Jacob Lawrence: The Migration Series from The Phillips Collection* (1996–7). Traveled to The Dixon Gallery and Gardens, Memphis (August 4–September 29); The Arkansas Arts Center, Little Rock (November 14, 1996–January 12, 1997).

Tyler Museum of Art, Tex., *Jacob Lawrence: The Hiroshima Paintings* (October 5–December 1).

DC Moore Gallery, New York, *Jacob Lawrence: Drawings, 1945 to 1996* (October 9–November 9). Traveled to The Arkansas Arts Center, Little Rock (November 14, 1996–January 12, 1997).

The Pollock Gallery, Hughes-Trigg Student Center, Southern Methodist University, Dallas, *After Vesalius: Drawings by Jacob Lawrence* (October 21–December 8).

Meadows Museum, Owens Art Center, Southern Methodist University, Dallas, *Jacob Lawrence: Paintings from Two Series, 1940 and 1994* (October 25–December 8).

1997

University of Kentucky Museum, Lexington, *Jacob Lawrence: Toussaint L'Ouverture Series* (January 1–March 31).

Museum of Northwest Art, La Conner, Wash., *Jacob Lawrence, An American Vision: Paintings and Prints 1942–1996* (March 15–July 2).

University of Iowa, Iowa City, *Jacob Lawrence: Toussaint L'Ouverture Series* (November 1–December 21).

1998

Pinnacle Gallery, Savannah College of Art and Design, Ga., *Jacob Lawrence* (January 8–March 1).

The Wood Street Galleries, Pittsburgh, *Jacob Lawrence: The Toussaint L'Ouverture Series* (January 23–March 7).

Francine Seders Gallery, Seattle, *Jacob Lawrence: Aesop's Fables* (1998–2000). Traveled to The Wood Street Galleries, Pittsburgh (January 23–March 7); Morgan Library, Colorado State University, Fort Collins (August 22–October 3); Tacoma Public Library, Wash. (January–March 1999); Hood Museum of Art, Dartmouth College, Hanover, N.H. (April 10–June 20, 1999); Gwinnett Fine Arts Center, Duluth, Ga. (January 15–May 28, 2000).

Francine Seders Gallery, Seattle, *Jacob Lawrence as Muralist* (July 2–August 2).

Henry Art Gallery, University of Washington, Seattle, *Jacob Lawrence: Painting Life* (July 2–September 27).

DC Moore Gallery, New York, *Jacob Lawrence: The Builders* (November 18–December 30).

1999

The Newark Museum, *Jacob Lawrence: Toussaint L'Ouverture Series* (January 1–March 31).

Indianapolis Museum of Art, *Jacob Lawrence: Toussaint L'Ouverture Series* (November 1–December 31).

GROUP EXHIBITIONS

1937

115th Street Public Library, New York, *An Exhibition of the Harlem Artists Guild* (April 24–May 15).

Alston-Bannarn Studios, New York.

American Artists School, New York.

1938

Harlem Community Art Center, New York, *Twenty-One NYC Negro Artists* (February–March).

Brooklyn College.

Dillard University, New Orleans.

Fisk University, Nashville.

1939

American Artists School, New York, *Jacob Lawrence and Samuel Wechsler* (February).

The Baltimore Museum of Art, *Contemporary Negro Art* (February 3–19).

The Labor Club, New York, *An Exhibition of Painting and Sculpture Presented by The Labor Club* (February 12–March 12).

1940

Tanner Gallery, American Negro Exhibition, Chicago, *Exhibition of the Art of the American Negro, 1851–1940* (July 2–September 2).

Fisk University, Nashville, *Afro-American Art* (December).

United States Library of Congress, Washington, D.C., *Seventy-Five Years of Freedom: Commemoration of the Seventy-Fifth Anniversary of the Proclamation of the Thirteenth Amendment to the Constitution of the United States.*

1941

The Downtown Gallery, New York, *American Negro Art: Nineteenth and Twentieth Centuries* (December 9, 1941–January 3, 1942).

1942

The Downtown Gallery, New York, *Watercolors—Drawings, by Leading American Artists* (January 7–24).

The Downtown Gallery, New York, *Spring Exhibition* (April 7–May 2).

The Downtown Gallery, New York, *Opening Exhibition: New Paintings and Sculpture* (September 22–October 10).

The Metropolitan Museum of Art, New York, *Artists for Victory: An Exhibition of Contemporary American Art* (December 7, 1942–February 22, 1943).

1943

University Art Galleries, University of Nebraska, Lincoln, *Fifty-Third Annual Exhibition of Contemporary Art* (March 7–April 4).

The Downtown Gallery, New York, *Spring Exhibition* (March 31–April 24).

The Metropolitan Museum of Art, New York, *An Exhibition of Contemporary American Paintings from the Collection of the University of Arizona* (April 7–27). Traveled to M. H. de Young Memorial Museum, San Francisco (August).

The Brooklyn Museum, *International Watercolor Exhibition, Twelfth Biennial* (April 9–May 23).

The Art Institute of Chicago, *The Twenty-Second International Exhibition of Watercolors* (May 13–August 22).

The Downtown Gallery, New York, *Eighteenth Annual Exhibition: New Paintings and Sculpture by Leading American Artists* (October 5–30).

Whitney Museum of American Art, New York, *1943–44 Annual Exhibition of Contemporary American Art: Sculpture, Paintings, Watercolors, and Drawings* (November 23, 1943–January 4, 1944).

The Museum of Modern Art, New York, *Christmas Sale of Paintings under $75* (December 8, 1943–January 9, 1944).

The Institute for Modern Art, Boston, *Paintings and Sculpture by American Negro Artists.*

1944

Museum of Art, Rhode Island School of Design, Providence, *A Selection of American Paintings of the Present Day* (January).

The Downtown Gallery, New York, *Group Exhibition* (February 1–12).

The Museum of Modern Art, New York, *Twelve Contemporary Painters* (1944–5). Traveled to Brown University, Providence, R.I. (February 3–24); Vassar College, Poughkeepsie, N.Y. (March 4–25); Skidmore College, Saratoga Springs, N.Y. (April 3–24); University of Texas at Austin (May 8–29); Dallas Museum of Fine Arts (June 11–July 2); San Francisco Museum of Art (July 19–August 13); University of Oregon, Eugene (October 6–27); Pomona College, Claremont, Calif. (November 10–December 1); Museum of New Mexico, Santa Fe (January 19–February 9, 1945); Joslyn Memorial Museum, Society of Liberal Arts, Omaha (February 23–March 16, 1945); Hamline University, Saint Paul (March 26–April 16, 1945); Wayne State University, Detroit (April 26–May 17, 1945).

City Art Museum, Saint Louis, *American Painting of Today* (February 5–March 13).

University Art Galleries, University of Nebraska, Lincoln, *Fifty-Fourth Annual Exhibition of Contemporary Art* (March).

The Newark Museum, *American Negro Art: Contemporary Painting and Sculpture* (April).

Atlanta University, *Third Annual Exhibition of Paintings, Sculptures, and Prints, by Negro Artists* (April 2–30).

The Downtown Gallery, New York, *Spring 1944: New Important Paintings and Sculpture by Leading Americans* (April 11–May 6).

The Art Institute of Chicago, *The Fifty-Fifth Annual American Exhibition: Water Colors and Drawings* (June 8–August 20).

Walker Art Center, Minneapolis, *One Hundred Ten American Painters of Today: The Second Annual Purchase Exhibition* (August 18–September 11).

The Downtown Gallery, New York, *Nineteenth Annual Fall Exhibition: New Paintings and Sculpture by Leading American Artists* (October 3–28).

Stuart Gallery, Boston (November).

1945

Whitney Museum of American Art, New York, *1945 Annual Exhibition of Contemporary American Sculpture, Watercolors, and Drawings* (January 3–February 8).

Albany Institute of History and Art, *The Negro Artist Comes of Age* (January 3–February 11).

United Modern Art in Boston [Institute of Modern Art, Boris Mirski Art Gallery, Stuart Art Gallery, Today's Art Gallery], *Art Panorama* (January 22–February 25).

City Art Museum, Saint Louis, *Thirty-Eighth Annual Exhibition: American Painting of Today* (February 10–May 12).

YMCA, Brooklyn (February 11–15).

Los Angeles County Museum of Art, *The First Biennial Exhibition of Drawings by American Artists* (February 18–April 22).

The Institute for Modern Art, Boston, *Four Modern American Painters: Peter Blume, Stuart Davis, Marsden Hartley, Jacob Lawrence* (March 2–April 1).

The Brooklyn Museum, *International Watercolor Exhibition, Thirteenth Biennial* (March 8–April 29).

Howard University Gallery of Art, Washington, D.C. (April).

Art Department, Providence Public Library, R.I., *The Negro in Literature and Art* (April 6–May 1).

The Downtown Gallery, New York, *Nineteenth Annual Spring Exhibition: Important New Paintings and Sculpture by Leading American Artists* (May 1–26).

California Palace of the Legion of Honor, San Francisco, *Contemporary American Painting* (May 17–June 17).

The Ohio State University Museum, Columbus (September).

The Downtown Gallery, New York, *All-Loan Exhibition of Outstanding Examples of American Progressive Art* (October 9–27).

The Downtown Gallery, New York, *1945: New Painting and Sculpture by Leading American Artists* (November 6–December 1).

1946

Salem College, Winston-Salem, N.C. (January).

Whitney Museum of American Art, New York, *1946 Annual Exhibition of Contemporary American Sculpture, Watercolors, and Drawings* (February 5–March 13).

University Art Galleries, University of Nebraska, Lincoln, *Fifty-Sixth Annual Exhibition of Contemporary Art* (March 3–31).

Fine Arts Gallery of San Diego, *Paintings by Matisse, Tom Lewis, and Chester Hayes; Watercolor Paintings by Jacob Lawrence and Willing Howard* (April).

Samuel M. Kootz Gallery, New York, *Modern American Paintings from the Collection of Mr. and Mrs. Roy R. Neuberger* (April 15–May 4). Traveled to Lawrence Art Museum, Williams College, Williamstown, Mass. (September 5–October 14).

The Downtown Gallery, New York, *Six Artists out of Uniform* (May 7–25).

Brooks Memorial Art Gallery, Memphis, *An Exhibition of Clowns and Carnival Scenes by Contemporary American Artists* (May 12–20).

The Downtown Gallery, New York, *New Important Paintings by Leading Americans* (June 4–29).

The Art Institute of Chicago, *The Fifty-Seventh Annual American Exhibition, Watercolors and Drawings* (June 6–August 18).

The Tate Gallery, London, *American Painting, from the Eighteenth Century to the Present Day* (June 14–August 5).

Black Mountain College, Asheville, N.C. (July 2–August 28).

Walker Art Center, Minneapolis, *One Hundred Thirty-Six American Artists: The Third Annual Purchase Exhibition* (August 25–September 22).

The Downtown Gallery, New York, *The Twenty-First Annual Fall Exhibition: New Paintings and Sculpture by Leading American Artists* (September 24–October 19).

Van Bark Studios, Studio City, Calif., *American Art by Leading American Progressive Contemporaries from The Downtown Gallery* (October 7–November 2).

Musée d'Art Moderne, Paris, *Exposition internationale d'art moderne* (November–December).

Phillips Memorial Gallery, Washington, D.C., *Three Negro Artists: Horace Pippin, Jacob Lawrence, Richmond Barthé* (December 14, 1946–January 6, 1947).

Encyclopedia Britannica Collection of Contemporary Paintings, Chicago, *The Rotating Annual Selection of Twelve Paintings: 1946–7.*

1947
American Federation of Arts, New York, *The Second Exhibition of the La Tausca Art Competition* (1947–8). Traveled to Riverside Museum, New York (January 24–February 8); Oklahoma Art Center, Oklahoma City (February 23–March 16); Layton Art Gallery, Milwaukee (March 31–April 20); Isaac Delgado Museum of Art, New Orleans (May 4–25); J. B. Speed Memorial Museum, Louisville, Ky. (June 8–29); Museum of Fine Arts, Houston (July 13–August 3); The Detroit Institute of Arts (August 17–September 7); The Baltimore Museum of Art (September 21–October 12); Walker Art Center, Minneapolis (October 26–November 16); Cleveland Museum of Art (December 2, 1947–January 4, 1948).

Van Bark Studios, Studio City, Calif. (February–March).

The Downtown Gallery, New York, *Important New Drawings* (February 4–March 1).

Wilmington Society of the Fine Arts, Del. (March).

Salem College, Winston-Salem, N.C. (March–April).

Whitney Museum of American Art, New York, *1947 Annual Exhibition of Contemporary American Sculpture, Watercolors, and Drawings* (March 11–April 17).

Randolph-Macon Women's College, Ashland, Va. (April).

The Downtown Gallery, New York, *Spring 1947* (April 1–26).

The Brooklyn Museum, *International Watercolor Exhibition, Fourteenth Biennial* (April 16–June 8).

Boris Mirski Art Gallery, Boston, *Boston/New York: First Exchange Exhibition* (April 29–May 17).

The Downtown Gallery, New York, *American Art 1800–1947* (June 10–August 8).

University of Iowa, Iowa City, *Third Summer Exhibition of Contemporary Art* (June 15–July 30).

Saint Paul Gallery (September).

The Downtown Gallery, New York, *Twentieth-Century American Watercolors* (September 3–27).

The Downtown Gallery, New York, *The Twenty-Second Annual Fall Exhibition: New Paintings and Sculpture by Leading American Artists* (September 23–October 18).

California Palace of the Legion of Honor, San Francisco (October).

Illinois Wesleyan University, Bloomington (October).

Van Bark Studios, Studio City, Calif. (October).

Carnegie Institute, Pittsburgh, *Painting in the United States, 1947* (October 9–December 7).

1948
Georgia Museum of Art, University of Georgia, Athens, *Holbrook Collection: New Acquisitions* (January 19–February 5).

Pennsylvania Academy of the Fine Arts, Philadelphia, *The One Hundred Forty-Third Annual Exhibition of Painting and Sculpture* (January 25–February 19).

Whitney Museum of American Art, New York, *1948 Annual Exhibition of Contemporary American Sculpture, Watercolors, and Drawings* (January 31–March 21).

Virginia Museum of Fine Arts, Richmond, *The Sixth Biennial Exhibition of Contemporary American Paintings, 1948* (February).

The Brooklyn Museum, *Thirty-Second Annual Exhibition: The Brooklyn Society of Artists* (February 4–March 7).

University Art Galleries, University of Nebraska, Lincoln, *Fifty-Eighth Annual Exhibition of Contemporary Art* (February 29–March 28).

Indiana University, Bloomington (March).

University of Wisconsin, Madison (March).

The Downtown Gallery, New York, *American Art* (March 22–April 3).

Brooks Memorial Art Gallery, Memphis (April).

Atlanta University, *Seventh Annual Exhibition of Paintings, Sculptures, Prints by Negro Artists* (April 4–May 2).

Whitney Museum of American Art, New York, *One Hundred Seventeen Oil and Water Color Originals by Leading American Artists* (May 21–June 18).

The American Academy of Arts and Letters, New York, *Exhibition of Work by Newly Elected Members, Recipients of Academy and Institute Honors, and Pictures Purchased from the Childe Hassam Fund* (May 22–June 30).

Walker Art Center, Minneapolis, *New Paintings to Know and Buy* (May 25–July 11).

University of Iowa, Iowa City, *Fourth Summer Exhibition of Contemporary Art* (June–July).

La Biennale di Venezia, *Esposizione Internazionale d'Art, 1948* (June–October).

Santa Barbara Museum of Art, Calif. (September).

The Downtown Gallery, New York, *The Twenty-Third Annual Exhibition: New Paintings and Sculpture by Leading American Artists* (September 28–October 2).

Evanston Art Center, Ill. (October).

Carnegie Institute, Pittsburgh, *Painting in the United States, 1948* (October 14–December 12).

The Art Institute of Chicago, *The Fifty-Ninth Annual Exhibition: Watercolors and Drawings* (November 4, 1948–January 2, 1949).

Pennsylvania Academy of the Fine Arts, Philadelphia, *The Forty-Sixth Annual Philadelphia Water Color and Print Exhibition* (November 7–December 12).

The Butler Institute of American Art, Youngstown, Ohio, *Fifty-Four Paintings, Drawings, Prints by Contemporary Americans Acquired during the Past Year by The Butler Institute* (November 12–December 12).

California Palace of the Legion of Honor, San Francisco, *Third Annual Exhibition of Painting* (December 1, 1948–January 16, 1949).

The Downtown Gallery, New York, *Christmas 1948* (December 7–December 31).

1949
Dallas Museum of Art (January).

Stephens College Art Gallery, Columbia, Mo. (March).

Walker Art Center, Minneapolis (March).

University Art Galleries, University of Nebraska, Lincoln, *NAA Fifty-Ninth Annual Exhibition of Contemporary Art* (March 6–April 3).

Whitney Museum of American Art, New York, *1949 Annual Exhibition of Contemporary American Sculpture, Watercolors, and Drawings* (April 2–May 8).

The Downtown Gallery, New York, *The Artist Speaks* (April 5–23).

The Brooklyn Museum, *International Watercolor Exhibition, Fifteenth Biennial* (May 4–June 19).

IBM traveling exhibition, *Contemporary Paintings: Twenty-Five Americans* (August 1949–July 1956).

The Downtown Gallery, New York, *Art and/or Money, Part III* (August 2–19).

Whitney Museum of American Art, New York, *Juliana Force and American Art: A Memorial* (September 24–October 30).

The Art Gallery of Toronto, *Contemporary Paintings from Great Britain, the United States and France, with Sculptures from the United States* (October).

Boris Mirski Art Gallery, Boston (October).

The Downtown Gallery, New York, *The Twenty-Fourth Annual Exhibition: New Paintings and Sculpture by Leading American Artists* (October 3–22).

Carnegie Institute, Pittsburgh, *Painting in the United States, 1949* (October 13–December 11).

Pennsylvania Academy of the Fine Arts, Philadelphia, *The Forty-Seventh Annual Philadelphia Water Color and Print Exhibition* (October 29–December 4).

Scripps College, Claremont, Calif. (November).

The Art Institute of Chicago, *The Fifty-Ninth Annual American Exhibition, Watercolors and Drawings* (November 4, 1949–January 14, 1950).

1950
Pennsylvania Academy of the Fine Arts, Philadelphia, *One Hundred Forty-Third Annual Exhibition of Paintings and Sculpture* (January 22–February 26).

The Detroit Institute of Arts, *Little Show of Work in Progress: Paintings by Robert Gwathmey and Jacob Lawrence, Ceramics by Edwin and Mary Sheier* (January 24–February 19).

Smith Music Hall, University of Illinois, Urbana-Champaign, *Music in Art* (February).

The Downtown Gallery, New York, *Aquamedia* (February 21–March 11).

University Art Galleries, University of Nebraska, Lincoln, *Sixtieth Annual Exhibition of Contemporary Art* (March 5–April 2).

The Downtown Gallery, New York, *In 1950: An Exhibition of Paintings and Sculpture by Leading Americans* (March 14–April 1).

Whitney Museum of American Art, New York, *1950 Annual Exhibition of Contemporary American Sculpture, Watercolors, and Drawings* (April 1–May 28).

Watkins Gallery, American University, Washington, D.C., *Objective and Non-Objective* (April 16–May 5).

Virginia Museum of Fine Arts, Richmond, *American Painting 1950* (April 22–June 4).

The Downtown Gallery, New York, *In 1950: New Paintings and Sculpture by Leading American Artists* (April 25–May 13).

The Baltimore Museum of Art, *Baltimore-Owned Paintings by Equity Artists* (summer).

The Metropolitan Museum of Art, New York, *Twentieth-Century Painters: A Special Exhibition of Oils, Watercolors, and Drawings Selected from the Collections of American Art in The Metropolitan Museum* (June–August).

The Downtown Gallery, New York, *Art for 13,000,000* (June 6–30).

The Minneapolis Institute of Arts, *Watercolor and Drawings from Twin Cities Collections* (July 1–October 1).

The Downtown Gallery, New York, *Twenty-Fifth Annual Exhibition* (September 26–October 21).

Pennsylvania Academy of the Fine Arts, Philadelphia, *The Forty-Eighth Annual Philadelphia Water Color and Print Exhibition* (October 28–November 26).

1951

The Museum of Modern Art, New York, *Recent Accessions* (February 13–May 13).

Whitney Museum of American Art, New York, *1951 Annual Exhibition of Contemporary American Sculpture, Watercolors, and Drawings* (March 17–May 6).

The Downtown Gallery, New York, *Spring 1951: New Paintings and Sculpture* (April 3–28).

The Brooklyn Museum, *International Watercolor Exhibition, Sixteenth Biennial* (May 9–June 24).

The Museum of Modern Art, New York, *The City* (1951–4). Traveled to Workshop Center of the Arts, Washington, D.C. (September 21–October 12); Vassar College, Poughkeepsie, N.Y. (October 22–November 12); Kansas City Art Institute, Mo. (November 26–December 17); Carleton College, Northfield, Minn. (January 8–29, 1952); Lawrence Art Museum, Williams College, Williamstown, Mass. (February 14–March 6, 1952); The Currier Gallery of Art, Manchester, N.H. (March 20–April 10, 1952); State Teachers College, Oneonta, N.Y. (April 24–May 14, 1952); University of Michigan, Ann Arbor (July 7–28, 1952); The Parthenon, Nashville (August 11–September 1, 1952); Mount Holyoke College, South Hadley, Mass. (September 21–October 5, 1952); Wells College, Aurora, N.Y. (October 14–November 5, 1952); University of Delaware, Newark (November 19–December 9, 1952); Skidmore College, Saratoga Springs, N.Y. (January 8–29, 1953); Wellesley College, Mass. (February 12–March 5, 1953); The Pennsylvania State College, State College (April 1–22, 1953); Michigan State College, East Lansing (May 6–27, 1953); Miami Beach Art Center (July 20–August 10, 1953); Cedar Rapids Art Association, Iowa (September 1–22, 1953); Joslyn Memorial Art Museum, Omaha (October 6–27, 1953); Southern Illinois University, Carbondale (November 10–30, 1953); Hunter Gallery of Art, Chattanooga, Tenn. (December 14, 1953–January 4, 1954); Kalamazoo Institute of Arts, Mich. (January 24–February 14, 1954); Quincy Art Club, Ill. (February 28–March 15, 1954), Schenectady Museum Association, N.Y. (April 4–25, 1954); Binghamton Museum of Fine Arts, N.Y. (May 10–31, 1954).

São Paulo, *I Bienal do Museum de Arte Moderna de São Paulo* (October–December).

The Downtown Gallery, New York, *Twenty-Fifth Annual Fall Exhibition: Paintings and Sculpture by Leading American Artists* (October 2–27).

The Downtown Gallery, New York, *Christmas Exhibition* (December 11–29).

Florida Gulf Coast Art Center, Clearwater, *Twelfth Annual Contemporary American Paintings Exhibition.*

1952

University of Illinois, Urbana-Champaign, *Contemporary American Painting and Sculpture* (March 2–April 13).

Whitney Museum of American Art, New York, *1952 Annual Exhibition of Contemporary American Sculpture, Watercolors, and Drawings* (March 13–May 4).

Perls Gallery, New York, *Paintings of New York* (April).

Texas Christian University, Fort Worth (April).

The Downtown Gallery, New York, *Annual Spring Exhibition: New Paintings and Sculpture by Leading American Artists* (April 1–19).

The Brooklyn Museum, *Brooklyn Artists Biennial Exhibition* (April 23–June 1).

Artists Equity, New York, *Founding Members Exhibition* (May).

Northside Art Center, New York (May).

Walker Art Center, Minneapolis, *Contemporary American Painting and Sculpture: Collection of Mr. and Mrs. Roy R. Neuberger* (May 24–August 10).

The Downtown Gallery, New York, *Art for the 67%* (June 3–27).

American Federation of Arts, New York, *A University Collects—Arizona* (1952–3). Traveled to University of California Art Gallery, Los Angeles (September 9–30); Rosicrucian Egyptian Oriental Museum, San Jose, Calif. (December 5–31); Fine Arts Gallery of San Diego (January 18–February 8, 1953); Texas Western College, El Paso (February 22–March 15, 1953); John and Mabel Ringling Museum of Art, Sarasota, Fla. (June 29–July 26, 1953); Miami Beach Art Center (August 10–September 7, 1953); Winston-Salem Public Library, N.C. (September 20–October 11, 1953); University of Arkansas, Fayetteville (October 25–November 15, 1953); University of Idaho, Moscow (November 28–December 18, 1953).

Dayton Art Institute, Ohio (October).

The Downtown Gallery, New York, *The Twenty-Fifth Anniversary Exhibition* (October).

Whitney Museum of American Art, New York, *Edith and Milton Lowenthal Collection* (October 1–November 2). Traveled to Walker Art Center, Minneapolis (November 29, 1952–January 17, 1953).

Denver Art Academy, *Sixteen Leading American Painters.*

Florida Gulf Coast Art Center, Clearwater, *Thirteenth Annual Contemporary American Paintings Exhibition.*

1953

John Herron Art Museum, Indianapolis, *Contemporary American Paintings* (January 18–February 22).

Contemporary Arts Museum, Houston, *Modern Painting: Ways and Means* (January 25–February 15).

The American Academy of Arts and Letters, New York, *Works by Candidates for Grants in Art for the Year 1953* (February 9–March 4).

Great Neck Education Association, N.Y., *Art in America: Twentieth Century* (March 1–14).

American Federation of Arts, New York, *American Watercolors, Drawings and Prints from The Metropolitan Museum, 1952* (1953–4). Traveled to Columbus Gallery of Fine Arts, Ohio (March 27–April 19); City Art Museum of Saint Louis (June 7–28); Currier Gallery of Art, Manchester, N.H. (July 12–August 2); University of Mississippi, Oxford (September 20–October 11); Watkins Institute, Nashville (October 25–November 15); J. B. Speed Art Museum, Louisville, Ky. (November 25–December 16); University of Georgia, Athens (January 4–25, 1954); Bowling Green State University, Ohio (February 5–26, 1954); Art Gallery of Hamilton, Ontario (March 12–April 2, 1954).

Whitney Museum of American Art, New York, *1953 Annual Exhibition of Contemporary American Sculpture, Watercolors, and Drawings* (April 9–May 29).

The Brooklyn Museum, *International Watercolor Exhibition, Seventeenth Biennial* (May 13–June 21).

The American Academy of Arts and Letters, New York, *Exhibition of Work by Newly Elected Members, Recipients of Honors, and Childe Hassam Fund Purchases* (May 28–June 28).

Washington International Center, Washington, D.C. (June–October).

Abraham Shapiro Athletic Center, Brandeis University, Waltham, Mass., *Festival of the Creative Arts: The Comic Spirit, An Exhibition* (June 10–14).

The Butler Institute of American Art, Youngstown, Ohio (July).

The Alan Gallery, New York, *Opening Exhibition* (September 29–October 24).

John Herron Art Museum, Indianapolis, *Contemporary American Watercolors* (December 27, 1953–January 31, 1954).

Florida Gulf Coast Circuit, *Fourteenth Southeastern Exchange.*

University Art Galleries, University of Nebraska, Lincoln, *Twenty-Fifth Anniversary Exhibition of the Frank M. Hall Bequest.*

1954

Pennsylvania Academy of the Fine Arts, Philadelphia, *The One Hundred Forty-Ninth Annual Exhibition of Paintings and Sculpture* (January 24–February 28).

The Downtown Gallery, New York, *International Exhibition: American, Belgian, British, Canadian, French, Italian, Mexican Painters under Forty* (February 2–27).

Virginia Museum of Fine Arts, Richmond, *American Painting 1954* (February 26–March 21). Traveled to Des Moines Art Center (April 4–May 2).

Whitney Museum of American Art, New York, *1954 Annual Exhibition of Contemporary American Sculpture, Watercolors, and Drawings* (March 17–April 18).

Walker Art Center, Minneapolis, *Reality and Fantasy: 1900–1954* (May 23–July 2).

Charles-Fourth Gallery, New Hope, Penn., *The Alan Gallery of New York* (May 31–September 26).

The Alan Gallery, New York, *From Museum Walls . . .* (June 15–August 20).

The Alan Gallery, New York, *Opening Exhibition: 1954–1955* (September 9–October 2).

The Museum of Modern Art, New York, *Twenty-Fifth Anniversary Exhibition* (October 19, 1954–January 2, 1955).

The Downtown Gallery, New York, *Skowhegan School of Painting and Sculpture: A Benefit Exhibition by Its Faculty and Visiting Artists for the Scholarship Fund* (November 9–20).

Whitney Museum of American Art, New York, *Roy and Marie Neuberger Collection: Modern American Painting and Sculpture* (November 17–December 19). Traveled to The Arts Club of Chicago (January 4–January 30, 1955); Art Galleries, University of California, Berkeley (February 21–March 11, 1955); Pasadena Art Museum, Calif. (March 14–April 3, 1955); San Francisco Museum of Art (April 26–June 5, 1955); City Art Museum of Saint Louis (June 27–August 7, 1955); Cincinnati Art Museum (August 29–September 25, 1955); The Phillips Gallery, Washington, D.C. (October 9–31, 1955).

Philadelphia Art Alliance (December 22, 1954–January 3, 1955).

1955
Philadelphia Art Alliance, *Reuben Tam and Jacob Lawrence* (January 3–24).

The Alan Gallery, New York, *The Denman Collection: Loan Exhibition* (February 15–March 5).

University of Illinois, Urbana-Champaign, *Contemporary American Painting and Sculpture* (February 27–April 3).

American Federation of Arts, New York, *World at Work, 1930–1955: An Exhibition of Paintings and Drawings Commissioned by* Fortune, *Presented on the Occasion of the Magazine's Twenty-Fifth Anniversary* (1955–6). Traveled to The Arts Club of Chicago (May 12–June 15); California Palace of the Legion of Honor, San Francisco (July 16–September 5); Albright Art Gallery, Buffalo (September 15–October 15); The Museum of Fine Arts of Houston (at Texas National Bank Building Assembly Room; October 26–November 26); Seattle Art Museum (December 11, 1955–January 8, 1956); Los Angeles County Museum (January 18–February 15, 1956); The Detroit Institute of Arts (March 1–31, 1956); City Art Museum of Saint Louis (May 15–June 15, 1956).

Abraham Shapiro Athletic Center, Brandeis University, Waltham, Mass., *Third Festival of the Creative Arts: Three Collections* (June 1–17).

The Alan Gallery, New York, *Opening Exhibition: 1955–1956* (September 8–October 1).

American Federation of Arts, New York, *A Collector's Choice* (1955–6). Traveled to National Arts Club, New York (September 10–20); Hackley Art Gallery, Muskegan, Mich. (October 1–23); Arts Council, Winston-Salem, N.C. (November 3–23); Dayton Art Institute, Ohio (December 4–25); Coe College, Cedar Rapids, Iowa (January 4–25, 1956); Texas Western College, El Paso (February 8–28, 1956); Atlanta Public Library (March 9–30, 1956); Nashville Artists Guild (April 8–29, 1956); Canton Art Institute, Ohio (June 10–July 10, 1956); Colorado State College, Fort Collins (July 22–29, 1956); University of Kansas, Lawrence (September 4–24, 1956).

De Cordova Museum and Sculpture Park, Lincoln, Mass., *American Painters: 1955* (October 9–November 4).

Whitney Museum of American Art, New York, *Mural Sketches and Sculpture Models* (October 25–November 5).

1956
The Brooklyn Museum, *Brooklyn Artists Biennial Exhibition* (January 18–February 19).

The Institute of Contemporary Art, Boston, *Twentieth-Century American Paintings from the Collection of Mr. and Mrs. Roy R. Neuberger* (March 13–April 8).

Tweed Gallery, University of Minnesota, Duluth, *Paintings from the Collection of Joseph H. Hirshhorn* (April).

Watkins Gallery, American University, Washington, D.C., *Art and Theater* (April 8–May 13).

La Biennale di Venezia, *Esposizione Internazionale d'Art, 1956: American Artists Paint the City* (June–November). Traveled to The Art Institute of Chicago (as *Sixty-Second Annual American Exhibition;* January 17–March 3, 1957).

Virginia Museum of Fine Arts, Richmond, *Watercolors U.S. 1956* (July).

The Alan Gallery, New York, *Opening Exhibition: 1956–1957* (September 5–29).

American Federation of Arts, New York, *Executive View, Art in the Office* (1956–8). Traveled to Time, Inc., New York (December 31, 1956–January 20, 1957); Canton Art Institute, Ohio (February 1–22, 1957); Frye Museum, Seattle (March 8–29, 1957); Fine Arts Society of California, San Diego (April 8–28, 1957); Arizona State College, Tempe (May 8–28, 1957); State Teachers College, Dickinson, N.C. (July 15–August 4, 1957); University of Kansas, Lawrence (September 1–22, 1957); Winston-Salem Public Library,

N.C. (October 3–23, 1957); Atlanta Art Association (November 3–24, 1957); Pensacola Art Center, Fla. (December 6–26, 1957); 1020 Art Center, Chicago (January 8–28, 1958).

1957
National Gallery of Canada, Ottawa, *Some American Paintings from the Collection of Joseph H. Hirshhorn* (January 10–31). Traveled to Montreal Museum of Fine Arts (March 20–31); Art Gallery of Toronto (May 12–April 26); Stratford Arena, Ontario (July 1–August 31); Winnipeg Art Gallery (October 6–November 3).

The Brooklyn Museum, *Golden Years of American Drawings: 1905–1956* (January 22–March 17).

Detroit Institute of Arts, *Painting in America: The Story of Four Hundred Fifty Years* (April 23–June 9).

Worcester Art Museum, Mass., *American Painting since the Armory Show from the William H. Lane Foundation* (July 1–September 10).

The Alan Gallery, New York, *Opening Exhibition: 1957–1958* (September 10–28).

The Pyramid Club, Philadelphia, *The Third Annual Review of Painting and Sculpture: 1957, In the United States* (October 25–November 30).

Whitney Museum of American Art, New York, *1957 Annual Exhibition: Sculpture, Paintings, Watercolors* (November 20, 1957–January 12, 1958).

1958
Georgia Museum of Art, University of Georgia, Athens, *Dedication Exhibition* (January 28–February 22).

Des Moines Art Center, *Art To-Day* (February 2–March 2).

Whitney Museum of American Art, New York, *The Museum and Its Friends: Twentieth-Century American Art from Collections of the Friends of the Whitney Museum* (April 30–June 15).

Philadelphia Museum of Art, *The Sonia and Michael Watter Collection* (June 13–October 5).

The Alan Gallery, New York, *Fifth Anniversary Exhibition: New Paintings and Sculpture* (September 8–27).

Pennsylvania Academy of the Fine Arts, Philadelphia, *Twentieth-Century American Painting and Sculpture from Philadelphia Private Collections* (October 25–November 30).

The Currier Gallery of Art, Manchester, N.H., *American Art from the William H. Lane Foundation* (November 1–December 14).

Whitney Museum of American Art, New York, *1958 Annual Exhibition: Sculpture, Paintings, Watercolors, Drawings* (November 19, 1958–January 4, 1959).

1959
Fitchburg Art Museum, Mass., *American Art from the William H. Lane Foundation* (February 20–April 1).

University of Illinois, Urbana-Champaign, *Contemporary American Painting and Sculpture* (March 1–April 5).

City Art Museum, Saint Louis (April).

Coliseum, New York, *Art: USA: 59, A Force, A Language, A Frontier* (April 3–19).

The Pushkin Museum of Fine Arts, Moscow, *American Sculpture and Painting: American National Exhibition in Moscow* (July 25–September 5). Traveled to Whitney Museum of American Art, New York (October 28–November 15).

Fort Wayne Museum of Art, Ind., *Twenty-Four Paintings by Contemporary American Artists from the Collection of Mr. and Mrs. Roy R. Neuberger of New York City* (September 13–October 20).

Mount Holyoke College Art Museum, South Hadley, Mass., *American Paintings Lent by the William H. Lane Foundation* (October 10–November 2).

Göteborgs Konstmuseum, Sweden, *Twenty-Five Years of American Painting 1933–1958.*

The University Gallery, University of Minnesota, Minneapolis, *Selected Works from the Collection of Ione and Hudson Walker.*

1960
The Corcoran Gallery of Art, Washington, D.C., *The Edith Gregor Halpert Collection* (January 16–February 28).

Whitney Museum of American Art, New York, *Business Buys American Art: Third Loan Exhibition by the Friends of the Whitney Museum of American Art* (March 17–April 24).

The Alan Gallery, New York, *New Work IV* (June 1–30).

Walker Art Center, Minneapolis, *First National Bank Exhibition* (November 1–30).

Slater Memorial Museum, Norwich Free Academy, Conn., *William H. Lane Foundation Exhibition* (November 2–22).

1961

Downtown Contemporary Gallery, Atlantic City, N.J. (February).

The Downtown Gallery, New York, *Aquamedia—Modern Masters* (February).

Krannert Art Museum, University of Illinois, Urbana-Champaign, *Contemporary American Painting and Sculpture* (February 26–April 2).

Howard University Gallery of Art, Washington, D.C., *New Vistas in American Art* (March–April).

Associated Artists' Gallery, Washington, D.C., *Exhibition of Contemporary Artists' Works Assembled in Tribute to The Barnett Aden Gallery* (March 8–April 2).

The Alan Gallery, New York, *New Work* (May 8–26).

The Alan Gallery, New York, *61/62 Opening Exhibition: From 1700 to 1961* (September).

The University Gallery, University of Minnesota, Minneapolis, *Art and the University of Minnesota* (September–November).

Whitney Museum of American Art, New York, *1961 Annual Exhibition: Contemporary American Painting* (December 13, 1961–February 4, 1962).

West African Cultural Center, American Society of African Culture, Lagos, Nigeria, *The Lagos Festival* (December 18–19).

1962

The Alan Gallery, New York, *62/63 Opening Exhibition: Tenth Anniversary Season* (September 25–October 13).

The Brooklyn Museum, *The Louis E. Stern Collection* (September 25, 1962–March 10, 1963).

The Corcoran Gallery of Art, Washington, D.C., *The Edith Gregor Halpert Collection* (September 28–November 11).

Saint Paul Gallery, *Drawings: USA* (1962–3). Traveled to University of South Florida, Tampa (October 6–27); Cincinnati Art Museum (November 10–December 1); Grinnell College, Iowa (January 20–February 10, 1963); Museum of Fine Arts, The University of Virginia, Charlottesville (March 31–April 21, 1963); Montclair Art Museum, N.J. (September 8–29, 1963).

Museum of Art, University of Michigan, Ann Arbor, *Contemporary American Painting: Selections from the Collection of Mr. and Mrs. Roy R. Neuberger* (October 21–November 18).

Coliseum, New York, *Art: USA: Now.*

1963

Pennsylvania Academy of the Fine Arts, Philadelphia, *The One Hundred Fifty-Eighth Annual Exhibition: Water Colors, Prints and Drawings* (January 18–March 3).

University Art Galleries, University of New Hampshire, Durham, *An Exhibition of Paintings from the William H. Lane Foundation* (February 13–March 15).

Albany Institute of History and Art, *Centennial Celebration of the Emancipation Proclamation* (April 10–30).

The Brooklyn Museum, *Art Festival for NAACP Legal Defense* (September 11–22).

Whitney Museum of American Art, New York, *Sixty Years of American Art* (September 16–October 20).

Time-Life Exhibition Gallery, New York, *Great Ideas of Western Man—Art and Ideas in Mass Communication* (September 28–October 27).

Realisti Americani Galleria/ACA, Rome (November 9–December 14).

De Cordova Museum, Lincoln, Mass., *Paintings from the William H. Lane Foundation* (November 23–December 29).

Whitney Museum of American Art, New York, *1963 Annual Exhibition: Contemporary American Painting* (December 1963–January 1964).

1964

The Downtown Gallery, New York, *Aquamedia—Modern Masters* (January).

Pennsylvania Academy of the Fine Arts, Philadelphia, *The One Hundred Fifty-Ninth Annual Exhibition of American Paintings and Sculpture* (January 25–March 1).

Radcliffe College Graduate Center, Cambridge, Mass., *Paintings from the William H. Lane Foundation* (February 26–March 26).

Wollman Hall, New School Art Center, New School for Social Research, New York, *The American Conscience: An Exhibition of Contemporary Paintings* (March 3–April 4).

Marina Exhibition Center, Lagos, Nigeria, *Exhibition of Paintings by American Residents in Nigeria* (April).

Whitney Museum of American Art, New York, *The Friends Collect: Recent Acquisitions by Members of the Friends of the Whitney Museum of American Art, Seventh Friends Loan Exhibition* (May 8–June 16).

Bowdoin College Museum of Art, Brunswick, Maine, *The Portrayal of the Negro in American Painting* (May 12–September 16).

The Detroit Institute of Arts, *American Heritage—People and Places* (June).

American Society of Contemporary Artists, New York, *American Painting Today: Pavilion of Fine Arts, New York World's Fair 1964–65* (June 15–October 22).

Whitney Museum of American Art, New York, *Between the Fairs: Twenty-Five Years of American Art, 1939–1964* (June 24–September 23).

Walker Art Center, Minneapolis, *1964 Biennial of Painting and Sculpture* (October 27–November 29).

American Society of African Culture, Lagos, Nigeria, *Jacob Lawrence and Gwendolyn Lawrence* (November).

George Walter Vincent Smith Art Museum, Springfield, Mass., *Twentieth-Century American Paintings Lent by the William H. Lane Foundation* (November 8–December 6).

Grand Rapids Art Museum, Mich. (December).

Whitney Museum of American Art, New York, *1964 Annual Exhibition* (December 1964–January 1965).

1965

Kitchener-Waterloo Art Gallery, Kitchener, Ontario, *Contemporary American Painters: From the Albright-Knox Gallery, Buffalo, New York* (February 19–March 28).

Hope College, Holland, Mich., *Fine Arts Festival Exhibition* (April 24–May 17).

The Brooklyn Museum, *Herbert A. Goldstone Collection of American Art* (May 15–September 12).

Temple Emanu-El, Yonkers, N.Y. (May 16–29).

The American Academy of Arts and Letters, New York, *Exhibition of Work by Newly Elected Members and Recipients of Honors and Awards* (May 20–August 29).

IBM Corporation, New York, *Crosscurrents in American Art: Twenty-Five Americans* (September–October).

Gallery of Modern Art, New York, *About New York: 1915–65* (October 19–November 14).

Whitney Museum of American Art, New York, *1965 Annual Exhibition: Contemporary American Painting* (December 8, 1965–January 30, 1966).

Johnson Collection of Contemporary Paintings, Racine, Wis., *Art: USA* (1965–7).

1966

Pennsylvania Academy of the Fine Arts, Philadelphia, *One Hundred Sixty-First Annual Exhibition of American Painting and Sculpture* (January 21–March 6).

Wollman Hall, New School Art Center, New School for Social Research, New York, *Contemporary Urban Visions* (January 25–February 24).

Peppers Art Center Gallery, University of Redlands, Calif., *Selections of Drawings and Watercolors from the Santa Barbara Museum of Art* (February 4–27).

Student Center, Baruch School, City College of New York (April–May).

First World Festival of Negro Arts, Dakar, Senegal, *Ten Negro Artists from the United States* (April 1–24).

ACA Galleries, New York, *Protest Paintings—USA: 1930–1945* (April 4–23).

Saint Paul Art Center, *Drawings USA 1966* (April 7–June 5).

Carroll Reese Museum, East Tennessee State University, Johnson City, *The Visual Arts as Taught and Practiced at Black Mountain College* (April 25–June 8).

Grippi and Waddell Gallery, New York, *Artists for CORE: Fifth Annual Exhibition and Sale* (April 27–May 7).

Harlem Cultural Council, New York, *The Art of the American Negro: Exhibition of Paintings* (June 27–July 26).

UCLA Art Galleries, Dickson Art Center, Los Angeles, *The Negro in American Art* (September 11–October 16). Traveled to University of California, Davis (November 1–December 15); Fine Arts Gallery of San Diego (January 6–February 12, 1967); Oakland Art Museum, Calif. (February 24–March 19, 1967).

Lehigh University, Penn., *Thirteenth Annual Contemporary Painting Exhibition* (September 14–October 15).

Whitney Museum of American Art, New York, *Art of the United States: 1670–1966* (September 28–November 27).

The Metropolitan Museum of Art, New York, *Two Hundred Years of Watercolor Painting in America* (December 8, 1966–January 29, 1967).

1967

Wollman Hall, New School Art Center, New School for Social Research, New York, *By the Faculty of the Art Workshops* (January 16–26).

Pennsylvania Academy of the Fine Arts, Philadelphia, *One Hundred Sixty-Second Annual Exhibition: Water Colors, Prints and Drawings* (January 20–March 5).

Goddard-Riverside Community Center, New York, *American Artists in West Side Collections* (April 13–May 3).

Waddell Gallery, New York, *Artists for SEDF: Exhibition and Sale* (April 27–May 6).

Whitney Museum of American Art, New York, *American Art from the Twentieth Century: Selections from the Permanent Collection* (June 30–September 24).

Exhibition Center, Time-Life Building, New York, Fortune: *Art in World Business* (September 14–October 7).

Amon Carter Museum, Fort Worth, *Image to Abstraction* (September 14–November 19).

Forum Gallery, New York, *The Portrayal of Negroes in American Painting: United Negro College Fund Exhibition* (September 25–October 6).

Great Hall, City College of New York, *The Evolution of Afro-American Artists: 1800–1950* (October 15–November 8).

Wollman Hall, New School Art Center, New School for Social Research, New York, *Protest and Hope: An Exhibition of Contemporary American Art* (October 24–December 2).

Carnegie Institute, Pittsburgh, *The Pittsburgh International Exhibition of Contemporary Painting and Sculpture* (October 27, 1967–January 7, 1968).

YM-YWHA Essex County, West Orange, N.J., *WPA Artists: Then and Now* (October 29–November 28).

The American Academy of Arts and Letters, New York, *Drawings by Members* (November 17, 1967–February 4, 1968).

American Federation of Arts, New York, *American Painting: The 1940s.*

1968

Hood Museum of Art, Dartmouth College, Hanover, N.H., *Six Black Artists* (January 10–31).

Lake Forest College, Ill., *Soul Week 1968: The Negro in American Culture* (January 22–February 3).

National Collection of Fine Art, Smithsonian Institution, Washington, D.C. (March–October).

Museum of Art, University of Connecticut, Storrs, *Edith Halpert and The Downtown Gallery* (May 25–September 1).

Sheraton Hotel, Philadelphia, *Afro-American Art Exhibition: Paintings, Drawings and Prints* (July).

Maine Coast Artists, Rockport, *Guest Exhibition: Hartgen, Laurent, Lawrence, and Shevis* (July 1–21).

Nassau Community College, Garden City, N.Y. (October).

Skowhegan School of Painting and Sculpture, New York, *Fourth Annual Exhibition and Sale* (October 3).

The National Academy of Design, New York, *Skowhegan School of Painting and Sculpture: Annual Art Exhibition and Sale* (October 4–13).

The Minneapolis Institute of Arts in association with Ruder & Finn Fine Arts, New York, *Thirty Contemporary Black Artists* (October 17–November 24). Traveled to High Museum of Art, Atlanta (December 15, 1968–January 12, 1969); Flint Institute of Arts, Mich. (January 31–March 1, 1969); Everson Museum of Art, Syracuse University, N.Y. (March 16–April 13, 1969); IBM Gallery of Arts and Sciences, New York (April 28–May 29, 1969); Museum of Art, Rhode Island School of Design, Providence (July 1–31, 1969); Memorial Gallery of the University of Rochester, N.Y. (August 22–October 5, 1969); San Francisco Museum of Art (November 16–December 31, 1969); Contemporary Arts Museum, Houston (January 20–February 16, 1970); New Jersey State Museum, Trenton (March 13–April 26, 1970); Roberson Center for the Arts and Sciences, Binghamton, N.Y. (July 12–August 9, 1970); Milwaukee Art Center (August 27–September 27, 1970); The Art Galleries, University of California, Santa Barbara (October 12–November 15, 1970) [renamed *Contemporary Black Artists* for venues after July 1969].

The American Academy of Arts and Letters, New York, *Paintings by Members* (October 25–December 22).

The Museum of Modern Art, New York, *In Honor of Dr. Martin Luther King Jr.: Contemporary American Painting and Sculpture Donated by Artists to Be Sold for the Benefit of the Southern Christian Leadership Foundation* (October 30–November 3).

James B. Duke Library, Johnson C. Smith University, Charlotte, N.C., *Encounters: An Exhibit in Celebration of the Charlotte-Mecklenburg Bi-Centennial* (November–December).

The Brooklyn Museum, *Listening to Pictures.*

Museum of Art, Rhode Island School of Design, Providence, *The Neuberger Collection: An American Collection.*

1969

IBM International Foundation, Armonk, N.Y., *People and Places* (January–March). Traveled.

Worcester Art Museum, Mass., *Art in America, 1830–1950: Paintings, Drawings, Prints, Sculpture from the Collection of the Worcester Art Museum* (January 9–February 23).

Marymount College, Tarrytown, N.Y., *Focus: The Black Artist* (February 12–14).

Mead Art Museum, Amherst College, Mass., *American Art of the Depression Era* (February 25–March 19).

Talladega College, Ala., *Arts Festival* (April 16–20).

Georgia Museum of Art, The University of Georgia, Athens, *A University Collects: The Georgia Museum of Art* (November 8–30). Traveled to Alabama Art Gallery, Mobile (September 7–28); Illinois Art Club, Quincy (October 2–30); University of Connecticut, Storrs (December 8–20); Tennessee State University, Memphis (January 11–February 1, 1970); Goucher College, Baltimore (February 22–March 15, 1970); Junior League of Amarillo, Tex. (April 5–26, 1970); Charles B. Goddard Center, Ardmore, Okla. (May 17–June 7, 1970); Tennessee Fine Arts Center, Nashville (September 20–October 11, 1970).

Terry Dintenfass Inc., New York, *Skowhegan School of Painting and Sculpture: Fifth Annual Art Exhibition and Sale* (October 22–25).

Municipal Arts Gallery, Philadelphia Civic Center, *Afro-American Artists: 1800–1969* (December 5–29).

Whitney Museum of American Art, New York, *1969 Annual Exhibition: Contemporary American Painting* (December 16, 1969–February 1, 1970).

1970

The Museum of the National Center of Afro-American Artists, Roxbury, Mass., *Five Famous Black Artists: Romare Bearden, Jacob Lawrence, Horace Pippin, Charles White, Hale Woodruff* (February 9–March 10).

La Jolla Museum of Art, Calif., *Dimensions of Black* (February 14–March 29).

Archer M. Huntington Art Gallery, University of Texas at Austin, *Afro-American Artists Abroad* (March 29–May 3). Traveled to North Carolina Museum of Art, Raleigh; Elma Lewis School of Fine Arts, Dorchester, Mass.; Peal Museum of Art, Baltimore.

Indiana University Museum of Art, Bloomington, *The American Scene, 1900–1970: An Exhibition of Twentieth-Century Painting Held in Honor of the Sesquicentennial of Indiana University* (April 6–May 17).

Muskingum College, New Concord, Ohio, *Black American Art: An Overview* (April 12–30).

The Museum of the National Center of Afro-American Artists, Roxbury, Mass., School of the Museum of Fine Arts, and Museum of Fine Arts, Boston, *Afro-American Artists, New York and Boston* (May 19–June 23).

Terry Dintenfass Inc., New York, *Concern* (June 9–26).

Colorado Springs Fine Arts Center, *New Accessions USA* (July–September).

Archer M. Huntington Art Gallery, University of Texas at Austin, *Recent Acquisitions of the Michener Collection* (August 3–30).

Milwaukee Art Museum (September 27–October 27).

Eastern Michigan University, Ypsilanti, *Contemporary Afro-American Artists* (October 19–November 20).

1971

Illinois Bell Telephone, Chicago, *Black American Artists / 71* (January 12–February 5).

City of Auckland Art Gallery, New Zealand, *Pacific Cities Loan Exhibition* (March–May).

Whitney Museum of American Art, New York, *Contemporary Black Artists in America* (April 6–May 16).

The Newark Museum, *Black Artists: Two Generations* (May 12–June 27).

The Museum of Modern Art, New York, *The Artist As Adversary* (July 1–September 27).

National Collection of Fine Art, Smithsonian Institution, Washington, D.C., *Art by Black Americans: 1930–1950* (October 19–December 6).

Weatherspoon Art Gallery, University of North Carolina at Greensboro, *Art on Paper* (November–December).

Archer M. Huntington Art Gallery, University of Texas at Austin, *American Social Realism between the Wars: From the Michener Collection* (November 14–21).

African Cultural Center, Inc., Buffalo (December 19, 1971–January 19, 1972).

American Federation of Arts, New York, *Realism and Surrealism in American Art: From the Sara Roby Foundation Collection* (1971–5).

1972

Birmingham Museum of Art, Ala., *American Watercolors: 1850–Present* (January).

Whitney Museum of American Art, New York, *1972 Annual Exhibition: Contemporary American Painting* (January 25–March 19).

National Collection of Fine Art, Smithsonian Institution, Washington, D.C., *Edith Gregor Halpert Memorial Exhibition* (April).

Henry Art Gallery, University of Washington, Seattle, *Art of the Thirties: The Pacific Northwest* (April 1–30). Traveled to Portland Art Museum, Ore. (May 24–June 25).

Archer M. Huntington Art Gallery, University of Texas at Austin, *Form and the Creative Process, Selections from the Michener Collection* (May 15–June 30).

Polk Hall, Civic Center, San Francisco, *Black Expo '72* (September 7–10).

Olin Art Gallery, Whitman College, Walla Walla, Wash., *Inaugural Exhibition* (September 30–October 24).

William Penn Memorial Museum, Harrisburg, Pa., *An Alumnus Salutes Dickinson College's Two Hundredth Anniversary* (November 19, 1972–January 3, 1973).

Archer M. Huntington Art Gallery, University of Texas at Austin, *The Michener Collection: American Paintings of the Twentieth Century* (November 22, 1972–March 1, 1973).

Southern Christian Leadership Council, Atlanta, *Black Motion.*

Winston-Salem Alumnae Chapter, Delta Sigma Theta, N.C., *Reflections: The Afro-American Artist—An Exhibition of Paintings, Sculpture, and Graphics.*

1973

The Lowe Art Museum, University of Miami, Coral Gables, Fla., *The American Prophets* (February 21–March 25).

The National Academy of Design, New York, *One Hundred Forty-Eighth Annual Exhibition* (February 24–March 18).

The University of Maryland Art Gallery, Baltimore, *The Private Collection of Martha Jackson* (June 22–September 30). Traveled to The Finch College Museum of Art, New York (October 16–November 25); Albright-Knox Art Gallery, Buffalo (January 8–February 10, 1974).

New York Cultural Center, *Blacks: USA: 1973* (September 26–November 15).

Amherst College, Mass., *Twentieth-Century American Art from the William H. Lane Foundation* (October 10–November 11).

High Museum of Art, Atlanta, *Highlights from the Atlanta University Collection of Afro-American Art* (November 11–December 9). Traveled to Baltimore Museum of Art; Hanes Community Center, Winston-Salem, N.C.

Addison Gallery of American Art, Phillips Academy, Andover, Mass., *William H. Lane Foundation Exhibition* (November 20, 1973–January 24, 1974).

1974

Des Moines Art Center, *The Kirsch Years, 1936–1958* (January 7–February 10).

Anacostia Neighborhood Museum, Smithsonian Institution, Washington, D.C., *The Barnett-Aden Collection* (January 20–May 6). Traveled to Corcoran Gallery of Art, Washington, D.C. (January 10–February 9, 1975).

The National Academy of Design, New York, *One Hundred Forty-Ninth Annual Exhibition* (February 23–May 16).

University of Nebraska Art Galleries, Lincoln (February 25–March 31).

Rockland Center for the Arts, West Nyack, N.Y., *Africa in Diaspora* (March–April).

Afro-American Pavilion, Expo '74, Spokane, Wash. (summer).

Albright-Knox Art Gallery, Buffalo, *American Art in Upstate New York: Drawings, Watercolors and Small Sculpture from Public Collections in Albany, Buffalo, Ithaca, Rochester, Syracuse and Utica* (July 12–August 25). Traveled to Memorial Art Gallery of the University of Rochester, N.Y. (September 10–October 13); Herbert F. Johnson Museum of Art, Cornell University, Ithaca, N.Y. (October 22–November 24); Everson Museum of Art of Syracuse and Onandaga County, N.Y. (December 5, 1974–January 12, 1975); Museum of Art, Munson-Williams-Proctor Institute, Utica, N.Y. (January 26–March 2, 1975); Albany Institute of History and Art (March 14–April 27, 1975).

Archer M. Huntington Art Gallery, University of Texas at Austin, *Twentieth-Century American Painting: The First Five Decades, from the Michener Collection* (July 22, 1974–January 5, 1975).

Herbert F. Johnson Museum of Art, Cornell University, Ithaca, N.Y., *Directions in Afro-American Art* (September 18–October 27).

Hirshhorn Museum and Sculpture Garden, Smithsonian Institution, Washington, D.C., *Inaugural Exhibition* (October 1, 1974–September 15, 1975).

Philadelphia Museum of Art, *American Watercolors and Drawings from the Museum Collection* (October 4–December 10).

Winston-Salem Delta Fine Arts, N.C., *Highlights from the Atlanta University Collection of Afro-American Art.*

1975

Archer M. Huntington Art Gallery, University of Texas at Austin, *American Paintings of the Twentieth Century: Selections from the Michener Collection* (February 2–December 28). Traveled to Museo Nacional de Bellas Artes, Santiago; Museo de Arte Italiano, Lima; Museo Nacional de Bellas Artes, Buenos Aires; Museu Nacional de Belas Artes, Rio de Janeiro; Biblioteca Luis-Angel Arango del Banco de la Republica, Bogotá; Museo de Arte Contemporaneo de Caracas; Instituto Guatemalteca-Americano de Cultura, Guatemala City; Museo de Arte Moderno, Mexico City.

Kennedy Galleries, New York, *One Hundred Artists Associated with the Art Students League of New York* (March 6–29).

New Orleans Museum of Art, *A Panorama of American Painting: The John J. McDonough Collection* (April–June). Traveled to Fine Arts Gallery of San Diego (June 30–August 10); Marion Koogler McNay Art Museum, San Antonio (September 12–October 19); Arkansas Arts Center, Little Rock (November 14–December 28); Westmoreland Museum of Art, Greensburg, Pa. (January 26–March 8, 1976); North Carolina Museum of Art, Raleigh (April–June 1976); Oklahoma Art Center, Oklahoma City (July 1–August 15, 1976); The Butler Institute of American Art, Youngstown, Ohio (October 3–31, 1976).

The William Benton Museum of Art, University of Connecticut, Storrs, *Selections from the William H. Lane Foundation* (May 17–May 25).

The Saint Louis Art Museum, *The Black Presence in Art* (October 3–November 10).

The National Academy of Design, New York, *A Century and a Half of American Art* (October 10–November 16).

Linda Farris Gallery, Seattle, *Images of Woman* (November 13–December 2).

The Museum of the National Center of Afro-American Artists, Roxbury, Mass., and Museum of Fine Arts, Boston, *Jubilee: Afro-American Artists on Afro-America* (November 13, 1975–January 4, 1976).

Albright-Knox Art Gallery, Buffalo, *The Martha Jackson Collection at the Albright-Knox Art Gallery* (November 21, 1975–January 4, 1976).

Department of Fine Art, Fisk University, Nashville, *Amistad II: Afro-American Art.*

1976

The Art Museum, Princeton University, N.J., *Fragments of American Life, An Exhibition of Paintings: Romare Bearden, Joseph Delaney, Rex Gorleigh, Lois Mailou Jones, Jacob Lawrence, Hughie Lee-Smith, Hale Woodruff* (January 25–March 28).

Moravian College, Bethlehem, Pa., *American Concern, The Humanist View: Selected Works on Paper* (February 9–March 4).

New Muse Community Museum, Brooklyn, *Black Artists of the WPA 1933–1943: An Exhibition of Drawings, Paintings and Sculpture* (February 15–March 30).

Hirschl and Adler Galleries, New York, *The Second Williams College Alumnae Loan Exhibition* (April 1–24).

Union Gallery, Auburn University, Ala., *Advancing American Art, 1946–47: An Exhibition of British and American Paintings* (April 11–30).

Bedford-Stuyvesant Restoration Corporation, Brooklyn, *Selected Works by Black Artists from the Collection of The Metropolitan Museum of Art* (April 14–June 14).

The Metropolitan Museum of Art, New York, *Selected Works by Black Artists* (April 14–June 14).

Williams College, Williamstown, Mass., *The Second Williams College Alumni Loan Exhibition* (May 9–June 13).

Institute of Contemporary Art, Boston, *A Selection of American Art: The Skowhegan School 1946–1976* (June 16–September 5).

United States Information Agency, Washington, D.C., *Two Hundred Years of American Painting, 1776–1976* (1976–7). Traveled to Rheinischen Landesmuseum, Bonn (June 30–August 1); Muzej Savremene Umetsosti, Belgrade (August 15–September 18); Galleria Nazionale d'Arte Moderna, Rome (October 1–26); Muzeum Narodowe, Warsaw (November 15–December 10); The Maryland Science Center, Baltimore (January 16–February 6, 1977).

The Brooklyn Museum, *American Watercolors and Pastels from the Museum Collection* (July 3–September 19).

Archer M. Huntington Art Gallery, University of Texas at Austin, *Twentieth-Century American Figurative Painting in the Michener Collection* (July 4–August 1).

North Carolina Museum of Art, Raleigh, *Two Hundred Years of the Visual Arts in North Carolina* (September 12–October 24).

Los Angeles County Museum of Art, *Two Centuries of Black American Art* (September 30–November 21). Traveled to High Museum of Art, Atlanta (January 8–February 20, 1977); Museum of Fine Arts, Dallas (March 30–May 15, 1977); The Brooklyn Museum (June 25–August 21, 1977).

Museum of Art, Colby College, Waterville, Maine (October 1–30).

Seattle Art Museum, *Masters of the Northwest* (November 1976–January 1977).

Pratt Institute Gallery, Brooklyn, *Fourteen Afro-American Artists* (December 1–21).

1977
The Gallery Association of New York State, *New Deal for Art: The Government Art Projects of the 1930s with Examples from New York City and State* (1977). Traveled to Tyler Art Gallery, College of Arts and Sciences, State University of New York, Oswego (January 20–February 17); The Picker Art Gallery, Colgate University, Hamilton, N.Y. (February 24–March 24); C. W. Post Gallery, Long Island University, Brookville, N.Y. (April 12–May 17); Joe and Emily Lowe Art Gallery, Syracuse University, N.Y. (June 1–30); Delaware Art Museum, Wilmington (July 15–August 15); Museum of Art, Munson-Williams-Proctor Institute, Utica, N.Y. (September 1–29); Fosdick-Nelson Gallery, Alfred, N.Y. (September 30–October 28); The Grey Art Gallery, New York (November 25–December 20).

Henry Art Gallery, University of Washington, Seattle, *Henry Art Gallery: Five Decades* (February 11–March 13).

Whitney Museum of American Art, New York, *Thirty Years of American Art: Selections from the Permanent Collection* (May 6–July 24).

Herbert F. Johnson Museum of Art, Cornell University, Ithaca, N.Y., *American Watercolors, 1855–1955* (May 17–July 3).

Hirshhorn Museum and Sculpture Garden, Smithsonian Institution, Washington, D.C., *Kin and Communities: Selected Works from the Hirshhorn Museum Collection* (June 14–August 23).

Beaumont-May Gallery, Hopkins Center, Dartmouth College, Hanover, N.H., *The Jay Wolf Bequest of Contemporary Art* (June 24–August 28).

Whitney Museum of American Art, New York, *Introduction to Twentieth-Century American Art: Selections from the Permanent Collection* (September 16–October 10).

Frick Fine Arts Museum, University of Pittsburgh, *Black American Art from the Barnett-Aden Collection* (September 17–October 23).

Indianapolis Museum of Art, *Perceptions of the Spirit in Twentieth-Century American Art* (September 20–November 27). Traveled to University Art Museum, University of California, Berkeley (December 28, 1977–February 12, 1978); Marion Koogler McNay Art Museum, San Antonio (March 5–April 16, 1978); Columbus Gallery of Fine Arts, Ohio (May 10–June 19, 1978).

Oklahoma City Art Museum, *Mid-America Collects* (October 23–November 27).

Nave Museum, Victoria, Tex., *Between the Wars: American Painting and Graphics* (November 3–December 18).

The Studio Museum in Harlem, New York, *New York/Chicago: WPA and the Black Artist* (November 13, 1977–January 8, 1978).

Paducah Art Guild, Ky. (December 1977–February 1978).

Kennedy Galleries, New York, *Artists Salute Skowhegan* (December 8–21).

Pushkin Museum, Moscow, *Representations of America* (December 15, 1977–February 15, 1978). Traveled to Hermitage Museum, Leningrad (March 15–May 15, 1978); Palace of Art, Minsk (June 15–August 15, 1978).

The University Gallery, University of Minnesota, Minneapolis, *Hudson D. Walker: Patron and Friend, Collector of Twentieth-Century American Art*.

1978
The Schomburg Center for Research in Black Culture, New York, *The Business of Slavery* (February 4–April 15).

Danforth Museum of Art, Framingham, Mass., *American Art: Selections from the William H. Lane Foundation* (March 21–June 4).

Montgomery Museum of Fine Arts, Ala., *American Art, 1934–1956: Selections from the Whitney Museum of American Art* (April 26–June 11). Traveled to Brooks Memorial Art Galleries, Memphis (June 30–August 6); Mississippi Museum of Art, Jackson (August 21–October 1).

National Portrait Gallery, Washington, D.C., *Time of Our Lives* (May 1, 1978–June 30, 1979). Traveled to Lyndon Baines Johnson Library and Museum, Austin, Tex. (July 21, 1979–January 1, 1980).

Gallery 62, National Urban League, New York, *Golden Opportunity* (September 18–November 30).

Oklahoma Art Center, *Cityscape 78* (October 27–November 29).

Mint Museum of Art, Charlotte, N.C., *American Painting and Sculpture 1900–1945* (November 12–December 23).

1979
The William Benton Museum of Art, University of Connecticut, Storrs, *Selections from The William H. Lane Foundation: Part II* (January 22–March 11).

New Jersey State Museum, Trenton, *American Art of the 1930s: A Survey* (February 10–April 22).

Lewis and Clark College, Portland, Ore. (March 26–April 8).

District 1199 Cultural Center, New York, *The Working American* (October 18–November 24). Traveled to Detroit Historical Museum; Memorial Art Gallery of the University of Rochester, N.Y.; Chicago Historical Society; Birmingham Museum of Art, Ala.; New Jersey State Museum, Trenton; Museum of Our National Heritage, Lexington, Mass.

1980
Museum of Art, Munson-Williams-Proctor Institute, Utica, N.Y., *The Olympics in Art: An Exhibition of Works of Art Related to Olympic Sports* (January 13–March 2).

New Jersey State Museum, Trenton, *Six Black Americans: Benny Andrews, Romare Bearden, Sam Gilliam, Richard Hunt, Jacob Lawrence, Betye Saar* (January 26–March 30).

National Archives and Records Service, Washington, D.C., *Afro-American Album* (February–April).

The Corcoran Gallery of Art, Washington, D.C., *National Conference on the Arts Honors Ten African-American Artists* (March 14–April 16).

The Morris Museum, Morristown, N.J., *American Realism of the Twentieth Century* (April 14–May 31).

Whitney Museum of American Art, New York, *The Figurative Tradition and the Whitney Museum of American Art: Paintings and Sculpture from the Permanent Collection* (June 25–September 28).

The Chrysler Museum of Art, Norfolk, Va., *American Figure Painting 1950–1980* (October 1–December 5).

Wichita Falls Museum and Arts Center, Tex., *Selections from the Michener Collection* (October 15–November 16).

New Society of Art, Berlin, *American Art: 1920–1940* (November 1980–February 1981).

International Communication Agency, Washington, D.C., *Painting in the United States from Public Collections in Washington, D.C.* (1980). Traveled to Museo del Palacio de Bellas Artes, Mexico City (November 18, 1980–January 31, 1981).

1981
Goucher College, Baltimore, *Afro-American Artists Exhibition* (February).

CBS Broadcasting, New York, *Art NY* (March).

Whitney Museum of American Art, New York, *Decade of Transition, 1940–1950: Selections from the Permanent Collection* (April 30–July 12).

Washington State Capitol Museum, Olympia, *1981 Governor's Invitational Art Exhibition* (August).

Fort Wayne Museum of Art, Ind., *Selections from the Sara Roby Foundation* (September 4–November 1).

ACA Galleries, New York, *Social Art in America, 1930–1945* (November 6–28).

The Arkansas Arts Center, Little Rock, *Annual Collectors Show* (December 4, 1981–January 3, 1982).

1982
Rutgers University Art Gallery, New Brunswick, N.J., *Realism and Realities: The Other Side of American Painting, 1940–1960* (January 17–March 26). Traveled to Montgomery Museum of Fine Arts, Ala. (April 15–June 13); The Art Gallery of the University of Maryland, College Park (September 7–October 18).

Oklahoma City Art Museum, *Forty Drawings from The Arkansas Arts Center Foundation Collection* (January 22–February 21).

Rossi Gallery, Morristown, N.J., *American Image* (January 31–March 3).

Eubie Blake Cultural Center, Baltimore, *African-American Artists* (February).

Danforth Museum of Art, Framingham, Mass., *Selections from the Sara Roby Foundation Collection* (February–July).

Bowie State University, Md., *The Black Heritage: A Look at Two Continents* (February 15–March 5).

Clark Humanities Museum, Scripps College, Claremont, Calif., *Jacob Lawrence and Gwendolyn Knight* (March).

Edwin W. Voller Gallery, Paul Robeson Cultural Center, The Pennsylvania State University, University Park, *Prints: Romare Bearden and Jacob Lawrence* (April 4–30).

The Tampa Museum, Fla., *Games Kids Play* (July 1–September 10).

Owensboro Museum of Fine Art, Ky., *Selections from the Sara Roby Foundation Collection* (September–December).

Henry Art Gallery, University of Washington, Seattle, *The Washington Year: A Contemporary View, 1980–1981.*

1983

The Emerson Gallery, Hamilton College, Clinton, N.Y., *The Re-gentrified Jungle* (January–February).

Fine Arts Museum of Long Island, Hempstead, N.Y., *Celebrating Contemporary American Black Artists* (March 13–May 1).

Mary and Leigh Block Gallery, Northwestern University, Evanston, Ill., *Selections from the Sara Roby Foundation Collection* (March 24–July 3).

Greater Lafayette Museum of Art, Lafayette, Ind. (April 7–June 15).

Gallery 1199, New York, *Social Concern and Urban Realism: American Painting of the 1930s* (April 8–May 14). Traveled to Boston University Art Gallery (October 13–November 10); Anchorage Historical and Fine Arts Museum (December 10, 1983–January 21, 1984); Lauren Rogers Library and Museum of Art, Laurel, Miss. (February 18–March 31, 1984); Butler Institute of American Art, Youngstown, Ohio (April 28–June 9, 1984); Norton Gallery and School of Art, West Palm Beach, Fla. (July 7–August 18, 1984); The Fine Arts Museum of the South, Mobile, Ala. (September 15–October 27, 1984).

Museum of Fine Arts, Boston, *The Lane Collection: Twentieth-Century Paintings in the American Tradition* (April 13–August 28). Traveled to San Francisco Museum of Modern Art (October 1–December 1); Amon Carter Museum, Fort Worth (January 7–March 5, 1984).

Georgia Museum of Art, University of Georgia, Athens, *Hidden Masterpieces* (June 16–September 11).

The Butler Institute of American Art, Youngstown, Ohio, *The Forty-Seventh Annual Mid-Year Show* (August).

Cedar Rapids Art Center, Iowa, *Selections from the Sara Roby Foundation Collection* (August 21–December 31).

Bowie State University, Md., *Great American Artists* (September 2–October 2).

Stewart Center Gallery, Purdue University, West Lafayette, Ind. (September 19–October 9) [*The Life of Harriet Tubman*].

1984

Montgomery Museum of Fine Arts, Ala., *Advancing American Art* (January 10–March 4). Traveled to The William Benton Museum of Art, University of Connecticut, Storrs (March 17–May 6); National Museum of American Art, Smithsonian Institution, Washington, D.C. (June 1–October 8); Terra Museum of American Art, Evanston, Ill. (October 21–December 9).

Oklahoma City Art Museum, *The Aaron Douglass Collection: Nineteenth and Twentieth Century Black Experience and the Arts* (January 14–February 17).

The Arkansas Arts Center, Little Rock, *Twentieth-Century American Drawings from The Arkansas Arts Center Foundation Collection* (1984–7). Traveled to Eastern Shore Art Center, Fairhope, Ala. (January 15–February 29); The Arkansas Arts Center, Little Rock (March 10–April 27); Louisiana Arts and Sciences Center, Baton Rouge (May 7–June 30); Bass Museum of Art, Miami Beach (July 5–August 18); Art Institute of the Permian Basin, Odessa, Tex. (September 8–October 31); Jacksonville Art Museum, Fla. (November 14, 1984–January 15, 1985); Cornell Fine Arts Center, Rollins College, Winter Park, Fla. (March 14–April 27, 1986); Meadows Museum, Southern Methodist University, Dallas (June 8–August 3, 1986); Sangre de Cristo Arts and Conference Center, Pueblo, Colo. (September 12–October 24, 1986); Alexandria Museum Visual Art Center, La. (November 3, 1986–January 3, 1987); The Columbus Museum of Art, Ohio (January 17–March 8, 1987); Alaska State Museum, Juneau (March 19–April 26, 1987); University of Alaska Museum, Fairbanks (May 8–June 21, 1987).

Alexandria Museum of Art, La., *The Rhythm of Life: Selected Works by Bearden, Gwathmey, and Lawrence* (January 25–March 30).

The Baltimore Life Insurance Company Gallery, *The Remarkable Morgan State Collection* (February).

Emily Lowe Gallery, Hofstra University, Hempstead, N.Y., *A Blossoming of New Promise: Art in the Spirit of the Harlem Renaissance* (February 5–March 18).

Alexandria Museum of Art, La., *Selections from the Sara Roby Foundation Collection* (March–June).

The Center Gallery, Bucknell University, Lewisburg, Pa., *Since the Harlem Renaissance: Fifty Years of Afro-American Art* (April 13–June 6). Traveled to The Amelie A. Wallace Art Gallery, State University of New York at Old Westbury (November 1–December 9); Museum of Art, Munson-Williams-Proctor Institute, Utica, N.Y. (January 11–March 3, 1985); The Art Gallery, University of Maryland, College Park (March 27–May 3, 1985); The Chrysler Museum, Norfolk, Va. (June 19–September 1, 1985); Museum of Art, The Pennsylvania State University, University Park (September 22–November 1, 1985).

High Museum of Art, Atlanta, *African-American Art in Atlanta: Public and Corporate Collections* (May 11–June 17).

IBM Gallery of Science and Art, New York, *American Images: Selections from the IBM Collection* (June–July).

Huntsville Museum of Art, Ala., *Selections from the Sara Roby Foundation Collection* (September 2–December 30).

Alford House–Anderson Fine Arts Center, Anderson, Ind. (October 4–31) [*The Life of Harriet Tubman*].

1985

The Studio Museum in Harlem, New York, *Tradition and Conflict: Images of a Turbulent Decade, 1963–1973* (January 27–June 30).

The Montpelier Cultural Center, Laurel, Md., *Morgan State University Collection* (February).

The Metropolitan Museum of Art, New York, *The Artist Celebrates New York: Selected Paintings from The Metropolitan Museum of Art* (1985). Traveled to The Bronx Museum of the Arts (February 1–March 24); Long Island University—Brooklyn Campus (April 5–June 2); Jamaica Art Center, New York (June 15–August 24); Staten Island Museum, New York (September 6–October 20); City College of New York (October 25–December 13).

American Federation of Arts, New York, *The Figure in Twentieth-Century American Art: Selections from The Metropolitan Museum of Art* (1985–6). Traveled to Jacksonville Art Museum, Fla. (February 9–April 14); Oklahoma City Art Museum (May 5–30); The National Academy of Design, New York (June 14–September 1); Terra Museum of American Art, Evanston, Ill. (September 22–November 10); The Arkansas Arts Center, Little Rock (December 1, 1985–January 19, 1986); Colorado Springs Fine Arts Center (February 9–March 30, 1986).

The Chrysler Museum of Art, Norfolk, Va. (February 19–March 16)[*The Life of Harriet Tubman*].

Montgomery Museum of Fine Arts, Ala., *Turning Point: The Harlem Renaissance* (March 26–May 30).

Washington Project for the Arts, Washington, D.C., *Art in Washington and Its Afro-American Presence, 1940–1970* (March 30–May 11).

Heritage Plantation of Sandwich, Mass., *Young America: Children and Art* (May 4–October 27).

National Museum of American Art, Smithsonian Institution, Washington, D.C., *The Martha Jackson Memorial Collection* (June 21–September 15).

The Sixth District Police Headquarters, Washington, D.C., *The Evans-Tibbs Collection, Selections from the Permanent Holdings: Nineteenth and Twentieth Century American Art* (August 25–31).

Bellevue Art Museum, Wash., *Hidden Heritage: Afro-American Art, 1800–1950* (September 14–November 10). Traveled to The Bronx Museum of the Arts (January 14–March 10, 1986); California Afro-American Museum, Los Angeles (April 14–June 2, 1986); Wadsworth Atheneum, Hartford, Conn. (July 4–August 31, 1986); Mint Museum of Art, Charlotte, N.C. (September 22–November 17, 1986); San Antonio Museum of Art (December 15, 1986–February 9, 1987); The Toledo Museum of Art, Ohio (March 8–May 3, 1987); The Baltimore Museum of Art (June 1–July 27, 1987); Pennsylvania Academy of the Fine Arts, Philadelphia (August 23–October 18, 1987); Oklahoma City Art Museum (November 1987).

The Newark Museum, *Twentieth-Century Afro-American Artists: Selections from the Collection of The Newark Museum* (October).

National Museum of American Art, Washington, D.C., *Art, Design, and the Modern Corporation: The Collection of the Container Corporation of America, A Gift to the National Museum of American Art* (October 24, 1985–January 19, 1986).

Wichita Art Museum, Kans., *American Art and the Great Depression: Two Sides of the Same Coin* (October 27–December 1).

Smithsonian Institution Traveling Exhibition Service, Washington, D.C., *Genre Scenes* (1985–7). Traveled.

1986

Albright-Knox Art Gallery, Buffalo, *The American Scene—Selections from the Permanent Collection* (January 17–March 2).

Museum of Science and Industry, Chicago, *Choosing: An Exhibition of Changing Perspectives in Modern Art and Art Criticism by Black Americans, 1925–1985* (February 1–March 15).

North Carolina Museum of Art, Raleigh, *Selections from the Sara Roby Foundation* (February 1–April 27, 1986).

The Butler Institute of American Art, Youngstown, Ohio, *Fiftieth National Midyear Exhibition* (June 29–August 24).

Francine Seders Gallery, Seattle, *Studies for Murals and Sculpture* (July 8–27).

Brooklyn College, *Tides of Immigration* (October 7–December 9).

Special Collections and Rare Books, University of Minnesota Libraries, Minneapolis, *Witnessing Afro-American Life, Literature, and Achievement: The Archie Givens, Sr. Collection* (October 24–December 19).

National Museum of American Art, Washington, D.C., *Treasures from the National Museum of American Art* (1986–7).

1987

The Arkansas Arts Center, Little Rock, *Works by Artists Who Are Black* (January 30–March 4).

National Museum of American Art, Washington, D.C., *Modern American Realism: The Sara Roby Foundation Collection* (January 30–August 16).

The Studio Museum in Harlem, New York, *Harlem Renaissance: Art of Black America* (February 12–August 30). Traveled to The Crocker Art Museum, Sacramento, Calif. (January 16–March 12, 1988); Mary and Leigh Block Gallery, Northwestern University, Evanston, Ill. (April 9–June 4, 1988); High Museum of Art, Atlanta (July 2–August 27, 1988); Bowdoin College Museum of Art, Brunswick, Maine (September 24–November 19, 1988); Laguna Gloria Art Museum, Austin, Tex. (December 17, 1988–February 11, 1989); Virginia Museum of Fine Arts, Richmond (March 27–May 21, 1989); The Tennessee Botanical Gardens and Fine Arts Center at Cheekwood, Nashville (June 3–July 29, 1989); New York State Museum, Albany (August 26–October 29, 1989).

California Afro-American Museum, Los Angeles, *The Portrayal of the Black Musician in American Art* (March 7–August 14). Traveled to Afro-American Historical and Cultural Museum, Philadelphia (January 8–March 11, 1988); Museum of the National Center of Afro-American Artists, Roxbury, Mass. (April 4–May 16, 1988); Studio Museum in Harlem, New York (July 22–August 28, 1988).

Evans-Tibbs Collection, Washington, D.C., *Aesthetics of the American Northwest* (April–June).

Seattle Art Museum, *Recent Modern Acquisitions* (August 27–October 18).

New York State Museum, Albany, *Diamonds Are Forever: Artists and Writers on Baseball* (September 5–November 8). Traveled to Norton Gallery of Art, West Palm Beach, Fla. (January 23–March 13, 1988); New York Public Library (May 2–June 12, 1988); The Contemporary Arts Center, Cincinnati (July 2–August 21, 1988); Utah Museum of Fine Arts, Salt Lake City (September 10–October 30, 1988); The Oakland Museum, Calif. (November 19, 1988–January 15, 1989); San Diego Museum of Art (February 11–April 9, 1989); Baltimore Museum of Art (May 13–June 25, 1989); Chicago Public Library (July 8–September 9, 1989); Museo de Arte e Historia de San Juan, Puerto Rico; Museum of Fine Arts, Houston; Institute of Contemporary Art, Boston (June 2–July 15, 1990); La Jolla Museum of Contemporary Art, Calif. (August 18–October 21, 1990); Southeastern Center for Contemporary Art, Winston-Salem, N.C. (November 17, 1990–February 3, 1991); Sky Dome, Toronto (February 25–July 10, 1991); Yurakucho Art Forum, Seibu Department Store, Tokyo (August 1–26, 1991); Taipei Fine Arts Museum, Taiwan (October 5–November 17, 1991); Scottsdale Center for the Arts, Ariz. (February 27–April 19, 1992); Albright-Knox Art Gallery, Buffalo (May 16–July 5, 1992).

Terry Dintenfass Inc., New York, *A Point of View* (October 2–29).

The Museum of African American Art, Los Angeles, *Los Angeles Collects: Works by Over Thirty Artists from Fifteen Private Collections* (October 9–December 27).

Albright-Knox Art Gallery, Buffalo, *Intimate Gestures, Realized Visions: Masterworks on Paper from the Collection of the Albright-Knox Art Gallery* (December 11, 1987–January 31, 1988).

1988

Francine Seders Gallery, Seattle, *Selected Works in Celebration of Black History Month* (February 5–March 6).

Pratt Manhattan Gallery, Pratt Institute, New York, *This Was Pratt* (March 12–April 16). Traveled to The Rubelle and Norman Schafler Gallery, Pratt Institute, Brooklyn (June 13–July 8).

Herbert F. Johnson Museum of Art, Cornell University, Ithaca, N.Y., *Afro-American Art from the Herbert F. Johnson Collection* (March 28–April 16).

Arizona Bank Galleria, Phoenix, *Artists of the Black Community/USA* (May 26–August 19).

Safeco Gallery, Safeco Insurance Companies, Seattle, *School of Art: 1960–1975* (June 3–July 29).

The Schomburg Center for Research in Black Culture, New York, *Augusta Savage and the Art Schools of Harlem* (October 9, 1988–January 28, 1989).

1989

Smithsonian Institution Traveling Exhibition Service, Washington, D.C., *African-American Artists 1880–1987: Selections from the Evans-Tibbs Collection* (1989–92). Traveled to Hood Museum of Art, Dartmouth College, Hanover, N.H. (January 28–March 12); Frances Loeb Art Center, Vassar College, Poughkeepsie, N.Y. (April 1–May 14); Afro-American Cultural Center, Charlotte, N.C. (June 3–July 16); The Patrick and Beatrice Haggerty Museum of Art, Marquette University, Milwaukee (August 12–September 24); Hillwood Art Museum, Long Island University/C. W. Post Campus, Brookville, N.Y. (October 7–November 19); Marion Koogler McNay Art Museum, San Antonio (December 9, 1989–January 21, 1990); Nevada Institute of Contemporary Art, Las Vegas (February 10–March 25, 1990); Grinnell College, Iowa (April 7–May 21, 1990); The Columbus Museum, Ga. (June 16–July 29, 1990); The Arkansas Arts Center, Little Rock (August 18–September 30, 1990); Museum of Art and Archaeology, University of Missouri, Columbia (October 20–December 2, 1990); Edison Community College Gallery, Fort Myers, Fla. (January 4–February 9, 1991); University Art Museum, University of Kentucky, Lexington (February 23–April 7, 1991); Terra Museum of American Art, Chicago (April 27–June 9, 1991); Telfair Academy of Arts and Sciences, Savannah, Ga. (June 29–August 11, 1991); Fort Wayne Museum of Art, Ind. (August 31–October 13, 1991); Knoxville Museum of Art, Tenn. (November 2–December 15, 1991); Stedman Art Gallery, Rutgers University, Camden, N.J. (March 14–April 26, 1992); Museum of African American History, Detroit (July 18–September 6, 1992); Western Gallery, Bellingham, Wash. (September 28–November 25, 1992).

Albright-Knox Art Gallery, Buffalo, *A View of the Ordinary* (January 31–April 2).

Philadelphia Museum of Art, *Selection of African American Works from the Collections* (February 1–April 9).

Terry Dintenfass Inc., New York, *The Way They Saw It: Peter Blume, Philip Evergood, Antonio Frasconi, Sidney Goodman, Robert Gwathmey, William King, Jacob Lawrence, Ben Shahn* (February 4–25).

Pennsylvania Academy of the Fine Arts, Philadelphia, *American Art from the Collection of Vivian and Meyer P. Potamkin* (June 10–October 1).

Downtown Arts Gallery at Church Street Centre, Nashville, *American Resources: Selected Works by African-American Artists* (June 18–August 18). Traveled to Bernice Steinbaum Gallery, New York (August 26–September 24).

Washington Project for the Arts, Washington, D.C., *The Blues Aesthetic: Black Culture and Modernism* (September 14–December 9). Traveled to California Afro-American Museum, Los Angeles (January 12–March 4, 1990); Duke University Museum of Art, Durham, N.C. (March 23–May 20, 1990); Sarah Campbell Blaffer Gallery, University of Houston (June 8–July 31, 1990); The Studio Museum in Harlem, New York (September 16–December 30, 1990).

The Washington State Capitol Museum, Olympia, *In Retrospect: Twenty-Five Years: The Governor's Invitational Art Exhibition* (September 23–November 12).

Tacoma Art Museum, Wash., *One Hundred Years of Washington Art: New Perspectives* (November 24, 1989– February 11, 1990).

Hampton University Museum, Va. [*The Life of Harriet Tubman*].

1990

The Corcoran Gallery of Art, Washington, D.C., *Facing History: The Black Image in American Art, 1710–1940* (January 13–March 25). Traveled to The Brooklyn Museum (April 20–June 25).

The Newark Museum of Art, N.J., *Against the Odds: African-American Artists and the Harmon Foundation* (January 15–April 15). Traveled to Gibbes Museum of Art, Charleston, S.C. (May 7–July 9); Chicago Cultural Center (July 28–September 29).

Philadelphia Museum of Art, *African American Art from the Collection* (January 20–April 1).

The Baltimore Museum of Art, *African-American Art from the Museum's Collection* (January 21–March 18).

Jon Taner Art Gallery, Montclair, N.J. (February).

Palm Springs Desert Museum, Calif., *Northwest by Southwest: Painted Fictions* (1990). Traveled to Yellowstone Art Center, Billings, Mont. (June 22–August 19); Western

Gallery, Western Washington University, Bellingham (September 24–October 20); Sarah Campbell Blaffer Gallery, University of Houston (November 9–December 30).

Herbert F. Johnson Museum of Art, Cornell University, Ithaca, N.Y., *Cornell Collects: A Celebration of American Art from the Collections of Alumni and Friends* (September).

Edith C. Blum Art Institute, Bard College, Annandale-on-Hudson, N.Y., *Art What Thou Eat: Images of Food in American Art* (September 2–November 18).

The Arkansas Arts Center, State Services Department, Little Rock, *African American Artists from The Arkansas Arts Center Foundation Collection* (1990–6). Traveled to Arkansas College, Batesville (September 3–28); Central High School Library, West Helena, Ark. (April 1–30, 1991); Addison Shoe Corporation, Wynne, Ark. (May 15–June 21, 1991; Delta Cultural Center, Helena, Ark. (September 23–October 25, 1991); Crittenden Arts Council, West Memphis, Ark. (January 6–24, 1992); Arkansas State University Museum, Jonesboro (February 3–28, 1992); Hot Springs Arts Center, Ark. (March 3–April 30, 1992); University of Arkansas, Fayetteville (July 31–August 21, 1992); Art Institute of the Permian Basin, Odessa, Tex. (March 13–June 13, 1993); Madison-Morgan Cultural Center, Madison, Ga. (October 1–31, 1993); Hot Springs Arts Center, Ark. (January 3–26, 1994); Museum, University of Tennessee at Martin (February 1–28, 1994); West Memphis Public Library, Ark. (May 1–31, 1994); Henderson State University, Arkadelphia, Ark. (June 6–30, 1994); Hot Springs Arts Center, Ark. (December 30, 1994–January 18, 1995); University of Central Arkansas, Conway (June 6–July 15, 1995); Austin College, Sherman, Tex. (February 1–28, 1996); Ridgecrest High School, Paragould, Ark. (March 18–April 19, 1996); Fort Smith Arts Center, Ark. (April 29–May 26, 1996).

The Arts and Science Center for Southeast Arkansas, Pine Bluff, *Drawings: A Survey of the Twentieth Century, Selections from The Arkansas Arts Center Foundation Collection* (September 6–October 14).

The Museum of Modern Art, New York, *Drawn in America, 1898–1945* (November 1, 1990–March 5, 1991).

National Building Museum, Washington, D.C., *GSA 1990 Design Excellence Awards* (November 26, 1990–January 4, 1991).

1991

Beach Institute/King-Tisdell Museum, Savannah, Ga., *The Walter O. Evans Collection of African-American Art* (January–April). Traveled to Hammonds House Galleries, Atlanta (May–September); St. John's Museum of Art, Wilmington, N.C. (September–December); Louisiana Arts and Science Center, Baton Rouge (January–March 1992); Junior Black Academy of Arts and Letters, Dallas (March–August 1992); Museum of Fine Arts, Saint Petersburg, Fla. (September–October 1992); Boston University Art Gallery (November 1992–January 1993); Cincinnati Arts Consortium (June–July 1993); Institute of Texan Cultures, San Antonio (July–October 1993); The Canton Art Institute, Ohio (November 1993–February 1994); Delaware Art Museum, Wilmington (March–May 1994); University of Hawaii at Manoa, Honolulu (June–August 1994); Flint Institute of Arts, Mich. (September–October 1994); The Ackland Art Museum, University of North Carolina, Chapel Hill (November 1994–April 1995); Kalamazoo Institute of Arts, Miss. (June–August 1995); Taylor Museum, Colorado Springs Fine Arts Center (November 1995–January 1996); Hofstra University Museum, Hempstead, N.Y. (February–March 1996); Art Museum of Western Virginia, Roanoke (April–June 1996); Asheville Art Museum, N.C. (July 1996–January 1997); Montgomery Museum of Fine Arts, Ala. (February–March 1997); Kuumba Trust, Foreland Street Studio, Pittsburgh (June–August 1997); Cheekwood Museum of Art, Nashville (September 1997–January 1998); Huntington Museum of Art, W.V. (February–April 1998); Walter Anderson Museum of Art, Ocean Springs, Miss. (August–October 1998); Lowe Art Museum, University of Miami, Coral Gables, Fla. (December 1998–January 1999); Meadows Museum of Art of Centenary College, Shreveport, La. (February–May 1999); Columbia Museum of Art, S.C. (June–September 1999); Museum of Art, Tallahassee, Fla. (October 1999–January 2000); Heckscher Museum of Art, Huntington, N.Y. (February–April 2000).

Addison Gallery of American Art, Phillips Academy, Andover, Mass., *The American City* (January 18–March 10).

Georgia Museum of Art, University of Georgia, Athens, *Through the Eyes of Artists: Portrayals of Blacks from the Collection of the University of Georgia* (February 2–March 10).

Tacoma Art Museum, Wash., *Recent Acquisitions to the Permanent Collection* (February 15–March 31).

The Museum of Modern Art, New York, *Art of the Forties* (February 24–April 30).

Albright-Knox Art Gallery, Buffalo, *African-American Art from the Permanent Collection* (March 15–April 28).

Addison Gallery of American Art, Phillips Academy, Andover, Mass., *American Abstraction at the Addison Gallery of American Art* (April 18–July 31). Traveled to Newport

Harbor Art Museum, Calif. (February 27–May 1, 1992); Terra Museum of American Art, Chicago (May 15–July 31); Huntington Museum of Art, W.V. (August. 28–November 6); Huntsville Museum of Art, Ala. (December 5, 1993–February 13, 1994); C. A. J. Memorial Gallery (March 12–May 21, 1994); Cheekwood Museum of Art, Nashville, Tenn. (June 12–August 28, 1994); Wichita Art Museum, Kans. (September 25–December 4, 1994).

Francine Seders Gallery, Seattle, *Twenty-Fifth Anniversary Exhibition: The Middle Years* (June 7–July 7).

Washington State Convention and Trade Center, Seattle, *1991 National Governor's Invitational Art Exhibition* (August).

Tacoma Art Museum, Wash., *Twentieth-Century American Painting* (August 22–October 20).

National Museum of American Art, Washington, D.C., *Recent Acquisitions in Graphic Arts* (October 4, 1991–February 2, 1992).

1992

Port Washington Public Library, N.Y., *One Hundred Years of American Art* (January 2–February 29).

Columbus Museum of Art, Ohio, *A Nature's Legacy: One Hundred Fifty Years of American Art* (January 19–October 5). Traveled to Isetan Museum of Art, Japan (April 9–May 5, 1993); Yamuguchi Prefectural Museum of Art, Japan (May 12–June 21, 1993); Fukushima Prefectural Museum of Art, Japan (June 27–August 2, 1993); Takamatsu City Museum of Art, Japan (August 7–September 6, 1993); Daimaru Museum, Japan (September 23–October 5, 1993).

Thomas J. Walsh Gallery, Fairfield University, Conn., *Human Conditions: American Twentieth-Century Paintings and Drawings* (February 7–March 7).

Tacoma Public Library, Wash., *Northwest Black Pioneers* (March 16–April 1).

The Nelson-Atkins Museum of Art, Kansas City, Mo., *American Drawings and Watercolors from the Kansas City Region* (July 19–September 6).

The Katonah Museum of Art, N.Y., *In Good Conscience: The Radical Tradition in Twentieth-Century American Illustration* (August 16–September 27). Traveled to Hood Museum of Art, Dartmouth College, Hanover, N.H. (October 17–December 26); Montgomery Museum of Fine Arts, Ala. (January 10–February 21, 1993).

The Jewish Museum, New York, *Bridges and Boundaries: African Americans and American Jews* (1992–4). Traveled to The Jewish Museum, San Francisco (October 13–December 20); The Strong Museum, Rochester, N.Y. (January 14–March 14, 1993); The Jewish Historical Society of Maryland, and Eubie Blake Cultural Center, Baltimore (April 18–June 10, 1993); National Afro-American Museum and Cultural Center, Wilberforce, Ohio (July 11–September 1, 1993); California Afro-American Historical and Cultural Museum, Los Angeles (September 22–December 6, 1993); Afro-American Historical and Cultural Museum, Philadelphia (January 7–March 13, 1994); Chicago Historical Society (April 7–July 4, 1994).

National Museum of American Art, Smithsonian Institution, Washington, D.C., *Free within Ourselves: African-American Artists in the Collection of the National Museum of American Art* (1992–4). Traveled to Wadsworth Atheneum, Hartford, Conn. (October 18, 1992–January 10, 1993); IBM Gallery of Science and Art, New York (February 9–April 10, 1993); Crocker Art Museum, Sacramento, Calif. (November 5–December 30, 1993); Memphis Brooks Museum of Art (January 1–March 27, 1994); The Columbus Museum, Ga. (May 1–June 26, 1994).

New Jersey State Museum, Trenton, and Prefecture of Fukui, Japan, *Dream Singers, Storytellers: An African-American Presence* (1992–4). Traveled to Fukui Fine Arts Museum, Japan (November 6–December 6); Tokushima Modern Art Museum, Japan (January 23–March 7, 1993); Nishinomiya Otani Memorial Art Museum, Japan (April 10–May 9, 1993); New Jersey State Museum, Trenton (August 7, 1993–March 20, 1994).

Exhibitions USA, Mid-America Arts Alliance, Kansas City, Mo., *Bold Strokes and Quiet Gestures: Twentieth-Century Drawings and Watercolors from the Santa Barbara Museum of Art* (1992–4). Traveled to Lowe Art Museum, University of Miami, Coral Gables, Fla. (November 12, 1992–January 17, 1993); Philharmonic Center for the Arts, Naples, Fla. (January 28–March 16, 1993); Texarkana Regional Arts and Humanities Council, Tex. (April 6–May 19, 1993); Wichita Falls Museum and Art Center, Tex. (June 9–August 11, 1993); J. Wayne Stark University Center Galleries, College Station, Tex. (September 1–October 14, 1993); Kalamazoo Institute of Arts, Mich. (November 4, 1993–January 7, 1994); Davenport Museum of Art, Iowa (January 28–March 16, 1994).

Tacoma Art Museum, Wash., *Collections on Paper: Recent Acquisitions* (November 13, 1992–February 7, 1993).

1993

New York Artists Equity Association, *Selected Works by Three Past Presidents: Yasuo Kuniyoshi, Jacob Lawrence, Louise Nevelson* (March 2–14).

Mount Holyoke College Art Museum, South Hadley, Mass., *Collective Pursuits: Mount Holyoke Investigates Modernism* (April 3–May 30).

Neuberger Museum of Art, Purchase College, State University of New York, *Roy R. Neuberger: Patron of the Arts* (April 25–July 25).

Museum of Fine Arts, Boston, *Awash in Color: Homer, Sargent, and the Great American Watercolor* (April 28–August 15).

Williams College, Williamstown, Mass., *Third Williams Alumni Loan Exhibition* (June 12–November 28).

Museum of Our National Heritage, Lexington, Mass., *Art from the Driver's Seat: Americans and Their Cars—From the Collection of Terry and Eva Herndon* (August 1, 1993–January 2, 1994). Traveled to Boise Art Museum, Idaho; Tarble Arts Center, Eastern Illinois University, Charleston; Kalamazoo Institute of Arts, Mich.; The Hudson River Museum of Westchester, Yonkers, N.Y.; Leigh Yawkey Woodson Art Museum, Wausau, Wis.; Hunter Museum of American Art, Chattanooga, Tenn.; Flint Institute of Arts, Mich.; Mobile Museum of Art, Ala.; The Columbus Museum, Ga.

Minnesota Museum of American Art, Saint Paul, *From the American Collection* (September 19–November 28).

Whitney Museum of American Art at Champion Plaza, Stamford, Conn., *Spheres of Influence: Artists and Their Students in the Permanent Collection of the Whitney Museum of American Art* (October 1–November 20).

Michael Rosenfeld Gallery, New York, *African-American Art: Twentieth Century Masterworks* (November 18, 1993–February 12, 1994).

Bellevue Art Museum, Wash., *Celebrations—No Place Like Home* (November 20, 1993–January 8, 1994).

Canton Art Institute, Ohio (December 10, 1993–March 3, 1994).

Philadelphia Art Alliance, *First in the Heart Is the Dream—African American Artists in the Twentieth Century: The Philadelphia Connection*.

1994

San Antonio Museum of Art, *The Harmon and Harriet Kelley Collection of African American Art* (February 4–April 3). Traveled to El Paso Museum of Art (April 15–June 5); Michael C. Carlos Museum, Emory University, Atlanta (June 15–August 20); The Butler Institute of American Art, Youngstown, Ohio (September 3–October 30); Hunter Museum of Art, Chattanooga, Tenn. (November 26, 1994–January 29, 1995); Center for African American History and Culture, Smithsonian Institution, Washington, D.C. (April–June 1995).

Galerie de l'École des Beaux-Arts de Lorient, France, *Le Temps d'un dessin* (March 16–April 6).

Nassau County Museum of Art, Roslyn Harbor, N.Y., *American Realism between the Wars: 1919–1941* (April 10–June 5).

Tampa Museum of Art, Fla., *New York Realism: Past and Present* (1994–5). Traveled to Odakyu Museum, Tokyo (May 18–June 5); Kagoshima City Museum of Art, Japan (July 1–August 7); Kitakyushu Municipal Museum of Art, Japan (August 13–September 25); The Museum of Art, Kintersu, Osaka (October 7–19); Fukushima Prefectural Museum of Art, Japan (November 1–December 11); Tampa Museum of Art, Fla. (January 27–March 12, 1995).

Terry Dintenfass Inc., New York, *Stars from the Lone Star State* (June).

Amon Carter Museum, Fort Worth, *Revealed Treasures: Watercolors and Drawings* (July 30–October 16).

Weatherspoon Art Gallery, University of North Carolina at Greensboro, *New Anatomies: The Figure in Twentieth Century Art, Selections from the Weatherspoon Collection* (August 21–November 13).

Seafirst Gallery, Seattle, *Tacoma Art Museum: Selections from the Northwest Collection* (September 2–October 20).

Chubb Group of Insurance Companies, Warren, N.J., *American Drawings 1900–1960 from the Permanent Collection of The Newark Museum* (September 3–November 1).

The Cleveland Museum of Art, *Recent Acquisitions: Prints, Drawings, Photographs* (September 13–November 27).

Smithsonian Institution Traveling Exhibition Service, Washington, D.C., *Louis Armstrong: A Cultural Legacy* (1994–6). Traveled to Queens Museum of Art, New York (September 22, 1994–January 8, 1995); African American Museum of Life and Culture, Dallas (January 28–April 2, 1995); Terra Museum of American Art, Chicago (April 15–June 25, 1995); Stedman Art Gallery, Rutgers University, Camden, N.J. (July 29–October 8, 1995); New Orleans Museum of Art (October 28, 1995–January 7, 1996); Strong Museum, Rochester, N.Y. (January 27–April 7, 1996); Telfair Academy of Arts and Sciences, Savannah, Ga. (April 27–June 15, 1996); National Portrait Gallery, Washington, D.C. (July 26–October 20, 1996).

Whitney Museum of American Art at Champion Plaza, Stamford, Conn., *Fables, Fan-tasies and Everyday Things* (October 14, 1994–January 30, 1995).

Museum of Art, Rhode Island School of Design, Providence, *Four Generations of African-American Art from the Permanent Collection* (November 17, 1994–February 19, 1995).

Samuel P. Harn Museum of Art, University of Florida, Gainesville, *America's Mirror: Painting in the United States, 1850–1950 from the Collection of The Georgia Museum of Art, the University of Georgia* (November 26, 1994–March 15, 1995).

James A. Michener Art Museum, Doylestown, Pa., *A Collector's Eye: Depression-Era Paintings from the Collection of John Horton* (December 10, 1994–January 22, 1995). Traveled to Lore Degenstein Gallery, Susquehanna University, Selinsgrove, Pa. (February 8–March 5, 1995).

1995

New Jersey State Museum, Trenton, *One Hundredth Anniversary Exhibition* (January 21–December 31).

U.S. Department of Transportation, Washington, D.C., *Black History Month Celebration, The James E. Lewis Museum of Art Collection Exhibition* (February).

Michael Rosenfeld Gallery, New York, *African-American Art: Twentieth Century Masterworks II* (February 1–April 8).

The Metropolitan Museum of Art, New York, *I Tell My Heart: The Art of Horace Pippin* (February 1–April 30).

Catherine G. Murphy Gallery, College of Saint Catherine, Saint Paul, *American Scene Painting* (February 4–March 3).

Pratt Manhattan Gallery, Pratt Institute, New York, *Jazz Y Son* (March 25–April 29). Traveled to The Rubelle and Norman Schafler Gallery, Pratt Institute, Brooklyn (September 21–October 20).

Neuberger Museum of Art, Purchase College, State University of New York, *Crossing State Lines: Twentieth-Century Art from Private Collections in Westchester and Fairfield Counties* (March 26–June 18).

Herbert F. Johnson Museum of Art, Cornell University, Ithaca, N.Y., *Exhibition of the Collection of William and Isabel Berley* (April 14–June 11).

Bellevue Art Museum, Wash., *Washington: One Hundred Years, One Hundred Paintings* (April 29–June 25).

Philadelphia Museum of Art, *Rolywholyover: A Circus* (May 21–July 30).

Weatherspoon Art Gallery, University of North Carolina at Greensboro, *The Everyday World: Selections from the Weatherspoon Collection* (June 4–November 26).

Richard J. Daley Center, Chicago, *Art in Public Places* (September 1995–January 1996).

American Federation of the Arts, New York, *In the Eye of the Storm: An Art of Conscience, 1930–1970, Selections from the Collection of Philip J. and Suzanne Schiller* (1995–8). Traveled to Terra Museum of American Art, Chicago (October 27, 1995–January 7, 1996); Greenville County Museum of Art, S.C. (January 24–March 31, 1996); Sheldon Memorial Art Gallery and Sculpture Garden, University of Nebraska-Lincoln (April 12–June 23, 1996); Knoxville Museum of Art, Tenn. (July 19–September 29, 1996); The Parrish Art Museum, Southampton, N.Y. (October 26, 1996–January 5, 1997); Norton Museum of Art, West Palm Beach, Fla. (March 8–April 20, 1997); Frederick R. Weisman Art Museum, Minneapolis (January 23–March 22, 1998).

DC Moore Gallery, New York, *Inaugural Exhibition* (November 16–December 30).

The Art Institute of Chicago, *Spiritual Expressions: Art for Private Contemplation and Public Celebration* (November 22, 1995–March 17, 1996).

San Jose Museum of Art, Calif., *American Art 1940–1965, Traditions Reconsidered. Selections from the Permanent Collection of the Whitney Museum* (December 2, 1995–March 30, 1997).

ACA Galleries, New York, *Voices of Conscience: Then and Now* (December 13, 1995–January 27, 1996).

1996

Michael Rosenfeld Gallery, New York, *African-American Art: Twentieth Century Masterworks III* (February 1–April 6).

Amistad Research Center, Tulane University, New Orleans, *Terms of Endurance: Living Legends in African American Art* (February 7–March 31).

Whitney Museum of American Art, New York, *An American Story* (March 20–October 6).

Addison Gallery of American Art, Phillips Academy, Andover, Mass., *Addison Gallery of American Art: Sixty-Five Years* (April 13–July 31).

Nassau County Museum of Art, Roslyn Harbor, N.Y., *Town and Country: In Pursuit of Life's Pleasures* (May 12–August 11).

The Art Institute of Chicago, *Since the Harlem Renaissance: Sixty Years of African-American Art* (May 18–August 25).

ACA Galleries, New York, *Voices of Conscience: Then and Now* (July 3–October 27).

Whitney Museum of American Art, New York, *New York, New York: City of Ambition* (July 3–October 27)

DC Moore Gallery, New York, *Pastels by Ten Contemporary Artists* (September 10–October 5).

American Federation of Arts, New York, *In the Spirit of Resistance: African-American Modernists and the Mexican Muralist School* (1996–8). Traveled to The Studio Museum in Harlem, New York (October 3–December 1); African American Museum, Dallas (January 5–March 2, 1997); Edsel and Eleanor Ford House, Grosse Point Shores, Mich. (March 26–May 25, 1997); California African-American Museum, Los Angeles (June 21–August 17, 1997); Diggs Gallery at Winston-Salem State University, N.C. (September 12–November 8, 1997); Dayton Art Institute, Ohio (December 13, 1997–February 1, 1998); The Mexican Museum, San Francisco (February 27–April 26, 1998).

The National Academy of Design, New York, *Powerful Expressions: Recent American Drawings* (October 16, 1996–January 5, 1997). Traveled to The Arkansas Art Center, Little Rock (January 20–March 5, 1997).

1997
Radford Study Collection Gallery, Georgia Museum of Art, University of Georgia, Athens, *Inspirations: Four Twentieth-Century African-American Artists* (January 17–February 16).

Michael Rosenfeld Gallery, New York, *African-American Art: Twentieth Century Masterworks IV* (January 24–March 26). Traveled to Fisk University Galleries, Nashville (April 1–June 1).

Atrium Gallery, Morristown, N.J., *This Is Why We Sing* (January 31–March 28).

Mary Ryan Gallery, New York, *Civil Progress: Images of Black America* (February 12–March 15).

Madison Art Center, Wis., *Dane County Collects: An Exhibition of Works from Area Corporate and Private Collections* (February 16–April 16).

Pennsylvania Academy of the Fine Arts, Philadelphia, *Founder's Day Exhibition* (May).

South Carolina State University, Orangeburg, *South Carolina Collects: Watercolors at S.C. State Museum* (June–September).

Hayward Gallery, London, *Rhapsodies in Black: Art of the Harlem Renaissance* (June 19–August 17). Traveled to Arnolfini, Bristol, England (September 6–October 19); Mead Gallery, University of Warwick, England (November 1–December 6); M. H. de Young Memorial Museum, San Francisco (January 17–March 22, 1998); The Corcoran Gallery of Art, Washington, D.C. (April 11–June 22, 1998); Los Angeles County Museum of Art (July 19–October 19, 1998).

DC Moore Gallery, New York, *Revealing Images: Selected Works on Paper* (October 7–November 1).

The National Academy of Design, New York, *The Artist's Eye: Will Barnet Selects from the Collection* (October 8, 1997–January 4, 1998).

1998
Springfield Museum of Art, Ohio, and the Riffe Gallery, Ohio Arts Council, Columbus, *Masterworks by Twentieth Century African-American Artists* (January 17–June 13, 1998).

Michael Rosenfeld Gallery, New York, *African-American Art: Twentieth Century Masterworks V* (January 22–March 21). Traveled to Newcomb Art Gallery, Tulane University, New Orleans (April 6–June 6).

Museum of Art, Rhode Island School of Design, Providence, *One Voice: Many Visions* (February 20–June 14).

Brooklyn Museum of Art, *Masters of Color and Light: Homer, Sargent and the American Watercolor Movement* (March 20–July 5).

David Winston Bell Gallery, Brown University, Providence, R.I., *The Harmon and Harriet Kelley Collection of African-American Art* (April 18–May 31).

Madison Art Center, Wis., *Modern American Realism: The Sara Roby Foundation Collection from the National Museum of American Art* (May 31–August 9).

DC Moore Gallery, New York, *Food for Thought: A Visual Banquet* (June 24–August 12).

New Jersey State Museum, Trenton, *Art by African Americans in the Collection of the New Jersey State Museum* (September 19–December 31).

University of Maryland, College Park, *Narratives of African American Art and Identity: The David C. Driskell Collection* (October 22–December 19). Traveled to African American Museum, Dallas (March 13–June 19, 1999); Colby College Museum of Art, Waterville, Maine (July 21–October 17, 1999); M. H. de Young Memorial Museum, San

Francisco (November 13, 1999–February 12, 2000); Cincinnati Art Museum (March 17–May 22, 2000); High Museum of Art, Atlanta (June 20–September 10, 2000); The Newark Museum, N.J. (October 20, 2000–February 25, 2001).

The Schomburg Center for Research in Black Culture, New York, *Black Artists of the Twentieth Century: Selections from The Schomburg Center Collections* (November 17, 1998–April 4, 1999).

Heckscher Museum of Art, Huntington, N.Y., *Modern American Realism: The Sara Roby Foundation Collection from the National Museum of American Art* (November 21, 1998–January 31, 1999).

Addison Gallery of American Art, Phillips Academy, Andover, Mass., *Form and Structure: Twentieth-Century Work from the Addison Collection* (December 28, 1998–April 25, 1999).

1999
DC Moore Gallery, New York, *The Reflective Image: American Drawings and Watercolors 1910–1960* (January 7–30).

Michael Rosenfeld Gallery, New York, *African-American Art: Twentieth Century Masterworks VI* (January 14–March 6). Traveled to Flint Institute of Arts, Mich. (April 30–June 20).

The George D. and Harriet W. Cornell Fine Arts Museum, Winter Park, Fla., *Beyond the Veil: Art of African American Artists at Century's End* (January 16–February 28).

Tacoma Art Museum, Wash., *American People, American Places* (January 30–March 28).

The Patrick and Beatrice Haggerty Museum of Art, Marquette University, Milwaukee, *Children in Art: A Century of Change* (February 12–May 23).

DC Moore Gallery, New York, *The Contemporary City: Red Grooms, Yvonne Jacquette, Jacob Lawrence, Philip Pearlstein, Paul Wonner* (March 3–27).

Addison Gallery of American Art, Phillips Academy, Andover, Mass., and The Studio Museum in Harlem, New York, *To Conserve a Legacy: American Art from Historically Black Colleges and Universities* (1999–2001). Traveled to The Studio Museum in Harlem, New York (March 17–July 11); Addison Gallery of American Art, Phillips Academy, Andover, Mass. (August 31–October 31); The Corcoran Gallery of Art, Washington, D.C. (November 20, 1999–January 31, 2000); The Art Institute of Chicago (February 19–April 30, 2000); Clark Atlanta University Art Galleries with High Museum of Art, Atlanta (June 6–September 25, 2000); North Carolina Central University Art Museum with Duke University Art Museum and Center for Documentary Studies, Durham (October 15–December 1, 2000); Fisk University with Tennessee State Museum, Nashville (January 2–March 31, 2001); Hampton University Museum, Va. (April 22–July 29, 2001).

National Museum of American Art, Washington, D.C., *Picturing Old New England: Image and Memory* (April 2–August 29).

Whitney Museum of American Art, New York, *The American Century: Art and Culture, 1900–1950* (April 23–August 22).

Meridian International Center, Washington, D.C., *Outward Bound: American Art at the Brink of the Twenty-First Century* (May 20–June 11).

The Aldrich Museum of Contemporary Art, Ridgefield, Conn., *The Nude in Contemporary Art* (June 6–September 12).

Susquehanna Art Museum, Harrisburg, Pa., *American Abstraction/American Realism: The Great Debate* (June 8–August 21).

DC Moore Gallery, New York, *Summer Group Show* (June 22–August 13).

Francine Seders Gallery, Seattle, *Ordinary People* (August 6–September 3).

Pinnacle Gallery, Savannah College of Art and Design, Ga., *Hindsight Is 20/20* (September 16, 1999–January 2, 2000).

Bibliography

This bibliography is organized by publication type. Books illustrated by the artist, monographs, exhibition catalogues, and periodicals are ordered chronologically and are listed first. All other publications are listed alphabetically. The bibliography tends towards all-inclusiveness in an effort to provide a detailed overview of the various literary and critical contexts in which Lawrence's work has appeared between 1935 and 1999. All known publications are listed. Though the periodical and newspaper section is extensive, it is by no means exhaustive. Nonmainstream periodicals or regional newspapers are included when known.

Books Illustrated by the Artist
(in chronological sequence)

Hughes, Langston. *One-Way Ticket*, with illustrations by Jacob Lawrence. New York: Alfred A. Knopf, 1948.

Lawrence, Jacob, with verses by Robert Kraus. *Harriet and the Promised Land*. New York: Windmill Books, Simon & Schuster, 1968; New York: Simon & Schuster, 1993.

Aesop's Fables, with illustrations by Jacob Lawrence. New York: Windmill Books, Simon & Schuster, 1970; Seattle: University of Washington Press, 1997.

Hersey, John, with silk-screen prints by Jacob Lawrence. *Hiroshima*. New York: The Limited Editions Club, 1983.

Genesis [King James version of the book of Genesis, illustrated with eight screen prints by Jacob Lawrence]. New York: The Limited Editions Club, 1990.

Monographs and Publications Related to Solo Exhibitions
(in chronological sequence)

[Alston, Charles]. *Jacob Lawrence*. Exh. cat. New York: James Weldon Johnson Literary Guild, 1938.

"Harlem" by Jacob Lawrence: Exhibition of Paintings in Gouache. Exh. brch. New York: The Downtown Gallery, 1943.

Jacob Lawrence: John Brown, A Series of Twenty-Two Paintings in Gouache. Exh. brch. New York: The Downtown Gallery, 1945.

The Life of John Brown by Jacob Lawrence. Exh. brch. Washington, D.C.: The Barnett Aden Gallery, 1946.

Jacob Lawrence: The War Series. Exh. brch. Trenton, N.J.: New Jersey State Museum, 1947.

War: Fourteen Paintings in Tempera by Jacob Lawrence. Exh. brch. New York: The Downtown Gallery, 1947.

Jacob Lawrence: John Brown Series. Exh. brch. American Association of University Women, 1949.

Jacob Lawrence. Exh. brch. New York: The Downtown Gallery, 1950.

Performance: A Series of New Paintings in Tempera by Jacob Lawrence. New York: The Downtown Gallery, 1952.

Jacob Lawrence: Struggle . . . From the History of the American People. Exh. brch. New York: The Alan Gallery, 1956.

Saarinen, Aline B. *Jacob Lawrence*. Exh. cat. New York: American Federation of Arts, 1960.

Jacob Lawrence: Painting Exhibition. Exh. brch. Miami Beach: Washington Federal Savings and Loan Association, 1961.

Jacob Lawrence. Exh. brch. New York: Terry Dintenfass Inc., 1963.

Jacob Lawrence Paintings. Exh. brch. New York: Terry Dintenfass Inc., 1965.

The Toussaint L'Ouverture Series. Exh. cat. Nashville: Fisk University Art Gallery, 1968.

Builders: Jacob Lawrence Paintings. Exh. brch. New York: Terry Dintenfass Inc., 1973.

Brown, Milton W. *Jacob Lawrence*. Exh. cat. New York: Whitney Museum of American Art, 1974.

Sharp, Ellen. *The Legend of John Brown*. Exh. cat. Detroit: The Detroit Institute of Arts, 1978.

Jacob Lawrence: Paintings and Graphics from 1936 to 1978. Exh. cat. Norfolk, Va.: The Chrysler Museum of Art, 1979.

Buell, James M., with an introduction by Grant Spradling. *The Toussaint L'Ouverture Series: A Visual Narration of the Liberation of Haiti in 1804 under the Leadership of General Toussaint L'Ouverture*. Exh. cat. New York: United Church Board for Homeland Ministries, 1982.

Lewis, Samella, with Mary Jane Hewitt. *Jacob Lawrence*. Exh. cat. Santa Monica, Calif.: Santa Monica College, 1982.

Lemakis, Emmanuel. *Jacob Lawrence: An Exhibition of His Work*. Exh. cat. Pomona, N.J.: Art Gallery, Stockton State College, 1983.

Jacob Lawrence: Fifty Years of His Work. Exh. brch. New York: Jamaica Arts Center, 1984.

Krane, Susan. *Jacob Lawrence: The Harriet Tubman Series*. Exh. cat. Buffalo: Albright-Knox Art Gallery, 1986.

Wheat, Ellen Harkins. *Jacob Lawrence: American Painter*. Exh. cat. Seattle and London: University of Washington Press in association with the Seattle Art Museum, 1986.

Lewis, Samella, with Mary Jane Hewitt. *Jacob Lawrence: Drawings and Prints*. Exh. cat. Claremont, Calif.: Scripps College of the Claremont Colleges, 1988.

Lewis, Samella, with Mary Jane Hewitt. *Jacob Lawrence: Paintings and Drawings*. Exh. cat. Claremont, Calif.: Scripps College of the Claremont Colleges, 1989.

Loucas, Penelope. *Jacob Lawrence: The Washington Years*. Exh. brch. Tacoma, Wash.: Tacoma Art Museum, 1989.

Wheat, Ellen Harkins. *Jacob Lawrence: The Frederick Douglass and Harriet Tubman Series of 1938–40*. Exh. cat. Hampton, Va., Seattle, and London: Hampton University Museum in association with University of Washington Press, Seattle, 1991.

Jacob Lawrence: An American Master. Exh. cat. Greenville, N.C.: Wellington B. Gray Gallery, School of Art, East Carolina University, 1992.

Powell, Richard J. *Jacob Lawrence*. New York: Rizzoli Art Series, 1992.

Sims, Patterson. *Jacob Lawrence: The Early Decades, 1935–1950*. Exh. brch. Katonah, N.Y.: The Katonah Museum of Art, 1992.

Everett, Gwen. *John Brown: One Man Against Slavery*. Paintings by Jacob Lawrence. New York: Rizzoli, 1993.

The Great Migration: An American Story. Paintings by Jacob Lawrence, with a poem by Walter Dean Myers. New York: HarperCollins, 1993.

Jacob Lawrence: An Exhibition Presented by the Black Alumni of Pratt Institute. Exh. brch. New York: Pratt Institute, 1993.

Jacob Lawrence: Paintings, Drawings, and Prints. Exh. cat. New York: Midtown Payson Galleries, 1993.

Turner, Elizabeth Hutton, ed. *Jacob Lawrence: The Migration Series.* Exh. cat. Washington, D.C.: Rappahannock Press in association with the Phillips Collection, 1993.

Jacob Lawrence: The Genesis Series; Paintings on Loan from the Collection of Walter O. Evans, Detroit, Michigan. Exh. brch. Dearborn, Mich.: University of Michigan, 1994.

Nesbett, Peter, with an essay by Patricia Hills. *Jacob Lawrence: Thirty Years of Prints (1963–1993), A Catalogue Raisonné.* Seattle: Francine Seders Gallery in association with University of Washington Press, 1994.

King-Hammond, Leslie. *Jacob Lawrence, An Overview: Paintings from 1936–1994.* Exh. cat. New York: Midtown Payson Galleries, 1995.

Howard, Nancy Shrover. *Jacob Lawrence: American Scenes, American Struggles.* Worcester, Mass.: Davis Publications, 1996.

Jacob Lawrence: Paintings from Two Series, 1940 and 1994. Exh. brch. Dallas: Meadows Museum, Owens Art Center, Southern Methodist University, 1996.

Myers, Walter Dean. *Toussaint L'Ouverture: The Fight for Haiti's Freedom.* New York: Simon & Schuster Books for Young Readers, 1996.

Van Keuren, Philip. *After Vesalius, Drawings by Jacob Lawrence.* Exh. cat. Dallas: Division of Art, Southern Methodist University, 1996.

Wolfe, Townsend. *Jacob Lawrence: Drawings, 1945 to 1996.* Exh. cat. New York and Little Rock, Ark.: DC Moore Gallery and Arkansas Arts Center, 1996.

Swanson, Lealan Nunn. *Jacob Lawrence: Community Artist.* Jackson, Miss.: The Margaret Walker Alexander National Research Center, Jackson State University, 1997.

Benson, Cynda L. *Jacob Lawrence.* Exh. cat. Savannah, Ga.: Savannah College of Art and Design, 1998.

Nesbett, Peter T. *Jacob Lawrence: The Builders.* Exh. cat. New York: DC Moore Gallery, 1998.

Venezia, Mike. *Jacob Lawrence.* New York: Children's Press, 1999.

Group Exhibition Catalogues and Related Publications

(in chronological sequence)

Locke, Alain. *Contemporary Negro Art.* Exh. cat. Baltimore: The Baltimore Museum of Art, 1939.

[Wilson, Sol]. *Jacob Lawrence and Samuel Wechsler.* Exh. cat. New York: American Artists School, 1939.

Seventy-Five Years of Freedom: Commemoration of the Seventy-Fifth Anniversary of the Proclamation of the Thirteenth Amendment to the Constitution of the United States. Exh. cat. Washington, D.C.: United States Library of Congress, U.S. Government Printing Office, 1940.

Artists for Victory: An Exhibition of Contemporary American Art. Exh. cat. New York: The Metropolitan Museum of Art, 1942.

The Twenty-Second International Exhibition of Water Colors. Exh. cat. Chicago: The Art Institute of Chicago, 1943.

1943–44 Annual Exhibition of Contemporary American Art: Sculpture, Paintings, Watercolors, and Drawings. Exh. cat. New York: Whitney Museum of American Art, 1943.

American Painting of Today: The Thirty-Seventh Annual Exhibition. Exh. cat. Saint Louis: City Art Museum, 1944.

A Selection of American Paintings of the Present Day. Exh. cat. Providence, R.I.: Museum of Art, Rhode Island School of Design, 1944.

American Painting: The Thirty-Eighth Annual Exhibition. Exh. cat. Saint Louis: City Art Museum, 1945.

Locke, Alain. *The Negro Artist Comes of Age.* Exh. cat. New York: Albany Institute of History and Art, 1945.

1945 Annual Exhibition of Contemporary American Sculpture, Watercolors, and Drawings. Exh. cat. New York: Whitney Museum of American Art, 1945.

Encyclopedia Britannica Collection of Contemporary American Painting: The Rotating Annual Selection of Twelve Paintings, 1946–1947. Exh. brch. Chicago: Encyclopedia Britannica, 1946.

Exposition internationale d'art moderne. Exh. cat. Paris: Museé d'Art Moderne, 1946.

Modern American Paintings from the Collection of Mr. and Mrs. Roy R. Neuberger. Exh. cat. New York: Samuel M. Kootz Gallery, 1946.

Three Negro Artists: Horace Pippin, Jacob Lawrence, Richmond Barthé. Exh. cat. Washington, D.C.: Phillips Memorial Gallery and the Catholic Inter-Racial Council, 1946.

1946 Annual Exhibition of Contemporary American Sculpture, Watercolors, and Drawings. Exh. cat. New York: Whitney Museum of American Art, 1946.

Catalogue of the Forty-Sixth Annual Water Color and Print Exhibition and the Forty-Seventh Annual Exhibition of Miniatures. Exh. cat. Philadelphia: Pennsylvania Academy of the Fine Arts, 1947.

International Watercolor Exhibition, Fourteenth Biennial. Exh. cat. Brooklyn: The Brooklyn Museum, 1947.

Painting in the United States, 1947. Exh. cat. Pittsburgh: Carnegie Institute, 1947.

Third Summer Exhibition of Contemporary Art. Exh. cat. Iowa City: University of Iowa, 1947.

1947 Annual Exhibition of Contemporary American Sculpture, Watercolors, and Drawings. Exh. cat. New York: Whitney Museum of American Art, 1947.

1947 La Tausca Art Exhibition. Exh. cat. New York: Riverside Museum, 1947.

The Brooklyn Society of Artists: Thirty-Second Annual Exhibition. Exh. cat. New York: The Brooklyn Museum, 1948.

Catalog of One Hundred Seventeen Oil and Water Color Originals by Leading American Artists. Exh. cat. Washington, D.C.: War Assets Administration, 1948.

Catalogue of the One Hundred and Forty-Third Annual Exhibition of Painting and Sculpture. Exh. cat. Philadelphia: Pennsylvania Academy of the Fine Arts, 1948.

Fifty-Four Paintings, Drawings, Prints by Contemporary Americans Acquired during the Past Year by The Butler Art Institute. Exh. cat. Youngstown, Ohio: The Butler Art Institute, 1948.

Fourth Summer Exhibition of Contemporary Art. Exh. cat. Iowa City: University of Iowa, 1948.

Painting in the United States, 1948. Exh. cat. Pittsburgh: Carnegie Institute, 1948.

Seventh Annual Exhibition of Paintings, Sculpture, and Prints by Negro Artists. Exh. brch. Atlanta: Atlanta University, 1948.

The Sixth Biennial Exhibition of Contemporary American Paintings, 1948. Exh. cat. Richmond: Virginia Museum of Fine Arts, 1948.

1948 Annual Exhibition of Contemporary American Sculpture, Watercolors, and Drawings. Exh. cat. New York: Whitney Museum of American Art, 1948.

Catalogue of the Forty-Seventh Annual Water Color and Print Exhibition and the Forty-Eighth Annual Exhibition of Miniatures. Exh. cat. Philadelphia: Pennsylvania Academy of the Fine Arts, 1949.

International Water Color Exhibition: Fifteenth Biennial. Exh. cat. New York: The Brooklyn Museum, 1949.

Painting in the United States, 1949. Exh. cat. Pittsburgh: Carnegie Institute, 1949.

Third Annual Exhibition of Painting. Exh. cat. San Francisco: California Palace of the Legion of Honor, 1949.

Water Colors and Drawings: Fifty-Ninth Annual American Exhibition. Exh. cat. Chicago: The Art Institute of Chicago, 1949.

1949 Annual Exhibition of Contemporary American Sculpture, Watercolors, and Drawings. Exh. cat. New York: Whitney Museum of American Art, 1949.

Catalogue of the Forty-Eighth Annual Water Color and Print Exhibition and the Forty-Ninth Annual Exhibition of Miniatures. Exh. cat. Philadelphia: Pennsylvania Academy of the Fine Arts, 1950.

Hale, Robert Beverly, ed. *One Hundred American Painters of the Twentieth Century.* Exh. cat. New York: The Metropolitan Museum of Art, 1950.

International Water Color Exhibition: Sixteenth Biennial. Exh. cat. New York: The Brooklyn Museum, 1950.

1950 Annual Exhibition of Contemporary American Sculpture, Watercolors, and Drawings. Exh. cat. New York: Whitney Museum of American Art, 1950.

Contemporary Painting in the United States: 1951 Annual Exhibition. Exh. cat. Los Angeles: Los Angeles County Museum, 1951.

I Bienal Do Museu de Arte Moderna De São Paulo. Exh. cat. São Paulo: Museu de Arte Moderna, 1951.

1951 Annual Exhibition of Contemporary American Sculpture, Watercolors, and Drawings. Exh. cat. New York: Whitney Museum of American Art, 1951.

American Water-Colors, Drawings, and Prints, 1952: A National Competitive Exhibition. Exh. cat. New York: The Metropolitan Museum of Art, 1952.

Contemporary American Painting and Sculpture. Urbana-Champaign, Ill.: College of Fine and Applied Arts, University of Illinois, 1952.

1952 Annual Exhibition of Contemporary American Sculpture, Watercolors, and Drawings. Exh. cat. New York: Whitney Museum of American Art, 1952.

Contemporary American Paintings. Exh. cat. Indianapolis: John Herron Art Museum, 1953.

International Water Color Exhibition: Seventeenth Biennial. Exh. cat. New York: The Brooklyn Museum, 1953.

1953 Annual Exhibition of Contemporary Sculpture, Watercolors, and Drawings. Exh. cat. New York: Whitney Museum of American Art, 1953.

American Painting 1954. Exh. cat. Richmond: Virginia Museum of Fine Arts, 1954.

The One Hundred and Forty-Ninth Annual Exhibition of Painting and Sculpture. Exh. cat. Philadelphia: Pennsylvania Academy of the Fine Arts, 1954.

1954 Annual Exhibition of Contemporary Sculpture, Watercolors, and Drawings. Exh. cat. New York: Whitney Museum of American Art, 1954.

Contemporary American Painting and Sculpture. Exh. cat. Urbana-Champaign, Ill.: University of Illinois, 1955.

The Denman Collection: Loan Exhibition. Exh. brch. New York: The Alan Gallery, 1955.

Mural Sketches and Sculpture Models. Exh. brch. New York: National Council for U.S. Art, 1955.

World at Work, 1930–1955: An Exhibition of Paintings and Drawings Commissioned by Fortune, *Presented on the Occasion of the Magazine's Twenty-Fifth Anniversary.* New York: Time, 1955.

Twenty-Eighth Venice Biennale: American Artists Paint the City. Exh. cat. Chicago: The Art Institute of Chicago, 1956.

Painting in America: The Story of Four Hundred Fifty Years. Exh. cat. Detroit: The Detroit Institute of Arts, 1957.

1957 Annual Exhibition: Sculpture, Paintings, Watercolors. Exh. cat. New York: Whitney Museum of American Art, 1957.

1958 Annual Exhibition: Sculpture, Paintings, Watercolors, Drawings. Exh. cat. New York: Whitney Museum of American Art, 1958.

Contemporary American Painting and Sculpture. Exh. cat. Urbana-Champaign, Ill.: University of Illinois, 1959.

Twenty-Five Years of American Painting 1933–1958. Exh. cat. Göteborg, Sweden: Göteborgs Konstmuseum, 1959.

Business Buys American Art: Third Loan Exhibition by the Friends of the Whitney Museum of American Art. Exh. cat. New York: Whitney Museum of American Art, 1960.

A Loan Exhibition from the Edith Gregor Halpert Collection. Exh. cat. Washington, D.C.: The Corcoran Gallery of Art, 1960.

Contemporary American Painting and Sculpture. Exh. cat. Urbana-Champaign, Ill.: University of Illinois, 1961.

Exhibition of Contemporary Artists' Works Assembled in Tribute to the Barnett Aden Gallery. Exh. cat. Washington, D.C.: Associated Artists' Gallery, 1961.

Porter, James A. *New Vistas in American Art.* Exh. cat. Washington, D.C.: The Gallery of Art, Howard University, 1961.

1961 Annual Exhibition: Contemporary American Painting. Exh. cat. New York: Whitney Museum of American Art, 1961.

61/62 Opening Exhibition: From 1700 to 1961. Exh. cat. New York: The Alan Gallery, 1961.

Contemporary American Painting: Selections from the Neuberger Collection. Exh. cat. Ann Arbor, Mich.: University of Michigan, 1962.

Drawings: USA. Exh. cat. Saint Paul: Saint Paul Gallery, 1962.

Nordness, Lee, ed. *Art: USA Now.* Exh. cat. Lucerne, Switzerland: C. J. Bucher, 1962.

62/63 Tenth Anniversary Season: Opening Exhibition. Exh. brch. New York: The Alan Gallery, 1962.

Catalogue of the One Hundred and Fifty-Eighth Annual Exhibition. Exh. cat. Philadelphia: Pennsylvania Academy of the Fine Arts, 1963.

1963 Annual Exhibition: Contemporary American Painting. Exh. cat. New York: Whitney Museum of American Art, 1963.

Herbert A. Goldstone Collection of American Art. Exh. cat. Brooklyn: The Brooklyn Museum, 1965.

1965 Annual Exhibition: Contemporary American Painting. Exh. cat. New York: Whitney Museum of American Art, 1965.

The Art of the American Negro: Exhibition of Paintings. Exh. cat. New York: Harlem Cultural Council, 1966.

Catalogue of the One Hundred Sixty-First Annual Exhibition of American Painting and Sculpture. Exh. cat. Philadelphia: Pennsylvania Academy of the Fine Arts, 1966.

Contemporary Urban Visions. Exh. cat. New York: New School for Social Research, 1966.

Goodrich, Lloyd. *Art of the United States: 1670–1966.* Exh. cat. New York: Whitney Museum of American Art, 1966.

Moore, Robert S. *The Visual Arts As Taught and Practiced at Black Mountain College.* Exh. cat. Johnson City, Tenn.: Carroll Reese Museum, East Tennessee State University, 1966.

Porter, James A. *The Negro in American Art.* Exh. cat. Los Angeles: UCLA Art Galleries, Dickson Art Center, 1966.

Protest Paintings—U.S.A.: 1930–1945. Exh. cat. New York: ACA Gallery, 1966.

Two Hundred Years of Watercolor Painting in America. Exh. cat. New York: The Metropolitan Museum of Art, 1966.

Woodruff, Hale. *Ten Negro Artists from the United States (Dix artistes nègres des Etats-Unis).* Washington, D.C.: United States Commission for the First World Festival of Negro Arts, and National Collection of Fine Arts, Smithsonian Institution, 1966.

Bearden, Romare, and Carroll Greene, Jr. *The Evolution of Afro-American Artists: 1800–1950.* Exh. cat. New York: City University of New York in cooperation with Harlem Cultural Council and New York Urban League, 1967.

The Pittsburgh International Exhibition of Contemporary Painting and Sculpture. Exh. cat. Pittsburgh: Carnegie Institute, 1967.

The Portrayal of Negroes in American Painting. Exh. cat. New York: Forum Gallery, 1967.

Protest and Hope: An Exhibition of Contemporary American Art. Exh. cat. New York: New School Art Center, 1967.

Walker, Lester C., Jr. *American Painting: The 1940s.* Exh. cat. New York: American Federation of Arts, 1967.

WPA Artists: Then and Now. Exh. cat. West Orange, N.J.: YM-YWHA Essex County, 1967.

Driskell, David C. *Afro-American Art Exhibition: Drawings, Paintings and Prints.* Exh. brch. Philadelphia: Sigma Pi Phi, 1968.

Edith Halpert and The Downtown Gallery. Exh. cat. Storrs, Conn.: Museum of Art, University of Connecticut, 1968.

Grigsby, Eugene. *Encounters: An Exhibit in Celebration of the Charlotte-Mecklenburg Bi-Centennial.* Exh. cat. Charlotte, N.C.: Johnson C. Smith University, 1968.

Robbins, Daniel, ed. *The Neuberger Collection: An American Collection.* Exh. cat. Providence, R.I.: Museum of Art, Rhode Island School of Design, 1968.

Afro-American Artists: 1800–1969. Exh. cat. Philadelphia: Division of Arts Education, The School District of Philadelphia, 1969.

American Art of the Depression Era. Exh. brch. Amherst, Mass.: Amherst College, 1969.

Art in America, 1830–1950: Paintings, Drawings, Prints, Sculpture from the Collection of the Worcester Art Museum. Exh. cat. Worcester, Mass.: Worcester Art Museum, 1969.

Thirty Contemporary Black Artists. Exh. cat. Minneapolis and New York: Minneapolis Institute of Arts in association with Ruder & Finn Fine Arts, 1968. Reprint. *Contemporary Black Artists.* New York: Ruder & Finn Fine Arts, 1969.

1969 Annual Exhibition: Contemporary American Painting. Exh. cat. New York: Whitney Museum of American Art, 1969.

Black American Art: An Overview. Exh. cat. New Concord, Ohio: Muskingum College, 1970.

Five Famous Black Artists: Romare Bearden, Jacob Lawrence, Horace Pippin, Charles White, Hale Woodruff. Exh. cat. Roxbury, Mass.: Museum of the National Center of Afro-American Artists, 1970.

Gaither, Edmund Barry. *Afro-American Artists, New York and Boston.* Exh. cat. Roxbury, Mass.: Museum of the National Center of Afro-American Artists with Museum of Fine Arts and the School of the Museum of Fine Arts, 1970.

Hope, Henry Radford. *The American Scene: 1900–1970.* Exh. cat. Bloomington, Ind.: Indiana University Museum of Art, 1970.

Lewis, James E. *Afro-American Artists Abroad.* Exh. cat. Austin, Tex.: The University of Texas, 1970.

Teihet, Jehanne, ed. *Dimensions of Black.* Exh. cat. La Jolla, Calif.: La Jolla Museum of Art, 1970.

Doty, Robert. *Contemporary Black Artists in America.* Exh. cat. New York: Whitney Museum of American Art, 1971.

Glauber, Robert H. *Black American Artist / 71.* Exh. cat. Chicago: Illinois Bell Telephone, 1971.

Allen, Simona A. *Reflections: The Afro-American Artist—An Exhibition of Paintings, Sculpture, and Graphics.* Exh. cat. Winston-Salem, N.C.: Winston-Salem Alumnae Chapter, Delta Sigma Theta, 1972.

Black Motion. Exh. brch. Atlanta: Southern Christian Leadership Conference, 1972.

Kingsbury, Martha. *Art of the Thirties: The Pacific Northwest.* Exh. cat. Seattle: University of Washington Press, 1972.

1972 Annual Exhibition: Contemporary American Painting. Exh. cat. New York: Whitney Museum of American Art, 1972.

Andrews, Benny. *Blacks: USA: 1973.* Exh. cat. New York: New York Cultural Center, 1973.

Highlights from the Atlanta University Collection of Afro-American Art. Exh. cat. Atlanta: High Museum of Art, 1973.

One Hundred Forty-Eighth Annual Exhibition. Exh. cat. New York: National Academy of Design, 1973.

Africa in Diaspora. Exh. cat. West Nyack, N.Y.: Rockland Center for the Arts, 1974.

The Barnett-Aden Collection. Exh. cat. Washington, D.C.: Smithsonian Institution, 1974.

Highlights from the Atlanta University Collection of Afro-American Art. Exh. cat. Winston-Salem, N.C.: Winston-Salem Delta Fine Arts, 1974.

One Hundred Forty-Ninth Annual Exhibition. Exh. cat. New York: National Academy of Design, 1974.

Bullard, E. John. *A Panorama of American Painting: The John J. McDonough Collection.* Exh. cat. New Orleans: New Orleans Museum of Art, 1975.

Driskell, David C. *Amistad II: Afro-American Art.* Exh. cat. Nashville: Department of Fine Art, Fisk University, 1975.

Gaither, Edmund Barry. *Jubilee: Afro-American Artists on Afro-America.* Exh. cat. Roxbury, Mass.: Museum of Fine Arts in cooperation with the Museum of the National Center of Afro-American Artists, 1975.

The Kennedy Galleries Are Host to the Hundredth Anniversary Exhibition of Paintings and Sculptures by One Hundred Artists Associated with the Art Students League of New York. Exh. brch. New York: Kennedy Galleries, 1975.

Morris, George North. *A Century and a Half of American Art.* Exh. cat. New York: National Academy of Design, 1975.

Black Artists of the WPA 1933–1943: An Exhibition of Drawings, Paintings and Sculpture. Exh. cat. Brooklyn: New Muse Community Museum, 1976.

Driskell, David C. *Two Centuries of Black American Art.* Exh. cat. Los Angeles: Los Angeles County Museum of Art, 1976.

Faison, S. Lane. *The Second Williams College Alumni Loan Exhibition.* Exh. cat. Williams-town, Mass.: Museum of Art, Williams College, 1976.

Goodrich, Lloyd. *A Selection of American Art: The Skowhegan School 1946–1976.* Exh. cat. Boston: Institute of Contemporary Art, 1976.

McMichael, Norma. *Fourteen Afro-American Artists.* Exh. cat. Brooklyn: Pratt Institute Gallery, 1976.

Moravian College. *American Concern, The Humanist View: Selected Works on Paper.* Exh. cat. Charlottesville, Va.: University of Virginia Press, 1976.

Selected Work by Black Artists from the Collection of The Metropolitan Museum of Art. Exh. cat. New York: Bedford-Stuyvesant Restoration Corporation, 1976.

Two Hundred Years of the Visual Arts in North Carolina. Exh. cat. Raleigh, N.C.: North Carolina Museum of Art, 1976.

Willis, John Ralph. *Fragments of American Life, An Exhibition of Paintings: Romare Bearden, Joseph Delaney, Rex Gorleigh, Lois Mailou Jones, Jacob Lawrence, Hughie Lee-Smith, Hale Woodruff.* Exh. cat. Princeton, N.J.: The Art Museum, Princeton University, 1976.

American Watercolors, 1855–1955. Exh. cat. Ithaca, N.Y.: Herbert F. Johnson Museum of Art, Cornell University, 1977.

Artists Salute Skowhegan. Exh. cat. New York: Kennedy Galleries, 1977.

Black American Art from the Barnett-Aden Collection. Exh. cat. Pittsburgh: Frick Fine Arts Museum, University of Pittsburgh, 1977.

Dillenberger, Jane, and John Dillenberger. *Perceptions of the Spirit in Twentieth-Century American Art.* Exh. cat. Indianapolis: Indianapolis Museum of Art, 1977.

North, Percy. *Hudson D. Walker: Patron and Friend, Collector of Twentieth-Century American Art.* Exh. cat. Minneapolis: University Gallery, 1977.

Park, Marlene, and Gerald E. Markowitz. *New Deal for Art.* Exh. cat. New York: The Gallery Association of New York, 1977.

Stewart, Ruth Ann. *New York/Chicago: WPA and the Black Artist.* Exh. cat. New York: The Studio Museum in Harlem, 1977.

American Painting and Sculpture 1900–1945. Exh. cat. Raleigh, N.C.: Mint Museum of Art, 1978.

Cityscape 78. Exh. cat. Oklahoma City: Oklahoma Art Center, 1978.

Gingold, Diane J. *American Art, 1934–1956: Selections from the Whitney Museum of American Art.* Exh. cat. Montgomery, Ala.: Montgomery Museum of Fine Arts, 1978.

Perry, Regenia A. *Golden Opportunity.* Exh. cat. New York: Gallery 62, National Urban League, 1978.

Hills, Patricia, and Abigail Booth Gerdts. *The Working American.* Exh. cat. Washington, D.C.: Smithsonian Institution Traveling Exhibition Service, 1979.

Hills, Patricia, and Roberta K. Tarbell. *The Figurative Tradition and the Whitney Museum of American Art: Paintings and Sculpture from the Permanent Collection.* Exh. cat. New York: Whitney Museum of American Art, 1980.

Six Black Americans: Benny Andrews, Romare Bearden, Sam Gilliam, Richard Hunt, Jacob Lawrence, Betye Saar. Exh. cat. Trenton, N.J.: New Jersey State Museum, 1980.

Styron, Thomas W. *American Figure Painting 1950–1980.* Exh. cat. Norfolk, Va.: The Chrysler Museum of Art, 1980.

Trovato, Joseph S. *The Olympics in Art: An Exhibition of Works of Art Related to Olympic Sports.* Exh. cat. Utica, N.Y.: Museum of Art, Munson-Williams-Proctor Institute, 1980.

Brown, Milton W. *Social Art in America, 1930–1945.* Exh. cat. New York: ACA Galleries, 1981.

Sims, Patterson. *Decade of Transition, 1940–1950: Selections from the Permanent Collection.* Exh. brch. New York: Whitney Museum of American Art, 1981.

Berman, Greta, and Jeffrey Wechsler. *Realism and Realities: The Other Side of American Painting, 1940–1960.* Exh. cat. New Brunswick, N.J.: Rutgers University Art Gallery, State University of New Jersey, 1982.

The Washington Year: A Contemporary View, 1980–1981. Exh. cat. Seattle: Henry Art Gallery, University of Washington, 1982.

Flomenhaft, Eleanor. *Celebrating Contemporary American Black Artists.* Exh. cat. Hempstead, N.Y.: Fine Arts Museum of New York, 1983.

Hills, Patricia, with an essay by Raphael Soyer. *Social Concern and Urban Realism: American Painting of the 1930s.* Exh. cat. Boston: Boston University Art Gallery, 1983.

African-American Art in Atlanta: Public and Corporate Collections. Exh. cat. Atlanta: High Museum of Art, 1984.

Ausfeld, Margaret Lynne, and Virginia M. Mecklenburg. *Advancing American Art: Politics and Aesthetics in the State Department Exhibition 1946–48.* Exh. cat. Montgomery, Ala.: Montgomery Museum of Fine Arts, 1984.

Gelburd, Gail. *A Blossoming of New Promise: Art in the Spirit of the Harlem Renaissance.* Exh. cat. Hempstead, N.Y.: Hofstra University, 1984.

The Rhythm of Life: Selected Works by Bearden, Gwathmey, and Lawrence. Exh. cat. Alexandria, La.: Alexandria Museum of Art, 1984.

Since the Harlem Renaissance: Fifty Years of Afro-American Art. Exh. cat. Lewisburg, Pa.: The Center Gallery of Bucknell University, 1984.

Driskell, David C. *Hidden Heritage: Afro-American Art, 1800–1950.* Exh. cat. San Francisco: Art Museums Association of America, 1985.

Rand, Harry. *The Martha Jackson Memorial Collection.* Exh. cat. Washington, D.C.: Smithsonian Institution Press, 1985.

Roudabush Norelli, Martina. *Art, Design, and the Modern Corporation: The Collection of the Container Corporation of America, A Gift to the National Museum of American Art.* Exh. cat. Washington, D.C.: Smithsonian Institution Press, 1985.

Selections from the Permanent Holdings: Nineteenth and Twentieth Century American Art. Exh. cat. Washington, D.C.: The Evans-Tibbs Collection, 1985.

Sims, Lowery S. *The Artist Celebrates New York: Selected Paintings from The Metropolitan Museum of Art.* Exh. brch. New York: The Metropolitan Museum of Art, 1985.

Tradition and Conflict: Images of a Turbulent Decade, 1963–1973. Exh. cat. New York: The Studio Museum in Harlem, 1985.

Wooden, Howard E. *American Art and the Great Depression: Two Sides of the Coin.* Exh. cat. Wichita, Kans.: Wichita Art Museum, 1985.

Gordon, Peter H., ed., with Sydney Waller and Paul Weinman. *Diamonds Are Forever: Artists and Writers on Baseball.* Exh. cat. San Francisco: Chronicle Books, 1987.

Los Angeles Collects: Works by over Thirty Artists from Fifteen Private Collections. Exh. cat. Los Angeles: The Museum of African American Art, 1987.

The Studio Museum in Harlem. *Harlem Renaissance: Art of Black America.* Exh. cat. New York: Harry N. Abrams, 1987.

Artists of the Black Community/USA. Exh. cat. Phoenix: The Arizona Bank Galleria, 1988.

Bibby, Deirdre L. *Augusta Savage and the Art Schools of Harlem.* Exh. cat. New York: The Schomburg Center for Research in Black Culture, 1988.

Selected Works in Celebration of Black History Month. Exh. brch. Seattle: Francine Seders Gallery, 1988.

American Resources: Selected Works by African-American Artists. Nashville: Fisk University Art Galleries, 1989.

Danly, Susan. *American Art from the Collection of Vivian and Meyer P. Potamkin.* Exh. cat. Philadelphia: Pennsylvania Academy of the Fine Arts, 1989.

Fonevielle-Bontemps, Jacqueline. *Choosing: An Exhibition of Changing Perspectives in Modern Art and Art Criticism to Black Americans, 1925–1985.* Washington, D.C.: Museum Press, Inc., 1989.

McElroy, Guy C., Richard J. Powell, and Sharon F. Patton. *African-American Artists 1880–1987: Selections from the Evans-Tibbs Collection.* Exh. cat. Washington, D.C.: Smithsonian Institution Traveling Exhibition Service, 1989.

One Hundred Years of Washington Art: New Perspectives. Exh. cat. Tacoma, Wash.: Tacoma Art Museum, 1989.

Powell, Richard J. *The Blues Aesthetic: Black Culture and Modernism.* Exh. cat. Washington, D.C.: Washington Project for the Arts, 1989.

Reynolds, Gary A., and Beryl J. Wright. *Against the Odds: African-American Artists and the Harmon Foundation.* Exh. cat. Newark: The Newark Museum, 1989.

Hough, Katherine Plake. *Northwest by Southwest: Painted Fictions.* Exh. cat. Palm Springs, Calif.: Palm Springs Desert Museum, 1990.

McElroy, Guy C. *Facing History: The Black Image in American Art, 1710–1940.* Exh. cat. San Francisco: Bedford Arts Publishers in association with The Corcoran Gallery of Art, 1990.

Castleman, Riva. *Art of the Forties.* Exh. cat. New York: The Museum of Modern Art, 1991.

Adams, Henry, Margaret Stenz, Jan M. Marsh, et al. *American Drawings and Watercolors from the Kansas City Region.* Exh. cat. Kansas City, Mo.: The Nelson-Atkins Museum of Art, 1992.

Perry, Regenia A. *Free within Ourselves: African-American Artists in the Collection of the National Museum of American Art.* Exh. cat. Washington, D.C.: National Museum of American Art, Smithsonian Institution in association with Pomegranate Art Books, 1992.

Weld, Alison, and Sadao Serikawa. *Dream Singers, Storytellers: An African-American Presence.* Exh. cat. Trenton, N.J.: New Jersey State Museum; Fukui, Japan: Fukui Fine Arts Museum, 1992.

Nelson, Naomi. *First in the Heart Is the Dream—African American Artists in the Twentieth Century: The Philadelphia Connection.* Exh. cat. Philadelphia: The Philadelphia Art Alliance, 1993.

Roznoy, C. *Spheres of Influence: Artists and Their Students in the Permanent Collection of the Whitney Museum of American Art.* Exh. cat. Stamford, Conn.: Whitney Museum of Art at Champion Plaza, 1993.

Sandler, Irving. *Roy R. Neuberger: Patron of the Arts.* Exh. cat. Purchase, N.Y.: Neuberger Museum of Art, 1993.

Selected Works by Three Past Presidents: Yasuo Kuniyoshi, Jacob Lawrence, Louise Nevelson. Exh. cat. New York: The Broome Street Gallery, New York Artists Equity Association, 1993.

Troyen, Carol, and Sue Welsh Reed. *Awash in Color: Homer, Sargent, and the Great American Watercolor.* Exh. cat. Boston: Museum of Fine Arts, 1993.

Wright, Beryl J. *African-American Art: Twentieth Century Masterworks.* Exh. cat. New York: Michael Rosenfeld Gallery, 1993.

A Collector's Eye: Depression-Era Paintings from the Collection of John Horton. Exh. cat. Doylestown, Pa.: James A. Michener Art Museum, 1994.

Harmon and Harriet Kelley Collection of African American Art. Exh. cat. San Antonio: San Antonio Museum of Art, 1994.

Miller, Mark H., ed. *Louis Armstrong: A Cultural Legacy.* Exh. cat. New York: Queens Museum of Art, 1994.

Schwartz, Constance, and Franklin Hill Perrell. *American Realism between the Wars: 1919–1941.* Exh. cat. Roslyn Harbor, N.Y.: Nassau County Museum of Art, 1994.

American Federation of the Arts. *In the Eye of the Storm: An Art of Conscience, 1930–1970, Selections from the Collection of Philip J. and Suzanne Schiller.* Exh. cat. New York: Pomegranate Art Books, 1995.

Powell, Richard J. *African-American Art, Twentieth Century Masterworks II.* Exh. cat. New York: Michael Rosenfeld Gallery, 1995.

Venn, Beth. *American Art 1940–1965, Traditions Reconsidered: Selections from the Permanent Collection of the Whitney Museum.* Exh. brch. San Jose, Calif.: San Jose Museum of Art, 1995.

African-American Art: Twentieth Century Masterworks III. Exh. cat. New York: Michael Rosenfeld Gallery, 1996.

Allen, Paula. *Terms of Endurance: Living Legends in African American Art.* Exh. brch. New Orleans: Amistad Research Center, 1996.

Flam, Jack. *Powerful Expressions: Recent American Drawings.* Exh. cat. New York: National Academy of Design, 1996.

Lefalle-Collins, Lizzetta. *In the Spirit of Resistance: African-American Modernists and the Mexican Muralist School.* New York: American Federation of Arts, 1996.

African-American Art: Twentieth Century Masterworks IV. Exh. cat. New York: Michael Rosenfeld Gallery, 1997.

Powell, Richard J. *Rhapsodies in Black: Art of the Harlem Renaissance.* Exh. cat. Los Angeles: University of California Press, 1997.

Gips, Terry, ed. *Narratives of African-American Art and Identity: The David C. Driskell Collection.* Exh. cat. College Park, Md.: University of Maryland, 1998.

King-Hammond, Leslie. *African-American Art: Twentieth Century Masterworks V.* Exh. cat. New York: Michael Rosenfeld Gallery, 1998.

Masterworks by Twentieth Century African-American Artists. Exh. cat. Springfield, Ohio: Springfield Museum of Art, 1998.

African-American Art: Twentieth Century Masterworks VI. Exh. cat. New York: Michael Rosenfeld Gallery, 1999.

Beyond the Veil: Art of African American Artists at Century's End. Exh. cat. Winter Park, Fla.: Cornell Fine Arts Museum, Rollins College, 1999.

Haskell, Barbara. *The American Century: Art and Culture, 1900–1950.* Exh. cat. New York: Whitney Museum of American Art, 1999.

Philbrick, Harry. *The Nude in Contemporary Art.* Exh. cat. Ridgefield, Conn.: The Aldrich Museum of Contemporary Art, 1999.

Powell, Richard J., and Jock Reynolds. *To Conserve a Legacy: American Art from Historically Black Colleges and Universities.* Exh. cat. Andover, Mass.: Addison Gallery of American Art; New York: The Studio Museum in Harlem, 1999.

Articles Published in Periodicals
(in chronological sequence)

McGleughem, Jean. "An Exhibition of Negro Art." *Baltimore Museum of Art Quarterly* 3, 4 (1938–9), pp. 10, 14.

Emmart, A. D. [Review of Toussaint L'Ouverture series.] *Baltimore Sun,* February 5, 1939.

"Baltimore Museum Becomes the First to Stage Large Show of Negro Art." *Newsweek* 13 (February 6, 1939), p. 26.

"Baltimore: Art by Negros." *ARTnews* (New York) 37, 20 (February 11, 1939), p. 17.

Lowe, Jeannette. "The Negro Sympathetically Rendered by Lawrence, Wechsler." *ARTnews* (New York) 37, 21 (February 18, 1939), p. 15.

"First Generation of Negro Artists: Paintings by Archibald J. Motley, Malvin Gray Johnson, Elton Fax, Jacob Lawrence." *Survey Graphic* (East Stroudsburg, Pa.) 28, 3 (March 1939), pp. 224–5.

Locke, Alain. "Advance on the Art Front." *Opportunity* (New York) 17, 5 (May 1939), pp. 132–6.

"Art Exhibit Depicts Life of Ouverture." *Crisis* (New York) 46 (June 1939), p. 180.

"December Exhibitions." *Magazine of Art* (Washington, D.C.) 33 (December 1940), p. 713.

"Life of Toussaint." *Art Digest* (New York) 15, 6 (December 15, 1940), p. 12.

DuBois, W. E. B. [Review of Alain Locke's *The Negro in Art.*] *Phylon* (Atlanta) 2 (2nd Quarter 1941), pp. 192–3.

Locke, Alain. "'. . . And The Migrants Kept Coming': A Negro Artist Paints the Story of the Great American Minority." *Fortune* 24 (November 1941), pp. 102–9.

McBride, Henry. [Review of *The Migration of the Negro.*] *New York Sun,* November 8, 1941.

Devree, Howard. "A Reviewer's Notebook: Brief Comment on Some of the Recently Opened Shows." *New York Times,* November 9, 1941, sec. X, p. 9.

"Art News of America: Picture Story of the Negro's Migration." *ARTnews* (New York) 40, 15 (November 15–30, 1941), pp. 8–9.

"American Negro Art Given Full-Length Review in New York Show." *Art Digest* (New York) 16, 6 (December 15, 1941), pp. 5, 16.

Coates, Robert M. "The Art Galleries: Negro Art." *The New Yorker* 17 (December 27, 1941), p. 33.

[Review of Downtown Gallery group exhibition.] *Springfield Sunday Union and Republican* (Mass.), January 1, 1942.

"Art You Aware: American Negro Art." *Design* (Columbus, Ohio) 43, 6 (February 1942), pp. 27–8.

"Here and There: Washington, D.C." *New York Times*, February 22, 1942, sec. 8, p. 9.

"And the Migrants Kept Coming." *South Today* (Atlanta) 7, 1 (spring 1942), pp. 5–6.

"Contemporary Americans at The Downtown Gallery." *Springfield Sunday Union and Republican* (Mass.), April 12, 1942.

[Review of Downtown Gallery's spring exhibition.] *Cue* (New York) (April 25, 1942).

"The Negro's War." *Fortune* 25 (June 1942), pp. 76–80.

"Artists to Sell Works for Bonds." *Dallas Morning News*, June 12, 1942.

Jewell, Edward Alden. "Downtown Holds Fall Art Display." *New York Times*, September 22, 1942, p. 24.

"Group Shows All Worth While." *New York World-Telegram*, September 26, 1942.

Jewell, Edward Alden. "Art: New Group and One-Man Exhibits." *New York Times*, September 27, 1942, sec. 8, p. 5.

"Downtown Reopens." *Art Digest* (New York) 17, 1 (October 1, 1942), p. 11.

Locke, Alain, ed. "How We Live in South and North: Paintings by Jacob Lawrence." *Survey Graphic* (East Stroudsburg, Pa.) 31, 11 (November 1942), pp. 478–9.

Farber, Manny. "Artists for Victory." *Magazine of Art* (Washington, D.C.) 35, 8 (December 1942), pp. 275–80.

"Artists for Victory Score Victory in Metropolitan Exhibition." *Art Digest* (New York) 17, 6 (December 15, 1942), pp. 5–7.

"Artists for Victory Announce Program, ARTnews to Organize; Show at Metropolitan to Be Subject of Special Issue Jan. 1." *ARTnews* (New York) 41, 15 (December 15–31, 1942), p. 6.

"Survey of the Month: Two Negro Artists Win Awards in Artists for Victory Exhibition." *Opportunity* (New York) 21, 1 (January 1943), p. 18.

Frankfurter, Alfred M. "The Artists for Victory Exhibition: The Paintings." *ARTnews* (New York) 41, 16 (January 1–14, 1943), pp. 8–13, 34.

"Paintings Tell History of Crusade." *The Sunday Journal-Herald Spotlight* (Dayton, Ohio), March 31, 1943.

"Victory Show Sales." *Art Digest* (New York) 17, 13 (April 1, 1943), p. 15.

Grey, Madeleine. "Art." *Gotham Life* (New York) 38, 34 (April 4, 1943).

Jewell, Edward Alden. "In Miniature." *New York Times*, April 4, 1943, sec. 2, p. 8.

"Who's News." *Art Digest* (New York) 27, 14 (April 15, 1943), p. 6.

"The Passing Shows." *ARTnews* (New York) 42, 5 (April 15–30, 1943), p. 19.

"Attractions in the Galleries." *New York Sun*, May 14, 1943, p. 26.

"Jacob Lawrence's Harlem." *New York Times*, May 15, 1943.

Riley, Maude. "Effective Protests by Lawrence of Harlem." *Art Digest* (New York) 17, 16 (May 15, 1943), p. 7.

"The Passing Shows." *ARTnews* (New York) 42, 7 (May 15–31, 1943), p. 22.

Devree, Howard. "From a Reviewer's Notebook: Brief Comment on Some Recently Opened Group and One-Man Shows—New Jersey Visitors, Jacob Lawrence's Harlem." *New York Times*, May 16, 1943, sec. 2, p. 12.

McCausland, Elizabeth. "Pictures of Harlem by Jacob Lawrence." *Springfield Sunday Union and Republican* (Mass.), May 16, 1943.

Genauer, Emily. "Surrealist Artists Show Similar Trend." *New York World-Telegram*, May 22, 1943, p. 9.

"Paintings by Lawrence." *New York World-Telegram*, May 23, 1943.

"Art Today, Jacob Lawrence's Harlem." *Daily Worker* (New York), May 29, 1943, p. 7.

Coates, Robert M. "In the Galleries." *The New Yorker* 19, 15 (May 29, 1943), p. 15.

"Migration of the Negro: Exhibition of Sixty Panels by Lawrence." *Portland Museum Bulletin* (Ore.) 4, 2 (June 1943), p. 2.

Albright Art Gallery. *Gallery Notes: Albright Art Gallery* 10, 2 (June 1943–December 1944).

"Art: Harlem in Color." *Newsweek* 21, 23 (June 7, 1943), p. 100.

Symason, Meyer. "Canvas and Film: The Young Negro Artist Jacob Lawrence Depicts Harlem in a Series of Paintings." *New Masses* (New York) 47, 10 (June 8, 1943), pp. 29–30.

"Young Artist Depicts Harlem." *Amsterdam Star News* (New York), June 19, 1943.

"Exhibition of Paintings by Jacob Lawrence." *Opportunity* (New York) 21 (July 1943), p. 124.

Pacheco, Patrick. "Artist in Harlem." *Vogue* 102 (September 15, 1943), pp. 94–5.

"Art News of America: The Last Word." *ARTnews* (New York) 42, 11 (October 15–31, 1943), p. 27.

"The Passing Shows." *ARTnews* (New York) 42, 11 (October 15–31, 1943), pp. 22–4.

J. W. "New Gallery Emphasizes Negro Art." *Washington Post* (D.C.), October 31, 1943, sec. V, p. 8.

"Five Paintings Purchased." *Portland Museum Bulletin* (Ore.) 5, 3 (November 1943), p. 3.

Frost, Rosamund. "Encore by Popular Demand: The Whitney." *ARTnews* (New York) 42, 14 (December 1–14, 1943), pp. 21–2, 51.

"Lawrence Paintings to Go on Exhibit." *Pittsburgh Courier*, December 4, 1943, p. 19.

Leavitt, Sam. "Jacob Lawrence, Nationally Known Negro Artist, Is at USCG Training Station." *Saint Augustine Record* (Fla.), December 15, 1943.

"Purchases Made from the Whitney Annual." *Art Digest* (New York) 18, 7 (January 1, 1944), p. 10.

"Americans Today." *Art Digest* (New York) 18, 8 (January 15, 1944), p. 12.

Gibbs, Josephine. "Edith Hapert Reviews Eighteen Years of Success." *Art Digest* (New York) 18, 10 (February 15, 1944), p. 14.

"The Passing Shows." *ARTnews* (New York) 43, 1 (February 15, 1944), p. 22.

"The Whitney Buys." *Art Digest* (New York) 18, 13 (April 1, 1944), p. 14.

"Virginia Biennial." *ARTnews* (New York) 43, 4 (April 1–14, 1944), p. 6.

Breuning, Margaret. "Wheat without Chaff." *Art Digest* (New York) 18, 14 (April 15, 1944), p. 14.

"Whitney Buys for Solid Worth." *ARTnews* (New York) 43, 5 (April 15–30, 1944), p. 22.

McBride, Henry. "Attractions in the Galleries." *New York Sun*, April 22, 1944.

Frost, Rosamund. "Dealers' Choices." *ARTnews* (New York) 43, 6 (May 1–14, 1944), p. 18.

"The Negro in Art." *Art Digest* (New York) 18, 17 (June 1, 1944), p. 15.

"Combat Artist Now Painting War Story." *Louisville Defender* (Ky.), June 17, 1944.

"Several New Group Shows Open." *New York World-Telegram*, June 17, 1944.

"Negro Art Show." *ARTnews* (New York) 43, 9 (July 1–31, 1944), pp. 6–7.

"Front-Page Coast Guard." *Newsweek* (August 7, 1944), pp. 78–9.

"M.M.A. Program." *ARTnews* (New York) 43, 11 (September 1–30, 1944), p. 6.

L[ouchheim], A[line] B. "Brisk and Brighter: An October Opening." *ARTnews* (New York) 43, 12 (October 1, 1944), p. 24.

Genauer, Emily. "Navyman Lawrence's Works at Modern Art." *New York World-Telegram*, October 14, 1944, p. 9.

Devree, Howard. "A Reviewer's Notes: Brief Comment on Some Recently Opened Exhibitions, Chiefly Contemporary." *New York Times*, October 15, 1944, sec. 2, p. 8.

Louchheim, Aline B. "Lawrence: Quiet Spokesman." *ARTnews* (New York) 43, 13 (October 15–31, 1944), p. 15.

Catlett, Elizabeth. [Review of Lawrence exhibition at Museum of Modern Art.] *People's Voice* (New York), October 21, 1944.

"Jacob Lawrence." *Bulletin of The Museum of Modern Art* (New York) 12 (November 1944), p. 11.

Gibbs, Josephine. "Jacob Lawrence's Migrations." *Art Digest* (New York) 19, 3 (November 1, 1944), p. 7.

Greene, Marjorie E. "Jacob Lawrence." *Opportunity* (New York) 23, 1 (January–March 1945), pp. 26–7.

Frost, Rosamund. "The Second Whitney Is Second Best." *ARTnews* (New York) 43, 19 (January 15–31, 1945), pp. 22, 34.

Wolf, Ben. "Negro Art Scores without Double Standards." *Art Digest* (New York) 19, 9 (February 1, 1945), p. 8.

"The Negro Artist Comes of Age." *ARTnews* (New York) 43, 20 (February 1–14, 1945), pp. 16, 29–30.

"The Passing Shows." *ARTnews* (New York) 44, 2 (March 1–14, 1945), p. 26.

Goodwin, Carter. [Review of *The Negro Artist Comes of Age* exhibition.] *Journal of Negro History* (Washington, D.C.) 30 (April 1945), pp. 227–8.

Blitzstein, Madelin. "The Negro Artist Comes of Age." *Negro Digest* (Chicago) 3 (May 1945), pp. 85–8.

Breuning, Margaret. "Sound Painting by the Downtown Group." *Art Digest* (New York) 19, 16 (May 15, 1945), p. 18.

Dabney, Virginius. "Negro Migrations." *New York Times Book Review*, June 10, 1945, p. 4.

"New York Critics Pick Exhibits for Armory Show—Prepare to Duck." *Art Digest* (New York) 19, 20 (September 15, 1945), pp. 6–7.

"Gallery Previews." *Pictures on Exhibit* (New York) 7, 1 (October 1945), p. 18.

Morese, John. "The Armory 1945: Critics' Choice." *ARTnews* (New York) 44, 12 (October 1–14, 1945), p. 23.

Berryman, Florence S. "News of Art and Artists: John Brown's Struggles." *Sunday Star* (Washington, D.C.), October 6, 1945.

Wolf, Ben. "Edith Halpert, Art Crusader, Marks Two Decades of Success." *Art Digest* (New York) 20, 2 (October 15, 1945), p. 10.

L[ouchheim], A[line] B. "Showing a Twenty-Year American Record." *ARTnews* (New York) 44, 13 (October 15–31, 1945), p. 26.

McCausland, Elizabeth. "Jacob Lawrence." *Magazine of Art* (Washington, D.C.) 38, 7 (November 1945), pp. 250–4.

Jewell, Edward Alden. "Negro Art Shown in Two Exhibits." *New York Times*, November 6, 1945, p. 26.

Breuning, Margaret. "This Is Their Best." *Art Digest* (New York) 20, 4 (November 15, 1945), p. 31.

Frost, Rosamund. "1945 Gift Guide to the Art Galleries." *ARTnews* (New York) 44, 16 (December 1, 1945), pp. 6–7.

[Review of *The Life of John Brown* at The Downtown Gallery.] *New York Sun*, December 8, 1945.

Devree, Howard. "By Groups and One by One: Three Who Have Grown." *New York Times*, December 9, 1945, sec. 2, p. 11.

"In the Galleries." *New York Herald Tribune*, December 9, 1945, sec. 5, p. 7.

McB[ride], H[enry]. "Attractions in the Galleries." *New York Sun*, December 9, 1945, p. 7.

Wolf, Ben. "The Saga of John Brown." *Art Digest* (New York) 20, 6 (December 15, 1945), p. 17.

"The Passing Shows." *ARTnews* (New York) 44, 17 (December 15–31, 1945), p. 23.

Wayne, Matt. "Sights and Sounds: 'Strange Fruit.'" *New Masses* (New York) 57, 12 (December 18, 1945), pp. 29–30.

"Art: John Brown's Body." *Newsweek* 26, 26 (December 24, 1945), p. 87.

"The Negro Artist Comes of Age." *Rhode Island School of Design Museum Notes* (Providence) 4 (January 1946), p. 2.

"Proceedings of the Annual Meeting of the Association Held in Columbus, Ohio, October 26–28, 1945." *Journal of Negro History* (Washington, D.C.) 31 (January 1946), pp. 1–8.

Butterfield, Alfred. "The Dark Heartbeat of Harlem." *New York Times Book Review*, February 10, 1946, p. 6.

"Arizona Art Collection: University Gets One Hundred U.S. Paintings." *Life* 20, 7 (February 18, 1946), pp. 76–80.

"The Passing Shows." *ARTnews* (New York) 45, 1 (March 1946), p. 57.

"Third Art Institute Summer 1946." *Black Mountain College Bulletin* (Asheville, N.C.) (April 1946).

Hess, Thomas B. "Veterans: Then and Now." *ARTnews* (New York) 45, 3 (May 1946), pp. 44–5, 71–2.

"Today's Collectors: Broker Buys American." *ARTnews* (New York) 45, 3 (May 1946), pp. 54–5, 68–9.

"The War's Effect on Artists: A Heightening of Their Talents Is Noted." *Pictures on Exhibit* (New York) 8, 8 (May 1946), pp. 14–5.

Wolf, Ben. "Roy Neuberger Collection on Exhibition." *Art Digest* (New York) 20, 15 (May 1, 1946), p. 14.

McB[ride], H[enry]. "Attractions in the Galleries." *New York Sun*, May 11, 1946.

Devree, Howard. "By Groups and One by One." *New York Times*, May 12, 1946, sec. 2, p. 11.

"In the Art Galleries." *New York Herald Tribune*, May 12, 1946.

Kruse, A. E. "At the Galleries: The Downtown Gallery." *Brooklyn Eagle*, May 12, 1946, p. 30.

McCausland, Elizabeth. "Postwar Paintings by Modern Artists." *Springfield Sunday Union and Republican* (Mass.), May 12, 1946.

"Loan to Britain—Two Hundred Years of Art." *Art Digest* (New York) 20, 16 (May 15, 1946), pp. 6–7.

"Summer Art Schools." *Art Digest* (New York) 20, 16 (May 15, 1946), p. 27.

Summers, Marion. "Art Today: Six Artists Come Back from the War." *Daily Worker* (New York), May 15, 1946.

Wolf, Ben. "Six Artists Return from the War." *Art Digest* (New York) 20, 16 (May 15, 1946), p. 13.

Coates, Robert M. "The Art Galleries." *The New Yorker* (May 18, 1946), pp. 77–9.

"Art: The Lost and Found." *Newsweek* (May 20, 1946), p. 102.

West, Dan. "I Love the South." *New Masses* (New York) 59, 9 (May 28, 1946), pp. 3–6.

"The Print Collector: U.S. Art Loan Arrives in England." *ARTnews* (New York) 45, 4 (June 1946), p. 11.

"Reviews and Previews: First Appearances." *ARTnews* (New York) 45, 4 (June 1946), p. 50.

Stroup, Jon. "Time Out: A Retrospective Review." *Town and Country* (New York) (June 1946), p. 48.

Burger, William Thor. "Sights and Sounds: Art and the War." *New Masses* (New York) 59, 2 (June 11, 1946), pp. 27–9.

"This Week in Art: Crawford Off to Bikini." *New York World-Telegram*, June 15, 1946.

Davidson, Martha. "Art News of Washington: State Department Plans." *ARTnews* (New York) 45, 5 (July 1946), p. 52.

Longman, Lester D. "Everybody Gets into the Act at Chicago's Watercolor Show." *ARTnews* (New York) 45, 5 (July 1946), pp. 20–1.

Moon, Bucklin. "The Harlem Nobody Knows." *Glamour* (July 1946), p. 68.

"Chicago Opens Fifty-Seventh Watercolor Annual." *Art Digest* (New York) 20, 18 (July 1, 1946), pp. 8, 31.

"A Matter of State." *Art Digest* (New York) 20, 18 (July 1, 1946), p. 15.

"Negro Artists: Their Works Win Top U.S. Honors." *Life* 21 (July 22, 1946), p. 65.

Pearson, Ralph M. "A Modernist Explains Modern Art." *New York Times Magazine*, September 1, 1946, pp. 20–1, 39, 41.

Reed, Judith Kaye. "Nostalgic Charm of Native Primitives." *Art Digest* (New York) 20, 20 (September 15, 1946), p. 7.

"Person and Places: New Designs in Teaching." *Phylon* (Atlanta) 7 (4th Quarter 1946), pp. 383–5.

[Cover illustration.] *Fortune* 34 (October 1946).

"Reviews and Previews: Progressive Moderns." *ARTnews* (New York) 45, 8 (October 1946), pp. 57–8.

Gibbs, Jo. "Britannica Inaugurates a Rotating Annual." *Art Digest* (New York) 21, 1 (October 1, 1946), p. 14.

Millier, Arthur. "Four Years of Whitney-Met Purchases." *Art Digest* (New York) 21, 1 (October 1, 1946), pp. 12, 35.

Wolf, Ben. "New at Downtown." *Art Digest* (New York) 21, 1 (October 1, 1946), p. 17.

Crane, Jane Watson. "John Brown's Stirring." *Sunday Star* (Washington, D.C.), October 5, 1946, p. B5.

———. "Lawrence's 'John Brown' Stirring: 'One of Most Gifted Young Artists Today.'" *Washington Post* (D.C.), October 6, 1946.

"John Brown's Struggles: Theme of Lawrence Show." *Washington Post* (D.C.), October 6, 1946, p. S10.

Louchheim, Aline B. "One More Carnegie." *ARTnews* (New York) 45, 9 (November 1946), pp. 40–1, 53–4.

[Container Corporation advertisement.] *Time* (November 11, 1946), p. 69.

Lerman, Leo. "The American Eye." *House and Garden* (New York) 90 (December 1946), pp. 120, 208–11.

Morse, John D. "Americans Abroad." *Magazine of Art* (Washington, D.C.) 40, 1 (January 1947), pp. 21–5.

Boswell, Peyton, Jr. "Review of the Year." *Art Digest* (New York) 21, 7 (January 1, 1947), pp. 7, 18–9, 30.

Campbell, Vivian. "American Negro Art." *The Woman's Press* (New York) (February 1947), pp. 7–9, 44.

Frankel, Robert S. "Pictures before Pearls: In La Tausca's New Contest." *ARTnews* (New York) 45, 12 (February 1947), pp. 32, 55–6.

"Reviews and Previews: Drawings." *ARTnews* (New York) 45, 12 (February 1947), p. 42.

Gibbs, Jo. "La Tausca Unpearls Its Artists—Unveils a Stronger Exhibition." *Art Digest* (New York) 21, 9 (February 1, 1947), p. 12.

Breuning, Margaret. "Modern Drawings." *Art Digest* (New York) 21, 10 (February 15, 1947), p. 15.

Look (Des Moines, Iowa) (February 18, 1947).

Breuning, Margaret. "Whitney Museum Presents Native Sculpture and Watercolors." *Art Digest* (New York) 21, 12 (March 15, 1947), pp. 9, 31.

Hess, Thomas B. "Triple Play to Center: In the Whitney Drawing, Watercolor, and Sculpture Event." *ARTnews* (New York) 46, 2 (April 1947), pp. 35, 59–60.

Zucker, Paul. "Social Scene." *Saint Louis Pageant*, April 1947.

"Group Show by Americans." *New York Herald Tribune*, April 6, 1947.

Lewis, Lloyd. "Frederick Douglass, The Abolitionist Who Began as a Slave." *New York Times Book Review*, April 6, 1947, p. 3.

Breuning, Margaret. "Vernal Preview." *Art Digest* (New York) 21, 14 (April 15, 1947), p. 21.

"Jacob Lawrence." *Magazine of Art, Flint Institute Edition* (Mich.) (May 1947).

Van Jackson, Wallace. "The Countee Cullen Memorial Collection and Atlanta University." *Crisis* (New York) 54 (May 1947), pp. 140–2.

Walker, Hudson D. "Artists Equity." *Magazine of Art* (Washington, D.C.) 40 (May 1947), p. 188.

Adlow, Dorothy. "Boston and New York Exchange Art Shows: Manhattan Painters Exhibit Works at Mirski Gallery." *Christian Science Monitor* (Boston), May 12, 1947, p. 4.

"John Brown Series by Jacob Lawrence." *Portland Museum Bulletin* (Ore.) 8 (July 1947), p. 2.

"New Paintings." *ARTnews* (New York) 46, 5 (July 1947), p. 35.

"Reviews and Previews: American Watercolors." *ARTnews* (New York) 46, 7 (September 1947), p. 39.

Jewell, Edward Alden. "Art: Examples of Modernism in New Shows." *New York Times*, September 28, 1947, sec. 2, p. 7.

"New Paintings." *ARTnews* (New York) 46, 8 (October 1947), p. 43.

Offin, Charles Z. "Gallery Previews in New York." *Pictures on Exhibit* (New York) 10, 1 (October 1947), p. 20.

"Promises of the New Season in New York." *ARTnews* (New York) 46, 8 (October 1947), pp. 17–8, 59.

Campbell, Vivian. "American Negro Art." *The Woman's Press* (New York) (November 1947), p. 9.

"Exhibit to Open." *New York Times*, November 2, 1947, p. 6.

Bennett, Gwendolyn. "Meet Jacob Lawrence, Harlem-Born, Nationally Known." *Masses and Mainstream* (New York) 2, 1 (winter 1947), p. 97.

Offin, Charles Z. "Gallery Previews in New York." *Pictures on Exhibit* (New York) 10, 3 (December 1947), pp. 18–35.

"Reviews and Previews: Jacob Lawrence." *ARTnews* (New York) 46, 10 (December 1947), p. 44.

Valente, Alfredo. "Jacob Lawrence." *Promenade* (New York) (December 1947), p. 44.

Wilder, M. A. "New Yorkers to See Jacob Lawrence Exhibition Christmas Week." *Design* (Columbus, Ohio) 49, 4 (December 1947), p. 15.

Carlson, Helen. "Inness and Some Moderns." *New York Sun*, December 5, 1947, p. 27.

Adlow, Dorothy. "Jacob Lawrence's War Pictures." *Christian Science Monitor* (Boston), December 6, 1947, p. 18.

Genauer, Emily. "Jacob Lawrence War Paintings Are Tragic." *New York World-Telegram*, December 6, 1947, p. 4.

Burrows, Carlyle. "In the Art Galleries." *New York Herald Tribune*, December 7, 1947, sec. 6, p. 4.

Devree, Howard. "An Annual Round-Up: Jacob Lawrence." *New York Times*, December 7, 1947, p. 16.

Wallace, Henry. "Violence and Hope in the South." *New Republic* (New York) 117, 23 (December 8, 1947), p. 15.

Gibbs, Jo. "Lawrence Uses War for New 'Sermon in Paint.'" *Art Digest* (New York) 22, 6 (December 15, 1947), p. 10.

"Art: Strike Fast." *Time* 50 (December 22, 1947), p. 61.

Denvir, Bernard. "Negro Art in the United States." *London Forum* 1 (Christmas 1947), p. 20.

"Revolt from Victorian Prettiness." *ARTnews Annual* (New York) 18 (1948), pp. 110–1.

"Our Box Score of the Critics." *ARTnews* (New York) 46, 2 (January 1948), p. 45.

Watts, Richard, Jr. "Books in Review: A Liberal View of the South." *New Republic* (New York) 118, 3 (January 19, 1948), p. 27.

Hess, Thomas B. "Pity the Poor Sculptor." *ARTnews* (New York) 47, 1 (March 1948), pp. 20–1, 56.

"Reviews and Previews: The Brooklyn Society of Artists." *ARTnews* (New York) 47, 1 (March 1948), p. 48.

Hunter, Sam. "Work by Equity Artists." *New York Times*, March 28, 1948, sec. 2, p. 8.

"Five Local Artists Get Atlanta U. Awards." *New York Times*, April 4, 1948, p. 63.

Lansford, Alonzo. "Virginia Biennial Presents Vital View of American Painting." *Art Digest* (New York) 22, 15 (May 1, 1948), pp. 9, 32.

"Academic Activities and Awards." *ARTnews* (New York) 46, 4 (summer 1948), p. 64.

"Reviews and Previews: Price Range." *ARTnews* (New York) 47, 4 (summer 1948), p. 56.

"College and School News." *Crisis* (New York) 55 (June 1948), pp. 164–5.

Breuning, Margaret. "American Academy Honors, Rewards Artists." *Art Digest* (New York) 22, 17 (June 1, 1948), pp. 10, 39.

Lansford, Alonzo. "Sic Transit." *Art Digest* (New York) 22, 18 (July 1, 1948), pp. 13, 21.

Devree, Howard. "Artists and Sales: Group Show Reinforces Art with Economics." *New York Times*, July 4, 1948, sec. 2, p. 8.

Evans, Walker. "In the Heart of the Black Belt." *Fortune* 37, 2 (August 1948), pp. 88–9.

Gibbs, Jo. "Contemporary Art, Artists and Museums in the U.S.A." *Art Digest* (New York) 22, 19 (August 1, 1948), pp. 10–1, 19, 22.

"The Americans at Venice." *ARTnews* (New York) 47, 5 (September 1948), p. 25.

"Prizes and Purchases in Four Annuals." *ARTnews* (New York) 47, 5 (September 1948), p. 51.

"In the World of Books—The Men of World War II Are Now Speaking Out." *Christian Science Monitor* (Boston), September 16, 1948, p. 15.

Schappes, Morris U. "Myths about Anti-Semitism." *Masses and Mainstream* (New York) 1, 8 (October 1948), p. 54.

Breuning, Margaret. "Downtown's Annual." *Art Digest* (New York) 23, 2 (October 15, 1948), p. 14.

Cayton, Horace. "Carey the Republican." *New Republic* (New York) 119, 16 (October 18, 1948), p. 11.

Reid, Ira De A. "Walden the Democrat." *New Republic* (New York) 119, 16 (October 18, 1948), p. 13.

"Art News of America: Chicago Prize Watercolors." *ARTnews* (New York) 47, 7 (November 1948), p. 7.

"Chicago Art Prize to Ivan Albright." *New York Times*, November 3, 1948, p. 25.

Bulliet, C. J. "More Integrated Modernism Marks Chicago Watercolor Biennial." *Art Digest* (New York) 23, 4 (November 15, 1948), pp. 24, 51.

Drummond, Dorothy. "Watercolor Annual at Pennsylvania Academy." *Art Digest* (New York) 23, 4 (November 15, 1948), pp. 26, 37.

Opportunity (New York) 26 (winter 1948), p. 78.

Robb, Marilyn. "Chicago: Surveying Watercolor." *ARTnews* (New York) 47, 8 (December 1948), p. 47.

"Worcester Biennial Holds Public Interest." *Art Digest* (New York) 23, 6 (December 15, 1948), p. 14.

Reed, Judith Kaye. "American Art Destined for Israeli Museums." *Art Digest* (New York) 23, 8 (January 15, 1949), p. 16.

Adlow, Dorothy. "The Artist Speaks." *Christian Science Monitor* (Boston), April 9, 1949, p. 6.

"Art: Questions and Answers." *Time* 53 (April 11, 1949), p. 57.

Lowengrund, Margaret. "Paintings for $250." *Art Digest* (New York) 23, 19 (August 1, 1949), p. 15.

Seckler, Dorothy. "Reviews and Previews: New Paintings." *ARTnews* (New York) 48, 6 (October 1949), pp. 44–5.

Adlow, Dorothy. "Personal Predilection." *Christian Science Monitor* (Boston), October 1, 1949, p. 10.

Breuning, Margaret. "Carnegie Presents Last and Best Alt American Annual." *Art Digest* (New York) 24, 2 (October 15, 1949), pp. 7–9.

"Kibitzers." *Pictures on Exhibit* (New York) 12 (November 1949), p. 5.

"Watercolors at Philadelphia: A Preview of Pennsylvania Academy's Forty-Seventh Annual Exhibition." *Pictures on Exhibit* (New York) 12, 2 (November 1949), pp. 4–5.

Dame, Lawrence. "Regarding Boston." *Art Digest* (New York) 24, 4 (November 15, 1949), p. 4.

"Institute's Candidate Show." *Art Digest* (New York) 24, 6 (December 15, 1949), p. 13.

Matter, Herbert. "Fifty-Three Living American Artists." *Vogue* 115, 2 (February 1, 1950), pp. 150–3.

"Miami Takes a Look at Leading Americans." *Art Digest* (New York) 24, 9 (February 1, 1950), p. 13.

Sharp, Marynell. "No Drought in the Water Mediums." *Art Digest* (New York) 24, 11 (March 1, 1950), p. 9.

"Fifty-Seventh Street in Review: Downtown of a Decade Ago." *Art Digest* (New York) 24, 12 (March 15, 1950), p. 23.

Ishikawa, Joseph. "How Nebraska University Builds a Collection from Its Annuals." *Art Digest* (New York) 24, 12 (March 15, 1950), pp. 12–3.

Chanin, A. L. "The World of Art: Art's in Bloom on Both Sides of the Tracks." *Sunday Compass* (New York), March 19, 1950.

Brian, Doris. "Abstraction Wins, Other Styles Show at the Whitney Sculpture Annual." *Art Digest* (New York) 24, 14 (April 15, 1950), pp. 8–9.

Sweeney, James Johnson. "Sweeney Setting His American Scene." *ARTnews* (New York) 49 (May 1950), pp. 18–20, 56–7.

Cheek, Leslie, Jr. "One-Man Direction Gives New Cast to Virginia's Biennial Show." *Art Digest* (New York) 24, 15 (May 1, 1950), pp. 7, 31.

Chanin, A. L. "The World of Art: You Can Buy Art Too, on Installment Plan." *Sunday Compass* (New York), June 5, 1950.

"Dutch Treat Themselves to an American Show." *Art Digest* (New York) 24, 19 (August 1, 1950), p. 9.

Breuning, Margaret. "Downtown Gallery Young at Twenty-Five." *Art Digest* (New York) 25, 1 (October 1, 1950), p. 10.

Chanin, A. L. "American Art: Twenty-Five Years." *Sunday Compass* (New York), October 1, 1950.

Devree, Howard. "Modern Panorama: Four New Group Shows Reveal Breadth and Variety of Contemporary Art." *New York Times*, October 1, 1950, sec. 2, p. 9.

Coates, Robert M. "In the Galleries: Slow Start." *The New Yorker* 26 (October 7, 1950), pp. 71–3.

"Fifty-Seventh Street in Review." *Art Digest* (New York) 25, 2 (October 15, 1950), p. 18.

Louchheim, Aline B. "An Artist Reports on the Troubled Mind." *New York Times Magazine*, October 15, 1950, pp. 15–6, 36, 38. Reprint. "Art in an Insane Asylum." *Negro Digest* (Chicago) 9 (February 1951), pp. 14–9.

Devree, Howard. "Modern Round-Up: Record of Growth." *New York Times*, October 29, 1950, sec. 2, p. 9.

Carlson, Helen. "Gallery Previews." *Pictures on Exhibit* (New York) 13, 2 (November 1950), p. 33.

Seckler, Dorothy. "Reviews and Previews: Jacob Lawrence." *ARTnews* (New York) 49, 7 (November 1950), p. 65.

Fitzsimmons, James. "Lawrence Documents." *Art Digest* (New York) 25, 3 (November 1, 1950), p. 16.

L. K. "Amsterdam: Una Mostra Storica della Pittura Americana." *Emporium* (Bergamo, Italy) 112 (December 1950), pp. 285–6.

Krasne, Belle. "Art for Grants." *Art Digest* (New York) 25, 6 (December 15, 1950), pp. 16, 28.

Seckler, Dorothy. "Reviews and Previews: Candidates for Grants." *ARTnews* (New York) 49, 9 (January 1951), p. 44.

Fitzsimmons, James. "Fifty-Seventh Street in Review: Tiffany Award Winners." *Art Digest* (New York) 25, 8 (January 15, 1951), p. 19.

"College and School News." *Crisis* (New York) 58 (February 1951), pp. 125–6.

"U.S.A.: Permanent Revolution, Part Three: The Problems of Free Men." *Fortune* (February 1951), pp. 108–12, 196, 198, 201.

Krasne, Belle. "Modern's Purchases." *Art Digest* (New York) 25, 11 (March 1, 1951), p. 11.

"Jacob Lawrence: New Paintings Portraying Life in Insane Asylum Project Him into Top Ranks of U.S. Artists." *Ebony* (Chicago) (April 1951), pp. 73–8.

"Washington Art Comes Home." *Our World* (New York) 6 (May 1951), pp. 30–2.

Krasne, Belle. "Brooklyn Biennial Surveys Watercolors." *Art Digest* (New York) 25, 16 (May 15, 1951), pp. 13, 28.

"New Equity Officials." *Art Digest* (New York) 25, 16 (May 15, 1951), p. 11.

Pearson, Ralph M. "A Modern Viewpoint." *Art Digest* (New York) 25, 16 (May 15, 1951), p. 16.

"A Brazil Biennial." *Art Digest* (New York) 25, 18 (July 1, 1951), p. 8.

Goodnough, Robert. "Reviews and Previews: Contemporary American Drawings." *ARTnews* (New York) 50, 5 (September 1951), p. 42.

Devree, Howard. "Group Annual." *New York Times*, October 7, 1951, sec. 2, p. 9.

Breuning, Margaret. "Birthday Downtown." *Art Digest* (New York) 26, 2 (October 15, 1951), p. 17.

"Guggenheim Fellows." *Art Digest* (New York) 26, 3 (November 1, 1951), pp. 53, 77.

"Who's Where." *Art Digest* (New York) 26, 3 (November 1, 1951), p. 74.

Burrows, Carlyle. "Art in Review: A Roundup of Work for the Holidays." *New York Herald Tribune*, December 16, 1951.

Chanin, A. L. "The World of Art: Galleries Provide Tempting Art for Christmas Shoppers." *Compass* (New York) (December 16, 1951).

Fitzsimmons, James. "Fifty-Seventh Street in Review: Dahle, Drummond, Gilliland." *Art Digest* (New York) 26, 8 (January 15, 1952), p. 23.

"Painting and Sculpture in The Museum of Modern Art." *MoMA Supplement 1952 Bulletin* (New York) 19, 3 (spring 1952).

"Equity Warms Up." *Art Digest* (New York) 26, 12 (March 15, 1952), p. 18.

"New Crop of Painting Protégés." *Life* 32 (March 17, 1952), pp. 87–8.

D. A. "Fifty-Seventh Street in Review: Spring Exhibition." *Art Digest* (New York) 26, 14 (April 15, 1952), p. 16.

"Recent Accessions: Portland Museum of Art, Oregon." *Art Digest* (New York) 26, 15 (May 1, 1952), p. 9.

Ashton, Dore. "Brooklyn Scores a Hit." *Art Digest* (New York) 26, 16 (May 15, 1952), pp. 16, 23.

Chanin, A. L. "The World of Art: Wedding Song." *Compass* (New York) (June 8, 1952), p. 30.

———. "The World of Art." *Compass* (New York) (October 5, 1952).

Ashton, Dore. "Fifty-Seventh Street in Review: Equity Workshop." *Art Digest* (New York) 27, 2 (October 15, 1952), pp. 17, 20.

Ritter, Chris. "Fifty-Seventh Street in Review: Downtown Group." *Art Digest* (New York) 27, 2 (October 15, 1952), p. 16.

———. "Fifty-Seventh Street in Review: Downtown Group." *Art Digest* (New York) 27, 5 (December 1, 1952), p. 18.

"Accessions: January 1, 1953–December 31, 1953." *Bulletin of the DIA* (Detroit) 33, 1 (1953–4).

"Coast-to-Coast Notes: Indianapolis, Indiana." *Art Digest* (New York) 27, 8 (January 15, 1953), p. 22.

Quick (Munich) (January 26, 1953).

Mitchell, Fred. "Gallery Previews in New York." *Pictures on Exhibit* (New York) 15, 5 (February 1953), pp. 20–33.

P[orter], F[airfield]. "Reviews and Previews: Jacob Lawrence." *ARTnews* (New York) 51, 10 (February 1953), p. 73.

Geist, Sidney. "Fifty-Seventh Street in Review: Jacob Lawrence." *Art Digest* (New York) 27, 9 (February 1, 1953), p. 17.

Preston, Stuart. "Recent Works by Stevens, David Smith, Lawrence." *New York Times*, February 1, 1953, sec. 2, p. 8.

"Stories with Impact." *Time* 61 (February 2, 1953), pp. 50–1.

"Accessions: Pittsburgh and Elsewhere." *Art Digest* (New York) 27, 16 (May 15, 1953), pp. 9, 21.

Barr, Donald. "Guilt Was Everywhere." *New York Times Book Review*, May 17, 1953, p. 5.

Campbell, Lawrence. "Reviews and Previews: Members and Honors." *ARTnews* (New York) 52, 4 (summer 1953), pp. 61–2.

Porter, Fairfield. "Reviews and Previews: New York Paintings." *ARTnews* (New York) 52, 4 (summer 1953), p. 52.

Locke, Alain. "The Negro in the Arts." *United Asia* (Bombay, India) 5, 3 (June 1953), pp. 177–81.

"Who's News." *Art Digest* (New York) 27, 18 (July 1953), p. 12.

"Fifty-Seventh Street: Gallery Groups: Crespi." *Art Digest* (New York) 27, 20 (September 1953), p. 25.

"New York Notes." *Art Digest* (New York) 27, 20 (September 15, 1953), pp. 17, 20, 25.

Blake, Patricia. "A Sprinkler on the Lawn." *New York Times Book Review*, September 20, 1953, p. 26.

Campbell, Lawrence. "Reviews and Previews: Opening Show." *ARTnews* (New York) 52, 6 (October 1953), p. 47.

McBrown, Gertrude Parthenia. "The Countee Cullen Memorial Collection of Atlanta University." *Negro History Bulletin* (Washington, D.C.) 17 (October 1953), pp. 11–3.

Mitchell, Fred. "Gallery Previews in New York: The Alan Gallery." *Pictures on Exhibit* (New York) 17, 1 (October 1953), p. 22.

Devree, Howard. "In Diverse Veins: From Old Masters to American Moderns Range the Week's Exhibitions." *New York Times*, October 4, 1953, sec. 2, p. 10.

Genauer, Emily. "Two Shows in Contrast." *New York Herald Tribune*, October 4, 1953.

"Portrait." *Art Digest* (New York) 28, 3 (January 15, 1954).

Feinstein, Sam. "Fifty-Seventh Street: Jackson Collection." *Art Digest* (New York) 29, 10 (February 15, 1954), p. 18.

"People in the News." *ARTnews* (New York) 53, 1 (March 1954), p. 56.

"Who's News." *Art Digest* (New York) 28, 14 (April 15, 1954), p. 4.

"Artists Equity Decides." *ARTnews* (New York) 53, 3 (May 1954), p. 66.

Devree, Howard. "Boston's Festival: Exhibitions in the Open and at Brandeis." *New York Times*, June 13, 1954, sec. 2, p. 7.

"American Artists and the Negro." *Negro Digest* (Chicago) 12 (July 1954), p. 47.

Burrows, Carlyle. "Art: New Group Shows Take the Lead." *New York Herald Tribune*, September 12, 1954.

S. P. "About Art and Artists: Group Shows at Two Galleries Open Local Season with Varied Works." *New York Times*, September 13, 1954, p. 18.

Reddick, Lawrence Dunbar. "Walter Simoon: The Socialization of an American Negro Artist." *Phylon* (Atlanta) 15 (4th Quarter 1954), pp. 373–92.

Kramer, Hilton. "Fortnight in Review: Brooklyn Artists." *Art Digest* (New York) 29, 4 (November 15, 1954), p. 28.

Neuberger, Roy. "Collecting American Art." *Art in America* (New York) 42, 4 (December 1954), pp. 283–90.

"Accessions, 1955–6." *Bulletin of the DIA* (Detroit) 35, 2 (1955–6).

"Lawrence and Tam in Joint Exhibit." *Philadelphia Art Alliance Bulletin* 33 (January 1955), p. 8.

Devree, Howard. "About Art and Artists: John Piper Blends Traditional English Romantic Landscape with Abstraction." [Includes review of Denman exhibition at Downtown Gallery.] *New York Times*, February 17, 1955, p. 25.

Munson, Gretchen T. "The Denman Collection." *ARTnews* (New York) 54, 1 (March 1, 1955), p. 52.

Grunfeld, Fred. "Strange Rhythms and a Peculiar Lilt." *New York Times Book Review*, April 3, 1955, p. 7.

Saarinen, Aline B. "A Pilot's World Famous Art Collection." *Cosmopolitan* (New York) 139, 1 (July 1955), pp. 64–7.

"C. P." *Print* (New York) 10 (September 1955), pp. 18–29.

D. A. "About Art and Artists." *New York Times*, March 29, 1956, p. 55.

"American Artists Paint the City." *Arts* (New York) 30, 9 (June 1956), pp. 26–9.

G. L. "In the Galleries: Christmas Exhibition." *Arts* (New York) 31, 3 (December 1956), p. 61.

"Exhibition at the Alan Gallery, New York." *Pictures on Exhibit* (New York) 20 (January 1957), p. 4.

J. R. M. "In the Galleries: Jacob Lawrence." *Arts* (New York) 31, 4 (January 1957), p. 53.

Newbill, Al. "Gallery Previews in New York." *Pictures on Exhibit* (New York) 20, 4 (January 1957), p. 23.

Tyler, Parker. "Reviews and Previews: Jacob Lawrence." *ARTnews* (New York) 55, 9 (January 1957), p. 24.

Devree, Howard. "Forceful Painting." *New York Times*, January 6, 1957, sec. 2, p. 15.

"Birth of a Nation." *Time* 69 (January 14, 1957), p. 82.

Thomson, Hugh. "Pictures Must Excite Me Twice." *Star Weekly Magazine* (Toronto), May 18, 1957.

"People in the Arts." *Arts* (New York) 31, 9 (June 1957), p. 12.

Genauer, Emily. "New Exhibit Proves Art Needn't Be Aloof." *New York Herald Tribune*, June 6, 1957, p. 10.

"American Struggle: Three Paintings." *Vogue* 130 (July 1957), pp. 66–7.

"Art News International: People in the ARTnews." *ARTnews* (New York) 56, 5 (September 1957), p. 8.

[Review of the Alan Gallery Exhibition.] *New York Herald Tribune*, September 15, 1957.

James, Milton M. "Jacob Lawrence." *Negro History Bulletin* (Washington, D.C.) 21, 1 (October 1957), p. 18.

Hess, Thomas B. "For Spacious Skies, and All That." *ARTnews* (New York) 56, 7 (November 1957), pp. 28–30, 58–60.

"Christmas Shopping for Art." *ARTnews* (New York) 56, 8 (December 1957), p. 8.

"Leading Young Artists." *Ebony* (Chicago) 13 (April 1958), pp. 33–8.

Devree, Howard. "Personal Visions: Work by Five Artists in Modes of Today." *New York Times*, May 11, 1958, sec. 2, p. 15.

Herdeg, Walter, ed. *59/60 Graphis Annual* (Zurich) 99 (1959), p. 86.

Wright, Clifford. "The Best Negro Painter in the U.S.A." *Kunst* (Munich) 6, 8 (April 1959).

[Container Corporation advertisement.] *Time* 73, 15 (April 13, 1959), p. 119.

[Container Corporation advertisement.] *Newsweek* (April 20, 1959), p. 108.

Goodrich, Lloyd. "American Painting and Sculpture, 1930–1959." *College Art Journal* (New York) 18 (summer 1959), pp. 288–301.

Breuning, Margaret. "Drawings at the National Arts Club." *Arts* (New York) 33, 9 (June 1959), p. 53.

Fax, Elton. "Puissance inouïe du peintre et du sculpteur." *Présence africaine* (Paris) 26 (June–July 1959), pp. 268–74.

"New Work at Alan Gallery." *Apollo* (London) 70, 106 (October 1959), p. 106.

Seckler, Dorothy Gees. "International Gallery Guide: New York." *Art in America* (New York) 48, 3 (1960), p. 103.

———. "Gallery Notes: 1961 Preview—The Figure." *Art in America* (New York) 48, 4 (1960), p. 87.

"People in the Arts." *Arts* (New York) 34, 6 (March 1960), p. 10.

Genauer, Emily. "Ideas Still Move Today's Painters." *New York Herald Tribune*, November 27, 1960.

Raynor, Vivien. "In the Galleries: Jacob Lawrence." *Arts* (New York) 35, 4 (January 1961), pp. 54–5.

Wright, Clifford. "Jacob Lawrence." *The Studio* (London) 161 (January 1961), pp. 26–8.

"'Narrative Painter' Lawrence's Works to Be Exhibited at Allegheny College." *Meadville Tribune* (Pa.), February 17, 1961.

Smith, Clifford. "Bright Sorrow." *Time* 77 (February 24, 1961), pp. 60–3.

Schiff, Bennett. "Closeup: The Artist as Man in the Street." *New York Post Magazine*, March 26, 1961, p. 2.

Fax, Elton. [Review of Cedric Dover's *American Negro Art.*] *Crisis* (New York) 68 (May 1961), pp. 309–11.

Hayes, Richard. "Reviews and Previews: New Work." *ARTnews* (New York) 60, 4 (summer 1961), p. 54.

Reinhardt, Ad. "1946: How to Look at Modern Art in America." *ARTnews* (New York) 60, 4 (summer 1961), p. 36.

Beier, Ulli. "Two American Negro Painters: Jacob Lawrence and William H. Johnson." *Black Orpheus* (Ibadan, Nigeria) 11 (1962), p. 27.

"Two Special One-Gallery Exhibitions of Paintings in the Museum Collection." *Bulletin of The Museum of Modern Art* (New York) 29, 2/3 (1962), p. 7.

Driskell, David C. "Jacob Lawrence." *The Talladegan* (Ala.) 79, 2 (February 1962), pp. 27–8.

Rigg, Margaret. "Jacob Lawrence: Painter." *Motive* (Nashville) (April 1962), pp. 20–1, 23.

"Art News International: People in the ARTnews." *ARTnews* (New York) 61, 6 (October 1962), p. 8.

Crisis (New York) 69 (October 1962), pp. 497–8.

"Lawrence and Kofi Exhibit in Lagos." *AMSAC Newsletter* (New York) 5, 3 (November 1962), pp. 1–2.

Getlein, Frank. "Work of Foremost American Negro Artist at Phillips." *Sunday Star* (Washington, D.C.), December 9, 1962, p. B10.

"Art Centers: Gallery Guide—Contemporary American Art." *Art in America* (New York) 51, 5 (1963), p. 128.

Elliot Rago, Louise. "A Welcome for Jacob Lawrence." *School Arts* (Worcester, Mass.) (February 1963), pp. 31–2, 88–9.

Beck, James H. "Jacob Lawrence." *ARTnews* (New York) 62, 2 (April 1963), p. 13.

"Major, A. Hyatt. "Painters' Playing Cards." *Art in America* (New York) 51, 2 (April 1963), pp. 39–42.

"Art: Black Mirror." *Newsweek* 61, 15 (April 15, 1963), p. 100.

O'Doherty, Brian. "Summary of Some Other Art Shows in Galleries This Week." *New York Times*, April 20, 1963, p. 24.

R[aynor], V[ivien]. "In the Galleries: Jacob Lawrence." *Arts* (New York) 37, 9 (May 1963), p. 112.

"'Art for Integration' Show Held on Long Island for Dr. King." *New York Times*, July 1, 1963, p. 14.

"Leading Negro Artists: Talent Breaks Bias Band." *Ebony* (Chicago) 18, 11 (September 1963), pp. 131–40.

[Cover illustration.] *Motive* (Nashville) 24, 1 (October 1963).

Lee-Smith, Hughie. "The Negro Artist in America Today." *Negro History Bulletin* (Washington, D.C.) 27 (February 1964), pp. 111–2.

Fax, Elton C. "Four Rebels in Art." *Freedomways* (New York) 4 (spring 1964), pp. 215–25.

Kramer, Hilton. "In the Museums." *Art in America* (New York) 52, 2 (March 1964), pp. 36–47.

Sadik, Marvin S. "The Negro in American Art." *Art in America* (New York) 52, 3 (April 1964), p. 74.

"U.S. Artist Commends Nigerian Art." *Sunday Times* (Lagos, Nigeria), April 26, 1964, p. 9.

"Art News International: Art Raises Record Funds for Civil Rights." *ARTnews* (New York) 63, 3 (May 1964), p. 8.

"Artist Extraordinary." *Interlink: The Nigerian American Quarterly Newsletter* (Lagos, Nigeria) 2 (July 1964), p. 4.

"Art Symposium." *Morning Post* (Nigeria), September 28, 1964.

"Art Exhibit Goes On." *West African Pilot* (Nigeria), November 13, 1964.

Hughes, Langston. "Christmas Gifts." *New York Post*, December 11, 1964, p. 50.

Barnitz, Jacqueline. "In the Galleries: Jacob Lawrence." *Arts* (New York) 39, 66 (February 1965).

Browne, Rosalind. "Reviews and Previews: Jacob Lawrence." *ARTnews* (New York) 63, 10 (February 1965), p. 17.

"Art Institute Names Thirteen Members for Noteworthy Creative Work." *New York Times*, February 9, 1965, p. 34.

"Lawrence Exhibit at Morgan." *The Sun* (Baltimore), March 7, 1965, p. D4.

Kay, Jane H. "Lawrence Retrospective: Capsulating a Career." *Christian Science Monitor* (Boston), March 26, 1965, p. 4.

"Artists in the News." *ARTnews* (New York) 64, 5 (September 1965), p. 62.

Neal, Laurance P. "The Black Revolution in Art: A Conversation with Joel Overstreet." *Liberator* (New York) 5 (October 1965), pp. 9–10.

Roberts, Lucille. "The Gallery of Eight." *Topic* (Washington, D.C.) 5 (1966), pp. 21–5.

[Photograph of Jacob and Gwendolyn Lawrence.] *AMSAC Newsletter* (New York) 8, 1 (February 1966), p. 2.

Glueck, Grace. "Safari to Senegal." *New York Times*, February 6, 1966, sec. 2, p. 24.

Maddocks, Melvin. "The Negro Writer's Scene." *Christian Science Monitor* (Boston), February 15, 1966, p. 9.

Navasky, Victor, S. "With Malice toward All." *New York Times Book Review*, February 27, 1966, p. 4.

Shepard, Richard F. "Ten Painters Quit Negro Festival in Dispute with U.S. Committee." *New York Times*, March 10, 1966, p. 29.

Berkson, William. "In the Galleries." *Arts* (New York) 40, 7 (May 1966), p. 66.

White, Claire Nicolas. "Reviews and Previews: Group Shows: A.C.A." *ARTnews* (New York) 65, 3 (May 1966), p. 55.

"Audrey Bracey Chosen Queen by Afro-American Art." *New York Amsterdam News*, July 16, 1966, p. 35.

Cooke, Paul Phillips. "The Art of Africa for the Whole World: An Account of the First World Festival of Negro Arts (*Premier Festival Mondial des Arts Negres*) in Dakar, Senegal—April 1–24, 1966." *Negro History Bulletin* (Washington, D.C.) 29 (December 1966), pp. 171–2.

"Festival Awards Presentation." *Negro Digest* (Chicago) 16 (December 1966), pp. 89–90.

Fuller, Hoyt W. "Editor's Notes." *Negro Digest* (Chicago) 16 (June 1967), p. 4.

"Images of Dignity: The Drawings of Charles White." *Negro Digest* (Chicago) 16 (June 1967), pp. 40–8.

Percy, Walker. "The Doctor Listened." *New York Times Book Review*, June 25, 1967, p. 7.

Roskolenko, Harry. "Junkie's Homecoming." *New York Times Book Review*, September 10, 1967, p. 56.

Pierre-Noel, Lois. "American Negro Art in Progress." *Negro History Bulletin* (Washington, D.C.) 30, 6 (October 1967), pp. 6–9.

Glueck, Grace. "Negro Art from 1800 to 1950 is on Display at City College." *New York Times*, October 16, 1967, p. 47.

Skowhegan School of Painting and Sculpture Bulletin/1968 (Maine) (1968).

Pomeroy, Ralph. "Reviews and Previews: Jacob Lawrence." *ARTnews* (New York) 66, 9 (January 1968), p. 15.

Glueck, Grace. "New York Gallery Notes: Who's Minding the Easel?" *Art in America* (New York) 56, 1 (January–February 1968), pp. 110–3.

Canaday, John. "The Quiet Anger of Jacob Lawrence." *New York Times*, January 6, 1968, p. 25.

Willis, Clayton. "Jacob Lawrence's Paintings on Exhibit." *New York Amsterdam News*, January 20, 1968, p. 16.

Dorset, Gerald. "In the Galleries: Jacob Lawrence." *Arts* (New York) 42, 4 (February 1968), p. 65.

Temple, Herbert. "Evolution of Afro-American Art, 1800–1950." *Ebony* (Chicago) 23, 4 (February 1968), pp. 116–8.

Greene, Carroll, Jr. "The Afro-American Artist." *The Art Gallery* (Ivoryton, Conn.) 11, 7 (April 1968), pp. 12–25.

Baker, Carlos. "Many Wars Ago." *New York Times Book Review*, April 14, 1968, p. 5.

Long, Richard A. "Crisis of Consciousness: Reflections on Afro-American Artists." *Negro Digest* (Chicago) 17 (May 1968), pp. 88–92.

Porter, James A. "Afro-American Art at Floodtide." *Arts in Society* (Madison, Wis.) 5 (summer–fall 1968), pp. 256–71.

Greene, Carroll, Jr. "Afro-American Artists: Yesterday and Now." *The Humble Way* (3rd Quarter 1968), pp. 10–5.

[Cover illustration depicting Lieutenant Colonel Ojukwu of Biafra.] *Time* (August 23, 1968).

Wilson, Edward N. "A Statement." *Arts in Society* (Madison, Wis.) 5 (fall–winter 1968), pp. 411–7.

"The Black Artist—At Last, Whites Are Looking." *Minneapolis Tribune*, October 13, 1968, Entertainment sec., p. 4.

Steele, Mike. "Negro Artists' Work Shown at Institute." *Minneapolis Tribune*, October 13, 1968, p. 20.

Kramer, Hilton. "Differences in Quality." *New York Times*, November 4, 1968, sec. 2, p. 27.

Glueck, Grace. "1930s Show at Whitney Picketed by Negro Artists Who Call It Incomplete." *New York Times*, November 18, 1968, p. 31.

Werners, Alfred. [Letter to the editor regarding Studio Museum exhibition.] *New York Times*, November 23, 1968, p. 46.

Iness-Brown, Virginia. "The First World Festival of Negro Arts." *International Art Exhibitions, Art Magazine Yearbook 10* (New York: Art Digest, 1969).

Skowhegan School of Painting and Sculpture Bulletin/1969 (Maine) (1969).

Bearden, Romare. "The Black Artist in America: A Symposium." *The Metropolitan Museum of Art Bulletin* (New York) 27, 5 (January 1969), pp. 245–60.

Greene, Carroll, Jr. "The Negro Artist in America, Part I." *The Journal* [United Church of Christ, Council for Higher Education] (New York) 7 (January 1969), pp. 5–18.

Kay, Jane Holtz. "Artists as Social Reformers." *Art in America* (New York) 57, 1 (January–February 1969), pp. 44–7.

Arnold, Martin. [Protests over *Harlem on My Mind* exhibit.] *New York Times*, January 17, 1969, p. 1.

"The Black Artists: A Unique Observation." *Tuesday* (Chicago) 4 (February 1969), pp. 16–7.

Glueck, Grace. "Negroes' Art Is What's In Just Now." *New York Times*, February 27, 1969, p. 34.

Hope, Henry R. "On Black Artists." *Art Journal* (New York) 28, 3 (spring 1969), p. 322.

Turner, Sherry. "An Overview of the New Black Arts." *Freedomways* (New York) 9 (spring 1969), pp. 156–63.

"The Martin Luther King Art Exhibit." [Sponsored by SCLC at Museum of Modern Art.] *Sepia* (Fort Worth) 18 (March 1969), pp. 48–51.

"A Festival: Arts and the Artist 1969." *The Art Gallery* (Ivoryton, Conn.) 12, 8 (May 1969), p. 22.

Werner, Alfred. "Black Is Not a Color." *Art and Artists* (New York) 4, 2 (May 1969), pp. 14–7.

Richard, Ethel. [Review of *Harriet and the Promised Land*.] *Interracial Books for Children* (New York) 2 (summer 1969), p. 8.

Greene, Carroll, Jr. "Jacob Lawrence: Story Teller." *American Way* (July–August 1969).

Driscoll, Edgar J., Jr. "Showcase for Black Artists." *Boston Globe*, July 6, 1969, p. A73.

Neal, Larry. "Any Day Now: Black Art and Black Liberation." *Ebony* (Chicago) 24 (August 1969), pp. 54–8.

Brumer, Miriam. "In the Museums: An Introduction to the Negro in American History." *Arts* (New York) 44, 1 (September–October 1969), p. 58.

Ghent, Henri. [Letter responding to Peter Schjeldahl's review of *Harlem Artists 69*.] *New York Times*, October 26, 1969, sec. 2, p. 27.

Canaday, John. "Art: Scanning America of the Nineteenth Century." *New York Times*, November 1, 1969, p. 29.

[Cover illustration.] *Freedomways* (New York) 9, 1 (winter 1969).

Skowhegan School of Painting and Sculpture Bulletin/1970 (Maine) (1970).

Price, Willadene. "The Artist as Interpreter of the Needs of Man." *Social Education* (Arlington, Va.) 34 (January 1970), pp. 36–8.

"Painter of Life: Jacob Lawrence." *Scholastic New Times* 36 (January 26, 1970), pp. 12–4.

Seldis, Henry J. "'Dimensions in Black': A Conclusion for America." *Los Angeles Times*, February 22, 1970, p. 46.

"The Michener Collection: The University of Texas at Austin." *Texas Quarterly* (Austin) 13, 1 (spring 1970), n.p.

"Art News in the Art Schools." *ARTnews* (New York) 69, 1 (March 1970), p. 7.

Lee, Virginia. "Jacob Lawrence—Story Teller." *Northwest Art News and Views* (Seattle) 1 (March–April 1970), pp. 16–21.

Loercher, Diana. "Black Artists' Exhibition Reveals Visual Eloquence." *Christian Science Monitor* (Boston), March 2, 1970, p. 11.

"Black Art: What Is It?" *The Art Gallery* (Ivoryton, Conn.) 13, 7 (April 1970), pp. 32–5.

Greene, Carroll, Jr. "Perspective: The Black Artist in America." *The Art Gallery* (Ivoryton, Conn.) 13, 7 (April 1970), pp. 1–29.

[Cover illustration depicting Jesse Jackson.] *Time* (April 6, 1970).

"Los Angeles: Dimensions of Black, La Jolla Museum." *Artforum* (New York) 8, 9 (May 1970), pp. 83–4.

Marvel, Bill. "In Art World, Too, the Word Is 'Soul.'" *National Observer* (Washington, D.C.) (May 11, 1970), p. 22.

Driscoll, Edgar J., Jr. "Art/Afro-American, A Smashing Roundup." *Boston Globe*, May 17, 1970, pp. 82, 85.

Sherman, Marjorie. "Afro-American Gets Biggest Show." *Boston Globe*, May 18, 1970, p. 36.

LeBrun, Caron. "Black Art." *Boston Herald Traveler*, May 24, 1970, pp. 10–3.

———. "Blacks' Art on Display." *Boston Herald Traveler*, May 26, 1970, p. 29.

Bourne, Kay. "The Callboard: Black Artists Show at Museum." *Bay State Banner* (Roxbury, Mass.), May 28, 1970, p. 10.

"College Art News." *Art Journal* (New York) 29, 4 (summer 1970), p. 456.

Holmes, Ann. "Report/Houston: The Summer Scene." *The Art Gallery* (Ivoryton, Conn.) 13, 10 (summer 1970), p. 62.

Caldwell, Earl. "Wilkins, at NAACP Convention, Calls on Negroes to Reject Racial Separatism." *New York Times*, July 1, 1970, p. 33.

"Jacob Lawrence to Receive Spingarn." *The Berkeley Post* (Calif.), July 2, 1970.

Lawrence, Jacob. "The Artist Responds." *Crisis* (New York) 77, 7 (August–September 1970), pp. 266–7.

Rustin, Bayard. "The Role of the Artist in the Freedom Struggle." *Crisis* (New York) 77, 7 (August–September 1970), pp. 260–3.

Murphy, Charles. "The Humanities and the Black Student." *Integrated Education* (Amherst, Mass.) 8 (September 1970), pp. 53–6.

Burnett, W. C. "Black Painter Explores Revolt by Slaves in Handshake Series." *Atlanta Journal and Constitution*, September 30, 1970, p. E2.

Hatcher, Richard G. "Art and Liberation: Culture and Freedom." *Freedomways* (New York) 10 (4th Quarter 1970), pp. 319–25.

"Jacob Lawrence." *Contact* (New York) (October 1970), pp. 20–1.

Craig, Randall J. "Focus on Black Artists." *School Arts* (Worcester, Mass.) 70 (November 1970), pp. 30–3.

Killens, John Oliver. "Another Time When Black Was Beautiful." *Black World* (Chicago) 20 (November 1970), pp. 20–36.

Wesley, Charles H. "Editorial: The American Negro Academy, 1897–1916, and the Black Academy of Arts and Letters, 1967–1970." *Negro History Bulletin* (Washington, D.C.) 33 (November 1970), pp. 156–7.

"Jacob Lawrence Is Named Professor of Art at Pratt." *New York Times*, November 14, 1970, p. 17.

Harley, Ralph L., Jr. "A Checklist of Afro-American Art and Artists." *Serif* (Kent, Ohio) 7 (December 1970), pp. 3–63.

Weisberger, Bernard A. "The Immigrant Within." *American Heritage* (New York) 22, 1 (December 1970), pp. 32–9, 104.

Skowhegan School of Painting and Sculpture Bulletin/1971 (Maine) (1971).

Rustin, Bayard. "Man, One in Beauty and Depravity." *Integrated Education* (Amherst, Mass.) 9 (January 1971), pp. 16–20.

Johnston, Robert P. "Six Major Figures in Afro-American Art." *Michigan Academician* (Ann Arbor) 3 (spring 1971), pp. 51–8.

Glueck, Grace. "Fifteen of Seventy-Five Black Artists Leave As Whitney Exhibition Opens." *New York Times*, April 6, 1971, p. 50.

Preston, Malcolm. "Art: Black Exhibit." *Boston Herald Traveler*, April 19, 1971, p. 17.

Grisby, Eugene, Jr. [Review of *The Negro in Art*.] *African Arts* (Los Angeles) 4 (summer 1971), pp. 68–9.

"Exhibitions: Coast to Coast." *The Art Gallery* (Ivoryton, Conn.) 14, 9 (June 1971), pp. 27–9.

Rennie, Dorothy B. "Three Black Artists." *North Carolina Museum of Art Bulletin* (Raleigh) 10, 4 (June 1971), pp. 3–17.

"Exhibitions Cross-Country." *ARTnews* (New York) 70, 5 (September 1971), p. 57.

Eagle, Joanna. "The Artistic Odyssey of a Black Painter from the Rural South." [Article on William H. Johnson.] *Smithsonian* (Washington, D.C.) 2 (November 1971), pp. 34–9.

Weiffenbach, Jennie. "PASTA MoMA, or the Strike-Bound Modern." *Studio International* (London) 182 (November 1971), pp. 175–7.

Elsen, Patricia. "College Museum Notes: Acquisitions." *Art Journal* (New York) 31, 2 (winter 1971/1972), pp. 186–91.

"Romare Bearden at the Studio Museum." *Black Shades: A Black Art Newsletter* (Washington, D.C.) 2, 8 (1972).

Driscoll, Edgar J., Jr. "Blacks Duncanson, Bannister Honored in Fine Arts Exhibit." *Boston Globe*, January 16, 1972, p. A94.

"Public Art Museum Notes." *Art Journal* (New York) 31, 3 (spring 1972), p. 310.

Williams, Randy. "Ellsworth Ausby and Bill Rivers; Artists of the Soul." *Black Creation* (New York) 3 (spring 1972), p. 42.

Kaiser, Ernest. [Review of Bearden and Henderson's *Six Black Masters of American Art*.] *Freedomways* (New York) 12 (2nd Quarter 1972), pp. 166–76.

Dooley, William Germain. "Home Forum." *Christian Science Monitor* (Boston), April 24, 1972, p. 8.

"Miscellany." *The Art Gallery* (Ivoryton, Conn.) 15, 8 (May 1972), p. 32.

Denvir, Bernard. "London Letter." *Art International* (Lugano, Switzerland) 16, 5 (May 20, 1972), pp. 38–43.

Eagle, Joanna. "Etcetera: Galleries: Washington." *The Art Gallery* (Ivoryton, Conn.) 15, 10 (summer 1972), p. W16.

Alan, Charles. "Letter: Information Please." *The Art Gallery* (Ivoryton, Conn.) 15, 9 (June 1972), p. 32.

Marr, Warren, II. "A Second Renaissance." *Crisis* (New York) 79 (June–July 1972), pp. 198–203.

"Pratt Graduates Hear Call for 'Committed Response.'" *New York Times*, June 3, 1972, p. 17.

"Ebony Magazine's New Home." *Ebony* (Chicago) 27 (September 1972), pp. 84–100.

"Ebony Book Shelf." *Ebony* (Chicago) 27 (October 1972), p. 34.

Sheridan, Lee. "'Blacks: USA: 1973' Excitingly New." *Springfield Daily News* (Mass.), October 5, 1972, p. 20.

Ghent, Henri. "Review of Art Books: Black Art." *Art in America* (New York) 60, 6 (November–December 1972), pp. 34–5.

The Saint Louis Art Museum Bulletin 8, 4 (November–December 1972).

Rumley, Larry. "Art from the Black Experience." *Seattle Times*, November 12, 1972, p. B4.

Williams, Randy. "The Black Artist as Activist." *Black Creation* (New York) 3 (winter 1972), pp. 42–5.

Bourdon, David. "Washington Letter." *Art International* (Lugano, Switzerland) 16, 10 (December 1972), pp. 35–9.

"Perspectives." *Black World* (Chicago) 22 (December 1972), pp. 49–50.

Horton, Joseph. "Rogue's Gallery for Prison Artists." *Sepia* (Fort Worth) 22 (April 1973), pp. 71–2.

Sims, Lowery S. "Black Americans in the Visual Arts: A Survey of Bibliographic Material and Research Resources." *Artforum* (New York) 11, 8 (April 1973), pp. 66–70.

Canaday, John. "Art: Vincent Smith's Expressive Style." *New York Times*, April 21, 1973, p. 23.

Stevenson, Evelyn. "The Artist as Social Commentator." *Christian Science Monitor* (Boston), August 7, 1973, p. 19.

Weathers, Diane. "Black Artists 'Taking Care of Business.'" *New York Times*, August 19, 1973, sec. 2, pp. 19–20.

"Eye on New York." *The Art Gallery* (Ivoryton, Conn.) 17, 1 (October 1973), pp. 83–4.

Tapley, Melvin. "About the Arts: 'Blacks: USA: 1973.'" *New York Amsterdam News*, October 27, 1973, p. D9.

Jones, Sumner. "'Black Artists: USA: 1973'—The Search for Meaning." *World* (New York) (November 17, 1973), pp. M6–7.

Davis, Pat. "Dindga McCannon: An Artist at War with Racism and Sexism." *Black Creation* (New York) 4 (winter 1973), pp. 53–5.

"The Johnson Publishing Company Art Collection." *Ebony* (Chicago) 29 (December 1973), pp. 37–40.

Mauldin, Eugenia. "Black Authors of Children's Books." *Interracial Books for Children* (New York) 5, 6 (1974), p. 1.

Bellow, Cleveland. "Regional Report: Our Taxes and Our Art: A Report." *Black Creation* (New York) 6 (1974/1975), p. 73.

"Kaleidoscope: Visuals 1971." *Black Creation* (New York) 6 (1974/1975), pp. 18–23.

Marr, Warren, II. "Black Artist Illuminated." [Review of M. Bunch Washington's *The Art of Romare Bearden*.] *Crisis* (New York) 81 (March 1974), p. 106.

Forgey, Benjamin. "The National Scene: Washington: A Noble Storehouse." *ARTnews* (New York) 73, 5 (May 1974), pp. 49–50.

Glueck, Grace. "Artists Here Honor Pope's Inspiration." *New York Times*, May 1, 1974, p. 58.

"Whitney to Show Art by Lawrence." *New York Times*, May 11, 1974, p. 18.

Kramer, Hilton. "Art: Lawrence Epic of Blacks." *New York Times*, May 18, 1974, p. 25.

———. "Art: Chronicles of Black History." *New York Times*, May 26, 1974, sec. 2, p. 17.

"Acquisitions: Tougaloo's Collections Grow." *Art Journal* (New York) 33, 4 (summer 1974), p. 351.

Glueck, Grace. "Sharing Success Pleases Lawrence." *New York Times*, June 3, 1974, p. 38.

Loercher, Diana. "Jacob Lawrence—World's Painter of Black Experience." *Christian Science Monitor* (Boston), June 6, 1974, p. F6.

Glueck, Grace. "Praise for UW Artist." *Seattle Post-Intelligencer*, June 9, 1974.

Tarzan, Delores. "Seattle's Best Kept Secret." *Seattle Times*, June 14, 1974.

Mainardi, Pat. "Review of Exhibitions: Jacob Lawrence at the Whitney." *Art in America* (New York) 62, 4 (July–August 1974), p. 84.

Williams, Tom, ed. "Exhibitions: Jacob Lawrence in Retrospect." *The Saint Louis Art Museum Bulletin* (July–August 1974).

Hess, Thomas. "The Mediums of Poverty." *New York* 7, 26 (July 1, 1974).

Williams, Milton. "America's Top Black Artist." *Sepia* (Fort Worth) 23, 8 (August 1974), pp. 75–8.

Berenson, Ruth. "Art: A Different American Scene." *National Review* (New York) 26, 33 (August 16, 1974), pp. 930–1.

"Briefs on the Arts." *New York Times*, August 20, 1974, p. 26.

Campbell, Lawrence. "Reviews: Jacob Lawrence." *ARTnews* (New York) 73, 7 (September 1974), p. 114.

Pincus-Witten, Robert. "Jacob Lawrence: Carpenter Cubism." *Artforum* (New York) 13, 66 (September 1974), pp. 66–7.

Kaiser, Ernest. "Recent Books." *Freedomways* (New York) 14 (4th Quarter 1974), p. 367.

Pantheon (Munich) 32, 4 (October–December 1974), p. 438.

Harris, Jessica B. "The Prolific Palette of Jacob Lawrence." *Encore* (New York) (November 1974), pp. 52–3.

Ghent, Henri. "Quo Vadis Black Art?" *Art in America* (New York) 62, 6 (November–December 1974), pp. 41, 43.

Andrews, Benny. "Art: Bob Blackburn." *New York Age* (New York) (November 2, 1974), p. 20.

Campbell, R. M. "Seattle Discovers Jacob Lawrence." *Seattle Post-Intelligencer*, November 17, 1974, pp. H6–7.

Tarzan, Deloris. "Jacob Lawrence Retrospective Opens at Museum." *Seattle Times*, November 17, 1974, p. H4.

Willig, Nancy Tobin. "Ithaca: Anger and Heritage." *ARTnews* (New York) 73, 10 (December 1974), pp. 62–3.

Lundin, Norman. "Jacob Lawrence." *Artweek* (Oakland, Calif.) (December 7, 1974), pp. 1–2.

Larrick, Nancy. "Minority Books for White Children? Some Teachers Say No." *Interracial Books for Children* (New York) 6, 3 (1975), p. 4.

"Artists Equity Association Declaration of Artists' Right." *American Artist* (New York) 39 (January 1975), pp. 40–1.

Smith, Roberta. [Review of *Directions in Afro-American Art* at Cornell University.] *Artforum* (New York) 13, 5 (January 1975), pp. 64–5.

Hoffman, Donald. "Pathos and Poignancy: Paintings by Jacob Lawrence." *Kansas City Star* (Mo.), January 12, 1975, p. D1.

Andrews, Benny. "Art: Closeup on the Arts." *Encore* (New York) 4 (January 20, 1975).

"The Book Tally." *The Art Gallery* (Ivoryton, Conn.) 18, 6 (March 1975), p. 63.

Sokol, David M. "The American Scene: American Painting of the 1930s—Book Review." *American Art Review* (Los Angeles) 2 (March–April 1975), pp. 128–32.

"Art Gallery Scene, May 1975." *The Art Gallery* (Ivoryton, Conn.) 18 (April 1975), p. 39.

Sheridan, Lee. "The Albany Ave—Atheneum Gap." *Valley Advocate* (Amherst, Mass.), April 3, 1975.

Caldwell, Bill. "Romare Bearden." *Essence* (New York) 6 (May 1975).

"Public Museum News: The Season—The New Orleans Museum of Art." *Art Journal* (New York) 34, 4 (summer 1975), p. 368.

Preisman, Fran. "The John J. McDonough Collection." *Artweek* (Oakland, Calif.) (July 26, 1975), p. 4.

Bontemps, Alex. "Culture: Despite the Odds, Blacks Mastered White Arts, Added New Twists of Their Own." *Ebony* (Chicago) 30 (August 1975), pp. 105–8.

"Public Museum News: The Museum of Fine Arts, Boston." *Art Journal* (New York) 35, 1 (fall 1975), p. 54.

Baur, John I. H. "Corcoran Premieres Bicentennial Portfolio." *The Art Gallery* (Ivoryton, Conn.) 19, 1 (October–November 1975), pp. 80–2.

"Ebony Book Shelf." *Ebony* (Chicago) 30 (November 1975), p. 33.

Loring, John. "American Portrait." *Arts* (New York) 50, 3 (November 1975), pp. 58–9.

"College Museum News: Exhibitions." *Art Journal* (New York) 35, 2 (winter 1975/1976), pp. 149–50.

Graves, Earl G. "The Publishers Page: The Importance of Art Patronage." *Black Enterprise* (New York) 6 (December 1975), p. 5.

Watkins, Richard. "Jacob Lawrence: The Famous Artist Who Chronicles Major Black Events in American History Says He Is Motivated and Inspired by the Black Experience." *Black Enterprise* (New York) 6, 5 (December 1975), pp. 66–8.

"Treasures for Toledo." *Museum News* (Toledo, Ohio) 19, 2–3 (1976), pp. 43–82.

Slater, Van E. "Letters to the Editor: Whitewashed 'Portrait.'" *American Artist* (New York) 40 (May 1976), p. 9.

[Container Corporation advertisement.] *Business Week* (May 10, 1976), p. 123.

Bearden, Romare. "The Black Man in the Arts." *New York Amsterdam News* (summer 1976), p. C7.

Coleman, Floyd. "African Influences on Black American Art." *Black Art* (New York) 1, 1 (fall 1976), pp. 4–15.

"College Museum News: Exhibitions." *Art Journal* (New York) 36, 1 (fall 1976), p. 58.

Kay, Jane Holtz. "The Skowhegan School: Down East to Madison Avenue." *ARTnews* (New York) 75, 7 (September 1976), pp. 84, 86.

"Traveling Exhibits." *Ocular* (Denver) 1 (September 1976), pp. 61–93.

Driskell, David C. "Art by Blacks: Its Vital Role in U.S. Culture." *Smithsonian* (Washington, D.C.) 7, 7 (October 1976), pp. 86–93.

———. "Black American Art." *Art and Artists* (New York) 11 (October 1976), p. 15.

Campbell, R. M. "The New Art of Jacob Lawrence." *Seattle Post-Intelligencer*, October 22, 1976.

"Black American Art, 1750–1950." *Crisis* (New York) 83 (November 1976), pp. 316–7.

Butler, Joseph T. "America: Two Centuries of Black American Art—Los Angeles County Museum of Art, California." *Connoisseur* (New York) 193 (November 1976), p. 246.

Simon, Leonard. "The American Presence of the Black Artist," *American Art Review* (Los Angeles) 3 (November–December 1976), pp. 104–19.

Grisby, Eugene, Jr. "Art Education: An Overview." *Black Art* (New York) 1, 2 (winter 1976), pp. 44–62.

Simms, Richard A. "Collector's Column." *Black Art* (New York) 1, 2 (winter 1976), pp. 24–9.

"Art across North America: Outstanding Exhibitions." *Apollo* (London) 104 (December 1976), pp. 510–2.

Harris, Jessica. "Book Reviews." [Review of Driskell's *Two Centuries of Black American Art*.] *Essence* (New York) 7 (December 1976), p. 29.

Krebs, Albin. "Notes on People." *New York Times*, December 30, 1976, p. 14.

"Notes on People." *New York Times*, December 30, 1976, p. 14.

"Seattle Artist to Paint Inaugural." *Seattle Times*, December 30, 1976.

Rickie, Mary. "The Art of Black America." *Eastern Review* 2 (January 1977), pp. 18–23.

Tarzan, Delores. "Great Paintings by Jacob Lawrence." *Seattle Times*, January 25, 1977, p. A11.

———. "Lawrence Set to Paint Inaugural." *Seattle Times*, January 25, 1977, p. A11.

Hoppin, Bonnie. "Arts Interview: Jacob Lawrence." *Puget Soundings* (Seattle) (February 1977), p. 6.

"Lawrence Honored with Inaugural Selection." *Washington Arts* (February 1977), p. 7.

Robinson, Louie. "Two Centuries of Black American Art." *Ebony* (Chicago) 32 (February 1977), pp. 33–6, 38.

Trescott, Jacqueline. "Woman of Two Worlds: Artist Enjoys Lively Renaissance." [Article on Elizabeth Catlett.] *Durham Morning Herald* (N.C.), March 8, 1977, p. A7.

Kaiser, Ernest. "Recent Books." *Freedomways* (New York) 17 (2nd Quarter 1977), pp. 117–29.

Long, Richard. "Two Hundred Years of Black American Art." *Contemporary Art/Southeast* (Atlanta) 1 (April–May 1977), pp. 42–3.

Andrews, Benny. "Art: New York's Twenty-One Club." *Encore* (New York) 6 (May 9, 1977), p. 40.

Forgey, Benjamin. "Carter Thanks Five Artists for Inaugural Works." *Washington Star* (D.C.), June 15, 1977, p. E2.

Hunter, Marjorie. "Carter Meets Five American Artists Who Portrayed His Inauguration." *New York Times*, June 15, 1977, p. B12.

Lewis, JoAnn. "An Artful Thank-You from President Carter." *Washington Post* (D.C), June 15, 1977, p. B4.

"Cinque Gallery: Harlem's Downtown Exposure." *New York Amsterdam News*, June 25, 1977, p. D2.

Rosenberg, Harold. "The Art World: Being Outside." *The New Yorker* 53, 27 (August 22, 1977), pp. 83–6.

Von Blum, Paul. "A Convergence of Conscience." *Black Art* (New York) 2, 1 (fall 1977), pp. 54–6.

The Black Scholar (Oakland, Calif.) 9, 1 (September 1977).

The Black Collegian (New Orleans) 8 (September–October 1977), p. 51.

[Letter from Judith Alexander.] *Contemporary Art/Southeast* (Atlanta) 1 (October–November 1977), p. 6.

Glueck, Grace. "The Twentieth Century Artists Most Admired by Other Artists." *ARTnews* (New York) 76, 9 (November 1977), pp. 78–103.

Major, Clarence. "Clarence Major Interviews: Jacob Lawrence, The Expressionist." *The Black Scholar* (Oakland, Calif.) 9, 3 (November 1977), pp. 23–34.

"Carter Taps University of Washington's Lawrence to Serve on National Council on the Arts." *Seattle Post-Intelligencer*, November 15, 1977, p. A3.

Krebs, Albin. "Notes on People." *New York Times*, November 15, 1977, p. 34.

Rubin, Joan. "An Interview with Norman Lewis." *Lofty Times* (winter 1977), pp. 6–7.

Diamonstein, Barbaralee. "Why Is There No Recent Women's Art in the White House?" *ARTnews* (New York) 76, 10 (December 1977), pp. 109–12.

Harris, Jessica. [Review of Elton Fax's *Black Artists of the New Generation*.] *Essence* (New York) 8 (December 1977), p. 14.

Driskell, David C. "Bibliographies in Afro-American Art." *American Quarterly* (Minneapolis) 30, 3 (1978), pp. 374–94.

Rosenbaum, Lee. "Artworld: People." *Art in America* (New York) 66, 1 (January–February 1978), p. 144.

Mann, Joan. "Artist Jacob Lawrence Commissioned by KCAC to Create His First Mural This Fall at King County Domed Stadium." *The Arts: Newsletter of the King County Arts Commission, Washington* (Seattle) (February 1978), pp. 1–2.

Wooster, Ann-Sargent. "New York Reviews: Artists Salute Skowhegan." *ARTnews* (New York) 77, 2 (February 1978), p. 148.

Catchings, Yvonne Parks. "Is Black Art For Real?" *Black Art* (New York) 2, 3 (spring 1978), pp. 41–3.

Coleman, Floyd. "Towards an Aesthetic Toughness in Afro-American Art." *Black Art* (New York) 2, 3 (spring 1978), pp. 32–40.

Albright, Thomas. "Perceptions of the Spirit." *ARTnews* (New York) 77, 3 (March 1978), pp. 118, 120, 122.

Prendergraft, Norman. "Tracing the Rise of the Afro-American Artist in North Carolina." *Art Voices/South* (West Palm Beach, Fla.) 1 (March–April 1978), pp. 73, 75.

"Three Confirmed for Arts Council." *New York Times*, April 4, 1978, p. 57.

"Dintenfass Gallery, New York." *ARTnews* (New York) 77, 5 (May 1978), p. 180.

Prendergraft, Norman. [Review of Elton Fax's *Black Artists of the New Generation*.] *Art Voices/South* (West Palm Beach, Fla.) 1 (May–June 1978), p. 79.

Milloy, Courtland. "Capturing the Builder: Jacob Lawrence's Theme, People in Motion." *Washington Post* (D.C.), May 13, 1978, p. C1.

"Artist Jacob Lawrence Garners Annual Faculty Lecturer Honor." *University of Washington Report* (Seattle) (summer 1978).

Pierce, Ponchitta. "Black Art in America," *Reader's Digest* (Pleasantville, N.Y.) 112 (June 1978).

Kaiser, Ernest. "Recent Books." *Freedomways* (New York) 18 (3rd Quarter 1978), p. 175.

"The Black Perspective." [Interview with Benny Andrews.] *Milwaukee Journal*, July 30, 1978, p. 4.

"Lawrence Paintings Reflect Concern for Human Struggles." *University of Washington Report* (Seattle) (autumn 1978), p. 2.

"Local Artist Speaks at Faculty Lecture." *University Herald* (Seattle), September 27, 1978, p. 4.

Winn, Steven. "Prints and Paintings by Jacob Lawrence." *Seattle Weekly* (December 13–19, 1978), pp. 42–7.

Campbell, R. M. "Artist Who Stuck to His Story: Jacob Lawrence's John Brown." *Seattle Post-Intelligencer*, December 20, 1978, pp. A8–9.

Tarzan, Deloris. "Washington and Lawrence Headline Shows." *Seattle Times*, December 22, 1978.

Tsutakawa, Mayumi. "Taking Risks and Sharing Hopes." *Seattle Times*, July 1, 1979, pp. L12–3.

Wilson, Judith. "Main Events: Art." *Essence* (New York) 10 (September 1979), pp. 12–4.

The Chrysler Museum Bulletin (Norfolk, Va.) 8, 9 (October 1979).

Fagan, Beth. "Black Painter Jacob Lawrence Opens One-Man Show at Wentz Gallery." *Portland Oregonian*, October 12, 1979, p. E7.

"Artist's Paintings Rely Heavily on Black Experience as Backdrop: Show in Portland." *Portland Oregonian*, October 14, 1979, p. C5.

Colby Library Quarterly (Waterville, Maine) 15, 4 (December 1979), p. 207.

Devaney, Sally G. "Utica's Olympus." *The Art Gallery* (Ivoryton, Conn.) (January 1980), p. 25.

Ahola, Nola. "Two Major Murals Dedicated February 27 at Kingdome." *The Arts: Newsletter of the King County Arts Commission, Washington* (Seattle) (January–February 1980), pp. 1–5.

"Three Seattle Artists Share Their Lives and Work in Film." *University Herald* (Seattle) (January 23, 1980).

Ratcliff, Carter. "Packaging the American Worker." *Art in America* (New York) 68, 2 (February 1980), pp. 14–5.

Nast, Stan. "Painter Lawrence Is Honored for a 'Protest' That Was Life." *Seattle Post-Intelligencer*, April 5, 1980.

Barnett, Douglas Q. "The Individual Artist's Perspective." *Seattle Arts* 4, 1 (August 1980).

[Cover illustration.] *Federal Bar News and Journal* (Washington, D.C.) 28, 9 (September 1980).

Forgey, Benjamin. "A Masterpiece of Mural Art." *Washington Star* (D.C.), December 4, 1980, p. D2.

Richard, Paul. "The Artist's Universe: Jacob Lawrence's Mural Unveiled at Howard." *Washington Post* (D.C.), December 4, 1980, pp. D1, D7.

Tarzan, Delores. "Washington and Lawrence Headline Shows." *Seattle Times*, December 22, 1980.

Gallati, Barbara. "Social Art in America: 1930–1945." *Arts* (New York) 56, 3 (November 1981), p. 7.

Campbell, Kimberly. "Artist's Labor Is of Love and Social Consciousness." *University Herald* (Seattle) (November 4, 1981).

Simmons, Charitey. "Bread and Roses Project Puts Art in Labor's Image." *Chicago Tribune*, December 10, 1981, sec. 4, pp. 1, 4.

Lewis, Samella, and Lester Sullivan. "Jacob Lawrence Issue." *Black Art* (New York) 5, 3 (1982).

Lewis, Samella. "Beyond Traditional Boundaries: Collecting Black Art for Museums." *Museum News* (Toledo, Ohio) 60, 3 (January–February 1982), pp. 41–7.

Campbell, R. M. "Personal Look at the Urban Scene." *Seattle Post-Intelligencer*, March 18, 1982.

Tate, Mae. "Husband, Wife Artists at Scripps." *Progress Bulletin* (New York) (March 21, 1982).

Gallati, Barbara. "Aspects of Realism: 1950–1970." *Arts* (New York) 56, 8 (April 1982), p. 19.

Raynor, Vivien. "Forty-One Paintings Tell a Tale of Haitian Revolt." *New York Times*, April 18, 1982, sec. 2, p. 20.

Slater, Jack. "A Spousal Odd Couple: Personalities in Paint." *Los Angeles Times*, April 26, 1982, pp. 1–2.

Wilson, William. "Art Review: Lawrence, Folk Roots Grow Slick." *Los Angeles Times*, April 26, 1982, sec. 6, p. 1.

Lawson, Carol. "A Group Shopping Spree Stocks a Museum with Art." *New York Times*, June 20, 1982, p. H28.

Hackett, Regina. "A Match of Form and Content." *Seattle Post-Intelligencer*, August 24, 1982, p. D3.

Van Cleve, Jane. "The Human Views of Jacob Lawrence." *Stepping Out Northwest* 12 (winter 1982), pp. 33–7.

Chin, Sue. "Jacob Lawrence: Expressing Life and Visions through Art." *Seattle Arts* 6, 4 (December 1982), p. 1.

Glowen, Ron. "Jacob Lawrence at Francine Seders." *Images and Issues* (Santa Monica, Calif.) (January–February 1983).

Glueck, Grace. "Fifty-Seventh Street: Expressionism Meets Minimalism." *New York Times*, February 18, 1983, pp. C1, C24.

———. "Art: Renato Guttuso." *New York Times*, April 22, 1983, p. C25.

Reel, Gary. "Lawrence." *Black on White* (May 1, 1983).

Lippard, Lucy. "Passionate Views of the Thirties." *In These Times* (Chicago) (June 1–14, 1983), p. 20.

Moss, Howard. "The Cream That Rises to the Top: Parnassus on Upper Broadway." *Vanity Fair* (New York) (August 1983), pp. 59–66.

Fisher, Patricia, and Carey Quan Gelernter. "Does Seattle 'Work' for Blacks?" *Seattle Times*, August 28, 1983, p. A16.

Russell, John. "Illustrated Books Are Making a Comeback." *New York Times*, August 28, 1983, p. A24.

"Professor Named to Academy." *Seattle Times*, December 3, 1983.

Hackett, Regina. "Activist Protests Review of Exhibit." *Seattle Post-Intelligencer*, December 17, 1983, p. D7.

"Announcing the First Annual Pacific Northwest Magazine Awards." *Pacific Northwest* (Seattle) (January–February 1984), p. 5.

Tarzan, Deloris. "Fifty Visions, There Is No Northwest Style, There Are Only Northwest Artists." *Seattle Times/Seattle Post-Intelligencer*, January 8, 1984, *Pacific* magazine, p. 1.

Smallwood, Lyn. "The Art and Life of Jacob Lawrence, Seattle's Old Master." *Seattle Weekly*, January 18–24, 1984, pp. 35–6.

Berman, Avis. "Jacob Lawrence and the Making of Americans." *ARTnews* (New York) 83, 2 (February 1984), pp. 78–86.

Mitchell, Carolyn. "The Hunter Museum, A Showcase for Modern American Art in Chattanooga." *Southern Accents* (Birmingham, Ala.) 7, 3 (May–June 1984).

"State Board of Regents: Broad Education Advocated." *New York Times*, May 25, 1984, p. B3.

Belt, Byron. "American Academy Inducts Thirteen." *Boston Globe*, June 8, 1984, p. 62.

Jones, Glory. "Jacob Lawrence: The Master Nobody Knows." *Washington* (Bellevue, Wash.) 1, 3 (November–December 1984), pp. 54–8.

"Art/Work: Jacob Lawrence, Artist." *Personnel Journal* (Baltimore) 64, 8 (August 1985), p. 128.

Hackett, Regina. "A Master's Mural: Top Artist Does a Big Job for UW." *Seattle Post-Intelligencer*, August 19, 1985, pp. C1, C7, C11.

Berger, David. "Identity Crisis." *Seattle Times*, October 6, 1985, pp. L1, L6.

Stokes Oliver, Stephanie. "Jacob Lawrence: A Master in Our Midst." *Seattle Times*, October 27, 1985, *Pacific* magazine, pp. 14–7.

Hackett, Regina. "Jacob Lawrence's Latest Series Has Slowed to a Standstill." *Seattle Post-Intelligencer*, December 10, 1985, p. C5.

Wheat, Ellen Harkins. "Jacob Lawrence and the Legacy of Harlem." *Archives of American Art Journal* (Washington, D.C.) 26, 1 (1986), pp. 18–25.

[Cover illustration.] *Arts Line* 4, 3 (July 1986).

"Jacob Lawrence Week Announced." *The Arts: Newsletter of the King County Arts Commission, Washington* (Seattle) 15, 7 (July 1986).

Weiman, Liz M. "Museum Notebook: The World of Jacob Lawrence." *Southwest Art* (Houston) 16, 2 (July 1986), p. 80.

Hackett, Regina. "Jacob Lawrence's Retrospective Show Celebrates Fifty Artistic Years." *Seattle Post-Intelligencer*, July 8, 1986, pp. C1–7.

Tarzan, Deloris. "SAM Celebrates Lawrence." *Seattle Times*, July 9, 1986, pp. C1–2.

Kangas, Matthew. "Looking Back at Jacob Lawrence." *Seattle Weekly*, July 16–22, 1986, pp. 35–6.

Turner, Wallace. "Painter Joins Seattle Art Lovers in Looking Back on His Career." *New York Times*, July 28, 1986, p. A6.

Berman, Avis. "Commitment on Canvas." *Modern Maturity* (Ojai, Calif.) (August–September 1986), pp. 68–75.

Wolff, Theodore F. "Touring Show Celebrates Jacob Lawrence's Style." *Christian Science Monitor* (Boston), August 4, 1986, p. 24.

Mumford, Esther. "Jacob Lawrence: In Retrospect." *Northwest Art Paper* (August 15–September 15, 1986), pp. 4–5, 18.

Glowen, Ron. "Jacob Lawrence: A Living History." *Artweek* (Oakland, Calif.) 17, 28 (August 23, 1986), p. 1.

"The Home Forum." *Christian Science Monitor* (Boston), August 28, 1986, p. 34.

Smallwood, Lyn. "The Nation, Seattle, Jacob Lawrence, Seattle Art Museum." *ARTnews* (New York) 85, 7 (September 1986), p. 53.

de Young, John. "Lawrence a Seattle Treasure." *Seattle Post-Intelligencer*, September 5, 1986.

Baker, Kenneth. "The Social Purpose of Jacob Lawrence." *San Francisco Chronicle* (October 15, 1986).

Muchnic, Suzanne. "A Painterly Panorama of Pain." *Los Angeles Times*, October 19, 1986, pp. 87–8.

Stokes Oliver, Stephanie. "Jacob Lawrence." *Essence* (New York) (November 1986), pp. 89–91, 134.

"Jacob Lawrence Capitol Artwork." *The Arts: Newsletter of the Washington State Arts Commission, Washington* (Seattle) 46 (December 1986).

Fox, Catherine. "Jacob Lawrence, Artist Lifted Beauty from Jaws of Waiting American Nightmare." *Atlanta Journal and Constitution*, December 14, 1986, pp. J1–6.

Wheat, Ellen Harkins. "Jacob Lawrence: American Painter." *American Visions* (Washington, D.C.) (1987).

———. "Jacob Lawrence: Chronicler of the Black Experience." *American Visions* (Washington, D.C.) 2, 1 (February 1987), pp. 31–5.

Layton, Mike. "New Murals May Grace Capitol." *Seattle Post-Intelligencer*, February 27, 1987, p. E6.

"Lawrence in Olympia." *Arts Line* 4, 11 (March 1987), pp. 3, 12.

Shaw-Eagle, Joanna. "Jacob Lawrence, American Painter, at the Phillips Collection, April 4 through May 31." *Museum and Arts Washington* (D.C.) (March–April 1987), pp. 10–1.

Stone, TaRessa. "Jacob Lawrence Interview." *Art Papers* (Atlanta) 11, 2 (March–April 1987), pp. 35–6.

Tarzan, Deloris. "Proposed Mural Touches Off New Debate on Art in Capitol, Is Jacob Lawrence Too Contemporary?" *Seattle Times*, March 13, 1987.

Hackett, Regina. "Art Again a Capitol Offense." *Seattle Post-Intelligencer*, March 14, 1987, pp. A1, A4.

Milloy, Courtland. "Portrait of the Artist." *Washington Post* (D.C.), March 31, 1987, p. B3.

Allen, Jane Addams. "Famed Artist Paints Niche in History." *Washington Times* (D.C.), April 2, 1987, pp. C1–2.

Richard, Paul. "The Light in the Mirror: Jacob Lawrence, Fifty Years of Images at the Phillips." *Washington Post* (D.C.), April 4, 1987, pp. C1–2.

Skinner, Alice B. "Spirit in Form." *Chrysalis* (Los Angeles) 11 (summer 1987), p. 149.

Wernick, Robert. "Jacob Lawrence: Art As Seen through a People's History." *Smithsonian* (Washington, D.C.) 18, 3 (June 1987), pp. 56–67.

"Jacob Lawrence American Painter." *Dallas Weekly*, June 25–July 1, 1987, pp. C1–2.

Kutner, Janet. "Powerful Folk Art, Lawrence's Paintings Celebrate Black Life." *Dallas Morning News*, June 30, 1987, pp. C1–2.

Nixon, Bruce. "Artist Paints Pulse of Life." *Dallas Times Herald*, June 30, 1987, pp. E2–3.

Johnson, Fridolf. "Art Books: Jacob Lawrence: American Painter." *American Artist* (New York) 51 (September 1987), pp. 28, 78–9.

Larson, Kay. "Museums: Jacob Lawrence." *New York* 20, 37 (September 21, 1987), pp. 66–7.

Solomon, Deborah. "The Book of Jacob." *New York Daily News Magazine*, September 27, 1987, pp. 18–21.

"Retrospective Exhibit on Afro-American Painter." *People's Daily World* (New York), September 30, 1987, p. A11.

Shepard, Joan. "Art Exhibit to Focus on Black Experience, Museum to Show Fifty Years of Work by Jacob Lawrence." *New York Daily News*, October 7, 1987.

Russell, John. "Art View: The Epic of a People Writ Large on Canvas." *New York Times*, October 11, 1987, sec. 2, p. 39.

Payne, Les. "A Great Creator of Movement in Paint," *Newsday*, October 18, 1987, Ideas sec., p. 5.

Larson, Kay. "Bound for Glory." *New York* 20, 41 (October 19, 1987), p. 112.

Hackett, Regina. "Gone to Gotham, Seattle Art Holds Its Own in New York." *Seattle Post-Intelligencer*, October 26, 1987, pp. C1, C5.

Heartney, Eleanor. "Reviews: Jacob Lawrence." *ARTnews* (New York) 86, 10 (December 1987), p. 143.

Collins, Amy Fine. "Jacob Lawrence: Art Builder." *Art in America* (New York) 76, 2 (February 1988), pp. 130–5.

Tarzan Ament, Deloris. "Gallery Celebrates Black History Month." *Seattle Times*, February 14, 1988, p. L7.

Brunsman, Laura. "Distinct Voices." *Reflex* (Seattle) (March–April 1988), p. 20.

Smallwood, Lyn. "The Many Colors of Black Artists." *Seattle Weekly*, March 2, 1988.

Burke, Kathleen M. "From Albany, a Feast for Fans." *Smithsonian* (Washington, D.C.) (April 1988), p. 184.

Christy, Duncan. "The Art of Baseball." *M: The Civilized Man* (New York) (April 1988), pp. 98–101.

"A Cubist of Today." *Scholastic: Art and Man* 19 (September–October 1988), p. 11.

Stevens, Kathleen. "Jacob Lawrence, Painter of the American Scene." *Highlights for Children* (Columbus, Ohio) (February 1989).

Mills, Pamela. "Always Reaching for a New Dimension Defines Lawrence's Fifty-Year Career." *People's Daily World* (New York), March 22, 1989.

Orenson, Michael. "Review/Art: Public Art at New Federal Building in Queens." *New York Times*, March 24, 1989, p. C32.

Williams, Chris. "His Vision Is Universal." *People's Daily World* (New York), April 13, 1989.

Quinn, Jim. "Hanging Out with the Potamkins." *Philadelphia* (July 1989).

Hackett, Regina. "Borough of Queens Is a New Outpost of Contemporary Public Art." *Seattle Post-Intelligencer*, July 18, 1989, p. C5.

"End Paper: If One Is Knowledgeable about Afro-America, Then One Knows the Blues." *Chronicle of Higher Education* 36, 14 (December 6, 1989), p. B80.

"Jacob Lawrence's Second Coming." *Interlink: The Nigerian American Quarterly Newsletter* (Lagos, Nigeria) (January 28, 1990).

Young, Joseph. "Jacob Lawrence: A Minor Master of Spirited Art." *Scottsdale Progress* (Ariz.), February 1, 1990, p. 13.

Cooper, Evelyn S. "ASU Showing Works of Noted Black Artist." *Arizona Republic/The Phoenix Gazette*, February 19, 1990, p. 10, ill.

Gibbs, Al. "Artist's Touch: Jacob Lawrence Leaves His Mark." *Morning News Tribune*, February 19, 1990, p. B4.

Brigham, David R. "Bridging Identities: Dox Thrash as African American and Artist." *Smithsonian Studies in American Art* (Washington, D.C.) 4, 2 (spring 1990), pp. 26–39.

"Citation for the Distinguished Artist Award for Lifetime Achievement." *College Art Association News* (New York) (March–April 1990), p. 9.

Hackett, Regina. "Lawrence Explores New Territory." *Seattle Post-Intelligencer*, March 30, 1990.

Ament, Deloris Tarzan. "Genesis from the Eighties." *Seattle Times*, April 1, 1990, p. L1.

Weser, Marcia Goren. "Artists Project Their Own Lives into Works at Carver." *San Antonio Light*, April 15, 1990.

Highwater, Jamake. "Stripping Art of Elitism." *Christian Science Monitor* (Boston), April 23, 1990, p. 16.

McLerran, Jennifer. "Aging and Pessimism." *Reflex* (Seattle) (May–June 1990), p. 22.

"Artists Announced for Harold Washington Library Center." *Public Art Update* [A Report from the City of Chicago Public Art Program.] (fall 1990).

Ament, Deloris Tarzan. "Artist Jacob Lawrence to Receive U.S. Award." *Seattle Times/Post-Intelligencer*, September 9, 1990, p. B2.

"Bush Bestows Honors on Thirteen Artists." *Seattle Post-Intelligencer*, September 11, 1990.

Roberts, Roxanne. "Thirteen Get Arts Medals: Controversy Avoided in White House Event." *Washington Post* (D.C.), September 11, 1990, p. B2.

"Art News, Jacob Lawrence, Recipient of the National Medal of Arts." *International Review of African American Art* (Santa Monica, Calif.) 9, 2 (October 1990), p. 40.

Hackett, Regina. "Exhibit Translates the Blues into Painting and Sculpture." *Seattle Post-Intelligencer*, October 17, 1990, pp. C1, C9.

Wallace, Michelle. "Defacing History." *Art in America* (New York) 78, 12 (December 1990), pp. 120–8, 184–6.

Howell, John. "Drastic Decade, Getting a Grip on the 'Forties.'" *Elle décor* (Neuilly-sur-Seine, France) (March 1991).

Raynor, Vivien. "The Theme Is Humanity (or Inhumanity)." *New York Times*, March 31, 1991, p. 6.

Hackett, Regina. "Jacob Lawrence Tribute to Ex-Chicago Mayor to Be Unveiled Next Month." *Seattle Post-Intelligencer*, July 6, 1991.

Bartley, Nancy. "Arts, Crafts and Eats." *Seattle Times*, July 27, 1991.

Rotenberk, Lori. "Library's Warm Welcome Captures Washington Spirit." *Chicago Sun-Times*, August 1, 1991.

Paschal, Huston. "Rethinking Familiar Images." *North Carolina Museum of Art Preview* (Raleigh) (autumn 1991).

Domini, John. "Tides of Change, Art of the Pacific Northwest." *Antiques and Fine Art* (San Jose, Calif.) (September–October 1991).

Kimmelman, Michael. "Art, Art, Everywhere Art." *New York Times*, September 20, 1991, p. C1.

———. "Review/Art: Stark or Sweet Images Tell Black History's Tale." *New York Times*, September 20, 1991, p. C24.

May, Stephen. "Revival: African-American Artists." *Antiques and Fine Art* (San Jose, Calif.) (November–December 1991).

Bass, Ruth. "Reviews: Jacob Lawrence, Studio Museum in Harlem," *ARTnews* (New York) 90, 10 (December 1991), pp. 120–1.

[Cover illustration.] *Flint Institute of Arts Annual Report, 1991–2* (Mich.) (1992).

Wheat, Ellen Harkins. *Portraits: The Lives and Works of Eminent Artists* 2, 3 (1992).

"Early Works of Jacob Lawrence in Katonah." *Patent Trader and Putnam Trader* (Cross River, N.Y.), February 20, 1992, p. 1.

Ross, Jeannette. "New Show Offers an Inside Look at Harlem." *Lewisboro Ledger* (Cross River, N.Y.), March 5, 1992, p. A5.

Jennings, Kate F. "Lawrence's Art Bursts with Life." *Darien News Review* (Conn.), March 8, 1992, pp. 36, 39.

Janis, Stefan. "Art of the Forties." *Star-Ledger* (Newark), March 19, 1992.

Grantham, Kathy. "Jacob Lawrence in Retrospect." *North County News* (March 25–31, 1992).

Farr, Sheila. "Labors of Love: Jacob Lawrence at the Whatcom Museum of History and Art." *Artweek* (Oakland, Calif.) 23, 12 (March 26, 1992), p. 9.

Lyke, M. L. "Jacob Lawrence to Talk about His Art." *Seattle Post-Intelligencer*, March 30, 1992, p. C6.

Zimmer, William. "A Painterly Storyteller Takes Black America as His Subject." *New York Times*, April 5, 1992, p. WC20.

"Jacob Lawrence: An American Master Exhibit to Open at WSSU's Diggs Gallery on April 24." *Winston-Salem Chronicle* (N.C.), April 16, 1992.

Johnson, Reggie. "Lawrence Exhibit at Diggs thru June 13." *Winston-Salem Chronicle* (N.C.), April 30, 1992.

Farr, Sheila. "The Power of Creation." *Reflex* (Seattle) (May–June 1992).

Patterson, Tom. "Timely Images: The Power and Genius of Jacob Lawrence." *Winston-Salem Journal* (N.C.), May 24, 1992, p. C4.

Rodgers, Joan S. "Ever Upward." *Winston-Salem Journal* (N.C.), May 24, 1992, pp. C1, C4.

Shearin, Margaret. "The Narrative Brilliance of Jacob Lawrence." *Style* (Fayetteville, Ark.) (May 27, 1992), p. 11.

"Remember and Understand." *Kansas Alumni Magazine* 90 (July–August 1992).

Woodward, Bill. "Strides toward Freedom." *Kansas Alumni Magazine* 90, 4 (July–August 1992).

Raynor, Vivien. "Politics and Artists, Then and Now." *New York Times*, August 30, 1992, p. 20.

"Jacob Lawrence: Greatest Living Black Painter." *Ebony* (Chicago) (September 1992), pp. 62, 64, 66.

Tennant, Donna. "Jacob Lawrence: The Frederick Douglass and Harriet Tubman Series, 1938–40." *Museum and Arts Houston* (September 1992), pp. 27–33.

Johnson, Patricia C. "A Painter of Stories." *Houston Chronicle*, September 11, 1992.

Chadwick, Susan. "Stirring Paintings Capture Spirit of Former Slaves." *Houston Post*, September 15, 1992, pp. D1, D8.

Mason, M. S. "Emancipation Heroes Get Their Due, in Art." *Christian Science Monitor* (Boston), September 15, 1992, p. 10.

"Museums: Houston, Texas: Jacob Lawrence." *Southwest Art* (Houston) 22, 5 (October 1992), p. 189.

Tyson, Janet. "Exhibit Pays Homage to Douglass, Tubman." *Austin American-Statesman* (Tex.), October 7, 1992, p. B5.

Sharp, Ellen. "The Legend of John Brown and the Series by Jacob Lawrence." *Bulletin of the DIA* (Detroit) 67, 4 (1993), pp. 14–35.

McMillan, Kyle. "Paintings about Abolitionists Still Hold Meaning." *Omaha World-Herald* (Neb.), February 13, 1993, pp. 55–6.

Agins, Teri. "Pretty Picture: Interest in Black Artists Grows, Drawing Attention from High-Profile Dealers and Collectors." *Wall Street Journal* (New York), February 19, 1993.

Varble, Bill. "Artist Plumbs Black Experience." *Mail Tribune* (Ashland, Ore.), March 14, 1993.

Plagens, Peter. "Art: Making Book the Hard Way, A Show of Painters and Authors Bound for Beauty." *Newsweek* 121, 13 (March 29, 1993), p. 64.

Azizian, Carol. "Painting Life Stories." *The Flint Journal* (Mich.), April 1, 1993, pp. B1, B3.

Weinstein, Joel. "Lawrence of America." *Sunday Oregonian* (Portland), May 17, 1993, pp. C1, C6.

Knight, Christopher. "Panels Take a Small Look at Large Lives." *Los Angeles Times*, June 14, 1993, pp. F1, F9.

Hartup, Cheryl. "Jacob Lawrence at Fairbanks Gallery, Oregon State University." *Reflex* (Seattle) (July–August 1993), p. 18.

Hackett, Regina. "A Northwest Tribute: The Art of Microsoft." *Seattle Post-Intelligencer*, July 1, 1993.

Frank, Peter. "Jacob Lawrence." *L.A. Weekly*, August 6–12, 1993.

Turner, Elizabeth Hutton. "Jacob Lawrence, Black Migration Series." *American Art Review* (Los Angeles) 5, 5 (fall 1993), pp. 132–5.

"Calendar: Jacob Lawrence, The Migration Series." *Museum News* (Toledo, Ohio) 72, 5 (September–October 1993), pp. 16–7.

Burchard, Hank. "On Exhibit: Lawrence's Moving Portrait." *Washington Post* (D.C.), September 24, 1993, *Weekend* magazine, p. 60.

Schwartz, Amy E. "Common for Blacks and White." *Washington Post* (D.C.), September 24, 1993, p. A23.

Myers, Chuck. "Art Depicts Black Exodus from South." *Richmond Times-Dispatch*, October 3, 1993, p. J9.

Gibson, Eric. "Painter's Pointers Are Helpful to Students." *Washington Times* (D.C.), October 15, 1993, p. C5.

Vincent, Steven. "Jacob Lawrence at Midtown Payson." *Art and Auction* (Doylestown, Pa.) (November 1993), pp. 78–80.

Kimmelman, Michael. "A Sense of the Epic, A Love of the Ordinary." *New York Times*, November 14, 1993, sec. 2, p. 39.

Maclay, Catherine. "History in the Making. Jacob Lawrence's Life, Art Sustain Each Other." *San Jose Mercury News*, November 14, 1993, pp. 3–4, 16.

Hughes, Robert. "Stanzas from a Black Epic." *Time* 142, 22 (November 22, 1993), pp. 70–1.

Hills, Patricia. "Jacob Lawrence as Pictorial Griot: The *Harriet Tubman* Series." *American Art* (New York) 7, 1 (winter 1993), pp. 40–59.

Gibson, Eric. "Exhibition Notes: 'Jacob Lawrence—The Migration Series' at the Phillips Collection." *The New Criterion* (New York) 12, 4 (December 1993), p. 51.

"Jacob Lawrence at Midtown Payson Galleries." *ART NOW Gallery Guide: New York* (December 1993), p. 10.

Kaufman, Jason Edward. "The Saga of American Blacks According to Jacob Lawrence." *The Art Newspaper* (London) 33, 4 (December 1993), p. 14.

Smallwood, Lyn. "A Child's History." *Seattle Weekly*, December 1, 1993, p. 33.

Cronin, Mary Elizabeth. "Finding Common Thread in an Uncommon Canvas." *Seattle Times*, December 22, 1993, pp. E1–3.

The New Yorker 54, 44 (December 27, 1993), p. 30.

Michalski, Karen. "Nationally Acclaimed Paintings at Library." *Michigan Journal* (Ann Arbor) 24, 19 (1994), p. 1.

Wilkin, Karen. "At the Galleries." *Partisan Review* (New York), 1 (1994), pp. 132–49.

James, Curtia. "Reviews: Jacob Lawrence, Phillips Collection," *ARTnews* (New York) 93, 1 (January 1994), p. 169.

"Jacob Lawrence's Paintings Depict Negro Exodus." *The Economist* (London) 330 (January 8, 1994), p. 82.

Higgins, Jim. "African-American Epic." *Milwaukee Sentinel*, January 28, 1994, pp. 14–5.

Weiss, Marion Wolberg. "Art Commentary." *Dan's Papers* (Bridgehampton, N.Y.) (January 28, 1994), p. 26.

"Jacob Lawrence Paintings Exhibited." *Reporter* (Dearborn, Mich.), January 31, 1994.

Hollingsworth, Lt. Charles H., Jr. "Jacob Armstead Lawrence, Famous Artist Served on Active Duty as CG Reservist from '43–'45." *Coast Guard Reservist* (Washington, D.C.) (February 1994).

Donohue, Marlena. "Telling History in Brushstrokes: Artist Jacob Lawrence Talks About His Sixty-Year Career and His Narrative Paintings." *Christian Science Monitor* (Boston), February 4, 1994, pp. 12–3.

Porter, Connie. "Children's Books." *New York Times Book Review*, February 13, 1994, p. 27.

"Jacob Lawrence." *American Way* 27, 4 (February 15, 1994).

"Art School Names Instructional Gallery as Tribute to Renowned Faculty Jacob Lawrence." *University Week* (Seattle), February 17, 1994.

Rass-Paulmier, Heike. "Journey through Racism." *People's Weekly World* (New York), February 19, 1994, p. 29.

Margolies, Beth Anne. "Bibliographic Essay on Three African American Artists: William H. Johnson, Romare Bearden, and Jacob Lawrence." *Art Documentation* (Tucson, Ariz.) 13, 1 (spring 1994), pp. 13–7.

Hackett, Regina. "Lawrence's Early Works Say So Much with So Little." *Seattle Post-Intelligencer*, March 10, 1994.

———. "True to Life, Jacob Lawrence's Art Honors the Real Lives of Real People." *Seattle Post-Intelligencer*, March 10, 1994, pp. C1, C4.

McLennon, Douglas. "Jacob Lawrence, Flat and Graphic Visual Shorthand Commands Viewers' Attention to Compelling Subjects." *News Tribune* (Tacoma, Wash.), March 13, 1994, pp. 10, 14.

Updike, Robin. "Lives of Tubman, Douglass à la Jacob Lawrence." *Seattle Times*, March 17, 1994, pp. E1–2.

"Jacob Lawrence's 'Migration Series' Comes to Portland." *Portland Skanner* (Ore.), March 30, 1994.

Turner, Elizabeth Hutton. "Jacob Lawrence: Chronicles of Color." *Southwest Art* (Houston) 23, 11 (April 1994), pp. 72–5.

Matthews, Lynn. "In Pursuit of Hope." *Columbian* (April 15, 1994), p. 3.

Gragg, Randy. "Masterpiece on the Move." *Oregonian* (Portland), April 17, 1994, pp. B1, B6.

———. "Jacob Lawrence, Chronicler." *Oregonian* (Portland), April 21, 1994, pp. D1, D6.

Matthews, Lynn. "Migration of Hope and Tears." *Columbian* (April 21, 1994), p. B1.

McLennan, Douglas. "Jacob Lawrence's Migration." *News Tribune* (Tacoma, Wash.), April 24, 1994, pp. 11–4.

Weinstein, Joel. "Profile: Jacob Lawrence." *Visions* (Los Angeles) (summer 1994), p. 47.

Jung, Helen E. "Renowned Artist Volunteers, Too." *Seattle Times*, June 10, 1994, p. B3.

Kaimann, Frederick. "Half-Century after Painting It, Lawrence and 'Migration Series' Still on the Move." *Birmingham News* (Ala.), July 3, 1994, pp. F1, F4.

Kemp, Kathy. "The Migration." *Birmingham Post-Herald* (Ala.), July 8, 1994, pp. B1, B8.

———. "Artist Migrates with His Paintings." *Birmingham Post-Herald* (Ala.), July 14, 1994, p. 1.

Hurwitz, Laurie S. "Exhibits: On Migration." *American Artist* (New York) 58 (August 1994), p. 8.

Wills, Gary. "The Real Thing." *New York Review of Books* 41, 14 (August 11, 1994), pp. 6–9.

Howard, Dan. "Jacob Lawrence: American Master." *Jefferson Monthly* (Ashland, Ore.) (October 1994), pp. 13, 31.

Crowe, John. "Boundless Art, Black Artist's Work Speaks to Us All." *Record Searchlight* (Redding, Calif.), October 6, 1994.

Crawford, Nicole. "In Search of the Promised Land." *Service Employees Union* (Washington, D.C.) 8, 1 (winter 1994), p. 7.

"Jacob Lawrence at Midtown Payson Galleries, The Art Show." *Artfair Magazine* (New York) 2, 2 (December 1994–February 1995), p. 13.

Hackett, Regina. "Painter Jacob Lawrence Finds Supermarket Ripe with Images." *Seattle Post-Intelligencer*, December 9, 1994.

Updike, Robin. "Lawrence Exhibit Is This Month's Star at Galleries." *Seattle Times*, December 14, 1994, pp. F1, F3.

White, Michelle-Lee. "Common Directions, Epic Dimensions: Jacob Lawrence's Murals at Howard University." *International Review of African American Art* (Santa Monica, Calif.) 12, 4 (1995), pp. 30–7.

Wallach, Amei. "Northern Exposure." *New York Newsday*, January 8, 1995.

Smith, Roberta. "Art Review: The Migration from the South in Sixty Images." *New York Times*, January 13, 1995, pp. C1, C29.

Johnson, Harod. "Jacob Lawrence: A Year in the Northwest." *Reflex* (Seattle) (February–March 1995), pp. 8–9.

Hughes, Sabrina K. "Jacob Lawrence: An Artist-Genius of Bold Colors." *Communicator* (Columbus, Ohio), February 23, 1995, p. 9.

Nesbett, Peter. "The Ubiquitous Jacob Lawrence." *University of Washington School of Art Newsletter* (Seattle) 4 (spring 1995), p. 3.

Rass-Paulmier, Heike. "Perspectives of Struggle in American Life: Jacob Lawrence and Horace Pippin." *The Hammer* (Kansas City, Mo.) (spring 1995).

"Series of Paintings Depicts Mass Exodus to North." *Folk Art Finder* (Essex, Conn.) (spring 1995).

Wilkin, Karen. "The Naïve and The Modern: Horace Pippin and Jacob Lawrence." *The New Criterion* (New York) 13, 7 (March 1995), pp. 33–8.

Fitzgerald, Sharon. "The Homecoming of Jacob Lawrence." *American Visions* (Washington, D.C.) 10 (April–May 1995), pp. 20–5.

"Jacob Lawrence." *Scholastic Art* (Monroe, Ohio) 25 (April–May 1995), pp. 2–3.

"Jacob Lawrence: The 'Migration' Series." *Maine Antique Digest* (Waldoboro) (April 1, 1995).

Ramirez, Marc. "Children Play 'Touching' Tribute to Famed Artist." *Seattle Times*, April 1, 1995.

Eisenlau, Wilma. "Jacob Lawrence: The Migration Series." *Atlanta Bulletin*, April 22, 1995.

Borum, Jennifer P. "Reviews: New York, Jacob Lawrence." *Artforum* (New York) 33, 9 (May 1995), pp. 101–2.

May, Lee. "It's Our Story." *Atlanta Daily*, May 1, 1995, p. B10.

"Jacob Lawrence: The Migration Series." *Antiques and the Arts Weekly* (Atlanta) (May 5, 1995).

Rodgers, Joan S. "Guest of Honor. *Winston-Salem Journal* (N.C.), May 14, 1995, pp. E1–5.

Shuter, Marty. "The Migration Series." *Savannah News-Press* (Ga.), May 14, 1995.

Willis, Judy M. "Jacob Lawrence: A Painter of History." *Atlanta Tribune*, May 15, 1995, p. 57.

Clemons, Veronica. "Best Choice Kids Engage Artists." *Winston-Salem Chronicle* (N.C.), May 18, 1995, pp. 1–2.

Fox, Catherine. "Lawrence Captures Blacks' Flight North." *Atlanta Constitution*, May 19, 1995.

Mason, Doug. "'Migration Series' on First-Ever Tour." *Knoxville News-Sentinel* (Tenn.), May 21, 1995.

Bolz, Diane M. "A Kaleidoscope of Black Culture." *Smithsonian* (Washington, D.C.) 26, 4 (July 1995), p. 26.

"Jacob Lawrence: The Migration Series." *Urban Spectrum* (Denver), July 1995, pp. 13, 46.

Hayden, Niki. "Due North." *Sunday Camera* (Boulder, Colo.), July 9, 1995, pp. B1–2.

Rosen, Steven. "Painting the Great Migration." *Denver Post Magazine*, July 9, 1995, pp. 8–10.

Chandler, Mary Voelz. "Jacob Lawrence's Art Is Larger Than it Looks." *Rocky Mountain News* (Denver), July 16, 1995.

Paglia, Michael. "Gone with the Wind." *Westwood* (Denver) (August 2–8, 1995), p. 55.

Mullen, William. "The Great Migration." *Chicago Tribune Magazine*, September 24, 1995, pp. 22–4.

Tomlinson, Glenn C. "Jacob Lawrence." *Philadelphia Museum of Art Bulletin* 90 (winter 1995), pp. 18–9.

"Hampton University Lawrence Series." *International Review of African American Art* (Santa Monica, Calif.) 13, 4 (1996), p. 57.

Green, Roger. "Jacob Lawrence: Full Circle." *ARTnews* (New York) 95, 67 (March 1996), p. 67.

Pacheco, Patrick. "Giving Black Artists Their Due: Harmon and Harriet Kelley." *Art and Antiques* (New York) 19, 3 (March 1996), pp. 72–3.

Schwabsky, Barry. "Black Exodus." *Art in America* (New York) 84, 3 (March 1996), pp. 88–93.

Goddard, Dan R. "Stories Are Told through Artist's Works." *San Antonio Express-News*, March 30, 1996, pp. G1, G16.

"Other People Art Looking at Us: Visual Commentaries on Social Change." *American Visions* (Washington, D.C.) 11 (April–May 1996), pp. 14–9.

Goddard, Dan R. "Windows on History." *San Antonio Express-News*, April 7, 1996.

Kimmelman, Michael. "An Invigorating Homecoming: At the Met and Modern with Jacob Lawrence." *New York Times*, April 12, 1996, pp. C1, C4.

Hackett, Regina. "Masters of Their Domain." *Seattle Post-Intelligencer*, May 27, 1996, pp. D1, D5.

Updike, Robin. "The Perfect Art for Aesop." *Seattle Times*, July 18, 1996.

Kutner, Janet. "Algur Meadows Award Given to Jacob Lawrence." *Dallas Morning News*, August 29, 1996.

"Artistic Couple Lectures, Exhibits in Separate Shows in Dallas." *Dallas Examiner*, October 24, 1996.

Kutner, Janet. "Mast and Mentor." *Dallas Morning News*, October 25, 1996, pp. C1–2.

———. "A Week of Inspiration." *Dallas Morning News*, October 25, 1996.

Lovelace, Carey. "Looking at Art: The Artist's Eye, Jacob Lawrence." *ARTnews* (New York) 95, 11 (December 1996), pp. 79–80.

Wallis, Stephen. "Jacob Lawrence: Portrait of a Serial Painter." *Art and Antiques* (New York) 19, 11 (December 1996), pp. 58–64.

Thompson Dodd, Jacci. "Jacob Lawrence: Recent Work." *International Review of African American Art* (Santa Monica, Calif.) 14, 1 (1997), pp. 10–3.

"A Harlem Painter Reveals His Roots." *Choices in American Public Affairs* (Birmingham, Ala.) 37, 1 (February 1997), p. 8.

Day, Jeffrey. "The Road to Freedom." *State* (Greenville, S.C.) (February 2, 1997), pp. F1–2.

Sturrock, Staci. "The Beauty of Struggle." *Greenville News* (S.C.), February 2, 1997, pp. E1, E6.

Athineos, Doris. "Eternity Is Delusional." *Forbes* (New York) (June 16, 1997), p. 288.

Payne, Les. "Paintings That March to Harlem's Drum." *Newsday* (Hempstead, N.Y.), May 17, 1998.

Updike, Robin. "A Modern Master." *Seattle Times*, June 28, 1998, *Pacific Northwest* magazine, pp. 14–22.

Hackett, Regina. "Jacob Lawrence: A Life in Art." *Seattle Post-Intelligencer*, July 2, 1998, pp. D1, D9.

Raether, Keith. "'Landscapes' of a Painter's Life." *News Tribune* (Tacoma, Wash.), July 2, 1998, pp. 3–7.

Updike, Robin. "Jacob Lawrence." *Seattle Times*, July 2, 1998, pp. E1–2.

McTaggart, Tom. "'Life' Has Its Ups and Downs." *Seattle Weekly*, July 9, 1998, p. 22.

Glowen, Ron. "Art Reflects Black History and Struggle." *Bellingham Herald* (Wash.), July 10, 1998, p. 3.

Hackett, Regina. "The Public Side of Jacob Lawrence." *Seattle Post-Intelligencer*, July 17, 1998, p. 21.

Updike, Robin. "Maquette Show Offers Taste of Jacob Lawrence's Large Works." *Seattle Times*, July 23, 1998.

"The Art of Jacob Lawrence Graces Walls of The Henry." *Seattle Gay News*, August 14, 1998.

Bell, Shaniece A. "Art of the African World, Jacob Lawrence: One of the World's Most Preeminent Artists." *The Black Collegian* (New Orleans) (October 1998), pp. 12–3.

Stabile, Tom. "Reconstructing Jacob Lawrence: A Scholarly Team Prepares the Master Catalog." *Humanities* (Washington, D.C.) 19, 6 (November–December 1998), pp. 26–9.

Sidime, Aissatou. "Lifting the Veil." *Tampa Tribune* (Fla.), January 22, 1999, *Bay Life* magazine.

Bishop, Philip. "A Celebration of African-American Art and Culture." *Orlando Sentinel* (Fla.), January 24, 1999.

Deery, Todd. "Color Blinds." *Orlando Weekly* (Fla.), January 28–February 3, 1999.

Naves, Mario. "Five Painters." *The New Criterion* (New York) 17, 6 (February 1999), pp. 49–52.

Nesbett, Peter T. "An IFAR Evening: The Jacob Lawrence Catalogue Raisonné Project." *International Foundation for Art Research Journal* (New York) 2, 2 (spring 1999), pp. 10–3.

Viveros-Faune, Christian. "New York: Jacob Lawrence at DC Moore." *Art in America* (New York) 87, 4 (April 1999), p. 143.

Related Publications, Dissertations, Articles, and Reference Works

(in alphabetical sequence by author's last name or by title if no author is cited)

Adams, Russell L., ed. *Great Negroes Past and Present*. 3rd ed. Chicago: Afro-American, 1969, pp. 191–205.

African Americans: Voices of Triumph. Creative Fire. Alexandria, Va.: Time-Life Books, 1994.

Alford, Sterling G. *Famous First Blacks*. New York: Vantage, 1974.

Allan, Lois. *Contemporary Art in the Northwest*. North Ryden, Australia: Craftsman House Art Books, 1995.

All Praises Due II: Paintings by Charles Searles and Stephanie Weaver, Sculpture by John Simpson. Exh. cat. New York: The Studio Museum in Harlem, 1971.

Alverman, Donna, ed. *Rare as Hen's Teeth*. Lexington, Mass.: Heath & Co., 1989.

An American Gallery: Volume VI. New York: Richard York Gallery, 1990.

American Paintings: An Illustrated Catalogue. Washington, D.C.: National Gallery of Art, 1980.

American Paintings: An Illustrated Catalogue. Washington, D.C.: National Gallery of Art, 1992.

American Paintings and Sculpture in the University Art Museum Collection. Minneapolis: University of Minnesota, 1986.

Ames, Joan Evelyn. *Masterly: Interviews with Thirty Remarkable People*. Portland, Ore.: Rudra Press, 1997.

An Analysis of Prejudice and Discrimination. 4th ed. New York: Harper, 1972.

Andrews, Benny. *Between the Lines*. New York: Pella, 1978.

Arnason, H. H., Marla F. Prather, and Daniel Wheeler. *History of Modern Art*. New York: Harry N. Abrams, 1998.

"Art Exhibition at Library of Congress." In *The Negro Handbook*, edited by Florence Murray. New York: Current Reference Publications, 1942, pp. 221–2.

Artists of the World. Columbus, Ohio: Essential Learning Products, 1992.

Art Students League: Centennial Decade, 1967. New York: The Art Students League of New York, 1967.

Asch, Moses, and Alan Lomax. *The Leadbelly Songbook*. New York: Oak Publications, 1962.

Atkins, Robert. *Art Spoke: A Guide to Modern Ideas, Movements, and Buzzwords, 1848–1944*. New York: Abbeville, 1993.

Atkinson, J. Edward. *Black Dimensions in Contemporary American Art*. New York: New American Library, 1971.

Bader, Barbara. *American Picturebooks from Noah's Ark to the Beast Within*. New York: Macmillan, 1976.

Baigell, Matthew. *The American Scene: American Painting of the 1930s*. New York: Praeger Publishers, 1974.

Bardolph, Richard. *The Negro Vanguard*. New York: Rinehart, 1959.

Barnes, Marian E., and Linda Goss, eds. *Talk That Talk: An Anthology of African American Storytelling*. New York: Simon & Schuster, 1989.

Barr, Alfred H., Jr. *Painting and Sculpture in The Museum of Modern Art*. New York: The Museum of Modern Art, 1942. Rev. eds. 1948, 1958, 1977.

Baur, John I. H., ed. *New Art in America: Fifty Painters of the Twentieth Century*. Greenwich, Conn.: New York Graphic Society, 1957.

———. *Whitney Museum of American Art: Selections from the Permanent Collection*. Chicago: University of Chicago Press, 1976.

Bearden, Romare, and Carl Holty. *The Painter's Mind*. New York: Crown Publishers, 1967.

Bearden, Romare, and Harry Henderson. *Six Black Masters of American Art*. Garden City, N.Y.: Doubleday, 1972.

———. *A History of African-American Artists from 1972 to Present*. New York: Pantheon Books, 1993.

Benny Andrews: The Bicentennial Series. Exh. cat. Atlanta: High Museum of Art, 1975.

Bethers, Monica. *Pictures, Painters and You*. New York: Pitman, 1948.

Black Art: The Known and the New. Battle Creek, Mich.: n.p., 1977.

Black Artists and Images. Milwaukee: Milwaukee Art Museum, 1988.

Bond, Julian, and Sondra Kathryn Wilson, eds. *Lift Every Voice and Sing: One Hundred Years, One Hundred Voices*. New York: Random House, 2000.

Boning, Richard A. *Profiles of Black Americans*. Vol. 1. Rockville Center, N.Y.: Dexter and Westbrook, 1969.

Bontemps, Arna. *The Story of the Negro*. New York: Knopf, 1960.

Boswell, Peyton, Jr. "Painting and Sculpture." In *Americana Annual 1947: An Encyclopedia of the Events of 1946*. New York: Americana, 1947.

Bowling, Frank. "Is Black Art about Color?" In *Black Life and Culture in the United States*, edited by Rhoda Lois Blumberg. New York: Crowell, 1971, pp. 302–21.

The Britannica Encyclopaedia of American Art. Chicago: Encyclopaedia Britannica, 1973.

Britton, Crystal. *African American Art: The Long Struggle*. New York: Todtri, 1996.

Brown, Evelyn S. "The Harmon Awards." In Lindsay Patterson, *The Negro in Music and Art*. New York: Publishers Company, 1967, pp. 247–9.

Brown, Jacquelin Rocker. "The Works Progress Administration and the Development of an Afro-American Artist, Jacob Lawrence, Jr." Unpublished paper, Howard University, Washington, D.C., 1974.

Brown, Marion E. "The Negro in the Fine Arts." In John Preston Davis, *The American Negro Reference Book*. Englewood Cliffs, N.J.: Prentice-Hall, 1966, p. 744.

Brown, Milton W. *Norman Lewis: A Retrospective*. Exh. cat. New York: City University of New York, 1976.

Brown, Milton W., Sam Hunter, John Jacobs, Naomi Rosenblum, and David M. Sokol. *American Art*. New York: Harry N. Abrams, 1979.

Brown, Milton W., with the assistance of Judith H. Lanius. *One Hundred Masterpieces of American Painting*. Washington, D.C.: Smithsonian Institution Press, 1983.

Bumiller, Kristin. *The Civil Rights Society: The Social Construction of Victims*. Baltimore: The John Hopkins University Press, 1988.

Butcher, Margaret. *The Negro in American Culture*. 2nd ed. New York: Knopf, 1972.

Carpenter, James M. *Visual Art: A Critical Introduction*. New York: Harcourt Brace Jovanovich, 1982.

Catalog of One Hundred Seventeen Oil and Water Color Originals by Leading American Artists. Exh./Sale cat. Washington, D.C.: War Assets Administration, 1948.

Catalogue of the Collection. New York: Whitney Museum of American Art, 1975.

[*Catalogue of the Georgia Museum of Art Collection.*] Athens, Ga.: Georgia Museum of Art, University of Georgia, 1969.

Cederholm, Theresa Dickason. *Afro-American Artists: A Bio-bibliographical Directory*. Boston: Trustees of the Boston Public Library, 1973.

Chambers, Bruce W. *American Painting in the High Museum of Art*. Atlanta: High Museum of Art, 1975.

Chase, Judith Wragg. *Afro-American Art and Craft*. New York: Van Nostrand, 1971.

Chilvers, Ian. *A Dictionary of Twentieth-Century Art*. New York: Oxford University Press, 1998.

Christian, Charles M. *Black Saga: The African American Experience, A Chronology*. Washington, D.C.: Civitas, 1995.

Chwast, Seymour, and Steven Heller, eds. *The Art of New York*. New York: Harry N. Abrams, 1983.

Clapp, Jane. *Art in Life*. New York: Scarecrow, 1959.

———. *Art Reproductions*. New York: Scarecrow, 1961.

Clarke, John Henrik. *The Middle Passage: Our Holocaust*. Detroit: Dr. Walter O. Evans, 1991.

Coker, Gylbert. *The World of Bob Thompson*. Exh. cat. New York: The Studio Museum in Harlem, 1978.

Colbert, Cynthia, and Martha Taunton. *Discover Art: Kindergarten*. Worcester, Mass.: Davis Publications, 1990.

Conn, Peter. *Literature in America: An Illustrated History*. New York and London: Cambridge University Press, 1989.

Contemporary Art Collection. Atlanta: Atlanta University, 1959.

Craven, Wayne. *American Art: History and Culture*. New York: Harry N. Abrams, 1994.

The Cross Section of the Gallery of Art. Baltimore: Morgan State University, 1976.

Cummings, Paul. *Dictionary of Contemporary American Artists*. New York: St. Martin's Press, 1988.

DaSilva, Benjamin, Milton Finklestein, and Arlene Loshin. *The Afro-American in U.S. History*. New York: Globe, 1969.

Davidson, Marshall B. *The Artist's America*. New York: American Heritage, 1973.

Davidson, Marshall B., and the Editors of American Heritage. *The American Heritage History of the Artist in America*. New York: American Heritage, 1973.

Davidson, Martha, and William H. Pierson, Jr., eds. *Arts of the United States: A Pictorial Survey*. New York: McGraw-Hill, 1960.

Davis, Lenwood G., and Janet L. Sims. *Black Artists in the United States: An Annotated Bibliography of Books, Articles, and Dissertations on Black Artists, 1779–1979*. Westport, Conn.: Greenwood Press, 1980.

Denmark, James. "Black Artists in the United States." In *Black Life and Culture in the United States*, edited by Rhoda Lois Blumberg. New York: Crowell, 1971, pp. 295–301.

Descriptive Catalogue of Painting and Sculpture in the National Museum of American Art. Boston: G. K. Hall & Company, 1983.

Dixon, Vernon J., and Badi G. Foster. *Beyond Black or White*. Boston: Little Brown, 1971.

Doty, Robert. "The Introduction in the Catalog of the 'Contemporary Black Artists in America' Exhibition at the Whitney Museum, April 1971." In *Black Art Notes*, edited by Tom Lloyd. New York: 1971, pp. 31–6.

Dover, Cedric. *American Negro Art*. Greenwich, Conn.: New York Graphic Society, 1960.

Drotning, Philip T. *A Guide to Negro History in America*. Garden City, N.Y.: Doubleday, 1968.

Duberman, Martin. *Black Mountain: An Exploration in Community*. New York: Dutton, 1972.

Ebony Editions. *The Negro Handbook*. Chicago: Johnson Publishing Company, 1966. Reprints. 1971 and 1974.

Edwards, Louis. *Ten Seconds*. Saint Paul: Graywolf Press, 1991.

Eliot, Alexander. *Three Hundred Years of American Painting*. New York: Time, 1957.

———. *Art of Our Time, 1950–1960: Painting, Architecture, and Sculpture*. New York: Omicron, 1959.

Embree, Edwin R. *American Negros: A Handbook*. New York: John Day, 1942.

———. *Brown Americans: The Story of a Tenth of the Nation*. New York: Viking, 1943.

Encyclopedia of American Art. New York: E. P. Dutton, 1981.

The Eva Underhill Holbrook Memorial Collection of the Georgia Museum of Art. Athens, Ga.: Georgia Museum of Art, University of Georgia, 1953.

Fabre, Michel. *Les noirs américains*. Paris: Librarie Armand Colin, 1970.

Fax, Elton C. "The American Negro Artist, 1968." In *Black America: 1968—The Year of Awakening*, edited by Patricia Romero. Washington, D.C.: Publishers Company, 1969.

———. *Seventeen Black Artists*. New York: Dodd, Mead and Co., 1971.

———. *Black Artists of the New Generation*. New York: Dodd, Mead and Co., 1977.

Feldman, Edmund Burke. *Art as Image and Idea*. Englewood Cliffs, N.J.: Prentice-Hall, 1967.

———. *Becoming Human through Art*. Englewood Cliffs, N.J.: Prentice-Hall, 1970.

———. *Varieties of Visual Experience: Art as Image and Idea*. 2nd ed. Englewood Cliffs, N.J.: Prentice-Hall, 1972.

———. *Varieties of Visual Experience*. New York: Harry N. Abrams, 1980.

———. *The Artist*. Englewood Cliffs, N.J.: Prentice-Hall, 1982.

Feldman, Frances T. "American Painting during the Great Depression, 1929–1939." Ph.D. dissertation. New York: New York University, 1963.

Filsinger, Cheryl. *Locus*. New York: Filsinger, 1975.

Fine, Elsa Honig. *The Afro-American Artist: A Search for Identity*. New York: Hacker Art Books, 1973. Reprint, 1982.

Finkelstein, Sidney. *Realism in Art*. New York: International Publishers, 1954.

———. *Charles White, Ein Kunstler Amerikas*. Dresden, Germany: VEB Verlag der Kunst, 1955.

Fleming, G. James. *Who's Who in Colored America: A Biographic Dictionary of Notable Living Persons of Negro Descent in America 7*. New York: Christian E. Burkel & Associates, 1950.

Foner, Moe, ed. *Images of Labor*. New York: Pilgrim Press, 1981.

Franc, Helen M. *An Invitation to See: One Hundred Twenty-Five Paintings from The Museum of Modern Art*. New York: The Museum of Modern Art, 1973.

Freedgood, Lillian. *An Enduring Image: American Painting from 1665*. New York: Crowell, 1970.

Fresella-Lee, Nancy. *The American Paintings in the Pennsylvania Academy of the Fine Arts*. Philadelphia: Pennsylvania Academy of the Fine Arts in association with the University of Washington Press, 1989.

Fundaburk, Emma L., and Mary Douglass Foreman. *Art in the Environment in the U.S.* Luverne, Ala.: E.L. Fundaburk, 1975.

Fundaburk, Emma Lila, and Thomas G. Davenport. *Art in Public Places in the United States*. Bowling Green, Ohio: Bowling Green University Popular Press, 1975.

Gaither, Edmund Barry. "The Spiral of Afro-American Art." In *American Art Analog, Volume III, 1874–1930*, edited by Michael David Zellman. New York: Chelsea Home Publishers in association with American Art Analog, 1986.

Gardner, Albert Ten Eyck. *History of Water Color Painting in America*. New York: Reinhold Publishing, 1966.

Garraty, John Arthur. *The American Nation: A History of the United States, A History of Men and Ideas*. London: Penguin Press, 1968.

Geske, Norman A., and Karen O. Janovy. *The American Painting Collection of the Sheldon Memorial Art Gallery*. Lincoln, Nebr.: University of Nebraska Press, 1988.

Ghent, Henri. "Some Historical Facts." *Huit artists afro-américains*. Geneva: Musée Rath, 1971.

Gilbert, Dorothy, B., ed. *Who's Who in American Art*. New York: R. R. Bowker, 1956.

Glubak, Shirley. "American Paintings." In *Freedom's Ground*, edited by Bernard J. Weiss and Lyman C. Hunt. New York: Holt, 1973.

———. *The Art of America since World War II*. New York: Macmillan, 1976.

Goodrich, Lloyd, and John I. H. Baur. *American Art of Our Century*. New York: Frederick A. Praeger, 1961.

Gordon, John, and L. Rust Hills. *New York, New York*. New York: Shorecrest, 1965.

Goss, Linda, and Marian E. Barnes, eds. *Talk That Talk: An Anthology of African American Storytelling*. New York: Simon & Schuster, 1989.

Green, Samula M. *American Art: A Historical Survey*. New York: Ronald, 1966.

Grisby, Jefferson Eugene, Jr. *Art and Ethics: Background for Teaching Youth in a Pluralistic Society*. Dubuque, Iowa: William C. Brown, 1977.

Gruskin, Alan. *Painting in the U.S.A.* Garden City, N.Y.: Doubleday & Co., 1946.

Guenther, Bruce. *Fifty Northwest Artists: A Critical Selection of Painters and Sculptors Working in the Pacific Northwest*. San Francisco: Chronicle Books, 1983.

Guide to Manuscripts and Archives in the Negro Collection of the Trevor Arnett Library. Atlanta: Atlanta University, 1971.

A Guide to the Public Art Collection of the Harold Washington Library Center. Chicago: Department of Public Affairs, 1993.

Guzman, Jessie Parkhurst. *The Negro Year Book: A Review of Events Affecting Negro Life 10 (1941–1946)*. Tuskegee, Ala.: Tuskegee Institute, Negro Year Book Publishing, 1947.

———. *The Negro Year Book: A Review of Events Affecting Negro Life 11 (1947–1951)*. Tuskegee, Ala.: Tuskegee Institute, Negro Year Book Publishing, 1952.

Halasz, Piri. "Directions, Concerns and Critical Perceptions of Paintings Exhibition in New York, 1940–1949: Abraham Rattner and His Contemporaries." Ph.D. dissertation. New York: Columbia University, 1982.

Hale, Robert Beverly. *One Hundred American Painters of the Twentieth Century*. New York: The Metropolitan Museum of Art, 1950.

Haley-James, Shirley. *English*. New York: Houghton Mifflin, 1990.

Havlice, Patricia Pate. *Art in Time*. Metuchen, N.J.: Scarecrow, 1970.

Hayes, Vertis. "The Negro Artists of Today." In Francis V. O'Connor, *Art for the Millions: Essays from the 1930s by Artists and Administrators of the WPA Federal Art Project*. Greenwich, Conn.: Graphic Society, 1973.

Henning, William, Jr. *Recent Acquisitions*. Chattanooga, Tenn.: Hunter Museum, 1982.

Herberholz, Donald, and Barbara Herberholz. *Artworks for Elementary Teachers*. 7th ed. Madison, Wis.: Brown and Benchmark, 1994.

"Hirshhorn Museum and Sculptural Garden." *African and African American Resources at the Smithsonian*. Washington, D.C.: Smithsonian Press, 1992.

Holifield, Karl. *George Washington Bush, Pioneer-Settler*. Olympia, Wash.: State Capitol Museum, 1994.

hooks, bell. *Outlaw Culture: Resisting Representation*. New York: Routledge, 1994.

Hoopes, Donelson, Jr. *American Watercolor Painting*. New York: Watson-Guptill, 1977.

Hopkins, Lee Bennett. *Important Dates in Afro-American History*. New York: Watts, 1969.

Horowitz, Benjamin. "Images of Dignity." In *Charles White*. Washington, D.C.: Howard University, 1967. Reprint. *The Drawings of Charles White*. Los Angeles: Ward Ritchie Press, 1968.

Huggins, Nathan Irvin. *Harlem Renaissance*. London, Oxford, and New York: Oxford University Press, 1971.

Huggins, Nathan Irvin, Martin Kilson, and Daniel M. Fox. *Key Issues in the Afro-American Experience*. New York: Harcourt, 1971.

Hughes, Langston, Milton Meltzer, and C. Eric Lincoln. *A Pictorial History of Black America*. 5th ed. New York: Crown Publishers, 1993.

Hughes, Robert. *American Visions: The Epic History of America in Art*. New York: Alfred A. Knopf, 1997.

Hume, Helen D. *A Survival Kit for the Secondary School Art Teacher*. West Nyack, N.Y.: Center for Applied Research in Education, 1990.

Huyghe, René. *Larousse Encyclopedia of Modern Art: From 1800 to the Present Day*. New York: Prometheus, 1965.

Igoe, Lynn Moody, with James Igoe. *Two Hundred Fifty Years of Afro-American Art: An Annotated Bibliography*. New York: R. R. Bowker Company, 1981.

Ingersoll, R. Sturgis. *The Louis E. Stern Collection*. Philadelphia: Philadelphia Museum of Art, 1964.

Introduction to the Collections. Rev. ed. Raleigh, N.C.: North Carolina Museum of Art, 1992.

Irvine, Betty Jo. *Fine Arts and the Black American*. Bloomington, Ind.: Indiana University Libraries, 1969.

Janson, H. W., and Anthony F. Janson. *History of Art*. New York: Harry N. Abrams, 1997.

Jefferson, Louise E. *Twentieth-Century Afro-Americans of Negro Lineage*. New York: Friendship Press, 1965.

Jefferson, Marjorie. *The Role of Racial Minorities in the U.S.: A Resource Book for Seattle Teachers*. Seattle: Seattle Public Schools, 1968.

Kaye, Harvey J. *Why Do the Ruling Classes Fear History?* New York: St. Martin's Griffin, 1997.

Kloss, William. *Treasures from the National Museum of American Art*. Washington, D.C.: National Museum of American Art and Smithsonian Press, 1985.

Krantz, Les. *American Artists: An Illustrated Survey of Leading Contemporary Americans*. New York: Facts on File Publications, 1985.

Lane, Christopher. *The Psychoanalysis of Race*. New York: Columbia University Press, 1998.

Larkin, Oliver W. *Art and Life in America*. New York: Rinehart & Company, 1950. Rev. ed. New York: Holt, Rinehart and Winston, 1960.

Larsen, Susan C. *Bold Strokes and Quiet Gestures: Twentieth-Century Drawings and Watercolors from the Santa Barbara Museum of Art*. Kansas City, Mo.: Mid-America Arts Alliance, 1992.

Lerner, Abram, ed. *The Hirshhorn Museum and Sculpture Garden*. New York: Abrams, 1974.

Lewis, Samella. *African American Art and Artists*. Berkeley, Calif.: University of California Press, 1990.

Lewis, Samella, and Ruth G. Waddy. *Black Artists on Art*. Los Angeles: Contemporary Crafts Publishers, 1969.

Lincoln, Charles Eric. *The Negro Pilgrimage in America*. New York: Bantam Pathfinder Books, 1967.

Lindey, Christine. *Art in the Cold War: From Vladivostok to Kalamazoo, 1945–1962*. New York: New Amsterdam Books, 1990.

Lipman, Jean. *What Is American in American Art?* New York: McGraw-Hill, 1963.

Lipman, Jean, and Helen M. Franc. *Bright Stars: American Painting and Sculpture since 1976*. New York: E. P. Dutton, 1976.

Littell, Joseph, ed. *The Language of Man*. Geneva, Ill.: McDougal, Littell & Co., 1971.

Locke, Alain. *The Negro in Art: A Pictorial Record of the Negro Artist and of the Negro Theme in Art*. Washington, D.C.: Associates in Negro Folk Education, 1940. Reprint. New York: Hacker Art Books, 1971.

Logan, Rayford Whittingham, and Irving S. Cohey. *The American Negro: Old World Background and New World Experience*. Boston: Houghton Mifflin, 1967.

Louis, Louis. *Ten Seconds*. Saint Paul: Graywolf Press, 1991.

Lucie-Smith, Edward. *Race, Sex, and Gender in Contemporary Art*. New York: Harry N. Abrams, 1994.

Mallett, Daniel Trowbridge. *Supplement to Mallett's Index of Artists*. New York: Peter Smith, 1948.

Martin Nagy, Rebecca, ed. *North Carolina Museum of Art: Handbook of the Collections*. Raleigh, N.C.: North Carolina Museum of Art, 1998.

Masterworks by Twentieth-Century African-American Artists. Exh. cat. Springfield, Ohio: Springfield Museum of Art, 1998.

Matney, William, ed. *Who's Who among Black Americans*. NorthBrook, Ill.: Who's Who among Black Americans, Inc. Publishing Co., 1976–7 [Included every year through 1999].

McCoubrey, John W. *American Painting 1900–1970*. New York: Time-Life Books, 1971.

McCurdy, Charles. *The American Tradition in the Arts*. New York: Harcourt, 1968.

———, ed. *Modern Art: A Pictorial Anthology*. New York: The Macmillan Company, 1958.

McLanathan, Richard. *The American Tradition in the Arts*. New York: Harcourt, Brace & World, 1968.

McPherson, James M., Lawrence B. Holland, James M. Banner, Jr., et al. *Blacks in America Bibliographic Essays*. Garden City, N.Y.: Doubleday, 1971.

Meltzer, Milton. *Violins and Shovels: The WPA Art Project*. New York: Delacorte Press, 1976.

Mendelowitz, Daniel. *A History of American Art*. 2nd ed. New York: Holt, 1970.

Miesel, Victor H. "Art." In *The Americana Annual 1969*. New York: Americana, 1969, pp. 95–9.

———. "Art." In *The Americana Annual 1971*. New York: Americana, 1971, pp. 110–4.

Millhouse, Barbara, with Robert Workman. *American Originals: Selections from Reynolda House, Museum of American Art*. New York: American Federation of Arts and Abbeville Press, 1990.

Monro, Isabel Stevenson, and Kate M. Monro. *Index to Reproductions of American Paintings*. New York: Wilson, 1948. Supplement. New York: Wilson, 1964.

Morris, Kelly, ed. *Highlights from the Collection: Selected Paintings, Sculpture, Photographs, and Decorative Art*. Atlanta: High Museum of Art, 1994.

Morsbach, Mabel. *The Negro in American Life*. New York: Harcourt, 1967.

Murray, Alma, and Robert Thomas, eds. *Black Perspectives*. New York: Scholastic Book Service, 1971.

Murray, Florence. *The Negro Handbook*. New York: Current Reference Publications, 1942. 2nd and 3rd eds. 1944 and 1947.

Myers, Bernard S., ed. *Encyclopedia of Painting*. New York: Crown Publishers, 1955.

Myers, Bernard S., and Shirley D. Meyers. *Dictionary of Twentieth Century Art*. New York: McGraw-Hill, 1974.

Negri, Antonello. *Tendenze del Realismo Nel Ventesimo Secolo*. Bari, Italy: Laterza, 1992.

Newmeyer, Sarah. *Enjoying Modern Art*. New York: Reinhold Publishing Company, 1955.

New Orleans Stories: Great Writers on the City. San Francisco: Chronicle Books, 1992.

New York Art Directors Club. *Twenty-Sixth Annual of Advertising and Editorial Art of the New York Art Directors Club*. New York: Pitman, 1947.

———. *Twenty-Eighth Annual of Advertising and Editorial Art of the New York Art Directors Club*. New York: Pitman, 1949.

New York Times Biographical Edition 5, 1. New York: Arno Press, 1974.

O'Connor, Francis V. *Federal Support for the Visual Arts: The New Deal Then and Now*. Greenwich, Conn.: New York Graphic Society, 1969.

———. *The New Deal Art Projects: An Anthology of Memories*. Washington, D.C.: Smithsonian Institution Press, 1972.

———, ed. *Art for the Millions: Essays from the 1930s by Artists and Administrators of the WPA Federal Art Project*. Greenwich, Conn.: New York Graphic Society, 1973.

Olana's Guide to American Artists: A Contribution towards a Bibliography (Vol. 1). Riverdale, N.Y.: Olana Gallery, 1978.

Osborne, Harold. *The Oxford Companion Guide to Twentieth-Century Art*. New York: Oxford, 1981.

Ottley, Roi. *Black Odyssey*. New York: Scribner's, 1948.

"Painting and Sculpture." *The Americana Annual 1961*. New York: Americana, 1961, pp. 566–70.

Paintings and Sculpture in the Permanent Collection. Tucson, Ariz.: Museum of Art, University of Arizona, 1983.

Paintings by Lois Mailou Jones. Exh. brch. Washington, D.C.: Alpha Kappa Alpha Sorority, Xi Omega Chapter, 1948.

Paintings in the Detroit Institute of Arts: A Checklist of the Paintings Acquired before June 1965. Detroit: The Detroit Institute of Arts, 1965.

Patterson, Lindsay. *International Library of Negro Life and History: The Negro in Music and Art*. New York: Publishers Company, 1967.

Patterson, Orlando. *Rituals of Blood: Consequences of Slavery in Two American Centuries*. Washington, D.C.: Civitas, 1998.

Patton, Sharon F. *African-American Art*. Oxford and New York: Oxford University Press, 1998.

Pearson, Ralph M. *The Modern Renaissance in American Art: Presenting the Work and Philosophy of Fifty-Four Distinguished Artists*. New York: Harper & Brothers, 1954.

The Permanent Collection of the Studio Museum in Harlem. New York: The Studio Museum in Harlem, 1983.

Phillips, Marjorie. *Duncan Phillips and His Collection*. Boston: Little, 1970.

The Phillips Collection Catalog. Washington, D.C.: The Phillips Collection, 1952.

Pierson, William H., Jr., and Martha Davidson, eds. *Arts of the United States: A Pictorial Survey*. New York: McGraw-Hill, 1960.

Piper, David. *The Illustrated Dictionary of Art and Artists*. New York: Random House, 1984.

Ploski, Harry A., and Ernest Kaiser. *Afro USA*. New York: Bellwether, 1971.

———. *The Negro Almanac*. Rev. ed. New York: Bellwether, 1971.

Ploski, Harry A., and James Williams. *The Negro Almanac: A Reference Work on African Americans*. New York: Gale Research, 1989.

Ploski, Harry A., and Roscoe C. Brown. *The Negro Almanac*. New York: Bellwether, 1967.

Ploski, Harry A., and Warren Marr II. *The Negro Almanac: A Reference Work on the Afro American*. 3rd. ed. New York: Bellwether, 1976.

Ploski, Harry A., Otto J. Lindenmayer, and Ernest Kaiser. *Reference Library of Black America*. Vol. 4. New York: Bellwether, 1971.

Porter, James A. *Modern Negro Art*. New York: The Dryden Press, 1943. Reprint. Washington, D.C.: Howard University Press, 1992.

———. "American Negro Art." In *Encyclopedia of the Arts*, edited by Dagobert D. Runes and Harry G. Schrickel. New York: Philosophical Library, 1946.

———. "One Hundred-Fifty Years of Afro-American Art." In *Prints by American Negro Artists*, edited by T.V. Roelof-Lanner. 2nd ed. Los Angeles: Culture Exchange Center, 1957.

———. "L'Art afro-americain contemporarian." In *Colloque: Fontion et signification de l'art negre dans la vie du peuple et pour le peuple. Premier Festival mondial des arts negres DAKAR*. Paris: Editions Presence Africaine, 1967.

———. "Contemporary Black Art." In Joseph S. Roucek and Thomas Kiernan, *The Negro Impact on Western Civilization*. New York: Philosophical Library, 1970.

Powell, Richard J. *Black Art and Culture in the Twentieth Century*. London: Thames and Hudson, 1997.

Preston, Stuart. "Painting in the United States: 1885–1957." In Charles McCurdy, *Modern Art: A Pictorial Anthology*. New York: Macmillan, 1958.

Puma, Fernando. *Modern Art Looks Ahead*. New York: The Beechhurst Press, 1947.

Rauschenbusch, Dr. Helmut. *International Directory of Arts*. 10th ed. Berlin: Deutsche Zentral druckerie, 1969/1970.

Reiff, Robert. "Lawrence, Jacob." In *McGraw-Hill Dictionary of Art*, edited by Bernard S. Myers. New York: McGraw-Hill, 1969.

———. "Lawrence, Jacob." In *Dictionary of Twentieth Century Art*, edited by Bernard S. and Shirley D. Myers. New York: McGraw-Hill, 1974.

Reynolds, Jock. *American Abstraction at the Addison*. Andover, Mass.: Addison Gallery of American Art, Phillips Academy, 1991.

Richardson, Ben. *Great American Negros*. New York: Crowell, 1956.

Richardson, E. P. *Painting in America: The Story of Four Hundred Fifty Years*. New York: Crowell, 1956.

———. *A Short History of Painting in America: The Story of Four Hundred Fifty Years*. New York: Crowell, 1963.

Robertson, Bruce. "Yankee Modernism." In *Picturing Old New England: Image and Memory*. Washington, D.C.: National Museum of American Art, Smithsonian Institution, 1999.

Rodman, Selden. *Horace Pippin: A Negro Painter in America*. New York: Quadrangle Press, 1947.

———. *Conversations with Artists*. New York: Devin-Adair, 1957.

Romare Bearden: The Prevalence of Ritual. Exh. cat. New York: The Museum of Modern Art, 1971.

Rose, Barbara. *American Art since 1900: A Critical History*. New York: Frederic A. Praeger, 1968.

Rosenblum, Paula R. "A Film Study of Jacob Lawrence." Ph.D. dissertation, University of Oregon, 1979.

Sayre, Henry. *A World of Art*. Upper Saddle River, N.J.: Prentice-Hall, 1997.

Schapiro, David, ed. *Social Realism: Art as Weapon*. New York: Patrick Ungar Publishing Company, 1973.

Schatz, Walter, ed. *Directory of Afro-American Resources*. New York: Bowker, 1971.

Schneider Adams, Laurie. *A History of Western Art*. New York: Harry N. Abrams, Inc., 1994.

Schulte-Nordholt, Dr. J. W. *Het volk dat in duisternis wandelt: de geschiedenis van de Negers in Amerika*. Arnhem, Netherlands: Van Loghum Slaterus, 1956. In Dutch.

———. *The People That Walk in Darkness: The History of the Negros in America*. New York: Ballantine, 1960.

Schwartz, Barry. *The New Humanism: Art in a Time of Change*. New York: Praeger, 1974.

Schwartzman, Myron. *Romare Bearden: His Life and Art*. New York: Harry N. Abrams, 1990.

The Sculpture of Richard Hunt. New York: The Museum of Modern Art, 1971.

Selected Works: Outstanding Painting, Sculpture, and Decorative Art from the Permanent Collection. Atlanta: High Museum of Art, 1987.